FILM MANIFESTOS AND GLOBAL CINEMA CULTURES

A Critical Anthology

Scott MacKenzie

UNIVERSITY OF CALIFORNIA PRESS

Berkeley Los Angeles London

University of California Press, one of the most distinguished university presses in the United States, enriches lives around the world by advancing scholarship in the humanities, social sciences, and natural sciences. Its activities are supported by the UC Press Foundation and by philanthropic contributions from individuals and institutions. For more information, visit www.ucpress.edu.

University of California Press
Berkeley and Los Angeles, California

University of California Press, Ltd.
London, England

For acknowledgments of permissions, see page 635.

Library of Congress Cataloging-in-Publication Data

MacKenzie, Scott, 1967–.
 Film manifestos and global cinema cultures : a critical anthology / Scott MacKenzie.
 p. cm.
 Includes index.
 ISBN 978-0-520-27674-1 (cloth : alk. paper)
 1. Motion pictures—Philosophy. I. Title.
 PN1995.M2335 2014
 791.4301—dc23 2013025528

Manufactured in the United States of America

23 22 21 20 19 18 17 16 15 14
10 9 8 7 6 5 4 3 2 1

The paper used in this publication meets the minimum requirements of ANSI/NISO Z39.48–1992 (R 2002) (Permanence of Paper).

CONTENTS

ACKNOWLEDGMENTS

This book has been a long time in the making as I have searched far, wide, and somewhat obsessively for film manifestos over the course of the last few years. I was aided in this Sisyphean task by a great many people who passed on manifestos, provided hard-to-find articles and essays on manifesto movements, helped me track down the diverse and often obscure documents I needed, and discussed in detail their own thoughts and theories on film and moving image manifestos. Many thanks, then, to those who sent materials my way, answered emails, spent time talking about niches in film history with which I was relatively unfamiliar, and all in all made this book far better as a result of their collegiality and generosity: Hata Ayumi, John Belton, Moinak Biswas, Marcel Beltrán, Paul Coates, Donald Crafton, Scott Forsyth, John Greyson, Lillah Halla, Sharon Hayashi, Jennie Holmes, Eli Horwatt, Takahiko Iimura, Stephen Kent Jusick, Ali Kazimi, David Kidman, Chuck Kleinhans, Paisley Livingston, Alan Lovell, Tadeusz Lubelski, Scott MacDonald, Nicholas Mercury, Sahar Moridani, Laura Mulvey, Zuzana M. Pick, Paula Potter, Eric Rentschler, Sarah Schulman, Elena Pinto Simon, Martin Stollery, Ava Tews, Thomas Waugh, and Brian Winston. Joseph Ditta at the New York Historical Society generously located and passed along some hard-to-find material, as did Mike Hamilton at the University of Toronto's Media Commons.

I must also thank the film studies and production students in my 2006–2007 film theory class at York University, all of whom wrote manifestos and took part in a project called *Manifest This!* My two teaching assistants, Shana MacDonald and Aimée Mitchell, went above and beyond the call of duty, helping type out student manifestos, writing their

own screeds, and co-organizing the *Manifest This!* launch-declamation event in which the students read out their manifestos (not on a soapbox but on a chair in a pub). I must also thank Aimée for pointing me in the direction of the Hye Bossin manifesto. Thanks also go to John McCullough, the head of film studies at York at the time, who allotted funds to print up the manifestos.

The book benefited greatly from the Experimental Writing Workshop in 2011; the workshop is held each year in conjunction with the Independent Imaging Workshop ("Film Farm") in Mount Forest, Ontario. The participants that year, Susan Lord and Mike Zryd, along with my co-organizer Janine Marchessault, helped structure the book and forced me to clarify many of my more extreme pronouncements (a process that goes hand in hand with writing on manifestos). Mike in particular compelled me to formalize my thoughts on "manifesto films," a concept he thought outlandish and untenable (and one about which, of course, he might very well be right). For Mike and Susan's collegiality, feedback, insights, friendship, and support, I offer my thanks.

The book was completed as I took up a post at Queen's University. My new colleagues in the Department of Film and Media deserve thanks for combining intellectual stimulation and generous conviviality.

Many friends, colleagues, and collaborators have played a central and ongoing role in the development and realization of this book. Thanks go first to Mette Hjort, as the work we did together on both national cinemas and Dogme '95 led me to consider the role of manifestos more generally in film culture. Thanks also to Bill Wees, whose course on the history of avant-garde cinema introduced me to avant-garde, experimental, and found footage film when I was an undergraduate at McGill. Having shared countless taco lunches with me over the past fifteen years, Bill has been a key resource for all things avant-garde, including introducing me to many of the manifestos that populate these pages. He's also been a great friend. Brenda Longfellow's friendship, acuity, and solidarity, over many glasses of red wine, were indispensable components in the completion of the book and in thinking through the political implications of many of the manifestos contained herein, especially those related to feminism and third cinemas. Anna Stenport also deserves a great deal of thanks for motivating me in her resolute and tenacious way to get this project finished, so I could move on to the next one, with her, on the Arctic. As the book was cascading to its conclusion, Anna read through all the introductory material for each chapter and offered incisive and invaluable feedback, all the while maintaining a glass-half-full attitude toward my writing, cheering me toward the finish line.

My partner, Darlene, put up with what must have seemed like (because it almost was) a never-ending project, providing many pleasurable diversions and some truly magnificent rants (she was born to write manifestos). She also helped with the Herculean task of data entry and, with a great deal of mock rage and good humor, argued with the ideas put forth in the manifestos that she undertook the unenviable task of transcribing, given her background in scientific thought. For this, her support, dark sense of humor, and so much more, she deserves my profound thanks and heartfelt gratitude.

Finally, I thank Janine Marchessault and Phil Hoffman. Much of the editorial material in the book was composed during writing sessions with Janine, who supported this project from the beginning. She read drafts of the editorial material, brainstormed endlessly, and was my main sounding board for the ideas in the book. Indeed, the present structure of the book came about after I spent a weekend talking with Janine and Phil. Janine was discussing the extensive primary materials she was using in her book on Expo '67. A couple of hours later, Phil handed me a copy of Fernando Birri's *Birth Certificate of the . . . School of Three Worlds* manifesto, saying, "I don't think you've seen this." The realization that my book ought to be built around the combination of primary materials composed of the plethora of manifestos that many film and media scholars have heard of but never seen, or indeed have just never heard of, became the backbone of the project and crystallized through the synthesis of these two conversations. Their friendship, generosity of spirit, and intellectual and artistic stimulation (as well as our shared, near-obsessive love of *The Office* and *Kitchen Nightmares*) have been a constant source of inspiration and, in the latter parenthetical case, pleasurable distraction for me. For all these reasons, and too many more to enumerate, I offer my heartfelt thanks.

The first steps of this project were possible thanks to initial funding from the British Academy. Queen's University generously provided a Fund for Scholarly Research and Creative Work and Professional Development research grant, which allowed me to undertake research at La Cinémathèque française in Paris; the Library of Congress in Washington, DC; and the British Film Institute in London.

Any mistakes remaining herein are my own.

INTRODUCTION

"An Invention without a Future"

The cinema is an invention without a future.
—LOUIS LUMIÈRE, AUTHOR OF THE
FIRST FILM MANIFESTO

To forge oneself iron laws, if only in order to obey
or disobey them *with difficulty* . . .
—ROBERT BRESSON, *NOTES ON THE CINEMATOGRAPHER*

THE FOURTH COLUMN

Manifestos are typically understood as ruptures, breaks, and challenges to the steady flow of politics, aesthetics, or history. This is equally true of film and other moving image manifestos. Paradoxically, film manifestos pervade the history of cinema yet exist at the margins of almost all accounts of film history itself. An examination of this elision raises not simply the question of whether manifestos have changed the cinema (even if their existence has often been marginalized in film history) but whether the act of calling into being a new form of cinema changed not only moving images but the world itself. For this proposition to make any sense at all, one cannot take moving images to be separate from the world or to be simply a mirror or reflection of the real. Instead, one must see moving images as a constitutive part of the real: as images change, so does the rest of the world. By way of introduction to *Film Manifestos and Global Cinema Cultures,* I examine what exactly a manifesto is, consider the role played by manifestos in film culture, offer an overview of some of the film manifestos and manifesto movements covered in the book, and map out a critical model of what constitutes a film manifesto and a manifesto-style of writing. My aim is to outline a theoretically informed counterhistory that places film manifestos, often neglected, at the center of film history, politics, and culture.

Film manifestos are a missing link in our knowledge of the history of cinema production, exhibition, and distribution. Often considered a subset of aesthetics or mere political propaganda, film manifestos are better understood as a creative and political engine, an often unacknowledged force pushing forward film theory, criticism, and history. Examining these writings as a distinct category—constituting calls to action for political and aesthetic changes in the cinema and, equally important, the cinema's role in the world—allows one not only to better understand their use-value but also the way in which

they have functioned as catalysts for film practices outside the dominant narrative paradigms of what Jean-Luc Godard pejoratively calls "Hollywood-Mosfilm." Yet manifestos and manifesto-style writing have also greatly influenced, and indeed regulated, narrative cinema, especially that of the classical Hollywood period.

One of the other goals of *Film Manifestos and Global Cinema Cultures* is to reconsider the status of the film manifesto in film theory and history. Part of my desire to do this stems from my coming of age, as an academic, during the "theory wars" of the 1990s (nowhere near as sexy as the "Clone Wars" but similarly populated with mutterings about the "dark side"). Many of the most contentious essays at the center of the "theory wars" are better understood not as theory *qua* theory, in some empirical sense, but as manifestos—calls to arms to change, destroy, and reimagine the cinema. Certainly, this is the political and aesthetic power that lies behind a multitude of central writings on the cinema, from Sergei Eisenstein's "The Method of Making Workers' Films," and Dziga Vertov's "WE: Variant of a Manifesto" through Laura Mulvey's "Visual Pleasure and Narrative Cinema" and Claire Johnston's "Women's Cinema as Counter-Cinema" (indeed, some of the writings from the analytic side of the debate by Noël Carroll and Gregory Currie can be read as manifestos for film theory itself).[1] To get tied up in positivist arguments about the empirical nature of these texts is to miss the means by which they functioned as catalysts for writers and filmmakers alike to reimagine the cinema.

Film Manifestos and Global Cinema Cultures brings together film manifestos from the global history of cinema, constituting the first historical and theoretical account of the role played by film manifestos in filmmaking and film culture.[2] Focusing equally on political and aesthetic manifestos (and the numerous ones that address the relationship between aesthetics and politics), *Film Manifestos and Global Cinema Cultures* uncovers a neglected yet central history of cinema through the exploration of a series of documents that postulate ways in which to reimagine the medium, how moving images intervene in the public sphere, and the ways film might function as a catalyst to change the world. Many film manifestos accomplish these goals by foregrounding the dialectical relationship between questions of aesthetic form and political discourse, raising salient questions about how cinematic form is in and of itself a form of political action and intervention in the public sphere. Indeed, one of the defining characteristics of film manifestos could be understood by the maxim "aesthetics as action."

Film Manifestos and Global Cinema Cultures brings together key manifestos of the last 110 years, alongside many little-known manifestos that, despite their obscurity, have nevertheless served to challenge and reimagine cinema aesthetics, politics, distribution, production, and exhibition. To this end the book includes the major European manifestos (those of Sergei Eisenstein, François Truffaut, Free Cinema, Oberhausen, Dogme '95, et al.), the Latin American political manifestos (Fernando Birri, Jorge Sanjinés, Julio García Espinosa, Fernando Solanas, et al.), those of the postcolonial nation-state independence movements (Scotland, Québec, Palestine) and those of avant-garde filmmakers and writers (Stan Brakhage, Maya Deren, Jonas Mekas, Keith Sanborn, et al.). *Film*

Manifestos and Global Cinema Cultures also brings to light many manifestos largely unknown in Anglo-American film culture, as the book contains many previously untranslated manifestos authored or coauthored by figures such as Icíar Bollaín, Luis Buñuel, Guy Debord, Jean-Luc Godard, Jaime Humberto Hermosillo, Isidore Isou, Krzysztof Kieślowski, and François Truffaut. The book also includes thematic sections addressing documentary cinema, feminist and queer film cultures, and state-controlled filmmaking and archives. Furthermore, it includes texts that have been traditionally left out of the canon of film manifestos, such as the Motion Picture Production Code and Pius XI's *Vigilanti Cura*, which have nevertheless played a central role in film culture (indeed, the Production Code can be seen as the most successful film manifesto of all time). Finally, I have also included many local manifestos, ones that were influential in specific scenes and micromovements. The counterhistory that emerges from these varied texts brings to life, in essence, a new history of the cinema.

WHAT IS A MANIFESTO?

Before turning to film manifestos, consideration must be given to what, in general, constitutes a manifesto. To begin, then, a perhaps audacious claim: the last three thousand years of Judeo-Christian history are based on a manifesto. The Decalogue, or the Ten Commandments, declaimed in both Exodus and Deuteronomy, functions as Western culture's first and most definitive manifesto. The rules it sets out defined the basic structures around which Western culture has organized itself and its belief systems. The Commandments, like any good subsequent manifesto, offer not only rules to live by but nothing less than a totalizing vision of how one ought to live one's life. An examination of the Decalogue also allows one to delineate the difference between a manifesto and what could be more broadly construed as rules: "You shall have no other gods before me" or "You shall not make wrongful use of the name of the Lord your God" (Exodus 20:3, 7; and Deuteronomy 5:7, 11) are imperatives that effect one's morality and ethics in a way that "don't run with scissors" does not (even though the latter may be considered a more pragmatic piece of advice).

While the Decalogue is only the most prominent of the myriad of totalizing theological proclamations of the way in which one ought to live one's life, contemporary manifestos and our understanding of them date from the upheavals of the eighteenth and nineteenth centuries, most notably with the United States' Declaration of Independence of 1776, the Constitution of 1788, and the Bill of Rights of 1791; France's Déclaration des droits de l'homme et du citoyen of 1789; and Karl Marx and Friedrich Engels's *Manifest der Kommunistischen Partei (The Communist Manifesto)* of 1848. These foundational documents of two of the three competing ideologies of the twentieth century (the other being fascism) have taken on a quasi-religious status, partly replacing old messianic principles with newly found societal and secular ones; for instance, James Madison once referred to the founding American documents as "political scripture." Here, the political

manifesto takes on the totalizing role of societal definition once held by the Decalogue. Indeed, Fredric Jameson sees connections between these forms of writings, codifies both manifestos and constitutions as subsets of utopian writing, and delineates the four different kinds of utopian writing: "the manifesto; the constitution; the 'mirror of princes'; and great prophecy, which includes within itself that mode called satire."[3] All four kinds of writing can be seen as means by which to reimagine the world by calling a new world into being through the act of writing.

The aesthetic manifesto demonstrates many of the same qualities as the classical political manifesto, even when lacking an overt political or ideological goal. The rules put forth in aesthetic manifestos set structures that not only pertain to artistic form but do so with the implicit or explicit belief that following aesthetic rules in artistic production has political, social, and cultural consequences in the world at large. The rules or constraints placed on poetic form, from haiku to iambic pentameter, may lead to aesthetically pleasing texts, but the rules themselves don't speak to larger cultural, political, or aesthetic issues. Aesthetic manifestos, then, make claims about not only the formal aspects of art but the ways in which these formal rules will help transform the world at large.

What constitutes the preferred discursive model of the manifesto in order to bring this transformation into being is open to debate. As a form of speech, manifestos have been understood as both monological and dialectical in nature. Janet Lyon, for instance, argues that traditional aesthetic and political modernist manifestos are both exhortations to action and simultaneous attempts to eradicate dissent and debate:

> The literary and political manifestoes that flag the history of modernity are usually taken to be transparent public expressions of pure will: whoever its author and whatever its subject, a manifesto is understood as the testimony of a historical present tense spoken in the impassioned voice of its participants. The form's capacity for rhetorical *trompe l'oeil* tends to shape its wide intelligibility: the syntax of a manifesto is so narrowly controlled by exhortation, its style so insistently unmediated, that it appears to say only what it means, and to mean only what it says. The manifesto declares a position; the manifesto refuses dialogue or discussion; the manifesto fosters antagonism and scorns conciliation. It is univocal, unilateral, single-minded. It conveys resolute oppositionality and indulges no tolerance for the faint hearted.[4]

For Lyon it is a strategic necessity for the manifesto to be monological in nature. To engage in a dialogical process in regard to what the manifesto is calling into being is to undercut its very efficacy as a speech act. In contrast, for Louis Althusser the manifesto is dialectical in nature, mediating past and present. Writing on Antonin Gramsci's reading of Machiavelli's *The Prince* as a manifesto, Althusser writes, "Machiavelli 'speaks' to Gramsci in the future tense. . . . Gramsci calmly writes that *The Prince* is a manifesto and a 'revolutionary utopia.' For the sake of brevity, let us say 'a revolutionary utopian manifesto.'"[5] He argues elsewhere, also in relation to *The Prince*, that "for the manifesto to be

truly political and realistic—materialistic—the theory that it states must not only be stated by the manifesto, but located by it in the social space into which it is intervening and which it thinks."[6] Manifestos for Althusser, then, are invocations: they call the future into being through a dialectical mediation of the present and the past. This utopian drive is central to the post-Enlightenment manifesto and to the calls for a radical reimagining of the cinema in film manifestos, bringing into being not only a new cinema but a new world.

MANIFESTOS AND UTOPIAS

What would a new intellectual history of film culture, read through the prism of the manifesto, look like; and how can one, in a theoretical frame, begin to synthesize this kind of history and writing with the concept of the utopian? What kind of form might this kind of "secret history" take, and what might this history reveal? One notion that comes to mind is that a radically different kind of dialogical process would occur among different historical, political, national, and cultural moments in film theory, criticism, and history. This reimagination of the history of cinema through the utopian ruptures of film manifestos has philosophical precedents: in strikingly different ways the works of Walter Benjamin and Guy Debord engage in this process, as both these Marxist philosophers examine the role of the image in twentieth-century culture.

Greil Marcus's *Lipstick Traces: A Secret History of the Twentieth Century*, his classic study of punk, the Diggers, the Lettristes, the Situationists, and a cornucopia of other "termite-like" political and aesthetic movements, is also an example of this kind of radical utopian critical approach to cultural history. Marcus traces dialogical relationships among different moments of radical cultural history and uses punk as a contemporary culmination of many of these cultural and political practices:

> In "Anarchy in the UK," a twenty-year-old called Johnny Rotten has rephrased a social critique generated by people who, as far as he knew, had never been born. Who knew what else was part of the conversation? If one can stop looking at the past and start listening to it, one might hear echoes of a new conversation; then the task of the critic would be to lead speakers and listeners unaware of each other's existence to talk to one another. The job of the critic would be to maintain the ability to be surprised at how the conversation goes, and to communicate that sense of surprise to other people, because a life infused with surprise is better than a life that is not.[7]

This analysis is both utopian and dialogical in nature. But it also speaks of the ways by which social and political breaks and ruptures take place in culture—in other words, how radical interventions from radical voices come about. Part of the task of *Film Manifestos and Global Cinema Cultures* is not simply to document, in some sort of Rankéan manner, the inexorable progression of one manifesto movement to another; instead, it is to place these manifestos, as if in a noisy room, in dialogue and debate with each other, much

like the role of the critics that Marcus outlines in the passage above. The reason to consider film manifestos as if they are in dialogue with each other is that this allows one to open up the possibility of seeing manifestos not simply as static, temporal texts but as discourses and exhortations, knowingly or not, in cacophonous debate, shouting from the margins an untold history of the cinema and its radical, utopian possibilities. This, in essence, is the goal of this collection: by placing film manifestos at the center of film history and culture, the book aims to reimagine a lost history of the cinema and to bring to light the way in which so many filmmakers, critics, theorists, archivists, activists, and historians have deployed cinema as a means to reconfigure the world.

This utopian, if not messianic, desire to radically reimagine the world deserves further consideration. Karl Mannheim was one of the first critical theorists to explore the role played by the utopian in contemporary theory, with his groundbreaking study *Ideology and Utopia*. Writing in 1936, he stated:

> A state of mind is utopian when it is incongruous with the state of reality within which it occurs. This incongruence is always evident in the fact that such a state of mind in experience, in thought, and in practice, is oriented towards objects which do not exist in the actual situation. However, we should not regard as utopian every state of mind which is incongruous with and transcends the immediate situation (and in this sense, "departs from reality"). Only those orientations transcending reality will be referred to by us as utopian which, when they pass over into conduct, tend to shatter, either partially or wholly, the order of things prevailing at the time.[8]

Paul Ricoeur analyzes the perceived strengths and limitations of Mannheim's theory by drawing distinctions between the utopian and the ideological: "ideologies relate mainly to dominant groups; to comfort the collective ego of these dominant groups. Utopias, on the other hand, are more naturally supported by ascending groups and therefore are more usually by the lower strata of society." He continues: "Utopia is not only a set of ideas but a mentality, a *Geist,* a configuration of factors which permeates a whole range of ideas and feelings. . . . Mannheim speaks here of the 'dominant wish,' something which can be retained as a methodological concept if we understand it as an organizing principle that is more felt than thought."[9] Ricoeur concludes by drawing into relief the clear distinctions between the two concepts: "If we call ideology false consciousness of our real situation, we can imagine a society without ideology. We cannot imagine, however, a society without utopia, because this would be a society without goals."[10] One of Ricoeur's critiques of Mannheim is that Mannheim postulates that society is moving toward a "gradual approximation of real life" and therefore no longer has a need to postulate utopias; Ricoeur fundamentally disagrees with this Rankéan conception. However, one can take away from Mannheim's conception of the utopian the notion of the "dominant wish," which echoes Walter Benjamin's concept of the "dialectical image," as outlined by Susan Buck-Morss:

As fore-history, the objects are prototypes, ur-phenomena that can be recognized as precursors to the present, no matter how distant or estranged they now appear. Benjamin implies that if the fore-history of an object reveals its possibility (including its utopian potential), its after-history is that which, as an object of natural history, it has in fact become. . . . In the traces left by the object's after-history, the conditions of its decay and the manner of its cultural transmission, the utopian images of past objects can be read as truth. . . . Benjamin was counting on the shock of this recognition to jolt the dreaming collective into a political "awakening."[11]

Here are the beginnings of what a theory of the manifesto might look like: manifestos not only as diagnostic but as causing a "shock of recognition," a blow to the dominant order's illusion of ideological and aesthetic coherence: one witnesses the revival of the utopian as a political form, recasting a leftist critique of both culture and theory. In essence, then, film manifestos, read as utopian texts, function in a similar way to the "dialectical image." Along similar lines this relationship between the utopian and the political, and specifically the ideological, is outlined quite clearly by Fredric Jameson in his analysis of the relationship between ideology and utopia: "A Marxist negative hermeneutic, a Marxist practice of ideological analysis proper, must in the practical work of reading and interpretation be exercised *simultaneously* with a Marxist positive hermeneutic, or a decipherment of the Utopian impulses of these same ideological cultural texts."[12] In a more recent article, evaluating the possibility of the utopian in a globalized world, Jameson notes that "it is difficult enough to imagine any radical political programme today without the conception of systematic otherness, of an alternative society, which only the idea of utopia seems to keep alive, however feebly. This clearly does not mean that, even if we succeed in reviving utopia itself, the outlines of a new and effective practical politics for the era of globalization will at once become visible; but only that we will never come to one without it."[13]

What Jameson does not address here is the fact that the utopian can and has been mobilized by the right as often as it has been by the left. Certainly, the rightist ideologies and manifestos of fascism and Stalinism both postulate utopian visions of a future world. This is in no way to discount the leftist manifesto and its relationship to the utopian, but it is to foreground the ways in which the utopian is postulated across the ideological spectrum. Broadly speaking, while leftist utopias look to the future for a better world, the utopias of the right position the utopian by harking back to the past. Both kinds of utopias run through the histories of film manifestos.

RADICALS, REACTIONARIES, AND THE FILM MANIFESTO

Within most accounts of cinematic history, the film manifesto plays a decidedly marginal role. While moving image manifestos are often seen as relevant to the study of national cinemas or as cornerstones to aesthetic movements such as surrealism or Dadaism, they are rarely understood as one of the driving forces behind large swathes of film theory and

practice. *Film Manifestos and Global Cinema Cultures* readdresses this critical elision. The book traces the interface between film manifestos and film practice in the broadest sense—-to consider not only the high art manifestos of surrealism, Dadaism, expressionism, and futurism, or more recently, the Oberhausen, Third Cinema, and Dogme '95 manifestos—-but also to examine "manifesto-style writing," found in documents as diverse as Laura Mulvey's highly influential essay "Visual Pleasure and Narrative Cinema," Hollywood's Motion Picture Production Code, and the papal encyclical *Vigilanti Cura*. The reason these documents can be usefully understood as instances of manifesto writing is precisely because of their authors' attempts through polemics to radically reimagine the nature of cinema (and, by extension, social and political relations) and to delineate in a programmatic and utopian manner what the cinema ought to be and how it should best function within the public sphere. At times, this reimagining is undertaken in order to bring about political, social, aesthetic, or cultural revolution. At other times it is undertaken to preserve a quite reactionary status quo. In most cases film manifestos postulate a discursive, imaginary, but politically charged utopia of one form or another, be it purely social, political, aesthetic, or some combination thereof. My aim, therefore, is to delineate a critical history of the role played by film manifestos in the construction of both the cinema itself and the theoretical and critical practices and apparatuses that surround and underpin it.

Throughout the history of the cinema, radicals and reactionaries alike have used the film manifesto as a means of stating their key aesthetic and political goals. Indeed, film manifestos are almost as old as the cinema itself; the first film manifesto can be traced to 1898. By the early 1910s and 1920s, Italian futurists, French Dadaists and surrealists, and German expressionists were all producing manifestos, stating their political, aesthetic, and philosophical principles. In most cases these texts were calls to revolution—a revolution of consciousness, of political hierarchies, and of aesthetic practices, which all bled together in an attempt to radically redefine the cinema and the culture in which it existed. Luis Buñuel's famous claim that the film *Un chien andalou* (France, 1928) was a call to murder is only the most infamous of the statements in circulation at the time; many others framed the ways in which avant-garde, experimental, and alternative film (and later, television and video) came to be understood throughout the history of moving images.[14] Furthermore, film manifestos can be seen as constituting the earliest form of film theory; for instance, Ricciotto Canudo's "The Birth of the Sixth Art" in many ways marks the beginnings of a theory of radical film practice. Similarly, Sergei Eisenstein, Vsevolod Pudovkin, and Grigori Alexandrov's "A Statement on Sound" marks the beginnings of critical discussions on the relations between image and sound in the cinema. Surrealism, Free Cinema, and the emergence of film archives were all framed, to varying degrees, by manifestos. In subsequent decades virtually every artistic and political movement existing outside mainstream, narrative cinema sallied forth with a manifesto, proclaiming the end of the old regimes of representation and the need to wipe the slate clean and begin anew. Here, the slicing open of the eye in *Un chien andalou* again stands as a nodal point, encapsulating the preferred mode of address adopted by manifesto scribes.

Despite the wide variety of ideological and political points of view put forth in film manifestos, the rhetorical stances adopted by the writers—which foregrounded both an urgent call to arms and a profoundly undialectical form of argumentation—led to a certain similarity in the cinematic manifesto genre, at least in its modernist iteration. Because of the programmatic, proclamatory nature of most manifesto writing—which is an unavoidable occurrence, precisely because of the inflammatory nature of the discourse involved—the intended outcomes of manifestos were, for the most part, hopelessly doomed; yet this hopelessness added to the nihilistic romance of dramatic intervention in the public sphere. This romance was fortified by the fact that manifestos were most often texts of the moment. Intrinsically tied not only to the cinema, but the immediate world surrounding the authors, manifestos have had, in most cases, quite short life spans; they quickly left the world of political intervention and became that most aberrant thing (at least in the eyes of the writers themselves), a declawed aesthetic text. This led to the need to write and rewrite basic principles, either by design, in order to maintain relevance, or by force, because of political pressures; one only has to look at the ways in which André Breton continually rewrote his manifestos of surrealism as an example of the former, or the ways in which the fundamental, guiding principles underlying the cinema of Sergei Eisenstein necessarily shifted as intellectual montage and Lenin led to Stalin and socialist realism—a sad but inevitable example of the latter.

Film Manifestos and Global Cinema Cultures elucidates, within this theoretical and historical framework, the role played by manifestos and manifesto-style writing in film culture. Through this analysis a very different, though crucial, history of the cinema comes to light—one that engages critically not only with moving images but also with the diverse and contradictory discourses that inevitably surround cinematic production and consumption within the public sphere. The perceived failure of film manifestos to create a new, utopian, revolutionary world through the moving image points to the fact that the interest they generate as texts, and as statements of purpose, are as tied to their extremism, and the possibility they offer the reader to reimagine the cinema, as they are to initiating programmatic changes in and of themselves. In many ways, therefore, it is the extremism of most manifestos that give them, if not their political foundation, then their intellectual appeal. Indeed, the cinema one imagines whilst reading these texts is often more compelling than some of the films produced under the auspices of their influence. Yet many manifesto writers have transformed the cinema: the raison d'être of the film manifesto is to provoke not only a new form of cinema but a way of reimagining the medium, and therefore the world, itself. If one is to analyze manifestos of any kind, one must return to Karl Marx. And while the spirit of *The Communist Manifesto* haunts everything from Godard to Dogme, it is most certainly Marx's posthumously published "Theses on Feuerbach" that sits at a key nodal point in the emergence of the manifesto-like nature of critical theory. Marx's most famous edict in the theses is number 11: "The philosophers have only *interpreted* the world, in various ways; the point is to *change* it."[15]

1

THE AVANT-GARDE(S)

Without a doubt the most prevalent type of film manifesto comes from the cinematic avant-garde. This makes a great deal of sense, as manifestos—whether political, aesthetic, or both—can be seen in the first instance as a form of avant-garde writing, calling into being a new future. From the early twentieth century onward, film manifestos played a formative role in the way in which the avant-garde was understood. This chapter begins with the "The Futurist Cinema" manifesto from 1916, a key early film manifesto made all the more relevant because of the disappearance of most futurist cinema films through loss and neglect. The various Russian formalist and surrealist statements all point to the way in which avant-garde practices allowed for filmmakers to conceptualize the cinema as a tool to release the unconscious, or allow for revolutionary transformation, moving away from the realist principles that the cinema embodies so well.

László Moholy-Nagy's "Open Letter" calls for a cinema determined not by capital but by artistic vision. This is a refrain that filmmakers will return to again and again throughout this book. Cinema determined by artistic vision is also the theme of Mary Ellen Bute's "Light*Form*Movement*Sound" and Jim Davis's "The Only Dynamic Art." Both artists, working in "Absolute Film," experiment with the cinema's capacity to capture light, and in their manifestos they argue that the cinema ought to be used to enhance and explore new ways of seeing.

In a different vein the French Situationist Guy Debord argues that the image had replaced the more traditional commodity at the heart of capitalism. In his manifesto (1967) and film (1973) *Society of the Spectacle* he states: "The spectacle is not a collection of images; it is a social relation between people that is mediated by images." In the three manifestos Debord authored or coauthored contained herein, we see the development of his notion of situations; indeed, it is present in his first film manifesto, and his first published work, "Prolegomena for All Future Cinema." Debord's thought is picked up by a new generation of American avant-garde and experimental filmmakers in the 1990s. Far more concerned with the image "detritus" that surrounds and at times bombards contemporary culture, filmmakers like Peggy Ahwesh, Craig Baldwin, and Keith Sanborn produced works that recycled the detritus images of contemporary culture into found footage films. Sanborn himself wrote one of the key avant-garde film manifestos of the time, "Modern, All Too Modern," modeled in part on the writings of Debord.

Other movements were far more polysemic than the surrealists, the Lettristes, and the Situationists. A key example is the New American Cinema movement of the late 1950s and early 1960s. The differences among George Kuchar's "8mm Film Manifesto," Stan Brakhage's *Metaphors on Vision*, Hollis Frampton's manifesto on metahistory, and the far more structural writings of Keewatin Dewdney on the "flicker film" speak to the heterogeneity of the American underground. Yet what united these filmmakers and their

manifestos was a profound concern with alternative ways of seeing. And underlying this concern, despite the subsequent claims that some of these manifestos were apolitical and ahistorical, was the conviction that different ways of seeing the cinema meant different ways for spectators to see the world, perhaps even the world as it actually was and not how they, through indoctrination and ideology, *thought* they saw it. Indeed, the opening lines of *Metaphors on Vision* point to this in a dramatic formulation: "Imagine an eye unruled by man-made laws of perspective, an eye unprejudiced by compositional logic, an eye which does not respond to the name of everything but which must know each object encountered in life through an adventure of perception. How many colors are there in a field of grass to the crawling baby unaware of 'Green'? How many rainbows can light create for the untutored eye?" Here Brakhage is not speaking of the cinema but of perception itself; cinema, therefore, is just a medium through which to rediscover the process of seeing.

Nick Zedd's "Cinema of Transgression" manifesto points toward the third wave of avant-garde and experimental filmmaking in the United States and demonstrates the profound influence of the punk aesthetic on experimental film in New York during the 1980s. If punk is a rebellion against older, corporatized forms of music and art, the "Let's Set the Record Straight" manifesto, issued at the International Film Congress in Toronto in 1989, points to the large schism that had developed between the old guard of the avant-garde and the new generation of American and Canadian experimental filmmakers. In contrast, Jonas Mekas's "Anti-100 Years of Cinema" manifesto derides the celebrations of the cinema's first century that nevertheless neglect the avant-garde, old and new.

The final manifesto comes from Canada and points to the ways in which the avant-garde and experimental cinema is being reimagined through the development of alternative forms of pedagogy and the emergence of local ateliers. Philip Hoffman's Independent Imaging Retreat in Mount Forest, Ontario, foregrounds the artisanal aspect of experimental filmmaking and supports not only the screening of new avant-garde works but their production as well. Avant-garde cinema can only be truly understood through an understanding of the manifestos produced by artists, and these documents point to the controversial, visionary, and deeply political nature of the avant-garde.

THE FUTURIST CINEMA (Italy, 1916)

F. T. Marinetti, Bruno Corra, Emilio Settimelli, Arnaldo Ginna, Giacomo Balla, Remo Chiti

[First published in Italian in *L'italia futurista*, 15 November 1916. First published in English in R. W. Flint, *Marinetti: Selected Writings* (New York: Farrar, Straus and Giroux, 1972).]

"The Futurist Cinema" manifesto argues for a total cinema, decrying the cinema of newsreels and documentaries as a shoddy subsection of the dramatic tradition. Thus, the writers call for a cinema of "polyexpressive symphony" that, through poetry and analogy, creates a cinema capable of a vast range of expression, while standing on its own as a distinctive art form. The futurists' critique of film's reliance on drama and its celebration of technology and the speed it brings to contemporary artistic practice foreshadows a line of attack present in many of the avant-garde manifestos to come.

The book, a wholly passéist means of preserving and communicating thought, has for a long time been fated to disappear like cathedrals, towers, crenellated walls, museums, and the pacifist ideal. The book, static companion of the sedentary, the nostalgic, the neutralist, cannot entertain or exalt the new Futurist generations intoxicated with revolutionary and bellicose dynamism.

The conflagration is steadily enlivening the European sensibility. Our great hygienic war, which should satisfy *all* our national aspirations, centuples the renewing power of the Italian race. The Futurist cinema, which we are preparing, a joyful deformation of the universe, an alogical, fleeting synthesis of life in the world, will become the best school for boys: a school of joy, of speed, of force, of courage, and heroism. The Futurist cinema will sharpen, develop the sensibility, will quicken the creative imagination, will give the intelligence a prodigious sense of simultaneity and omnipresence. The Futurist cinema will thus cooperate in the general renewal, taking the place of the literary review (always pedantic) and the drama (always predictable), and killing the book (always tedious and oppressive). The necessities of propaganda will force us to publish a book once in a while. But we prefer to express ourselves through the cinema, through great tables of words-in-freedom and mobile illuminated signs.

With our manifesto "The Futurist Synthetic Theatre," with the victorious tours of the theatre companies of Gualtiero Tumiati, Ettore Berti, Annibale Ninchi, Luigi Zoncada,

with the two volumes of *Futurist Synthetic Theatre* containing eighty theatrical syntheses, we have begun the revolution in the Italian prose theatre. An earlier Futurist manifesto had rehabilitated, glorified, and perfected the Variety Theatre. It is logical therefore for us to carry our vivifying energies into a new theatrical zone: the *cinema*.

At first look the cinema, born only a few years ago, may seem to be Futurist already, lacking a past and free from traditions. Actually, by appearing in the guise of *theatre without words,* it has inherited all the most traditional sweepings of the literary theatre. Consequently, everything we have said and done about the stage applies to the cinema. Our action is legitimate and necessary in so far as the cinema up to now *has been and tends to remain profoundly passéist,* whereas we see in it the possibility of an eminently Futurist art and *the expressive medium most adapted to the complex sensibility of a Futurist artist.*

Except for interesting films of travel, hunting, wars, and so on, the film-makers have done no more than inflict on us the most backward looking dramas, great and small. The same scenario whose brevity and variety may make it seem advanced is, in most cases, nothing but the most trite and pious analysis. Therefore all the immense *artistic* possibilities of the cinema still rest entirely in the future. The cinema is an autonomous art. The cinema must therefore never copy the stage. The cinema, being essentially visual, must above all fulfill the evolution of painting, detach itself from reality, from photography, from the graceful and solemn. It must become antigraceful, deforming, impressionistic, synthetic, dynamic, free-wording.

One must free the cinema as an expressive medium in order to make it the ideal instrument of a new art, immensely vaster and lighter than all the existing arts. We are convinced that only in this way can one reach that *polyexpressiveness* towards which all the most modern artistic researches are moving. Today the *Futurist cinema* creates precisely the *polyexpressive symphony* that just a year ago we announced in our manifesto "Weights, Measures, and Prices of Artistic Genius." The most varied elements will enter into the Futurist film as expressive means: from the slice of life to the streak of color, from the conventional line to words-in-freedom, from chromatic and plastic music to the music of objects. In other words it will be painting, architecture, sculpture, words-in-freedom, music of colors, lines, and forms, a jumble of objects and reality thrown together at random. We shall offer new inspirations for the researchers of painters, which will tend to break out of the limits of the frame. We shall set in motion the words-in-freedom that smash the boundaries of literature as they march towards painting, music, noise-art, and throw a marvelous bridge between the word and the real object. Our films will be:

I. *Cinematic analogies* that use reality directly as one of the two elements of the analogy. Example: If we should want to express the anguished state of one of our protagonists, instead of describing it in its various phases of suffering, we would give an equivalent impression with the sight of a jagged and cavernous mountain.

The mountains, seas, woods, cities, crowds, armies, squadrons, aeroplanes will often be our formidable expressive words: *the universe will be our vocabulary.*

Example: We want to give a sensation of strange cheerfulness: we show a chair cover flying comically around an enormous coat stand until they decide to join. We want to give the sensation of anger: we fracture the angry man into a whirlwind of little yellow balls. We want to give the anguish of a hero who has lost his faith and lapsed into a dead neutral skepticism: we show the hero in the act of making an inspired speech to a great crowd; suddenly we bring on Giovanni Giolitti who treasonably stuffs a thick forkful of macaroni into the hero's mouth, drowning his winged words in tomato sauce.

We shall add color to the dialogue by swiftly, simultaneously showing every image that passes through the actors' brains. Example: representing a man who will say to his woman: "You're as lovely as a gazelle," we shall show the gazelle. Example: if a character says, "I contemplate your fresh and luminous smile as a traveler after a long rough trip contemplates the sea from high on a mountain," we shall show traveler, sea, mountain.

This is how we shall make our characters as understandable *as if they talked.*

2. *Cinematic poems, speeches, and poetry.* We shall make all of their component images pass across the screen.

Example: "Canto dell'amore" [Song of Love] by Giosuè Carducci:

> In their German strongholds perched
>
> Like falcons meditating the hunt

We shall show the strongholds, the falcons in ambush.

> From the churches that raise long marble
>
> arms to heaven, in prayer to God
>
> From the convents between villages and towns
>
> crouching darkly to the sound of bells
>
> like cuckoos among far-spaced trees
>
> singing boredoms and unexpected joys . . .

We shall show churches that little by little are changed into imploring women, God beaming down from on high, the convents, the cuckoos, and so on.

Example: "Sogno d'Estate" [Summer's Dream] by Giosuè Carducci:

> Among your ever-sounding strains of battle, Homer, I am conquered by
>
> the warm hour: I bow my head in sleep on Scamander's bank, but
>
> my
>
> heart flees to the Tyrrhenian Sea.

We shall show Carducci wandering amid the tumult of the Achaians, deftly avoiding the galloping horses, paying his respects to Homer, going for a drink with Ajax to the inn, The Red Scamander, and at the third glass of wine his heart, whose palpitations we ought to see, pops out of his jacket like a huge red

balloon and flies over the Gulf Of Rapallo. This is how we make films out of the most secret movements of genius.

Thus we shall ridicule the works of the passéist poets, transforming to the great benefit of the public the most nostalgically monotonous weepy poetry into violent, exciting, and highly exhilarating spectacles.

3. *Cinematic simultaneity and interpenetration* of different times and places. We shall project two or three different visual episodes at the same time, one next to the other.

4. *Cinematic musical researches* (dissonances, harmonies, symphonies of gestures, events, colors, lines, etc.).

5. *Dramatized states of mind on film.*

6. *Daily exercises in freeing ourselves from mere photographed logic.*

7. *Filmed dramas of objects.* (Objects animated, humanized, baffled, dressed up, impassioned, civilized, dancing—objects removed from their normal sur-roundings and put into an abnormal state that, by contrast, throws into relief their amazing construction and nonhuman life.)

8. *Show windows of filmed ideas, events, types, objects, etc.*

9. *Congresses, flirts, fights and marriages of funny faces, mimicry,* etc. Example: a big nose that silences a thousand congressional fingers by ringing an ear, while two policemen's moustaches arrest a tooth.

10. *Filmed unreal reconstructions of the human body.*

11. *Filmed dramas of disproportion* (a thirsty man who pulls out a tiny drinking straw that lengthens umbilically as far as a lake and dries it up *instantly*).

12. *Potential dramas and strategic plans of filmed feelings.*

13. *Linear, plastic, chromatic equivalences, etc.,* of men, women, events, thoughts, music, feelings, weights, smells, noises (with white lines on black we shall show the inner, physical rhythm of a husband who discovers his wife in adultery and chases the lover—rhythm of soul and rhythm of legs).

14. *Filmed words-in-freedom in movement* (synoptic tables of lyric values—dramas of humanized or animated letters—orthographic dramas—typographical dramas—geometric dramas—numeric sensibility, etc.).

Painting + sculpture + plastic dynamism + words-in-freedom + composed noises *[intonarumori]* + architecture + synthetic theatre = Futurist cinema.

This is how we decompose and recompose the universe according to our marvelous whims, to centuple the powers of the Italian creative genius and its absolute preeminence in the world.

LENIN DECREE (USSR, 1919)

Vladimir Ilyich Lenin

[First published as a decree by the Kremlin, 27 August 1919. First appeared in English in the Art Council of Great Britain's *Art in Revolution: Soviet Art and Design Since 1917* (London: Hayward Gallery, 1971), 97. Trans. Jay Leyda.].

Lenin's most famous statement on the cinema, which could be construed as a manifesto itself, comes from an interview he did with Anatoli Lunacharsky in 1922, where he stated: "Among the people you are reported to be a patron of art so you must remember that of all the arts for us the cinema is most important." This importance is reflected in the nationalizing of the film and photo industries, which is outlined here as the primary role of the cinema in the nascent USSR.

On the transfer of the Photographic and Cinematographic Trade and Industry to the Peoples Commissariat of Education.

1. The entire photographic and cinematographic trade and industry, their organisation as well as the supply and distribution of technical means and materials appertaining to them, throughout the territory of the RSFSR, shall be placed within the province of the People's Commissariat of Education.[1]
2. To this end the People's Commissariat of Education is herewith empowered:
 a. to nationalise, by agreement with the Supreme Council of National Economy, particular photo and cinema enterprises, as well as the entire photo and cinema industry;
 b. to requisition enterprises as well as photo and cinema goods, materials and equipment;
 c. to fix stable and maximum prices for photo and cinema raw materials and manufactured products;
 d. to exercise supervision and control over the photo and cinema trade and industry and
 e. to regulate the entire photo and cinema trade and industry by issuing decisions which shall be binding on enterprises and private persons, as well as on Soviet Institutions, insofar as they relate to photo and cinema matters.

Chairman of the Council of the Peoples Commissars: V Ulyanov (Lenin)
Executive Officer of the Council of People's Commissars: Vlad Bonch-Bruyevich

THE ABCs OF CINEMA
(France, 1917–1921)

Blaise Cendrars

[Written between 1917 and 1922. First published in French as *L'ABC du cinéma* (Paris: Aux Sans Pareil, 1926). First published in English in Blaise Cendrars, *Modernities and Other Writings* (Lincoln: University of Nebraska Press, 1992), 25–29. Trans. Esther Allen and Monique Chefdor.]

Swiss-born modernist poet Blaise Cendrars was fascinated by the cinema throughout his artistic life in Paris. Cendrars worked with Abel Gance on *J'accuse!* (France, 1919), which led to his writing the manifesto on the cinema contained herein. Cendrars's ideas then went on to influence Gance in the making of *La roue* (France, 1922). Cendrars's vision of the cinema foregrounds fragmentation, which leads to a heightened sense of the real on the part of what he saw as the cinema's global audience. For Cendrars film is the culmination of a series of revolutions stretching from ancient times to the present.

Cinema. Whirlwind of movement in space. Everything falls. The sun falls. We fall in its wake. Like a chameleon, the human mind camouflages itself, camouflaging the universe. The world. The globe. The two hemispheres. Leibniz' monads and Schopenhauer's representation. My will. The cardinal hypotheses of science end in a sharp point and the four calculators cumulate. Fusion. Everything opens up, tumbles down, blends in today, caves in, rises up, blossoms. Honor and money. Everything changes. Change. Morality and political economy. New civilization. New humanity. The digits have created an abstract, mathematical organism, useful gadgets, intended to serve the senses' most vulgar needs, and that are the brain's most beautiful projection. Automatism. Psychism. New commodities. Machines. And it is the machine which recreates and displaces the sense of direction, and which finally discovers the sources of sensibility like the explorers Livingston, Burton, Speke, Grant, Baker, and Stanley, who located the sources of the Nile. But it is an anonymous discovery to which no name can be attached. What a lesson! And what do the celebrities and the stars matter to us! A hundred worlds, a thousand movements, a million dramas simultaneously enter the range of the eye with which cinema has endowed man. And, though arbitrary, this eye is more marvelous than the multi-faceted eye of a fly. The brain is overwhelmed by it. An uproar of images. Tragic unity is displaced. We learn. We drink. Intoxication. Reality no longer makes any sense. It has no significance. Everything is rhythm, word, life. No more need to demonstrate. We are in communion. Focus the lens on the hand, the corner of the mouth, the ear, and drama emerges, expands on a background of luminous

mystery. Already there is no need for dialogue, soon characters will be judged useless. At high speed the life of flowers is Shakespearean; all of classicism is present in the slow motion flexing of biceps. On screen the slightest effort becomes painful, musical, and insects and microbes look like our most illustrious contemporaries. Eternity in the ephemeral. Gigantism. It is granted an aesthetic value which it has never had before. Utilitarianism. Theatrical drama, its situation, its devices, becomes useless. Attention is focussed on the sinister lowering of the eyebrows. On the hand covered with criminal calluses [sic]. On a bit of fabric which bleeds continually. On a watch-fob which stretches and swells like the veins at the temples. Millions of hearts stop beating at the same instant in all the capitals of the world and gales of laughter rack the countryside in far-flung villages. What is going to happen? And why is the material world impregnated with humanity? To such a point! What potential! Is it an explosion or a Hindu poem? Chemistries blend and dissolve. The least pulsation germinates and bears fruit. Crystallizations come to life. Ecstasy. Animals, plants and minerals are ideas, emotions, digits. A number. As in the Middle Ages, the rhinoceros is Christ; the bear, the devil; jasper, vivacity; chrysoprase, pure humility. 6 and 9. We see our brother the wind and the ocean is an abyss of men. And this is not abstract, obscure and complicated symbolism, it is part of a living organism that we startle, flush out, pursue, and which had never before been seen. Barbaric evidence. Sensitive depths in an Alexandre Dumas drama, a detective novel or a banal Hollywood film. Over the audience's heads, the luminous cone quivers like a cetacean. Characters, beings and things, subjects and objects stretch out from the screen in the hearth of the magic lantern. They plunge, turn, chase each other, encounter each other with fatal, astronomical precision. A beam. Rays. The prodigious thread of a screw from which everything is whirled in a spiral. Projection of the fall of the sky. Space. Captured life. Life of the depths. Alphabet. Letter. ABC. Sequence and close-up. *What is ever seen is never seen.* What an interview! "When I began to take an interest in cinematography, film was a commercial and industrial novelty. I've put all my energies into expanding it and raising it to the level of a human language. My only merit consists in having been able to find the first two letters of this new alphabet which is still far from complete: the *cut-back* and the *close-up*," David Wark Griffith, the world's foremost director declares to me. "Art at the movies? Great Art?" responds Abel Gance, France's foremost director, to a journalist who came to watch him at work in Nice. "Perhaps we could have made it that from the beginning. But first we had to learn the visual alphabet ourselves, before speaking and believing in our power; then we had to teach this elementary language." Carlyle wanted to trace the origin of the modern world back to the legendary founder of the city of Thebes, to Cadmus. As he imported the Phoenician alphabet into Greece, Cadmus invented writing and the book. Before him, writing, mnemonic, ideographic or phonetic, was always pictorial—from prehistoric man to the Egyptians, from the drawings which grace

the walls of stone-age caves to hieroglyphics, the hieratic, traced on stone tablets, or the demotic, painted on ceramics, by way of the pictographs used by Eskimos and Australian aborigines, the Red Skins' colorful tattoos and the embroidery on Canadian wampum, the ancient Mayans' decorative quipus and the burls of the forest tribes of central Africa, the Tibetan, Chinese and Korean calligrammes—writing, even cuneiform writing, was above all else an aid to memory, a memorial to a sacred initiation: autocratic, individual. Then comes the black marketeer Cadmus, the magus, the magician, and immediately writing becomes an active, living thing, the ideal democratic nourishment, and the common language of the spirit FIRST WORLD REVOLUTION. Human activity redoubles, intensifies. Greek civilization spreads. It embraces the Mediterranean. Commercial conquest and the literary life go hand in hand. The Romans engrave their history on copper or pewter plates. There's a library in Alexandria. The Apostles and the Holy Fathers write on parchment Propaganda. Finally, painting interpenetrates the Christian world and, during the 14th century, Jan van Eyck of Bruges invents oil painting. Adam and Eve, naked. SECOND WORLD REVOLUTION. In 1438, Koester prints with wood blocks in Harlem. Six years later, Jean Gensfleisch, known as Gutenberg, invents the mobile letter, and thirteen years later Schaeffer casts that letter in metal. With Caxton, printing intensifies. There is a deluge of books. Everything is reprinted and translated, the monastic missals and the writings of the ancients. Sculpture, drama and architecture are reborn. Universities and libraries proliferate. Christopher Columbus discovers a new world. Religion splits in two. There is much general progress in commerce. Industry constructs boats. Fleets open up faraway markets. The antipodes exist. Nations are formed. People emigrate. New governments are founded on new principles of liberty and equality. Education becomes democratic and culture refined. Newspapers appear. The whole globe is caught in a network of tracks, of cables, of lines—overland lines, maritime lines, air lines. All the world's peoples are in contact. The wireless sings. Work becomes specialized, above and below. THIRD WORLD REVOLUTION. And here's Daguerre, a Frenchman, who invents photography. Fifty years later, cinema was born. Renewal! Renewal! Eternal Revolution. The latest advancements of the precise sciences, world war, the concept of relativity, political convulsions, everything foretells that we are on our way toward a new synthesis of the human spirit, toward a new humanity and that a race of new men is going to appear. Their language will be the cinema. Look! The pyrotechnists of Silence are ready. The image is at the primitive sources of emotion. Attempts have been made to capture it behind outmoded artistic formulas. Finally the good fight of white and black is going to begin on all the screens in the world. The floodgates of the new language are open. The letters of the new primer jostle each other, innumerable. Everything becomes possible! The Gospel of Tomorrow, the Spirit of Future Laws, the Scientific Epic, the Anticipatory Legend, the Vision of the Fourth Dimension of Existence, all the Interferences. Look! The revolution.

A

On location.

The camera which moves, which is no longer immobile, which records all levels simultaneously, which reverberates, which sets itself in motion.

B

In the theatres.

The spectator who is no longer immobile in his chair, who is wrenched out, assaulted, who participates in the action, who recognizes himself on the screen among the convulsions of the crowd, who shouts and cries out, protests and struggles.

C

On earth.

At the same time, in all the cities of the world, the crowd which leaves the theatres, which runs out into the streets like black blood, which like a powerful animal extends its thousand tentacles and with a tiny effort crushes the palaces, the prisons.

Z

Deep In the heart.

Watch the new generations growing up suddenly like flowers. Revolution. Youth of the world. Today.

WE: VARIANT OF A MANIFESTO (USSR, 1922)

Dziga Vertov

[First published in Russian as "My. Variant manifesta," in the program for the kino-documentarist group in 1919. First appeared in print in the journal *Kino-Fot* 1 (1922): 11–12. First appeared in English in the Art Council of Great Britain's *Art in Revolution: Soviet Art and Design Since 1917* (London: Hayward Gallery, 1971), 94–96.]

Vertov's manifesto charts a different path from those of his Soviet contemporaries, focusing on the documentary. Like the futurists before him, Vertov argued for a pure cinema, a break away from the "cinematographers" who drew on theater traditions and told stories, and for the creation instead of a scientific cinema, so that humanity could become as finely tuned as what Hollis Frampton would later call the "cinema machine" itself. Like many who follow, Vertov calls for the death of cinema, so that it can be reborn anew.

We call ourselves *kinoks*—as opposed to "cinematographers," a herd of junkmen doing rather well peddling their rags.

We see no connection between true kinochestvo[2] and the cunning and calculation of the profiteers.

We consider the psychological Russo-German film drama—weighed down with apparitions and childhood memories—an absurdity.

To the American adventure film with its showy dynamism and to the dramatizations of the American Pinkertons the kinoks say thanks for the rapid shot changes and the close-ups. Good . . . but disorderly, not based on a precise study of movement. A cut above the psychological drama, but still lacking in foundation. A cliché. A copy of a copy.

WE proclaim the old films, based on the romance, theatrical films and the like, to be leprous.

—Keep away from them!

—Keep your eyes off them!

—They're mortally dangerous!

—Contagious!

WE affirm the future of cinema art by denying its present.

"Cinematography" must die so that the art of cinema may live. *WE call for its death to be hastened.*

We protest against that mixing of the arts which many call synthesis. The mixture of bad colors, even those ideally selected from the spectrum, produces not white, but mud.

Synthesis should come at the summit of each art's achievement and not before.

WE are cleansing *kinochestvo* of foreign matter—of music, literature, and theater; we seek our own rhythm, one lifted from nowhere else, and we find it in the movements of things.

WE invite you:

—to flee—

the sweet embraces of the romance,

the poison of the psychological novel,

the clutches of the theater of adultery;

to turn your back on music,

—to flee—

out into the open, into four dimensions (three + time), in search of our own material, our meter and rhythm.

The "psychological" prevents man from being as precise as a stopwatch; it interferes with his desire for kinship with the machine.

In an art of movement we have no reason to devote our particular attention to contemporary man.

The machine makes us ashamed of man's inability to control himself, but what are we to do if electricity's unerring ways are more exciting to us than the disorderly haste of active men and the corrupting inertia of passive ones?

Saws dancing at a sawmill convey to us a joy more intimate and intelligible than that on human dance floors.

For his inability to control his movements, WE temporarily exclude man as a subject for film.

Our path leads through the poetry of machines, from the bungling citizen to the perfect electric man.

In revealing the machine's soul, in causing the worker to love his workbench, the peasant his tractor, the engineer his engine—

we introduce creative joy into all mechanical labor,

we bring people into closer kinship with machines,

we foster new people.

The new man, free of unwieldiness and clumsiness, will have the light, precise movements of machines, and he will be the gratifying subject of our films.

Openly recognizing the rhythm of machines, the delight of mechanical labor, the perception of the beauty of chemical processes, WE sing of earthquakes, we compose film epics of electric power plants and flame, we delight in the movements of comets and meteors and the gestures of searchlights that dazzle the stars.

Everyone who cares for his art seeks the essence of his own technique.

Cinema's unstrung nerves need a rigorous system of precise movement.

The meter, tempo, and type of movement, as well as its precise location with respect to the axes of a shot's coordinates and perhaps to the axes of universal coordinates (the three dimensions + the fourth—time), should be studied and taken into account by each creator in the field of cinema.

Radical necessity, precision, and speed are the three components of movement worth filming and screening.

The geometrical extract of movement through an exciting succession of images is what's required of montage.

Kinochestvo is the art of organizing the necessary movements of objects in space as a rhythmical artistic whole, in harmony with the properties of the material and the internal rhythm of each object.

Intervals (the transitions from one movement to another) are the material, the elements of the art of movement, and by no means the movements themselves. R is they (the intervals) which draw the movement to a kinetic resolution.

The organization of movement is the organization of its elements, or its intervals, into phrases.

In each phrase there is a rise, a high point, and a falling off (expressed in varying degrees) of movement.

A composition is made of phrases, just as a phrase is made of intervals of movement.

A kinok who has conceived a film epic or fragment should be able to jot it down with precision so as to give it life on the screen, should favorable technical conditions be present.

The most complete scenario cannot, of course, replace these notes, just as a libretto does not replace pantomime, just as literary accounts of Scriabin's compositions do not convey any notion of his music.[3]

To represent a dynamic study on a sheet of paper, we need graphic symbols of movement.

WE are in search of the film scale.

WE fall, we rise . . . together with the rhythm of movements slowed and accelerated, running from us. past us. toward us.

in a circle, or straight line, or ellipse,

to the right and left, with plus and minus signs;

movements bend, straighten, divide, break apart,

multiply, shooting noiselessly through space.

Cinema is, as well, the *art of inventing movements* of things in space in response to the demands of science; it embodies the inventor's dream—be he scholar, artist, engineer, or carpenter; it is the realization by kinochestvo of that which cannot be realized in life.

Drawings in motion. Blueprints in motion. Plans for the future. The theory of relativity on the screen.

WE greet the ordered fantasy of movement.

Our eyes, spinning like propellers, take off into the future on the wings of hypothesis.

WE believe that the time is at hand when we shall be able to hurl into space the hurricanes of movement, reined in by our tactical lassoes.

Hurrah for *dynamic geometry,* the race of points, lines, planes, volumes.

Hurrah for the poetry of machines, propelled and driving; the poetry of levers, wheels, and wings of steel; the iron cry of movements; the blinding grimaces of red-hot streams.

THE METHOD OF MAKING
WORKERS' FILMS (USSR, 1925)

Sergei Eisenstein

[First published in Russian in *Kino*, 11 August 1925. First published in English in Sergei Eisenstein, *Film Essays, with a Lecture*, ed. and trans. Jay Leyda (London: Dennis Dobson, 1968), 17–19.]

In this statement from 1925 Eisenstein outlines the importance of the "montage of attractions" in the making of films for workers, drawing on his first feature, *Strike* (USSR, 1924) as an exemplar. He also warns that the "montage of attractions" can be used for neutral, revolutionary, or counterrevolutionary ends, foregrounding the fact that formalism alone is not a revolutionary practice.

There is one *method* for making *any* film: montage of attractions. To know what this is and way, see the book, *Cinema Today*, where, rather dishevelled and illegible, my approach to the construction of film works is described.

Our class approach introduces:

1. *A specific purpose for the work*—a socially useful emotional and psychological affect on the audience; this is to be composed of a chain of suitably directed stimulants. *This socially useful affect* I call the *content of the work*.

It is thus possible, for example, to define the content of a production. *Do You Hear, Moscow?:* the maximum tension of aggressive reflexes in social protest. *Strike:* an accumulation of reflexes without intervals (satisfaction), that is, a focussing of reflexes on struggle (and a lifting of potential class tone).

2. *A choice of stimulants.* In making a correct appraisal of the class inevitability of their nature, certain stimulants are capable of evoking a certain reaction (affect) only among spectators of a certain class. For a more precise effect the audience must be even more unified, if possible along professional lines: any director of "living newspaper" performances in clubs know [*sic*] how different audiences, say metal workers or textile workers, react completely differently and at different places in the same work.

Such class "inevitability" in matters of action can be easily illustrated by the amusing failure of one attraction that was strongly affected by the circumstances of one audience: I refer to the slaughter-house sequence of *Strike*. Its concentratedly associative affect of bloodiness among certain strata of the public is well known. The Crimean censor even cut it, along with the latrine scene. (That certain sharp affects are inadmissible was indicated by an American after seeing *Strike:* he declared that this scene would surely have been removed before the film was sent abroad.) It was the same kind of simple reason that prevented the usual "bloody" affect of the slaughter-house sequence from shocking certain worker-audiences: among these workers the blood of oxen is first of all associated

with the by-product factories near the slaughter-house! And for peasants who are accustomed to the slaughter of cattle this affect would also be cancelled out.

The other direction in the choice of stimulants appears to be the class accessibility of this or that stimulant.

Negative examples: the variety of sexual attractions that are fundamental to the majority of bourgeois works placed on the market: methods that lead one away from concrete reality, such as the sort of expressionism used in *Caligari;* or the sweet middle-class poison of Mary Pickford, the exploited and systematically trained stimulation of all middle class inclinations, even in our healthy and advanced audiences.

The bourgeois cinema is no less aware than we are of class taboos. In New York City's censorship regulations we find a list of thematic attractions undesirable for film use: "relations between labour and capital" appears alongside "sexual perversion," "excessive brutality," "physical deformity" . . .

The study of stimulants and their montage for a particular purpose provides us with exhaustive materials on the question of form. As I understand it, content is the *summary of all that is subjected to the series of shocks* to which in a particular order the audience is to be exposed. (Or more crudely: so much per cent of material to fix the attention, so much to rouse the bitterness, etc.) But this material must be organised in accordance with a principle that leads to the desired affect.

Form is the *realisation of these intentions* in a particular material, as precisely those stimulants which are able to summon this indispensable per cent are created and assembled in the concrete expression of the factual side of the work.

One should, moreover, keep in mind the "attractions of the moment," that is, those reactions that flame forth temporarily in connection with certain courses or events of social life.

In contrast to these there are a series of "eternal" attractions, phenomena and methods.

Some of these have a class usefulness. For example, a healthy and integrated audience always reacts to an epic of class struggle.

Equal with these are the "neutrally" affective attractions, such as death-defying stunts, *double entendres,* and the like.

To use these independently leads to *l'art pour l'art* so as to reveal their counter-revolutionary essence.

As with the attraction moments, one ought to remember that neutral or accidental attractions cannot, ideologically, be taken for granted, but should be used only as a method of exciting those unconditioned reflexes that we wish to combine with certain objectives of our social aims.

CONSTRUCTIVISM IN THE CINEMA (USSR, 1928)

Alexei Gan

[First published in *SA* 3 (1928). First published in English in Stephen Bann, ed., *The Tradition of Constructivism* (New York: Viking, 1974), 129–132. Trans. John Bowlt.]

Written for the constructivist architecture magazine *SA* (Contemporary Architecture), Gan's manifesto shares many similarities with the constructivist film writings and manifestos published in the better-known *LEF*. Here Gan celebrates Esther Shub's *The Great Road* (USSR, 1928) as a key example of revealing the truth of the Revolution by constructing a cine document through the creation of an actorless cinema; Shub does so through her pioneering use of found footage.

The constructivists have also entered the cinema with their materialistic program. The cinema is the aggregate of an optical and mechanical apparatus. The cinema *shows* on the screen a sequence of photographic stills, i.e. movement. This provides us with the opportunity to capture immediately and dynamically the processes of all kinds of work and activity of society.

The cinema must become a cultural and active weapon of society. It is essential to master the scientific and technical methods of cinema in order to learn how to display reality as it really is, and not as the philistine imagines it. It is essential to find the right devices and to develop a working method of demonstration. This is not a dry logic of objects; it is not a formal definition. This is the class content of the new cinema industry in a country with a dictatorship of labor and socialist construction.

How does the Soviet state differ from other forms of social order?

First and foremost, it *actively*, by its own conduct, fights the old world. All class forces participate in this fight. The economic system, industrial relations, and the trifles of everyday life are being revolutionized, reorganized, and shifted from the positions they have occupied so long. Everyday reality is passing into a state of restive fermentation. The countless millions are encountering the unexpected and the unfamiliar. It is up to the avant-garde of our society to breach the strong walls of prejudice and superstition. And this is put into practice not through long roads of systematic education; it is fostered within the conditions of everyday reality, by the vital acts of revolutionary actuality. A mass method of education is impelled to search for faster, more mobile, and truer means of information and communication.

The printed word, the telegraph, the telephone, even radio broadcasts narrating events cannot replace the real demonstration and illustration of events. Only cinema, wrested from the tenacious paws of businessmen and art makers, is able to fulfill this national

and international service. Only the cinema can, by visual apprehension, join society together and show the active struggle and construction of the evolving proletarian class.

Film that demonstrates real life documentarily, and not a theatrical film show playing at life—that's what our cine production should become. It is essential to find a new cine film. It is not enough to link, by means of montage, individual moments of episodic phenomena of life, united under a more or less successful title. The most unexpected accidents, occurrences, and events are always linked organically with the fundamental root of social reality. While apprehending them within the shell of their outer manifestation, one should be able to expose their inner essence by a series of other scenes. Only on such a basis can one build a vivid film of concrete, active reality—gradually departing from the newsreel, from whose material this new cine form is developing.

This platform was promoted as a school at a time (1922) when the Soviet cine industry was just emerging and when the restoration of the old, prerevolutionary cinema was proceeding more energetically.

At first the school's platform was ridiculed and our pamphlet, *Long Live the Demonstration of Life,* was characterized by the cine press as "the demonstration of stupidity." Following this, the Agitation and Propaganda Department of the Party Central Committee declared at one of its conferences (1925) that "carefully selected films, both Soviet and foreign, can serve as agitational material on questions of politics and construction."

The newsreel and the film magazine [its resolution says] should be considered as particularly useful films. The production of films of this type should be put on the right lines, and in essential cases a purposeful character should be imparted to separate strips.

Films of this type should be acknowledged as more useful material for the needs of agitation and propaganda than the so-called topical films on everyday questions.

This resolution underlines the vitality of the cine platform of constructivism. The actorless cinema is becoming a "legitimate phenomenon" in the Soviet cinema industry and a serious rival to the idealistic concoctions of the theatrical cinema art. This was particularly clear during the tenth October anniversary. At this time several jubilee films were shown: on the one hand, Esther Shub's *The Great Road,* on the other, Pudovkin's *End of St. Petersburg,* Barnet's *Moscow in October,* and the Alexandrov-Eisenstein *October.* In the first, the historical truth of the Revolution was demonstrated, its victory and construction, as genuine cine documents. In the others, art makers attempted by various ways and means to re-create historical events by mobilizing all the magic forces of idealistic art. And despite the unequal conditions in production and the disparity in material resources, *The Great Road* proved to be the victor in this unfair competition.

Constructivism in architecture has been quite fully expressed in the magazine *SA.* Our opponents openly confess that it is precisely in this field that our school has achieved its firm and stable position, and they remark somewhat despondently that "for the time being architectural thought cannot counter constructivism with anything and thereby evidently recognizes its ideological superiority."

PREFACE: *UN CHIEN ANDALOU*
(France, 1928)

Luis Buñuel

[First published in French as a preface to the script of *Un chien andalou* in *La révolution surréaliste* 12 (1929). Published in English in Luis Buñuel, *An Unspeakable Betrayal: Selected Writings of Luis Buñuel* (Berkeley: University of California Press, 2000), 162. Trans. Garrett White.]

One of the shortest manifestos in the book, and one of the most infamous. Here, Buñuel decries the polite, bourgeois, aesthete response to his film, which he nevertheless sees as a violent call to insurrection.

The publication of this screenplay in *La Révolution surréaliste* is the only one I have authorized. It expresses, without any reservations, my complete adherence to surrealist thought and activity. *Un Chien andalou* would not exist if surrealism did not exist.

A box-office success, that's what most people think who have seen the film. But what can I do about those who seek every novelty, even if that novelty outrages their most profoundly held convictions, about a sold-out or insincere press, about which this imbecilic crowd that has found *beautiful* or *poetic* that which, at heart, is nothing but a desperate, impassioned call for murder?

MANIFESTO OF THE SURREALISTS CONCERNING *L'AGE D'OR*
(France, 1930)

The Surrealist Group (Maxime Alexandre, Louis Aragon, André Breton, René Char, René Crevel, Salvador Dalí, Paul Eluard, Benjamin Péret, Georges Sadoul, André Thirion, Tristan Tzara, Pierre Unik, Albert Valentin)

[First published in French by Studio 28 Cinema (Paris) for the launch of *L'âge d'or* on 29 November 1930. First published in English in Paul Hammond, *The Shadow and Its Shadow: Writings on Surrealist Cinema* (London: BFI, 1977), 115–122.]

One of the most extensive surrealist manifestos on the cinema, this text lays out the goals of Buñuel's *L'âge d'or*, which was quickly banned upon its release. The Surrealist Group argues that the film is psychoanalytic and explicitly explores the link Freud claims there is between sexuality and death. The manifesto also echoes the ideas raised in the Surrealist Group's "Hands Off Love," on the divorce of Charlie Chaplin from Lita Grey in 1927 (see "Hands Off Love" in chap. 5 of this volume).

On Wednesday 12 November 1930 and on subsequent days several hundred people, obliged to take their seats daily in a theatre, drawn to this spot by very different not to say contradictory aspirations covering the widest spectrum, from the best to the worst, these people generally unfamiliar with each other and even, from a social point of view, avoiding each other as much as they can, yet nevertheless conspiring, whether they like it or not, by virtue of the darkness, insensitive alignment and the hour, which is the same for all, to bring to a successful conclusion or to wreck, in Buñuel's *L'Age d'or,* one of the maximum lists of demands proposed to human consciousness to this day, it is fitting perhaps, rather than giving in to the pleasure of at last seeing transgressed to the *nth* degree the prohibitive laws passed to render inoffensive any work of art over which there is an outcry and faced with which we endeavour, with hypocrisy's help, to recognise in the name of beauty nothing but a muzzle, it is certainly fitting to measure with some rigour the wing span of this bird of prey so utterly unexpected today in the darkening sky, in the darkening western sky: *L'Age d'or.*

THE SEXUAL INSTINCT AND THE DEATH INSTINCT

Perhaps it would be asking too little of today's artists that they confine themselves to establishing the brilliant fact that the sublimated energy smouldering within them will continue to deliver them up, bound hand and foot, to the existing order of things and will not make victims, through them, of anybody but themselves. It is, we believe, their most elementary duty to submit the activity which results from this sublimation of mysterious origin to intense criticism and not to shrink before any apparent excess, since above all else it is a question of loosening the muzzle we were speaking of. To give in, with all the cynicism this enterprise entails, to the tracking down within oneself and the affirmation of all the hidden tendencies of which the artistic end product is merely an extremely frivolous aspect, must not only be permitted but demanded of them. Beyond this sublimation of which they are the object and which could not be held without mysticism to be a natural aim, it only remains for them to propose to scientific opinion another term, once account has been taken by them of this sublimation. Today one expects of the artist that he know to what fundamental machination he *owes* his being an artist, and one can only give him title to this denomination as long as one is sure he is perfectly aware of this machination.

Now, disinterested examination of the conditions in which the problem is, or tends to be, resolved, reveals to us that the artist, Buñuel for example, merely succeeds in being the immediate location of a series of conflicts that two none the less associated human instincts distantly engage in: the sexual instinct and the death instinct.

Given that the universally hostile attitude involving the second of these instincts differs in each man only in its application, that purely economic reasons oppose themselves within present-day bourgeois society to whatever this attitude profits by in the way of other than extremely incomplete gratifications, these same reasons being themselves an unfailing source of conflict derived from what they might have been, and which it would be permissible then to examine, one knows that the amorous attitude, with all the egoism it implies and the much more appreciable chance of realisation it has, is the one which, of the two, succeeds in best sustaining the spirit's light. Whence the miserable taste for *refuge* of which much has been made in art for centuries, whence the great tolerance displayed to all that, in exchange for a good many tears and much gnashing of teeth, still helps place this amorous attitude above all else.

It is no less true, dialectically, that either one of these attitudes is only humanly possible as a function of the other, that these two instincts for *preservation,* tending, it has been pointed out, to re-establish a state troubled by the appearance of life, creates a perfect balance in every man, that social cowardliness which anti-Eros allows, at the expense of Eros, to be born. It is no less true that in the violence we see in an individual's spirited amorous passion we can assess his capacity for refusal, we can, from a revolutionary viewpoint, making light of the fleeting inhibition in which his education may or may not sustain him, give him more than a symptomatic role.

Once, and this is always the case, this amorous passion shows itself to be so clear about its own determination, once it bristles the disgusting spines of the blood of what one wants to love and what, occasionally, one loves, once the much maligned frenzy has taken over, outside of which we, Surrealists, refuse to hold up any expression of art as valid, and we know the new and dramatic limit of compromise through which every man passes and through which, in proposing to write or paint, we are the first and the last to have, without more ample information—this more ample information being *L'Age d'or*—consented to pass.

IT'S THE MYTHOLOGY THAT CHANGES

At the present, undoubtedly most propitious time for a psychoanalytic investigation which aims to determine the origin and formation of moral myths, we believe it possible, by simple induction, marginal to all scientific accuracy, to conclude in the possible existence of a criterion that would free itself in a precise way from everything that can be synthesised in the general aspirations of Surrealist thought and which would result, from the biological point of view, in an attitude contrary to that which permits the admission of the various moral myths as the residue of primitive taboos. Completely opposed

to this residue we believe (paradoxical as it may seem) that it is within the domain of what one is in the habit of reducing to the limitations (!) of the congenital, that a depreciative hypothesis of these myths would be possible according to which the divination and mythification of certain fetishistic representations of moral meaning (such as those of maternity, old age, etc.) would be a product which, by its relation to the affective world, at the same time as its mechanism of objectification and projection to the external, could be considered as an obviously complicated case of collective transference in which the demoralising role would be played by a powerful and profound sense of ambivalence.

The often complete individual psychological possibilities of destruction of a vast mythic system coexist with the well-known and no less frequent possibility of rediscovering in earlier times, by a process of regression, already existing archaic myths. On the one hand that signifies the affirmation of certain symbolic constants in unconscious thought, and on the other, the fact that this thought is independent of every mythic system. So everything comes back to a question of language: through unconscious language we can rediscover a myth, but we are very much aware that mythologies change and that on every occasion a new psychological hunger of paranoiac tendency overtakes our often miserable feelings.

One must not trust in the illusion that may result from the lack of comparison, an illusion similar to the illusion of the moving off of a stationary train when another train passes by the carriage window and, in the instance of ethics, similar to the tendency of facts towards evil: everything happens as if, contrary to reality, what is changing was not events exactly but, more seriously, mythology itself.

Sculptural reproductions of various allegories will take their place in a perfectly normal way in the moral mythologies of the future, among which the most exemplary will prove to be the one of a couple of blind people eating each other and that of an adolescent "spitting with pure delight on his mother's portrait," a nostalgic look on his face.

THE GIFT OF VIOLENCE

Waging the most desperate struggle against all artifice, subtle or vulgar, the *violence* in this film divests solitude of all it decks itself out in. In isolation each object, each being, each habit, each convention, even each image, intends to revert to its reality, without materialising, intends to have no more secrets, to be defined calmly, uselessly, by the atmosphere it creates, the illusion being lost. But here is a mind *that does not accept* remaining alone and which wants to revenge itself on everything it seizes on in the world imposed on it.

In his hands sand, fire, water, feathers, in his hands arid joy of privation, in his eyes anger, in his hands violence. After having been for so long the victim of confusion man replies to the calm that's going to cover him in ashes.

He smashes, he sets to, he terrifies, he ransacks. The doors of love and hatred are open, letting violence in. Inhuman, it sets man on his feet, snatches from him the possibility of putting an end to his stay on earth.

Man breaks cover and, face to face with the vain arrangement of charm and disenchantment, is intoxicated with the strength of his delirium. What does the weakness of his arms matter when the head itself is so subjected to the rage that shakes it?

LOVE AND DISORIENTATION

We are not far from the day when it will be seen that, despite the wear and tear that bites into us like acid, and at the foundation of that liberating or sombre activity which is the seeking after a cleaner life in the very bosom of the machinery with which ignominy industrialises the city,

<div align="center">LOVE</div>

alone remains without perceptible limits and dominates the deepness of the wind, the diamond mine, the constructions of the mind and the logic of the flesh.

The problem of the bankruptcy of feelings intimately linked with the problem of capitalism, has not yet been resolved. One sees everywhere a search for new conventions that would help in living up to the moment of an as yet illusory liberation. Psychoanalysis can be accused of having created the greatest confusion in this area, since the very problem of love has remained outside the signs that accompany it. It is the merit of *L'Age d'or* to have shown the un-reality and insufficiency of such a conception. Buñuel has formulated a theory of revolution and love that goes to the very core of human nature, by the most moving of debates, and determined by an excess of well-meaning cruelty, that unique moment when you obey the wholly distant, present, slow, most pressing voice that yells through pursed lips so loudly it can hardly be heard:

LOVE . . . LOVE . . . Love . . . love . . .

It is useless to add that one of the culminating points of this film's *purity* seems to us crystallised by the image of the heroine in her room, when the power of the mind succeeds in sublimating a particularly baroque situation into a poetic element of the purest nobility and solitariness.

SITUATION IN TIME

Nothing is more useless today than that a very pure, unassailable thing be the expression of what is most pure, most unassailable in man, when whatever he does, whatever we do, to insure his labours against injury, against misunderstanding—by which we mean merely to point out the worst that consists in the turning of that thought to the profit of another not on a par with it—whatever he does, we say, is done in vain. At present everything seems indifferently usable towards ends we have denounced and reproved too often to be able to disregard every time we come up against them, for instance when we read

in *Les annales*[4] a statement in which the last clown to have done so indulged in some delirious commentary on *Un Chien andalou* and felt qualified by his admiration to discover a link between the film's inspiration and *his own* poetry. There can, however, be no mistake. But whatever fence we put around a seemingly well-protected estate we can be sure it will immediately be covered in shit. Although the means of aggression capable of discouraging swindling can hardly be contained within a book, painting or film, despite everything we continue to think that provocation is a precaution like any other and, on this plane, that nothing prevents *L'Age d'or* deceiving whoever hopes conveniently to find in it grist for his mill. The taste for scandal which Buñuel displayed, not from deliberate whimsy, but for reasons on the one hand personal to him that invoke, on the other, the desire to alienate forever the curious, the devotees, jokers and disciples who were looking for an opportunity to exercise their more or less large capacity for airing their views, if such a mind has succeeded this time in the scheme it undertook, we could think he had no other ambition. It's up to the critical profession to look for more, and concerning this film, to put questions about the scenario, technique, use of dialogue. As long as nobody expects us to furnish them with arguments meant to fuel their debate on the expediency of silence or sound, for we maintain that this is a quarrel as vain, as resolved as the one between classical and free verse. We are too sympathetic to what, in a work or in an individual, is *left to be desired* to be very interested in perfection, wherever that idea of perfection comes from, in some progress it seems to initiate. That is not the problem Buñuel sets out to solve. And can one even speak of a problem in reference to a film in which nothing that moves us is evaded or remains in doubt? What do we retain of the interminable reel of film put before our eyes till today and now dispersed, certain fragments of which were just the recreation of an evening to be killed, certain others the subject of despondency or unbelievable cretinisation, others the cause of a brief and incomprehensible exaltation, if not the voice of the arbitrary perceived in some of Mack Sennett's comedies, of defiance in *Entr'acte*, of a savage love in *White Shadows*,[5] the voice of equally unlimited love and despair in Chaplin's films? Apart from these, nothing outside of *The Battleship Potemkin*'s indomitable call to revolution. Nothing outside of *Un Chien andalou* and *L'Age d'or*, both situated beyond anything that exists.

Let's give way, therefore, to that man who, from one end of the film to the other, passes through it, traces of dust and mud on his clothes, indifferent to all that does not uniquely concern the love occupying him, driving him on, around which the world is organised and rotates, this world he is not on terms with and to which, once again, we belong only to the degree we protest against it.

SOCIAL ASPECT—SUBVERSIVE ELEMENTS

One would have to go back a long way to find a cataclysm comparable to the age we live in. One would probably have to go right back to the collapse of the ancient world. The curiosity attracting us to those troubled times, times similar, with certain reservations, to our own,

would love to rediscover in that time something more than history. A Christian heaven, alas, has completely obliterated everything else, and there is nothing in it that one has not already seen on the ceilings of the Ministry of the Interior or on the rocks by the seaside. This is why the genuine traces left on the human retina by the needle of a great mental seismographer will always be, unless they disappear along with everything else when capitalist society is annihilated, of utmost importance to those whose chief concern is to define the critical point at which reality is replaced by "simulacra." Whether the sun sets once and for all depends on the will of mankind. Projected at a time when banks are being blown up, rebellions breaking out and artillery rumbling out of arsenals, *L'Age d'or* should be seen by all those who are not yet disturbed by the news which the censors still let the papers print. It is an indispensable moral complement to the stock-market scare, and its effect will be direct precisely because of its Surrealist nature. For there is no fictionalisation of reality. The first stones are laid, conventions become a matter of dogma, the cops push people around just as they have always done, and, as always too, various accidents occur within bourgeois society that are received with total indifference. These accidents which, it will be noticed, are presented in Buñuel's film as philosophically pure, weaken the powers of endurance of a rotting society which is trying to survive by using the clergy and the police as its only buttresses. The ultimate pessimism issuing from the very bosom of the ruling class as its optimism disintegrates becomes in turn a powerful force in the decomposition of that class, takes on the value of negation immediately translated into anticlerical, therefore revolutionary, action since *the struggle against religion is also the struggle against the world*.

The transition from pessimism to the stage of action is brought about by Love, the root, according to bourgeois demonology, of all evil, that Love which demands the sacrifice of everything: status, family, honour, the failure of which within the social framework leads to revolt. A similar process can be seen in the life and work of the Marquis de Sade, a contemporary of that *golden age* of absolute monarchy interrupted by the implacable physical and moral repression of the triumphant bourgeoisie. It is not by chance that Buñuel's sacrilegious film is an echo of the blasphemies screamed by the Divine Marquis through the bars of his prison cells. Obviously the final outcome of this pessimism in the struggle and triumph of the proletariat, which will mean the decomposition of class society, remains to be seen. In a period of "prosperity" the social value of *L'Age d'or* must be established by the degree to which it satisfies the destructive needs of the oppressed, and perhaps also by the way in which it flatters the masochistic tendencies of the oppressors. Despite all threat of suppression this film will, we feel, serve the very useful purpose of bursting through skies always less beautiful than those it shows us in a mirror.

MANIFESTO ON "QUE VIVA MEXICO" (USA, 1933)

The Editors of *Experimental Film*

[First published in *Experimental Film* 2, no. 5 (1934): 14.]

The following manifesto emerged from the controversy surrounding the tumultuous end of filming of Eisenstein's *Que viva Mexico*, which he made at the end of his Hollywood sojourn after the debacle of trying to work for Jesse L. Lasky at Paramount studios in the early 1930s. Many on the filmmaking left believed that Eisenstein was betrayed by writer and political activist Upton Sinclair, allowing Eisenstein's work to be edited by someone else in order to try and recoup the expenditures on the film. The closest to an integral version of the film that follows Eisenstein's notes for the film's montage is Grigori Alexandrov's cut of the film, released in 1979.

The notion of anyone doing the montage of Eisenstein's film except Eisenstein himself is outrageous to all the canons of Art. No economic situation justifies such an aesthetic crime.

—WALDO FRANK

Of the grandeur of the undamaged original *(The Last Supper)* we can only guess. . . . Dreadful restorations were made by heavy-handed meddlers; some imbecile Dominican monks cut a door through the lower central part; Napoleon's dragoons stabled their horses in the refectory and threw their boots at Judas Iscariot; more restorations and more disfigurements.

—THOMAS CRAVEN, *MEN AND ART*

TO OUR READERS

Last year, a great deal of space was devoted to a film entitled *Que Viva Mexico!*, which S. M. Eisenstein, the renowned Soviet director was making at that time. There were two articles on the film, one of them an authorized interpretation by Augustin Aragon Leiva, Eisenstein's special assistant throughout the production. In addition, there were ten pages of still reproductions, which, to quote Laurence Stallings, gave a "foretaste" of the film. The editors of *Experimental Cinema* were more than merely enthusiastic about it: they had been given a copy of the scenario by Eisenstein himself and they were convinced that *Que Viva Mexico!* would materialize, as no film had ever done, the highest principles of the cinema as a fine art.

There is now being released on the world market a movie called *Thunder Over Mexico*, which is what it is: a fragmentary and entirely conventional version of Eisenstein's original majestic conception. The story behind this commercialized version is without

doubt the greatest tragedy in the history of films and one of the saddest in the history of art. It represents the latest instance of a film director, in this case a genius of the first rank, forfeiting a masterpiece in a hopeless struggle against sordid commercial interests.

We decry this illegitimate version of "QUE VIVA MEXICO!" and denounce it for what it is—a mere vulgarization of Eisenstein's original conception put forth in his name in order to capitalise on his renown as a creative artist. We denounce the cutting of "QUE VIVA MEXICO!" by professional Hollywood cutters as an unmitigated mockery of Eisenstein's intention. We denounce "THUNDER OVER MEXICO" as a cheap debasement of "QUE VIVA MEXICO!"

As all students of the cinema are aware, Eisenstein edits ("mounts") his own films. Contrary to the methods generally employed by professional directors in Hollywood, Eisenstein gives final form to the film in the cutting-room. The very essence of his creative genius, and of his oft-quoted theory of the cinema, consists in the editing of the separate shots after all the scenes have been photographed. Virtually every film director of note has testified, time and again, to the revolutionary consequences of Eisenstein's montage technique on the modern cinema, and every student of the cinema knows how impossible it is for anyone except Eisenstein to edit his pictures. *"THUNDER OVER MEXICO" has not been edited by Eisenstein and yet is being exploited into [sic] as his achievement. The editing of "THUNDER OVER MEXICO" is not Eisenstein montage.*

Out of approximately 200,000 feet of film shot by Eisenstein in Mexico, a picture of some 7,000 feet cut according to conventional Hollywood standards, has been produced,—an emasculated fragment of Eisenstein's original scenario which provided for *six* interrelated episodes, in which were included a dramatic prologue depicting the life of ancient Yucatan and an epilogue foreshadowing the destinies of the Mexican people. What has happened to this material?

Eisenstein's original prologue, which was intended to trace the sources and primitive manifestations of Mexican culture, thus projecting the most vital cultural forms among the Aztecs, Toltecs and the Mayans, has been converted into a pseudo-travelogue.

Worse than this is the fate of Eisenstein's original epilogue, which was intended to establish the timeless continuity of types from ancient Yucatan to modern Mexico, and which was meant to anticipate the revolutionary urge dormant in the descendants of those ancient races. Under the guidance of Eisenstein's backers, who have never from the start shown a due consciousness of what the film is all about, the epilogue has now been converted into a cheerful ballyhoo about "a new Mexico," *with definite fascist implications.*

The remaining mass of material, consisting of more than 180,000 feet, is in danger of being sold piecemeal to commercial film concerns.

Thus, Eisenstein's great vision of the Mexican ethos, which he had intended to present in the form of a "film symphony," has been destroyed. Of the original conception, as revealed in the scenario and in Eisenstein's correspondence with the editors of *Experimental Cinema,* nothing remains in the commercialized version except the photography,

which no amount of mediocre cutting could destroy. As feared by Eisenstein's friends and admirers, the scenario, written in the form of a prose poem, merely confused the professional Hollywood cutters. The original *meaning* of the *film* has been perverted by reduction of the whole to a single unconnected romantic story which the backers of the picture are offering to please popular taste. The result is *"Thunder Over Mexico"*: a "Best-Picture-of-the-Year," Hollywood special, but in the annals of true art, the saddest miscarriage on record of a high and glorious enterprise.

For more than a year Eisenstein's friends and admirers in the United States have been appealing to his backers, represented by Upton Sinclair, to save the picture and to preserve it so that eventually Eisenstein might edit it. A campaign was even launched *to* raise $100,000 to purchase the material for Eisenstein. Finally, a Committee for Eisenstein's Mexican Film was formed, consisting of the editors of *Experimental Cinema* and including Waldo Frank, Lincoln Kirstein, Augustin Aragon Leiva and J. M. Valdes-Rodriguez. All these efforts however, were unsuccessful. It is now too late to stop the release of *"Thunder Over Mexico."*

But there is one alternative left to those who wish to save the original negative of "QUE VIVA MEXICO!": *the pressure of world-wide appeal to the conscience of the backers may induce them to realize the gravity of the situation and give the film to Eisenstein.*

The purpose of this manifesto, therefore, is two-fold: (1) to orient and forewarn public taste on the eve of the arrival of a much misrepresented product, *"Thunder Over Mexico"*; and (2) to incite public opinion to bring pressure to bear upon the backers in a last effort to save the complete negative, both cut and uncut, for Eisenstein.

Lovers of film art! Students of Eisenstein! Friends of Mexico! Support this campaign to save the negative of "QUE VIVA MEXICO!" *Do not be satisfied with any substitutes for Eisenstein's original vision! Make this campaign an unforgettable precedent that will echo throughout film history, a warning to all future enemies of the cinema as a fine art!!!*

Send letters of protest and appeal to Upton Sinclair, 614 North Arden Drive, Beverly Hills, California, and communicate immediately with the Committee for Eisenstein's Mexican Film, c/o Experimental Cinema, International Film Quarterly, 1625 North Vine Street, Hollywood, California.

<div align="center">EDITORS OF EXPERIMENTAL CINEMA.</div>

Foreign Film Journals: Please copy! Immediate Propaganda essential! Film Societies: Duplicate this manifesto! Distribute to your members!

Write for extra copies.

Do not allow this cowardly assassination of Eisenstein's Mexican film!

SPIRIT OF TRUTH (France, 1933)

Le Corbusier

[First published in French as "Esprit de vérité," *Mouvement* (France) 1 (1933): 10–13. First published in English in Richard Abel, ed., *French Film Theory and Criticism*, vol. 2, 1929–1939 (Princeton, NJ: Princeton University Press, 1988), 111–113. Trans. Richard Abel.]

Like many of the early avant-garde manifestos in this book, Swiss/French architect Le Corbusier's manifesto considers the way in which mechanization, and in particular the mechanization brought about by the camera lens, changes the viewer's relationship to the real, revealing in the process a heretofore unseen scientific reality. Like the constructivists, Le Corbusier sees mechanization as the twentieth century's defining principle, but he also considers the role played by vision in a way that foreshadows Stan Brakhage's infamous manifesto on vision (see the excerpt from Brakhage's *Metaphors on Vision* later in this chapter).

Sprit of Truth!

Here, too, and fundamentally. In the cinema: spirit of truth.

I have claimed it insistently for architecture; and, in 1924, at the time of the preparations for the International Exposition of Decorative Arts, I intimated clearly by that insistence that decorative art had no right to exist—at least as the distressingly encumbered, bloated facade that it had become.

The splendor and drama of life emerges from the truth; and 90 percent of the cinema's production is delusion. It simply exploits a remarkable technical advantage: the elimination of transitions, the easy possibility of suppressing "dead spaces." Thus, it soothes us with images, sometimes engaging ones. And we wait patiently, we wait.

We await the truth.

Assuredly, everything is architecture, that is, ordered or arranged according to proportions and the selection of proportions: *intensity*. But intensity is possible only if the objects considered are precise, exact, sharply angled (a fog bank can not very well be considered as a precise event).

Therefore, it's necessary to *conceive* and then to *see*. It's necessary to have the *notion* of vision. For, to seek out men who see is to test the experiment of Diogenes.

The theater and theater people who tell stories have led the cinema into perdition. These people who are so full of bombast and grandiloquence have interposed themselves between us and the true *voyeur:* the lens.

Since we have fallen so low, it would be useful, for a time, to put our trust once again in technique itself, in order to return to essential things. To the basic elements. To culminate, consequently, in a recovery of the consciousness of the possibilities of the cinema.

And thus to be able *to discover life, in what there is that's true,* in what it contains that's so prodigiously intense, varied, multiple.

The base is the apparatus of physics, the lens of the camera—as eye.

An eye which is impassive, insensitive, implacable, pitiless, insusceptible to emotion. *This eye sees differently from our own,* and here's why:

The recording instrument of our human vision is perhaps the most wonderful and perfect optical machine. But what it *sees is* only perceived *by* means of our understanding, the keyboard of the totality of human sensation, which is theoretically infinite in its range. Here we are limited in the recording of our vision, however, by the simultaneous presence of other perceptions intervening at the same moment, encumbering our keyboard, overwhelming it, deluging it. If everything, for us, is symphonic, synthetic, synchronic, everything also exists only according to an ordinary measure, to human scale: a kind of central zone which circumscribes our understanding. And we know how much it is limited. And what efforts those whom we call scientists or geniuses must make in order to extend some path farther, whether to the left or the right.

But if, through a fortunate conjunction, some discovery is made, we can appreciate the beacon of light it projects beyond the things we accept as given. Science and its still youthful daughter, the Machine, have extended certain of our means of perception and have thrown out bridges beyond the impassable zones of our senses and our skills.

Thus, the various calculating machines, created in the last few years, have allowed us to undertake series of calculations previously considered *inaccessible* and suddenly have propelled certain investigations far ahead. Without the machine, such calculations had been chimerical. The scientist who previously attempted such an adventure had to suffer weeks of wear and tear in order to come up with just one of the terms of a still indecisive equation. So fatiguing was the effort that the imagination, the spiritual impulse, which had launched the enterprise, dissipated, drained away, and disappeared; reasoning was exhausted in the steady march of days, weeks, and months, engulfed in weighty calculations.

A mechanical creation: the impassive, indefatigable machine . . . and it liberates thinking. In several days, the scientist clinches the parabolic coordinates of his hypothesis; he concludes, sets forth an opinion, then a formula. A law emerges. And infinite consequences can result from that for men's lives.

The lens of the camera is one of these machines which dispel fatigue.

While you suffer the effect of contingencies, you're hot or cold, you're fatigued or distracted, your own consciousness is weighted down by internal events, you're overwhelmed by the tumult or silence, etc., etc. . . . a single lens and a sensitive filmstock go on working brilliantly.

A god's eye, demiurge, while you yourself are only a poor good-natured fellow assailed by life.

Documentary, especially the scientific kind (Painlevé, or the miraculous films on the growth of seeds and plants), has revealed mysteries of the universe which previously have been beyond our perception.

But I want the lens now to disclose the intensity of human consciousness to us through the intermediary of visual phenomena which are so subtle and so rapid in nature that we have no means ourselves to discover and record them: we are unable to observe them, we simply feel their radiance.

Yet, when some pleasure arises in us, *within us,* when restlessness oppresses us, when anxiety fills all the planes of our sensibility, whether on the street or at home, we seem to encompass so many diverse, almost immaterial events—faces, gestures, attitudes—as if we were a mold or a vessel. And the friend we meet says to us: "Do you feel this way? Do you feel that way?" He has known it from perceptible signs: the nuance, the infinite nuances of the game of life, within us. This unexpected meeting with a friend represents precisely the distance needed to establish a sense of proportion.

I say, therefore, that the nerveless, soulless lens is a prodigious voyeur, a discoverer, a revealer, a proclaimer.

And through it, we can enter into the truth of human consciousness. The human drama is wide open to us.

That's what interests me.

On the one hand, the spectacle of the world (where the airplane, the microphone, slow motion, the electric light, etc. . . . bring their immense resources to the cinema), the spectacle of the world can be accessible to us. On the other hand, the truth of our consciousness can be shown, more than that, it can be revealed by means of our very own selves.

Nature and human consciousness are the two terms of the equation, which interests us. Nothing else is needed, everything is there.

Let us construct [the cinema] on these realities, on these truths: composition, balance, rhythm! Let lyricism infuse it in order that this quest be carried out on the terrain of creative work!

I believe I've shown that from now on the cinema is positioning itself on its own terrain. That it is becoming a form of art in and of itself, a kind of genre, just as painting, sculpture, literature, music, and theater are genres. And that everything is open to its investigation.

It's no longer appropriate to dream of magnificent mise-en-scenes in the studios, of expensive paraphernalia, of superfilms and superproductions.

Great art employs limited means.

Great art, in truth, is only a matter of proportions.

The cinema appeals "to the eyes that see." To the men sensitive to truths. Diogenes has found a light for his lantern: no need for him to embark for Los Angeles.

AN OPEN LETTER TO THE FILM INDUSTRY AND TO ALL WHO ARE INTERESTED IN THE EVOLUTION OF THE GOOD FILM (Hungary, 1934)

László Moholy-Nagy

[First published in *Sight and Sound* 3, no. 10 (1934): 56–57.]

Former Bauhaus faculty member László Moholy-Nagy wrote this for the UK publication *Sight and Sound* shortly before his immigration to London in 1935. He had a long-standing interest in the cinema, publishing *Malerei, Fotografie, Film* (Material, Photography, Film) in 1925. This manifesto decries the commercialization of the cinema and calls for state and educational support in the nurturing of a new generation of filmmakers. It is worth noting that a mere thirty-nine years after the arrival of the cinema, many in the avant-garde were already fulminating against its decline, if not calling for its death outright, as did Vertov some years before.

I.

SHALL we look on while the film, this wonderful instrument, is being destroyed before our eyes by stupidity and a dull-witted amateurism? The unbiased observer cannot fail to see, to his great distress, that the film production of the world is growing more and more trivial every year. To the trained eye and mind the present-day film can give no pleasure. This criticism is not confined to the artistic side of film-making. The whole film industry is in danger. This is shown by its increasing incapacity to produce a financial return. Gigantic sums are swallowed up by desperate experiments, extravagance in superficial matters not strictly proper to the film; monster decorations, piling up of stars, paying huge salaries to secure performers who turn out unsuitable for filming. This expenditure will never bring in its return, so that the film is slipping back. With increasing certainty into the hands of the adventurers, from whom it had been rescued after its initial period of being a purely speculative business.

II.

The root of all evil is the exclusion of the experimental film creator, of the free independent producer.

III.

Yesterday there were still crowds of pioneers in all countries; to-day the whole field is made a desert, mown bare. But art can know no further development without the artist,

and art requires full sovereignty over the means to be employed. Every work of art attains its achievement only through the responsible activity of the artist, driven to his objective by his vision of the whole. This is true of architecture, of painting, of drama. It is equally true of the film, and cannot be otherwise.

IV.

From the nature of the film arises the difficulty of experimentation, the nursery-garden of good film work; for to the film there is attached a machinery of production and distribution, the organisation of which stretches from the scenario through acting, photography, sound recording, direction, and film-cutting up to press propaganda, leasing and cinema halls. Only thus could what was once a side-show at a fair be converted into a world-wide business. Amongst the economic complications of this enormous machine the artistic aspect is treated so incidentally, judged so entirely from the mercantile standpoint, that the significance of the creative artist of the film is completely eliminated. One might almost say the director is forced through fear of penalisation to do without the cinematograph art. By becoming part of the prevailing system of production, even the best pioneers have, to the bitter disappointment of all those interested in films, sunk to the level of the average director. The independent producers were an embarrassment to the industry. The existence of the pioneers implied a destructive criticism of official production. The vitality of the small works, their faith in the cinematographic art, while hardly removing mountains, did box the ears of the industry soundly. They swung out for a counter-blow without realizing the soundness of these pioneer movements, their effort to press forward on the artistic side. So the industry carefully stamped out anything which was even suggestive of pioneer effort. Their crowning victory was found in the necessity of specially constructed buildings for sound-film production and showing, and consequently the final business monopolisation of the "art of the film."

V.

The way was freed once more for mechanized business. The industry was victorious all along the line.

Everything contributed to help them; legislation regulations concerning quotas and import restrictions, censorship, leasing, cinema owners and short-sighted critics. But the victory of the industry has been a costly one. Art was to be destroyed in the interests of business, but the boomerang has whizzed back and struck the business side. People do not go to boring films, in spite of the calculation of returns made by the film magnate on the theory that every adult *must* visit the cinema twice weekly at an average price of so many cents, pennies, pfennigs or sous, per ticket.

VI.

Shall the artist now, after all the kicks he has received, turn round and help the business side to think? Shall he take a hand again, and beg with economic arguments for the weapons of the spirit that were struck from his hands?

VII.

Good, we will do so.

Now *we* start estimating profits.

VIII.

The culture of the film grew with the onlooker. History records no similar process of general passive participation, extending to all nations and continents, in an applied art and its development to that relating to the cinema. By the numerically enormous part played in human life generally by attendance at cinemas, even the most primitive member of an audience is in a position to exercise criticism of the film and register any slackening of creative interest. This means the necessity of straining every nerve in creative work. But where is that work to come from, if the artist is to he excluded from the creative process?

IX.

A pioneer group is thus not only an artistic but an economic necessity.

X.

All barriers against pioneer effort must therefore be removed. Encouragement, private, industrial and official, must therefore be extended to the independent cinematograph artist.

XI.

This means that we demand for him:

 (1) From the State
 (a) Removal of censorship restrictions.
 (b) *No* taxation on his creations.
 (c) Payment of allowances.
 (2) From the industry, in accordance with output.
 (a) Studio
 (b) Sound

(c) Material

(d) Obligatory performances by leasing agents and theatres.

(3) Education in artistic film work must be begun long before the practical side. The antiquated art school curriculum must be replaced by the establishment of

(a) Studios for lighting (artificial light)

(b) Photo and film studios (camera technique)

(c) Dramatic classes

(d) Theoretical, physical and experimental departments.

XII.

To formulate and fight for these demands is terribly necessary at the present time, for our generation is beginning to exploit without initiative or talent the magnificent technical heritage of the previous century. It remains to be hoped that these statements of opinion will remind a few, at least, of the intellectual problems which the conscience of the thinking man bids him solve.

LIGHT*FORM*MOVEMENT *SOUND (USA, 1935)

Mary Ellen Bute

[First published in *Design Magazine* (New York), 1956.]

Experimental animator Mary Ellen Bute's manifesto outlines some of the key elements of Absolute Film—a cinema that relies primarily on visual and aural abstraction. Like her contemporary abstract animators Norman McLaren, Len Lye, and Oskar Fischinger, Bute argues for a synesthetic cinema that disavows realism and instead explores the nature of the visual and aural fields.

The Absolute Film is not a new subject. It is concerned with an art which has had as logical a development as other arts, perhaps slowly but naturally.

This art is the interrelation of light, form, movement, and sound—combined and projected to stimulate an aesthetic idea. It is unassociated with ideas of religion, literature, ethics or decoration. Here light, form, and sound are in dynamic balance with kinetic space relations.

The Absolute Film addresses the eye and the ear. Other motion pictures, although making use of sensations of sight and sound, address not the eye and the ear but the intellect.

For example, in realistic films, the medium is subordinate to story, symbol or representation. We view an Absolute Film as a stimulant by its own inherent powers of sensation, without the encumbrance of literary meaning, photographic imitation, or symbolism. Our enjoyment of an Absolute Film depends solely on the effect it produces: whereas, in viewing a realistic film, the resultant sensation is based on the mental image evoked.

Cinematographers, painters and musicians find a common enthusiasm in the absolute film. Through using the motion picture camera creatively, cameramen find a seemingly endless source of new possibilities and means of expression undreamed of while the camera was confined to use merely as a recording device. But we must turn back to painters and musicians to find the ideas which probably motivated the Absolute Film into a state of being.

Work in the field of the Absolute Film is accelerating both here and abroad. The foundations for it were laid years ago, and it was more recently anticipated by Cézanne and his followers with whom we have an abstract art of painting taking form. Cézanne used the relationships between color and form, discarding the former mixture of localized light and shade by stressing relationship, he lifted color from imitating objective nature to producing a visual sensation in itself. His paintings of still lifes: apples and tablecloth, are not conceived in a spirit of objective representation; they are organized groups of forms having relationships, balanced proportions and visual associations. His use of color on a static surface reaches a point where the next step demanded an introduction of time sequence and a richer textural range.

The Cubists tried to produce on a static surface a sensation to the eye, analogous to the sensation of sound to the ear. That is, by the device of presenting simultaneously within the same visual field the combined aspects of the same object views from many different angles or at different intervals. They tried to organize forms distantly related to familiar objects to convey subjective emotions aroused by the contemplation of an objective world.

The element of music appears in the paintings of Kandinsky. He painted abstract compositions based on an arbitrary chromatic scale of the senses.

The word *color* appears often in the writing of Wagner. In the "Reminis of Amber" (1871) he writes: "Amber made his music reproduce each contrast, every blend in contours and color—we might almost fancy we had actual music paintings."

There is simply no end to the examples which we might cite. Some musicians have gone on record as having color associations with specific instruments.

These experiments by both musicians and painters, men of wide experience with their primary art material, have pushed this means of combining the two mediums up into our consciousness. This new medium of expression is the Absolute Film. Here the artist creates a world of color, form, movement, and sound in which the elements are in a state of controllable flux, the two materials (visual and aural) being subject to any conceivable interrelation and modification.

PROLEGOMENA FOR ALL FUTURE CINEMA (France, 1952)

Guy Debord

[First published in French as "Prolégomènes à tout cinéma futur," *Ion* (France) 1, 1952. Trans. Scott MacKenzie.]

This manifesto is Guy Debord's first published work, from the one-shot journal *Ion*, dedicated to Lettriste cinema. Debord deploys the Lettriste concepts of the "chiseling" and "amplic" phases of art in this manifesto, but one can see he is already moving away from Isidore Isou's brand of Lettrism as he postulates his theory of "situations" in the concluding line of the manifesto. Published slightly before the release of his first film, *Hurlements en faveur de Sade* (France, 1952), this issue of *Ion* also includes the preliminary script to the film, which contained found footage elements and is quite different from the final version, which is made up of alternating clear film and black leader with voice-overs on the clear leader. The last twenty-four minutes of the film consist only of black leader and are silent.

Love is only valid in a revolutionary period.

I made this film while there is still time to talk.

One must rise with the most violence possible against an ethical order that will later be obsolete.

As I do not like writing, I lack the leisure to create a work that will be less than eternal: my film will remain among the most important in the history of the reproductive hypostasis of cinema by means of a terrorist disorganization of the discrepant.

Chiseling of the photograph and lettrism (found elements) are envisioned as the expression of such a revolt.

Chiseling bars certain moments of the film which closes the eyes in the face of the excess of the disaster. Lettriste poetry howls for a broken universe.

The commentary is thrown into question by:

The censored phrase, or the suppression of words (cf. *Appel pour la destruction de la prose théorique*) denounces repressive forces.

Spelled words, sketch an even more total dislocation.

The destruction will follow an overlap of image and sound with:

The torn visual-sound phrase, or the photo invading verbal expression.

Spoken-written dialogue, when phrases are written on the screen, continue on the soundtrack, and respond to each other.

Finally, I come to the death of discrepant cinema by the relation of two non-senses (images and words perfectly insignificant), a relation that will be overtaken by a scream.

But all of this belongs to an epoch that is finishing, and that no longer interests me.

The values of creation are shifting toward the conditioning of the spectator, with what I have called *three-dimensional psychology,* and the *nuclear cinema* of Marc'O that begins another amplic stage.

The arts of the future will be radical transformations of situations or nothing at all.

NO MORE FLAT FEET!
(France, 1952)

Lettriste International (Serge Berna, Jean-Louis Brau, Guy Debord, and Gil J. Wolman)

[First distributed at Charlie Chaplin's press conference for *Limelight* in Paris on 29 October 1952. First published in *Internationale Lettriste* 1 (1952). First published in English in Greil Marcus, *Lipstick Traces: A Secret History of the Twentieth Century* (Cambridge, MA: Harvard University Press, 1989), 340–341. Trans. Sophie Rosenberg.]

The Lettriste International's (an offshoot of the Lettristes founded by Debord) protest of Charlie Chaplin—a figure usually revered by the European avant-garde, and celebrated by Debord earlier in the year in his first film, *Hurlements en faveur de Sade*—is not noted in either Chaplin's autobiography or any of the standard accounts of his life and work. Perhaps this is because of the political situation that overshadowed Chaplin's arrival in Europe: on his way to the European premieres of *Limelight* (US, 1952), the American attorney general withdrew Chaplin's reentry visa, under pressure from HUAC and allegations he was a communist. The protest where the LI tract was distributed took place at the Ritz Hotel, where Chaplin was thanking the French government for awarding him the Légion d'honneur. While trying to get through to where Chaplin was speaking, Debord and Serge Berna were stopped by the police in the kitchen of the hotel (ironically, they were thwarted because the police thought they were overexuberant fans of Charlot).

Sub Mack Sennett director, sub-Max Linder actor, Stavisky of the tears of unwed mothers and the little orphans of Auteuil, you are Chaplin, emotional blackmailer, master-singer of misfortune.

The cameraman needed his Delly. It's only to him that you've given your works, and your good works: your charities.

Because you've identified yourself with the weak and the oppressed, to attack you has been to attack the weak and oppressed—but in the shadow of your rattan cane some could already see the nightstick of a cop.

You are "he-who-turns-the-other-cheek"—the other cheek of the buttock—but for us, the young and beautiful, the only answer to suffering is revolution.

We don't buy the "absurd persecutions" that make you out as the victim, you flat-footed Max de Veuzit. In France the Immigration Service calls itself the Advertising Agency. The sort of press conference you gave at Cherbourg could offer no more than a piece of tripe. You have nothing to fear from the success of *Limelight*.

Go to sleep, you fascist insect. Rake in the dough. Make it with high society (we loved it when you crawled on your stomach in front of little Elizabeth).[6] Have a quick death: we promise you a first-class funeral.

We pray that your latest film will truly be your last.

The fires of the kleig lights have melted the makeup of the so-called brilliant mime— and exposed the sinister and compromised old man.

Go home, Mister Chaplin.

THE LETTRISTES DISAVOW THE INSULTERS OF CHAPLIN
(France, 1952)

Jean-Isidore Isou, Maurice Lemaître, and Gabriel Pomerand

[First published in French as "Les lettristes désavouent les insulteurs de Chaplin," *Combat* (France), 1 November 1952. Trans. NOT BORED!]

Isou and the Lettristes responded to the new Lettriste International with a defense of Chaplin. The fact that the LI went after this icon underscores the fact that they wanted to instantiate a radical break not only with capitalist cultures but also with the previous avant-gardes.

The members of the Lettriste movement are united on the basis of new principles of knowledge and each keeps his independence as far as the details of the application of

these principles. We all know that [Charles] Chaplin was been "a great creator in the history of the cinema" but "the total (and baroque) hysteria" that has surrounded his arrival in France has embarrassed us, as does the expression of all mental instability. We are ashamed that the world today lacks more profound values than these, which are secondary and "idolatrous" of the "artist." Only the Lettristes who signed the tract against Chaplin are responsible for the extreme and confused content of their manifesto. As nothing has been resolved in this world, "Charlot" receives, along with applause, the splashes [*éclaboussures*] of this non-resolution.

We, the Lettristes who were opposed to this tract of our comrades from the beginning, smile at the maladroit expression of the bitterness of their youth.

If "Charlot" must receive mud, it won't be us who throw it at him. There are others, who paid to do it (the Attorney General, for example).[7]

We thus revoke our solidarity from the tract of our friends and we associate ourselves with the homage rendered to Chaplin by the entire populace.

In their turn, the other Lettristes can explain themselves, in their own journals or in the press.

But "Charlot" and all this only constitutes a simple nuance.

THE ONLY DYNAMIC ART (USA, 1953)

Jim Davis

[First published in *Films in Review* 4, no. 10 (1953): 511–515.]

Jim Davis's manifesto describes his realization that the cinema was the only media that could properly encapsulate the demands of the twentieth century. Like Mary Ellen Bute before him, Davis—the director of such abstract films as *Light Reflections* (USA, 1952), *Energies* (USA, 1957), and *Impulses* (USA, 1959)—uses abstract cinema as a means to create a dynamic experience that expands in visual field and allows for the temporal, and not solely the static, to be the subject of visual art. While somewhat forgotten today, Davis's visually stunning work greatly influenced Stan Brakhage, among many others.

After thirty years as a painter and sculptor I have come to the conclusion that the only recording medium with which a visual artist can express the ideas of our time adequately is motion picture film.

My own experience and observation of the work of contemporary painters and sculptors have convinced me that the traditional media of painting and sculpture are too

limited for the full, or even satisfactory, depiction of the complexities of the twentieth century. I believe the artist who clings to these old tools dooms himself to repetition of ideas better expressed in previous cultures, or to regression into the primitive, or to being so subjective he ceases to communicate with anyone but himself.

I have therefore abandoned painting and sculpture and adopted the film medium.

In the motion picture camera the artist has a tool that enables him to communicate to his fellow men all that is new and progressive in contemporary existence and thought. The motion picture camera opens up a vast new subject matter—the unexplored world of visual movement. Now, for the first time in history, an artist can express reality dynamically instead of statically. In the artist's increasing perception of the role of motion in nature and the universe (and man's life) future historians will discern our day's major contribution to the development of the visual arts.

Because motion picture film is a *dynamic* medium, the artist, by means of it, can depict and deploy concepts of modern science that have hitherto defied representation. Current scientific dogma describes reality statistically not statically, as a never ending flux, a continuous process of becoming. Even the man on the street now speaks of time as the fourth dimension, however ignorant he may be of what physicists imply by a space-time continuum. As our minds become accustomed to the notion of time as the fourth dimension, to the relativism implicit in the space-time concept, and to electronically revealed glimpses of the microscopic and the macroscopic, our thoughts, and our dreams, alter. With what, if not with these alterations, should the genuine artist be concerned? And with what but the motion picture camera can the artist express these new perceptions and intuitions?

When the artists of the Renaissance abandoned the flat, two-dimensional painting of the primitives for the then revolutionary three-dimensional kind, they also abandoned tempera, mosaic, stained glass, etc., for the newly invented medium of oil painting. Similarly, the artist who has abandoned the static concepts of the nineteenth century for the more inclusive space-time ones of today, must abandon oil painting for something more dynamic. What else is there but motion picture film?

So-called modern art is static and is a regression to the two-dimensional perceptions of the primitive, or the child, or to three-dimensional concepts of the last five centuries. I agree with that large section of the public, which says: "If this is art, give me the movies." For implicit in the public's preference is an instinctive sense of the universal fact that nothing is static and that the only changeless thing we know is change (i.e., motion).

In the past artists have used forms of color to represent—or imitate—the forms of familiar objects in nature. Whenever the artist did not imitate nature, and used non-representational, or invented, forms, he did so merely for decorative purposes. Not so the architect. To solve his problems he has evolved shapes and forms that have no counterparts in nature. So must the artist who is aware of the miracles that occur in our body's cells and in the all-pervasive ramifications of light, and in those workings of the atom that are so prescient of the future.

Invented forms are abstractions and the serious artist uses them to suggest the *causative* processes of nature, not the concrete objects which are their results. These processes or nature are dynamic, and to be expressed adequately must be shown in motion. Abstract painting and sculpture, of course, are static, and thereby invalid. Without motion abstract forms and patterns are meaningless. At best, they are mere decoration. At worst, they are esthetic and psychological obfuscation.

The artist who uses film adds, to the problem of how to organize space, the element of time. Other arts have been concerned with time, most notably music, and the abstract film is more closely related to music than to traditional painting, which has predominantly been concerned with the literary, and only recently with the abstract.

Just as the musician organizes rhythms of sound in order to stimulate imagination and produce an emotional response, so I organize visual rhythms of moving forms of color. Also like the musician, who doesn't use the sounds of nature but invented sounds, produced by various instruments, I use invented forms of color, which I produce artificially with brightly colored transparent plastics. I set them in motion, play light upon them, and film what happens. Obviously, I am not trying to present facts or to tell a story. I am trying to stir the creative imagination of my fellow men.

When watching my films it is a mistake to search for hidden meanings or to try to identify shapes with familiar concrete objects. I do not know what these invented forms signify, or adumbrate. Nor does anyone else—yet. I only know they have the power to elicit emotional, imaginative, and intellectual, responses, which vary with each individual. Their meaning is of the future, and may lie in the realm of kinetics, or in that of optics. Their meaning may ultimately be nuclear. But my purpose is to stimulate interest in hitherto unperceived aspects of the physical universe, in hitherto unrecognized potentialities in the human imagination, and not to explain them.

But I do not deal in fantasy. My invented forms should not be confused with distortions of natural objects irrationally produced. I work rationally toward *nature,* not away from it into psychological unreality. Let us remember that though mathematical symbols are abstractions, they elucidate the workings of nature, and that although when Reimann invented his tensors he did not know of any application for them, Einstein supplied one.

Although I am interested in suggesting analogies to science, I am more interested in the analogies in my films to music. I deem music the most abstract, as well as the most human, of all the arts, and the art that comes closest to expressing the truth.

I also consciously suggest relations to the dance, for the art of gesture is a basic ingredient of moving pictures. Film also has the power to express subjective ideas, and it is with these that the artist is temperamentally most concerned. I personally prefer fact to fiction, for I believe there to be more poetry in the former, and that human beings ought, as W. D. Howells said, to have "due regard for the poetry which exists in facts and which resides nowhere else." It is, of course, as all artists know, possible to organize facts in a manner more related to poetry than to fiction. In the films I have photographed from

nature I have preferred not to use visual forms for documentation, but for the creation of subjective moods and the suggestion of ideas. This is a personal predilection.

In photographing nature I have concentrated upon aspects of it, which are so obvious, and commonplace they are usually unnoticed. As, for example, the reflection and refraction of light from and in moving objects. The artist who concerns himself with nature's unperceived natural phenomena need not travel to faraway places. All he needs is an open eye and certain serenity, a freedom from his own concerns, and, above all, release from the anthropomorphic compulsion. He also needs light, and a motion picture camera.

So incredible are the forms and movements of nature that when they are shown on the screen, they are often confused with the inventions of the abstract artist. Needless to say, they should not be.

In addition to recording unnoticed aspects of uncontrolled nature, I also make abstract films. But these derive from my nature films. For I am at some pains to study the principles underlying those phenomena of nature, which visually can be so astonishing, and after I have mastered these scientific principles, I try to apply them when I create wholly invented forms and movements.

For example: I recently made a motion picture of the astonishing images produced by the reflections of houses, trees, clouds, etc. on the surface of moving water. Later, I made a film of equally surprising images produced by the reflections of invented objects on the moving surfaces of sheets of highly polished plastics. It may be asked: what do these photographed reflections of invented objects connote? Do they appertain to the nature of light, or are they psycho-physiological phenomena? I think much about these things, and believe the philosophic concept of "becoming" has relevance here.

Abstract films *do* refer to reality, be it chemical, electrical, physical, or psycho-physiological, be the reference ever so remote. But films of fantasy do not. They refer to unreality—the unreality of the dream, or of the subconscious mind. Fantasy arises not from objective fact, or from invention. But from distortion of fact. Now when distortions of fact are set in motion the effect is surprisingly powerful. Need I say that it is film, not painting or sculpture, which makes even the unreal world of fantasy seem more "real"?

I recently made a film that is pure fantasy. In it I did not record nature accurately, nor present new, invented forms and movements. Instead, I distorted nature's forms. Specifically, I distorted the forms of the human body to such a degree that they are almost unrecognizable. The effect is quite nightmarish. In making this film I did exactly what the surrealist and other modern painters do—i.e. I irrationally distorted nature's forms in accordance with the dictates of the whims, obsessions, rationalizations, delusions and compulsions of my subconscious mind.

Unfortunately, the subjective fantasies and distortions of reality in present day painting and sculpture are accepted *as reality by* a great many people who ought to know better (most of whom profess a disdain for the movies). Even Picasso's absurd "I detest nature" is taken seriously. Because it is taken seriously it is a far graver threat to culture than

Grade B movies. For they, at least, do not lead to a rejection of nature and of *the life of our period as well.* Modern art is not revolutionary, and presents nothing that is new. It merely distorts the old and the familiar.

Today, the artist who prefers reality to fantasy, and his own period in history to that of the past, will find there are few things the old tools of painting and sculpture can do that film can not do better, and many things film can do the older media cannot do at all. Clinging to the old tools obliges the artist to reject the new ideas of today simply because they cannot be expressed in the old media. Thus, by clinging to painting and sculpture the artist impedes the development of a new culture.

William James said that history "is nothing but the record of man's struggle to find the ever more inclusive order." Today we live in a dynamic, scientific, industrial and democratic order, not in a static, religious, agricultural and socially exclusive order. The old hand tools are as inadequate in the arts as they are in the crafts. It has been said "everyone sides with the priests or the prophets." As an artist I side with the prophets rather than with the high priests of art.

Therefore I have no choice, I must adopt this new medium of the motion picture film.

A STATEMENT OF PRINCIPLES
(USA, 1961)

Maya Deren

[First distributed by Deren at private screenings of her films. First published in *Film Culture* 22/23 (1961): 161–162.]

Unlike many of the manifestos in this book, Maya Deren's was written after the fact, as an overall statement on her work. A pioneering avant-garde filmmaker, her first film, *Meshes of the Afternoon* (1943), was also highly influential for avant-garde feminist film theorists and filmmakers in the 1970s. In "A Statement of Principles" Deren offers a complex, universal tapestry of the psyche and argues that her films capture and reflect these internal contradictions.

My films are for everyone.

I include myself, for I believe that I am a part of, not apart from humanity; that nothing I may feel, think, perceive, experience, despise, desire, or despair of is really unknowable to any other man.

I speak of man as a principle, not in the singular nor in the plural.

I reject the accountant mentality which could dismember such a complete miracle in order to apply to it the simple arithmetic of statistics—which would reduce this principle

to parts, to power pluralities and status singularities, as if man were an animal or a machine whose meaning was either a function of his size and number—or as if he were a collector's item prized for its singular rarity.

I reject also that inversion of democracy which is detachment, that detachment which is expressed in the formula of equal but separate opinions—the vicious snobbery which tolerates and even welcomes the distinctions and divisions of differences, the superficial equality which stalemates and arrests the discovery and development of unity.

I believe that, in every man, there is an area which speaks and hears in the poetic idiom . . . something in him which can still sing in the desert when the throat is almost too dry for speaking.

To insist on this capacity in all men, to address my films to this—that, to me, is the true democracy . . .

I feel that no man has a right to deny this in himself; nor any other man to accept such self debasement in another, under this guise of democratic privilege.

My films might be called metaphysical, referring to their thematic content. It has required millenniums of torturous evolution for nature to produce the intricate miracle which is man's mind. It is this which distinguishes him from all other living creatures, for he not only reacts to matter but can mediate upon its meaning. This metaphysical action of the mind has as much reality and importance as the material and physical activities of his body. My films are concerned with meanings—ideas and concepts—not with matter.

My films might be called poetic, referring to the attitude towards these meanings. If philosophy is concerned with understanding the meaning of reality, then poetry—and art in general—is a celebration, a singing of values and meanings. I refer also to the structure of the films—a logic of ideas and qualities, rather than causes and events.

My films might be called choreographic, referring to the design and stylization of movement which confers ritual dimension upon functional motion—just as simple speech is made into song when affirmation of intensification on a higher level is intended.

My films might be called experimental, referring to the use of the medium itself. In these films, the camera is not an observant, recording eye in the customary fashion. The full dynamics and expressive potentials of the total medium are ardently dedicated to creating the most accurate metaphor for the meaning.

In setting out to communicate principles, rather than to relay particulars, and in creating a metaphor which is true to the idea rather than to the history of experience of any one of several individuals, I am addressing myself not to any particular group but to a special area and definite faculty in every or any man—to that part of him which creates myths, invents divinities, and ponders, for no practical purpose whatsoever, on the nature of things.

But man has many aspects—he is a many-faceted being—not a monotonous one-dimensional creature. He has many possibilities, many truths. The question is not, or should not be, whether he is tough or tender, and the question is only which truth is important at any given time.

This afternoon, in the supermarket, the important truth was the practical one; in the subway the important truth was, perhaps, toughness; while later, with the children, it was tenderness.

Tonight the important truth is the poetic one.

This is an area in which few men spend much time and in which no man can spend all his time. But it is this, which is the area of art, which makes us human and without which we are, at best, intelligent beasts.

I am not greedy. I do not seek to possess the major portion of your days.

I am content if, on those rare occasions whose truth can be stated only by poetry, you will, perhaps, recall an image, even only the aura of my films.

And what more could I possibly ask, as an artist, than that your most precious visions, however rare, assume, sometimes, the forms of my images.

THE FIRST STATEMENT OF THE NEW AMERICAN CINEMA GROUP (USA, 1961)

New American Cinema Group

[First published in *Film Culture* 22–23 (1961): 131–133.]

This manifesto for the New American Cinema outlines many of the precepts to be followed by what was variously called experimental, underground, and avant-garde film in New York in the 1960s, becoming the backbone to what P. Adams Sitney would later canonize in *Visionary Film* (1974). This manifesto, concerned more with production than aesthetics, nevertheless delineates the co-operative, communal, and artisanal practices that would dominate New American Cinema in its early years. The corruption addressed in this manifesto was a recurring theme in the writings of the New York avant-garde and in those of Jonas Mekas in particular.

In the course of the past three years we have been witnessing the spontaneous growth of a new generation of film makers—the Free Cinema in England, the Nouvelle Vague in France, the young movements in Poland, Italy, and Russia, and, in this country, the work of Lionel Rogosin, John Cassavetes, Alfred Leslie, Robert Frank, Edward Bland, Bert Stern and the Sanders brothers.

The official cinema all over the world is running out of breath. It is morally corrupt, esthetically obsolete, thematically superficial, temperamentally boring. Even the seemingly worthwhile films, those that lay claim to high moral and esthetic standards and have

been accepted as such by critics and the public alike, reveal the decay of the Product Film. The very slickness of their execution has become a perversion covering the falsity of their themes, their lack of sensibility, their lack of style.

If the New American Cinema has until now been an unconscious and sporadic manifestation, we feel the time has come to join together. There are many of us—the movement is reaching significant proportions—and we know what needs to be destroyed and what we stand for.

As in the other arts in America today—painting, poetry, sculpture, theatre, where fresh winds have been blowing for the last few years—our rebellion against the old, official, corrupt and pretentious is primarily an ethical one. We are concerned with Man. We are concerned with what is happening to Man. We are not an esthetic school that constricts the filmmaker within a set of dead principles. We feel we cannot trust any classical principles either in art or life.

1. We believe that cinema is indivisibly a personal expression. We therefore reject the interference of producers, distributors and investors until our work is ready to be projected on the screen.

2. We reject censorship. We never signed any censorship laws. Neither do we accept such relics as film licensing. No book, play or poem—no piece of music needs a license from anybody. We will take legal action against licensing and censorship of films, including that of the U.S. Customs Bureau. Films have the right to travel from country to country free of censors and the bureaucrats' scissors. [The] United States should take the lead in initiating the program of free passage of films from country to country.

Who are the censors? Who chooses them and what are their qualifications? What's the legal basis for censorship? These are the questions which need answers.

3. We are seeking new forms of financing, working towards a reorganization of film investing methods, setting up the basis for a free film industry. A number of discriminating investors have already placed money in *Shadows, Pull My Daisy, The Sin of Jesus, Don Peyote, The Connection, Guns of the Trees*. These investments have been made on a limited partnership basis as has been customary in the financing of Broadway plays. A number of theatrical investors have entered the field of low budget film production on the East Coast.

4. The New American Cinema is abolishing the Budget Myth, proving that good, internationally marketable films can be made on a budget of $25,000 to $200,000. *Shadows, Pull My Daisy, The Little Fugitive* prove it. Our realistic budgets give us freedom from stars, studios, and producers. The film maker is his own producer, and paradoxically, low budget films give a higher return margin than big budget films.

The low budget is not a purely commercial consideration. It goes with our ethical and esthetic beliefs, directly connected with the things we want to say, and the way we want to say them.

5. We'll take a stand against the present distribution-exhibition policies. There is something decidedly wrong with the whole system of film exhibition; it is time to blow

the whole thing up. It's not the audience that prevents films like *Shadows* or *Come Back, Africa* from being seen but the distributors and theatre owners. It is a sad fact that our films first have to open in London, Paris or Tokyo before they can reach our own theatres.

6. We plan to establish our own cooperative distribution center. This task has been entrusted to Emile de Antonio, our charter member. The New York Theatre, The Bleecker St. Cinema, Art Overbrook Theatre (Philadelphia) are the first movie houses to join us by pledging to exhibit our films. Together with the cooperative distribution center, we will start a publicity campaign preparing the climate for the New Cinema in other cities. The American Federation of Film Societies will be of great assistance in this work.

7. It's about time the East Coast had its own film festival, one that would serve as a meeting place for the New Cinema from all over the world. The purely commercial distributors will never do justice to cinema. The best of the Italian, Polish, Japanese, and a great part of the modern French cinema is completely unknown in this country. Such a festival will bring these films to the attention of exhibitors and the public.

8. While we fully understand the purposes and interests of Unions, we find it unjust that demands made on the independent work, budgeted at $25,000 (most of which is deferred), are the same as those made on a $1,000,000 movie. We shall meet with the unions to work out more reasonable methods, similar to those existing off-Broadway—a system based on the size and nature of the production.

9. We pledge to put aside a certain percentage of our film profits so as to build up a fund that would be used to help our members finish films or stand as a guarantor for the laboratories.

In joining together, we want to make it clear that there is one basic difference between our group and organizations such as United Artists. We are not joining together to make money. We are joining together to make films. We are joining together to build the New American Cinema. And we are going to do it together with the rest of America, together with the rest of our generation. Common beliefs, common knowledge, common anger and impatience binds us together—and it also binds us together with the New Cinema movements of the rest of the world. Our colleagues in France, Italy, Russia, Poland or England can depend on our determination. As they, we have had enough of the Big Lie in life and the arts. As they, we are not only for the new cinema: we are also for the New Man. As they, we are for art, but not at the expense of life. We don't want false, polished, slick films—we prefer them rough, unpolished, but alive; we don't want rosy films—we want them the color of blood.

FOUNDATION FOR THE INVENTION AND CREATION OF ABSURD MOVIES (USA, 1962)

Ron Rice

[First published in *Film Culture* 24 (1962): 19.]

A humorous manifesto by filmmaker Ron Rice that nevertheless gets to the heart of the aesthetic he developed with a pre-Warholian Taylor Mead. In *Underground Films: A Critical History* (1969), Parker Tyler labeled Rice's work as Kerouacian "dharma-bum films," which, in the tradition of the Beats, worked to break down the distinction between art and life.

Taylor Mead and I were often asked how we worked on the conception, actin [*sic*] and shooting of *The Flower Thief*. Merely answering this question would give away our whole secret of developing the kino-eye technique of advanced underground study and aplication [*sic*].

The collaboration between a director and his actor can take a wide variety of forms and positions. In the classic Cinema there is a seperation [*sic*] of scenario and image, in short content and form. We decided to completely throw out content and concentrate only on form. After this was decided I called Hollywood and asked J. B. to send up to San Francisco a complete "Direct it yourself technician kit."

The following Friday I received a CABLEGRAM, it read . . . SORRY: HOLLYWOOD UNABLE TO SEND KIT; SUGGEST YOU CONTACT THE NEAREST MENTAL HOSPITAL: JB.

After years of underground study we were refused. Reluctantly I told Taylor. The San Francisco film festival was drawing near and we had not one foot of film to show. I was distressed and feeling sad. As a last resort I decided to call Jungle Sam Katzman.[8] Jungle Sam came through. He sent five thousand feet of unused 16mm war surplus machine gun film for our vision.

We now had the film and I borrowed a camera from a friend who was involved in a film scratching and coloring contest. My friend was completely disinterested in the possibilities of photography at this time. He let me use the camera rent free.

We went to our location, everything was ready to roll, I was just gonna press the button on the camera when Taylor asked me what makes Cinema an Art Form.

I was struck dumm [*sic*], but I managed to get out the words . . . Film is an art because of the differences between a natural event and its appearance on the screen. This difference makes film an art form. Taylor said NO. The thing that makes film an art is that film creates a reality with forms.

We could not agree. We argued and fought until the light disappeared.

The following day we realized how absurd we were and agreed not to argue the subject. From this agreement *The Flower Thief* was born.

FROM *METAPHORS ON VISION* (USA, 1963)

Stan Brakhage

[First published in *Film Culture* 30 (1963): 25–34.]

Metaphors on Vision is one of the key, if not the key, manifestos of the New American Cinema movement. Influenced by Paul Cézanne, Ezra Pound, and William Blake, among many others, Stan Brakhage's manifesto on vision stresses the power of the cinema to strip away our acculturated experience of sight, and to allow us to see, as if for the first time, anew. Brakhage argues that sight allows for knowledge that's beyond the capabilities of language. His cinema is to some degree a cinema of interiority, placing onscreen the dialectic between the artist and the viewfinder, the synthesis projected as a reimagined world.

Imagine an eye unruled by man-made laws of perspective, an eye unprejudiced by compositional logic, an eye which does not respond to the name of everything but which must know each object encountered in life through an adventure of perception. How many colors are there in a field of grass to the crawling baby unaware of "Green"? How many rainbows can light create for the untutored eye? How aware of variations in heat waves can that eye be? Imagine a world alive with incomprehensible objects and shimmering with an endless variety of movement and innumerable gradations of color. Imagine a world before the "beginning was the word."

To see is to retain—to behold. Elimination of all fear is in sight—which must be aimed for. Once vision may have been given—that which seems inherent in the infant's eye, an eye which reflects the loss of innocence more eloquently than any other human feature, an eye which soon learns to classify sights, an eye which mirrors the movement of the individual toward death by its increasing inability to see.

But one can never go back, not even in imagination. After the loss of innocence, only the ultimate of knowledge can balance the wobbling pivot. Yet I suggest that there is a pursuit of knowledge foreign to language and founded upon visual communication, demanding a development of the optical mind, and dependent upon perception in the original and deepest sense of the word.

Suppose the Vision of the saint and the artist to be an increased ability to see—vision. Allow so-called hallucination to enter the realm of perception, allowing that mankind always finds derogatory terminology for that which doesn't appear to be readily usable, accept dream visions, day-dreams or night-dreams, as you would so-called real scenes, even allowing that you are focused upon and attempt to sound the depths of all visual influence. There is no need for the mind's eye to be deadened after infancy, yet in these times the development of visual understanding is almost universally forsaken.

This is an age which has no symbol for death other than skull and bones of one stage of decomposition . . . and it is an age which lives in fear of total annihilation. It is a time haunted by sexual sterility yet almost universally incapable of perceiving the phallic nature of every destructive manifestation of itself. It is an age which artificially seeks to project itself materialistically into abstract space and to fulfill itself mechanically because it has blinded itself to almost all external reality within eyesight and to the organic awareness of even the physical movement properties of its own perceptibility. The earliest cave paintings discovered demonstrate that primitive man had a greater understanding than we do that the object of fear must be objectified. The entire history of erotic magic is one of possession of fear thru holding it. The ultimate searching visualization has been directed toward God out of the deepest possible human understanding that there can be no ultimate love where there is fear. Yet in this contemporary time how many of us even struggle to deeply perceive our own children?

The artist has carried the tradition of visual [*sic*] and visualization down through the ages. In the present time a very few continued the process of visual perception in its deepest sense and transformed their inspirations into cinematic experiences. They create a new language made possible by the moving picture image. They create where fear before them has created the greatest necessity. They are essentially preoccupied by and deal imagistically with—birth, sex, death, and the search for God.

THE CAMERA EYE

Oh transparent hallucination, superimposition of image, mirage of movement, heroine of a thousand and one nights (Scheherazade must surely be the muse of this art), you obstruct the light, muddle the pure white beaded screen (it perspires) with your shuffling patterns. Only the spectators (the unbelievers who attend the carpeted temples where coffee and paintings are served) think your spirit is in the illuminated occasion (mistaking your sweaty, flaring, rectangular body for more than it is). The devout, who break popcorn together in your humblest double-feature services, know that you are still being born, search for your spirit in their dreams, and dare only dream when in contact with your electrical reflection. Unknowingly, as innocent, they await the priests of this new religion, those who can stir cinematic entrails divinely. They await the prophets who can cast (with the precision of Confucian sticks) the characters of this new order across filmic mud. Being innocent, they do not consciously know that this church too is corrupt; but they react with counter hallucinations, believing in the stars, and themselves among these Los Angelic orders. Of themselves, they will never recognize what they are awaiting. Their footsteps, the dumb drum which destroys cinema. They are having the dream piped into their homes, the destruction of the romance thru marriage, etc.

So the money vendors have been at it again. To the catacombs then, or rather plant this seed deeper in the undergrounds beyond false nourishing of sewage waters. Let it draw nourishment from hidden uprising springs channeled by gods. Let there be no

cavernous congregations but only the network of individual channels, that narrowed vision which splits beams beyond rainbow and into the unknown dimensions. (To those who hand their freedom, and allow the distant to come to you; and when mountains are moving, you will find no fat in this prose.) Forget ideology, for film unborn as it is has no language speaks like an aborigine—monotonous rhetoric. Abandon aesthetics—the moving picture image without religious foundations, let alone the cathedral, the art form, starts its search for God with only the danger of accepting an architectural inheritance from the categorized "seven," other arts its sins, and closing its circle, stylish circle, therefore zero. Negate technique, for film, like America, has not been discovered yet, and mechanization, in the deepest possible sense of the word, traps both beyond measuring even chances—chances are these twined searches may someday orbit about the same central negation. Let film be. It is something . . . becoming. (The above being for creator and spectator alike in searching, an ideal of religion where all are priests both giving and receiving, or witch doctors, or better witches, or . . . o, for the unnameable).

And here, somewhere, we have an eye (I'll speak for myself) capable of any imagining (the only reality). And there (right there) we have the camera eye (the limitation, the original liar); yet lyre sings to the mind so immediately (the exalted selectivity one wants to forget that its strings can so easily make puppetry of human motivation (for form as finality) dependent upon attunation [sic], what it's turned to (ultimately death) or turned from (birth) or the way to get out of it (transformation). I'm not just speaking of that bird on fire (not thinking of circles) or of Spengler (spirals neither) or of any known progression (nor straight lines) logical formation (charted levels) or ideological formation (mapped for scenic points of interest); but I am speaking for possibilities (myself), infinite possibilities (preferring chaos).

And here, somewhere, we have an eye capable of any imaginings. And then we have the camera eye, its lenses grounded to achieve 19th-century Western compositional perspective (as best exemplified by the 19th-century architectural conglomeration of details of the "classic" ruin) in bending the light and limiting the frame of the image just so, its standard camera and projector speed for recording movement geared to the feeling of the ideal slow Viennese waltz, and even its tripod head, being the neck it swings on, balled with bearings to permit it that Les Sylphides motion (ideal to the contemplative romantic) and virtually restricted to horizontal and vertical movements (pillars and horizon lines), a diagonal requiring a major adjustment, its lenses coated or provided with filters, its light meters balanced, and its color film manufactured, to produce that picture postcard effect (salon painting) exemplified by those oh so blue skies and peachy skins.

By deliberately spitting on the lens or wrecking its focal intention, one can achieve the early stages of impressionism. One can make this prima donna heavy in performance of image movement by speeding up the motor, or one can break up movement, in a way that approaches a more direct inspiration of contemporary human eye perceptibility of movement, by slowing the motion while recording the image. One may hand hold the camera and inherit worlds of space. One may over- and underexpose the film. One may use the

filters of the world, fog, downpours, unbalanced lights, neons with neurotic color temperatures, glass which was never designed for a camera, or even glass which was but which can be used against specifications, or one may photograph an hour after sunrise or an hour before sunset, those marvelous taboo hours when the films labs will guarantee nothing, or one may go into the night with a specified daylight film or vice versa. One may become the supreme trickster, with hatfulls of all the rabbits listed above breeding madly. One may, out of incredible courage, become Méliès, that marvelous man who gave even the "art of the film" its beginning in magic. Yet Méliès was not witch, witch doctor, priest, or even sorcerer. He was a 19th-century stage magician. His films are rabbits.

What about the hat? or if you will, the stage, the page, the ink, the hieroglyphic itself, the pigment shaping that original drawing, the musical and/or all other instruments for copula-and-then-procreation? Kurt Sachs talks sex (which fits the hat neatly) in originating musical instruments, and Freud's revitalization of symbol charges all contemporary content in art. Yet possession thru visualization speaks for fear-of-death as motivating force—the tomb art of the Egyptian, etc. And then there's "In the beginning," "Once upon a time," or the very concept of a work of art being a "Creation." Religious motivation only reaches us thru the anthropologist these days—viz., Frazer on a golden bough. And so it goes—ring around the rosary, beating about the bush, describing. One thread runs clean thru the entire fabric of expression—the trick-and-effect. And between those two words, somewhere, magic . . . the brush of angel wings, even rabbits leaping heavenwards and, given some direction, language corresponding. Dante looks upon the face of God and Rilke is head among the angelic orders. Still the Night Watch was tricked by Rembrandt and Pollack was out to produce an effect. The original word was a trick, and so were all the rules of the game that followed in its wake. Whether the instrument be musical or otherwise, it's still a hat with more rabbits yet inside the head wearing it i.e., thought's trick, etc. Even The Brains for whom thought's the world, and the word and vision audibility of it, eventually end with a Ferris wheel of a solar system in the middle of the amusement park of the universe. They know it without experiencing it, screw it lovelessly, find "trick" or "effect" derogatory terminology, too close for comfort, are utterly unable to comprehend "magic." We are either experiencing (copulating) or conceiving (procreating) or very rarely both are balancing in that moment of living, loving, and creating, giving and receiving, which is so close to the imagined divine as to be more unmentionable than "magic."

In the event you didn't know "magic" is realmed in "the imaginable," the moment of it being when that which is imagined dies, is penetrated by mind and known rather than believed in. Thus "reality" extends its picketing fence and each is encouraged to sharpen his wits. The artist is one who leaps that fence at night, scatters his seeds among the cabbages, hybrid seeds inspired by both the garden and wits-end forest where only fools and madmen wander, seeds needing several generations to be . . . finally proven edible. Until then they remain invisible, to those with both feet on the ground, yet prominent enough to be tripped over. Yes, those unsightly bulges between those oh so even rows will find their flowering moment . . . and then be farmed. Are you really thrilled at the

sight of a critic tentatively munching artichokes? Wouldn't you rather throw overalls in the eventual collegic chowder? Realize the garden as you will—the growing is mostly underground. Whatever daily care you may give it—all is planted only by moonlight. However you remember it—everything in it originates elsewhere. As for the unquotable magic—it's as indescribable as the unbound woods it comes from.

(A foot-on-the-ground-note: The sketches of T. E. Lawrence's "realist" artist companion were scratches to Lawrence's Arab friends. Flaherty's motion picture projection of *Nanook of the North* was only a play of lights and silhouettes to the Aleutian Islander Nanook himself. The schizophrenic does see symmetrically, does believe in the reality of Rorschach, yet he will not yield to the suggestion that pinpoint light in a darkened room will move, being the only one capable of perceiving its stasis correctly. Question any child as to his drawing and he will defend the "reality" of what you claim to be "scribbles." Answer any child's question and he will shun whatever quest he'd been beginning.)

Light, lens concentrated, either burns negative film to a chemical crisp which, when lab washed, exhibits the blackened pattern of its ruin or, reversal film, scratches the emulsion to eventually bleed it white. Light, again lens concentrated, pierces white and casts its shadow-patterned self to reflect upon the spectator. When light strikes a color emulsion, multiple chemical layers restrict its various wave lengths, restrain its bruises to eventually produce a phenomenon unknown to dogs. Don't think of creatures of uncolored vision as restricted, but wonder, rather, and marvel at the known internal mirrors of the cat which catch each spark of light in the darkness and reflect it to an intensification. Speculate as to insect vision, such as the bee's sense of scent thru ultraviolet perceptibility. To search for human visual realities, man must, as in all other homo motivation, transcend the original physical restrictions and inherit worlds of eyes. The very narrow contemporary moving visual reality is exhausted. The belief in the sacredness of any man-achievement sets concrete about it, statutes becoming statues, needing both explosives and earthquakes for disruption. As to the permanency of the present or any established reality, consider in this light and thru most individual eyes that without either illumination or photographic lens, any ideal animal might claw the black off a strip of film or walk ink-footed across transparent celluloid and produce an effect for projection identical to a photographed image. As to color, the earliest color films were entirely hand painted a frame at a time. The "absolute realism" of the motion picture image is a human invention.

What reflects from the screen is shadow play. Look, there's no real rabbit. Those ears are index fingers and the nose a knuckle interfering with the light. If the eye were more perceptive it would see the sleight of 24 individual pictures and an equal number of utter blacknesses every second of the show. What incredible films might ultimately be made for such an eye. But the machine has already been fashioned to outwit even that perceptibility, a projector which flashes advertisement at subliminal speed to up the sale of popcorn. Oh, slow-eyed spectator, this machine is grinding you out of existence. Its electrical storms are manufactured by pure white frames interrupting the flow of the

photographed images, its real tensions are a dynamic interplay of two-dimensional shapes and lines, the horizon line and background shapes battering the form of the horseback rider as the camera moves with it, the curves of the tunnel exploding away from the pursued, camera following, and tunnel perspective converging on the pursuer, camera preceding, the dream of the close-up kiss being due to the linear purity of facial features after cluttersome background, the entire film's soothing syrup being the depressant of imagistic repetition, a feeling akin to counting sheep to sleep. Believe in it blindly, and it will fool you—mind-wise, instead of sequins on cheesecloth or max-manufactured make-up, you'll see stars. Believe in it eye-wise, and the very comet of its overhead throw from projector to screen will intrigue you so deeply that its fingering play will move integrally with what's reflected, a comet-tail integrity which would lead back finally to the film's creator. I am meaning, simply, that the rhythms of change in the beam of illumination which now goes entirely over the heads of the audience would, in the work of art, contain in itself some quality of a spiritual experience. As is, and at best, that hand spreading its touch toward the screen taps a neurotic chaos comparable to the doodles it produces for reflection. The "absolute realism" of the motion picture image is a 20th-century, essentially Western, illusion.

Nowhere in its mechanical process does the camera hold either mirror or candle to nature. Consider its history. Being machine, it has always been manufacturer of the medium, mass-producer of stilled abstract images, its virtue—related variance, the result—movement. Essentially, it remains fabricator of a visual language, no less a linguist than the typewriter. Yet in the beginning, each of an audience thought himself the camera, attending a play or, toward the end of the purely camera career, being run over by the unedited filmic image of a locomotive which had once rushed straight at the lens, screaming when a revolver seemed fired straight out of the screen, motion of picture being the original magic of medium. Méliès is credited with the first splice. Since then, the strip of celluloid has increasingly revealed itself suited to transformations beyond those conditioned by the camera. Originally Méliès' trickery was dependent upon starting and stopping the photographic mechanism and between times creating, adding objects to its field of vision, transformations, substituting one object for another, and disappearances, removing the objectionable. Once the celluloid could be cut, the editing of filmic images began its development toward Eisensteinian montage, the principal [sic] of 1 plus 2 making 3 in moving imagery as anywhere else. Meantime labs came into the picture, playing with the illumination of original film, balancing color temperature, juggling double imagery in superimposition, adding all the acrobatic grammar of the film inspired by D. W. Griffith's dance, fades to mark the montage sentenced motion picture paragraph, dissolves to indicate lapse of time between interrelated subject matter, variations in the framing for the epic horizontal composition, origin of Cinemascope, and vertical picture delineating character, or the circle exclamating a pictorial detail, etc. The camera itself taken off the pedestal, began to move, threading its way in and around its source of material for the eventual intricately patterned fabric of the edited film. Yet editing is still

in its 1, 2, 3 infancy, and the labs are essentially still just developing film, no less trapped by the standards they're bearing than the camera by its original mechanical determination. No very great effort has ever been made to interrelate these two or three processes, and already another is appearing possible, the projector as creative instrument with the film show a kind of performance, celluloid or tape merely source of material to the projectioning interpreter, this expression finding its origins in the color, or the scent, or even the musical organ, its most recent manifestations—the increased programming potential of the IBM and other electronic machines now capable of inventing imagery from scratch. Considering then the camera eye as almost obsolete, it can at last be viewed objectively and, perhaps, view-pointed with subjective depth as never before. Its life is truly all before it. The future fabricating machine in performance will invent images as patterned after cliché vision as those of the camera, and its results will suffer a similar claim to "realism," IBM being no more God nor even a "Thinking machine" than the camera eye all-seeing or capable of creative selectivity, both essentially restricted to "yes-no," "stop-go," "on-off," and instrumentally dedicated to communication of the simplest sort. Yet increased human intervention and control renders any process more capable of balance between sub-and-objective expression, and between those two concepts, somewhere, soul. . . . The second stage of transformation of image editing revealed the magic of movement. Even though each in the audience then proceeded to believe himself part of the screen reflection, taking two-dimension visual characters as his being within the drama, he could not become every celluloid sight running thru the projector, therefore allowance of another viewpoint, and no attempt to make him believe his eye to be where the camera eye once was has ever since proven successful—excepting the novelty of three-dimension, audiences jumping when rocks seemed to avalanche out of the screen and into the theater. Most still imagine, however, the camera a recording mechanism, a lunatic mirroring, now full of sound and fury presenting its half of a symmetrical pattern, a kaleidoscope with the original pieces of glass missing and their movement removed in time. And the instrument is still capable of winning Stanford's bet about horse-hooves never all leaving the ground in galloping, though Stanford significantly enough used a number of still cameras with strings across the track and thus inaugurated the flip-pic of the penny arcade, Hollywood still racing after the horse. Only when the fans move on to another track can the course be cleared for this eye to interpret the very ground, perhaps to discover its non-solidity, to create a contemporary Pegasus, without wings, to fly with its hooves, beyond any imagining, to become gallop, a creation. It can then inherit the freedom to agree or disagree with 2000 years of Western equine painting and attain some comparable aesthetic stature. As is, the "absolute realism" of the motion picture image is a contemporary mechanical myth. Consider this prodigy for its virtually untapped talents, viewpoints it possesses more readily recognizable as visually non-human yet within the realm of the humanly imaginable. I am speaking of its speed for receptivity which can slow the fastest motion for detailed study, or its ability to create a continuity for time compression, increasing the slowest motion to a comprehensibility. I am praising its

cyclopean penetration of haze, its infra-red visual ability in darkness, its just developed 360-degree view, its prismatic revelation of rainbows, its zooming potential for exploding space and its telephonic compression of same to flatten perspective, its micro- and macroscopic revelations. I am marvelling at its Schlaeran self capable of representing heat waves and the most invisible air pressures, and appraising its other still camera developments which may grow into motion, its rendering visible the illumination of bodily heat, its transformation of ultra-violets to human cognizance, its penetrating x-ray. I am dreaming of the mystery camera capable of graphically representing the form of an object after it's been removed from the photographic scene, etc. The "absolute realism" of the motion picture is unrealized, therefore potential, magic.

KUCHAR 8mm FILM MANIFESTO (USA, 1964)

George Kuchar

[First presented at the 8 mm: Avant-Garde of the Future!? symposium at the Eventorium, New York City, 11 December 1964. First published in the *Village Voice*, 17 December 1964.]

George Kuchar's manifesto is one of the first statements of the role of 8 mm in the New American experiential/avant-garde/underground cinema. Kuchar was one of the pioneers of 8 mm filmmaking in New York, and this manifesto proselytizes for the small gauge in the nuclear age. Other participants in the symposium included Lenny Lipton, Alfred Leslie, Serge Gavronsky, and Kuchar's twin brother, Mike.

Yes, 8mm is a tool of defence in this society of mechanised corruption because through 8mm and its puny size we come closer to the dimension of the atom.

We in this modern world of geological dormanicity are now experiencing an evolution evolving around minutenocities. We no longer think big except in the realm of nuclear bombardment, and therefore, it is now unusual to find human beings with little things. Eight mm is one of those little things, but 8mm becomes enormous when light from a projector bulb illuminates to a great dimension the abnormalities of the psychotic.

In the hands of a potential pervert, this medium becomes like a sculpture of clay with a base of yeast. Sprinkle a few smatters of liquid upon the sculpture and it will blow up and expand to startling and gargantuan proportions. But, as you will see, the clay shell that envelops the overall piece of work will crack and make dirt everywhere.

The inner-beauty of the work will be revealed while at the same time the film-maker will crack and eventually suicide. Looking upon the face of one's own evil is enough

to bring the sting of acid to an esophagus that has previously experienced only buttermilk.

That 8mm will become avant-garde is a contagious disease-breeder because we are all avant-garde to the point of annihilation, and only when we face the after-effects of total deformity can we then think more clearly and cry because we couldn't concentrate on moral isolation.

Who are we to ask whether 8 mm will be the avant-garde of the moral future when only God and the Vatican know for sure? Moral issues of this nature should never be left for the filthy hands of the beatnik to twist into pretzels of degeneracy. Let the beatnik and the frustrated executive twist 8mm film into his own image and thereby give others a chance to sniff the world of narcotics and total spiritual breakdown.

Having worked with 8mm for twelve years, I have seen what it can do to a person. The creative intellect undergoes a great revolt and the bars of restraint are ripped from the casement of sanity until everything is a whirlpool of incandescent pudding. Eight mm has taught me to think more clearly and to express myself in direct terms. Like my religion, I was born into 8mm because my aunt had loaned me her movie camera and then my mother bought me one for Christmas. Now I'm going to make a 16mm picture called *Corruption of the Damned* and I'm making it in 16mm because I can't make it in 7mm. Therefore I'm going up instead of down, which has been the usual trend in my life for wanton pleasures. I enjoyed working in 8mm and I'm enjoying 16mm, and if both were taken from me, I'd enjoy vegetating because a life of stagnation is one of disease and only through disease can we realise what sickness is.

FILM ANDEPANDAN [INDEPENDENTS] MANIFESTO (Japan, 1964)

Takahiko Iimura, Koichiro Ishizaki, Nobuhiko Obayashi, Jyushin Sato, Donald Richie

[First released at the Knokke-Le-Zoute Experimental Film Festival, Belgium, December 1964. Trans. Julian Ross.]

Written after a series of Japanese experimental films were accepted in the Knokke-Le-Zoute Experimental Film Festival in Belgium, this film manifesto calls for a cinema independent of capital and industrial filmmaking (it shared these goals with other Japanese experimental groups such as the Nihon University Cinema Club). Nobuhiko Obayashi, one of the signatories to the manifesto, won an award for his film *An Eater* (Japan, 1963), codirected by painter Kazutomo Fujino, at the festival. Once the Film Independents event began in Japan, organized by cosignatory Takahiko Iimura, Obayashi screened his next film, *Complex* (Japan, 1964), during the inaugural event.

For cinema of genuine freedom: The Film Andepandan Proposal

With film critic Jyushin Sato and filmmaker Takahiko Iimura at its centre, the "Film Independents" project [with a call for the Film Independents Festival] is underway. The new art movement is drawing a lot of attention as it looks into the possibilities of private filmmaking which differentiates itself from commercial cinema.

Their mission statement is as follows:

The Japanese film industry has not yet given birth to truly independent cinema.

Of course, there have been independent films and independent productions prior to us. Yet could we say that these products have stayed true to independence from production to exhibition? Independent films have so far been subordinate to industrial filmmaking, where commercial and political ideologies have burdened their shoulders day and night. Their requirements have continually suffocated the package-films, those films that fill our screens at cinemas for approximately an hour and a half a night. Cinema must disassociate itself from such commercial and political strategies in order to obtain the true meaning of freedom.

This "Film Independents" event is the only place in existence at the moment where we allow ourselves to ignore such prerequisites. We will have free cinema to oppose industrial filmmaking; we will have private films to oppose 35mm features that screen at cinemas. Our proposal, and the reason for our existence, is to return to the personal as a departure point and hand back filmmaking to the individual.

Expression in 120 seconds

For example, have you ever imagined a two-minute film? [A call for 2 minutes film entry for the Film Independents Festival] Two minutes. 120 seconds. If we counted by frames, that would [be] 2800 frames. 120 seconds captured by the camera frame possesses the possibility for infinite content and, of course, no content at all as well.

Through the process of eliminating of all the constraint, the Film Independents aims to release film from the limitations imposed by commercial and political ideologies and to return cinema to the truly creative artist. Whilst before we could have only imagined totally free cinema, now on the other hand the filmmaking has become possible for everybody due to the wide spread of (small) camera. In such [a] situation indolence is the only excuse of the filmmaker who could be not able to work creatively. Personal filmmaking and the language of moving imagery have become as familiar to us as a pen and paper or a paintbrush and a canvas. In other words, cinematic production has become a much freer space

than before and we have the freedom of expression for ourselves. This will most definitely generate a change in the nature of film.

Pronouncing the bankruptcy

It is true that filmmakers overseas have made daring attempts to break through the suffocation of commercial cinema. Filmmakers involved in free-cinema, off-Hollywood cinema and experimental film are good examples. The fact that more than 300 films were submitted to the International Experimental Film Festival held in January this year [1964] in Brussels, Belgium, and seven Japanese films received a Special Award in the festival, testifies that there is an international shift in approaches to cinema. The Film Independents, who depart from a point of isolation from the established film industry, are a challenge against the Japanese film world that is in imminent danger of becoming a relic of the previous century. This is conceived as a pronouncement of their bankruptcy.

DISCONTINUOUS FILMS
(Canada, 1967)

Keewatin Dewdney

[First distributed as a mimeograph in 1967. First published in *Canadian Journal of Film Studies* 10, no. 1 (2001): 96–105.]

A professor emeritus of mathematics and computer science at the University of Western Ontario, Dewdney made a number of key experimental films in the late 1960s, most notably *Maltese Cross Movement* (1967), a key structuralist film. In "Discontinuous Films" Dewdney argues the "flicker" film reveals how the technology of the projector, and not the camera, lies at the heart of the specificity of the cinema.

1. *THE FLICKER*

Tony Conrad's *The Flicker* is a raw, archetypal statement about the nature of film, a statement which few understood. *The Flicker* revealed at one stroke that the projector, not the camera, is the film-maker's true medium. This is not to say film-makers are unaware of the projector and screen, the movie-house environment (they must learn to visualize a screen in the viewfinder of their camera). But this does say that the very use of the camera as a film-making tool has imposed the assumption of continuity on film, an assumption entirely foreign to the projector. Yet continuity has hypnotized both Hollywood and the experimental almost equally.

For some reason, we are now released from continuity. Warhol fulfills a very important satiric function in pushing the continuous scene to its outer limits. This is why his films possess a drollity beyond their subject matter.

It's like saying "Here's continuity, Jack!"

CAMERA VS. PROJECTOR

During the 18th and 19th centuries, a great deal of energy was expanded in a search for "moving pictures." Some of these were: phantasmagorias, peepshows, dioramas, magic lantern shows, phenakisticopes, viviscopes, chronophotographs, kinetoscopes, etc. The great majority of these devices sought a direct translation of some image or series of images into a moving picture. The emphasis was clearly on the theatrical environment, the release of light. With Marey's Rifle-Camera (1882) we have the true precursor of the modern movie camera and the beginning of a great split in the capture of light (camera) and its release (projector). With photography it had become possible to make instant pictures and only a few more instants would be required to make a continuous run of pictures. It was in building the projector that the late 19th and early 20th Century built better than it knew. For, ideally suited as it is to the projection of whatever the motion picture camera photographs, the projector is a MACHINE CAPABLE OF PROJECTING TWENTY FOUR TRANSPARENCIES IN SEQUENCE EVERY SECOND.

The motion picture camera is quite limited in function. Generally speaking, it gathers light onto a sequence of frames in rapid order; it manufactures only continuous scenes; it will display whatever is put into it and is completely unlimited in the environment of the frame.

We are now in the process of being released from the assumption of continuity and the cinematic schools this assumption has imposed. Delightful as it has been, continuity has given us little more than a visual re-hash of the literary experience (poems included). Anyone objecting violently to this statement surely has a big stake in continuous cinema. The same person will feel enormously threatened by discontinuous film. At the Fourth Ann Arbor Film Festival last year, many in the auditorium groaned during *The Flicker*, not bored but frightened.

AN EXPERIMENT

The sort of Insight provided by William M. Ivins and Marshall McLuhan is particularly valuable when applied to the projector's environment. For example, Ivins, by isolating a sense in *Art and Geometry* is able to make the most obvious statements about touch and yet draw the most amazing conclusions from them. (Greek temples look the way they do because they are appreciated by the "hand" and not the "eye.")

In a room is a projector and screen. People who have never seen a projector (or camera) before are brought into the room, given cans of clear and dark leader, editing tools,

paint, bleach, whatever one may think of. They are told only that in a years time we want to see some interesting films.

After projecting the various kinds of leader, our people become bored. To be less bored they would begin to make marks on the leader. Yes, much better. They would not be very likely to animate because animation grows out of a consciousness of the camera. This means a rapid appearance on the screen of designs flashing by at subliminal speeds. If our people were all intelligent, creative, etc., one would see at the end of the year a more exciting collection of films than at Cannes, New York, Ann Arbor or anywhere. If they ultimately invented a camera, continuous run would be regarded as a "gimmick" on theirs, just as single frame is on ours. Hopefully, this conceptual experiment has placed the reader outside his familiar film environment long enough to realize the tyranny of the motion picture camera.

The logical result of using a camera in filming is the use of the splicer. Splices used to bother a good many people, that is, not the appearance of splice-bars on the screen but the sudden cut from one continuous scene to the next. It bothered people because here, for one fraction of a second, the true power of the projector was revealed. The cuts were bandaged with dissolves. Considering how much more expensive a dissolve is, it really is amazing that film-makers (including Hollywood) ever used them, the conventions that came to be associated with dissolvers (time passing, place changing) have nothing to do with their true function. Splices do not bother people like Conrad who spend most of a year doing them for *The Flicker* or Brakhage who admits "one whale of an aesthetic involvement in The Splice." This shows a healthy attitude toward the motion picture camera, described by Brakhage as a light-gathering instrument. Conrad could really have done without it entirely (like our people in the room). For if continuity is a corollary to the camera, an aesthetic use of splices is far removed from the continuous scene mentality.

THE FLICKER IS THE FILM

Many film-makers have begun to show a healthy interest in discontinuity, even though sometimes more than degree (namely insight) separates a film like Vanderbeek's *Breath-death* from *The Flicker*. *Breathdeath*, in no detectable rhythm, lays down an exciting barrage of visuals. Some of the scenes probably get down to 6 frames or so, though prolonged use of shorter scenes is certainly lacking. Bienstock, last year, with *Nothing Happened This Morning*, used a series of very rapid zooms from many angles at once on a single action, giving one a sense of simultaneity and seeing the action (in this case, a young man punching out an alarm clock) from all directions at once. This year with *Brummer's* he is clearly on the trail of the discontinuous cinema. In a restaurant a couple converse while the camera, on a trip of its own, explores them and the restaurant interior with very fast, sharp scenes, none of them subliminal but all contributing to a sense of hurried excitement about the restaurant. Bang bang bang. The NFB's Norman McLaren

and Arthur Lipsett, though from quite different traditions, show an awareness of discontinuous film. McLaren in *Blankety Blank* [*sic*], a somewhat older production than these others, uses a very short subliminal sequence and hues from frame to frame, giving one a floating sense of "lost" beauty. Arthur Lipsett's *Free Fall* and *Very Nice Very Nice* are clean, documentary versions of *Breathdeath* from the point of view of scene length and content.

A changing sense of the function of the camera can be attributed to *Fat Feet* by Red Grooms and others, in which, against a pasteboard facade of city, people act out stock roles as drunks, firemen, prostitutes, etc., all of them wearing enormous cardboard shoes. The technique is stop-motion and the jerky, uneven movements of the actors give the picture a nervous, hysterical quality. One hopes that a great talent like Larry Jordan will begin to explore discontinuity because he is naturally equipped, as an animator, to do it.

To postulate the existence of a kind of film which as yet publicly exists in one example alone would seem foolish were it not for the very clearly detectable trend toward shorter and shorter scenes, more and more discontinuous. For convenience we will call this kind of film, a Flicker Film, recalling that during the 20's films did flicker, and that in one sense at least, the flicker is more important than the film.

DESCRIPTION AND TECHNIQUES

The discontinuous or flicker film will replace Conrad's blacks and whites with dark and light images. Subliminal runs (lengths of film in which the image changes entirely from frame to frame) will come into their own as an aesthetic device. A kind of visual (or even audiovisual) grammar will be built up within each film. Hypermontage. Sound will take on an entirely new dimension—no longer a slave to the continuous scene, it will cease to act as a radio or phonograph and mesh with the visual component of the film in a way never before imagined.

As an example of this kind of film, Gerard Malanga was recently filmed both reading poetry and dancing. The sounds (reading and music) were recorded on 1/4" tape and transferred to 16 mm sound stock. Both the reading and dancing scenes lasted 2 1/2 minutes (one hundred feet of film each) and the original film was painted with black acetate ink on the base side in the following manner. First, 24 frames reading, then 24 frames black, 23 frames reading, 23 frames black, down to a frame of each. Alternate frames were blackened for nearly a full minute after this, after which the blackened frames occurred in twos, then in threes, various distances apart. The other film (dancing) was painted in complementary fashion so that when the two films were A and B rolled onto one print, one simply had an alternation from one scene to the other, an alternation whose speed was governed by how close together blackened frames were put in the original. The 16 mm sound track was cut so that sounds would confirm to action right down to the frame. The result was a highly interesting study of simultaneity. The effect one might think, would be of double exposure, but it does not work this way at all. A powerful technique.

Since disparate images being flashed 24 per second on a screen are almost entirely lost on the viewer in his normal conscious state, it would certainly help if they had been seen before. This means starting such a film with one or more key images which by the increasing complexity of their context as the film progresses, heighten the value of the image. Somewhere after this (one should pay close attention to the build up of pace in *The Flicker*), we begin subliminal runs which to someone just walking into the theatre may be meaningless but which to the clued-in audience are working a special magic all their own. Sound, working with image, does not merely "fill-in" the ear, but links it to the eye to an almost sensuous extent.

Persistence of Vision.

HAND-MADE FILMS MANIFESTO
(Australia, 1968)

UBU Films, Thoms

[First published in *Chaos* (Australia) 1 (1968).]

Founder of the Australian experimental film collective UBU films, for which this manifesto is written, and the Sydney Filmmakers Cooperative, filmmaker and writer Albie Thoms's "Hand-Made Films Manifesto" is exemplary of the early DIY ethos, a forerunner of the artisanal films and process cinema movements (see Hoffman's "Your Film Farm Manifesto on Process Cinema" later in this chapter). In this manifesto he outlines the centrality of the materiality of film to the experimental filmmaking process.

1. Let no one say anymore that they can't raise enough money to make a film—any scrap of film can be turned into a hand-made film at no cost.
2. Let photography be no longer essential to filmmaking—hand-made films are made without a camera.
3. Let literary considerations of plot and story no longer be essential to filmmaking—hand-made films are abstract.
4. Let no more consideration be given to direction and editing—hand-made films are created spontaneously.
5. Let no media be denied to hand-made films—they can be scratched, scraped, drawn, inked, coloured, dyed, painted, pissed on, black and white, or coloured, bitten, chewed, filed, rasped, punctured, ripped, burned, burred, bloodied with any technique imaginable.

6. Let written and performed music be rejected by the makers of hand-made films—let hand-made music be created directly onto the film by any technique of scratching, drawing etc. imaginable.

7. Let no orthodoxy of hand-made films be established—they may be projected alone or in groups, on top of each other, forward, backwards, slowly, quickly, in every possible way.

8. Let no standard of hand-made films be created by critics—a film scratched inadvertently by a projector is equal to a film drawn explicitly by a genius.

9. Let hand-made films not be projected in cinemas, but as environments, not to be absorbed intellectually, but by all the senses.

10. *Most of all,* let hand-made film be open to everyone, for hand-made films must be popular art.

CINEMA MANIFESTO
(Australia, 1971)

Arthur Cantrill and Corinne Cantrill

[First published in *Cantrills Filmnotes* 1 (1971): 1.]

Published in the first issue of their long-running journal *Cantrills Filmnotes*, Australian filmmakers Arthur and Corinne Cantrill's manifesto argues for a formal cinema that eschews from political and cultural commentary, and indeed from narrative, concentrating on the materiality of film itself. The authors have much in common in this regard with the then-emergent structural filmmakers in the United States and the United Kingdom.

WE'VE EXHAUSTED THE HUMAN SITUATION as film material—we've seen a million love affairs, intrigues, socially committed films, anti-war films; we're not interested in who's up who and who's paying any longer. We've been sated by countless films of Man and his confrontation with Life (mainly from East Europe—it didn't get them very far). Freud and Marx are dead. All we want now is the film experience—the optical and aural stimulation it can give. We want to be intellectually involved with the film form. Concerned with the *matter* of film, rather than its content. (The greatest films are those in which the form *is* the content, as in music.)

LOVE MATTER TO DEATH, LET IT FEEL YOUR BREATH—HOOTON

FOR EACH MAN KILLS THE THING HE LOVES—WILDE

Television news now gives us all we want to see on the condition of man (that's reportage). We want to *improve* the condition of man with our images and sounds, to create a

new awareness of visual and aural beauty. To wrap our film frames round the world and warm it up a little. Man has lost the ability to see, to hear; his senses have become stunted. We want to regenerate them. Our films have no story because all the stories have been told and retold, on the grey pages of literature until they are meaningless, like a word repeated again and again. They have been dissected, analyzed in the morgues of Universities. We want to make films which defy analysis, which present a surface so clean, so hard, that it defies the director's blade.

WE MUST HAVE APPETITE, TASTE IS THE APPROACH OF DEATH; THE EVASIVE VALUE OF THOSE WHO ARE LOSING THEIR APPETITE—HOOTON

"Frankly, I find aspects of that statement frightening in its arrogance and its fanaticism"—Dr. H. C. Coombs, Chairman of the Australian Council for the Arts.

FOR A METAHISTORY OF FILM: COMMONPLACE NOTES AND HYPOTHESES (USA, 1971)

Hollis Frampton

[First published in *Artforum* 10, no. 1 (1971): 32–35.]

In this manifesto Hollis Frampton describes the cinema as "the last machine." Yet his notion of what the cinema "machine" consists of is what sets Frampton's manifesto apart from others that address cinema and technology. Surveying the metahistory of moving image technologies, Frampton argues that the "cinema machine" is constituted by all the cameras, projectors, and filmstrips extant, creating what he calls the "most ambitious single artifact yet conceived and made by man." The cinema is the "last machine," then, because it subsumes all others, while turning the real into the illusory in the process.

The cinematograph is an invention without a future.

—LOUIS LUMIÈRE

Once upon a time, according to reliable sources, history had its own Muse, and her name was Clio. She presided over the making of a class of verbal artifacts that extends from a half-light of written legend through, possibly, Gibbon.

These artifacts shared the assumption that events are numerous and replete beyond the comprehension of a single mind. They proposed no compact systematic substitute

for their concatenated world; rather, they made up an open set of rational fictions within that world.

As made things strong in their own immanence, these fictions bid as fairly for our contemplative energy as any other human fabrications. They are, finally, about what it felt like to reflect consciously upon the qualities of experience in the times they expound.

In order to generate insights into the formal significance of their pretext (that is, "real history"), such fictions employ two tactics. First of all, they annihilate naive intuitions of causality by deliberately ignoring mere temporal chronology. And then, to our cultural dismay, they dispense, largely, with the fairly recent inventions we call facts.

These fictions were what we may call metahistories of event. They remain events in themselves.

· · ·

It is reasonable to assume that Dean Swift, desiring in his rage to confound the West, invented the fact. A fact is the indivisible module out of which systematic substitutes for experience are built. Hugh Kenner, in *The Counterfeiters,* cites a luminous anecdote from the seed-time of the fact. Swift's contemporary savants fed dice to a dog. They (the dice) passed through the dog visibly unchanged, but with their weight halved. Thenceforth a dog was to be defined as a device for (among other things) halving the weight of dice.

The world contained only a denumerable list of things. Any thing could be considered simply as the intersection of a finite number of facts. Knowledge, then, was the sum of all discoverable facts.

Very many factual daubs were required, of course, to paint a true picture of the world; but the invention of the fact represented, from the rising mechanistic point of view, a gratifying diminution of horsepower requirement from a time when knowledge had been the factorial of all conceivable contexts. It is this shift in the definition of knowledge that Swift satirizes in *Gulliver's Travels,* and Pope laments in *The Dunciad.*

The new view went unquestioned for generations. In most quarters it still obtains: from which it should be quite clear that we do not all live in the same time.

· · ·

Who first centered his thumbs on Clio's windpipe is anyone's guess, but I am inclined to blame Gotthold Lessing. His squabbling progeny, the quaintly disinterested art historians of the 19th century, lent a willing hand in finishing her off. They had Science behind them. Science favored the fact because the bet seemed to favor predictability. Hoping to incorporate prophecy wholesale into their imperium, 19th-century historians went whole hog for the fact, and headfirst into what James Joyce later called the "nightmare" of history.

There were, quite simply, too many facts. They adopted the self-contradictory stratagem of "selecting" quintessential samples, and conjuring from them hundred-legged

theories of practically everything. They had backed themselves into a discriminatory trap, and Werner Heisenberg wasn't there to save them: it was a time of utmost certainty.

. . .

Isaac Newton spent the last part of his life writing a score of Latin volumes on religion: the nascent atomization of knowledge was a fierce wind from which he took shelter in his age. As young physicists, he and Leibniz had inherited the analytic geometry of Descartes, and the triumph of its use by Kepler, to predict the motions of the planets. Algebraic equations dealt well enough with the conic sections, but Newton was absorbed by the motion of bodies that describe more intricate paths.

Complex movement in space and time was difficult to make over into numbers. The number "one" was much too large; the mathematical fact must be vastly smaller. Even the arithmetic unit was surely an immense structure built of tiny stones: infinitesimal *calculi,* indivisible increments.

Given that much, it was a short step to the assumption that motion consists of an endless succession of brief instants during which there is only stillness. Then motion could be factually defined as the set of differences among a series of static postures.

Zeno had returned with his paradoxes to avenge himself through the deadpan Knight of Physics.

. . .

In the 1830's, Georg Buchner wrote *Woyzeck.* Evariste Galois died, a victim of political murder, leaving to a friend a last letter which contains the foundations of group theory, or the metahistory of mathematics. Fox-Talbot and Niepce invented photography. The Belgian physicist Plateau invented the phenakistiscope, the first true cinema.

In the history of cinema these four facts are probably unrelated. In the metahistory of cinema, these four events may ultimately be related.

Fox-Talbot and Niepce invented photography because neither of them could learn to draw, a polite accomplishment comparable to mastery of the tango later and elsewhere.

Plateau had the calculus in his mother's milk, so that its assumptions were for him mere reflex. He took an interest in sense-perception and discovered, by staring at the sun for twenty minutes, one of our senses' odder failings, euphemistically called "persistence of vision."

His hybridization of a sensory defect with the Newtonian infinitesimal began vigorously to close a curve whose limbs had been widening since the invention of the alphabet.

Plateau's little device started putting Humpty Dumpty together again. Like dozens of other dead end marvels, it became a marketable toy, and was succeeded by generically similar novelties: zoetrope, praktinoscope, zoopraxiscope.

All of them, unconsciously miming the intellectual process they instigated, took the form of spliceless loops: an eternity of hurdling horses and bouncing balls.

And they were all hand-drawn. Photography was not mapped back upon the sparse terrain of palaeocinema until the first photographic phenakistiscope was made, three generations later.

. . .

The union of cinema and the photographic effect followed a clumsy mutual seduction spanning six decades. There was a near-assignation in the vast *oeuvre* of Eadweard Muy-bridge, before whose fact-making battery of cameras thousands paraded their curiously obsolete bodies.

In one sequence, piercingly suggestive of future intricacies, the wizard himself, a paunchy naked old man, carried a chair into the frame, sat down, and glared ferociously back at his cameras.

But the series suggested to Muybridge only the ready-made analogy of book space: successive, randomly accessible, anisotropic with respect to time. Accordingly, he published them as editions of plates.

The crucial tryst was postponed, to await the protection of two brothers bearing the singularly appropriate name of Lumière.

. . .

The relationship between cinema and still photography is supposed to present a vexed question. Received wisdom on the subject is of the chicken/egg variety: cinema somehow "accelerates" still photographs into motion.

Implicit is the assumption that cinema is a special case of the catholic still photograph. Since there is no discoverable necessity within the visual logic of still photographs that demands such "acceleration," it is hard to see how it must ever happen at all.

It is an historic commonplace that the discovery of special cases precedes in time the extrapolation of general laws. (For instance, the right triangle with rational sides measuring 3, 4, and 5 units is older than Pythagoras.) Photography predates the photographic cinema.

So I propose to extricate cinema from this circular maze by superimposing on it a second labyrinth (containing an exit)—by positing something that has by now begun to come to concrete actuality: we might agree to call it an infinite cinema.

A polymorphous camera has always turned, and will turn forever, its lens focussed upon all the appearances of the world. Before the invention of still photography, the frames of the infinite cinema were blank, black leader; then a few images began to appear upon the endless ribbon of film. Since the birth of the photographic cinema, all the frames are filled with images.

There is nothing in the structural logic of the cinema film strip that precludes seques-tering any single image. A still photograph is simply an isolated frame taken out of the infinite cinema.

History views the marriage of cinema and the photograph as one of convenience; meta-history must look upon it as one of necessity.

The camera deals, in some way or other, with every particle of information present within the field of view; it is wholly indiscriminate. Photographs, to the joy or misery of all who make them, invariably tell us more than we want to know.

The ultimate structure of a photographic image seems to elude us at the same rate as the ultimate structure of any other natural object. Unlike graphic images, which decay under close scrutiny into factual patterns of dots or lines, the photograph seems a virtually perfect continuum. Hence the poignancy of its illusions: their amplitude instantly made the photograph—within the very heart of mechanism—the subversive restorer of contextual knowledge seemingly coterminous with the whole sensible world.

Cinema could already claim—from within the same nexus—a complementary feat: the resurrection of bodies in space from their dismembered trajectories.

The expected consummation took place at quitting time in a French factory, on a sunny afternoon towards the end of the century, as smiling girls waved and cheered. The immediate issue was an exceptional machine.

. . .

Typically, all that survives intact of an era is the art form it invents for itself. Potsherds and garbage dumps are left from neolithic times, but the practice of painting continues unbroken from Lascaux to the present. We may surmise that music comes to us from a more remote age, when the cables were first strung for the vertebrate nervous system.

Such inventions originally served the end of sheer survival. The nightingale sings to charm the ladies. Cave paintings presumably assisted the hunt; poems, Confucius tells us in the *Analects,* teach the names of animals and plants: survival for our species depends upon our having correct information at the right time.

As one era slowly dissolves into the next, some individuals metabolize the former means for physical survival into new means for psychic survival. These latter we call art. They promote the life of human consciousness by nourishing our affections, by reincarnating our perceptual substance, by affirming, imitating, reifying the process of consciousness.

What I am suggesting, to put it quite simply, is that no activity can become an art until its proper epoch has ended and it has dwindled as an aid to gut survival, into total obsolescence.

. . .

I was born during the Age of Machines.

A machine was a thing made up of distinguishable "parts," organized in imitation of some function of the human body. Machines were said to "work." How a machine

"worked" was readily apparent to an adept, from inspection of the shape of its "parts." The physical principles by which machines "worked" were intuitively verifiable.

The cinema was the typical survival-form of the Age of Machines. Together with its subset of still photographs, it performed prize-worthy functions: it taught and reminded us (after what then seemed a bearable delay) how things looked, how things worked, how to do things . . . and, of course (by example), how to feel and think.

We believed it would go on forever, but when I was a little boy, the Age of Machines ended. We should not be misled by the electric can opener: small machines proliferate now as though they were going out of style because they are doing precisely that.

Cinema is the Last Machine. It is probably the last art that will reach the mind through the senses.

It is customary to mark the end of the Age of Machines at the advent of video. The point in time is imprecise: I prefer radar, which replaced the mechanical reconnaissance aircraft with a static anonymous black box. Its introduction coincides quite closely with the making of Maya Deren's *Meshes of the Afternoon,* and Willard Maas' *Geography of the Body.*

The notion that there was some exact instant at which the tables turned, and cinema passed into obsolescence and thereby into art, is an appealing fiction that implies a special task for the metahistorian of cinema.

· · ·

The historian of cinema faces an appalling problem. Seeking in his subject some principle of intelligibility, he is obliged to make himself responsible for every frame of film in existence. For the history of cinema consists precisely of every film that has ever been made, for any purpose whatever.

Of the whole corpus the likes of *Potemkin* make up a numbingly small fraction. The balance includes instructional films, sing-alongs, endoscopic cinematography, and much, much more. The historian dares neither select nor ignore, for if he does, the treasure will surely escape him.

The metahistorian of cinema, on the other hand, is occupied with inventing a tradition, that is, a coherent wieldy set of discrete monuments, meant to inseminate resonant consistency into the growing body of his art.

Such works may not exist, and then it is his duty to make them. Or they may exist already, somewhere outside the intentional precincts of the art (for instance, in the prehistory of cinematic art, before 1943). And then he must remake them.

· · ·

There is no evidence in the structural logic of the filmstrip that distinguishes "footage" from a "finished" work. Thus, any piece of film may be regarded as "footage," for use in any imaginable way to construct or reconstruct a new work.

Therefore, it may be possible for the metahistorian to take old work as "footage," and construct from it identical new work necessary to a tradition.

Wherever this is impossible, through loss or damage, new footage must be made. The result will be perfectly similar to the earlier work, but "almost infinitely richer."

. . .

Cinema is a Greek word that means "movie." The illusion of movement is certainly an accustomed adjunct of the film image, but that illusion rests upon the assumption that the rate of change between successive frames may vary only within rather narrow limits. There is nothing in the structural logic of the filmstrip that can justify such an assumption. Therefore we reject it. From now on we will call our art simply: film.

The infinite film contains an infinity of endless passages wherein no frame resembles any other in the slightest degree, and a further infinity of passages wherein successive frames are as nearly identical as intelligence can make them.

. . .

I have called film the Last Machine.

From what we can recall of them, machines agreed roughly with mammals in range of size. The machine called film is an exception.

We are used to thinking of camera and projector as machines, but they are not. They are "parts." The flexible film strip is as much a "part" of the film machine as the projectile is part of a firearm. The extant rolls of film out-bulk the other parts of the machine by many orders of magnitude.

Since all the "parts" fit together, the sum of all film, all projectors and all cameras in the world constitutes one machine, which is by far the largest and most ambitious single artifact yet conceived and made by man (with the exception of the human species itself). The machine grows by many millions of feet of raw stock every day.

It is not surprising that something so large could utterly engulf and digest the whole substance of the Age of Machines (machines and all), and finally supplant the entirety with its illusory flesh. Having devoured all else, the film machine is the lone survivor.

If we are indeed doomed to the comically convergent task of dismantling the universe, and fabricating from its stuff an artifact called *The Universe,* it is reasonable to suppose that such an artifact will resemble the vaults of an endless film archive built to house, in eternal cold storage, the infinite film.

. . .

If film strip and projector are parts of the same machine, then "a film" may be defined operationally as "whatever will pass through a projector." The least thing that will do that is nothing at all. Such a film has been made. It is the only unique film in existence.

. . .

Twenty years ago, in the grip of adolescent needs to "modernize" myself, I was entranced by Walter Pater's remark that "all the arts aspire to the condition of music," which I then understood to approve of music's freedom from reference to events outside itself.

Now I expound, and attempt to practice, an art that feeds upon illusions and references despised or rejected by other arts. But it occurs to me that film meets what may be, after all, the prime condition of music: it produces no object.

The western musician does not ordinarily make music; his notation encodes a set of instructions for those who do. A score bears the sort of resemblance to music that the genetic helix bears to a living organism. To exist, music requires to be performed, a difficulty that John Cage abjures in the preface to *A Year from Monday,* where he points out that making music has hitherto largely consisted in telling other people what to do.

The act of making a film, of physically assembling the film strip, feels somewhat like making an object: that film artists have seized the materiality of film is of inestimable importance, and film certainly invites examination at this level. But at the instant the film is completed, the "object" vanishes. The film strip is an elegant device for modulating standardized beams of energy. The phantom work itself transpires upon the screen as its notation is expended by a mechanical virtuoso performer, the projector.

. . .

The metahistorian of film generates for himself the problem of deriving a complete tradition from nothing more than the most obvious material limits of the total film machine. It should be possible, he speculates, to pass from *The Flicker* through *Unsere Afrikareise,* or *Tom, Tom, the Piper's Son,* or *La Région Centrale* and beyond, in finite steps (each step a film), by exercising only one perfectly rational option at each move. The problem is analogous to that of the Knight's Tour in chess.

Understood literally, it is insoluble, hopelessly so. The paths open to the Knight fork often (to reconverge, who knows where). The board is a matrix of rows and columns beyond reckoning, whereon no chosen starting point may be defended with confidence.

Nevertheless, I glimpse the possibility of constructing a film that will be a kind of synoptic conjugation of such a tour—a Tour of Tours, so to speak, of the infinite film, or of all knowledge, which amounts to the same thing. Rather, some such possibility presents itself insistently to my imagination, disguised as the germ of a plan for execution.

. . .

Film has finally attracted its own Muse. Her name is Insomnia.

ELEMENTS OF THE VOID
(Greece, 1972)

Gregory Markopoulos

[First published in *Cantrills Filmnotes* 12 (1972): 3.]

In this manifesto New American Cinema/experimental filmmaker Gregory Markopoulos—best known for his 1950s and 1960s films such as *Flowers of Asphalt* (USA, 1951), *Serenity* (USA, 1961), and *Twice a Man* (USA, 1963), all of which were pulled from circulation after he left the United States for Greece in 1967—outlines what he calls the new language of the image, the element of the void, a language that could potentially bring about new national film cultures.

I am writing this essay in utter disbelief which lays bare the road of hope for the Temenos.

FORTHWITH WILL THE MIGHTY HAND ELEVATE MY PURPOSE.

Possibilities and contributions should lead naturally, one from another. They do not. The situation is impossible, and at the same time the situation is improbable. Improbable because of the nature of particular men.

It would seem that it might be in the interest of Man to change his nature as has been proposed at one of America's greatest universities of Puritan origins. This would seem so, even now, with the advance of certain measures adopted by populations. However, such controls, rather than protection of populations, advanced as they may seem, are not in the very interest of Mankind; but only add toward the greater frustrations, humiliations, and disembodiments of the popular psyches. They are indeed contributions at a great speed to the ultimate destruction of society as we have loved and hated it, to this moment.

If we are interested in possibilities we would be creating ideal situations for cineastes to develop as they would in each respective country, according to the needs of each respective country. And as for contributions they must of necessity become and do become mere perversions of the original possibility. The Ascent towards Possibility and the Descent towards Contribution are steep and costly for the individual to seek; only a few succeed. The effects of Elevation towards what is possible and its fellow contribution are today a basis of mortification. Few will willingly accept the task; and even with those who accept the task, one or two may only succeed in the rarefied space of the world will, accompanied as it is by the unchangeable eminence of a particular nation, in establishing, quite unwillingly, not only a national heritage, but in this case the beginning of a true cinematic culture. Yet, no longer, truly a cinematic culture, *but the language of the image*.

I firmly do not believe that it is a matter of change that is needed for the element of the void which we may call the language of the image that is being developed today. The

change is only in the essence, in the manner in which we chose to build before the spontaneous gift of energy which is the soul of the universe. It is the infinitesimal part that we are always unaware of during this mostly unhealthy scientific period when accelerated Time reveals the average human being as a dead body in Eternity. A dead body breathlessly harmonising to events without choice.

But who has the time, the energy, and most of all the need to trust to any of the preceding suggestions in this short essay? Therefore, more fortunate [are] those who do not [lay] claim to contributions, to possibilities, to developments. And sublimely unfortunate [are] those who continue in their Ascent. Those like Ezra Pound who have symbolically witnessed the death of Adam in all of its awesome solemnity in the beginning of Time, yet continue to breathe in the rarefied space of the world will, by the Grace of God.

SMALL GAUGE MANIFESTO
(USA, 1980)

JoAnn Elam and Chuck Kleinhans

[First distributed as a pamphlet at Chicago Filmmakers in February 1980. First published in *Viewpoint: Chicago Filmmakers Newsletter* 5 (1980).]

This manifesto points to the capacity of 8 mm and S8 film to become an agent for community building and to change the relationship between, and democratize the roles of, filmmakers and audiences. Elam and Kleinhans's manifesto echoes such groundbreaking participatory practices as the National Film Board of Canada's Challenge for Change / Société nouvelle program.

Small gauge film (regular 8 and Super 8) is low cost, technically accessible, and appropriate for small scale viewing.

Because it's cheap and you can shoot a lot of film, filming can be flexible and spontaneous. Because the equipment is light and unobtrusive, the filming relationship can be immediate and personal.

The appropriate viewing situation is a small space with a small number of people. Therefore it invites films made for or with specific audiences. Often the filmmaker and/ or people filmed are present at a screening. The filming and viewing events can be considered as part of the editing process. Editing decisions can be made before, during, and after filming and can incorporate feedback from an audience. Connections can be made between production and consumption, filmmaker and audience and subject matter.

Small gauge film is not larger than life, it's part of life.

CINEMA OF TRANSGRESSION
MANIFESTO (USA, 1985)

Nick Zedd

[First published (under the pseudonym Orion Jericho) in *The Underground Film Bulletin* 2 (1985).]

Greatly influenced by Punk and the No Wave scene in New York, Nick Zedd's "Cinema of Transgression Manifesto" delineated a new form of underground cinema that traded in the kind of shock and humor typically left out of the canon of New York avant-garde cinemas, drawing as it does on some of the tropes of exploitation film. Zedd, and other "Transgression" filmmakers like Richard Kern, produced no-budget, Super-8 films that challenged the boundaries of the underground, labeling itself as an "Other" cinema. Indeed, unlike other iterations of the New York avant-garde that espouse various degrees of spirituality, Zedd proclaims the "Cinema of Transgression" as atheist. Zedd also decries the academicism of experimental filmmaking, dismissing film schools and film theory in the process.

We who have violated the laws, commands and duties of the avant-garde; i.e. to bore, tranquilize and obfuscate through a fluke process dictated by practical convenience stand guilty as charged. We openly renounce and reject the entrenched academic snobbery which erected a monument to laziness known as structuralism and proceeded to lock out those filmmakers who possessed the vision to see through this charade. We refuse to take their easy approach to cinematic creativity; an approach which ruined the underground of the sixties when the scourge of the film school took over. Legitimizing every mindless manifestation of sloppy movie making undertaken by a generation of misled film students, the dreary media arts centers and geriatric cinema critics have totally ignored the exhilarating accomplishments of those in our rank—such underground invisibles as Zedd, Kern, Turner, Klemann, DeLanda, Eros and Mare, and DirectArt Ltd, a new generation of filmmakers daring to rip out of the stifling straight jackets of film theory in a direct attack on every value system known to man. We propose that all film schools be blown up and all boring films never be made again. We propose that a sense of humour is an essential element discarded by the doddering academics and further, that any film which doesn't shock isn't worth looking at. All values must be challenged. Nothing is sacred. Everything must be questioned and reassessed in order to free our minds from the faith of tradition. Intellectual growth demands that risks be taken and changes occur in political, sexual and aesthetic alignments no matter who disapproves. We propose to go beyond all limits set or prescribed by taste, morality or any other traditional value system shackling the minds of men. We pass beyond and go over boundaries of millimeters, screens and projectors to a state of expanded cinema. We violate the command and law that we bore audiences to death in rituals of circumlocution and

propose to break all the taboos of our age by sinning as much as possible. There will be blood, shame, pain and ecstasy, the likes of which no one has yet imagined. None shall emerge unscathed. Since there is no afterlife, the only hell is the hell of praying, obeying laws, and debasing yourself before authority figures, the only heaven is the heaven of sin, being rebellious, having fun, fucking, learning new things and breaking as many rules as you can. This act of courage is known as transgression. We propose transformation through transgression—to convert, transfigure and transmute into a higher plane of existence in order to approach freedom in a world full of unknowing slaves.

MODERN, ALL TOO MODERN
(USA, 1988)

Keith Sanborn

[First published in *Cinematograph* 3 (1988): 107–116. Slightly revised and annotated for this publication by the author.]

This manifesto, echoing both Hollis Frampton's "For a Metahistory of Film" (see earlier in this chapter) and Guy Debord's 1967 manifesto *Society of the Spectacle*—a key influence for Sanborn—draws a line in the sand between the "Visionary Film" school of avant-garde film and the new generation of politically engaged American experimental filmmakers far more interested in the effects of mass culture and dominant ideology than with high art obscurantism. Sanborn also takes issue with those filmmakers and theorists who he sees as having appropriated and diluted Situationist thought, most notably Jean Baudrillard's concept of simulation and the *bête noire* of the SI, Jean-Luc Godard.

I.

Lenin to Lunacharsky: "Amongst our people you are reported to be a patron of art so you must remember that of all the arts for us the most important is cinema."

2.

Goebbels on Potemkin: "It is a marvelously well made film, and one which reveals incomparable cinematic artistry. Its uniquely distinctive quality is the line it takes. This is a film, which could turn anyone with no firm ideological convictions into a Bolshevik. Which means that a work of art can very well accommodate a political alignment, and that even the most obnoxious attitude can be communicated if it is expressed through the medium of an outstanding work of art."

3.

Film is the most modern of the arts. Its powers and structure have served as a paradigm for the arts of the twentieth century, from Balla's strolling dog to Duchamp's descending nude. Film was fated to play a central role for modernist utopians from Lenin to Goebbels, from Eisenstein to Riefenstahl. For the first half of the twentieth century it represented something more than the degree zero of technology, it projected the fundamental myths of the new Metropolis, resolving their complexities in Chaplin's sentimental "The End" or Vertov's reflexive "Kinets."[9] As we have passed beyond modernism, film has become the victim of its own paradigmatic modernity.

4.

"The cinematographe is an invention without a future."—Louis Lumière, 1895

5.

"The cinematographe is an invention without a future."—Hollis Frampton, 1971

6.

In 1988, the cinematographe is not only an invention without a future, it is an invention without history. For when the cinematographe superceded its identity as a mechanical technology, history was superceded by what Frampton called "metahistory." But in deploying "metahistory," we must keep in mind our position in the labyrinth of etymology: just as "metaphysics" first meant "the works which follow the physics" [in the writings of Aristotle], so "metahistory" first means "the work which follows history." In the inevitable montage of temporal successivity, metahistory will necessarily be taken as commentary on that which came before, but it should not be assumed from the outset, that its ambition is to contain its object in succeeding it. It is a question of developing a strategy for comparing the incommensurable: what comes before and what comes after.

7.

The avant-garde is dead. Long live the avant-garde.

8.

The death of the avant-garde coincides with the death of modernism. For film, that was sometime between 1973 and 1978, at the latest, though the five year span a decade earlier suggests itself as well. Unfortunately, it was only in 1987 that the voice of the critics began to register any notice.

9.

"When stupidity reaches a certain level it becomes public offense."—Ezra Pound, before 1920

10.

Sitney's *Visionary Film* constitutes a kind of dictionary of received ideas for the avant-gardiste. It is high modernist in design, nationalist if not provincial in outlook, sexist in its particular omissions, and ethnocentric in the formalist circumscription of its discourse. We are presented with the search for form as the *telos* of cinema. We are shown how all important, i.e. European, film historical roads lead in the post-war era to New York, though San Francisco is mentioned as a kind of exception, which proves the rule. We are told of Carolee Schneemann only that she was an actress in a Brakhage film. We are told that Joyce Wieland was alive but not what films she made or what they might have meant. And we are told nothing about Mary Ellen Bute, Barbara Hammer, Yvonne Rainer, Barbara Rubin, Chick Strand, Germaine Dulac, Esther Shub, Gunvor Nelson or Anne Severson to name only an obvious few. St. Maya is the exception, which seems to prove an implicit rule. The few persons of color admitted to the discussion, must be able to "pass" formally. Homoeroticism is filtered exclusively through considerations of myth and form.

Visionary Film[10] is the master logocentric narrative of a closed pantheon of form. In spite of its author's denials of a project of totalization, it is essentially an extended explication of the post-war segment of the collection of the Anthology Film Archives. As a justification of the choices for the eternal pantheon of film form, it becomes a project to foreclose discourse and downplay difference. By obscuring difference along the margins of film practice, the institutionalization of Sitney's views has retarded the recognition and to some extent even the creation of a cinema of resistance. Sitney, however, is not alone here. Even the deliberately Eurocentric, reverse colonialism of Le Grice's formalist *Abstract Cinema and Beyond*—written to limit the damage of the onslaught of the Sitney-Mekas great American art machine—comes up short on the score of recognizing sexual and ethnic difference. But these are not simply the ethical and aesthetic limitations of particular individuals, they are the symptoms of an intellectual period style. Modernism, nationalism, sexism and ethnocentrism—while *not* related by pure synonymy—must finally be recognized as part of the same master lexicon to be resisted and overcome.

11.

Time: the late 1970s.

BRAKHAGE: "I'm planning to give a lecture on the theme 'No woman ever made an important work of art.'"

FRAMPTON: "You do and I guarantee you, I will personally make certain that you'll have Judy Chicago in your audience to dispute the point."

The lecture was never given.

12.

History is always ironic or perhaps never so. What insight can be gained, then, from the observation that *Triumph of the Will,* easily the most widely known and highly praised fascist film in history, a prime vehicle for the dissemination of the century's most evil and transparently patriarchal ideology, was made by a woman? How is it that the sterile kitschy beauty of Riefenstahl's films has elevated her to the status of the most famous and perhaps the most respected woman ever to make films? And what of the attempt to reclaim her for the modernist pantheon of the avant-garde through a strictly formal consideration of her work when Esther Shub is ignored? Shall we call "ironic" her success at playing the game of history with the boys? How shall we evaluate her repeated and repeatedly exposed deceptions concerning her relation to the National Socialist party? Once upon a time there were facts. Occasionally there are still.

13.

Now at the Metropolis: Part I of Leni Riefenstahl's *Olympia* vs. James Nares's *Rome '78.* The Aryan neo-nude meets the togas of simulation! Texas Death Match Rules.

14.

During the question and answer period of a recent panel discussion in New York on the Responsibility of Representing the Other, a white male European in the audience questioned what he saw as the hyper intellectuality of Trinh T. Min-ha's treatment of the Africans she filmed in *Reassemblage.* He especially objected to her voice-over commentary. He offered Leni Riefenstahl's book on a certain African people—he couldn't remember their name but he said it didn't matter—as a counterexample of a more direct, accessible practice. Eye brows were raised and mouths opened by not a few members of the audience and of the panel. Min-ha with some puzzlement admitted her film could be thought of as an "art film" in the context of ethnography, but had little to say about the alternative praxis offered by the example of Riefenstahl's book.

A differing response came from Sarah Maldoror, a Black woman born in Guadeloupe, living in France and making films in Africa. Though I cannot say with certainty that Ms. Maldoror entirely understood the remarks because she spoke only in French (her remarks were translated into English by another woman) and the question was posed in English, I can say that her response was exemplary and unexpected. Maldoror first informed her interlocutor that the people in question were the Nuba. She then continued to say that while she thought Riefenstahl detestable for her relationship to German Fascism and her stand with respect to Israel, she found her book wonderful. Michelle Wallace, a Black American writer and the moderator of the panel, queried Ms. Maldoror whether she did not find the book to be racist in its representations. Maldoror responded that she did not, saying that the matter was quite straight forward: Riefenstahl had gone to Africa and photographed these people. Maldoror explained that she found the images Riefenstahl had created quite beautiful, those of the men in particular. Queried again by Ms. Wallace,

she simply responded, "The images are beautiful and I'm powerless against them." A member of the audience who spoke "as a German woman" expressed her repulsion at the images saying they only celebrated power and violence. Clearly one Other's Other is not another Other's Other. Or is it?

15.

"I had to shoot him. He had too much control over my life."—Valerie Solanas, 1968

16.

Andy Warhol began to make films in 1963, the year Zapruder shot Kennedy on film. Warhol's own five year plan for film was completed in 1968 when he himself was shot by a woman who had acted in his films. Warhol survived all the shooting, but he is now permanently dead.

17.

Film is not dead. He is just marvelously sick. Film is famous. Film is dead.

18.

In the mid 1970s Hollis Frampton was given a tour of Buenos Aires by the National Librarian of Argentina. Borges proceeded with an elegant and measured gait from slums to governmental palaces, noting in critical and loving detail the history and sociology of each section of the city they visited. In the course of that tour, Borges, who was already blind, on several occasions lifted his cane to draw attention to architectural details of buildings, which no longer stood. Frampton, whose passion for knowledge and whose stubbornness for being correct are well-known, made no attempt to disabuse him. For Frampton could never quite determine whether Borges was unaware of the changes, or that he chose to ignore them, or that he was constructing for the benefit of his interlocutor (i.e., Frampton) an ironic imaginary city from the convergences and divergences between the ocular evidence and the notations of his own mind's eye.[11]

19.

To celebrate the death of the cinematographe and of the avant-garde, Frampton conceived his metahistory, *Magellan*. At first glance, the project seems to share the utopian ambitions we have come to associate with modernism. But this Utopia is not a capital of purity, of pain, of vision, of a century, or even of an art, but an invisible city at the center of a rich labyrinth of quotations—filmic and otherwise—where every street opens onto an infinity of other streets and each of those streets implies another vast imaginary city. Our loss of Frampton is irreparable as it was inevitable. And while we are the poorer for the loss of the completed cycle, its particular state of determinate incompletion only underscores its congruence with the postmodern city it resembles. For it is not fragments shorn against Frampton's ruin, but a map of the circular ruins of our culture drawn from fragments.

20.

The "new talkie" proudly traces its paternity to Godard; in so doing it betrays its ignorance of Godard's own questionable origins. Praise among English and American academics (e.g., Wollen) for Godard's bourgeois Sunday-Maoist recuperation of the formal devices of Situationist film has been possible, first, because it coincides with the impostures of those academicians and, second, because Situationist film remains virtually unknown outside of Paris.

21.

The Situationist International is dead. Long live the Situationist International.

22.

Contrary to popular belief, Guy Debord was not the only member of the Situationist International, nor the only Situationist to make films. But as a central figure in the group, his case may still serve as illustration.

When the man who backed most of Debord's films and created a special theatre for screening them was assassinated several years ago, Debord withdrew his films from distribution. In recent years, Debord has refused to allow his films to be shown in public except under conditions so extraordinary as to be impossible in practice to fulfill. He has gone to great lengths to isolate himself from those interested in his work: using a post office box in the Massif Central while he was probably living elsewhere, demanding lengthy and exacting descriptions of the screening conditions, seldom even responding to the requests. In constructing an elaborate protective maze, he has labored to preserve his films from the fate of all films as they enter the discourse of history. He has attempted to prevent recuperation by the agents of the spectacle: mannerist feature filmmakers such as Godard, advertising hacks such as Godard, the historians of the "avant-garde." The films were made at a specific time for a specific purpose. Perhaps Debord believes that their time has simply passed as the time had passed for the Situationist International when its members chose to disband it. Perhaps his films have become films without a present and without a future. Left with the bare fact of their historicity, he chose erasure, an act of metahistory perversely reminiscent of Warhol's withdrawal of his films.

23.

It is all too easy to attribute to Warhol purely economic motives for withdrawing his films. He took them off the market—say the dictates of the Warholian logic of commodification as they are officially and vulgarly understood—in order to make them scare, to make more money with them later. Probably, he just got bored with them and wanted to move on without dragging so much of his personal history around with him. An act of strategic self-erasure perfectly congruent with the aesthetic of commercial anonymity of his factory system paintings and of the films themselves, performed to enable him to move on, to

travel light, to accommodate the demand for the new which drives the logic of the art work as commodity. Warhol, in fact, had allowed the films to sit neglected for many years, ignoring several offers to put them back in distribution. When he finally acceded to the offer from MOMA for the entire lot, he was surely aware that this would permanently alter their commercial exploitability for the 60s underground revival and assure their embalming as film historical corpses. But then history is an expensive commodity and Andy actually managed to manufacture and sell it, as well as to collect it.[12]

<div align="center">24.</div>

Debord, we might assume, withdrew his films from an excess of intellectual scruples, yet the effect is the same. Just as Warhol's films have existed mainly in books for the past 20 years, the films of Debord are accessible now only in book form through his *Œuvres Cinématographiques Complètes* in French, two scripts translated in the *Situationist International Anthology,* and two other extremely rare publications in French. Through the absence coded into their shadowy presence, Debord's films have assumed the status of myth, the secret map to the buried origins of postmodernist film practice in France, much as Warhol's films, in their obscurity, have held the allure of the lost Ark of the underground, the sacred treasure of the postmodern here.[13]

Now that Warhol has attained the perfect biological anonymity of the dead and his films are receiving their first significant exposure in twenty years, we can begin again the endless ritual of bringing their secrets to light. Unseen, they have captivated many; their position in our imaginary will be altered as they pass from the underground to the museological mausoleum. This is hardly cause for alarm, however, since necromancy and necrophilia are the filmgoer's favorite vices.

For the living, concerned with the practice of everyday life, however, it is unfortunate that Debord, in protecting his own work unsuccessfully from the ravages of recuperation, has deprived his contemporaries in France and abroad as well as his historical successors of the insights his work might offer. The occultation of these films has preserved the historical integrity of the work at the ironic cost of inflating their fetishistic value as intellectual commodity. Meanwhile, Godard, in *King Lear,* explicitly and with unintentioned irony reveals himself to be the Woody Allen of France, Barbara Kruger recycles Situationist form as she laughs her way to the bank and the biennial ("Shop til you drop") and Robert Longo is taken for a critic of the society of the spectacle instead of its hypostasis. But who can blame Debord? In the current cultural climate, offering one's life work to one's contemporaries—let alone to one's historical successors—has all the attraction of binding and offering oneself for gang rape, vivisection and piecemeal transplantation.

<div align="center">25.</div>

"Plagiarism is necessary; progress implies it. It embraces an author's phrase, makes use of his expressions, eliminates a false idea, replaces it with a true one."—Lautréamont, 1870

26.

"Plagiarism is necessary; progress implies it. It embraces an author's phrase, makes use of his expressions, eliminates a false idea, replaces it with a true one."—Debord, 1967

27.

Patti Astor, star of Eric Mitchell's *Underground U.S.A.*, founded the ephemeral and influential Fun Gallery on East 10th street in New York in the early 1980s. During the height of her influence as a dealer, she would find herself deluged with slides from unaffiliated painters from all over the country. Rene Ricard, a veteran of the Warhol scene turned critic and a co-star in the Mitchell film, summed up the situation this way in his "Pledge of Allegiance" to the Fun stable of the period: "Nobody wants artists. Artists are supposed to create a culture around themselves to be noticed, set off drumbeats in the jungle, then get a gallery. Nobody wants to see slides; they're a pain in the ass. Open your own gallery. You can have your own fun. Start your own war."

28.

Makers of film on the margins perform many rituals of complaint; the litany includes: lack of money for their films and other vices, lack of audiences, lack of critical attention, lack of position. The complaints are all more or less justified. I have performed them dutifully myself; they come with the territory. But the time has long passed for looking to the Sitneys, the Taubins, the Campers and the Hobermans of the world for intelligent critical response to film or anything else. Start your own magazine. Write your own reviews. Build your own audience. If there is a cinema of resistance that perseveres in the midst of the wake for modernism and the "avant-garde" then it must speak with its own voice or not at all. Because if you're waiting for just that review that will put your career over the top, you are waiting for hell to freeze over and deserve to. The lame will walk, the blind see, the deaf hear and a critic will pass through the eye of a needle before a writer for the *Village Voice* will depart one word from the perpetuation of a tired official journalistic anti-decorum.[14] And should that review come bearing a resemblance to your intentions, I advise you to write it off to coincidence or to Nancy Reagan's horoscope, or to pause and reflect just where you went wrong.

29.

Deconstruction is dead. Long live deconstruction.

30.

For deconstruction: Within the few short years since his death, research has brought to light Paul De Man's carefully concealed collaborationist past. It now seems that Heidegger was a better Nazi than previously thought. Nietzsche—betrayed by his sister and bastard-ized—was at least dead before his corpse was handed over to the party. Though his

pathological ambiguity, sweeping generalizations and sexism continue to be his downfall, Nietzsche was outspoken against anti-semitism during his lifetime. De Man and Heidegger were very much alive when they spoke out respectively against Jews and on behalf of the party. Derrida has travelled along many of the same intellectual paths as Heidegger and De Man; he assisted in the French reanimation of Nietzsche in the 1970s. While it seems unlikely that Derrida will simply lie down and die as deconstruction enters history as a dead form of literature, one may well wonder what awaits his eventual reanimators. For history refuses to be subjugated to literature. It has a way of leaking out around the edges, trickling down the bindings onto the shelves, and staining the library floor. Someone notices sooner or later. It returns where repressed and with a vengeance.

31.

Baudrillard is dead. Long live Baudrillard.

32.

Q: How did Professor Baudrillard of the University of Nanterre spend the spring of 1968? A: The records have not yet been uncovered, but it is important to find out now as the consequences of his passive nihilist stance come to be tested.

33.

For nearly 20 years, Baudrillard's *idée fixe* has been to discredit Debord's analytic model of the "society of the spectacle." So many trees have died, so many careers have been made in the art world and academia simply because the Situationists recognized Baudrillard in 1967 for the modernist he remains. He has spent his career trying to deny that relegation to the realm of dead history. While his currency as an intellectual pop star is unquestionable, his strategy of the transcendence of history through a literary eternal present is problematic at best. While few doubt that the past 20 years have departed radically from the previous 100 and many affirm that history may be a thing of the past, even the law of entropy dictates the concrete passage of time.

34.

The decentered subject, which inhabits the Baudrillard world, is allowed no distance between himself and the world. He cannot be alienated because she is "always already" alien. There is no longer an inside and an outside set at a critical distance from which to judge. With the collapse of this distance we are left with the "ecstasy of communication" and with "seduction," the play of attractions between decentered self and other.

In exploring this relation, Baudrillard focusses his critique with an attack on the allegiance of one strain of feminist thought to the self-representing subject. Baudrillard speaks of "feminist naïveté" in analysing "feminine striptease" in advertising as a form of "prostitution." It is just "putting on an act," a kind of simulation. For where everyone and everything is equally alien, "alienation" can carry no meaning. But if there is no space

between consciousness and the world for self-representation, precisely how can one "put on an act"? How can simulation be possible without a void between consciousness and an imaginary? But accepting this most "melancholy" of all possible worlds, we find nonetheless that some Others are still more incommensurable than others.

A methodology banal in its anti-subjectivity—American behaviorist industrial psychology—informed us long ago that an advertising message need neither be consciously registered nor remembered in order to affect our behavior at critical moments. Some circuits of power are not reversible with the turn of a phrase or the touch of a finger on the remote control. We are left with yet another attempt to recuperate the fashionable discourse of sexual difference for a master literary if not simple-mindedly logocentric narrative. Baudrillard here has performed yet another critic's paraphrase of Rimbaud. He recycles "Je est un autre" quite directly, changing "Je veux devenir nègre" to "Je veux devenir femme." Baudrillard's claim of the reversibility of the terms as a facet of current socio-economic life is at best a masturbatory fantasy.

The strategy of Baudrillard's rhetoric in presenting his world view is to collapse the dualistic oppositions of language itself (metaphor vs. metonymy or similarity vs. contiguity) to an aphasic superimposition. Similarity disorder simulates contiguity disorder. The threatened triumph of metaphor explodes into isomorphic holographic fragments placed in vertiginous atemporal contiguity. Or, to summarize the observations of Meaghan Morris: beneath the ecstasy of communication, we find the ecstasy of description, beneath the ecstasy of description, a kind of hyperrealism, and beneath this hyperrealism, a kind of hype. In the posture of a McLuhanesque nihilist, Baudrillard seems willing to take the media's things for words about the status of the global village, while ignoring the concrete aspects of its economy, multinational capitalism. See no production, hear no production, speak no production. The third world is reserved for exotic vacations.

35.

If there are still those who persist in believing that Baudrillard's critique may offer a solution for film to the endgame of modernism, let us consider Baudrillard's particular sense of just what is important about film:

> This collusion between images and life, between the screen and daily life, can be experienced everyday [sic] in the most ordinary manner. Especially in America, not the least charm of which is that even outside the cinemas the whole country is cinematographic. You cross the desert as if in a western; the metropolis is a continual screen of signs and formulae. Life is a travelling shot, a kinetic, cinematic, cinematographic sweep. There is as much pleasure in this as in those Dutch or Italian towns where, upon leaving the museum, you rediscover a town in the very image of the paintings, as if it had stepped out of them. It is a kind of miracle which, even in a banal American way, gives rise to a sort of aesthetic form, to an ideal confusion which transfigures life, as in a dream. Here, cinema does not take on the exceptional form of a work of art, even a brilliant one, but invests the whole of life with a mythical

ambience. Here it becomes truly exciting. This is why the idolatry of stars, the cult of Hollywood idols, is not a media pathology but a glorious form of the cinema, its mythical transfiguration, perhaps the last great myth of our modernity. Precisely to the extent that the idol no longer represents anything but reveals itself as a pure, impassioned, contagious image, which effaces the difference between the real being and its assumption into the imaginary.

All these considerations are a bit wild, but that is because they correspond to the unrestrained film buff that I am and have always wished to remain—that is in a sense uncultured and fascinated. There is a kind of primal pleasure, of anthropological joy in images, a kind of brute fascination unencumbered by aesthetic, moral, social or political judgments. It is because of this that I suggest that they are immoral, and that their fundamental power lies in this immorality. (*The Evil Demon of Images*, pp. 26–27)

Et tout cela sortait de ma tasse de thé. From the preceding two paragraphs it would appear that M. Baudrillard does on occasion when abroad leave his cork-lined motel room for a drive to the 7–11. The filmic variant of his project might be formulated as a combination of "Je est un touriste" and either "Je veux devenir américaine" or "Je veux devenir image." The latter two seem nearly synonymous for him. And while the for[e]going text is moderately amusing as an exercise in colonialist provocation of an Australian university film audience, it is hardly novel. In view of the fact that the Australians have considered Baudrillard much more closely and critically than most Americans, one wonders whether those words were not the occasion for the ultimate discrediting of his project there among the film community where his work seems particularly to have flourished. [See *Seduced and Abandoned: The Baudrillard Scene*.] It is somewhat ironic that here, at yet another arguable Antipodes from both France and Australia, the Baudrillard scene has been confined almost entirely to the realm of the so-called "visual arts." To circle back to the text above for a final if not definitive pass: while the power of film to fascinate is undeniable, one wonders whether Professor Baudrillard would respond with the same blithely melancholic indifference to the brute leveling of the distinction between the imaginary and the real historically effected by *Triumph of the Will* or *Der ewige Jude*. Perhaps in our era hyperbole is its own reward.

36.

Tonight on Channel 4 at 3: *I Walked with a Zombie* and *Baudrillard visits Disneyland*.

37.

We could always have an ocean ending.

38.

The pope is resting comfortably in his private offices, daydreaming about the Avignon papacy and the French Riviera, when his chief nuncio with unusually abbreviated ceremony enters. "Your Holiness, Your Holiness. I've got some good news and some bad

news." The Holy Father responds: "My son, my son. The Gospel means 'good news' so let us have the good news first." The nuncio: "It's the Second Coming, Holy Father and Jesus Christ, who died on the cross to take away the sins of the world, is on the phone and wants to talk to you." The pope: "My son, my son, with such joyous and momentous news for which Christians have been waiting nearly two millennia, what could possibly be amiss?" "Well, Your Holiness," answers the nuncio, "She's calling from Salt Lake City."

OPEN LETTER TO THE EXPERIMENTAL FILM CONGRESS: LET'S SET THE RECORD STRAIGHT (Canada, 1989)

Peggy Ahwesh, Caroline Avery, Craig Baldwin, Abigail Child, Su Friedrich, Barbara Hammer, Todd Haynes, Lewis Klahr, Ross McLaren, John Porter, Yvonne Rainer, Berenice Reynaud, Keith Sanborn, Sarah Schulman, Jeffrey Skoller, Phil Solomon, and Leslie Thornton, and fifty-nine other filmmakers

[First distributed at the International Experimental Film Congress, Toronto, Ontario, 28 May 1989. First published in the *Independent Film and Video Monthly* 12, no. 8 (1989): 24.]

If the "Cinema of Transgression" was a postpunk rebellion against the ageing New York avant-garde, the "Let's Set the Record Straight" manifesto, issued at the International Experimental Film Congress in Toronto in 1989, points to the large schism between the old guard of the avant-garde and the new generation of American and Canadian experimental filmmakers, and the move from high art to pop culture and political commitment. Like "Modern, All Too Modern," "Let's Set the Record Straight" dismisses the *Visionary Film* generation out of hand, claiming the old guard is apolitical, sexist, and ahistorical, and calls for the new generation of avant-garde filmmakers, concerned with both the political and the post-Debordian mediascape, to have their work screened, acknowledged, and debated.

We challenge the official History promoted by the International Experimental Film Congress to be held in Toronto this Spring. The time is long overdue to unwrite the Institutional Canon of Master Works of the Avant-Garde. It is time to shift focus from the History of Film to the position of film within the construction of history. The narratives which take up this new task must respect the complexity of relations among the many competing and overlapping histories which make up the activity within the field.

We are concerned by the tone which pervades the announcements for the Congress. The recognition belatedly accorded to "the founding women of the avant-garde," the ceremonious embalming of lively, refractory work, the minimal attention given new work, the organization of screenings along nationalistic lines, and the "open"—read "unpaid"— screenings for those willing to pay $100 for the privilege, all betray a tokenism blind to any activities outside the officially sanctioned margins. And if our analytic concerns seem to prejudge the event, they are borne out with desolate clarity by the record of the Congress organizers in attempting to suppress dissent within their own community. Their efforts in Toronto against the Funnel Experimental Film Centre and against feminist film theory speak for themselves.

And while the putatively timeless Internationalism of the Congress should make it all things to all people, the overwhelming majority of the announced participants consists of representatives of the 60's Avant-Garde and its decaying power base. Only one or two younger filmmakers have been made part of the official program, though some of us will at least be discussed in our absence. Workshops are dominated by technological values and are lead [sic] exclusively by older men. In this context, the organization of screenings along nationalistic lines promises a replay of the results with which we have become all too familiar over the past decade: a government-subsidized inventory of products suitable for export. Work is chosen to minimize linguistic, sexual, and cultural difference, typically to conform to the model of the "universal language of form" so dear to institutional esperantists. Difference is recognized only where it can be recuperated and diluted to a tepid pluralism.

The "open screenings" at best provide an image of damage control. These screenings, as the de facto venue for new and unrecognized work, have been scheduled mostly for late in the evening at the end of full days of featured panels, workshops and screenings. Even without average festival delays, this scheduling usually bodes poorly for attendance. The priorities of the Congress organizers are clear: those without established institutional credentials are to be marginalized within the consolidation of the official margins, to be presented as Film Historical leftovers.

There is a spirit of mind which continues to challenge the hegemony of industry, of government, of bureaucracy. The revolutionary frame of mind pervading activity in film in the Teens and Twenties and again in the Fifties and Sixties—which seemed to die in the Seventies—continues to thrive, but *only* where it has shifted and migrated according to changing historical conditions. The issues which galvanized the Cinema Avant-Gardes of earlier decades arose from different conditions than those which confront us today. An event which promotes itself as of major importance to Experimental Film and fails to reflect the vitality and breadth, the vulnerability and urgency of current oppositional practice in the media renders nothing but obeisance to a moribund officialdom. It risks nothing but its own historical relevance.

The Avant-Garde is dead; long live the avant-garde.

ANTI-100 YEARS OF CINEMA
MANIFESTO (USA, 1996)

Jonas Mekas

[First presented 11 February 1996 at the American Center, Paris. First published in
Point d'ironie (France) 0 (1997).]

This manifesto, a response to the celebration and marketing of the centenary of the
cinema, makes a case that the official histories written at the time were dictated by
capital, like much of film production throughout its history. Mekas celebrates the
artisanal aspect of experimental cinema and shines light on the importance of the
cinema as a shared experience between viewers and audiences but most importantly
between friends.

As you well know it was God who created this Earth and everything on it. And he thought
it was all great. All painters and poets and musicians sang and celebrated the creation
and that was all OK. But not for real. Something was missing. So about 100 years ago
God decided to create the motion picture camera. And he did so. And then he created a
filmmaker and said, "Now here is an instrument called the motion picture camera. Go
and film and celebrate the beauty of the creation and the dreams of human spirit, and
have fun with it."

But the devil did not like that. So he placed a money bag in front of the camera and
said to the filmmakers, "Why do you want to celebrate the beauty of the world and the
spirit of it if you can make money with this instrument?" And, believe it or not, all the
filmmakers ran after the money bag. The Lord realized he had made a mistake. So, some
25 years later, to correct his mistake, God created independent avant-garde filmmakers
and said, "Here is the camera. Take it and go into the world and sing the beauty of all
creation, and have fun with it. But you will have a difficult time doing it, and you will
never make any money with this instrument."

Thus spoke the Lord to Viking Eggeling, Germaine Dulac, Jean Epstein, Fernand
Léger, Dmitri Kirsanoff, Marcel Duchamp, Hans Richter, Luis Buñuel, Man Ray, Caval-
canti, Jean Cocteau, and Maya Deren, and Sidney Peterson, and Kenneth Anger, Gregory
Markopoulos, Stan Brakhage, Marie Menken, Bruce Baillie, Francis Lee, Harry Smith
and Jack Smith and Ken Jacobs, Ernie Gehr, Ron Rice, Michael Snow, Joseph Cornell,
Peter Kubelka, Hollis Frampton and Barbara Rubin, Paul Sharits, Robert Beavers, Chris-
topher McLaine, and Kurt Kren, Robert Breer, Dore O, Isidore Isou, Antonio De Bernardi,
Maurice Lemaître, and Bruce Conner, and Klaus Wyborny, Boris Lehman, Bruce Elder,
Taka Iimura, Abigail Child, Andrew Noren and too many others. Many others all over
the world. And they took their Bolex[e]s and their little 8mm and Super 8 cameras and
began filming the beauty of this world, and the complex adventures of the human spirit,

and they're having great fun doing it. And the films bring no money and do not do what's called useful.

And the museums all over the world are celebrating the one-hundredth anniversary of cinema, costing them millions of dollars the cinema makes, all going gaga about their Hollywoods. But there is no mention of the avant-garde or the independents of our cinema.

I have seen the brochures, the programs of the museums and archives and cinematheques around the world. But these say, "we don't care about your cinema." In the times of bigness, spectaculars, one hundred million dollar movie productions, I want to speak for the small, invisible acts of human spirit: so subtle, so small, that they die when brought out under the clean lights. I want to celebrate the small forms of cinema: the lyrical form, the poem, the watercolor, etude, sketch, portrait, arabesque, and bagatelle, and little 8mm songs. In the times when everybody wants to succeed and sell, I want to celebrate those who embrace social and daily tailor to pursue the invisible, the personal things that bring no money and no bread and make no contemporary history, art history or any other history. I am for art which we do for each other, as friends.

I am standing in the middle of the information highway and laughing, because a butterfly on a little flower somewhere in China just fluttered its wings, and I know that the entire history, culture will drastically change because of that fluttering. A Super 8mm camera just made a little soft buzz somewhere, somewhere on the lower east side of New York, and the world will never be the same.

The real history of cinema is invisible history: history of friends getting together, doing the thing they love. For us, the cinema is beginning with every new buzz of the projector, with every new buzz of our cameras. With every new buzz of our cameras, our hearts jump forward my friends.

THE DECALOGUE (Czech Republic, 1999)

Jan Švankmajer

[Originally published in Czech in Jan Švankmajer, *Síla imaginace* (Prague: Dauphin, 2001), 113–116. Published in English in Peter Hames, ed., *The Cinema of Jan Švankmajer: Dark Alchemy*, 2nd ed. (London: Wallflower, 2007), 141.]

Czech animator Jan Švankmajer's surrealist cinema has influenced filmmakers as diverse as Terry Gilliam, the Brothers Quay, and Tim Burton. Švankmajer's manifesto "The Decalogue" is a statement of principles that proclaims the need of the filmmaker to channel the forces of the imagination and the subconscious. For Švankmajer, immersion and affect are the guiding principles of both the filmmaker and the audience. His manifesto is a self-reflexive account of his own practice—not a set of edicts as much as a reflection of how to explode the perception of everyday life as the only viable representation of the real.

1. Remember that there is only one poetry. The antithesis of poetry is professional expertise.

Before you start filming, write a poem, paint a picture, put together a collage, write a book or an essay etc. Because only the nurture of the universality of expression will guarantee that you create a good film.

2. Succumb totally to your obsessions. You have nothing better anyway. Obsessions are relics of your childhood. And from those very depths of your childhood come the greatest treasures.

The gate has to always remain open in that direction. It's not about memories but about emotions. It's not about consciousness but about subconsciousness. Let this underground stream freely flow through your inner self. Focus on it but, at the same time, let yourself go. When you are filming you have to be "immersed" for 24 hours-a-day. Then all your obsessions, all your childhood transfers itself onto film without you even noticing it. In this way your film becomes a triumph of infantility. And that's what it's about.

3. Use animation as a magical act. Animation isn't moving about inert things but their revival. More precisely their awakening to life. Before you attempt to bring some object to life try to comprehend it. Not its utilitarian role but its inner life. Objects, particularly old ones, have witnessed all sorts of events and lives, and bear their imprint. People have touched them in different situations and with different emotions and printed into them their psychological states. If you wish to make their hidden contents visible through the use of a camera then you have to listen to them. Sometimes for several years. You have to become a collector and only then a film-maker. Reviving objects using animation must proceed naturally. It must come from the objects and not from your wishes. Never violate an object! Don't tell your own stories with the help of subjects (objects) but tell their stories.

4. Keep interchanging dream for reality and vice versa. There are no logical bridges. Between dream and reality there is only one slight physical operation: the raising and closing of eyelids. With daydreams even that is unnecessary.

5. If you are deciding which to give priority to—whether visual perspective or physical experience—then always trust the body because touch is an older sense than eyesight and its experience is more fundamental. Furthermore, the eye is pretty tired and "spoiled" in our contemporary audio-visual civilisation. The experience of the body is more authentic, not yet encumbered by aesthetics. A marker which you shouldn't lose sight of is synaesthesia.

6. The deeper you go into a fantastic plot the more you have to be realistic in detail. Here it's necessary to rely on the experience of the dream. Don't be afraid of "a boring description," pedantic obsessions, "unimportant detail," or documentary emphasis if you want to persuade the audience that everything they see in the film relates to them, that it does not concern something outside of their world but that it's about something,

without them realising it, in which they are up to their ears. And use all tricks at your disposal to convince them of this.

7. Imagination is subversive because it puts the possible up against the real. That's why always use the craziest imagination possible. Imagination is humanity's greatest gift. It is imagination that makes us human, not work. Imagination, imagination, imagination . . .

8. As a matter of principle chose [sic] themes toward which you feel ambivalent. That ambivalence must be so strong (deep) and unshakeable that you can thread its knife-edge without falling off on one side or the other, or, as the case may be, falling off both sides at the same time. Only this way will you avoid the greatest pitfall: the film à la thèse.

9. Nurture creativity as a means of auto-therapy. Because this anti-aesthetic standpoint brings art nearer to the gates of freedom. If creativity has a point at all then it is only in that it liberates us. No film (painting, poem) can liberate a member of an audience if it doesn't bring this relief to the artist himself. Everything else is a thing of "general subjectivity." Art as permanent liberation.

10. Always give priority to creativity, to the continuity of the inner model or psychological automation over an idea. An idea, even the most poignant, cannot be a sufficient motive to sit behind a camera. Art isn't about stumbling from one idea to another. An idea has its place in art only at the moment when you have a fully digested topic which you wish to express. Only then will the right ideas come to the surface. An idea is part of a creative process, not an impulse towards it.

Never work, always improvise. The script is important for the producer but not for you. It's a non-binding document which you turn to only in moments when inspiration fails you. If it happens to you more than three times during the shooting of a film then it means: either you are making a "bad" film or you're finished.

Just because I've formulated The Decalogue doesn't necessarily mean I have consciously abided by it. These rules have somehow emerged from my work, they haven't preceded it. In fact, all rules are there to be broken (not circumvented). But there exists one more rule which if broken (or circumvented) is devastating for an artist: Never allow your work of art to pass into the service of anything but freedom.

YOUR FILM FARM MANIFESTO ON
PROCESS CINEMA (Canada, 2012)

Philip Hoffman

[Distributed annually to participants at the beginning of the Independent Imaging Retreat.]

One of the most innovative examples of practice-based alternative filmmaking can be found at Canadian experimental filmmaker Philip Hoffman's Independent Imaging Retreat, colloquially known as "Film Farm," which has taken place most summers on his farm in rural Mount Forest, Ontario, since 1994. "Film Farm" is a processed-based film workshop, where over the course of a week filmmakers, both experienced practitioners and artists working in other media, come together to shoot, hand-process, tint, tone, scratch, and edit films in a barn. This manifesto codifies the philosophy behind the practice.

Enter through the big barn doors, without sketches, scripts, props, actors, or cell phones. Your films will surface through the relationship between your camera and what passes in front. It may take the whole of the workshop for you to shake away the habit of planning, what has become the guiding light of the profit-driven film world. Without the blanket of preconception, the processes of *collect, reflect, revise* mirror the underpinnings of your formation.

Dive deep to encounter those strange fish who stare without seeing. Mental processes effect the physical when the mind is open to what appears in front of you. These images you make will be charged with your inner architecture. Don't be surprised if a person, animal, place or thing shows you a way to go. These pathways can be provocative, treacherous and joyful. They are places you have to go, one way or another, so you might as well start your trip.

The camera holds the film, and waits for light to pass through the lens. When you release the trigger, a mechanical shutter lets the image in, focused through the lens which controls the quantity of the light. What you film will be effected by uncontrollable sun bursts, and the various tones and textures that the camera passes over. With the open field before you, these little gifts can have a say, in the making of your film.

In the darkroom you watch the image surface. The big world you filmed isn't bigger than the small world that slowly appears. Hand processing movie film is a complex soup of various forces. Heat, time, light, movement, all work together and an image somehow forms through the silvery magic of the photo-chemical process. ~~Errors~~ of time and application can render your film opaque or clear, but you still have a latent image burned into your mind, which can be brought forward on another filming trip. Slighter ~~inconsistencies~~ can upset your expectations and pose a question you would never ask, if all went ~~perfectly~~.

Leaving the workshop can be as difficult as entering. If you have found intensity it might seem that the world you return to has gone somewhat askew . . . when perception shifts the familiar becomes strange. Holding on to the experience allows it to resonate for months to come and hopefully fuels the finishing of your film and the initiation of new ones.

2

NATIONAL AND TRANSNATIONAL CINEMAS

．　　　．　　　．

Although there has been a great deal of scholarship on the emergence and development of national cinemas, the role played by film manifestos in their histories has often been marginalized. The waves and movements that arose in Europe from the rubble of World War II were greatly tied to film manifestos. There are many salient reasons for this: the destruction of the European infrastructure from six years of war and bombing meant that all industry, including the creative ones, had to be reimagined. On an economic level, the Marshall Plan meant that a majority of European screens were showing Hollywood films. And because of the war, the Hollywood studios had six years worth of backlogged films that could now be released, along with the new films they were producing (among other things, this backlog led to French critics discovering *film noir*). This led to at least two developments. First, many European countries wanted to counteract the influence of American culture. Second, because of the destruction wrought by the war, the various European film industries had to radically rethink the modes and means of production in their respective countries. Each country faced its own specific issues, along with the pan-European concern with Americanization. The issues facing Britain, for instance, were distinct, as the United Kingdom's market had to compete with American films that shared a common language. In Italy the destruction brought on the country meant that new modes of filmmaking needed to be developed. In France, the country with perhaps the most cinephiles, over time an interstitial cinema developed in response to the staid "quality" films being produced. Germany, as an occupied country, had its production tightly controlled by the Allies. In the twenty-five years following the war, each of these countries developed distinct national cinema "waves." In each case these waves were tied to manifestos.

The case of Britain in this regard is telling. One of the "victors" of the War, much of its industrial infrastructure had been destroyed, and, as noted, the British shared the English language with Americans. And like other English language countries, such as Canada, there was a turn toward documentary. The Free Cinema manifesto of 1956 was, according to Lindsay Anderson, as much an attempt to call into being the possibility of making films, and a promotional tool, as it was a coherent aesthetic movement. And while Free Cinema became, over time, international in its scope (exemplified by Polanski's *Two Men and a Wardrobe* [Poland, 1958], Truffaut's *Les mistons* [France, 1957], and McLaren's *Neighbours* [Canada, 1952]), its key goal was to make alternative forms of filmmaking acceptable and, more important, to screen them in Britain. Yet the movement also was part of a larger change taking place in the United Kingdom centrally concerned with the promises of the war and how the country itself would change its class-bound heritage. The Free Cinema films introduced the images and voices of the British working classes to the screen. Slightly preceding the Angry Young Men of British literature and

drama, Free Cinema attempted to reimagine British cinema but also to determine what kinds of images of "Britishness" would appear on the screens. The Free Cinema movement also was a key precursor and influence on the Kitchen Sink films of the late 1950s and 1960s.

European cinemas continued to respond to American hegemony of the screens. Indeed, the latest manifestation of a Euro-wave, the Dogme '95 manifesto, is all about this history and the supposed death of European waves. For Lars von Trier and Thomas Vinterberg the beginning of this death can be traced back to the arrival of the French *nouvelle vague* in 1960. Trier and Vinterberg contend that Jean-Luc Godard, François Truffaut, Claude Chabrol, Eric Rohmer, and Jacques Rivette were all for the overthrowing of the cinema of the past but did not make anywhere near a decisive enough break with the past to bring about a new cinema. Yet the *auteur* cinema of *la nouvelle vague* was not a consolidated film style; it did not follow uniform rules of cinematic evolution or revolution, in the manner implied by the Dogme brothers. Truffaut himself had put this vision of *la nouvelle vague* to rest twenty-eight years earlier, when he stated:

> People who say "The New Wave has failed" without defining what they mean by that, I suppose they're thinking of "intellectual" films which were not successful at the box-office, and with this in mind they refuse to "label" films which pleased them or were successful—an arbitrary division since the New Wave is just as much *L'Homme de Rio* as *L'Immortelle*, *Le Vieil homme et l'enfant* as *La Musica*, *Les Cœurs verts* as *Un Homme et une femme*. . . . The New Wave did not have an aesthetic programme, it was simply an attempt to rediscover a certain independence which was lost somewhere around 1924, when films became too expensive, a little before the talkies.[1]

It is individualism that the Dogme group sees as the failure of *la nouvelle vague,* yet as Truffaut points out, it is precisely the individual visions of numerous dissimilar *auteurs* that were the backbone of New Wave cinema. Nevertheless, it is the received idea that post-1960 cinema movements (New German Cinema, *cinéma direct,* British "kitchen sink" films) stultified their radical possibilities by adopting "styles" of their own. Therefore, it is this kind of stylistic individualism that Dogme contends was the downfall of the art cinemas that followed in the wake of *la nouvelle vague.*

If I concentrate of Dogme '95 to such an extent here, it is because the manifesto has both revitalized film manifesto writing and inspired filmmakers from documentarians to digital activists to such a great degree over the last twenty years, as we will see throughout this book. Trier echoes these assumptions:

> But I still think that Dogme might persist in the sense that a director would be able to say, "I feel like making that kind of film." I think that would be amusing. I'm sure a lot of people could profit from that. At which point you might argue that they could just as easily profit from a different set of rules. Yes, of course. But then go ahead and formulate them. Ours are just a proposal.[2]

Therefore, Dogme is not the only way to make film, as Vinterberg notes: "I think to make another Dogme film right now would be suicidal, because the fine thing about Dogme is to create renewal, and to do another Dogme film right after would be creating another convention, which would be very oppressive." The manifestos in this chapter continually reimagine the possibilities of distinct national cinemas in the face of American globalization.

Indeed, other national cinemas confronted the same problems in the face of the global juggernaut of Hollywood cinema, and in the case of colonial and postcolonial countries in Africa and the Middle East, a profound lack of infrastructure and capital with which one could produce films. These national and transnational manifestos all point to the fact that national cinemas are not simply created after the fact, like film noir, but are parts of cultural, political, and economic debates about the nature of cinema, what function it plays in national cultures, and the way in which different nation-states can have, to paraphrase Virginia Woolf, a cinema of their own.

FROM "THE GLASS EYE" (Italy, 1933)

Leo Longanesi

[Originally published in Italian as "L'occhio di vetro," *L'Italiano: Periodico della rivoluzione fascista* 8, no. 17–18 (gennaio-febbraio 1933) [numero speciale dedicato al cinema]: 35–45. Trans. Frank Burke.]

This manifesto by right-wing journalist and Italian fascist supporter Leo Longanesi (who, perhaps apocryphally, came up with the slogan "Mussolini is always right") argues for an Italian realist cinema years before the same calls were made by Cesare Zavattini and other neorealist directors (see Zavattini, "Some Ideas on the Cinema" later in this chapter). Longanesi argues that other cinemas engage in social realities while Italian cinema neglects and disavows these realities. It is striking to see the importance of realism for this fascist critic because neorealism is often understood as a response to the fascist era.

I do not believe that, in Italy, there is need for set designers to make a film. We should put together films simple and unadorned in their mise-en-scène, films without artifice, directed as much as possible from the real.

It is in fact the real that is missing from our films. We need to throw ourselves into the streets, carry our cameras into byways, courtyards, barracks, and railway stations. We need only leave the beaten path, stop at some un-predetermined point, and observe what goes on during a half hour, with eyes attentive and without stylistic preconceptions, to make a natural and logical Italian film. Stop at the corner of a street downtown or in the suburbs, stay somewhat removed from what is happening around us, and observe with calm everything as if it were appearing anew--as when, getting out of bed after a long illness, we are naturally inclined to see people and objects with indulgent eyes, and everything appears so extraordinary only because we have not gazed at it for a long time. The life of any given street is truly surprising! It is marvelous how everything can move so naturally, in a harmony so unordered; one is witness to a spectacle that has no plot. People and things seem to belong more to dream than to reality; for an instant one feels a sense of extraordinary suspension, of poetic stupor, that then becomes lost at the slightest movement of our eyes. A woman who passes hurriedly and disappears behind a carriage becomes at times the extraordinary apparition of an unsuspected truth. We happen in this way to discover during brief moments a reality different from the ordinary, more profound and distinct, which we will never again know how to re-evoke.

Habit takes away every direct and innocent emotion with which we relate to reality; our gaze no longer knows how to be surprised, to hold, as it were, for a moment, what passes within its ambit. Surprise is replaced by observation and subjective analysis.

An Italian film must be conceived and constructed in this sense. It isn't a matter of simple documentaries but of transporting onto the screen certain aspects of the seemingly pure reality that escapes the passerby and dominates at every moment the life of men and things. We happen, at times, to retrieve in some rare photograph the trace of these apparitions of which I am speaking, to be conducted back to reality as if we had forgotten it or had attempted to distance ourselves from it with fear.

American films shot outdoors have never succeeded in freeing themselves from the concept of spectacle: constructing the scene, enhancing reality, coloring the landscape, rendering luminous the images, educating the actors in a particular mimetic style. From Griffith to Murnau, American directors have not yet moved away from the film *directed* with criteria exclusively artistic: painting, literature, theater, and the optical are fused with mastery in their films. They move the public but don't succeed in transporting it into a world where the cinematographic is the only reality. They are too worried about displaying their culture and talent to be able to renounce the lighting effects, the play of figures within the frame, the decorative and rhetorical elements of their cinema.

They can't resist a beautiful horse that rears up a few steps from the lens, a cloud that appears reflected in the clear water of a lake, a shadow that divides a face, a burst of sunlight that brightens a courtyard, the puddles in a street made more luminous by the floodlights, and all the facile and complex uses of the camera. Reality interests them little: they only approximate the real, illustrating and mounting a narrative with great art, with no concern other than that of representing an event with taste and bravura. King Vidor, in *The Crowd*, in certain brief scenes, has arrived at a reality that is solid, simple, poetic, and without obvious stylistic aims. In *Kameradschaft*, Pabst achieves some extraordinary moments when he captures the crowd that, in prey to blind terror, runs towards the mine. For a few seconds, there appears onscreen a chilling landscape, in a suspended air of disaster, animated by the figures of a terrible reality; it is as if one were brought back to certain painful moments of existence, to certain fears experienced in infancy.

What Pabst has above all rendered is that instant of sudden premonition, followed by growing certainty, of a disaster that devastates one who has been unexpectedly confronted by misfortune. Premonition, fear of a dreadful event, and desperation--all of which infuse themselves in the landscape.

To encounter the face of reality, we must feel extraordinary emotion that lifts us and detaches us from ourselves; jolted by emotion, we see men and things differently, as I was saying before, in a new light, in an unsuspected reality: strange, autonomous, unwavering above all else. But reality always has this aspect; it is always beyond our time and space, even if habit has created an intimacy with it, a veil that covers our eyes. The cinema, if it can leave behind pretensions of painting-in-motion and of literature, of

bizarre techniques and operetta, will increasingly seek a greater adherence to the real, carrying to the screen the secrets only *a machine* knows how to seize from reality.

THE CINEMATIC CLIMATE

A film is the unfolding of a motif—psychological, social, rhetorical, or poetic—through a complex of images.

The motif of a film is not only a logical succession of scenes, the elaboration of a plot, as happens in the theater (where everything is entrusted to the ability of the actors and the staging of the fiction is limited) but a particular rhythm that dominates the progression of images onscreen. Every motif has an atmosphere *of its own:* that is, its own poetry, expressed in the backgrounds or scenery. But a cinematic background is not only an internal or external setting ably reproduced, that remains fixed, detached from the actors; it is a series of images able, by themselves, to produce an emotion. So, in the unfolding of the plot, the development of a motif, the action of the characters must be fused with place in such a way as to generate a climate of extraordinary authenticity.

When a writer prefaces a human situation with a description of the landscape or ambience, he does in two strokes what a film can accomplish in just one. But the atmosphere is not realized exclusively with the perfect photographic reproduction of one landscape or another, with a marvelous background; it is important instead that every use of background be in rapport with the story: in such straight rapport as to fuse with it and vanish. . . .

CINEMATIC POLEMICS

Considering that the cinema in Italy can be polemical, to serve fascism and sustain a thesis, it is important to define with clarity what thesis it needs to demonstrate. Italian cinema, up till today, has not had any myth, more or less like its literature; our films have been and continue to be poor formal imitations of American, French, and sometimes Russian ([Blasetti's] *Terra madre*) cinema. It has never encountered a thesis and tried to address it, even if only ingenuously, because a thesis didn't exist and because the exponents of our cinema have no critique to bring to bear on Italian society. Among us, making a film is extraneous to the interests and political ideas of our country. One tries to obtain the sympathy of the Regime and of the public with expedients that are rhetorical, patriotic, and indecorous in the extreme; one does one's best not to bump up against censorship and the mentality of the times—and, on the other hand, to conserve the old physiognomy of lighthearted-sentimental, petty-bourgeois film production.

Now, the cinema in Italy, without exercising a violent partisan polemic, as happened in Russia, should react to that particular custom, to that particular mentality, that our production houses are so obstinate in illustrating. Custom and mentality of a false class, without physiognomy, facile in improvisation, neither bourgeois nor working class.

Frivolous and dilettantish, full of pretenses and vices, this custom and this mentality end up dominating public opinion and giving to the country a tone of unmerited banality.

It is not difficult to discover this small world in its various and diverse aspects: from the small fascist leader to the bureaucrat, from the bon vivant to the female readers of *Domus* magazine, from the beachside loungers to the dandies with mustaches à la Menjou—all part of a crowd to be judged severely. But to be able to represent this world with a touch of irony and satire does not mean belonging to it or, at the least, means not accepting it.

The American cinema has succeeded in being original and vital only because, in contrast with ours, it has, in one sense or another, exercised a moral function; it hasn't limited itself to show to the public the joyful legs of a ballerina or the pathos on the face of an actress. David W. Griffith, in each of his films, embarks on a Quaker crusade; King Vidor, in *The Crowd,* shows the tragedy of the little clerk who wants to rise above the masses. Erich von Stroheim doesn't hesitate to satirize himself, even to show the paradoxes of the old military aristocracies. He takes money from his servant, cheats at cards, gets slapped, cries with fear, violates poor girls, spies on people—yet his uniform is always impeccable. His every gesture remains austere, rigid as though in the presence of an emperor. All is allowed to a true aristocrat as long as he maintains his "style." Stroheim is always Baron von Stroheim even in the most squalid of situations. No one succeeded better than he to represent certain types of officers who, having lost the prestige of command and uniform, experience a cataclysmic fall. All film directors from Fritz Lang to René Clair, from Chaplin to Pabst, whether they be French, German, or American, have tried to interpret reality in terms of moral criteria. Each in his way has *directed* social critique. Whether defending the worker or the prostitute, demonstrating the pitfalls of capitalism or the boredom of the rich, weaving an elegy on order or on the happiness of the savage. No one of them has ever distanced himself from social themes. Only Italian cinema, worthy follower of our rhetorical literature, has contented itself with making use of the camera with artistic and purely stylish pretensions.

Our cinema is too lacking in arguments to be effective; whatever story it represents does not ever succeed to get to the bottom of things. It glosses over precisely what should be addressed in depth and focuses on what should be treated in passing. It does not have problems to resolve or preferences because it has no opinions to defend. It will never know how to offer any interpretation of reality. Everything flees before its lens. A camera is a magnifying glass that one must know how to make serviceable.

None of the films made up till now in Italy have succeeded in moving us for even a moment; they have failed to demonstrate either protestation or affection. Affection: one can use this word even in terms of cinema. Affection for the character represented. (A metteur-en-scène can show affection towards the same world that he depicts ironically, as is the case with Stroheim.) Affection: a quality that is lacking to our directors.

With *The Champ,* King Vidor reprises with affection an old American boxing theme, showing how one can make a film without resorting to the most recent lessons of German

and Russian cinema, by this point so dominant in Hollywood. *The Champ* is an American film par excellence, in technique, in acting style, and in mise-en-scène. Everything is resolved with a naturalness that does not hide the fiction. The film moves along without ruptures, making the public forget it is in a theater. King Vidor does not avail himself of his ability as a *metteur-en-scène* to show us visual variations on a theme. He doesn't insist on highly particular descriptions of environments, and he doesn't indulge in the cinematic magic of Mamullian [*sic,* Mamoulian], for example. He hides himself behind the actors, concerned only to lead them to an extraordinary and poetic interpretation of the subject matter. Every detail is attended to with artistry, but the images, the cuts, and the infinite other technical resources do not assault the viewers. The plot is advanced without expressionistic aids, without insistence, with a tranquil rhythm. It has been a while since one has been able to see such a well-made, simple, film that does not get caught up in fashionable mysteries of the subconscious. Avant-gardism has truly bored us! King Vidor succeeds in moving us without expedients, finally! . . .

THE ARCHERS' MANIFESTO (UK, 1942)

Michael Powell and Emeric Pressburger

[First written in a letter from Michael Powell to Wendy Hiller to convince her to star in *The Life and Death of Colonel Blimp* (UK,1943). First published in Kevin Macdonald, *Emeric Pressburger: The Life and Death of a Screenwriter* (London: Faber, 1994): 189–190.]

The Archers' manifesto delineates the strategy used by Powell and Pressburger to invent many of the aspects of independent cinema some thirty years before its rise in the United States. One of the key reasons that the Archers, and other UK producers, were at the forefront of independent cinema was the profound need to draw a distinction between the English-language cinema of Great Britain and that of Hollywood. It is also an *avant la lettre* statement of auteurist principles.

One: we owe allegiance to nobody except the financial interests which provide our money; and, to them, the sole responsibility of ensuring them a profit, not a loss.

Two: every single foot in our films is our own responsibility and nobody else's. We refuse to be guided or coerced by any influence but our own judgment.

Three: when we start work on a new idea we must be a year ahead, not only of our competitors, but also of the times. A real film, from idea to universal release, takes a year. Or more.

Four: no artist believes in escapism. And we secretly believe that no audience does. We have proved, at any rate, that they will pay to see the truth, for other reasons than her nakedness.

Five: at any time, and particularly at the present, the self respect of all collaborators, from star to prop-man, is sustained, or diminished, by the theme and purpose of the film they are working on.

WHAT IS WRONG WITH INDIAN FILMS?
(India, 1948)

Satyajit Ray

[First appeared in the *Calcutta Statesman*, 1948.]

Written the year after Indian Independence, this manifesto by Satyajit Ray laments the state of Indian cinema and the fact that Indian films never play outside of India. He claims that the language of the cinema, as it presently stands, is an American idiom but can easily be adapted to other cultures. Ray wrote this manifesto shortly before beginning *Pather Panchali* (India, 1955), which placed Indian realist cinema on the international map alongside Italian neorealism, a movement that greatly influenced Ray. "What Is Wrong with Indian Films" also echoes the thesis of *la caméra stylo* put forward by Alexandre Astruc the same year, namely that the cinema "can handle Shakespeare and psychiatry with equal facility" (see Astruc, "The Birth of a New Avant Garde" in chap. 11 of this volume).

One of the most significant phenomena of our time has been the development of the cinema from a turn-of-the-century mechanical toy into the century's most potent and versatile art form. In its early chameleon-like phase the cinema was used variously as an extension of photography, as a substitute for the theater and the music hall, and as a part of the magician's paraphernalia. By the twenties, the cynics and know-alls had stopped smirking and turned down their nose.

Today, the cinema commands respect accorded to any other form of creative expression. In the immense complexity of its creative process, it combines in various measures the functions of poetry, music, painting, drama, architecture and a host of other arts, major and minor. It also combines the cold logic of science with the subtlest abstractions of the human imagination. No matter what goes into the making of it, no matter who uses it and how—producer for financial profits, a political body for propaganda or an avant-garde intellectual for the satisfaction of an aesthetic urge—the cinema is basically the expression of a concept or concepts in aesthetic terms; terms which have crystallized through the incredibly short years of its existence.

It was perhaps inevitable that the cinema should have found the greatest impetus in America. A country without any deep-rooted cultural and artistic traditions was perhaps

best able to appraise the new medium objectively. Thanks to pioneers like Griffith, and to the vast-sensation mongering public with its constant clamor for something new, the basic style of filmmaking was evolved and the tolls of its production perfected much quicker than would be normally possible. The cinema has now attained a stage where it can handle Shakespeare and psychiatry with equal facility. Technically, in the black and white field, the cinema is supremely at ease. Newer development in color and three-dimensional photography are imminent, and it's possible that before the decade is out, the aesthetics of film making will have seen far-reaching changes.

Meanwhile, "studios sprang up" to quote an American writer in *Screenwriter,* "even in such unlikely lands as India and China." One may note in passing that this spring up has been happening in India for nearly forty years. For a country so far removed from the centre of things, India took up film production surprisingly early.

The first short was produced in 1907 and the first feature in 1913. By the twenties it had reached the status of big business. It is easy to tell the world that film production in India is quantitatively second only to Hollywood; for that is a statistical fact. But can the same be said of its quality? Why are our films not shown abroad? Is it solely because India offers a potential market for her own products? Perhaps the symbolism employed is too obscure for foreigners? Or are we just plain ashamed of our films?

To anyone familiar with the relative standards of the best foreign and Indian films, the answers must come easily. Let us face the truth. There has yet been no Indian film which could be acclaimed on all counts. Where other countries have achieved, we have only attempted and that too not always with honesty, so that even our best films have to be accepted with the gently apologetic proviso that it is "after all an Indian film."

No doubt this lack of maturity can be attributed to several factors. The producers will tell you about the mysterious entity "the mass," which "goes in for this sort of thing," the technicians will blame the tools and the director will have much to say about the wonderful things he had in mind but could not achieve. In any case, better things have been achieved under much worse conditions. The internationally acclaimed post-war Italian cinema is a case in point. The reason lies elsewhere. I think it will be found in the fundamentals of film-making.

In the primitive state films were much alike, no matter where they were produced. As the pioneers began to sense the uniqueness of the medium, the language of the cinema gradually evolved. And once the all important function of the cinema—e.g., movement—was grasped, the sophistication of style and content, and refinement of technique were only a matter of time. In India it would seem that the fundamental concept of a coherent dramatic pattern existence of time was generally misunderstood.

Often by a queer process of reasoning, movement was equated with action and action with melodrama. The analogy with music failed in our case because Indian music is largely improvisational.

This elementary confusion plus the influence of the American cinema are the two main factors responsible for the present state of Indian films. The superficial aspects [of] the American style, no matter how outlandish the content, were imitated with reverence.

Almost every passing phase of the American cinema has had its repercussion on the Indian film. Stories have been written based on Hollywood success and the clichéd preserved with care. Even where the story has been [a] genuinely Indian one, the background has revealed an irrepressible penchant for the jazz idiom.

In the adoptions of novels, one of two courses has been followed: either the story has been distorted to conform to the Hollywood formula, or it has been produced with such devout faithfulness to the original that the purpose of filmic interpretations has been defeated.

It should be realized that the average American film is a bad model, if only because it depicts a way of life so utterly at variance with our own. Moreover, the high technical polish which is the hallmark of the standard Hollywood products, would be impossible to achieve under existing Indian conditions. What the Indian cinema needs today is not more gloss, but more imagination, more integrity, and a more intelligent appreciation of the limitations of the medium.

After all, we do possess the primary tools of film-making. The complaint of the technician notwithstanding, mechanical devices such as the crane shot and the process shot are useful, but by no means indispensable. In fact, what tools we have, have been used on occasion with real intelligence. What our cinema needs above everything else is a style, an idiom, a sort of iconography of cinema, which would be uniquely and recognizably Indian.

There are some obstacles to this, particularly in the representation of the contemporary scene. The influence of Western civilization has created anomalies which are apparent in almost every aspect of our life. We accept the motor car, the radio, the telephone, streamlined architecture, European costume, as functional elements of our existence. But within the limits of [the] cinema frame, their incongruity is sometimes exaggerated to the point of burlesque. I recall a scene in a popular Bengali film which shows the heroine weeping to distraction with her arms around a wireless—an object she associates in her mind with her estranged lover who was once a radio singer.

Another example, a typical Hollywood finale, shows the heroine speeding forth in a sleek convertible in order to catch up with her frustrated love who has left town on foot; as she sights her man; she abandons the car in a sort of a symbolic gesture and runs up the rest of the way to meet him.

The majority of our films are replete with visual dissonances. In *Kalpana,* Uday Shankar used such dissonances in a conscious and consistent manner so that they became part of his cinematic style. But the truly Indian film should steer clear of such inconsistencies and look for its material in the more basic aspects of Indian life, where habit and speech, dress and manner, background and foreground, blend into a harmonious whole.

It is only in drastic simplification of style and content that hope for the Indian cinema resides. At present, it would appear that nearly all the prevailing practices go against such simplification.

Starting a production without adequate planning, sometimes even without a shooting script; a penchant for convolutions of plot and counter-plot rather than the strong, simple unidirectional narrative; the practice of sandwiching musical numbers in the most unlyrical

situation; the scope, and at the same time when all other countries are turning to the documentary for inspiration—all these stand in the way of the evolution of a distinctive style.

There have been rare glimpses of an enlightened approach in a handful of recent films. IPTA's *Dharti ke Lal* is an instance of a strong simple theme put over with style, honesty and technical competence. Shankar's *Kalpana,* an inimitable and highly individual experiment, shows a grasp to the peak of cinematic achievement. The satisfying photography which marks the UN documentary of Paul Zils shows what a discerning camera can do with the Indian landscape.

The raw material of the cinema is life itself. It is incredible that a country which has inspired so much painting and music and poetry should fail to move the film-maker. He has only to keep his eyes open, and his ears. Let him do so.

BUÑUEL THE POET (Mexico, 1951)

Octavio Paz

[First distributed at the Cannes Film Festival, 4 April 1951. First published in *Neuvo ciné* (Mexico), 1961. First published in English in Octavio Paz, *On Poets and Others* (New York: Arcade, 1990), 152–156. Trans. Michael Schmidt.]

For the international release of Buñuel's third Mexican film, *Los Olvidados* (1950), Mexican writer, poet, diplomat, and Nobel Laureate Octavio Paz wrote this manifesto on the surrealist filmmaker and his new film, which was circulated at the Cannes Film Festival in 1951, where Buñuel went on to win the Best Director prize for the film that year. Paz coxtextualizes Buñuel's latest film in relation to his earlier works with Salvador Dalí and his surrealist documentary *Las Hurdes: Tierra sin pan (Land without Bread* [Spain, 1933])·

The release of *L'Age d'or* and *Un chien andalou* signals the first considered irruption of poetry into the art of cinematography. The marriage of the film image to the poetic image, creating a new reality, inevitably appeared scandalous and subversive—as indeed it was. The subversive nature of Buñuel's early films resides in the fact that, hardly touched by the hand of poetry, the insubstantial conventions (social, moral, or artistic) of which our reality is made fall away. And from those ruins rises a new truth, that of man and his desire. Buñuel shows us that a man with his hands tied can, by simply shutting his eyes, make the world jump. Those films are something more than a fierce attack on so-called reality; they are the revelation of another reality which contemporary civilization has humiliated. The man in *L'Age d'or* slumbers in each of us and waits only for a signal to awake: the signal of love. This film is one of the few attempts in modern art to reveal the terrible face of love at liberty.

A little later, Buñuel screened *Land Without Bread,* a documentary which of its genre is also a masterpiece. In this film Buñuel the poet withdraws; he is silent so that reality can speak for itself. If the subject of Buñuel's surrealist films is the struggle of man against a reality which smothers and mutilates him, the subject of *Land Without Bread* is the brutalizing victory of that same reality. Thus this documentary is the necessary complement to his earlier creations. It explains and justifies them. By different routes, Buñuel pursues his bloody battle with reality. Or rather, against it. His realism, like that of the best Spanish tradition—Goya, Quevedo, the picaresque novel, Valle-Inclán, Picasso—consists of a pitiless hand-to-hand combat with reality. Tackling it, he flays it. This is why his art bears no relation at all to the more or less tendentious, sentimental, or aesthetic descriptions of the writing that is commonly called realism. On the contrary, all his work tends to stimulate the release of something secret and precious, terrible and pure, hidden by our reality itself. Making use of dream and poetry or using the medium of film narrative, Buñuel the poet descends to the very depths of man, to his most radical and unexpressed intimacy.

After a silence of many years, Buñuel screens a new film: *Los Olvidados.* If one compares this film with those he made with Salvador Dali, what is surprising above all is the rigor with which Buñuel takes his first intuitions to their extreme limits. On the one hand, *Los Olvidados* represents a moment of artistic maturity; on the other, of greater and more total rage: the gate of dreams seems sealed forever; the only gate remaining open is the gate of blood. Without betraying the great experience of his youth, but conscious of how times have changed, that reality which he denounced in his earlier works has grown even more dense—Buñuel constructs a film in which the action is precise as a mechanism, hallucinatory as a dream, implacable as the silent encroachment of lava flow. The argument of *Los Olvidados*—delinquent childhood has been extracted from penal archives.

Its characters are our contemporaries and are of an age with our own children. But *Los Olvidados* is something more than a realist film. Dream, desire, horror, delirium, chance, the nocturnal part of life, also play their part. And the gravity of the reality it shows us is atrocious in such a way that in the end it appears impossible to us, unbearable. And it is: reality is *unbearable;* and that is why, because he cannot bear it, man kills and dies, loves and creates.

The strictest artistic economy governs *Los Olvidados.* Corresponding to this greater condensation is a more intense explosion. That is why it is a film without "stars"; that is why the "musical background" is so discreet and does not set out to usurp what music owes to the eyes in films; and finally, that is why it disdains local color. Turning its back on the temptation of the impressive Mexican landscape, the scenario is reduced to the sordid and insignificant desolation, but always implacable, of an urban setting. The physical and human space in which the drama unfolds could hardly be more closed: the life and death of some children delivered up to their own fate, between the four walls of abandonment. The city, with all that this word entails of human solidarity, is alien and strange. What we call civilization is for them nothing but a wall, a great No which closes the way. Those children are Mexicans, but they could be from some other country, could

live in any suburb of another great city. In a sense they do not live in Mexico, or anywhere: they are the forgotten, the inhabitants of those wastelands which each modern city breeds on its outskirts. A world closed on itself, where all acts are reflexive and each step returns us to our point of departure. No one can get out of there, or out of himself, except by way of the long street of death. Fate, which opens doors in other worlds, here closes them.

In *Los Olvidados* the continuous presence of the hazard has a special meaning, which forbids us from confusing it with mere chance. The hazard which governs the action of the protagonists is presented as a necessity which, nonetheless, *could have been avoided.* (Why not give it its true name, then, as in tragedy: *destiny?*) The old fate is at work again, but deprived of its supernatural attributes: now we face a social and psychological fate. Or, to use the magical word of our time, the new intellectual fetish: an historical fate. It is not enough, however, for society, history, or circumstances to prove hostile to the protagonists; for the catastrophe to come about, it is necessary for those determinants to coincide with human will. Pedro struggles against chance, against his bad luck or his bad shadow, embodied in the Jaibo; when, cornered, he accepts and faces it, he changes fate into destiny. He dies, but he makes his death his own. The collision between human consciousness and external fate constitutes the essence of the tragic act. Buñuel has rediscovered this fundamental ambiguity: without human complicity, destiny is not fulfilled and tragedy is impossible. Fate wears the mask of liberty; chance, that of destiny. *Los Olvidados* is not a documentary film. Nor is it a thesis, propagandistic, or moralizing film. Though no sermonizing blurs his admirable objectivity, it would be slanderous to suggest that this is an art film, in which all that counts are artistic values. Far from realism (social, psychological, and edifying) and from aestheticism, Buñuel's film finds its place in the tradition of a passionate and ferocious art, contained and raving, which claims as antecedents Goya and Posada, the graphic artists who have perhaps taken black humor furthest. Cold lava, volcanic ice. Despite the universality of his subject, the absence of local color, and the extreme bareness of his construction, *Los Olvidados* has an emphasis which there is no other word for but *racial* (in the sense in which fighting bulls have *casta*). The misery and abandonment can be met with anywhere in the world, but the bloodied passion with which they are described belongs to great Spanish art. We have already come across that half-witted blind man in the Spanish picaresque tradition. Those women, those drunks, those cretins, those murderers, those innocents, we have come across in Quevedo and Galdós, we have glimpsed them in Cervantes, Velásquez and Murillo have depicted them. Those sticks— the walking sticks of the blind—are the same which tap down all the history of Spanish theater. And the children, the forgotten ones, their mythology, their passive rebellion, their suicidal loyalty, their sweetness which flashes out, their tenderness full of exquisite ferocity, their impudent affirmation of themselves in and for death, their endless search for communion—even through crime—are not and cannot be anything but Mexican. Thus, in the crucial scene in the film—the "libation" scene—the subject of the mother is resolved in the common supper, the sacred feast. Perhaps unintentionally, Buñuel finds in the dream of his protagonists the archetypal images of the Mexican people: Coatlicue [Aztec

goddess of death and fertility] and sacrifice. The subject of the mother, a Mexican obsession, is inexorably linked to the theme of fraternity, of friendship unto death. Both constitute the secret foundation of this film. The world of *Los Olvidados* is peopled by orphans, by loners who seek communion and who do not balk at blood to find it. The quest for the "other," for our likeness, is the other side of the search for the mother. Or the acceptance of her definitive absence: the knowledge that we are alone. Pedro, the Jaibo, and his companions thus reveal to us the ultimate nature of man, which perhaps consists in a permanent and constant state of orphandom.

Witness to our age, the moral value of *Los Olvidados* bears no relation at all to propaganda. Art, when it is free, is witness, conscience. Buñuel's work proves what creative talent and artistic conscience can do when nothing but their own liberty constrains or drives them.

FRENCH CINEMA IS OVER
(France, 1952)

Serge Berna, Guy Debord, François Dufrêne, Monique Geoffrey, Jean-Isidore Isou, Yolande du Luart, Marc'O, Gabriel Pomerand, Poucette, and Gil J. Wolman

[Tract first distributed in French as "Fini le cinéma français" at the 5th Cannes Film Festival, April 1952. Published in French in Guy Debord, *Oeuvres complètes* (Paris: Gallimard, 2006), 59. First published in English in Thomas Y. Levin, "Dismantling the Spectacle: The Cinema of Guy Debord," in Thomas McDonough, ed., *Guy Debord and the Situationist International: Texts and Documents* (Cambridge, MA: MIT Press, 2002), 340–341. Trans. Thomas Y. Levin.]

This tract, distributed at the Cannes Film Festival, appeared at the same time as the first and only issue of *Ion*, the Lettriste journal dedicated to cinema, which also included Guy Debord's first published work (see Debord, "Prolegomena for All Future Cinema" in chap. 1 of this volume). The Lettristes, self-described "men of the new cinema," disrupted the festival to such an extent that they were arrested.

A number of men, dissatisfied with what they have been given, surpass the world of official expressions and the festivals of its poverty.

After **L'ESTHETIQUE DU CINEMA** by Isidore **ISOU, TAMBOURS DU JUGEMENT PREMIER,** the essay in imaginary cinema by François **DUFRENE,** systematizes to the utmost extreme the exhaustion of filmic means, by locating it beyond all of its technology.

Guy-Ernest **DEBORD** with

HURLEMENTS EN FAVEUR DE SADE arrives at the end of cinema in its insurrectional phase.

After these refusals, definitively outside the norms which you like, the

CINEMA NUCLEAIRE by **MARC'O.** integrates the exhibition space and the spectator into the cinematographic representation.

From now on, cinema can no longer be anything but **NUCLEAR.** Thus we want to go beyond these derisory competitions of sub-products between little businessmen who are already either illiterate or destined to soon become so. Our mere presence here makes them die.

And here are the men of the new cinema: Serge **BERNA, G.E. DEBORD,** François **DUFRENE,** Monique **GEOFFROY,** Jean Isidore **ISOU,** Yolande du **LUART, MARC'O.,** Gabriel **POMERAND, POUCETTE,** Gil J. **WOLMAN.**

SOME IDEAS ON THE CINEMA
(Italy, 1953)

Cesare Zavattini

[First published in Italian as a recorded interview in *La revista de cinema italiano* 2 (1952). First published in English in *Sight and Sound* 23, no. 2 (1953): 64–69. Trans. Pier Luigi Lanza.]

Screenwriter Cesare Zavattini's manifesto for neorealism stands as both a descriptive and philosophical statement on the nature of the movement and on cinema's possibilities in capturing the "real," echoing in some ways André Bazin's "Ontologie de l'image photographique" (1945). Zavattini's manifesto harkens back to Longanesi's "The Glass Eye" in many ways, but whereas Longanesi celebrated aspects of American cinema, Zavattini deplores it.

I

No doubt one's first and most superficial reaction to everyday reality is that it is tedious. Until we are able to overcome some moral and intellectual laziness, in fact, this reality will continue to appear uninteresting. One shouldn't be astonished that the cinema has always felt the natural, unavoidable necessity to insert a "story" in the reality to make it exciting and "spectacular." All the same, it is clear that such a method evades a direct approach to everyday reality, and suggests that it cannot be portrayed without the intervention of fantasy or artifice.

The most important characteristic, and the most important innovation, of what is called neorealism, it seems to me, is to have realized that the necessity of the "story" was only an unconscious way of disguising a human defeat, and that the kind of imagination

it involved was simply a technique of superimposing dead formulas over living social facts. Now it has been perceived that reality is hugely rich, that to be able to look directly at it is enough; and that the artist's task is not to make people moved or indignant at metaphorical situations, but to make them reflect (and, if you like, to be moved and indignant too) on what they and others are doing, on the real things, exactly as they are.

For me this has been a great victory. I would like to have achieved it many years earlier. But I made the discovery only at the end of the war. It was a moral discovery, an appeal to order. I saw at last what lay in front of me, and I understood that to have evaded reality had been to betray it.

Example: Before this, if one was thinking over the idea of a film on, say, a strike, one was immediately forced to invent a plot. And the strike itself became only the background to the film. Today, our attitude would be one of "revelation": we would describe the strike itself, try to work out the largest possible number of human, moral, social, economic, poetic values from the bare documentary fact.

We have passed from an unconsciously rooted mistrust of reality, an illusory and equivocal evasion, to an unlimited trust in things, facts and people. Such a position requires us, in effect, to excavate reality, to give it a power, a communication, a series of reflexes, which until recently we had never thought it had. It requires, too, a true and real interest in what is happening, a search for the most deeply hidden human values, which is why we feel that the cinema must recruit not only intelligent people, but, above all, "living" souls, the morally richest people.

II

The cinema's overwhelming desire to see, to analyse, its hunger for reality, is an act of concrete homage towards other people, towards what is happening and existing in the world. And, incidentally, it is what distinguishes "neorealism" from the American cinema.

In fact, the American position is the antithesis of our own: while we are interested in the reality around us and want to know it directly, reality in American films is unnaturally filtered, "purified," and comes out at one or two removes. In America, lack of subjects for films causes a crisis, but with us such a crisis is impossible. One cannot be short of themes while there is still plenty of reality. Any hour of the day, any place, any person, is a subject for narrative if the narrator is capable of observing and illuminating all these collective elements by exploring their interior value.

So there is no question of a crisis of subjects, only of their interpretation. This substantial difference was nicely emphasised by a well-known American producer when he told me: "This is how *we* would imagine a scene with an aeroplane. The 'plane passes by . . . a machine-gun fires . . . the 'plane crashes. . . . And this is how *you* would imagine it. The 'plane passes by . . . The 'plane passes by again . . . the 'plane passes by once more . . ."

He was right. But we have still not gone far enough. It is not enough to make the aeroplane pass by three times; we must make it pass by twenty times.

What effects on narrative, then, and on the portrayal of human character, has the neorealist style produced?

To begin with, while the cinema used to make one situation produce another situation, and another, and another, again and again, and each scene was thought out and immediately related to the next (the natural result of a mistrust of reality), today, when we have thought out a scene, we feel the need to "remain" in it, because the single scene itself can contain so many echoes and reverberations, can even contain all the situations we may need. Today, in fact, we can quietly say: give us whatever "fact" you like, and we will disembowel it, make it something worth watching.

While the cinema used to portray life in its most visible and external moments—and a film was usually only a series of situations selected and linked together with varying success—today the neorealist affirms that each one of these situations, rather than all the external moments, contains in itself enough material for a film.

Example: In most films, the adventures of two people looking for somewhere to live, for a house, would be shown externally in a few moments of action, but for us it could provide the scenario for a whole film, and we would explore all its echoes, all its implications.

Of course, we are still a long way from a true analysis of human situations, and one can speak of analysis only in comparison with the dull synthesis of most current production. We are, rather, still in an "attitude" of analysis; but in this attitude there is a strong purpose, a desire for understanding, for belonging, for participating—for living together, in fact.

III

Substantially, then, the question today is, instead of turning imaginary situations into "reality" and trying to make them look "true," to make things as they are, almost by themselves, create their own special significance. Life is not what is invented in "stories"; life is another matter. To understand it involves a minute, unrelenting, and patient search. Here I must bring in another point of view. I believe that the world goes on getting worse because we are not truly aware of reality. The most authentic position anyone can take up today is to engage himself in tracing the roots of this problem. The keenest necessity of our time is "social attention."

Attention, though, to what is there, *directly:* not through an apologue, however well conceived. A starving man, a humiliated man, must be shown by name and surname; no fable for a starving man, because that is something else, less effective and less moral. The true function of the cinema is not to tell fables, and to a true function we must recall it.

Of course, reality can be analysed by ways of fiction. Fictions can be expressive and natural; but neorealism, if it wants to be worthwhile, must sustain the moral impulse that characterised its beginnings, in an analytical documentary way. No other medium of expression has the cinema's original and innate capacity for showing things that we

believe worth showing, as they happen day by day—in what we might call their "dailiness," their longest and truest duration. The cinema has everything in front of it, and no other medium has the same possibilities for getting it known quickly to the greatest number of people.

As the cinema's responsibility also comes from its enormous power, it should try to make every frame of film count, by which I mean that it should penetrate more and more into the manifestations and the essence of reality. The cinema only affirms its moral responsibility when it approaches reality in this way.

The moral, like the artistic, problem lies in being able to observe reality, not to extract fictions from it.

IV

Naturally, some film-makers, although they realise the problem, have still been compelled, for a variety of reasons (some valid, others not), to "invent" stories in the traditional manner and to incorporate in these some fragments of their real intuition. This effectively has served for neo-realism for some filmmakers in Italy. For this reason, the first endeavour was often to reduce the story to its most elementary, simple, and, I would rather say, banal form. It was the beginning of a speech that was later interrupted. *Bicycle Thieves* provides a typical example. The child follows his father along the street; at one moment, the child is nearly run over, but the father does not even notice. This episode was "invented," but with the intention of communicating an everyday fact about these people's lives, a little fact—so little that the protagonists don't even care about it—but full of life.

In fact *Paisa, Open City, Sciuscià, Bicycle Thieves, La terra trema*, all contain elements of an absolute significance—they reflect the idea that everything can be recounted; but their sense remains metaphorical, because there is still an invented story, not the documentary spirit. In other films, such as *Umberto D.*, reality as an analysed fact is much more evident, but the presentation is still traditional.

We have not yet reached the centre of neorealism. Neorealism today is an army ready to start; and there are the soldiers—behind Rossellini, De Sica, Visconti. The soldiers have to go into the attack and win the battle.

We must recognize that all of us are still only starting, some farther on, others farther behind. But it is still something. The great danger today is to abandon that position, the moral position implicit in the work of many of us during and immediately after the war.

V

A woman is going to buy a pair of shoes. Upon this elementary situation it is possible to build a film. All we have to do is to discover and then show all the elements that go to create this adventure, in all their banal "dailiness," and it will become worthy of attention,

it will even become "spectacular." But it will become spectacular not through its exceptional, but through its *normal* qualities; it will astonish us by showing so many things that happen every day under our eyes, things we have never noticed before.

The result would not be easy to achieve. It would require an intensity of human vision both from the creator of the film and from the audience. The question is: how to give human life its historical importance at every minute.

VI

In life, in reality today, there are no more empty spaces. Between things, facts, people, exists such interdependence that a blow struck for cinema in Rome could have repercussions around the world. If this is true, it must be worthwhile to take any moment of a human life and show how "striking" that moment is: to excavate and identify it, to send its echo vibrating into other parts of the world.

This is as valid for poverty as for peace. For peace, too, the human moment should not be a great one, but an ordinary daily happening. Peace is usually the sum of small happenings, all having the same moral implications at their roots.

It is not only a question, however, of creating a film that makes its audience understand a social or collective situation. People understand themselves better than the social fabric; and to see themselves on the screen, performing their daily actions—remembering that to see oneself gives one the sense of being unlike oneself—like hearing one's own voice on the radio—can help them to fill up a void, a lack of knowledge of reality.

VII

If this love for reality, for human nature directly observed, must still adapt itself to the necessities of the cinema as it is now organised, must yield, suffer and wait, it means that the cinema's capitalist structure still has a tremendous influence over its true function. One can see this in the growing opposition in many places to the fundamental motives of neorealism, the main results of which are a return to so-called "original" subjects, as in the past, and the consequent evasion of reality, and a number of bourgeois accusations against neorealist principles.

The main accusation is: *neorealism only describes poverty.* But neorealism can and must face poverty. We have begun with poverty for the simple reason that it is one of the most vital realities of our time, and I challenge anyone to prove the contrary. To believe, or to pretend to believe, that by making half a dozen films on poverty we have finished with the problem would be a great mistake. As well believe that, if you have to plough up a whole country, you can sit down after the first acre.

The theme of poverty, of rich and poor, is something one can dedicate one's whole life to. We have just begun. We must have the courage to explore all the details. If the rich turn up their noses especially at *Miracolo a Milano*, we can only ask them to be a little

patient. *Miracolo a Milano* is only a fable. There is still much more to say. I put myself among the rich, not only because I have some money (which is only the most apparent and immediate aspect of wealth), but because I am also in a position to create oppression and injustice. That is the moral (or immoral) position of the so-called rich man.

When anyone (he could be the audience, the director, the critic, the State, or the Church) says, "STOP the poverty," i.e. stop the films about poverty, he is committing a moral sin. He is refusing to understand, to learn. And when he refuses to learn, consciously or not, he is evading reality. The evasion springs from lack of courage, from fear. (One should make a film on this subject, showing at what point we begin to evade reality in the face of disquieting facts, at what point we begin to sweeten it.)

If I were not afraid of being thought irreverent, I should say that Christ, had He a camera in His hand, would not shoot fables, however wonderful, but would show us the good ones and the bad ones of this world—in actuality, giving us close-ups of those who make their neighbours' bread too bitter, and of their victims, if the censor allowed it.

To say that we have had "enough" films about poverty suggests that one can measure reality with a chronometer. In fact, it is not simply a question of choosing the theme of poverty, but of going on to explore and analyse the poverty. What one needs is more and more knowledge, precise and simple, of human needs and the motives governing them. Neorealism should ignore the chronometer and go forward for as long as is necessary.

Neorealism, it is also said, *does not offer solutions. The end of a neorealist film is particularly inconclusive.* I cannot accept this at all. With regard to my own work, the characters and situations in films for which I have written the scenario, they remain unresolved from a practical point of view simply because "this is reality." But every moment of the film is, in itself, a continuous answer to some question. It is not the concern of an artist to propound solutions. It is enough, and quite a lot, I should say, to make an audience feel the need, the urgency, for them.

In any case, what films *do* offer solutions? "Solutions" in this sense, if they are offered, are sentimental ones, resulting from the superficial way in which problems have been faced. At least, in my work I leave the solution to the audience.

The fundamental emotion of *Miracolo a Milano* is not one of escape (the flight at the end), but of indignation, a desire for solidarity with certain people, a refusal of it with others. The film's structure is intended to suggest that there is a great gathering of the humble ones against the others. But the humble ones have no tanks, or they would have been ready to defend their land and their huts.

VIII

The true neorealistic cinema is, of course, less expensive than the cinema at present. Its subjects can be expressed cheaply, and it can dispense with capitalist resources on the present scale. The cinema has not yet found its morality, its necessity, its quality, precisely because it costs too much; being so conditioned, it is much less an art than it could be.

The cinema should never turn back. It should accept, unconditionally, what is contemporary. *Today, today, today.*

It must tell reality as if it were a story; there must be no gap between life and what is on the screen. To give an example:

A woman goes to a shop to buy a pair of shoes. The shoes cost 7,000 lire. The woman tries to bargain. The scene lasts, perhaps, two minutes. I must make a two-hour film. What do I do?

I analyse the fact in all its constituent elements, in its "before," in its "after," in its contemporaneity. The fact creates its own fiction, in its own particular sense. The woman is buying the shoes. What is her son doing at the same moment? What are people doing in India that could have some relation to this fact of the shoes? The shoes cost 7,000 lire. How did the woman happen to have 7,000 lire? How hard did she work for them, what do they represent for her? And the bargaining shopkeeper, who is he? What relationship has developed between these two human beings? What do they mean, what interests are they defending, as they bargain? The shopkeeper also has two sons, who eat and speak: do you want to know what they are saying? Here they are, in front of you . . .

The question is, to be able to fathom the real correspondences between facts and their process of birth, to discover what lies beneath them. Thus to analyse "buying a pair of shoes" in such a way opens to us a vast and complex world, rich in importance and values, in its practical, social, economic, psychological motives. Banality disappears because each moment is really charged with responsibility. Every moment is infinitely rich. Banality never really existed.

Excavate, and every little fact is revealed as a mine. If the gold-diggers come at last to dig in the illimitable mine of reality, the cinema will become socially important.

This can also be done, evidently, with invented characters; but if I use living, real characters with which to sound reality, people in whose life I can directly participate, my emotion becomes more effective, morally stronger, more useful. Art must be expressed through a true name and surname, not a false one.

I am bored to death with heroes more or less imaginary. I want to meet the real protagonist of everyday life, I want to see how he is made, if he has a moustache or not, if he is tall or short, I want to see his eyes, and I want to speak to him.

We can look at him on the screen with the same anxiety, the same curiosity as when, in a square, seeing a crowd of people all hurrying up to the same place, we ask, What is happening? What is happening to a real person? Neorealism has perceived that the most irreplaceable experience comes from things happening under our own eyes from natural necessity.

I am against "exceptional" personages. The time has come to tell the audience that they are the true protagonists of life. The result will be a constant appeal to the responsi-

bility and dignity of every human being. Otherwise the frequent habit of identifying oneself with fictional characters will become very dangerous. We must identify ourselves with what we are. The world is composed of millions of people thinking of myths.

X

The term neorealism—in a very Latin sense—implies, too, elimination of technical-professional apparatus, screen-writer included. Handbooks, formulas, grammars, have no more application. There will be no more technical terms. Everybody has his personal shooting-script. Neorealism breaks all the rules, rejects all those canons, which, in fact, exist only to commodify limitations. Reality breaks all the rules, which you can discover if you walk out with a camera to meet it.

The figure of a screen-writer today is, besides, very equivocal. He is usually considered part of the technical apparatus. I am a screen-writer trying to say certain things, and saying them in my own way. It is clear that certain moral and social ideas are at the foundation of my expressive activities, and I can't be satisfied to offer a simple technical contribution. In films which do not touch me directly, also, when I am called in to do a certain amount of work on them, I try to insert as much as possible of my own world, of the moral emergencies within myself.

On the other hand, I don't think the screenplay in itself contains any particular problems; only when subject, screenplay and direction become three distinct phases, as they so often do today, which is abnormal. The screen-writer as such should disappear, and we should arrive at the sole author of a film.

Everything becomes flexible when only one person is making a film, everything continually possible, not only during the shooting, but during the editing, the laying of tracks, the post-synchronization, to the particular moment when we say, "Stop." And it is only then that we put an end to the film.

Of course, it is possible to make films in collaboration, as happens with novels and plays, because there are always numerous bonds of identity between people (for example, millions of men go to war, and are killed for the same reasons), but no work of art exists on which someone has not set the seal of his own interests, of his own poetic world. There is always somebody to make the decisive creative act, there is always one prevailing intelligence, there is always someone who, at a certain moment, "chooses," and says, "This, yes," and "This, no," and then resolves it: reaction shot of the mother crying Help!

Technique and capitalist method, however, have imposed collaboration on the cinema. It is one thing to adapt ourselves to the imposed exigencies of the cinema's present structure, another to imagine that they are indispensable and necessary. It is obvious that when films cost sixpence and everybody can have a camera, the cinema would become a creative medium as flexible and as free as any other.

XI

It is evident that, with neorealism, the actor—as a person fictitiously lending his own flesh to another—has no more right to exist than the "story." In neorealism, as I intend it, everyone must be his own actor.

To want one person to play another implies the calculated plot, the fable, and not "things happening." I attempted such a film with Caterina Rigoglioso; it was called "the lightning film." But unfortunately at the last moment everything broke down. Caterina did not seem to "take" to the cinema. But wasn't she "Caterina"?

Of course, it will be necessary to choose themes excluding actors. I want, for example, to make a report on children in the world. If I am not allowed to make it, I will limit it to Europe, or to Italy alone. But I will make it. Here is an example of the film not needing actors. I hope the actors' union will not protest.

XII

Neorealism does not reject psychological exploration. Psychology is one of the many premises of reality. I face it as I face any other. If I want to write a scene of two men quarrelling, I will not do so at my desk. I must leave my den and find them. I take these men and make them talk in front of me for one hour or for twenty, depending on necessity. My creative method is first to call on them, then to listen to them, "choosing" what they say. But I do all this not with the intention of creating heroes, because I think that a hero is not "certain men" but "every man."

Wanting to give everyone a sense of equality is not levelling him down, but exalting his solidarity. Lack of solidarity is always born from presuming to be different, from a *But:* "Paul is suffering, it's true. I am suffering, too, *but* my suffering has something that . . . my nature has something that . . ." and so on. The *But* must disappear, and we must be able to say: "That man is bearing what I myself should bear in the same circumstances."

XIII

Others have observed that the best dialogue in films is always in dialect. Dialect is nearer to reality. In our literary and spoken language, the synthetic constructions and the words themselves are always a little false. When writing a dialogue, I always think of it in dialect, in that of Rome or my own village. Using dialect, I feel it to be more essential, truer. Then I translate it into Italian, thus maintaining the dialect's syntax. I don't, therefore, write dialogue in dialect, but I am interested in what dialects have in common: immediacy, freshness, verisimilitude.

But I take most of all from nature. I go out into the street, catch words, sentences, discussions. My great aids are memory and the shorthand writer. Afterwards, I do with

the words what I do with the images. I choose, I cut the material I have gathered to give it the right rhythm, to capture the essence, the truth. However great a faith I might have in imagination, in solitude, I have a greater one in reality, in people. I am interested in the drama of things we happen to encounter, not those we plan.

In short, to exercise our own poetic talents on location, we must leave our rooms and go, in body and mind, out to meet other people, to see and understand them. This is a genuine moral necessity for me and, if I lose faith in it, so much the worse for me.

I am quite aware that it is possible to make wonderful films, like Charlie Chaplin's, and they are not neorealistic. I am quite aware that there are Americans, Russians, French-men and others who have made masterpieces that honour humanity, and, of course, they have not wasted film. I wonder, too, how many more great works they will again give us, according to their particular genius, with actors and studios and novels. But Italian film-makers, I think, if they are to sustain and deepen their cause and their style, after having courageously half-opened their doors to reality, must (in the sense I have mentioned) open them wide.

A CERTAIN TENDENCY IN FRENCH CINEMA (France, 1954)

François Truffaut

[First published in French as "Une certaine tendance dans le cinéma français," *Cahiers du cinéma* 31 (1954): 15–29. First published in English in *Cahiers du cinema in English* 1 (1966): 31–41.]

François Truffaut loved American cinema and despised much of what French cinema had become. His "A Certain Tendency in French Cinema" became a foundational document of auteur theory and, indeed, of the French *nouvelle vague*; it was a scorched-earth assault on the *cinéma du qualité* or, more derisively, *la cinéma du papa* that dominated postwar French cinema. This led, in the first instance, to the valoriza-tion of American auteur cinema and, soon thereafter, to a new kind of French cinema, one that was intensely devoted to the history of cinema in all its forms. If Zavattini looked for truth in the real, Truffaut looked for it in Hollywood and in the work of a few key French directors, such as Robert Bresson. Truffaut, Jean-Luc Godard, Claude Chabrol, and Eric Rohmer all began, in strikingly different ways, to make films infused with, but nevertheless undercutting, themes from Hollywood. And this sensibility emerged, in large part, from Truffaut's manifesto. As a filmmaker, Truffaut would often later be criticized for the sentimentality of his films—Godard at the front line of this criticism in the 1970s when Truffaut released *La nuit américaine* (*Day for Night* [France, 1973])—but in his early writings Truffaut was as brutal as Godard would ever become.

These notes have no other object than to attempt to define a certain tendency of the French cinema—a tendency called "psychological realism"—and to sketch its limits.

If the French cinema exists by means of about a hundred films a year, it is well understood that only ten or twelve merit the attention of critics and cinephiles, the attention, therefore of "Cahiers."

These ten or twelve films constitute what has been prettily named the "Tradition of Quality"; they force, by their ambitiousness, the admiration of the foreign press, defend the French flag twice a year at Cannes and at Venice where, since 1946, they regularly carry off medals, golden lions and *grands prix*.

With the advent of "talkies," the French cinema was a frank plagiarism of the American cinema. Under the influence of *Scarface*, we made the amusing *Pépé Le Moko*. Then the French scenario is most clearly obliged to Prévert for its evolution: *Quai des Brumes* remains the masterpiece of poetic realism.

The war and the post-war period renewed our cinema. It evolved under the effect of an internal pressure and for poetic realism—about which one might say that it died closing *Les Portes de la nuit* behind it—was substituted psychological realism, illustrated by Claude Autant-Lara, Jean Dellannoy, René Clement, Yves Allégret and Marcel Pagliero.

SCENARISTS' FILMS

If one is willing to remember that not so long ago Delannoy filmed *Le Bossu* and *La Part de l'ombre*, Claude Autant-Lara *Le Plombier amoureux* and *Lettres d'amour*, Yves Allégret *La boite aux rêves* and *Les demons de l'Aube*, that all these films are justly recognized as strictly commercial enterprises, one will admit that, the successes or failures of these cineastes being a function of the scenarios they chose, *La Symphonie Pastorale, Le Diable au Corps, Jeux Interdits, Manèges, Un homme Marche dans la ville*, are essentially *scenarists' films*.

TODAY NO ONE IS IGNORANT ANY LONGER . . .

After having sounded out directing by making two forgotten shorts, Jean Aurenche became a specialist in adaptation. In 1936, he was credited, with Anouilh, with the dialogue for *Vous n'avez rien a declarer* and *Les De Gourdis de la île*. At the same time Pierre Bost was publishing excellent little novels at the N.R.F. Aurenche and Bost worked together for the first time while adapting and writing dialogue for *Douce*, directed by Claude Autant-Lara.

Today, no one is ignorant any longer of the fact that Aurenche and Bost rehabilitated adaptation by upsetting old preconceptions of being faithful to the letter and substituting for it the contrary idea of being faithful to the spirit—to the point that this audacious aphorism has been written: "An honest adaptation is a betrayal" (Carlo Rim, "Traveling and Sex-Appeal").

In adaptation there exists filmable scenes and unfilmable scenes, and that instead of omitting the latter (as was done not long ago) it is necessary to invent *equivalent* scenes, that is to say, scenes as the novel's author would have written them for the cinema.

"Invention without betrayal" is the watchword Aurenche and Bost like to cite, forgetting that one can also betray by omission.

The system of Aurenche and Bost is so seductive, even in the enunciation of its principles, that nobody even dreamed of verifying its functioning close-at-hand. I propose to do a little of this here.

The entire reputation of Aurenche and Bost is built on two precise points: 1. *Faithfulness* to the spirit of the works they adapt: 2. The talent they use.

THAT FAMOUS FAITHFULNESS . . .

Since 1943 Aurenche and Bost have adapted and written dialogue for: *Douce* by Michel Davet, *La Symphonie Pastorale* by Gide, *Le Diable au corps* by Radiguet, *Un Recteur a l'île De Sein* (*Dieu A Besoin Des Hommes*) by Queffelec, *Les Jeux Inconnus* (*Jeux Interdits*) by Francois Boyer, *Le blé en herbe* by Colette.

In addition, they wrote an adaptation of *Journal d'un Curé de campagne* that was never filmed, a scenario on Jeanne D'Arc of which only one part has been made (by Jean Delannoy) and, lastly, scenario and dialogue for *L'Auberge Rouge* (directed by Claude Autant-Lara).

You will have noticed the profound diversity of inspiration of the works and authors adapted. In order to accomplish this tour de force which consists of remaining faithful to the spirit of Michel Davet, Gide, Radiguet, Queffelec, François Boyer, Colette and Bernanos, one must oneself possess, I imagine, a suppleness of spirit, a habitually geared-down personality as well as singular eclecticism.

You must also consider that Aurenche and Bost are led to collaborate with the most diverse directors: Jean Delannoy, for example, sees himself as a mystical moralist. But the petty meanness of *Garçon Sauvage,* the shabbiness of *La minute de vérité,* the insignificance of *La Route Napoleon* show rather clearly the intermittent character of that vocation.

Claude Autant-Lara, on the contrary, is well known for his non-conformity, his "advanced" ideas, his wild anti-clericalism; let us recognize in this cineaste the virtue of always remaining, in his films, honest with himself.

Pierre Bost being the technician in tandem, the spiritual element in this communal work seems to come from Jean Aurenche.

Educated by the Jesuits, Jean Aurenche has held on to nostalgia and rebellion, both at the same time. His flirtation with surrealism seemed to be out of sympathy for the anarchists of the thirties. This tells how strong his personality is, also how apparently incompatible it was with the personalities of Gide, Bernanos, Queffelec, Radiguet. But an examination of the works will doubtless give us more information.

Abbot Amédée Ayffre knew very well how to analyse *La Symphonie Pastorale* and how to define the relationship between the written work and the filmed work:

"Reduction of Faith to religious psychology in the hands of Gide, now becomes a reduction to psychology, plain and simple . . . with this qualitative abasement we will now have, according to a law well-known to aestheticians, a corresponding quantitative augmentation. New characters are added: Piette and Casteran, charged with representing certain sentiments. Tragedy becomes drama, melodrama." (*Dieu au Cinéma*, p. 131).

WHAT ANNOYS ME . . .

What annoys me about this famous process of equivalence is that I'm not at all certain that a novel contains unfilmable scenes, and even less certain that these scenes, decreed unfilmable, would be so for everyone.

Praising Robert Bresson for his faithfulness to Bernanos, André Bazin ended his excellent article "La Stylistique de Robert Bresson," with these words. "After *The Diary Of A Country Priest*, Aurenche and Bost are no longer anything but the Viollet-Leduc of adaptation."

All those who admire and know Bresson's film well will remember the admirable scene in the confessional when Chantal's face "began to appear little by little, by degrees" (Bernanos).

When, several years before Bresson, Jean Aurenche wrote an adaptation of *Diary*, refused by Bernanos, he judged this scene to be unfilmable and substituted for it the one we reproduce here.

"Do you want me to listen to you here?" He indicates the confessional. "I never confess."

"Nevertheless, you must have confessed yesterday, since you took communion this morning?"

"I didn't take communion." He looks at her, very surprised. "Pardon me, I gave you communion."

Chantal turns rapidly towards the pri-Dieu she had occupied that morning. "Come see."

The curé follows her. Chantal indicates the missal she had left there.

"Look in this book, Sir. Me, I no longer, perhaps, have the right to touch it." The curé, very intrigued, opens the book and discovers, between two pages, the host that Chantal had spit out. His face is stupified and confused.

"I spit out the host," says Chantal.

"I see," says the curé, with a neutral voice.

"You've never seen anything like that, right?" says Chantal, harsh almost triumphant.

"No, never," says the curé, very calmly. "Do you know what must be done?"

The curé closes his eyes for a brief instant. He is thinking or praying, he says, "It is very simple to repair, Miss. But it's very horrible to commit."

He heads for the altar, carrying the open book. Chantal follows him.

"No, it's not horrible. What is horrible is to receive the host in a state of sin."

"You were, then, in a state of sin?"

"Less than the others, but then—it's all the same to them." "Do not judge."
"I do not judge, I condemn," says Chantal with violence. "Silence in front of the body of
 Christ!"
He kneels before the altar, takes the host from the book and swallows it.

In the middle of the book, the curé and an obtuse atheist named Arsène are opposed in a discussion on Faith. This discussion ends with this line by Arsène, "When one is dead, everything is dead." In the adaptation, this discussion takes place on the very tomb of the curé, between Arsène and another curé, and *terminates the film*. This line, "When one is dead, everything is dead," carries, perhaps the only one retained by the public. Bernanos did not say, for conclusion, "When one is dead, everything is dead," but "What does it matter, all is grace."

"Invention without betrayal," you say—it seems to me that it's a question here of little enough invention for a great deal of betrayal. One or two more details. Aurenche and Bost were unable to make *The Diary Of A Country Priest* because Bernanos was alive. Bresson declared that were Bernanos alive he would have taken more liberties. Thus, Aurenche and Bost are annoyed because someone is alive, but Bresson is annoyed because he is dead.

UNMASK

From a simple reading of that extract, there stands out:

1. A constant and deliberate care to be *unfaithful* to the spirit as well as the letter;
2. A very marked taste for profanation and blasphemy.

This unfaithfulness to the spirit also degrades *Le Diable au corps*—a love story that becomes an anti-militaristic, anti-bourgeois film, *La Symphonie Pastorale*—a love story about an amorous pastor—turns Gide into a Beatrix Beck, *Un Recteur a l'ile de Sein* whose title is swapped for the equivocal one of *Dieu a besoin des hommes* in which the islanders are shown like the famous "cretins" in Bunuel's *Land Without Bread*.

As for the taste for blasphemy, it is constantly manifested in a more or less insidious manner, depending on the subject, the metteur-en-scène nay, even the star.

I recall from memory the confessional scene from *Douce*, Marthe's funeral in *Le Diable*, the profaned hosts in that adaptation of *Diary* (scene carries over to *Dieu a besoin des hommes*), the whole scenario and the character played by Fernandel in *L'Auberge Rouge*, the scenario in toto of *Jeux Interdits* (joking in the cemetery).

Thus, everything indicates that Aurenche and Bost are the authors of frankly anti-clerical films, but, since films about the cloth are fashionable, our authors have allowed themselves to fall in with that style. But as it suits them—they think—not to betray their convictions, the theme of profanation and blasphemy, dialogues with double meanings, turn up here and there to prove to the guys that they know the art of "cheating the

producer," all the while giving him satisfaction, as well as that of cheating the "great public," which is equally satisfied.

This process well deserves the name of "alibi-ism"; it is excusable and its use is necessary during a time when one must ceaselessly feign stupidity in order to work intelligently, but if it's all in the game to "cheat the producer," isn't it a bit scandalous to re-write Gide, Bernanos and Radiguet?

In truth, Aurenche and Bost work like all the scenarists in the world, like pre-war Spaak and Natanson.

To their way of thinking, every story includes characters A, B, C, and D. In the interior of that equation, everything is organized in function of criteria known to them alone. The sun rises and sets like clockwork, characters disappear, others are invented, the script deviates little by little from the original and becomes a whole, formless but brilliant: a new film, step by step makes its solemn entrance into the "Tradition of Quality."

SO BE IT, THEY WILL TELL ME . . .

They will tell me, "Let us admit that Aurenche and Bost are unfaithful, but do you also deny the existence of their talent . . . ?" Talent, to be sure, is not a function of fidelity, but I consider an adaptation of value only when written by a *man of the cinema*. Aurenche and Bost are essentially literary men and I reproach them here for being contemptuous of the cinema by underestimating it. They behave, vis-à-vis the scenario, as if they thought to reeducate a delinquent by finding him a job; they always believe they've "done the maximum" for it by embellishing it with subtleties, out of that science of nuances that make up the slender merit of modern novels. It is, moreover, only the smallest caprice on the part of the exegetists of our art that they believe to honor the cinema by using literary jargon. (Haven't Sartre and Camus been talked about for Pagliero's work, and phenomenology for Allegret's?)

The truth is, Aurenche and Bost have made the works they adapt insipid, for *equivalence* is always with us, whether in the form of treason or timidity. Here is a brief example: in *Le Diable au corps,* as Radiguet wrote it, François meets Marthe on a train platform with Marthe jumping from the train while it is still moving; in the film, they meet in the school which has been transformed into a hospital. What is the point of this *equivalence?* It's a decoy for the anti-militarist elements added to the work, in concert with Claude Autant-Lara.

Well, it is evident that Radiguet's idea was one of mise-en-scène, whereas the scene invented by Aurenche and Bost is literary. One could, believe me, multiply these examples infinitely.

ONE OF THESE DAYS . . .

Secrets are only kept for a time, formulas are divulged, new scientific knowledge is the object of communications to the Academy of Sciences and since, if we will believe

Aurenche and Bost, adaptation is an exact science, one of these days they really could apprise us in the name of what criterion, by virtue of what system, by what mysterious and internal geometry of the work, they abridge, add, multiply, devise and "rectify" these masterpieces.

Now that this idea is uttered, the idea that these equivalences are only timid astuteness to the end of getting around the difficulty, of resolving on the soundtrack problems that concern the image, plundering in order to no longer obtain anything on the screen but scholarly framing, complicated lighting-effects, "polished" photography, the whole keeping the "Tradition of Quality" quite alive—it is time to come to an examination of the ensemble of these films adapted, with dialogue, by Aurenche and Bost, and to research the permanent nature of certain themes that will explain, without justifying, the constant *unfaithfulness* of two scenarists to works taken by them as "pretext" and "occasion."

In a two line resume, here is the way scenarios treated by Aurenche and Bost appear:

La Symphonie Pastorale: He is a pastor, he is married. He loves and has no right to.

Le Diable au corps: They make the gestures of love and have no right to. *Dieu a besoin des hommes:* He officiates, gives benedictions, gives extreme unction and has no right to.

Jeux Interdits: They bury the dead and have no right to.

Le Blé en herbe: They love each other and have no right to.

You will say to me that the book also tells the same story, which I do not deny. Only, I notice that Gide also wrote *La Porte Etroite,* Radiguet *La Bal Du Comte d'Orgel,* Colette *La Vagabonde* and that each one of these novels did not tempt Delannoy or Autant-Lara.

Let us notice also that these scenarios, about which I don't believe it useful to speak here, fit into the sense of my thesis: *Au-Delà Des Grilles, Le Château De Verre, L'Auberge Rouge* . . .

One sees how competent the promoters of the "Tradition of Quality" are in choosing only subjects that favour the misunderstandings on which the whole system rests.

Under the cover of literature—and, of course, of quality—they give the public its habitual dose of smut, non-conformity and facile audacity.

THE INFLUENCE OF AURENCHE AND BOST IS IMMENSE . . .

The writers who have come to do film dialogue have observed the same imperatives; Anouilh, between the dialogues for *Dé Gourdis de la Ile* and *Un Caprice De Caroline Cherie* introduced into more ambitious films his universe with its affection of the bizarre with a background of Nordic mists transposed to Brittany (Pattes Blanches). Another writer Jean Ferry, made sacrifices for fashion, he too, and the dialogue for *Manon* could just as well have been signed by Aurenche and Bost: "He believed me a virgin and, in private life, he is a professor of psychology!" Nothing better to hope for from the young scenarists. They simply work their shift, taking good care not to break any taboos.

Jacques Sigurd, one of the last to come to "scenario and dialogue," teamed up with Yves Allégret. Together, they bequeathed the French cinema some of its blackest masterpieces: *Dêdée D'Anvers, Manèges, Une Si Jolie Petite Plage, Les Miracles N'Ont Lieu Qu une Fois, La Jeune Folle*. Jacques Sigurd very quickly assimilated the recipe; he must be endowed with an admirable spirit of synthesis, for his scenarios oscillate ingeniously between Aurenche and Bost, Prévert and Clouzot, the whole lightly modernized. Religion is never involved, but blasphemy always makes its timid entrance thanks to several daughters of Mary or several good sisters who make their way across the field of vision at the moment when their presence would be least expected (*Manèges, Une Si Jolie Petite Plage*).

The cruelty by which they aspire to "rouse the trembling of the bourgeois" finds its place in well-expressed lines like: "he was old, he could drop dead" (*Manèges*). In *Une Si Jolie Petite Plage*, Jane Marken envies Berck's prosperity because of the tubercular cases found there: *Their family comes to see them and that makes business good!* (One dreams of the prayer of the rector of Sein Island.)

Roland Laudenbach, who would seem to be more endowed than most of his colleagues, has collaborated on films that are most typical of that spirit: *La minute de vérité, Le bon Dieu sans confession, La Maison du silence*.

Robert Scipion is a talented man of letters. He has only written one book; a book of pastiches. Singular badges: the daily frequenting of the Saint-Germain-des-Près cafes, the friendship of Marcel Pagliero who is called the Sartre of the cinema, probably because his films resemble the articles in "Temps Modernes." Here are several lines from *Amants De Brasmort*, a populist film in which sailors are "heroes," like the dockers were in *Un Homme Marche dans la ville*:

"The wives of friends are made to sleep with."

"You do what agrees with you; as for that, you'd mount anybody, you might well say." In one single reel of the film, towards the end, you can hear in less than ten minutes such words as *prostitute, whore, slut* and *bitchiness*. Is this realism?

PRÉVERT IS TO BE REGRETTED . . .

Considering the uniformity and equal filthiness of today's scenarios, one takes to regretting Prévert's scenarios. He believed in the Devil, thus in God, and if, for the most part, his characters were by his whim alone charged with all the sins in creation, there was always a couple, the new Adam and Eve, who could end the film, so that the story could begin again.

PSYCHOLOGICAL REALISM, NEITHER REAL NOR PSYCHOLOGICAL . . .

There are scarcely more than seven or eight scenarists working regularly for the French cinema. Each one of these scenarists has but one story to tell, and, since each only aspires

to the success of the "two greats," it is not exaggerating to say that the hundred-odd French films made each year tell the same story: it's always a question of a victim, generally a cuckold. (The cuckold would be the only sympathetic character in the film if he weren't always infinitely grotesque: Blier-Vilbert, etc. . . .) The knavery of his kin and the hatred among the members of his family lead the "hero" to his doom; the injustice of life, and for local color, the wickedness of the world (the cures, the concierges, the neighbours, the passers-by, the rich, the poor, the soldiers, etc. . . .).

For distraction, during the long winter nights, look for titles of French films that do not fit into this framework and, while you're at it, find among these films those in which this line or its equivalent does not figure, spoken by the most abject couple in the film: "It's always they that have the money (or the luck, or love, or happiness). It's too unjust, in the end."

This school which aspires to realism destroys it at the moment of finally grabbing it, so careful is the school to lock these beings in a closed world, barricaded by formulas, plays on words, maxims, instead of letting us see them for ourselves, with our own eyes. The artist cannot always dominate his work. He must be, sometimes, God and, sometimes, his creature.

You know that modern play in which the principal character, normally constituted when the curtain rises on him, finds himself crippled at the end of the play, the loss of each of his members punctuating the changes of acts. Curious epoch when the least flash-in-the-pan performer uses Kafkaesque words to qualify his domestic avatars. This form of cinema comes straight from modern literature—half Kafka, half Bovary!

A film is no longer made in France that the authors do not believe they are re-making *Madame Bovary.*

For the first time in French literature, an author adopted a distant, exterior attitude in relation to his subject, the subject becoming like an insect under the entomologist's microscope. But if, when starting this enterprise, Flaubert could have said, "I will roll them all in the same mud—and be right" (which today's authors would voluntarily make their exergue), he could declare afterwards "I am Madame Bovary" and I doubt that the same authors could take up that line and be sincere!

MISE-EN-SCÈNE, METTEUR-EN-SCÈNE, TEXTS

The object of these notes is limited to an examination of a certain form of cinema, from the point of view of the scenarios and scenarists only. But it is appropriate, I think, to make it clear that the *metteurs-en-scène* are and wish to be responsible for the scenarios and dialogues they illustrate.

Scenarists' films, I wrote above, and certainly it isn't Aurenche and Bost who will contradict me. When they hand in their scenario, the film is done; the *metteur-en-scène,* in their eyes, is the gentleman who adds the pictures to it and it's true, alas! I spoke of the mania for adding funerals everywhere. And, for all that, death is always juggled away. Let us remember Nana's admirable death, or that of Emma Bovary, presented by Renoir; in

La Pastorale, death is only a make-up job and an exercise for the camera man: compare the close-ups of Michèle Morgan in *La Pastorale,* Dominique Blanchar in *Le Secret De Mayerling* and Madeleine Sologne in *L'eternel Retour:* it's the same face! Everything happens after death.

Let us cite, lastly, that declaration by Delannoy that we dedicate, with perfidy, to the French scenarists: "When it happens that authors of talent, whether in the spirit of gain or out of weakness, one day let themselves go to 'write for the cinema,' they do it with the feeling of lowering themselves. They deliver themselves rather to a curious temptation towards mediocrity, so careful are they to not compromise their talent and certain that, to write for the cinema, one must make oneself understood by the lowliest" ("*La Symphonie Pastorale ou* L'Amour Du Métier," review Verger, November 1947).

I must, without further ado, denounce a sophism that will not fail to be thrown at me in the guise of argument: "His dialogue is spoken by abject people and it is in order to better point out their nastiness that we give them this hard language. It is our way of being moralists."

To which I answer: it is inexact to say that these lines are spoken by the most abject characters. To be sure, in the films of "psychological realism" there are nothing but vile beings, but so inordinate is the authors' desire to be superior to their characters that those who, perchance, are not infamous are, at best, infinitely grotesque.

Well, as for these abject characters, who deliver these abject lines—I know a handful of men in France who would be INCAPABLE of conceiving them, several cinéastes whose world-view is at least as valuable as that of Aurenche and Bost, Sigurd and Jeanson. I mean Jean Renoir, Robert Bresson, Jean Cocteau, Jacques Becker, Abel Gance, Max Ophuls, Jacques Tati, Roger Leenhardt; these are, nevertheless, French cinéastes and it happens—curious coincidence—that they are *auteurs* who often write their dialogue and some of them themselves invent the stories they direct.

THEY WILL STILL SAY TO ME . . .

"But why," they will say to me, "why couldn't one have the same admiration for all those cinéastes who strive to work in the bosom of this "Tradition of Quality" that you make sport of so lightly? Why not admire Yves Allégret as much as Becker, Jean Delannoy as much as Bresson, Claude Autant-Lara as much as Renoir?" ("Taste is made of a thousand distastes"—Paul Valéry).

Well—I do not believe in the peaceful co-existence of the "Tradition of Quality" and an "auteur's cinema."

Basically, Yves Allégret and Delannoy are only caricatures of Clouzot, of Bresson. It is not the desire to create a scandal that leads me to depreciate a cinema so praised elsewhere. I rest convinced that the exaggeratedly prolonged existence of psychological realism is the cause of the lack of public comprehension when faced with such new works as *Le Carrosse d'or, Casque d'or,* not to mention *Les Dames du Bois de Boulogne* and *Orphée.*

Long live audacity, to be sure; still it must be revealed as it is. In terms of this year, 1953, if I had to draw up a balance-sheet of the French cinema's audacities, there would be no place in it for either the vomiting in *Les Orgueilleux* or Claude Laydu's refusal to be sprinkled with holy water in *Le Bon Dieu Sans Confession* or the homosexual relationships of the characters in *Le Salaire de la Peur*, but rather the gait of *Hulot*, the maid's soliloquies in *La rue de L'Estrapade*, the *mise-en-scène* of *La Carrosse d'or*, the direction of the actors in *Madame de O*, and also Abel Gance's studies in Polyvision. You will have understood that these audacities are those of *men of the cinema* and no longer of scenarists, directors and literateurs.

For example, I take it as significant that the most brilliant scenarists and *metteurs-en-scène* of the "Tradition of Quality" have met with failure when they approach comedy: Ferry-Clouzot *Miguette et sa Mère*, Sigurd-Boyer *Tous les chemins mènent a Rome*, Scipion-Pagliero *La Rose Rouge*, Laudenbach-Delannoy *La Route Napoléon*, Auranche-Bost-Autant-Lara *L'Auberge Rouge* or, if you like, *Occupe-toi d'Amelie*.

Whoever has tried, one day, to write a scenario wouldn't be able to deny that comedy is by far the most difficult genre, the one that demands the most work, the most talent, also the most humility.

ALL BOURGEOIS . . .

The dominant trait of psychological realism is its anti-bourgeois will. But what are Aurenche and Bost, Sigurd, Jeanson, Autant-Lara, Allégret, if not bourgeois, and what are the fifty thousand new readers, who do not fail to see each film from a novel, if not bourgeois?

What then is the value of an anti-bourgeois cinema made by the bourgeois for the bourgeois? Workers, you know very well, do not appreciate this form of cinema at all even when it aims at relating to them. They refused to recognize themselves in the dockers of *Un Homme Marche Dans La Ville*, or in the sailors of *Les Amants De Brasmort*. Perhaps it is necessary to send the children out on the stairway landing in order to make love, but their parents don't like to hear it said, above all at the cinema, even with "benevolence." If the public likes to mix with low company under the alibi of literature, it also likes to do it under the alibi of society. It is instructive to consider the programming of films in Paris, by neighbourhoods. One comes to realize that the public-at-large perhaps prefers little naive foreign films that show it men "as they should be" and not in the way that Aurenche and Bost believe them to be.

LIKE GIVING ONESELF A GOOD ADDRESS . . .

It is always good to conclude, that gives everyone pleasure. It is remarkable that the "great" *metteurs-en-scène* and the "great" scenarists have, for a long time, all made minor films, and the talent they have put into them hasn't been sufficient to enable one to distinguish them from others (those who don't put in talent). It is also remarkable that they all came

to "Quality" at the same time, as if they were giving themselves a good address. And then, a producer—even a director—earns more money making *Le blé en herbe* than by making *Le Plombier Amoureux*. The "courageous" films are revealed to be very profitable. The proof: someone like Ralph Habib abruptly renounces demi-pornography, makes *Les Compagnes De La Nuit* and refers to Cayatte. Well, what's keeping the André Tabets, Companeer, the Jean Guittons, the Pierre Vérys, the Jean Lavirons, the Ciampis, the Grangiers, from making, from one day to the next, intellectual films, from adapting masterpieces (there are still a few left) and, of course, adding funerals, here, there and everywhere?

Well, on that day we will be in the "Tradition of Quality" up to the neck and the French cinema, with rivalry among "psychological realism," "violence," "strictness," "ambiguity," will no longer be anything but one vast funeral that will be able to leave the studio in Billancourt and enter the cemetery directly—it seems to have been placed next door expressly in order to get more quickly from the producer to the grave-digger.

Only, by dint of repeating to the public that it identified with the "heroes" of the films, it might well end by believing it, and on the day that it understands that this fine big cuckold whose misadventures it is solicited to sympathize with (a little) and to laugh at (a lot), is not, as had been thought, a cousin or neighbour down the hall but ITSELF, that abject family ITS family, that scoffed-at religion ITS religion—well, on that day it may show itself to be ungrateful to a cinema that will have labored so hard to show it life as one sees it on the fourth floor in Saint-Germain-des-Près.

To be sure, I must recognize it, a great deal of emotion and taking-sides are the controlling factors in the deliberately pessimistic examination I have undertaken of a certain tendency of the French cinema. I am assured that this famous "school of psychological realism" had to exist in order that, in turn, *The Diary of a Country Priest, La Carrosse d'or, Orpheus, Casque d'or, Mr. Hulot's Holiday* might exist.

But our authors who wanted to educate the public should understand that perhaps they have strayed from the primary paths in order to become involved with the more subtle paths of psychology; they have passed on to that sixth grade so dear to Jouhandeau, but it isn't necessary to repeat a grade indefinitely!

SALAMANCA MANIFESTO & CONCLUSIONS OF THE CONGRESS OF SALAMANCA (Spain, 1955)

Juan Antonio Bardem

[First published in Spanish in *Objetivo* (Spain) 6 (1955). First published in English in Vincent Molina-Foix, *New Cinema in Spain* (London: BFI, 1977), 11, 45–47. Trans. Vincent Molina-Foix]

The Salamanca conference came together through the work of a group of writers from the leftist film journal *Objetivo*, who were greatly influenced by neorealism. The conference outlined the problems with Spanish cinema and endeavored to offer a way forward for filmmakers working under a repressive regime. Below is an excerpt from the manifesto proper and the conclusions of the Congress. As a consequence of this conference, the Francoist state shut down *Objetivo*.

SALAMANCA MANIFESTO

Spanish cinema lives in isolation. Isolated not only from the world but from our own reality . . . Spanish cinema is still a cinema of painted dolls. The problem with Spanish cinema is that it has no problems, that it is not that witness of our time which our time requires of every human creation. . . . Our purpose must be to give content to this uninhabited body of Spanish cinema, a content which must be inspired by our general traditions (painting, theatre, fiction). This is plainly a program for Spanish cinema! It will enable it to save its soul, which is today on sale to any poor devil. Our mission is not easy. Centuries of feat have preceded "novelty." But "novelty" must now mean raising the cinema to the level of what a Ribera and a Goya, a Quevedo and a Mateo Alemán, created in their day. And to make it "new" with respect to the problems of today, which are themselves new.

CONCLUSIONS OF THE CONGRESS OF SALAMANCA

I. SURVEY OF THE PRESENT STATE OF OUR CINEMA.

The present Spanish cinema is:

1. Politically futile
2. Socially false
3. Intellectually worthless
4. Aesthetically valueless
5. Industrially paralytic

II. THE CONTENT OF OUR CINEMA.

Gathered in Salamanca and in the University of that city for the First National Film Congress "we believe that our cinema should acquire a national character, producing films reflecting the social condition of the Spaniard, his conflicts and his reality" in the past and, above all, in our time.

III. THE OBSTACLES CONFRONTING OUR CINEMA.

1. The state must formulate and apply a policy corresponding *to* its true principles and not to those which have been applied to the cinema hitherto. It must provide a stimulus for a cinema which serves these principles and which is aesthetically valid.

2. Economic aid for the Spanish cinema must be concentrated on films of artistic quality and national interest.

3. Greater juridical authority must be used to determine clearly the subjects to be prohibited. Sufficient broadness of mind must be retained to enable Spanish cinema to deal with important topics. This Code will be applied to all films, whatever their provenance, shown on national territory and in the colonies. Representatives of the professional film industry must participate both in drawing up and in applying this Code.

 The decrees of the precensor must be restricted to the field concerned, while those of the actual censor must be definite, excluding the possibility of subsequent interventions by any organ or organisation.

 There must be a legal system of appeal against the dispositions of the censor. . . .

V. ECONOMIC PROBLEMS.

1. Spanish cinema requires the economic protection of the state.

2. The present system of protection has not fulfilled its purpose, as is proved by its failure to produce a stable film industry.

 [. . .]

5. Financial credits preceding production must preferably be given to new producers, with sufficient guarantees, and must not be restricted to those who have already made a film. They must not be given to producers who possess, or who should possess, a consolidated industrial framework.

6. Financial aid to films already made must depend on the quality of these films, to be judged by a constituted assembly. Through the number of members of this Assembly and their frequent variation, all possibility of pressure or arbitrary judgment must be avoided. The said aid must be limited to a part of the cost of the film.

 [. . .]

8. The distribution of national films must be ensured by obliging distributors to take them on according to percentages established by the needs of the moment.

9. The state must encourage the creation, and contribute to the functioning, of some organisation devoted to the distribution of Spanish films abroad.

10. As an additional means of protection, the taxes on cinemas must be reduced or abolished for the showing of national films in view of the fact that the cinema is an art more than an industry and that there is no reason to refuse *to* the cinema a privilege enjoyed by the dramatic theatre.

11. Dubbing must be progressively restricted by the reduction of the corresponding permits in such a way as to familiarise the public with the system.

12. 16mm films must be encouraged so as to expand our home market.

13. Co-productions must be scrupulously controlled so as to ensure the expansion of our market and a reasonable participation of our film industry.

14. A radical distinction must be made between purely commercial cinema and a cinema which, owing to its artistic qualities or its religious, national or social values, deserves special protection, although this protection should be extended to certain commercial films with artistic merits.

VI. THE REQUIREMENTS OF CRITICISM.

1. We need an honest and free system of criticism which takes into account the basic ethical, aesthetic and social principles regulating the art of the cinema in our time.

2. We propose that the editors of Spanish publications should select as critics intelligent, honourable men acquainted with the aforesaid principles.

3. We request the Under-Secretary for the Press to guarantee the dignity of the critical function of the Press, and to prevent with the utmost rigour any confusion between criticism and publicity. We demand that the Law of the Press at present under examination clearly adopt this distinction.

4. In order to guarantee the realisation of these requests and the integrity of criticism, we propose the creation of an independent Association of Film Critics which would have, among others, the following objects:

 (a) The defence of the Spanish cinema.

 (b) The corporate defence of Spanish critics. The Association will make sure that no critic is subjected to any form of coercion and reprisal in the honest and free performance of his duties.

 (c) The guarantee of freedom of expression for critics.

 (d) The securement of professional training and information obtainable through the Institute de Investigaciones y Experimentaciones Cinematograficas [Institute of Film Research and Experimental Cinema], the School of Journalism, special lecture courses or any other means. The appointment of persons intended to work as critics may then be made with these educational criteria in mind. We therefore propose also that the Under Secretary for the Press make of film criticism a recognised journalistic specialisation.

(e) Finally the safeguard of professional ethics to guarantee at all times the noble execution of our mission and to prevent even ourselves from turning criticism into a personal instrument for our own benefit. [...]

IX. DOCUMENTARY CINEMA.

1. Our documentary cinema must acquire a national character, creating films which fulfil a social purpose and reflect the social condition of the Spaniard, his ideas, his conflicts and his reality in our time.

2. We request the abrogation of the present legislation which accords the monopoly of newsreels to the organisation "Noticiarios y documentales NO-DO," and of the legislation which makes it obligatory to show these films. We demand the establishment of a system of free competition duly guaranteed and by which the state will ensure the liberty to include a percentage of news items of general interest to the nation.

3. We request the exclusion of the organisation "NO-DO" from all transactions preceding the permit now authorising the making of documentaries and short films and from all boards responsible for classification and the award of prizes.

4. Documentaries and short films must enjoy the following privileges:
 (a) The compulsory showing of a Spanish documentary in every programme composed of one or two feature films.
 (b) This showing is to be independent from the showing of newsreels.
 (c) By Spanish documentaries we mean documentaries made entirely by teams of Spanish technicians.
 (d) The extension to documentaries and short films of all those privileges granted to feature films and which have not been included in the above paragraphs.

X. THE CONTRIBUTION OF OUR INTELLECTUALS.

Spanish universities must participate in the activity of our cinema and should produce a significant number of contributors.

With this in mind, and until the day when this art is duly incorporated in the university faculties, we propose:

1. The creation of a professorship of film history at the University of Salamanca and the oganisation of lectures by the most qualified Spanish and foreign personalities.

2. That the Spanish universities should protect more effectively the cinematographic activities of the students, such as film clubs, and above all that they should organise lecture courses on the cinema.

3. The examination of the possibility that our universities should create artistic, scientific and experimental films on their own.

4. That the Sindicato Español Universitario [Spanish Union of Students] should provide a sufficient number of grants to facilitate the professional education in the main Centres in Spain and abroad of those university students who have given some proof of their vocation for the cinema and their capacity in this, the art of our time.

FREE CINEMA MANIFESTOS (UK, 1956–1959)

Committee for Free Cinema

[First distributed at Free Cinema screenings at the National Film Theatre, London, on 5 February 1956, 25–29 May 1957, and 18–22 March 1959.]

Free Cinema was a series of six screenings organized by Lindsay Anderson, Karel Reisz, Tony Richardson, and Lorenza Mazzetti at the National Film Theatre in London. Emerging shortly after the Festival of Britain in 1951 and at the same time as the "Angry Young Men" plays of John Osborne and novels of Kingsley Amis, the screenings, three of which featured UK work (the other three showing international shorts by François Truffaut, Norman McLaren, and Roman Polanski, among others) spotlighted working-class culture in the United Kingdom and a new form of documentary cinema in Britain. The manifestos from the UK screenings are provided here. Free Cinema also championed a DIY aesthetic at odds with Hollywood and British feature films and the tradition of the Griersonian documentary, turning instead to UK documentary iconoclast Humphrey Jennings for inspiration.

STATEMENT (1956)

Lorenza Mazzetti, Lindsay Anderson, Karel Reisz, and Tony Richardson

These films were not made together; nor with the idea of showing them together. But when they came together, we felt they had an attitude in common. Implicit in this attitude is a belief in freedom, in the importance of people and in the significance of the everyday.

As filmmakers we believe that
No film can be too personal.
The image speaks. Sound amplifies and comments. Size is irrelevant.
Perfection is not an aim.
An attitude means a style. A style means an attitude.

LOOK AT BRITAIN! FREE CINEMA 3 (1957)

The Committee for Free Cinema

This program is not put before you as an achievement, but as an aim. We ask you to view it not as critics, nor as a diversion, but in direct relation to a British cinema still obstinately class-bound; still rejecting the stimulus of contemporary life, as well as the responsibility to criticize; still reflecting a metropolitan, Southern English culture, which excludes the rich diversity of tradition and personality which is the whole of Britain.

With a 16mm camera, and minimal resources, and no payment for your technicians, you cannot achieve very much in commercial terms. You cannot make a feature film, and your possibilities of experiment are severely restricted. But you can use your eyes and ears. You can give indications. You can make poetry.

The poetry of this program is made out of our feelings about Britain, the nation of which we are all a part. Of course these feelings are mixed. There are things to make us sad, and angry; things we must change. But feelings of pride and love are fundamental, and only change inspired by such feelings will be effective.

"We have the Welfare State and the domestic upheavals of the Huggetts . . . Bleak, isn't it . . ." So someone wrote in a letter to the *Observer*, "explaining" why vital art is no longer possible in this country. This kind of snobbish, self-derisive, pseudo-liberalism is the most pernicious and sapping enemy of faith. We stand against it.

To work on 16mm film, is of course not enough—though there is room for far more enterprise in this field from young film makers with something to say. We feel, therefore, the sponsorship of *Every Day Except Christmas* by the Ford Motor Company is something of particular importance. We are grateful to Fords [sic] for their enterprising policy which made this film possible; and for letting us show it in this program. We hope other sponsors, and other film makers will follow the lead. First to look at Britain, with honesty and with affection. To relish its eccentricities; attack its abuses; love its people. To use the cinema to express our allegiances, our rejections and our aspirations. This is our commitment.

FREE CINEMA 6: THE LAST FREE CINEMA (1959)

Lindsay Anderson, John Fletcher, Walter Lassally, and Karel Reisz

It is just over three years since we presented our first FREE CINEMA program at the National Film Theatre—as a Challenge to Orthodoxy. It made something of a stir. We were called "White Hopes" . . . "Rebels" . . . "A serious venture of enormous promise. . . ." Audiences were large and enthusiastic. And, largely as a result of this favorable response, the thing became a movement. Now it is the sixth of these programs. It is also the last. We have decided that this movement, under this name, has served its purpose. So this is the last FREE CINEMA.

Some will be glad. Others may regret. Ourselves, we feel something of each emotion. The strain of making film in this way, outside the system, is enormous, and cannot be supported indefinitely. It is not just a question of finding the money. Each time, when the films have been made, there is the same battle to be fought, for the right to show our work. As the madman said as he hit his head against the brick wall—"It's nice when you stop . . ."

But our feeling is not one of defeat. We have had our victories. FREE CINEMA films have won awards for Britain at Cannes (*Together*, 1956), and Venice (*Nice Time*, special mention; *Every Day Except Christmas*, Grand Prix 1957) and America (*O Dreamland*, First Prize Cleveland Experimental Festival 1957). The programs have been shown, and acclaimed, in Paris and New York; in Italy, Finland, Denmark and Japan; in Moscow and Hampstead. What started, in fact, as a single program of films has grown into a movement that already has its place in the history books of the cinema. It remains only for us to thank the Experimental Fund of the British Film Institute for their assistance throughout the venture; Leon Clore of Graphic Films for his unfailing support and help with facilities; and the Ford Motor Company, whose sponsorship of *Every Day Except Christmas* and *We Are the Lambeth Boys*, we feel to be among the most enlightened and imaginative acts of patronage in the records of British documentary.

In making these films, and presenting these programs, we have tried to make a stand for independent, creative film-making in a world where the pressures of conformism and commercialism are becoming more powerful every day. We will not abandon those convictions, nor attempt to put them into practice. But we feel that this movement, under this particular banner, has one [*sic*] its job. Another year, and FREE CINEMA itself might be just another pigeon-hole. We prefer to end in full career.

And the situation itself is changing. Superficially it may seem for the worse—how many cinemas have closed in the last three years—and how many today are scheduled for transformation into dance halls or skittle alleys? But we do not believe that this is the end of the cinema, we prefer to regard it as the death agony of a bad system. And the sooner it dies, the better. Already there are signs of a healthier atmosphere in British features. *Room at the Top* is a beginning; and *Look Back in Anger* is to come. (And there is some significance in the fact that Tony Richardson, the young director of *Look Back in Anger*, was a contributor to the first FREE CINEMA program, as codirector with Karel Reisz of *Momma Don't Allow*).

Even British documentary is beginning to stir. A voluntary Social Documentary group has formed with the A.C.T. and has already started work. A film like *March to Aldermaston* shows a revival of courage, initiative and vitality among young technicians. This last FREE CINEMA show includes the first work of two new outlaw directors, Elizabeth Russell and Robert Vas and a whole group of new technicians involved for the first time in this sort of venture—Louis Wolfers, Allan Forbes, Michael Tuchner, Jack Gold, Robert Allen.

And most significant of all, we feel, is the birth of UNIT FIVE SEVEN, the group of young Granada Television technicians in Manchester, whose fine first production, *Enginemen,* we are happy to be able to present in this program. With twelve members, mostly under 25, this group already has half a dozen projects under way; the accent is independent, poetic, social and humane. We believe that UNIT FIVE SEVEN will also grow into something important. We greet them with heartfelt thanks.

FREE CINEMA is dead, long live FREE CINEMA!

THE OBERHAUSEN MANIFESTO
(West Germany, 1962)

Alexander Kluge, Edgar Reitz, Bodo Blüthner, Boris von Borresholm, Christian Doermer, Bernhard Dörries, Heinz Furchner, Rob Houwer, Ferdinand Khittl, Pitt Koch, Walter Krüttner, Dieter Lemmel, Hans Loeper, Ronald Martini, Hansjürgen Pohland, Raimond Ruehl, Peter Schamoni, Detten Schleiermacher, Fritz Schwennicke, Haro Senft, Franz-Josef Spieker, Hans Rolf Strobel, Heinz Tichawsky, Wolfgang Urchs, Herbert Vesely, and Wolf Wirth

[First distributed in German as "Oberhausener Manifest" at the 8th Oberhausen Short Film Festival, 28 February 1962. Published in English in Eric Rentschler, ed., *West German Filmmakers on Film: Visions and Voices* (New York: Holmes and Meier, 1988), 2. Trans. Eric Rentschler.]

A central precursor to what would shortly become Young German Cinema and New German Cinema, the "Oberhausen manifesto" was, like Truffaut's "A Certain Tendency in French Cinema," a repudiation of the old ways of making film and an argument for experimentation and risk-taking using the short film as a Petri dish for developing new forms of feature films in West Germany. The "Oberhausen manifesto" haunted German cinema in the 1960s, 1970s, and 1980s, as evidenced by the number of times the manifesto is referenced and debated in subsequent documents, such as the untitled Oberhausen manifesto of 1965, "The Mannheim Manifesto" and the "Hamburg Declaration."

The collapse of the conventional German film finally removes the economic basis for a mode of filmmaking whose attitude and practice we reject. With it the new film has a chance to come to life.

German short films by young authors, directors, and producers have in recent years received a large number of prizes at international festivals and gained the recognition of international critics. These works and these successes show that the future of the German film lies in the hands of those who have proven that they speak a new film language.

Just as in other countries, the short film has become in Germany a school and experimental basis for the feature film.

We declare our intention to create the new German feature film.

This new film needs new freedoms. Freedom from the conventions of the established industry. Freedom from the outside influence of commercial partners. Freedom from the control of special interest groups.

We have concrete intellectual, formal, and economic conceptions about the production of the new German film. We are as a collective prepared to take economic risks.

The old film is dead. We believe in the new one.

UNTITLED [OBERHAUSEN 1965]
(West Germany, 1965)

Jean-Marie Straub, Rodolf Thome, Dirk Alvermann, Klaus Lemke, Peter Nestler, Reinald Schnell, Dieter Süverkrüp, Kurt Ulrich, Max Zihlmann

[First released as a pamphlet at the Oberhausen Film Festival in February 1965. First published in Ralph Eue and Lars Henrik Gass, eds. *Provokation der Wirlichkeit: Das Oberhauser Manifest und die Folgen* (Munich: edition text + kritik, 2012), 80. Trans. Paul Kelley.]

This second, untitled, Oberhausen manifesto, which is previously untranslated, demonstrates that the three years following the first Oberhausen manifesto still left a great deal of filmmakers out of circulation. Peter Nestler, for instance, who made some brilliant documentaries in the early 1960s, was left out of the festival because his work was documentary and engaged with social realities. This manifesto, propelled by Jean-Marie Straub and released the same year as his groundbreaking film *Nicht versöhnt* (*Not Reconciled*, codirected with Danièle Huillet [West Germany, 1965]), attacks the rise of fictional art cinema that evades and elides reality.

[West German] Short Film Days have a meaning only when they help to discover still unknown [West German] filmmakers.

Lenica, Kristil, Kluge, and so on, are no longer discoverable.

However, for three years in this country, Peter Nestler, the truest and most reliable film-maker, has had three of his films, *Aufsätze* [*Essays*], *Mülheim (Ruhr)*, and *Ödenwaldstetten* rejected by the Selection Committee.

The same happened to the very good-looking (first) film, *Die Versöhnung* [*The Reconciliation*], by Thome-Lemke-Zihlman.

And there are still others.

 J.-M. S.

This year the Selection Committee has rejected films whose authors dared to take reality into serious consideration. The Selection Committee thus held strictly to the rule of recent years to select only those films that correspond to its conception of film art: subtle or violent distortion of reality. This procedure supports a fashion the source of which is either contempt or stupidity or helplessness. It is understandable that many directors of short films pay homage to it; it requires neither experience nor engagement (only a little formal skill). It suits the Federal Republic, and it will prevail.

Today this fashion is already becoming a dictatorship. It has a large international festival. It shows a few films and says: This is German film, and that's all, and it pleases us.

Whether Mannheim, whether Oberhausen, whether the Gloria or Constantin Production Company—they are the same thing at the same level.

O, it is such a progressive critique of society!

It is called the art of camouflage, a lie. The bad makes conscience sensitive: honesty becomes affront.

THE MANNHEIM DECLARATION
(West Germany, 1967)

Joseph von Sternberg, Alexander Kluge,
Jacob Heidbüchel, Reiner Keller, Fee Vaillant,
Herbert Pötgens, K. F. Göltz, Walter Talmon-Gros,
Edgar Reitz, Hans Rolf Strobel, Norbert Kückelmann,
Michael Lentz, Heinrich Tichawsky, Peter M. Ladiges

[First released at the International Film Festival, Mannheim-Heidelberg, 1967. Published in English in Eric Rentschler, ed., *West German Filmmakers on Film: Visions and Voices* (New York: Holmes and Meier, 1988), 2. Trans. Eric Rentschler.]

This manifesto is a riposte to a new Film Funding Law in West Germany, which the signatories felt would return the nascent German cinema to the conventionality and stagnation of the past.

Six years have passed since the Oberhausen Declaration. The renewal of German film has not yet taken place. The initial international successes have suggested new directions. Before one can move in these directions they are already being blocked off again.

The undersigned repeat the Oberhausen demand for the renewal of German film. They wish to intervene in the international duping of the public and declare:

1. A film industry even in business matters cannot do without imagination. For that reason there is no such thing as strictly business matters.

2. The future of an industry is only as good as its younger generation.

3. An industry dare not be only a closed club for the established few.

The Oberhausen Declaration proclaimed:

> The collapse of the conventional German film finally removes the economic basis for a mode of filmmaking whose attitude and practice we reject.

Those who signed the document were not wrong. But the attitude they rejected at that time once again is becoming prominent. By gaining influence over the legislative powers this attitude seeks to gain a new economic basis.

The planned Film Subsidy Law one-sidedly demands large distributors and large-scale productions.

It discriminates against the typical economic patterns of film culture and young directors ("small budgets").

We reject the law in its present form.

SITGES MANIFESTO (Spain, 1967)

Manuel Revuelta, Antonio Artero, Joachin Jordà, and Julián Marcos

[First released in Spanish at the First International Congress of Film Schools, Sitges, Spain, October 1967. First published in English in Vicente Molina-Foix, *New Cinema in Spain* (London: BFI, 1977), 23. Trans. Vicente Molina-Foix.]

The Sitges conference amounted to the first public forum to talk about the cinema in Spain in the twelve years since the Salamanca conference in 1955. The "Sitges Manifesto," a.k.a. the "Barcelona School Manifesto," is in actuality a statement of principles for the Barcelona School, which saw itself irrevocably at odds with New Spanish Cinema—the outcome of the Salamanca conference—and with Francoist models of cinematic production. The conference was polarizing enough that the State police shut it down before its conclusion. The Barcelona School became the center for politically engaged, leftist and experimental cinema in Spain in the late 1960s.

Conclusions of the First International Congress of Film Schools, Sitges, October 1967:

1. We advocate the creation of an independent cinema, free of any industrial political or bureaucratic constraint.

 To obtain this the following conditions are indispensable:

 (a) Free access to professional activity, with the following implications.

 (b) The abolition of the Sindicato Nacional del Espectáculo [National Entertainment Syndicate] and the setting-up of a truly democratic union.

 (c) The abolition of the "prior permit" for shooting a film and of any other kind of permits.

 (d) Freedom to show films without control by the government or any other official body.

 (e) The abolition of the pre-censorship, the censorship of finished films and any other form of censorship.

 (f) The abolition of the "interes especial" [special interest films] and of any other type of subsidy as a means of control.

 (g) Control by the Democratic Union of the means of production, distribution and exhibition.

 (h) All resources for professional education must be in the hands of the Democratic Union. This implies the transformation of the present structure of the E.O.C. [Official Film School].

 In this new school the students would be full members of the Democratic Union.

2. The following points have been resolved:

 (a) To continue this Congress in the future.

 (b) To inform the other film schools about the activities and outcome of this Congress.

 (c) To organise the next Congress on a democratic and elective basis, appointing the various committees in charge of the procedure.

Goals of the Barcelona School subsequently published by Joachin Jordà:

1. Self-financing and co-operative system of production.
2. Team work with constant interchange of functions.
3. Preponderantly formal preoccupation referring to the field of the structure of the image and the structure of the narrative.
4. Experimental and avant-gardist in character.
5. Subjectivity, within the limits allowed by censorship, in the treatment of themes.
6. Characters and situations different from those of the cinema of Madrid.
7. Use, within the limits of union regulations, of non-professional actors.

8. Film production outside the distribution outlets, not something we desire but something we are forced to accept by the circumstances and narrow-mindedness of most distribution companies.

9. Apart from a few exceptions the non-academic, non-professional training of directors.

HOW TO MAKE A CANADIAN FILM
(Canada, 1967)

Guy Glover

[First published simultaneously in English and French in André Pâquet, ed., *How to Make or Not to Make a Canadian Film* (Montréal: La Cinémathèque canadienne, 1967); *Comment faire ou pas faire un film canadien* (Montréal: La Cinémathèque canadienne, 1967).]

The following two manifestos from Guy Glover and Claude Jutra point to the profound influence of the French *nouvelle vague* on Québécois and Anglo-Canadian cinema in the 1960s. Both men worked for the National Film Board of Canada / Office national du film—Glover mostly as a producer of animated and documentary films; Jutra as a director, most notably of *Mon oncle Antoine* (1971). These two manifestos also foreground the importance of *cinéma direct* and DIY aesthetics on the nascent cinemas of the country.

*

It is understood that when one speaks of "a Canadian film" one has in mind ONLY:

(a) a feature-length film; or

(b) a multi-screen presentation of unspecified complexity but tending to the "total."

* *

A film is not a piano. Anyone can "play" a film without being obliged to learn or practice it. The less you know about the rules and technique the better.

* * *

A young man makes better films than an older man.
An adolescent makes better films than a young man.

A child, if not discriminated against by the educational system, *would make* better films than an adolescent.

In the future we can foresee a technology permitting the creation of foetal films—the ultimate unsocialized perceptional expression.

SUBJECT

1. It is difficult to be dogmatic about the type of subject matter which should be treated in a Canadian film except to say that it should reflect the preoccupations of the director and will usually be autobiographical or confessional in nature. The Fiction Film is an infantile practical joke—a fake cigar with a charge of fake gunpowder. The Confessional Film substitutes real, for fake, gunpowder, the film-maker (in authentic cases) rather than the audience, "losing face." Much to be recommended.

Youth in revolt is a perfect subject-area. Post-teens in revolt is perfect for a post-teens director.

Departures from mental and sexual norms (so-called) are especially desirable.

Documentary is decrepit.

The "Candid" record (or "Witness-film") is, however, acceptable. This is not so much a technique as a state of mind. It sometimes unfortunately falls into sequential order, but the editor will know how to remedy this (see para. 9 below).

DIRECTION

2. The script (which has been written preferably by the director) should, having been used to sell the product to a financier and/or distributor, be thrown away. It is better working without a script, or as little script as possible to avoid having a plan for shooting. Improvisation, here, (see below) is all-important. The director see *** above) should be committed to as little as possible before shooting (see Editing).

3. Actors also (when they are used) who have no talent for improvisation should, nevertheless, be obliged to improvise. Where improvisation extends to dialogue, improvisational incompetence is a virtue much to be prized since with verisimilitude it depicts the incompetence of the actors and *any* verisimilitude is better than none.

4. Any attempt to build into your composition a "normal" chronological sequence, since it is naive anyway, should be rejected. Continuity (spatial and temporal) should be as novel as possible: only the unexpected will function with an image-sated and time-sated audience. "It's not so much where you are, as what you are" and "It's not so much what you say but when you say it"—these principles, applied forcefully, have a tonic effect on the audience's organs and muscles. The medium is the massage.

5. A 50:1 shooting ratio is *at least* ten times as auspicious as a 10:1 shooting ratio. (Film Mathematics: Theorem 1). A special characteristic of Film Math is that a number may be assigned either a plus, or a minus, value according to the age and experience of the director. (See *** above.)

6. It is important not to pay too much attention to the real movement of actors or personages in front of the camera, or to the movement as it will appear finally on film. This would interfere with the freedom of the director to say nothing of the freedom of the actors and cameraman—all of whom should be as free as possible. Total freedom in all parts of the film-making "event" should be the aim. Only the unpremeditated is true.

CAMERA

7. Poor picture-quality is more authentic than good picture-quality. Raw-stock should be used in unlimited quantities (see 5, above). The camera should be as small as possible. A tripod should never be used. Telephoto lenses are required accessories.

Ambient light only to be used.

Colour film—aesthetically and technologically—has had a contemptible history and should be treated with contempt.

According to the theory of Colour Degradation, colour film can be made (by choice of light, by exposure and printing) to look very like black and white.

On the other hand, black and white film, printed through colour filters, can be made to look like colour film.

The director should give the cameraman more or less freedom according to

1) his (the director's) age
2) the cameraman's age.

The cameraman may, or may not, know the subject of the film. If he does *not* know, the chances are he *may*, in deciding for himself what the subject is, shoot a better film than the director had in mind (or partly in mind) (see para. 1).

SOUND

8. Poor sound quality is more authentic than good sound quality. The desirable poor-quality can be easily achieved even with so-called "good equipment." An alert sound man can spot ambient sound sources upon which to focus his microphones, putting dialogue (according to well-understood theory) squarely "in place." The cameraman can aid in refusing to use a blimped camera and a director can further help matters by a number

of simple steps including "free" or random slating and requiring the actors to reduce voice levels to *below* that of the ambient sound. Giving the sound-man a half a day's holiday has been known to produce interesting results especially if the required post-synching is good (i.e. "bad"). Post synch which is out-of-synch is more sincere than the more mechanical perfection of precise synchronization.

EDITING

9. Editing rules need not (indeed should not) be observed.

Film punctuation devices (fades, dissolves, etc.) should be the first to go. All traces of rhythm or rhythmic structure should be avoided as exercising an intolerable artificiality on the natural rhythm of the subject. Action is continually reactionary and, in any case, has been often rendered impossible by the director. Where the director has for some reason achieved non-continuity, a number of obvious alternatives are open to the enterprising director.

* * * *

Unconventional films are by film-makers under 25 years of age. Here, there are no bad films; only bad audiences.

Between 25 and 30 years (the difficult age) film-makers frequently make good-bad films or bad-good films—which are acceptable. If these film-makers survive, their future is certain and neither hair-dye, plastic surgery nor hormone therapy will for long turn back the clock. Conventional films are by film-makers over 30 years of age and are bad. For these individuals, death would be the kindest fate—however since this is unlikely, forcible restraint and ejection from film-making establishments are the most practical alternatives

* * *

In general, the film-maker is always *Right*. All others—especially the man who puts up the money—are always *Wrong*.

* *

Disorder is merely a not-yet-emerged order.

*

Box-office success is always failure; box-office failure is success.

HOW TO NOT MAKE A CANADIAN FILM
(Canada, 1967)

Claude Jutra

1) Choose an uncommercial subject, so intimate as to be indecent, uninteresting, futile, immoral, sordid, etc. . . .

2) Make yourself a big star, and crowd around with old pals.

3) Don't write a line of script, but improvise day by day, not too seriously, but convincing yourself the result will be coherent and significant.

4) Shoot everything in 16mm black and white, with makeshift equipment.

5) Have your best friends participate, call them to meetings with only a few minutes' notice at any hour of the day or night; make them understand they're working for the sake of Art, and not at all for vile pecuniary considerations.

6) For the inevitable expenditures, borrow money from the bank and have your loan endorsed by members of your family and their friends; get what you need as credit, and if that isn't enough, find a friend who's rich enough and idiotic enough to invest a few thousand dollars of his own in the doubtful enterprise.

7) Most of all, don't worry about getting distribution guarantees.

If you take good care not to commit any of these horrible mistakes, you'll avoid the following vexations:

 a) wasting many precious years of your life;
 b) being in debt for many years to come;
 c) looking desperately for someone to whom to "sell" your film;
 d) suffering shame from the critics, or what's worse, humiliation from an indifferent public;

Nevertheless . . .

 a) if these drawbacks are overcome by your passion for cinema;
 b) if creative freedom gives you an inexpressible joy;

c) . . . and if succeeding in an enterprise that common sense has already con-
demned gives you an exquisite enjoyment;

d) if you are willing to put your friendships to the test in the hope of making them
closer at the end;

e) if modesty is not one of your handicaps;

f) or if you simply want to make a Canadian film . . .

here is my advice:

1) Choose an uncommercial subject, so intimate as to be indecent, etc., etc., etc. . . .

FROM "THE ESTATES GENERAL OF THE FRENCH CINEMA, MAY 1968" (France, 1968)

Thierry Derocles, Michel Demoule, Claude Chabrol, and Marin Karmitz

[First published in French as "Etats généraux du cinéma français," *Cahiers du cinéma* 203 (1968): 42–60. First published in English in *Screen* 13, no. 4 (1972–1973): 58–89.]

In the aftermath of May '68, French film directors (whose actions in many ways precipitated the events of May with the uprisings around *l'Affaire Langlois* in February 1968) came together to radically reimagine the French cinema in light of the recent student and workers strikes. Below is perhaps the most utopian and anticapitalist report in the series issued by the Estates General in its call for a new, egalitarian, politically engaged cinema.

PROJECT 4

Proposed by Thierry Derocles and drawn up by Michel Demoule, Claude Chabrol, Marin Karmitz. This was considered to be totally utopian by some and by others (a growing number, it's true) as the only truly revolutionary project presented. It was to this unique-ness that it owed its extremely positive role of stimulus, agitation, and provocation of bad faith. But its role was also in some senses a negative one. Its defenders opposed the final project so violently that they prevented any serious debate, and this hinged on a confusion which was never brought out: should the new structures in question at Suresnes be con-cerned with a militant, politicised and revolutionary cinema, or should they rather simply organise and improve the conditions of that same consumers' cinema—albeit coloured by political consciousness—which we have to deal with in France. *(Cahiers du Cinéma)*

It is just and proper that every person should have the right to participate with his fellows in the development of all. The breadth and content of the events of May '68 have made it impossible to go on accepting past alienations. This is what gives these events a revolutionary significance. As a participant in the cultural development of all, the audio-visual area must revolutionise its way of existing. This is what the following project proposes.

The audio-visual area must become a public service, independent of the Government, within the framework of an Office which brings film and television together on a national level and establishes:

—free access to its presentations;
—a genuine decentralisation of culture;
—an opportunity for all to become professionals;

This Office would be divided into two services: one for television, the other for the cinema. While these two sections have to overlap in the brief of the Estates General, we have nevertheless confined ourselves to a consideration of the cinema.

FINANCING

The cost of a system of free admission and of production (film stock, salaries, etc.) is met through the participation of the country as a whole.

For example, an annual fee of 10F (about £8) for every five inhabitants establishes an annual budget of one thousand million francs (about £80 million) which generously exceeds the present finances available to the French film industry. The spectators become producers.

This system of financing allows for an increase in the number of films produced and consequently in the numbers of jobs available, thus militating against unemployment.

The average cost per production will be calculated annually. Any budget that is less than or equal to this average cost is accepted automatically. Every budget higher than the average cost will be discussed by a committee composed of film workers and spectators.

The budget of a film is drawn up by all those involved in its production, and responsible for it from the initial stage to release.

The Office will buy foreign films and sell French films abroad.

The Office will organise and administer the distribution of these films and their exhibition through the cinemas, whose directors will become managers appointed by the Office.

From the moment he starts work on his first film the film worker will be paid a uniform monthly salary.

He will receive a second salary calculated on the basis of qualifications for every film he works on. A minimum work standard can be established.

Where a film is sold abroad, the sale price is divided equally between the Office and the production team. The sum received by the production team is divided equally among all the members of the team and is in addition to the two previously mentioned salaries.

EXTENSION

The cinema must search out its public and its workers in their own environment.

The regional centres of the Office must therefore not only provide for film exhibition, but also for film production and professional training in all regions of the country.

Film studios must be created at each of these regional centres. New cinemas must be established, but mobile projection units must also be set up so that films may reach factories and rural communities where a cinema would not be appropriate.

PROFESSIONAL TRAINING

Genius and talent are not learnt. Technique is acquired by experience. Therefore all traditional notions about schools have to be abandoned. Direct contact with the profession before professional training has been acquired will discourage doubtful vocations. To this end all potential candidates would go through two stages:

—a first stage of basic information completed by discussions among the trainees;
—a second, during which the student would take part in a school production and in discussions with professionals.

These two stages can be organised in any centre of the Office, but the students will be financed by the Ministry of Education as laid down by the new University structures. After these two stages the students will take part in two all-student productions, work on which will have included discussions by the students among themselves and with professionals. These films will be financed by the Office. While working on them students will be in receipt of a uniform monthly pre-salary. On completion of the two films, the students will be considered professionals and will enjoy the same conditions.

An experimental centre for professional film workers open to students must be created:

—to allow for pure research;
—to provide technicians with training for the new techniques which may emerge during their career;
—to prevent excessive isolation into specialisations and provide for a genuine advancement within the profession.

The authors of this project are aware of the utopian air of this document. They neverthe-less give their assurance that this utopia is realisable practically in any economic system, and they consider its apparent insanity as the very proof of its seriousness. They are prepared to defend and explain it in any circumstances.

MANIFESTO OF THE NEW CINEMA MOVEMENT (India, 1968)

Arun Kaul and Mrinal Sen

[First published in *Close Up* (India) 1 (July 1968).]

Twenty years after Satyajit Ray's "What Is Wrong with Indian Films?" the "Manifesto of the New Cinema Movement," by Arun Kaul and Ray disciple Mrinal Sen—director of such films as *Akash Kusum* (*Up in the Clouds*, India, 1965) and *Bhuvan Shome* (India, 1969)—calls for a New Cinema movement to emerge in India. Kaul and Sen propose not only the creation of a new form of Indian cinema, similar to *la nouvelle vague* in France and the American underground film (an admittedly strange combina-tion, in the first instance), but also new forms of production and distribution to allow these films to be seen and to circulate. Based in the first instance in Bombay, this New Cinema Movement allows for low budget features to be made that will then cross-subsidize the distribution of shorts and documentaries.

The Indian film, especially Hindi Cinema, is at its lowest ebb today. Spiralling costs of production, rocketing star prices, exorbitant rates of interest charged by financiers, wide-spread acceptance of "black money" transactions in all sectors of the film industry—all this, together with the inane stress of non-essential and an incredible dearth of ideas and imagination in creative matters, has reduced the Indian film industry to a sorry mess. Most of the film-makers—directors, writers and all—seem to have stopped thinking. Almost to everybody, making a film seems to be just a mechanical business of putting together popular stars, gaudy sets, glossy colour and a large number of irrelevant musical sequences and other standard meretricious ingredients. Hardly anyone conceives of a film in terms of aesthetic experience and creative expression. In the prevailing conditions, even a film maker finds it possible to make a film of some artistic aspiration, the problem of finding a channel for circulating it continues to stare him in the face. Theoretically it would mean that in order to find and reach the audience for his kind of film, the maker of an off-beat film must not only be his own producer but also assume the role of a dis-tributor to circulate his film, and then proceed to hire a theatre where he can run it. And even this effort of the film-maker to combine these three roles would not guarantee a

sufficient number of spectators will be attracted to the theatre. The experience of many a good off-beat film playing in nearly empty houses, has inhibited conscientious film makers from attempting truly artistic significant films. If the number of discriminating spectators appears, at first sight, to be heartbreakingly small, the reason is that the established film industry, motivated by the grossest economic considerations, has been for decades dishing out crudest vehicles of their notions of mass entertainment and thus conditioning the tastes of the majority of film goers.

A reaction to the vulgarities of the established commercial cinema has been in existence for several years in a large number of film-making countries, crystallising in many places, into a regular, conscious movement for better cinema. This New Cinema Movement (NCM), as it might be termed has manifested itself through the "New Wave" in France, the "Underground" in America, and other yet unlabelled currents in other countries. The time for launching such a movement in India is now ripe, for, we believe, that the climate needed to nourish it obtains today.

WHAT IS NEW CINEMA?

It would be impossible to find a completely satisfactory definition of New Cinema. New Cinema is not only a matter of finished results and effects, it also involves methods and conditions of film-making, the relationship between the creative artist and his audience, awareness of the changing grammar, expanding powers and soaring ambitions of the film medium. New Cinema offers the film-maker, above all, the indispensable freedom to realise his vision, untrammelled by all considerations except creative and aesthetic. New Cinema looks upon a film as the personal expression of an individual artist. New Cinema aspires to the conditions in which a film would bear the distinct stamp of the creative artist behind it and not of a studio.

New Cinema stands for a film "with a signature." New Cinema engages itself in a ruthless search for "truth" as an individual artist sees it. New Cinema lays stress on the right questions and bothers less about the right answers. New Cinema believes in looking fresh at everything including old values and in probing deeper everything, including the mind and the conditions of man.

New Cinema seeks the clues to mankind's riddles in men's personal relationships and private worlds. New cinema encourages film-makers to bring to their work improvisation, spontaneity and youthful enthusiasm. New Cinema expects of its audience the kind of participation and involvement which modern art demands.

THE NEW CINEMA MOVEMENT IN INDIA

To ensure that New Cinema films will be made and seen by people, it is necessary to evolve an elaborate scheme that will cut across the various vicious circumstances which inhibit the growth of New Cinema. In this scheme, New Cinema Movement is conceived

as a self-sufficient structure embracing all three branches of film-making: production, distribution and exhibition. Taking it upon itself to produce films as well as distribute and exhibit them, the Movement has to strive for not only making new types of films but also for developing a new kind of audience. The Movement must eliminate the situation in which exhibitors and distributors finance film-making and by virtue of that circumstance claim the right of interference with the process of film-making.

NEW CINEMA AND NEW AUDIENCE

The two major constituents of the New Cinema Movement are: the enlightened film-maker and the enlightened audience. The latter, thanks to the dedicated work done by film societies the world over, is a rapidly growing phenomenon. In India, about one hundred active film societies have succeeded in creating a new discriminating audience which demands better cinema and is ready to go to take some pains to secure it. But in terms of total numerical strength, film societies are not enough to sustain the new film-maker. They have to be supplemented by a new force: "art theatres."

An Art Theatre, generally, is a modest size auditorium where discriminating audiences can, for a moderate admission fee, hope to see a better film which would not, in common course, find a place on the usual exhibition circuit. The screens of Art Theatres will also be to the superior product of the commercial cinema.

The New Cinema Movement in India will start a chain of Art Theatres to begin with, in Bombay where apart from showing the selected best films from commercial and non-commercial in India and abroad, all films made by film-makers belonging to the New Cinema Movement shall be released. The Movement ultimately aims at recovering the entire investment of the New Cinema films from the revenue of the Art Theatre chain.

To keep the Movement afloat, it is perhaps necessary that films should be able to recover the invested capital. And since the audience from which it is hoped to get this money is a limited one—the essential minority audience of the off-beat cinema—it is obvious that the New Cinema Movement films must be made at the lowest possible cost. Shooting on actual locales, "post-dubbing" and, as far as possible, a continuous schedule of shooting will be factors which will help keep the budget low. This has been the practice over the world—on the Continent as well as among the young rebels in the USA. We in India have to take lessons from the successful exciting experience and equip ourselves accordingly.

Moderate length feature films will help the Movement to circulate short films and documentaries which it also intends to produce from time to time. In the support of short films and documentaries, the Movement aims at supporting "Avant Garde" and experimental efforts of a new kind which would normally be denied sponsorship elsewhere in India. These films will normally be of 10–20 minutes in duration. With the length of the feature films being moderate, it will be easy to exhibit these shorts along with the Movement features.

NCM will have a special panel which will examine the scripts proposed to be filmed and give its opinion on whether they deserve to be taken up by the NCM or not.

There shall be a separate panel for recommending the circulation on NCM circuit films acquired from other agencies. NCM's films will be director oriented, that is to say that the director shall be the arbiter of the film's quality and the principal architect responsible for its shape. He will have the freedom to choose subjects of his own liking and transform them into films of the manner that conforms most to his aesthetic values. Subjects in human as well as cinematic values—whether based on reputed literary works or originally written—will be favoured for filming.

To begin with, it shall take the form of Sunday Morning Shows at the various theatres in the city of Bombay. The circuit will in time be extended to small theatres and suitable halls (for 35 and 16mm projection), available in the city of Bombay. This scheme can later be established in other cities, also.

The films (both Indian and foreign) shown by the Art Theatres will be of artistic value. Apart from the usual public participation, the Academy Cinema will have a membership. This membership will be open to the public on the payment of Rs. 10/- per person per year. The membership will entitle the members to various benefits not available to the general public.

ACADEMY CINEMA

As mentioned in the Manifesto, NCM's Academy Cinema in Bombay (before it is extended to other cinemas) will take the shape of Sunday morning (and holiday) screenings in a selected few regular commercial theatres in the city. As soon as arrangements are complete, the Chain will be enlarged to include assembly halls belonging to schools, colleges and charitable, cultural and social organisations, which could be converted into art theatres for two shows, on Saturday and Sunday evenings.

DISTRIBUTION OF FILMS

NCM plans three categories of distribution. In the first category, films (35mm and 16mm) will be acquired, hired or purchased for its own Academy Cinema chain. In the second category, films will be acquired, hired or purchased for distribution on the Film Society Circuit, among universities, college and school clubs as well as clubs showing children's films. In the third category, NCM's own films, off-beat films made by independent filmmakers as well as foreign films of proven merit will be offered for release on regular commercial circuits in all film territories on normal business terms.

WHAT IS TO BE DONE? (France, 1970)

Jean-Luc Godard

[First published in English and French in *Afterimage* (UK) 1 (1970): 10–16. Trans. Mo Tietelbaum.]

Written at the request of Peter Whitehead for the first issue of the radical UK film journal *Afterimage*, this manifesto, one of Jean-Luc Godard's many, exemplifies the kind of dialectical thinking the filmmaker embraced during his Maoist, Dziga-Vertov Group period. Godard illustrates what is to be done through an analysis of his recent film *British Sounds* (UK, 1970).

1. We must make political films.

2. We must make films *politically*.

3. 1 and 2 are antagonistic to each other and belong to two opposing conceptions of the world.

4. 1 belongs to the idealistic and metaphysical conception of the world.

5. 2 belongs to the Marxist and dialectical conception of the world.

6. Marxism struggles against idealism and the dialectical against the metaphysical.

7. This struggle is the struggle between the old and the new, between new ideas and old ones.

8. The social existence of men determines their thought.

9. The struggle between the old and the new is the struggle between classes.

10. To carry out 1 is to remain a being of the bourgeois class.

11. To carry out 2 is to take up the proletarian class position.

12. To carry out 1 is to make descriptions of situations.

13. To carry out 2 is to make concrete analysis of a concrete situation.

14. To carry out 1 is to make *British Sounds*.

15. To carry out 2 is to struggle for the showing of *British Sounds* on English television.

16. To carry out 1 is to understand the laws of the objective world in order to explain that world.

17. To carry out 2 is to understand the laws of the objective worlds in order to actively transform that world.

18. To carry out 1 is to describe the wretchedness of the world.

19. To carry out 2 is to show people in struggle.

20. To carry out 2 is to destroy 1 with the weapons of criticism and self-criticism.

21. To carry out 1 is to give a complete view of events in the name of truth in itself.

22. To carry out 2 is not to fabricate over-complete images of the world in the name of relative truth.

23. To carry out 1 is to say how things are real. (Brecht)

24. To carry out 2 is to say how things really are. (Brecht)

25. To carry out 2 is to edit a film before shooting it, to make it during filming and to make it after the filming. (Dziga Vertov)

26. To carry out 1 is to distribute a film before producing it.

27. To carry out 2 is to produce a film before distributing it, to learn to produce it following the principle that: it is production which commands distribution, it is politics which commends economy.

28. To carry out 1 is to film students who write: Unity—Students—Workers.

29. To carry out 2 is to know that unity is a struggle of opposites (Lenin) to know that the two are one.

30. To carry out 2 is to study the contradiction between the classes with images and sounds.

31. To carry out 2 is to study the contradiction between the relationships of production and the productive forces.

32. To carry out 2 is to dare to know where one is, and where one has come from, to know one's place in the process of production in order then to change it.

33. To carry out 2 is to know the history of revolutionary struggles and be determined by them.

34. To carry out 2 is to produce scientific knowledge of revolutionary struggles and of their history.

35. To carry out 2 is to know that film making is a secondary activity, a small screw in the revolution.

36. To carry out 2 is to use images and sounds as teeth and lips to bite with.

37. To carry out 1 is to only open the eyes and the ears.

38. To carry out 2 is to read the reports of comrade Kiang Tsing.

39. To carry out 2 is to be militant.

THE WINNIPEG MANIFESTO
(Canada, 1974)

Denys Arcand, Colin Low, Don Shebib, David Acomba, Linda Beth, Milad Bessada, Kirwan Cox, Jack Darcus, Martin DeFalco, Sandra Gathercole, Jack Grey, Ági Ibrányi-Kiss, Len Klady, Peter Pearson, Tom Shandel, Jean-Pierre Tadros, Frank Vitale, Les Wedman, John Wright

[First launched at the Canadian Film Symposium in Winnipeg, Manitoba, Canada, on 8 February 1974. First published in *Cinema Canada* 13 (1974): 14–15.]

One of the only film manifestos to emerge from Canada to contain both Anglophone and Francophone signatories, along with filmmakers from both the private and public sectors, "The Winnipeg Manifesto" echoes the Québécois APCQ manifesto from 1971 (see Association professionnelle des cinéastes du Québec, "The Cinema: Another Face of Colonised Québec," in chap. 3 of this volume), demanding a publically funded alternative to private sector filmmaking. This goal was realized to some extent with the transformation of the CFDC (Canadian Film Development Corporation, founded in 1967, and the "half-hearted" measure decried herein) into Telefilm Canada in 1984. The Winnipeg Symposium also led to the emergence of the Winnipeg Film Group, whose filmmakers, most notably Guy Maddin, would go on to great acclaim in the 1980s and 1990s.

We the undersigned filmmakers and filmworkers wish to voice our belief that the present system of film production/distribution/exhibition works to the extreme disadvantage of the Canadian filmmaker and film audience. We wish to state unequivocally that film is an expression and affirmation of the cultural reality of this country first, and a business second.

We believe the present crisis in the feature film industry presents us with an extraordinary opportunity. The half-hearted measures taken to date have failed. It is now clear that slavishly following foreign examples does not work. We need public alternatives at every level in the film industry. We must create our own system to allow film-makers the option of working in the creative milieu of their choice.

We insist that the various governments of Canada implement the necessary policies to provide an alternative and a complement to the private production capacity in the Canadian feature film industry by providing a public mechanism and the resources to fully finance Canadian features.

Therefore, we call on the federal government in cooperation with the provincial governments:

1. To create a public production capacity that will allow full financing of Canadian feature films.

2. To create a public distribution organization with broad responsibilities for promotion and dissemination of Canadian films here and abroad.

3. To create a quota for Canadian films in theatres across the country.

HAMBURG DECLARATION OF GERMAN FILMMAKERS (West Germany, 1979)

Rainer Werner Fassbinder, Werner Herzog, Wim Wenders, and fifty-seven others

[First distributed at the Hamburg Film Festival in September 1979. First published in German as "Die Hamburger Erklärung," *medium* (Germany) (November 1979): 27. First published in English in Eric Rentschler, ed., *West German Filmmakers on Film: Visions and Voices* (New York: Holmes and Meier, 1988), 4. Trans. Eric Rentschler.]

In 1979, West German film culture had changed dramatically from the time of Oberhausen, with New German Cinema cresting on a wave of international successes. This manifesto reflects the solidarity and optimism on the part of West German filmmakers, while eliding some divisions: that most West German films were firmly ensconced in the narrative tradition, and that women were largely left out of the New German Cinema. The latter led to the "Manifesto of the Women Filmmakers" (see chap. 4 of this volume), released as a response to this manifesto.

On the occasion of the Hamburg Film Festival we German filmmakers have come together. Seventeen years after Oberhausen we have taken stock.

The strength of the German film is its variety. In three months the eighties will begin.

Imagination does not allow itself to be governed. Committee heads cannot decide what the productive film should do. The German film of the eighties can no longer be governed by outside forces like committees, institutions, and interest groups as it has been in the past.

Above all:

We will not let ourselves be divided

—the feature film from the documentary film

—experienced filmmakers from newcomers

—films that reflect on the medium (in a practical way as experiments) from the narrative and commercial film

We have proved our professionalism. That does not mean we have to see ourselves as a guild. We have learned that our only allies can be the spectators:

That means the people who work, who have wishes, dreams, and desires, that means the people who go to the movies and who do not, and that also means people who can imagine a totally different kind of film.

We must get going.

MANIFESTO I (Denmark, 1984)

Lars von Trier

[First published 3 May 1984 for the Danish premiere of *The Element of Crime*.]

Among his many accomplishments Lars von Trier is largely responsible for newfound interest in film and moving image manifestos, especially the plethora that have popped up on the Internet in the last ten to fifteen years. In the next three manifestos, written partly as statements of purpose, partly as publicity, Trier outlines some perhaps enigmatic concerns about his "Europe trilogy", *The Element of Crime* (Denmark, 1984), *Epidemic* (Denmark, 1987), and *Europa* (Denmark/France/Germany, 1991). Trier emphasizes the generational aspects of filmmaking in the first two manifestos, which foreshadow Dogme '95, and introspects on his own self-described onanistic creativity in the final manifesto.

Everything seems to be all right: film-makers are in an unsullied relationship with their products, possibly a relationship with a hint of routine, but, nonetheless, a good and solid relationship, where everyday problems fill the time more than adequately, so that *they alone* form the content! In other words, an ideal marriage that not even the neighbours could be upset by: no noisy quarrels in the middle of the night . . . no half-baked compromising episodes in the stairwells, but a union between both parties: the film-maker and his "film-wife," to everyone's satisfaction . . . at peace with themselves . . . but anyway . . . We can all tell when The Great Inertia has arrived!

How has film's previously stormy marriage shrivelled up into a marriage of convenience? What's happened to these old men? What has corrupted these old masters of sexuality? The answer is simple. Misguided coquetry, a great fear of being uncovered (what does it matter if your libido fades when your wife has already turned her back on you?) . . . have made them betray the thing that once gave this relationship its sense of vitality: *Fascination!*

The film-makers are the only ones to blame for this dull routine. Despotically, they have never given their beloved the chance to grow and develop in their love. . . . Out of pride they have refused to see the miracle in her eyes . . . and have thereby crushed her . . . and themselves.

These hardened old men must die! We will no longer be satisfied with "well-meaning films with a humanist message," we want more—of the real thing, fascination, experience—childish and pure, like all real art. We want to get back to the time when love between film-maker and film was young, when you could see the joy of creation in every frame of the film!

We are no longer satisfied with surrogates. We want to see religion on the screen. We want to see "film-lovers" sparkling with life: improbable, stupid, stubborn, ecstatic, repulsive, monstrous and *not* things that have been tamed or castrated by a moralistic,

bitter old film-maker, a dull puritan who praises the intellect-crushing virtues of niceness.

We want to see heterosexual films, made for, about and by men.

We want visibility!

MANIFESTO II (Denmark, 1987)

Lars von Trier

[First published 17 May 1987 to coincide with the premiere of *Epidemic* at the Cannes Film Festival.]

Everything seems fine. Young men are living in stable relationships with a new generation of films. The birth-control methods which are assumed to have contained the epidemic have only served to make birth control more effective: no unexpected creations, no illegitimate children—the genes are intact. These young men's relationships resemble the endless stream of Grand Balls in a bygone age. There are also those who live together in rooms with no furniture. But their love is growth without soul, replication without any bite. Their "wildness" lacks discipline and their "discipline" lacks wildness.

LONG LIVE THE BAGATELLE!

The bagatelle is humble and all-encompassing. It reveals creativity without making a secret of eternity. Its frame is limited but magnanimous, and therefore leaves space for life. *Epidemic* manifests itself in a well-grounded and serious relationship with these young men, as a bagatelle—because among bagatelles, the masterpieces are easy to count.

MANIFESTO III: I CONFESS!
(Denmark, 1990)

Lars von Trier

[First published 29 December 1990 to coincide with the premiere of *Europa*.]

Seemingly all is well: Film director Lars von Trier is a scientist, artist, and human being. And yet I say: I am a human being. But I'm an artist. But I'm a film director.

I cry as I write these lines, for how sham was my attitude. Who am I to lecture and chastise? Who am I to scornfully brush aside other people's lives and work? My shame is only compounded by my apology that I had been seduced by the arrogance of science falling to the ground as a lie! For it is true that I have been trying to intoxicate myself in a cloud of sophistries about the purpose of art and the artist's obligations, that I have thought up ingenious theories on the anatomy and the nature of film, but—and I confess this openly—I have never come close to disguising my innermost passion with this pathetic smoke screen: MY CARNAL DESIRE.

Our relationship with film can be described and explained in many ways. We should make films with the intention to educate, we may want to use film as a ship that will take us on a journey to unknown lands, or we can claim that the goal of our films is to make the audience laugh or cry, and pay. This may all sound plausible, but I do not believe in it.

There is only one excuse for living through—and forcing others to live through—the hell of the filmmaking process: the carnal satisfaction in that fraction of a second when the cinema's loudspeakers and projector in unison and inexplicably give rise to the illusion of motion and sound like an electron leaving its orbit and thus creating light, in order to create ONLY ONE THING—a miraculous breath of life! This is the filmmaker's only reward, hope, and craving. This carnal experience when movie magic really works, rushing through the body like a quivering orgasm. . . . It is my quest for this experience that has always been and always will be behind all my work and efforts . . . NOTHING ELSE! There, I've written it, and it felt good. And forget all the bogus explanations about "childlike fascination" and "all-encompassing humility." For here is my confession: LARS VON TRIER, A SIMPLE MASTURBATOR OF THE SILVER SCREEN.

Still, in part three of the trilogy, *Europa,* I have not made even the slightest attempt at a diversion. Purity and clarity have been achieved at last! Here nothing conceals reality under a sickly layer of "art." . . . No trick is too tacky, no device too cheap, no effect too tasteless.

JUST GIVE ME A SINGLE TEAR OR ONE DROP OF SWEAT; I WILL GLADLY GIVE YOU ALL THE WORLD'S "ART" IN RETURN.

One final word. Let only God judge my alchemic attempts at creating life on celluloid. One thing is certain. Life outside the cinema can never be equaled, for it is his creation and therefore divine.

THE CINEMA WE NEED (Canada, 1985)

R. Bruce Elder

[First published in *Canadian Forum* 64, no. 746 (1985): 32–35.]

The ongoing and seemingly endless debate about what constitutes a truly (Anglo-) Canadian cinema came to a head with the publication in 1985 of experimental film-maker and critical theorist R. Bruce Elder's manifesto "The Cinema We Need." Elder—whose films include *The Art of Worldly Wisdom* (Canada, 1979) and *"1857" (Fool's Gold)* (Canada, 1981)—attacks the attempt on the part of Canadian filmmakers to make "New Narrative film": a cinema that differs from Hollywood cinema's desire for traditional storytelling by drawing on the aesthetics of the Canadian avant-garde. Elder claims that Canadian narrative cinema will never be able to compete with American product and that this "New Narrative film" engages in a process of vandalization and commercialization of the Canadian avant-garde tradition. Elder also claims that technology is overwhelming our ability to introduce new experiences and new insights into our conditions of living, and that this colonization is American. For this reason, Elder argues, Canada needs an avant-garde cinema that redresses this technological imperialism.

The task of achieving some clarity about our cultural situation and of developing the means to deal with the present cultural crisis is an urgent one—I believe the most important task now demanded of Canadians, even more important, all the exhortatory rhetoric to the contrary, than the formulation of social policy on employment in an era of electronic technology.

To formulate good policy on these matters, some questions about "the good itself" must first be thought through and the consequent problems—what degree of equality in the distribution of goods is proper in a just society? What would be the relationship in a just society between one's contributions to society, in services and labour—and the material rewards one receives? Can a life of complete leisure be truly good? These questions cannot be answered until we know something about what is good for a person and of the sorts of relations with others it is good for a person to have.

If these questions seem abstract, even preposterous (certainly they are amongst the last matters which a policy maker would, in the present age, be called upon to consider), it is only because they have come to seem that way in an age when the dominant mode of thinking is a technical and managerial one, an age in which the purpose of thinking has been reduced to discovering the means of realizing some goal, not discovering whether the goal itself is good; of finding a way to subject nature and other people to our will; not finding out what the relationship of people to nature and of people to other people ought to be. After all, these unasked questions are those which any reasonable person would consider to be central to what makes us human. If they seem obscure, the

darkness around them comes from our way of thinking about them, not from any murkiness in their own natures. Far from being abstract, these questions lie at the centre of our concrete existence and are answered by careful attention to our individual responses to the concrete situations in which we find ourselves.

I raise these questions not to try to answer them but to indicate what we who live in a technical age have lost and because a recognition of this loss is essential to formulating an answer to the most important question posed by this retrospective of Canadian cinema, namely, "What sort of cinema do we, as Canadians, need?"[3] I also ask these questions to explain why my answer about a Canadian cinema differs so completely from those of Peter Harcourt and Piers Handling, two people who have not only thought about the question more thoroughly than anybody else but have also articulated the fullest and most informed responses to it, responses which take into account, as any strong response must, the history of our previous involvement in making films. I feel I must rebut their answers since I believe that they are not just wrong, but dangerous in their implications which, if embedded in policy, would thwart the potential of those current developments in cinema which represent the little hope our country now has for reopening the closed system of thought imposed by technique, that is to say, by the U.S.

We are creatures of the modern technical system. To say that is to claim that the horizon of our thinking is circumscribed by technique. The will to mastery has penetrated all aspects of the human personality and we have become no more than functionaries of the will to control and master. To pretend that our consciousness (and so our personality) transcends the situation in which we live, that it is the site of the origin of will and that it escapes conditioning by the situation in which it finds itself is a delusion that masks the most terrifying aspect of our modern technical system. Our "individual" wills have been brought into conformity with the will to mastery and we, ourselves, have become technique.

This penetration of technique into the deepest recesses of the human personality has resulted in our losing our capacity to think in ways other than those that develop from the will to mastery. We are so colonized by the technical empire that we cannot even think against the imperial system of technology. Our historical amnesia, to use Adorno's phrase, our inability to even conceive of what we have lost under the aggrandizing hegemony of technical culture, is a measure of the extent to which we are dispossessed of any other realm, including that realm known to the ancients, the realm of mystery and wonder. We have lost our wonder at the gift of things, at what should be the wonder of wonders, that things are given. Consequently, we have become oblivious of values.

The power of technological domination attains its ends by encouraging us to conceive of ourselves as utterly free, by inducing us to think of ourselves as formulating projects for ourselves and as shaping ourselves into what we become. It leads us to believe that we have unlimited freedom to make the world the way we want it, since it portrays the universe as entirely devoid of values and as indifferent to the ends we choose. These delusions lie at the heart of the will to mastery. Overcoming that drive will disabuse us

of these delusions, but to overcome the will to mastery, we must find some other focus for our being than wilfulness. That other focus is to be found in attuning ourselves to what is revealed to us, to what is given. This attunement is not a form of quietism, but a process of letting go, so that our experiences can, in revealing their depths to us, change us as profoundly as possible. In attuning ourselves to what is given, we surrender ourselves to that givenness and allow ourselves to be remade anew. If we are to escape the enclosure of human thoughts and beliefs, we must surrender ourselves to something wholly other. We must learn to listen for the intimation of the Good of which we have become deprived and learn to appreciate the gift of what is given in experience.

We need—urgently need, if we are to find some way out of the modern technical system—a cinema that can manifest this dynamic attuning. What characteristics would such a cinema have?

Harcourt and Handling argue that a "realistic" cinematic image of ourselves is sociologically and psychologically important because it shows us as we really are (does "realism" ever really do this?) and so engenders, or at least reinforces, our sense of identity. They argue that just as a child finds itself (that is, discovers it is a unified and bounded being) in the mirror, so we find ourselves in our imaginary relations to portraits of our "type" or our "family." Setting aside the cavil that what we really acquire in such imaginary relations is an illusory sense of our identity, one would still have to object to this claim. For what the "realist" cinema presents are pictures of ourselves in our present condition and it presents these portraits as though they were portraits of the natural order. In this way, it suggests that the present order of things cannot be transcended.

But my objections to the Harcourt/Handling thesis run deeper. "Realism" relies on descriptions and descriptions follow experience; they are not simultaneous with it. Representations can only deal with the past. We need a cinema that can deal with the here and now. Any cinema that wishes to deal with the experience of the moment must not offer description; rather, it must reveal how events come to be in experience, that is, the dynamic by which events are brought into presence in experience. To do this, it must avoid using forms which present synoptic views of how some situation or another has come to be what it is, for views of that sort can be formulated only after the fact, after the process of creating the situation has been completed, and the explanations that they provide depend upon such disreputable intellectual abstractions as teleology and final causes.

One form that is clearly based on synoptic views of process and on teleology is the narrative. Narrative first creates and then reconciles discord. In a narrative, the end is already present in the beginning. It is obvious that such a form can be created only by looking back at the beginning from the end. Narrative, therefore, is reminiscence. We need a form that presents perceptions. We need a form that will immediately present the coming into presence (that is, the formulation) of present experience.

Given our present cultural imperatives, narratives pose a problem because they misrepresent experience. Narrative misrepresents because, in order to organize the past into comprehensible structures, it eliminates the unmanageable ambiguities and the painful

contradictions inherent in experience. Only in fictions can we be certain of anything. Narrative explains how events lead up to the final event in order to clarify the past but the notion of causality on which narrative is based is all too simple and serves only to cover over mysteries.

This idea is not new. Pound, speaking through the figure of his esteemed Kung in *Canto XIII*, recalled a time when historians did not try to cover over gaps in their explanatory constructs:

> And Kung said, "Wan ruled with moderation,
> In his day the State was well kept
> And even I can remember
> A day when the historians left blanks in their writings,
> I mean for things they didn't know."

But in technocracy nothing can be left uncontrolled, for technocracy is the will to mastery. Narrative is the artistic structure of technocracy. Accordingly, the cinema we need, the cinema that combats technocracy, will be non-narrative. It will not be fuelled by a rage for order—and order's concomitant, concealment. It will accept that every discovery involves dissimulation. It will accept error and lingering mystery, for its maker's negative capability will afford him the strength to accept what Keats terms the "Penetralium of Mystery." If these strike you as too modest, even valueless, aspirations, perhaps your doubts can be mitigated by the idea that this cinema will also use constant repetition—not to reminisce, but to progress through states of discovery and to reveal ever more about the ordinary world around us.

Peter Harcourt and Piers Handling have been celebrating the advent of the so-called New Narrative film and advocating further work in the form. The New Narrative is a form of narrative that makes use of some of the strategies and devices usually found only in avant-garde films, especially constructions that refer to the work's material base and its constructed character and that are less emotionally "engaging" than most narratives. According to these critics, New Narrative combines those virtues of formal complexity and self-consciousness that generally associate avant-garde film with the values of accessibility and with the potential for significant mass appeal (and so significant social value) which avant-garde films generally lack. Harcourt and Handling have argued that the best feature movies ever made in Canada were the low-budget, independent, personal features made in the years from about 1962 to 1974. These films represented an indigenous development similar in important respects to the European Art Film. Harcourt and Handling view the New Narrative film as a revitalization of the "Canadian Art Film" after the dark years of the Capital Cost Allowance films, for, like those earlier works, New Narrative films are independent, personal feature movies.[4]

While admittedly there isn't much to be proud of in the Capital Cost Allowance films, I don't for a moment believe that their failure gives us reason to praise the "Canadian Art

Film," nor do I believe that the development of the New Narrative film unites the strength of our avant-garde tradition (which is very great indeed!) with that of our "Art Film"; nor that such a cinema, if it were to come into being, would represent our best possibility for countering the hegemony of the technical/managerial system.

The reasons for my disbelief are many. One is that these films are still fundamentally narrative, while the cinema we need is not. Another is that I do not credit claims about the strength of our indigenous Art Film tradition. *Nobody Waved Goodbye,* for example, strikes me as a film that is interesting only for the fact that it was made here. A significant work of art it is not. Thirdly, I do not believe that the self-reflexive strategies used in some forms of avant-garde filmmaking can be comfortably accommodated within story-telling forms or that they serve important ends when they are used in that context. Self-reflexive ideas were developed to stress the autotelicity of a work of art. The notion that a work of art is autotelic is a development of the idea that every work of art is unique and that it is impossible to paraphrase or otherwise translate any work of art. But in New Narrative films, self-reflexive constructions serve primarily to create an unconventional surface— something desired for its ability to vivify perception. Unfortunately, such breaches of convention have little lasting value, for what seems unconventional one day often be- comes a cliché the next, while Milton's rhetoric, for example, has never been turned into clichés and most likely never will be.

This celebration of New Narrative angers me, too, because in Canada we have a long and very fine tradition of work in avant-garde cinema. This work has never received the attention it merits because the professors of movies at our universities have been too busy to take any notice of it. Now, after years of neglecting this form of cinema, they propose to honour it by advocating its being vandalized and commercialized, for their praise for New Narrative is tantamount to legitimating the mainstream cinema's hijacking of the hard-won, unrewarded achievements of vanguard cinema.

But remarks thus far have been negative—an effort to clear the ground. I turn now to more positive comments—to suggesting something of about what the cinema we need would be like. It would be, in the first place, a cinema not of imagination but of percep- tion. To escape from inwardness and domination of events by the ego, we must, even when "creating" works of art, cease to impose ideas on experience. We must rid art, and ourselves, of self-consciousness, for only when this is done can art manifest the process by which the subject-in-experience becomes identical with the subject-of-experience.

The cinema we need will be a cinema of perceptions, of immediate experiences. It will not be a cinema of ideas. Like narratives, ideas are formed only after the fact, serve only to present what is already past. We must therefore find a form that is capable of orienting us toward the present, a form not based on ideas (just as we must re-conceive morality and learn to think of it as concerned with attention, not with intention). Such a form must not depend on separating out one aspect of experience from all the others, nor on any pre- or post-conception. It would not depend, to use a few examples from recent films, on taxonomic or morphological principles, the alphabet, the structure of

discourse or the Kabbalah. It will present, simply and directly, the manifold of forces and relations that come into interplay in the coming-to-presence of an event. To achieve this, the form will have to allow for multiplicity and contradiction, since contraries are present in all experience. The attempt to dispose of contraries-in-experience is due to reason, not perception. It will incorporate the full diversity of the manifold of experience by making simultaneous use of multiple images representing internal speech and a variety of auditory phenomena. It will be a polyphonic cinema, possessing several concurrent lines of development.

In order to be true to its commitment to reveal the process by which events come to presence, this form of cinema we need will reveal the process of its own emergence into being. In fact, it can truly present only its process of coming-into-being; all other emergent phenomena it can only represent after the fact. It would, therefore, include those fits and starts, those hesitancies, suspensions and reformulations, those repetitions and periphrases—what T. E. Hulme somewhere referred to as "the cold walks and the lines that lead nowhere." Accordingly, the encounter with such a work at its best will strike one with the force of the emergence of being. In such a form, truth and method will become one.

This characteristic of our proposed cinema is hardly its most radical or original feature. It would, after all, share this feature with such well-known works as Alain Robbe-Grillet's *The Erasers* (1953), Pierre Boulez' *Structures* (1952) and Morton Feldman's *Last Pieces* (1959). However, it would come to this feature by a somewhat different route and this difference in its manner of creation would mean that this feature itself would be modified. Rather than being a calculated meta-description of the "creative process" it will, literally, enact the process of its own emergence into being. The temporal development of such cinematic work will be like that of a piece of totally improvised jazz (which also enacts the piece's emergence into being) rather than like a schematized meta-description of the manner by which a work might emerge into being, which is what Feldman or Boulez provide. As a result, as in jazz, the marks and traces of spontaneity will be valued more highly than through preconceptions.

As it happens, the dynamic by which events come to presence in experience is permeated by rhythm. Our cinema therefore should also be profoundly rhythmic. Rhythm also happens to be among the most physical of the features of any art form and that physicality, moreover, has a close relationship to the physical experience of the body. This fact points toward the importance the body will play in this form of cinema. This association of the rhythmicality of the process by which events come to presence in experience with the physicality and rhythmicality of bodily processes means that the rhythmic form of a work of art can, by uniting the pulse of the body with patterns inherent in emergent events (event phenomena), unite the mind and the body. The cinema we need will, accordingly, make extensive use of rhythmic constructions.

By dealing with immediate experience, the cinema we need would be rooted in the place where we have our being. But where we are, always, is in language, for nothing is given experience outside of language. The thing given in experience is intelligible, is a

meaning-being, because it is a meaning-being. It is intelligible precisely because language belongs to its internal constitution. A word fits a thing only because the thing itself is a word-thing. What we experience, what experience intends, is made in language and it is language which establishes things in the whole. This being so, the cinema we need, a cinema devoted to enacting the process by which events emerge into presence in experience, will engage with the formative role that language plays in making present that which is given in experience. It will not be a purely visual cinema, will not be a cinema against the word, but a cinema of the power of the word.

The makers of the cinema we need will be those who have the strength to abide with doubt and uncertainty and still open themselves up to unfolding situations, allow themselves, even, to be remade by experiences the destiny of which they cannot foresee. It is only through this process that truth will arise, for truth, as Heidegger kept reminding us, is *aletheia,* an uncovering.

One virtue of this conception of truth is that it is more vital and more richly embedded in time than traditional Aristotelian conception. Our cinema must insist on the primordiality of temporality. The strong makers, the makers who will fashion the cinema we need, will not seek for intimations of eternity and immortality but for intimations of the interchange of being with non-being, and so, of time, for it is the process of temporality which moves something from non-being and then into non-being again.

Since the cinema we need is a cinema that is not just a cinema in time, but one of time, a consideration of some basic and obvious truths about time is, perhaps, the most direct route to identifying key features of this cinema. Here are a few of the obvious but nonetheless ineluctable and intransigent peculiarities of temporal processes:

1) It is always true, that is, true for all instants, that right now is now.

2) Many things are happening right now, of which I am aware of only a limited subset. (The partition dividing that subset from the set of phenomena of which we are aware is determined by my spatial position, my neural constitution, the extent of my anxiety and other factors. Even so, it seems accurate to say that all temporal instants are related to a multiplicity of phenomena.) Hence:

3) It is not true to say that one thing follows another. It is only true to say that many things follow many.

4) Some events just joined the past. They are gone and cannot be resurrected except in memory. Their traces, however, can be found in the present and (this is somewhat more certain than even death and taxes) in the future.

The cinema we need will build upon the formal consequences of these obvious propositions; it will be a cinema of immediacy, multiplicity; will use non-causal, non-teleological forms of instruction and will not attempt to arrest time.

A cinema that is based on openness to experience will have extremely individualistic characteristics. Will critics who love "common patterns in art" be up to dealing with such

works, or will they sack and pillage them, hijacking their forms and trading them off for use in more traditionally structured works? I don't know the answer to that question but I do know that of all the forms of cinema we have at present, it is the experimental cinema that most closely approximates the cinema I have proposed and that the critical neglect of that cinema would, in a country that cared about its arts—as Canada must learn to do if it is to become anything more than a geographic landmass within the empire of technology—be considered a national disgrace. Right now, critics are proposing to feature filmmakers that the experimental cinema is a good site to pillage. One is tempted to remark, in this period of cultural tedium and human numbness; art is brief but life is long. We endure, in a sacked city, for what?

PATHWAYS TO THE ESTABLISHMENT OF A NIGERIAN FILM INDUSTRY
(Nigeria, 1985)
Ola Balogun

[First published in the *Guardian Sunday Supplement* (Nigeria), 10 March 1985.]

Long before the rise of Nollywood, Nigerian filmmaker Ola Balogun—director of such acclaimed films as *Ajani Ogun* (1975); *Black Goddess* (1978); *Cry Freedom* (1981); *River Niger, Black Mother* (1989); and *The Magic of Nigeria* (1993)—argued for a locally based, inexpensive model of filmmaking for Nigeria and Africa more generally, denying the need for large studios to make local cinemas. Balogun's model was prescient in many ways: near the end of the manifesto he claims Nigerian films can have the same dominance in Africa that Egyptian ones have in the Arab world. Filmmaking in Nigeria changed rapidly and drastically with the rise of Nollywood in the early 1990s with the rise of Betacam and then digital technology, and Nigeria's straight-to-video industry now makes it the third largest cinema-producing country in the world. Balogun, along with pioneering Nigerian cinema in the 1960s, has also gone on to be a renowned musician.

It has long been evident that most African nations are severely handicapped in the mass communications field by the inability of our various national leaderships to grasp the crucial role of mass media in the modern era. This deficiency of long-term vision and understanding on the part of the vast majority of African leaders is further compounded by the fact that in most cases our leaders tend to rely heavily on the views and advice of Civil Service administrators who are about twenty years or so behind time in their perception of the present age, and whose heavy-footed bureaucratic logic is ill-suited to the

requirements of large-scale social mobilization for genuine national development. Disastrously wrong priorities, consistently poor analysis, and repeated instances of bureaucratic bungling that inevitably lead to wasteful dilapidation of previous national resources seem to be all too frequently characteristic of the handling of national affairs in virtually all African countries since independence, irrespective of the type of government in power.

Needless to state, Nigeria has been no exception to the general rule, in spite of the extraordinary volume of resources available to our country for national development purposes, compared to most other African countries. It is therefore hardly surprising to find that in the twenty-five years that have elapsed since independence, successive Nigerian governments have remained thoroughly confused about how best to harness film and television to the nation's needs, while much empty rhetoric over the years by government officials on the need for a film industry in Nigeria has failed to produce even the slightest practical results in this field.

Obviously, the bureaucratic and governmental approach to these issues is not getting us anywhere. It is now long overdue for the people and nation of Nigeria to turn to the views of persons who may be a little bit knowledgeable about the role of mass media in the world of today, in order to determine the best course of action for providing our country with the capacity to make suitable use of film and television in the nation-building process. It is a great pity indeed that many of those who have anything useful to contribute to this country are generally condemned as "radicals," "trouble-makers" and "agitators" and never listened to, while mediocrity and ignorance seem to have become a prerequisite for the exercise of decisive influence on the governmental decision-making process. . . . Why does Nigeria need a film industry? Hopefully, it should not be altogether impossible for the leading lights in our society to comprehend that there is hardly any point in obliging our school children and citizens to memorize the national anthem and to wave little replicas of the national flag in the air if, when they come home in the evening from their various schools or places of work, the main ideas that are to guide them in life come from watching *Dallas* or *F.B.I.* on television, or watching Indian and Kung Fu films in the cinema houses. Surely, it does not require too much effort to understand that people who never have a chance to see their own fellow-countrymen or fellow Africans and other black people portrayed as heroes may wave the national flag as many times a day as they are required to, but will never really acquire a self-confident vision of their own nation as a source of ideas and progress.

In fact, most people in Nigeria (including many of our leaders themselves) know little or nothing about the history of our country and of the African continent. Although nationalistic fervour is constantly being urged on us, names like Jaja of Opobo, Oba Overanmwen, Sultan Attahiru, and Nana Olomu, to name a few of the heroes who played leading roles in Nigerian resistance to the imposition of British rule, are virtually unknown to most of us. In the wider African and black context, how many Nigerians have ever heard of Toussaint L'Ouverture, Marcus Garvey, Chaka the Great, Sonni Ali Ber, or Sundiata Keita? National unity is a constantly recurring leitmotif in official government

speech-making, but how easy is it for Nigerians from one part of the country to learn about the culture and customs of those from another part of the country?

The question therefore becomes: Beyond sacking hapless workers for being unable to recite the national pledge, what can actually be done to instill a worthwhile vision of our goals as a nation in the minds of our people, and to create a collective sense of a shared national destiny in our land?

It may well be that those who are in charge of formulating the nation's policies in the mass media field do not perceive any link between the need to harness our mass media capacities in a positive direction and the achievement of our overall objective of building a strong and self-reliant nation in which all citizens are effectively mobilized for the nation-building effort. It may also be that these folks are right to sit back and hope that one day, M.G.M. or Universal Television in Hollywood will come to Nigeria and make a film about Nana Olomu's resistance to British rule, which they can then purchase during their annual jamborees to world television markets to be shown to our people in between *The Incredible Hulk* and the latest James Bond film. Who knows? Stranger things have been known to happen . . .

It could well happen one day also that a film producer from Hong Kong may get bored with churning out endless remakes of Bruce Lee films and decide to come to Nigeria and make a film centred on Hausa culture, so that people living in Buguma may obtain a better idea of the outlook and life of their fellow-citizens in Katsina. Who knows? According to those who know about such matters, even more wonderful miracles have been known to occur in this world, and many more will no doubt occur in the future. After all, is this not a nation in which we are accustomed to seeking revelations about the names of our future rulers in the Bible?

For those whose faith in miracles may be a bit weak, however, it may well appear evident that if we desire that mass media, like film and television, should play a meaningful role in the future evolution of our nation, we do need to take some practical steps of our own to bring about the desired results, rather than wait for miracles to drop into our laps from the skies above.

What then are the basic steps that need to be taken in order to establish a film industry in Nigeria?

In attempting to answer this question, it would perhaps be useful to begin by dispelling some of the wrong ideas and mistaken notions that have gained ground in this country over the years in connection with our requirements in the field of feature film production.

First of all, it must be pointed out that the much publicized "film village" concept has little or no relevance to the establishment of a film industry in Nigeria. This rather odd concept seems to have surfaced in various forms in the recent past, ranging from absurd projects by a gentleman based in Ondo state, who at one time claimed to be planning to establish a N100 million film village where "honeymoon couples would go to watch Nigerian films being made," to another no less ridiculous claim about plans in hand by

the still-born Nigerian Film Corporation to build a one billion naira film industry in a Nigerian Film Village located on "300 hectares of scenic property in the Shere Hills near Jos" which would form "the most comprehensive film village in Africa."

Needless to state, however, the film village idea, whether costing one hundred million naira or one billion naira, is a red herring that need not occupy anybody's time or attention, whether for honeymoon purposes or film production. Huge capital investment[s] in real estate development are certainly not an essential prerequisite for film production, no matter how impressive it may sound to some of us to hear of gigantic plans to sink fabulous sums of money into the establishment of so-called film villages (or white elephant villages?).

As for film studios, it is useful to bear in mind that the great majority of films that are made today in the world are no longer shot in studios. Most film makers now favour natural locations in order to stress authenticity, with a result that film studios are now mostly useful for certain types of television situation comedies, where all the action occurs within the four walls of an apartment building. Nigeria is a *very* diverse multi-cultural setting, and it can well be imagined that the expense of reconstructing a series of Yoruba or Nupe villages in Jos and of transporting a sufficient number of villagers from the required ethnic areas to act as film extras and occupy the villages in a convincing manner so as to provide an adequate background for filming is far more trouble than deciding to go and film in an authentic Yoruba or Nupe setting, especially as film equipment is now so compact and lightweight that filming on location does not pose as many challenges as in the past. In any case, it would be useful to point out to those who advocate the massive construction of film studios in Nigeria as a preliminary step to the establishment of a film industry that a large-sized film studio has in fact been in existence at the Federal Film Unit lkoyi for well *over* twenty-five years now, but has never been made use of, and is now merely used to store odd items of equipment, while it is equally interesting to recall that a fully equipped television studio existed at lbadan University's Faculty of Education for well *over* ten years without once being utilized. It may also be of interest to point out that none of the numerous feature films that have been made to date in countries as diverse as Nigeria, Senegal, Niger Republic, Mali and Cameroun was made in a film studio. It is simply not true that the construction of gigantic film studios is a prerequisite for film production.

Attention also needs to be drawn to the fact that the relative paucity of technical infrastructure for film making in Nigeria at the moment is by no means an insurmountable obstacle to film production, even though it may constitute a relatively annoying handicap. For Nigerian film makers to be obliged to depend on overseas facilities for such requirements as film laboratory processing is certainly an added source of difficulty for film makers in this country, but we do not need to wait until all these facilities are provided right here in Nigeria before we proceed to make films. In fact, the foreign exchange requirements of Nigerian film makers in connection with overseas technical facilities and laboratories are certainly far smaller than what is generally issued for a single import

licence to importers of sundry commercial items. At the current level of production, less than N15 million is required each year to pay for overseas technical facilities for Nigerian films, which is surely an extremely modest figure if this area of activity is considered important to the nation.

On the other hand, it is a mistake that will surely result in colossal loss of money to seek to build government-run film laboratories, since past experience has amply demonstrated that this kind of infrastructure cannot be efficiently run under bureaucratic management. It is interesting to recall that a government-owned colour film laboratory that was declared open with considerable pomp and fanfare some years ago in Port Harcourt by no less a person than the then Head of State, General Olusegun Obasanjo, has so far hardly been able to process any films at-all, due to assorted problems of lack of suitable chemicals and frequent breakdown of machinery and equipment. Anyone who has been exposed to the realities of government-run technical infrastructures in the field of film in this country will know that it is nothing but an idle pipe dream to hope that such facilities can ever be efficiently managed and maintained within a civil service set-up.

A far better approach to the issue of infrastructure would therefore be to fund the production of Nigerian films to an adequate level of output that would automatically stimulate the provision of infrastructural services by private companies. Thus, if there were for instance to be a certitude that at least twenty Nigerian feature films would be produced in a year, gradually increasing to a hundred and more, private entrepreneurs would then be motivated to establish laboratory, sound mixing and editing infrastructure for film production, and to maintain and run such services properly, contrary to what obtains in government-owned facilities, where equipment is nearly always poorly maintained and badly utilized. Colossal investment by government in technical infrastructure in this field will not really be beneficial to film makers, and will only help fill the pockets of government functionaries who specialize in receiving 20 per cent cuts from purchase of equipment.

In reality, even the already existing technical infrastructure is very much underutilized, while there has been considerable duplication in the purchase of cameras, tape recorders and lighting equipment, both by private film companies and government film units. The sad fact is that at present those private film companies which own complete sets of filming equipment rarely make use of their equipment much more than about once a year, and could therefore well afford to hire out this equipment to other film makers if there were sufficient guarantee of payment, but have so far been deterred from doing so in most cases because many of those who come to hire equipment hardly ever pay in the long run and do not take proper care of other peoples' equipment, partly out of sheer ignorance and lack of professional experience, and partly because they simply do not care. If this kind of attitude could be overcome, there is no doubt that there are more than enough cameras and tape recorders in Nigeria at the moment to meet our needs, particularly at the level of 16mm production. What is mostly needed at the moment is an increase in existing editing facilities and the provision of sound-mixing facilities. Whatever be the

case, however, the massive purchase of millions of naira worth of equipment by the Federal Government is certainly not a pre-requisite for the establishment of a film industry in Nigeria.

Another idea that needs to be laid to rest once and for all is the curious bureaucratic notion that the views and ideas of Nigerian film makers are totally irrelevant to the establishment of a film industry in Nigeria. An analysis of past steps taken by the Federal Government in connection with the proposed establishment of a Nigerian film industry will reveal the following glaring anomalies:

1) At no stage did the powers that be in the Federal Ministry of Information consult any Nigerian or African film makers on the various plans formulated by the Ministry to establish a film industry in Nigeria. Although a panel of film makers and intellectuals who had been assembled by the Ministry of Internal Affairs as far back as 1978 to review the existing Cinematograph laws, and who worked *free of charge* on the task for several weeks, submitted a well-thought-out blueprint for the establishment of a film industry as part of the recommendations they submitted, the Federal Government was misled by certain unpatriotic functionaries to ignore the recommendations of the Nigerian film makers.

2) Instead, the Federal Ministry of Information awarded contracts for feasibility studies to two obscure organizations, one named Francis Associates Ltd. (whose address was said to be 63–66, Martin's Lane, London) in 1978, and another named British Films Nigeria Ltd. (a company registered in Nigeria under the Chairmanship of Alhaji Ado Ibrahim, a leading figure in the defunct N.P.N.) in 1980.[5] It is noteworthy that neither of these two companies has ever been involved in feature film production anywhere else in the world. Francis Associates, for its part, is mainly noted for the fact that it brought the Ipi Tombi dance troupe to Nigeria, while British Films of London, the overseas partner (currently in receivership) of British Films Nigeria, was mainly a manufacturer of film projectors and was also occasionally involved in making documentary films for a few Third World Countries. Quite curiously, Nigeria neither sought the assistance of any of the major European or American companies involved in feature film production, such as M.G.M., Universal, Rank, Gaumont etc., nor of any governments in the west or the east that could share useful information or experiences with us in this field. Those who had pioneered feature film production in Nigeria itself were of course completely ignored in the course of the whole dubious exercise. The Nigerian Federal Ministry of Information instead chose to expend a total amount of money, close to half a million naira, in awarding contracts for bogus "feasibility studies" to two small and relatively unknown entities that are in no way connected with the production of feature films. When blind men lead the equally blind, the results can easily be predicted. It therefore comes as no great surprise to find that the original feasibility study by Francis Associates Ltd. eventually had to be discarded as a perfectly worthless document by the Federal Ministry of Information itself barely one year after it had served as the basis for the promulgation of Decree no. 61 of 1979 setting up the Nigerian Film Corporation. The second feasibility study, which

was commissioned from British Films Nigeria Ltd. at an astronomic cost to this country, has equally been a disastrous failure, as a recent review by a panel set up by the current military administration has now clearly demonstrated.

3) The Nigerian Film Corporation, as established by the Federal Government was set up with a Board of Directors comprising ten members, of whom only one was supposed to represent the interests of Nigerian Film Makers. Given the absolute preponderance on the board of persons totally unconnected with films and almost completely uninformed on the subject of films, it is still not entirely clear if the aim of gathering together such a large and motley crowd of persons to serve on the Board of the Film Corporation was to constitute a football team, to act as a social club, or to help swell the number of guests at cocktail parties hosted by the Nigerian Film Corporation. All that can be said, however, is that four years after it came into existence by decree, and after two years of valiant efforts directed from a very expensive office site in Victoria Island, Lagos, the Nigerian Film Corporation has never managed to produce even five seconds' length of film of any shape, size or description, despite total expenditure to date well in the region of N1 million, if payments for the various "feasibility studies" are taken into account.

Obviously, the past approaches by the Federal Government to the issue of setting up a film industry in Nigeria have so far not yielded much result, to state matters mildly. Hopefully, matters may improve slightly under the present government, although certain signs point to a continuing preponderance of the bureaucratic point of view. Unfortunately also, a number of uninformed persons, masquerading as media experts, have confused issues considerably by publishing various misleading articles on the situation of Nigerian film in the newspapers, and in one case, in a thoroughly fraudulent book published by the Mass Communications Department of one of the country's leading universities. Amazingly enough, most of these self-proclaimed experts have never before set foot where a Nigerian film is being made or taken the elementary trouble of finding out how films are actually made, or seen fit to find out what the economic, social and material context of film production in Nigeria actually is. And yet all these people have theories about how a film industry should be established in Nigeria, while some of them who happen to be strategically located within the bureaucratic establishment itself actually exercise the power of decision over matters about which they are entirely uninformed!

Ironically enough, even those who are somewhat better informed on the subject, but who are hesitant to take a firm stance on such matters, are quick to castigate those who insist that the issue of the establishment of a film industry in Nigeria demands clarity of thought for displaying what is labelled as "intellectual arrogance" in such circles. Somehow, one is expected to concede that there may be several different equally correct points of view on the same issue, even after one has proved by logical analysis that many of those points of view are in fact erroneous. It is difficult to understand why a desire to remain within the scope of logical analysis in such matters should be deemed to be a display of intellectual arrogance. The fact is that, just as in mathematics, it is not possible to come

up with fifty different correct answers to the same problem, there can only be one correct approach to the optimal manner of setting up a film industry in Nigeria if the problem is approached on the basis of a serious analysis of the material factors involved. It is not intellectual arrogance to be impatient with people who spring up overnight with ridiculous concepts of "film villages" as the best approach to establishing a Nigerian film industry. It is simply that after a while one gets tired of being confronted with illogical and woolly reasoning. Ideas that spring from insufficient analysis and inadequate understanding of a given problem can only be wrong. And if an idea is wrong, it is wrong. It cannot at the same time be right. Why then waste time postulating that there can be fifty different solutions to the same problem once it has been demonstrated that forty-nine are wrong and one is right? Is it "intellectual arrogance" to value clarity of thought?

Obviously, if at some stage in time, the people and government of Nigeria truly desire to see a film industry established in this country, it may prove useful for the following points to be taken into consideration as the only correct approach to the establishment of a Nigerian film industry:

1.) The basic prerequisites for a film industry in any country are:
 a) People to make films,
 b) Funds for the production of films, and
 c) Outlets for the screening of completed films.

2.) Nigeria has abundant materials to serve as subjects for films, ranging from our folk tales to our cultural heritage, episodes of our past history, published plays and novels, original screenplays etc. Nigeria also has a wide variety of potentially proficient actors, quite a few persons capable of directing films (including some who are currently employed as television producers), a small but gradually increasing reservoir of technical personnel, and a fabulously large and enthusiastic population who are eager to watch Nigerian films. What Nigeria therefore lacks for film production to actually take off are funds for the production of films and outlets for completed films to be shown (including on television).

3.) Funds for the production of films can be provided in the following ways:
 a) Direct subvention by government.
 b) Tax deductions and other incentives to encourage investment in film production by the private sector. (This has been the key to the recent rapid growth of a home-based film industry in a country like Australia.)
 c) Allocation of all revenue derived from entertainment tax paid by cinema-goers into a central fund to be used in financing indigenous film production. Nigerian and African films should also be exempted from paying any form of tax whatsoever in Nigerian cinema houses for as long as it takes to build up a sizeable volume of such films.

d) Additional taxation imposed on the importation of all foreign films screened in Nigeria, including on television. Such additional taxes should go to swell the funds set aside for indigenous film production.

e) Instructions to all banks and financial institutions by government to devote a small minimum percentage of their lending portfolio to activities related to the entertainment industry, including film.

f) Government guaranteed loans and other financial facilities granted to film makers to facilitate the production of films.

4.) Outlets for the screening of Nigerian films can be ensured by:

a) A reorganization of Nigerian television broadcasting to ensure that scope is provided for the screening of Nigerian films on Nigerian television. It is noteworthy that in twenty-five years of existence, Nigerian television (which sometimes screens as many as ten or more foreign films each and every weekend) has never once purchased and screened even a single Nigerian feature film.

b) Legislation to oblige all film houses in the country to screen a minimum number of Nigerian films each year, and to pay a fixed minimum percentage of gate proceeds to the producers of these films. In Brazil, for instance, each cinema house must prove that it has shown Brazilian films for 110 days out of 365 days during the preceding year in order to qualify to have its licence renewed.

c) Imposition of a quota system designed to gradually restrict the quantity of foreign films imported into Nigeria, in direct proportion to the growth of indigenous film production.

d) Strict copyright controls and outright ban of pirate video recordings.

e) Construction of more cinema houses and imposition of minimum standards of safety and comfort in cinema houses. It is noteworthy that cities like Bombay, Paris or New York have more cinema houses each than the whole of Nigeria combined, while over 95 per cent of existing cinema houses in Nigeria are so far lacking in facilities and comfort that they cannot be described as cinema theatres. Most are merely makeshift open air cinemas functioning with antiquated and poorly maintained projection equipment dating back twenty years or more in many cases.

f) Creation of a chain of low-cost 16 mm format cinema theatres integrated into civic centres or town halls all over the federation.

g) Active arrangements through Nigerian trade missions and commercial representatives to distribute Nigerian films in other African countries and in some selected overseas markets. Needless to state, Nigeria has more than sufficient ability to dominate the whole of the black Africa in the area of supply of films, in rather the same way as Egypt has dominated nearly all of the Arab world for several decades now. Un-

doubtedly, Nigeria stands to earn considerable foreign revenue from a judicious programme of distribution of Nigerian films across the African continent.

h) If enough outlets are provided for the distribution of Nigerian films both within and outside Nigeria, enough income will be generated to gradually make the Nigerian film industry almost entirely self-supporting in the long run.

In conclusion, it must be pointed out that Nigeria has both the means and the capacity to establish and sustain a film industry. With judicious planning, the establishment of a film industry in Nigeria requires relatively little effort. If, however, the issue continues to be approached from the point of view of bureaucratic procedures and methods, it is obvious that we will continue to grope and stumble in the dark in this field for the next twenty years without succeeding in establishing a film industry.

MANIFESTO OF 1988 (German Democratic Republic, 1988)

Young DEFA Filmmakers

[This manifesto was first written to be circulated at the 5th Congress of Film and Television Workers of the GDR in 1988. First published in German in *Film und Fernsehen* 10 (1990): 21. First published in English in *Film History* 15 (2003): 452. Trans. Roger P. Minert.]

This manifesto emerged out of discussions between filmmakers in East Germany near the very end of the Cold War. Originally, it was to be read at the 5th Congress of Film and Television workers that year, but was not, for fear of reprisals and the loss of jobs. The manifesto therefore went unmentioned at the conference. The manifesto shows the internal contradictions and political confusion in the GDR at the time, with talk of both censorship and autocritique right before the fall of the Berlin Wall.

1. Motion pictures are a medium of society. Stagnation in the control of influence over our motion pictures and the social processes evident in recent years represents principally the surrender of our responsibility, but at the same time the expression of the social condition. Society must reveal itself in every aspect to the motion pictures. It must trust this medium and challenge and support it. We declare our willingness to actively and positively cooperate in the socialistic development of our society and to assume responsibilities.

2. The motion picture theater in the GDR is in a state of crisis. This involves not only national production, but also distribution, the film experience, critique, and theory. Thus the spectator is also involved. Motion pictures are primarily an expression of the merely temperate artistic and the ideological and economical effect and result of the nation's motion picture production. Personal involvement is in only too great opposition to the actual possibilities, affecting the public consciousness tangibly. Individual successes no longer change the situation. Only through radical questioning of existing conditions and cooperative action can we regain for the motion picture theater its place in public life.

3. Our films are devoid of extreme situations. By special emphasis we can make inroads in the processes of reality, the results of which cannot yet be determined. The goal is to re-discover the enjoyment of a provocative view. It is necessary to promote motion pictures with greater energy and to confront critical topics directly. By doing so we further the re-awakening of artistic methods that distinctly expose the conflicts and actually carry these to completion.

4. It is the social responsibility of motion pictures in a socialist country to reflect reality in a partisan manner in the spirit of national unity, and to exercise influence over this process. The prerequisite for this is independent intercourse between critique and self-critique. No critical thought in a film, about a film, or about motion picture production should be placed in the camp of enemy observations.

5. In order for a renewal and improvement of our motion picture production to take place, there must be a break with existing taboos—taboos in topics and in perspectives. The internalization of taboos has led to self-censoring, which has made a more or less serious impression on all those involved in the collective creative process and has led for all practical purposes to distinct restrictions in the effectiveness of motion pictures.

6. In order to have precise points for the actual status of DEFA motion pictures, we need true statistics on the number of theater goers as well as an accessible and differentiated analysis of the effects. From those reports a recognizable strategic and tactic review must be formulated, in order to raise the effect of our motion pictures—and above all the effect thereof on the masses.

7. The production structures of the past do not allow the production of motion pictures in the necessary thematic and design variety. Thus we propose the construction of a facility that can be managed by minimal administrative effort and can take advantage of strong personal involvement. This would be a highly-valued facility in which successive generations of production talents would find an opportunity to work, but where experienced colleagues could also make films.

8. An inevitable condition for the development of our motion pictures would be the perspective of foreign films, student travel in foreign countries, and participation in international film festivals. In short: a comparison with the outside world. In an era when mankind is threatened qualitatively by new forces and enticements, more than ever before we will have to understand and produce motion pictures and guide their effect as a system open to the world.

IN PRAISE OF A POOR CINEMA
(Scotland, 1993)

Colin McArthur

[First published in *Sight and Sound* 3, no. 8 (1993): 30–32.]

Much of Colin McArthur's work (most notably the seminal *Scotch Reels* [BFI, 1982]) can be understood as series of manifestos arguing for a local, culturally engaged Scottish cinema that throws off the incessant drive to compete with Hollywood. If *Scotch Reels* lambastes the reliance of tartanry and kailyard as defining and self-colonizing representations of Scotland, "In Praise of a Poor Cinema" aims its sights at Scottish funding agencies' own self-colonizing tendencies in the search for capital.

". . . to ensure the development of a viable, vigorous, and substantial Scottish film industry designed to attract and deploy the talents of Scottish film-makers and to enable them to make films in their own country . . ." (From the 1991 Annual Report, Scottish Film Production Fund.)

This, of course, is a fantasy which has beguiled the Scottish Film Production Fund (SFPF) and its parent body, the Scottish Film Council (SFC), since its inception in 1982. As, in these post-Marxist days, babies are being thrown out with the bathwater all over Europe, many indispensable concepts are being jettisoned. One such concept, *uneven development,* describes perfectly Scotland's relationship with diverse sectors of the UK economy, not least film production. To put it bluntly, Scotland is, on the film-making front, a third world country—but this is tragically misrecognised by those holding the purse strings north of the border. There have always been signs that the SFPF and SFC were on a collision course with reality. One of the earliest officers of the fund talked about discovering "the next generation of Bill Forsyths" and senior officers of the SFC, at their most delirious, have been heard to speak of "Hollywood on the Clyde."

When the stated policy is compared with the reality of the fund's most recent invest-ment, *Prague*, the gulf is stark. Apart from the fact that producer Christopher Young, producer/director Ian Sellar and one of the principal actors, Alan Cumming, are Scots, *Prague* has nothing to do with Scotland and could not be remotely construed to fulfil what might be assumed to be a central impulse of a new national cinema—the exploration of the contradictions of the society from which it comes.

Individual film-makers should not be blamed for using whatever production mecha-nisms are available, but the Scots involved in *Prague* were the figleaf which allowed the project to absorb a massive proportion of the SFPF and decorated the Euro-pudding the film was to become. During the period when *Prague* was in development and production, the SFPF stood at about £250,000 per annum. Over two financial years it invested no less than £130,000 in *Prague*, having in previous years put an equally generous £100,000 into an earlier film, *Venus Peter* (1989), by the same production/direction team. This tendency to put available eggs into a small number of baskets is reminiscent of central Scotland's costly dependence on a few heavy industries earlier in the century.

The precise details of the discussions between Young/Sellar and the SFPF will prob-ably never be known, but what is clear is that Young himself would like to be making considerably cheaper films than *Prague*, at £1.95 million, turned out to be. Did the SFPF actively steer *Prague* towards inflationary mechanisms like the BBC's Screen Two, which put up about £500,000 of the budget?

There are cultural as well as economic questions to be asked. For example, it seems that Young, in the letter which accompanied his original script submission, indicated that the central character might be American (rather than, as in the realised film, Scot-tish). Despite the fact that this would further distance the already tenuous connection of the project with Scotland, the SFPF did not regard it as in any way problematic. While the fund's annual report makes much of the fact that the great bulk of *Venus Peter's* budget entered the economy of the film's location, the Orkneys, it is silent about the destination of the budget for *Prague*, which entered economies far distant from Scotland's. A major insertion of French money brought *Prague's* budget up to nearly £2 million and the project was designated a British/French co-production. In recompense, the French required that some 45 per cent of the budget be spent in France, a condition realised primarily by having the film processed at a French lab. As far as I am aware, none of *Prague's* budget was spent in Scotland.

The main impulse of the SFPF is towards projects which will attract finance from diverse sources and consequently compete for attention on the world stage. A largely unrecognised contradiction here is that the larger the project, the less Scottish it becomes. It might be argued that the fund's most successful area of operation has been in spring-boarding a handful of Scottish film-makers into international production. It has been the fund's practice to subsidise the graduation films of Scots students at the National Film and Television School in Beaconsfield. One such was Michael Caton-Jones' The *Riveter* (1986). Caton-Jones is now comfortably ensconced in Los Angeles. In an interview in the

Observer Magazine in 1991, he remarked: "In a way I had no roots. I had left Scotland at 18 and drifted to the London area. Leaving for Los Angeles was no great wrench. . . . I doubt if I'll go back to Britain." So much for the policy "to enable [Scottish film-makers] to make films in their own country." Caton-Jones is currently listed as director of the forthcoming *Rob Roy* (producer Peter Broughan, writer Alan Sharp), which is already in receipt of development finance from the fund.

COMMITMENT TO THE MAINSTREAM

This springboarding of individual careers is joined by a complete misconception of what might constitute an appropriate production policy for Scotland's economic and cultural circumstances. There is one statistic which should be branded on the foreheads of those who call the shots in the SFPF and the SFC: of the eight feature films analysed in the 1993 *BFI Film and Television Handbook,* the average budget was £1.8 million, and the average net revenue only £0.8 million. Presumably data of this order was available to the SFPF when it became involved with *Prague.*

The root cause of the SFPF's and SFC's failure to articulate a meaningful production policy lies in their surrender to an industrial model rather than in posing the question in terms of *cultural* need. The fund's commitment to film as commodity is evident from the projects into which it puts the bulk of its funds and from the backgrounds of those who have recently served as part of the group which makes the funding decisions, including Roger Crittenden (NTFS); Bill Forsyth (director); Charles Gormley (director); Mamoun Hassan (producer); Liz Lochead (writer); Bernard MacLaverty (writer); Lynda Myles (producer); Bill Paterson (actor); Iain Smith (producer) and Archie Tait (producer).

Individually these are all bright and able people, but collectively, with the exception of Liz Lochead, the orthodoxy of their recent backgrounds and their commitment to mainstream and therefore expensive aesthetic forms are overwhelming. A costing of the projects in which they have been involved within recent years would be hardly likely to dip beneath the average of £1.8 million cited above and would most likely be considerably above it. The most glaring absence from the list is of any figure who could bring in a feature film (such as Derek Jarman's *Wittgenstein*) for around £300,000. The absence is not accidental. Like the SFC, the SFPF has from the outset set its face firmly against the aesthetic tradition of such films. One of the most unfortunate results of their freezing out of alternative voices is that public funders and potential private investors in Scotland are kept in the dark about film production practices which are not only more commercially viable, but more culturally necessary than the practices currently funded.

Institutions are rarely monolithic, and the current Director of the SFPF, Kate Swan, was herself the producer of *Play Me Something* (1989), an excellent film by Timothy Neat which managed, on a budget of £375,000 and in a way *Prague* did not, to be both Scottish and European (and a great deal more) simultaneously. To underline the lack of monolithicism, the SFPF put a small amount of money into *Play Me Something.* But the prom-

ising track record of the fund's current Director and its own occasional backing of the right horse must be set against the orthodoxy of those making the funding decisions and where they have put the vast bulk of available monies.

The present board gives even less comfort to those looking for a low-budget cinematic aesthetic: Allan Shiach (Chairman); David Aukin (Head of Drama, Channel 4); Colin Cameron (Head of Television, BBC Scotland); Paddy Higson (independent producer); Sandy Johnson (independent television director); Margaret Matheson (independent film producer for television); Scott Meek (independent film producer for television); George Mitchell (Controller of Programmes, Grampian TV); Colin Young (former Director of the National Film and Television School). There is one figure in the above line-up who has recently become a key player. Under the name Allan Shiach he is a rich and prominent businessman (Chairman of the Macallan-Glenlivet whisky operation); under the name Allan Scott he is a successful Hollywood screenwriter, most notably in his collaborations with Nicolas Roeg. He is now chairman of both the SFC and the SFPF.

It is possibly not accidental that following Shiach/Scott's entry to the Scottish film scene there should emerge Movie Makers, an event designed to explore the craft of classic Hollywood screenwriting which brought William Goldman to Scotland. The discourse about classic Hollywood screenwriting is immensely interesting and has achieved considerable prominence in recent years through manuals such as Syd Field's *Screenplay* and *The Screen-writer's Workbook* and through Robert McKee's Screen Structure Course. But one of its effects is to fetishise the classic two-hour Hollywood script and forbid entry to other ways of thinking and making cinema. As such, it dovetails perfectly with the dominant ideology of film production in Scotland.

One other recently created mechanism has given the final impetus to Scotland's headlong rush towards an industrial conception of film-making—the Glasgow Film Fund. It currently stands at £150,000 per annum, made up of contributions from the Glasgow Development Agency, Strathclyde Business Development, Glasgow City Council and the European Regional Development Fund, and will be administered by the SFPF, concentrating nearly all public funding of film-making in Scotland within a tight group of individuals working to highly exclusive policy criteria. The GFF's terms of reference are frankly commercial, designed to stimulate film-making in the Glasgow conurbation and to pull money into the local economy. Only feature film projects with a budget of at least £500,000 are said to be eligible to apply.

STAGGERING BANALITY

It is perhaps understandable, given the career profiles of those who serve on its board, that the SFPF should lock on to an industrial model of film-making. It is more surprising that an ostensibly cultural body like the SFC should espouse the same values. It recently produced *The Charter for the Moving Image in Scotland,* a document of staggering banality, which, when it is not whining about inequity of public funding of the moving image in

Scotland in relation to the rest of the UK, proposes utopian structures of truly megalo-maniac proportions such as a Scottish Screen Agency which would subsume all existing film mechanisms and concentrate funding powers in even fewer hands. Symptomatically, during the period when the resounding phrases of the charter were being sculpted, Scotland's only independent film studio and lab facility closed down.

All this would be serious enough, but conversations with Scottish film-makers who have had dealings with these bodies suggest a more disturbing picture in which those projects most rooted in Scottish culture and most challenging to the dominant ideology of production are actively opposed, if not as a matter of explicit policy by these bodies, then by powerful voices within them. It might indeed be asserted that the most distinctively Scottish of recent films *(Silent Scream; Tickets To The Zoo; Blue Black Permanent; As An Eilean)* have been made because forces outside Scotland, particularly two English commissioning editors at Channel 4, Alan Fountain and Rod Stoneman, have been prepared to put money into projects figures in the Scottish film establishment would have preferred to see die. As a footnote to that establishment's judgment, the projects it has been most hostile to are the ones which have won awards at foreign festivals.

The absence of cultural analysis in the discourses of the SFC and the SFPF has meant that they have both been unequipped to think of alternatives to the industrial model, or to recognise the problems relating to national culture and identity that the industrial model might create. For instance, a recent article in the Scottish press indicated that research had revealed that German executives have an image of Scotland which leads them to think of it as a place to rest in rather than to invest in. In short, "dream Scotland." To the extent that the main impulse of Scottish films is to address a wider "market"—a key principle of the SFPF—the dilemma they face is how to do so without recourse to regressive discourses such as "dream Scotland." It might be thought, given their commitment to an industrial model of film-making and their rhetoric about attracting investment into Scotland, that the SFPF and SFC would have given some thought to how the "dream Scotland" narrative might be dislodged from the heads of German executives to be replaced by other narratives more conducive to seeing Scotland as a modern industrial nation. But there is no evidence that the SFPF and SFC are even aware of the problem. The SFC and SFPF have had too easy a ride. Mainly because film-making grew out of the sponsored documentary tradition of Films of Scotland, there have been no substantial cadres of avant-garde independents putting pressure on them, analogous to that exercised on the BFI in England and Wales. With a few honourable exceptions, local film journalists have shown no capacity to interrogate, as opposed to simply report, the initiatives of Scottish film institutions. This environment has reinforced the sleekitness of the SFC and SFPF and ensured that they would face no sustained pressure to articulate policy options and discuss them with their constituencies. Thus the industrial model of film-making simply "emerged" in Scotland, rather as the leader of the Conservative Party used to, without any proper discussion of alternatives. What, then, is to be done?

When the SFC and SFPF finally face up to the fact that film-making in Scotland of a kind relevant to questions of national identity and culture must be low-budget film-making, they are going to have to educate themselves and their constituencies into a different set of aesthetic strategies and institutional arrangements. An obvious first step would be to strengthen the workshop sector in Scotland, the only sector (apart from a handful of independents) with the necessary expertise to facilitate what could be called a Poor Scottish Cinema, that is to say poor in resources and rich in imagination. The Scottish workshops ought, in effect, to become mini-studios through which grantees from the SFPF should realise their projects. The SFPF must also begin to recruit to its board figures who have some understanding of the ·aesthetics and economics of Poor Cinema. One obvious such figure is James Mackay (as it happens, a Scot from Inverness), whose production credits include Ron Peck's *What Can I Do With A Male Nude?* (budget £5,000), Derek Jarman's *The Last of England* (budget under £250,000) and *The Garden* (budget £370,000), and *Man To Man* (budget £155,000). Mackay's projects have consistently used Super-8 (often blown up to 35mm for cinematic release) and, increasingly, electronic imaging. Another recruit to the SFPF ought to be the man who coined the term "electronic imaging," Colin MacLeod, a world authority on the subject working at Napier University, Edinburgh.

The SFC and the SFPF must then lead their constituencies through a process of discussion about how imaginative and culturally relevant cinema can be achieved on meagre resources. There are good examples from within Scottish film history itself, for example the Bill Douglas trilogy, the early feature films of Bill Forsyth and certain of the films of Murray Grigor, Brian Crumlish and Mike Alexander. But examples should also be drawn from further afield: Chris Marker's *La Jetée,* which is wholly, and Alain Resnais' *Night and Fog,* which is partly, made up of still images; Jean-Luc Godard's *Les Carabiniers* and Dusan Makavejev's *The Switchboard Operator,* which make extensive use of pre-existing footage; Hans Jurgen Syberberg's *Ludwig: Requiem For A Virgin King,* which instead of built sets uses blown-up transparencies as background to the action; the austere cinema of Robert Bresson; the cinema of Derek Jarman and other English independents; third world cinemas, particularly those of Africa and Latin America.

Getting budgets below £300,000 would not only make profitability more likely for individual films, but would see many more specifically Scottish features emerging, perhaps eventually reaching the critical mass of ten features a year which the SFC is fond of canvasing. What it would produce at least is a pack of cards whereby the nature of a Scottish cinema, its recurrent themes and styles, might begin to be discerned. As things stand, the possibility of a nationally specific Scottish cinema (which need not preclude influences from Hollywood and elsewhere or fail to recognise the necessary hybridity of all national cultures in the modern world) is becoming increasingly remote as Scots film-makers are forced into contortions to raise money from American and pan-European sources.

This leads naturally to the question of how critical recognition of national cinemas is generated. Festival entry and subsidy for distribution and exhibition may not (by themselves) be the most effective or economic routes. There is a historical lesson to be learned here. Italian neo-realism, French *nouvelle vague,* Brazilian *cinema novo* and so on were internationally recognised as such mainly because they were taken up and discussed in film criticism and journalism. It is not beyond the bounds of imagination that a *nouveau cinema ecossais* might be similarly constructed. As is so often the case in Scotland (as with *Gregory's Girl*), celebration abroad might facilitate recognition (and further funding) at home. It would be nice to think that a simple journal could be sent free of charge to every cinematheque, film festival, film magazine and Channel 4–type television network in the world which, without being a hype or lap-dog journal, would have as its main aim to outline what is happening in Scottish cinema and to construct its diverse films as some kind of collectivity. There are several historical precedents for this, for example the journals circulated by Unifrance and Film Polski.

TARTAN SHORTS

This essay will be read perversely on several fronts. It will be suggested that it is intrinsically hostile to classic, narrative cinema, though that can be easily discounted by the most cursory glance at the author's other critical writings. It will be suggested that the concept of Poor Cinema envisages a restricted range of aesthetic forms. Quite the reverse, as the examples cited (from the Loachian realism of *Tickets To The Zoo* to the Brechtian multi-textuality of *Les Carabiniers*) indicate. Finally, it will be suggested that it trashes the entrepreneurial efforts of individual Scots film-makers. This also is not true. One can have nothing but admiration for those Scots who have fought their way through to some kind of international recognition (well, most of them) although they may have had to pay a price in terms of the relevance of their work to Scottish culture.

As this article was going to press the SFPF did two things which encapsulate all that is wrong with its policy. It issued a press release hailing the success of the first round of short films it funds jointly with BBC Scotland. Renamed "Tartan Shorts"—appropriately, the project wraps itself in that most regressive of Scottish discourses, Tartanry—it provides for three ten-minute shorts to be funded each year at a cost of £30,000 per short. The press release is clear about the kind of films to be funded. They must be "narrative shorts" and it is envisaged that grantees will "springboard from the making of a short on to a first feature film."

Concurrent with the press release, two young Glasgow-based film/video-makers, Douglas Aubrey and Alan Robertson, received a letter from the SFPF informing them that their request for funding to complete their feature film had been turned down. *Work, Rest and Play* is a bitter, Kerouacian road movie in five 20-minute parts, two of which have already been completed with £6,000 of Aubrey and Robertson's own money and the down time of sympathetic facilities houses, independent producers and educational institutions. It is

also a technological palimpsest for our time, involving video footage shot on VHS, low- and high-band U-matic, Hi8 and Betacam SP; computer graphics realised by Quantel Paintbox, Spaceword Matisse and Wavefront; and the deployment of sound samplers and digital storage systems. In short, it is a superb example of Poor Cinema.

It is scarcely credible, but at the very moment when it was passing up the chance to put £15,000 (the sum requested) towards the realisation of a feature-length Scottish road movie, the SFPF was trumpeting abroad the fact that it had invested £90,000 in three ten-minute shorts. By a cruel irony, the director of one of these shorts is Peter Capaldi, writer of the flashily empty road movie *Soft Top, Hard Shoulder*, which has none of the "condition of Britain" bite of *Work, Rest and Play*.

More than ever, the creeping centralisation of film funding in Scotland needs to be reversed and the following key issue addressed: what kind of cultural and economic (in that order) policies need to be adopted by Scottish film institutions to create in the first instance a culturally relevant and in the longer term economically viable Scottish cinema? To raise such an issue implies the possibility of change in those great lumbering dinosaurs of Scottish film culture, the SFC and the SFPF. Dream on![6]

DOGME '95 MANIFESTO AND VOW OF CHASTITY (Denmark, 1995)

Lars von Trier and Thomas Vinterberg

[First distributed on 15 March 1995 at *Le cinéma vers son deuxième siècle* conference in Paris.]

The Dogme '95 manifesto is largely responsible for the revitalized interest in film manifestos in recent years. Lars von Trier, one of the two coauthors, had been writing manifestos to accompany many of his films. An ironic call to action, Dogme '95 and the Vow of Chastity both invoked the supposed failures of previous aesthetic revolutions in the cinema, most notably *la nouvelle vague*, and at the same time, proclaimed a dogmatic list of technical constraints never found in antecedents such as neorealism, *la nouvelle vague*, or New German Cinema. Dogme's greatest success was as a publicity tool, placing New Danish Cinema on the map in the process. While not a national movement per se, the critical success of the Dogme films is largely tied to the Danish ones—such as *Festen* (*The Celebration*, Thomas Vinterberg, 1998); *Idioterne* (*The Idiots*, Lars von Trier, 1998); *Mifunes sidste sang* (*Mifune's Last Song*, Søren Kragh-Jacobsen, 1999); *The King Is Alive* (Kristian Levring, 2000); *Italiensk for begyndere* (*Italian for Beginners*, Lone Scherfig, 2000); *En Kærlighedshistorie* (*Kira's Reason: A Love Story*, Ole Christian Madsen, 2001); and *Elsker dig for evigt* (*Open Hearts*, Susanne Bier, 2002)—while most of the international productions were largely, and quite justifiably, quickly forgotten.

DOGME 95 is a collective of film directors founded in Copenhagen in spring 1995.

DOGME 95 has the expressed goal of countering "certain tendencies" in the cinema today.

DOGME 95 is a rescue action!

In 1960 enough was enough! The movie was dead and called for resurrection. The goal was correct but the means were not! The new wave proved to be a ripple that washed ashore and turned to muck.

Slogans of individualism and freedom created works for a while, but no changes. The wave was up for grabs, like the directors themselves. The wave was never stronger than the men behind it. The anti-bourgeois cinema itself became bourgeois, because the foundations upon which its theories were based was the bourgeois perception of art. The auteur concept was bourgeois romanticism from the very start and thereby . . . false!

To DOGME 95 cinema is not individual!

Today a technological storm is raging, the result of which will be the ultimate democratisation of the cinema. For the first time, anyone can make movies. But the more accessible the media becomes, the more important the avant-garde. It is no accident that the phrase "avant-garde" has military connotations. Discipline is the answer . . . we must put our films into uniform, because the individual film will be decadent by definition!

DOGME 95 counters the individual film by the principle of presenting an indisputable set of rules known as THE VOW OF CHASTITY.

VOW OF CHASTITY

I swear to submit to the following set of rules drawn up and confirmed by DOGME 95:

1. Shooting must be done on location. Props and sets must not be brought in (if a particular prop is necessary for the story, a location must be chosen where this prop is to be found).
2. The sound must never be produced apart from the images or vice versa. (Music must not be used unless it occurs where the scene is being shot).
3. The camera must be hand-held. Any movement or immobility attainable in the hand is permitted. (The film must not take place where the camera is standing; shooting must take place where the film takes place).

4. The film must be in colour. Special lighting is not acceptable. (If there is too little light for exposure the scene must be cut or a single lamp be attached to the camera).

5. Optical work and filters are forbidden.

6. The film must not contain superficial action. (Murders, weapons, etc. must not occur.)

7. Temporal and geographical alienation are forbidden. (That is to say that the film takes place here and now.)

8. Genre movies are not acceptable.

9. The film format must be Academy 35 mm.

10. The director must not be credited.

Furthermore I swear as a director to refrain from personal taste! I am no longer an artist. I swear to refrain from creating a "work," as I regard the instant as more important than the whole. My supreme goal is to force the truth out of my characters and settings. I swear to do so by all the means available and at the cost of any good taste and any aesthetic considerations.

Thus I make my VOW OF CHASTITY.

Copenhagen, Monday 13 March 1995

On behalf of DOGME 95

I SINEMA MANIFESTO (Indonesia, 1999)

Dimas Djayadinigrat, Enison Sinaro, Ipang Wahid, Jay Subiykto, Mira Lesmana, Nan T. Achnas, Richard Butario, Riri Riza, Rizal Mantovani, Sentot Sahid, Srikaton, Nayato Fio Nuala

[First published in Tilman Baumgärtel, ed., *Southeast Asian Independent Cinema* (Hong Kong: Hong Kong University Press, 2012), 151. Trans. Dimas Djayadinigrat.]

A central manifesto for the post-Soeharto Indonesia, the "I Sinema" manifesto played a key role in the developing critical discourse of the emerging Indonesian cinema, though the manifesto was more well-remembered by filmmakers than read, and was only published for the first time in 2012, in English.

1. Film as Freedom of Expression.
2. To find a new art form and genre in Indonesian film industry.
3. To maintain originality from censorship.
4. The ability to use any film material to achieve feature film standard.
5. To maintain independence in production and distribution.

3

THIRD CINEMAS, COLONIZATION, DECOLONIZATION, AND POSTCOLONIALISM

Next to the avant-garde, the debates surrounding Third Cinema have produced more manifestos than any other area of the cinema. This chapter begins with a collection of the major Third Cinema manifestos and their precursors in Latin America, which trace the developing sense of urgency in Latin America to produce a local cinema that addresses the needs and aspirations of both Latin American filmmakers and audiences. Mexico, often left out of the debates about the need for a *Third Cinema*—a key term coined in one of the manifestos contained herein—was particularly fertile ground for the development of an indigenous cinema, as Mexican films often lived in the shadow of Luis Buñuel. This chapter also includes the key manifestos of the Third Cinema movement, including texts by Fernando Birri, Julio García Espinosa, Fernando Solanas, Octavio Getino, and Jorge Sanjinés. All these filmmakers call for a new kind of cinema, one that disavows the escapism and ideology of Hollywood and forgoes the celebration of the director as auteur. These manifestos argue, instead, for a collective, politically engaged cinema.

The goal of decolonization also inspired groups outside of Latin America. The manifesto of the Palestinian Cinema Group, for instance, addresses the dire need for an independent and revolutionary form of cinema practice to work hand in hand with the Palestinian Liberation Organisation in the creation of an independent Palestine. The influence of Third Cinema and the discourses of decolonization are also taken up in the first world. For instance, the independence movement in Québec was greatly influenced by writers such as Frantz Fanon and Albert Memmi. In "The Cinema: Another Face of Colonised Québec," the Association professionnelle des cinéastes du Québec argues that the dominance of American cinema and international capitalism marginalized the possibility of Québec's producing films that reflect the lives of Québécois filmmakers and audiences, where a great deal of local production simply amounted to soft-core pornography (and part of a larger subset of 1970s Canadian production that has retrospectively been dubbed Maple Syrup Porn).

African-born French filmmaker Med Hondo argues for a new form of cinema that reflects the lived experiences of Africans and the African diaspora. The "Niamey Manifesto of African Filmmakers" codifies many of these problems and outlines the goals and need for a pan-African cinema. In a similar vein John Akomfrah's "Black Independent Filmmaking: A Statement by the Black Audio Film Collective" addresses the need for a black-British filmmaking practice and outlines the ways in which the Black Audio Film Collective will undertake such a program. The "FeCAViP Manifesto" outlines similar goals for pan-Caribbean filmmakers. The chapter ends with a manifesto of protest from the first world, released by writers and filmmakers protesting TIFF's (Toronto International Film Festival) programming of a series of films celebrating Tel Aviv at a time when

Israel was taking aggressive actions against Palestine. All these manifestos point to the global nature of the cinema. While these global tendencies are often celebrated, most notably just before the emergence of sound, they nevertheless work in an ideological fashion, to marginalize and disavow voices from developing countries, especially when these voices are engaged in radical dissent.

MANIFESTO OF THE NEW CINEMA GROUP (Mexico, 1961)

El grupo nuevo cine: José de la Colina, Rafael Cordiki, Salvador Elizondo, J. M. García Ascot, Emilia García Riera, J. L. González de León, Heriberto Lafranchi, Carlos Monsiváis, Julio Pliego, Gabriel Ramírez, José María Sbert, and Luis Vicens. Subsequently signed by José Baez Esponda, Armando Bartra, Nancy Cárdenas, Leopoldo Chagoya, Ismael García Llaca, Alberto Isaac, Paul Leduc, Eduardo Lizalde, Fernando Macotela, and Francisco Pina

[First published in Spanish as "Manifiesto del Grupo nuevo cine," *Nuevo cine* (Mexico) 1 (1961). Trans. Fabiola Caraza.]

It is often forgotten that along with Cuba, Mexico was at the forefront of arguing for new forms of Latin American cinema. This manifesto from 1961 not only argues for the cinema as a means of personal and national expression, but also for the need for Mexican audiences to see the emerging world cinemas so as to be in dialogue with developments taking place in the cinema globally. If later Latin American manifestos argue for the need of an expressly political cinema, this manifesto lays the groundwork for the ways in which Mexican cinema can take its place beside other national film "waves"—what will soon come to be known as "Second Cinema"—that reimagined the cinema at the beginning of the 1960s.

Hereby the undersigned the New Cinema group, filmmakers, aspiring filmmakers, critics and cinema club owners; we declare that our objectives are the following:

Improving the depressing state of Mexican Cinema. In order to accomplish that we feel it is imperative to open the doors to new filmmakers. In our opinion, nothing justifies the obstacles presented to those (directors, screenwriters, photographers, etc.) capable of making new cinema in Mexico, which without a doubt will be a far superior cinema than the one today. Any plan for renewal of the national cinema that does not take into account this problem is deemed to fail.

We state that filmmakers have as much right as the writer, painter or musician to express themselves freely. We will fight so that there is not only one type of cinema but

that there is a free endeavor for creation, with the diversity in aesthetics, morals and political points of view that that implies. Therefore we oppose all censure that curtails freedom of expression in cinema.

We promote the production and freedom of exhibition of an independent cinema produced in the margins of conventions and limitations imposed by those who monopolize film production. In the same manner, we will argue so that the short film and documentary films should have the support and encouragement they deserve and will be able to be screened to the greater audiences in fair conditions.

We promote the development of the filmmaking culture in Mexico through the following statements:

Achieve the establishment of a reputable institution for cinematography that will be specifically dedicated to the training of new filmmakers.

Achieve support and encouragement of the creation of film clubs, whether it be within or outside of the Distrito Federal (the Capital).

Achieve the establishment of a cinematheque that has the necessary resources and which will be in the charge of competent and responsible people.

Create specialized publications that guide the public, analyzing in depth the problems of cinema. In achieving the latter, the undersigned propose to publish the monthly magazine *Nuevo cine.*

Endeavor to study and research all aspects of Mexican Cinema.

Endeavor to gain the support of experimental cinema groups.

We promote to overcome the clumsiness that rules the collective criteria of the exhibitors of foreign films in Mexico, which has prevented us from knowing many great works of filmmakers such as Chaplin, Dreyer, Ingmar Bergman, Antonioni, Mizoguchi, etc. Works that have even been of great benefit to those who exhibit them in other countries.

To defend the *Reseña de Festivales* (Festivals in Review) in favor of the communication through films and actors within the best of world cinema. And to attack the flaws that have prevented the accomplished Reviews from reaching their goals.

These objectives circumscribe and complement each other. In order to accomplish these objectives, the New Cinema group hopes to enlist the support of film audiences, and of the growing spectator masses who see the cinema not only as a form of entertainment, but as one of the most formidable medium[s] of expression of our century.

CINEMA AND UNDERDEVELOPMENT
(Argentina, 1962)

Fernando Birri

[First published in Spanish as "Cine y subdesarrollo," in *Cine cubano* 64 (1967). First published in English in Michael Chanan, ed., *Twenty-Five Years of the New Latin American Cinema* (London: BFI, 1983), 9–12. Trans. Malcolm Coad.]

Founder of the Santa Fe Documentary School, Fernando Birri wrote "Cinema and Underdevelopment" shortly after one of the most violent juntas in Argentina. Birri argues for a cinema of the working classes and foreshadows Fernando Solas and Octavio Getino's call for a cinema that is counter-Hollywood. He argues that film pedagogy is central to the cultivation of a new, independent Argentine cinema and argues against Western models of "modernization" that feed into colonial attitudes toward "development," taking, in particular, Argentine director Torre Nilsson to task.

The following answers should all be understood, and very concretely so, as concerned with a sub-cinematography, that of Argentina and the region of underdeveloped Latin America of which it is a part. Furthermore, they reflect the point of view of a film director from a capitalist and neocolonialist country, the opposite pole from the situation in Cuba.

WHAT KIND OF CINEMA DOES ARGENTINA NEED? WHAT KIND OF CINEMA DO THE UNDER-DEVELOPED PEOPLES OF LATIN AMERICA NEED?

A cinema which develops them.

A cinema which brings them consciousness, which awakens consciousness; which clarifies matters; which strengthens the revolutionary consciousness of those among them who already possess this; which fires them; which disturbs, worries, shocks and weakens those who have a "bad conscience," a reactionary consciousness; which defines profiles of national, Latin American identity; which is authentic; which is anti-oligarchic and anti-bourgeois at the national level, and anti-colonial and anti-imperialist at the international level; which is pro-people, and anti-anti-people; which helps the passage from underdevelopment to development, from sub-stomach to stomach, from sub-culture to culture, from sub-happiness to happiness, from sub-life to *life*.

Our purpose is to create a new person, a new society, a new history and therefore a new art and a new cinema. Urgently.

And with the raw material of a reality which is little and badly understood: that of the underdeveloped countries of Latin America (or, if you prefer the euphemism favoured by the Organisation of American States, the developing countries of Latin America). Understanding—or, rather, misunderstanding—of these countries has always come

about by applying analytical schemes imposed by foreign colonialists or their local hench-
men (whose particular mentality has deformed such ideas even further).

WHAT KIND OF CINEMA DOES ARGENTINA HAVE AT THE MOMENT?

One with a solid industrial tradition whose Golden Age was in the 30s and 40s
(Lucas Demare's *La Guerra Gaucha*, for example). It conquered the markets of Latin
America, then prostituted itself under Peronism, before recovering once again, culturally
speaking, under the guidance of Torre Nilsson, during the so-called "revolution of lib-
eration" (actually a military dictatorship). It then evolved into an independent movement
in which the left began to play a role. This development coincided with Frondizi's rise to
power in 1961–2, when more than fifteen new feature directors and many more directors
of shorts took their places in the national cinema. After the 1962 *frondizazo*, however,
and during the provisional presidency of Guido, such independent efforts turned in on
themselves, and "dependent" production became dominant once again. Only one
independent film was made, Manuel Antín's *Los venerables todos*, the very epitome of
alienation.

The problem is that cinema is a cultural product, a product of the superstructure. So
it is subject to all the superstructure's distortions. In the case of cinema these are exac-
erbated further than in the other arts due to its nature as an industrial art. In countries
like ours, which are in the throes of incipient industrialisation, political shocks make this
condition chronic.

Furthermore, cinema is a language. A language, like others, which enables commu-
nication and expression at both the mass and personal levels. Here as well things get out
of balance as bourgeois attitudes—which are either reactionary or, at best, liberal and
always sub-cultural—typically give most attention to the "cinema of expression." This
cinema (typified by Torre Nilsson) is set in opposition to "commercial" cinema (such as
that of Amadori, Demare or Tynaire). At its height, in 1955, this opposition became a
veritable battle within the structures of bourgeois culture. "Expression" won—and now
where are we? What and who is to benefit from such "expression" (à la Torre Nilsson,
Kohon, Kuhn, Antín)? The navel of Buddha? "Commercial" cinema has won its audience
by any method going; or more precisely, the worst methods going. We cannot support *it*.
The "cinema of expression" uses the best methods, and scorns the mass audience. We
cannot support it either. Once again, the contradiction between art and industry is re-
solved very badly, except for the "select" minority which makes up the audience of the
"cinema of expression," for whom such a solution is perfectly satisfactory.

We have already pointed out that cinema manifests the cultural and economic values
of a society's superstructure. Neither its generic lack of culture nor its economic pre-
cariousness precludes it from these categories. Argentina, Latin America, 1963: a bour-
geois superstructure, semi-colonial and underdeveloped. Its cinema, therefore, expresses
these conditions, consciously or unconsciously if it favours them, always consciously if
it is against.

This is the fact of the matter, and there is no way round it, like it or not, and whether or not we care to recognise it. It is true wherever you look, from Lucas Demare and Torre Nilsson, as representatives of those in favour, to the short filmmakers Oliva and Fisherman, new directors who have declared themselves against.

For the first group, those who are consciously or unconsciously in favour of the existing order of things, no problem arises. The superstructure keeps them, pampers them, and gives them official credits, prizes, national exhibition, "Argentinian Film Weeks" abroad, international festivals, travel as representatives of national culture, and press coverage of their triumphs and supposed triumphs (in its local newspapers an anxious but finally negative European criticism transforms a failure into "a polemical and very worthy film," as happened with Antín's *Los venerables todos* in Cannes in 1963, or Nilsson's *Homenaje a la hora de la siesta* in Venice in 1962). The superstructure serves them, when all is said and done, as a pedestal. A fragile enough pedestal for eternal glory, you may admonish us. Certainly, but meanwhile, down here, in the here-and-now, it keeps them able to produce films.

The only problems these directors have ever had to face have come from personal rivalry or, at worst, from the irrational infraction of some ultramontane moral taboo (as in the case of Beatriz Guido, for example) to do with sex or violence, never from any "political" offence. Such sins were rapidly forgiven, like those of prodigal children, when from 1957 onwards new and independent currents began to appear in our national cinema, pursuing not expression but ideas. Among those representing these currents were Murua, Feldman, Martinez Suarez, Alventosa, the Institute of Cinematography at the National University of the Litoral, sectors of the Association of Short Film Directors, Cinema Workshops, the Association of Experimental Cinema, the Nucleus Cinema Club, *Cinecritica* magazine, the writer of this article.

GIVEN THIS SITUATION, HOW AND WHY WAS THE INSTITUTE OF CINEMATOGRAPHY AT THE NATIONAL UNIVERSITY OF THE LITORAL FORMED?

Today the Institute of Cinematography is a material fact. But in 1956 it was only an idea.

This idea was born at a time when Argentinian cinematography was disintegrating, both culturally and industrially. It affirmed a goal and a method. The goal was realism. The method was training based in theory and practice.

To locate this goal historically, remember that the dominant characteristic of Argentinian cinema at that time was precisely its "unrealism." This was true of both its extremes. The opportunism of the numerous box-office hits (such as those of the main studio Argentina Sono Films, or the Demare-Pondal Rios *Después del silencio*, or *chanchada* comedies) and the evasiveness of the few "intellectualised" films (Torre Nilsson's *La casa del angel*, Ayala's *El jefe*) made the cinematographic images of the country they presented to audiences equally unreal and alien. Popular and art cinema were falsely made out to be irreconcilable opposites, when what were actually being discussed were "commercial" and "elitist" cinema.

Our objective was a realism which would transcend this tendentious duality. In it we were joined by other non-cinematic groups all of whom shared the aspiration towards an art which would be simultaneously popular and of high quality.

To locate our method historically, remember that the national cinema industry had always been founded on the purest empiricism, usually manifest in a frustrating degree of improvisation.

Remember also that at this time there was not even a plan for a National Film School, despite the inclusion of the idea in the 1957 Decree Law 62 (it was not carried through). The teaching facilities which did exist made no impact on the industry itself, much less on public opinion.

We should be wary of schematic generalisation, for there were exceptions which proved the rule and we must give credit to the significant positive moments on the curve of the old national cinema (such as Mario Soffici's *Prisioneros de la tierra,* or Hugo del Carril's *Las aguas bajan turbias*). But any objective analysis must finally lead to the general negative conclusion recorded here.

The goal and method I have described, those of a realist cinematography and a theoretico-practical training, came together polemically in the Documentary School at Santa Fe. They did so as a simultaneously critical and constructive contribution—or constructively critical, if you prefer—to national cinema, and as a response to a need for national transformation which we believe exists throughout Latin America, given the continent's common condition of underdevelopment. It was these artistic principles which inspired our work from *Tire Die,* the Institute's first film of social inquiry, to *Los inundados,* our first fictional feature, which synthesised our experience. On the way we also made *Los 40 cuartos,* a documentary which was banned and whose prints and negative were confiscated under the 1959 Decree 4965, which was passed by provisional President Guido to suppress "insurrectionary activities." This banning and confiscation remain in force to the present day. *Los inundados* synthesises the experience of the Institute, enlarging its scope and giving it its fullest expression both professionally and as entertainment, in the best senses of these terms. For these reasons, and because it answers to the founding intentions of the Santa Fe Documentary School, both experimental and academic, this film bears the responsibility of being our movement's manifesto, carried forth under the banner of a national cinematography which is "realist, critical and popular."

WHAT ARE THE FUTURE PERSPECTIVES FOR LATIN AMERICAN CINEMA?

Seen from the general perspective of developments in cinema, and given that this is an Argentinian film, a Latin American film, the most important thing right now if we are to ensure such a future is that the film should be seen. In other words, the most important thing is exhibition and distribution.

The starting point for this statement is the fact that our films are not seen by the public, or are only seen with extreme difficulty. This happens—and we denounce the

fact—not because of the films themselves or our public, but because the films are systematically boycotted by both national and international distributors and exhibitors, who are linked to the anti-national and colonial interests of foreign producers, above all those of North American cinema and the monopoly it has imposed on us. Of about 500 films shown in 1962, 300 were in English, and most of them North American, while some 30 were Argentinian.

An additional fact: Latin America has a potential market of 200 million spectators, more than enough to provide a natural market for our films. It would save us the effort of sporadic entry into other markets, and the outlay of hard currency which is being drained away in importing mediocre foreign films.

The urgent need, and only firm solution, must therefore be to guarantee the distribution and exhibition of nationally produced films in each of our countries individually, and in Latin America as a whole. This must come about through government action. The procedures may be different, but in the same way that a government can cancel an oil contract so, for the same reasons of the social good and with the same authority, that same government can and should regulate the prejudicial cultural and economic exploitation that comes with the uncontrolled flow of foreign films into its territory. Exhibitors and distributors justify their permanent blocking of nationally produced films by appealing to the spectator's right to choose what films he or she wishes to see. But this free-market sophism omits one small detail: that for an audience to choose a film, it must first be exhibited, which generally does not happen with national films, or does so only in appalling conditions. State aid, bank credits, and prizes are also means of stimulating the development of Latin American cinema, so long as inflation is avoided by making ticket-receipts the basis of the system. Film must be funded by its audience. As well as maintaining financial health, the fact that the audience pays for its tickets confirms its interest in the film, and keeps film-makers committed to their audience.

Such a solution must be complemented by a reduction in non-essential industrial costs. We must have low-cost production. This may not provide an overall or permanent solution but it is at the very least the beginning of a solution in current circumstances. If it is valid for independent production in developed countries, it is even more so in underdeveloped countries. Such a formula would protect the independent producer from the fluctuations of recovering capital in a market where income from nationally produced films is uncertain. Furthermore, a more rapid recovery of production costs would allow the possibility of continuous investment in new productions. Low costs would also allow participation by non-state capital, which would free the film-maker of all, or almost all, dependence on official credits, which restrict freedom, and always bring with them censorship and self-censorship. This kind of production also renews expressive creativity, because it requires the replacement of the traditional crew by a more functional method of operation, adapted to the actual conditions of filming. Such a conception and practice of making films not with the resources one would like but with those which are possible,

will determine a new kind of language, hopefully even a new style, the fruit of convergent economic and cultural necessity. We Latin American film-makers must transform ail such technical limitations into new expressive possibilities, if we are not to remain paralysed by them.

In the same way, the moment has come not only to oblige the "commercial" circuits to carry national films, but also to set up "independent" circuits in trade unions, schools, neighbourhood associations, sports centres and in the countryside through mobile projection units. A circuit based in existing grass-roots organisations, where films can be shown which, because they are openly didactic (or documentary) or ideologically progressive, come up against the greatest resistance from "commercial" distributors and exhibitors.

FOR WHAT AUDIENCE DO YOU YOURSELF MAKE FILMS?

Having set aside any residual notions of "art for art's sake," and committed ourselves to "useful" creation, we find our intention of the last few years, that of making films not for ourselves but for the audience, is no longer enough. Following our most recent experience, which was our first with a fictional feature shown to a so-called "ordinary" or "commercial" audience, we can no longer put off defining the audience—or, more precisely, the *class* of audience, in the economic and historical sense of the term—for whom we are making our films.

We'll not delay the answer. We are making our films for a working-class audience, both urban and rural. This is our most fundamental purpose. Let us spell it out very clearly. We are interested in making our future films *only* if they reach a working-class and peasant audience, an audience made up of workers from the existing industrial belts of our great cities, the urban and suburban proletariat in areas of newer industrialisation, and peasants, small farmers and herdsmen on both small immigrant farms and large estates belonging to the oligarchy (where film, if it speaks the people's own language, can be a means of culture of unequalled impact, given existing rates of literacy). Then, having made this clear, let us add that we also wish to reach sections of the petty bourgeoisie and even of the bourgeoisie proper (the so-called "national bourgeoisie"), including them in the audience for this new cinema which seeks to awaken consciousness, and which is directed towards spectators who are open to being enlightened and also to working out matters for themselves in a new light.

But I am talking about Argentina as it is now, where there is no such cinema and no national cinema to stimulate the gathering together of such an audience, and where even *if* such a cinema did exist there would be nowhere to show it.

As for the rest of Latin America, we would say from what we know of it that the audience which interests us—I should say, which preoccupies us—will be made up of the same sections of the population everywhere, depending on variations in the degree of backwardness or development in each country, or whether it is dominated by an agricultural and rural economy, or is in the process of industrialisation. To conjure away any

fetishes which may make this proposal seem utopian, we would recall that the audience which already sees our "national films"—which are so scorned by the bourgeoisie and only accepted with reservations by the petty-bourgeoisie—is in its great majority already made up of the kinds of people we have described. But there is an urgent need here for large-scale market research, complete with tables and social statistics. Even in our country we still lack such research. It must be one of the priority tasks of the CLAC (Latin American Cinematography Centre) as it documents, analyses and plans film production.

WHAT IS THE REVOLUTIONARY FUNCTION OF CINEMA IN LATIN AMERICA?

Underdevelopment is a hard fact in Latin America. It is an economic and statistical fact. No invention of the left, the term is used as a matter of course by "official" international organisations, such as the UN, or Latin American bodies, such as the OAS or the ECLA, in their plans and reports. They have no alternative.

The cause of underdevelopment is also well known: colonialism, both external and internal.

The cinema of our countries shares the same general characteristics of this super-structure, of this kind of society, and presents us with a false image of both society and our people. Indeed, it presents no real image of our people at all, but conceals them. So, the first positive step is to provide such an image. This is the first function of documentary.

How can documentary provide this image? By showing how reality *is,* and in no other way. This is the revolutionary function of social documentary and realist, critical and popular cinema in Latin America. By testifying, critically, to this reality—to this sub-reality, this misery—cinema refuses it. It rejects it. It denounces, judges, criticises and deconstructs it. Because it shows matters as they irrefutably are, and not as we would like them to be (or as, in good or bad faith, others would like to make us believe them to be).

As the other side of the coin of this "negation," realist cinema also affirms the positive values in our societies: the people's values. Their reserves of strength, their labours, their joys, their struggle, their dreams.

The result—and motivation—of social documentary and realist cinema? Knowledge and consciousness; we repeat: the awakening of the consciousness of reality. The posing of problems. Change: from sub-life to life.

Conclusion: to confront reality with a camera and to document it, filming realistically, filming critically, filming underdevelopment with the optic of the people. For the alternative, a cinema which makes itself the accomplice of underdevelopment, is sub-cinema.

THE AESTHETICS OF HUNGER
(Brazil, 1965)

Glauber Rocha

[First presented at Latin American Cinema conference, Genoa, Italy, 1965. First published in Portuguese as "A estética de fome," in *Revista civilização brasileira* 3 (1965). First published in English as "The Aesthetics of Violence," in *Afterimage* 1 (UK) (1970). Published in English as "The Aesthetics of Hunger," in Michael Chanan, ed., *Twenty-Five Years of the New Latin American Cinema* (London: BFI, 1983), 13–14. Trans. Burnes Hollyman and Randal Johnson.]

Glauber Rocha—director of such films as *Deus e o Diabo na Terra do Sol* (*Black God, White Devil*, Brazil, 1964)—articulates in "The Aesthetics of Hunger," his statement of principles for Brazil's *cinema novo*. Here he speaks to underdevelopment, hunger, and violence as the engines behind a politically engaged cinema. Influenced by Frantz Fanon, Rocha argues that the colonizers will recognize the colonized only though acts of violence, both in the realm of the real and in the realm of representation.

Dispensing with the informative introduction that has become so characteristic of discussions about Latin America, I prefer to discuss the relationship between our culture and "civilised" culture in less limiting terms than those which characterise the analysis of the European observer. Thus, while Latin America laments its general misery, the foreign observer cultivates a taste for that misery, not as a tragic *symptom*, but merely as a formal element in his field of interest. The Latin American neither communicates his real misery to the "civilised" man, nor does the "civilised" man truly comprehend the misery of the Latin American.

Basically, this is the situation of the arts in Brazil. Until now, only lies elaborated from truth (the formal exoticism that vulgarises social problems) have been communicated in quantitative terms, provoking a series of misunderstandings which are not confined to the area of art but rather continue far beyond into the political domain. For the European observer, the process of artistic creation in the underdeveloped world is of interest only in so far as it satisfies his nostalgia for primitivism. This primitivism is generally presented as a hybrid form, disguised under the belated heritage of the "civilised" world and poorly understood since it is imposed by colonial conditioning. Undeniably, Latin America remains a colony. What distinguishes yesterday's colonialism from today's is merely the more refined forms employed by the contemporary coloniser. Meanwhile, those who are preparing future domination try to replace these with even more subtle forms. The problem facing Latin America in international terms is still that of merely exchanging colonisers. Thus, our possible liberation is always a function of a new dependency.

This economic and political conditioning has led us to philosophical undernourishment and to impotence—sometimes conscious, other times not. The first engenders sterility; the second, hysteria. It is for this reason that hunger in Latin America is not simply an alarming symptom; it is the essence of our society. Herein lies the tragic originality of Cinema Novo in relation to world cinema. Our originality is our hunger and our greatest misery is that this hunger is felt but not intellectually understood.

We understand the hunger that Europeans and the majority of Brazilians have failed to understand. For the European, it is a strange tropical surrealism. For the Brazilian, it is a national shame. He does not eat, but is ashamed to say so; and yet, he does not know where this hunger comes from. We know—since we made those ugly, sad films, those screaming, desperate films in which reason has not always prevailed—that this hunger will not be assuaged by moderate government reforms and that the cloak of technicolor cannot hide, but rather only aggravates, its tumours. Therefore, only a culture of hunger can qualitatively surpass its own structures by undermining and destroying them. The most noble cultural manifestation of hunger is violence.

Cinema Novo reveals that violence is normal behaviour for the starving. The violence of a starving man is not a sign of a primitive mentality. Is Fabiano primitive? Is Antão primitive? Is Corisco primitive? Is the woman in *Porto das Caixas* primitive?

Cinema Novo teaches that the aesthetics of violence are revolutionary rather than primitive. The moment of violence is the moment when the coloniser becomes aware of the existence of the colonised. Only when he is confronted with violence can the coloniser understand, through horror, the strength of the culture he exploits. As long as he does not take up arms, the colonised man remains a slave. The first policeman had to die before the French became aware of the Algerians.

In moral terms, this violence is not filled with hatred; nor is it linked to the old, colonising humanism. The love that this violence encompasses is as brutal as violence itself, because it is not the kind of love which derives from complacency or contemplation, but rather a love of action and transformation.

The time when Cinema Novo had to explain itself in order to exist has passed. Cinema Novo is an ongoing process of exploration that is making our thinking clearer, freeing us from the debilitating delirium of hunger. Cinema Novo cannot develop effectively while it remains marginal to the economic and cultural processes of the Latin American continent. Because the New Cinema is a phenomenon belonging to new peoples everywhere and not a privileged entity of Brazil. Wherever there is a film-maker prepared to film the truth and to oppose the hypocrisy and repression of intellectual censorship, there will be the living spirit of Cinema Novo. Wherever there is a film-maker prepared to stand up against commercialism, exploitation, pornography and the tyranny of technique, there is to be found the living spirit of Cinema Novo. Wherever there is a film-maker, of any age or background, ready to place his cinema and his profession at the service of the great causes of his time, there will be the living which sets Cinema Novo apart from the commercial industry because the commitment of industrial cinema is to untruth and exploitation.

Cinema Novo's ability to integrate itself economically and industrially depends on freedom for Latin America. Cinema Novo makes every effort toward achieving this freedom, both in its own name and in that of its nearest and more far-flung participants—from the most ignorant to the most talented, from the weakest to the strongest. It is a moral question that will be reflected in our films, whether we're filming a man *nor a single film but an evolving complex of films that will ultimately make the public aware of its own misery.*

For this reason, we do not have broader points of contact with the rest of world cinema, except for shared technical and artistic origins.

Cinema Novo is a project that has grown out of the politics of hunger and suffers, for that very reason, all the consequent weaknesses which are a product of its particular situation.

FOR AN IMPERFECT CINEMA
(Cuba, 1969)

Julio García Espinosa

[First published in Spanish as "Por un cine imperfecto," in *Cine cubano* 66/67 (1969). First unabridged translation into English in *Jump Cut* 20 (1979): 24–26. Trans. Julianne Burton-Carvajal.]

Because of the *Movimiento 26 de Julio* leading to the eventual Cuban revolution of 1959, Cuba plays a pivotal role in the development of radical Latin American cinema. Like many of the other Latin American manifestos of the 1960s, Espinosa's argues against the aesthetics of mainstream cinema in order to break down the relationship between filmmaker and spectator, leading to the democratization of the cinema. Harking back to the writings of Eisenstein, "For an Imperfect Cinema" foregrounds the dialectical relationship between the film and the viewer as a means to create a new, revolutionary consciousness. Espinosa argues for a politically committed "imperfect cinema" that foregrounds process over analysis, which he claims leads only to judgment and closure.

Nowadays, perfect cinema—technically and artistically masterful—is almost always reactionary cinema. The major temptation facing Cuban cinema at this time—when it is achieving its objective of becoming a cinema of quality, one which is culturally meaningful within the revolutionary process—is precisely that of transforming itself into a perfect cinema.

The "boom" of Latin American cinema—with Brazil and Cuba in the forefront, according to the applause and approval of the European intelligentsia—is similar, in the present moment, to the one of which the Latin American novel had previously been the

exclusive benefactor. Why do they applaud us? There is no doubt that a certain standard of quality has been reached. Doubtless, there is a certain political opportunism, a certain mutual instrumentality. But without doubt there is also something more. Why should we worry about their accolades? Isn't the goal of public recognition a part of the rules of the artistic game? When it comes to artistic culture, isn't European recognition equivalent to worldwide recognition? Doesn't it serve art and our peoples as well when works produced by underdeveloped nations obtain such recognition?

Although it may seem curious, it is necessary to clarify the fact that this disquiet is not solely motivated by ethical concerns. As a matter of fact, the motivation is for the most part aesthetic, if indeed it is possible to draw such an arbitrary dividing line between both terms. When we ask ourselves why it is we who are the film directors and not the others, that is to say, the spectators, the question does not stem from an exclusively ethical concern. We know that we are filmmakers because we have been part of a minority which has had the time and the circumstances needed to develop, within itself, an artistic culture; and because the material resources of film technology are limited and therefore available to some, not to all. But what happens if the future holds the universalization of college level instruction, if economic and social development reduce the hours in the work day, if the evolution of film technology (there are already signs in evidence) makes it possible that this technology ceases being the privilege of a small few? What happens if the development of videotape solves the problem of inevitably limited laboratory capacity, if television systems with their potential for "projecting" independently of the central studio renders the ad infinitum construction of movie theaters suddenly superfluous?

What happens then is not only an act of social justice—the possibility for everyone to make films—but also a fact of extreme importance for artistic culture: the possibility of recovering, without any kinds of complexes or guilt feelings, the true meaning of artistic activity. Then we will be able to understand that art is one of mankind's "impartial" or "uncommitted" activities [via actividad desinteresada]. That art is not work, and that the artist is not in the strict sense a worker. The feeling that this is so, and the impossibility of translating it into practice, constitutes the agony and at the same time the "phariseeism" of all contemporary art.

In fact, the two tendencies exist: those who pretend to produce cinema as an "uncommitted activity" and those who pretend to justify it as a "committed" activity. Both find themselves in a blind alley.

Anyone engaged in an artistic activity asks himself at a given moment what the meaning is of whatever he is doing. The simple fact that this anxiety arises demonstrates that factors exist to motivate it—factors which, in turn, indicate that art does not develop freely. Those who persist in denying art a specific meaning feel the moral weight of their egoism. Those who, on the other hand, pretend to attribute one to it, buy off their bad conscience with social generosity. It makes no difference that the mediators (critics, theoreticians, etc.) try to justify certain cases. For the contemporary artist, the mediator is like an aspirin, a tranquilizer. As with a pill, the artist only temporarily gets rid of the headache. The

sure thing, however, is that art, like a capricious little devil, continues to show its face sporadically in no matter which tendency.

No doubt it is easier to define art by what it is not than by what it is, assuming that one can talk about closed definitions not just for art but for any of life's activities. The spirit of contradiction permeates everything now. Nothing, and nobody lets himself be imprisoned in a picture frame, no matter how gilded. It is possible that art gives us a vision of society or of human nature and that, at the same time, it cannot be defined as a vision of society or of human nature. It is possible that a certain narcissism of conscious-ness—in recognizing in oneself a little historical, sociological, psychological, philosoph-ical consciousness—is implicit in aesthetic pleasure, and at the same time that this sensation is not sufficient in itself to explain aesthetic pleasure.

Is it not much closer to the nature of art to conceive of it as having its own cognitive power? In other words, by saying that art is not the "illustration" of ideas, which can also be expressed through philosophy, sociology, psychology. Every artist's desire to express the inexpressible is nothing more than the desire to express the vision of a theme in terms that are inexpressible through other than artistic means. Perhaps the cognitive power of art is like the power of a game for a child. Perhaps aesthetic pleasure lies in sensing the functionality (without a specific goal) of our intelligence and our own sensitivity. Art can stimulate, in general, the creative function of man. It can function as constant stimulus toward adopting an attitude of change with regard to life. But, as opposed to science, it enriches us in such a way that its results are not specific and cannot be applied to anything in particular. It is for this reason that we can call it an "impartial" or "uncommitted" activity, and can say that art is not strictly speaking a "job," and that the artist is perhaps the least intellectual of all intellectuals.

Why then does the artist feel the need to justify himself as a "worker," as an "intel-lectual," as a "professional," as a disciplined and organized man, like any other individual who performs a productive task? Why does he feel the need to exaggerate the importance of his activity? Why does he feel the need to have critics (mediators) to justify him, to defend him, to interpret him? Why does he speak proudly of "my critics"? Why does he find it necessary to make transcendental declarations, as if he were the true interpreter of society and of mankind? Why does he pretend to consider himself critic and conscience of society when (although these objectives can be implicit or even explicit in certain cir-cumstances) in a truly revolutionary society all of us—that is to say, the people as a whole—should exercise those functions? And why, on the other hand, does the artist see himself forced to limit these objectives, these attitudes, these characteristics? Why does he at the same time set up these limitations as necessary to prevent his work from being transformed into a tract or a sociological essay? What is behind such pharisee-ism? Why protect oneself and seek recognition as a (revolutionary, it must be understood) political and scientific worker, yet not be prepared to run the same risks?

The problem is a complex one. Basically, it is neither a matter of opportunism nor cowardice. A true artist is prepared to run any risk as long as he is certain that his work

will not cease to be an artistic expression. The only risk which he will not accept is that of endangering the artistic quality of his work.

There are also those who accept and defend the "impartial" function of art. These people claim to be more consistent. They opt for the bitterness of a closed world in the hope that tomorrow history will justify them. But the fact is that even today not everyone can enjoy the *Mona Lisa*. These people should have fewer contradictions; they should be less alienated. But in fact it is not so, even though such an attitude gives them the possibility of an alibi which is more productive on a personal level. In general they sense the sterility of their "purity" or they dedicate themselves to waging corrosive battles, but always on the defensive. They can even, in a reverse operation, reject their interest in finding tranquility, harmony, and a certain compensation in the work of art, expressing instead disequilibrium, chaos, and uncertainty, which also becomes the objective of "impartial" art.

What is it, then, which makes it impossible to practice art as an "impartial" activity? Why is this particular situation today more sensitive than ever? From the beginning of the world as we know it, that is to say, since the world was divided into classes, this situation has been latent. If it has grown sharper today it is precisely because today the possibility of transcending it is coming into view. Not through a *prise de conscience*, not through the expressed determination of any particular artist, but because reality itself has begun to reveal symptoms (not at all utopian) which indicate that "in the future there will no longer be painters, but rather men who, among other things, dedicate themselves to painting" (Marx).

There can be no "impartial" or "uncommitted" art, there can be no new and genuine qualitative jump in art, unless the concept and the reality of the "elite" is done away with once and for all. Three factors incline us toward optimism: the development of science, the social presence of the masses, and the revolutionary potential in the contemporary world. All three are without hierarchical order, all three are interrelated.

Why is science feared? Why are people afraid that art might be crushed under obvious productivity and utility of science? Why this inferiority complex? It is true that today we read a good essay with much greater pleasure than a novel. Why do we keep repeating then, horrified, that the world is becoming more mercenary, more utilitarian, more materialistic? Is it not really marvelous that the development of science, sociology, anthropology, and psychology is contributing to the "purification" of art? The appearance, thanks to science, of expressive media like photography and film made a greater "purification" of painting and theatre possible (without invalidating them artistically in the least). Doesn't modern day science render anachronistic so much "artistic" analysis of the human soul? Doesn't contemporary science allow us to free ourselves from so many fraudulent films, concealed behind what has been called the world of poetry? With the advance of science, art has nothing to lose; on the contrary, it has a whole world to gain. What, then, are we so afraid of? Science strips art bare, and it seems that it is not easy to go naked through the streets.

The real tragedy of the contemporary artist lies in the impossibility of practicing art as a minority activity. It is said—and correctly—that art cannot exercise its attraction

without the cooperation of the subject. But what can be done so that the audience stops being an object and transforms itself into the subject?

The development of science, of technology, and of the most advanced social theory and practice has made possible as never before the active presence in the masses in social life. In the realm of artistic life, there are more spectators now than at any other moment in history. This is the first stage in the abolition of "elites." The task currently at hand is to find out if the conditions which will enable spectators to transform themselves into agents—not merely more active spectators, but genuine co-authors—are beginning to exist. The task at hand is to ask ourselves whether art is really an activity restricted to specialists, whether it is, through extra-human design, the option of a chosen few or a possibility for everyone.

How can we trust the perspectives and possibilities of art simply to the education of the people as a mass of spectators? Taste as defined by high culture, once it is "overdone," is normally passed on to the rest of society as leftovers to be devoured and ruminated over by those who were not invited to the feast. This eternal spiral has today become a vicious circle as well. "Camp" and its attitude toward everything outdated is an attempt to rescue these leftovers and to lessen the distance between high culture and the people. But the difference lies in the fact that camp rescues it as an aesthetic value, while for the people the values involved continue to be ethical ones.

Must the revolutionary present and the revolutionary future inevitably have "its" artists and "its" intellectuals, just as the bourgeoisie had "theirs"? Surely the truly revolutionary position, from now on, is to contribute to overcoming these elitist concepts and practices, rather than pursuing *ad eternum* the "artistic quality" of the work. The new outlook for artistic culture is no longer that everyone must share the taste of a few, but that all can be creators of that culture. Art has always been a universal necessity; what it has not been is an option for all under equal conditions. Parallel to refined art, popular art has had a simultaneous but independent existence.

Popular art has absolutely nothing to do with what is called mass art. Popular art needs and consequently tends to develop the personal, individual taste of a people. On the other hand, mass art (or art for the masses) requires the people to have no taste. It will only be genuine when it is actually the masses who create it, since at present it is art produced by a few for the masses. Grotowski says that today's theater should be a minority art form because mass art can be achieved through cinema. This is not true. Perhaps film is the most elitist of all the contemporary arts. Film today, no matter where, is made by a small minority for the masses. Perhaps film will be the art form which takes the longest time to reach the hands of the masses, when we understand mass art as popular art, art created by the masses. Currently, as Hauser points out, mass art is art produced by a minority in order to satisfy the demand of a public reduced to the sole role of spectator and consumer.

Popular art has always been created by the least learned sector of society, yet this "uncultured" sector has managed to conserve profoundly cultured characteristics of art. One of the most important of these is the fact that the creators are at the same time the spectators and vice versa. Between those who produce and those who consume, no sharp

line of demarcation exists. Cultivated art, in our era, has also attained this situation. Modern art's great dose of freedom is nothing more than the conquest of a new interlocutor: the artist himself. For this reason, it is useless to strain oneself struggling for the substitution of the masses as a new and potential spectator for the bourgeoisie. This situation, maintained by popular art, adopted by cultivated art, must be dissolved and become the heritage of all. This and no other must be the great objective of an authentically revolutionary artistic culture.

Popular art preserved another even more important cultural characteristic: It is carried out as but another life activity. With cultivated art, the reverse is true. It is pursued as a unique, specific activity, as a personal achievement. This is the cruel price of having had to maintain artistic activity at the expense of its inexistence among the people. Hasn't the attempt to realize himself on the edge of society proved to be too painful a restriction for the artist and for art itself? To posit art as a sect, as a society within society, as the promised land where we can fleetingly fulfill ourselves for a brief instant—doesn't this create the illusion that self-realization on the level of consciousness also implies self-realization on the level of existence? Isn't this patently obvious in contemporary circumstances? The essential lesson of popular art is that it is carried out as a life activity: man must not fulfill himself as an artist but fully; the artist must not seek fulfillment as an artist but as a human being.

In the modern world, principally in developed capitalist nations and in those countries engaged in a revolutionary process, there are alarming symptoms, obvious signs of an imminent change. The possibilities for overcoming this traditional disassociation are beginning to arise. These symptoms are not a product of consciousness but of reality itself. A large part of the struggle waged in modern art has been, in fact, to "democratize" art. What other goal is entailed in combating the limitations of taste, museum art, and the demarcation lines between the creator and the public? What is considered beauty today, and where is it found? On Campbell's soup labels, in a garbage can lid, in gadgets? Even the eternal value of a work of art is today being questioned. What else could be the meaning of those sculptures, seen in recent exhibitions, made of blocks of ice, which melt away while the public looks at them? Isn't this—more than the disappearance of art—the attempt to make the spectator disappear? Don't those painters who entrust a portion of the execution of their work to just anyone, rather than to their disciples, exhibit an eagerness to jump over the barricade of "elitist" art? Doesn't the same attitude exist among composers whose works allow their performers ample liberty?

There's a widespread tendency in modern art to make the spectator participate ever more fully. If he participates to a greater and greater degree, where will the process end up? Isn't the logical outcome—or shouldn't it in fact be—that he will cease being a spectator altogether? This simultaneously represents a tendency toward collectivism and toward individualism. Once we admit the possibility of universal participation, aren't we also admitting the individual creative potential which we all have? Isn't Grotowski mistaken when he asserts that today's theater should be dedicated to an elite? Isn't it rather

the reverse: that the theater of poverty in fact requires the highest refinement? It is the theater which has no need for secondary values: costumes, scenery, make-up, even a stage. Isn't this an indication that material conditions are reduced to a minimum and that, from this point of view, the possibility of making theater is within everyone's reach? And doesn't the fact that the theater has an increasingly smaller public mean that conditions are beginning to ripen for it to transform itself into a true mass theater? Perhaps the tragedy of the theater lies in the fact that it has reached this point in its evolution too soon.

When we look toward Europe, we wring our hands. We see that the old culture is totally incapable of providing answers to the problems of art. The fact is that Europe can no longer respond in a traditional manner but at the same time finds it equally difficult to respond in a manner that is radically new. Europe is no longer capable of giving the world a new "ism"; neither is it in a position to put an end to "isms" once and for all. So we think that our moment has come, that at last the underdeveloped can deck themselves out as "men of culture." Here lies our greatest danger and our greatest temptation. This accounts for the opportunism of some on our continent. For, given our technical and scientific backwardness and given the scanty presence of the masses in social life, our continent is still capable of responding in a traditional manner, by reaffirming the concept and the practice of elite art. Perhaps in this case the real motive for the European applause which some of our literary and cinematic works have won is none other than a certain nostalgia which we inspire. After all, the European has no other Europe to which to turn.

The third factor, the revolution—which is the most important of all—is perhaps present in our country as nowhere else. This is our only true chance. The revolution is what provides all other alternatives, what can supply an entirely new response, what enables us to do away once and for all with elitist concepts and practices in art. The revolution and the ongoing revolutionary process are the only factors which make the total and free presence of the masses possible. And this will mean the definitive disappearance of the rigid division of labor and of a society divided into sectors and classes. For us, then, the revolution is the highest expression of culture because it will abolish artistic culture as a fragmentary human activity.

Current responses to this inevitable future, this uncontestable prospect, can be as numerous as the countries on our continent. Because characteristics and achieved levels are not the same, each art form, every artistic manifestation, must find its own expression. What should be the response of the Cuban cinema in particular? Paradoxically, we think it will be a new poetics, not a new cultural policy. A poetics whose true goal will be to commit suicide, to disappear as such. We know, however, that in fact other artistic conceptions will continue to exist among us, just like small rural landholdings and religion continue to exist.

On the level of cultural policy we are faced with a serious problem: the film school. Is it right to continue developing a handful of film specialists? It seems inevitable for the present, but what will be the eternal quarry that we continue to mine: the students in Arts

and Letters at the University? But shouldn't we begin to consider right now whether that school should have a limited lifespan? What end do we pursue there—a reserve corps of future artists? Or a specialized future public? We should be asking ourselves whether we can do something now to abolish this division between artistic and scientific culture.

What constitutes in fact the true prestige of artistic culture, and how did it come about that this prestige was allowed to appropriate the whole concept of culture? Perhaps it is based on the enormous prestige which the spirit has always enjoyed at the expense of the body. Hasn't artistic culture always been seen as the spiritual part of society while scientific culture is seen as its body? The traditional rejection of the body, of material life, is due in part to the concept that things of the spirit are more elevated, more elegant, serious and profound. Can't we, here and now, begin doing something to put an end to this artificial distinction? We should understand from here on in that the body and the things of the body are also elegant, and that material life is beautiful as well. We should understand that, in fact, the soul is contained in the body just as the spirit is contained in material life, just as—to speak in strictly artistic terms—the essence is contained in the surface and the content in the form.

We should endeavor to see that our future students, and therefore our future filmmakers, will themselves be scientists, sociologists, physicians, economists, agricultural engineers, etc., without of course ceasing to be filmmakers. And, at the same time, we should have the same aim for our most outstanding workers, the workers who achieve the best results in terms of political and intellectual formation. We cannot develop the taste of the masses as long as the division between the two cultures continues to exist, nor as long as the masses are not the real masters of the means of artistic production. The revolution has liberated us as an artistic sector. It is only logical that we contribute to the liberation of the private means of artistic production.

A new poetics for the cinema will, above all, be a "partisan" and "committed" poetics, a "committed" art, a consciously and resolutely "committed" cinema—that is to say, an "imperfect" cinema. An "impartial" or "uncommitted" (cinema), as a complete aesthetic activity, will only be possible when it is the people who make art. But today art must assimilate its quota of work so that work can assimilate its quota of art.

The motto of this imperfect cinema (which there's no need to invent, since it already exists) is, as Glauber Rocha would say, "We are not interested in the problems of neurosis; we are interested in the problems of lucidity." Art no longer has use for the neurotic and his problems, although the neurotic continues to need art—as a concerned object, a relief, an alibi or, as Freud would say, as a sublimation of his problems. A neurotic can produce art, but art has no reason to produce neurotics. It has been traditionally believed that the concerns of art were not to be found in the sane but in the sick, not in the normal but in the abnormal, not in those who struggle but in those who weep, not in lucid minds but in neurotic ones. Imperfect cinema is changing this way of seeing the question. We have more faith in the sick man than in the healthy one because his truth is purged by suffering. However, there is no need for suffering to be synonymous with artistic

elegance. There is still a trend in modern art—undoubtedly related to Christian tradi-tion—which identifies seriousness with suffering. The specter of Marguerite Gautier still haunts artistic endeavor in our day. Only in the person who suffers do we perceive ele-gance, gravity, even beauty; only in him do we recognize the possibility of authenticity, seriousness, sincerity. Imperfect cinema must put an end to this tradition.

Imperfect cinema finds a new audience in those who struggle, and it finds its themes in their problems. For imperfect cinema, "lucid" people are the ones who think and feel and exist in a world which they can change. In spite of all the problems and difficulties, they are convinced that they can transform it in a revolutionary way. Imperfect cinema therefore has no need to struggle to create an "audience." On the contrary, it can be said that at present a greater audience exists for this kind of cinema than there are filmmakers able to supply that audience.

What does this new interlocutor require of us—an art full of moral examples worthy of imitation? No. Man is more of a creator than an innovator. Besides, he should be the one to give us moral examples. He might ask us for a fuller, more complete work, aimed—in a separate or coordinated fashion—at the intelligence, the emotions, the powers of intuition.

Should he ask us for a cinema of denunciation? Yes and no. No, if the denunciation is directed toward the others, if it is conceived that those who are not struggling might sympathize with us and increase their awareness. Yes, if the denunciation acts as infor-mation, as testimony, as another combat weapon for those engaged in the struggle. Why denounce imperialism to show one more time that it is evil? What's the use if those now fighting are fighting primarily against imperialism? We can denounce imperialism but should strive to do it as a way of proposing concrete battles. A film which denounces those who struggle against the evil deeds of an official who must be executed would be an excel-lent example of this kind of film-denunciation.

We maintain that imperfect cinema must above all show the process which generates the problems. It is thus the opposite of a cinema principally dedicated to cel-ebrating results, the opposite of a self-sufficient and contemplative cinema, the opposite of a cinema which "beautifully illustrates" ideas or concepts which we already possess. (The narcissistic posture has nothing to do with those who struggle.) To show a process is not exactly equivalent to analyzing it. To analyze, in the traditional sense of the word, always implies a closed prior judgment. To analyze a problem is to show the problem (not the process) permeated with judgments which the analysis itself generates a priori. To analyze is to block off from the outset any possibility for analysis on the part of the interlocutor.

To show the process of a problem, on the other hand, is to submit it to judgment without pronouncing the verdict. There is a style of news reporting which puts more emphasis on the commentary than on the news item. There is another kind of reporting which presents the news and evaluates it through the arrangement of the item on the page or by its position in the paper. To show the process of a problem is like showing the

very development of the news item, without commentary; it is like showing the multi-faceted evolution of a piece of information without evaluating it. The subjective element is the selection of the problem, conditioned as it is by the interest of the audience—which is the subject. The objective element is showing the process which is the object.

Imperfect cinema is an answer, but it is also a question which will discover its own answers in the course of its development. Imperfect cinema can make use of the documentary or the fictional mode, or both. It can use whatever genre, or all genres. It can use cinema as a pluralistic art form or as a specialized form of expression. These questions are indifferent to it, since they do not represent its real alternatives or problems, and much less its real goals. These are not the battles or polemics it is interested in sparking.

Imperfect cinema can also be enjoyable, both for the maker and for its new audience. Those who struggle do not struggle on the edge of life, but in the midst of it. Struggle is life and vice versa. One does not struggle in order to live "later on." The struggle requires organization—the organization of life. Even in the most extreme phase, that of total and direct war, the organization of life is equivalent to the organization of the struggle. And in life, as in the struggle, there is everything, including enjoyment. Imperfect cinema can enjoy itself despite everything that conspires to negate enjoyment.

Imperfect cinema rejects exhibitionism in both (literal) senses of the word, the narcissistic and the commercial (getting shown in established theaters and circuits). It should be remembered that the death of the star-system turned out to be a positive thing for art. There is no reason to doubt that the disappearance of the director as star will fail to offer similar prospects. Imperfect cinema must start work now, in cooperation with sociologists, revolutionary leaders, psychologists, economists, etc. Furthermore, imperfect cinema rejects whatever services criticism has to offer and considers the function of mediators and intermediaries anachronistic.

Imperfect cinema is no longer interested in quality or technique. It can be created equally well with a Mitchell or with an 8mm camera, in a studio or in a guerrilla camp in the middle of the jungle. Imperfect cinema is no longer interested in predetermined taste, and much less in "good taste." It is not quality which it seeks in an artist's work. The only thing it is interested in is how an artist responds to the following question: What are you doing in order to overcome the barrier of the "cultured" elite audience which up to now has conditioned the form of your work?

The filmmaker who subscribes to this new poetics should not have personal self-realization as his object. From now on he should also have another activity. He should place his role as revolutionary or aspiring revolutionary above all else. In a word, he should try to fulfill himself as a man and not just as an artist, that its essential goal as a new poetics is to disappear. It is no longer a matter of replacing one school with another, one "ism" with another, poetry with anti-poetry, but of truly letting a thousand different flowers bloom. The future lies with folk art. But let us no longer display folk art with demagogic pride, with a celebrative air. Let us exhibit it instead as a cruel denunciation, as a painful testimony to the level at which the peoples of the world have been forced to limit their

artistic creativity. The future, without doubt, will be with folk art, but then there will be no need to call it that, because nobody and nothing will any longer be able to again paralyze the creative spirit of the people.

Art will not disappear into nothingness; it will disappear into everything.

TOWARDS A THIRD CINEMA: NOTES AND EXPERIENCES FOR THE DEVELOPMENT OF A CINEMA OF LIBERATION IN THE THIRD WORLD (Argentina, 1969)

Fernando Solanas and Octavio Getino

[First published in Spanish as "Hacia un tercer cine," in *Tricontinental* (Cuba) 13 (1969). First translated into English in *Afterimage* (UK) 3 (1971): 16–35. This translation from *Cineaste* revised by Julianne Burton and Michael Chanan and published in Michael Chanan, ed., *Twenty-Five Years of the New Latin American Cinema* (London: BFI, 1983), 17–27.]

This profoundly influential manifesto, which coins the term *Third Cinema*, lays out Solanas and Getino's strategy in making their groundbreaking *La hora de los hornos* (*The Hour of the Furnaces*, Argentina, 1968). They position Third Cinema in contradistinction to Hollywood film (First Cinema) and European "waves" and art cinema, including *cinema novo* (Second Cinema). They give priority to the documentary as a form of cinema that allows for social and political analysis and transformation, calling it the main basis of revolutionary filmmaking. They set out to transform not only what kinds of images appear on the screen but also the ways in which moving images are distributed and screened in Latin America, arguing for exhibition practices that lie outside the dominant, capitalist modes of spectatorship. As Jonathan Buchsbaum has demonstrated, Solanas and Getino did not mean for this manifesto to be static; as such they revised it over the years, adapting it to political changes and to what they discovered through their collective Cine Liberación and through screenings of *Hour of the Furnaces* throughout Latin America.

. . . we must discuss, we must invent . . .

—FRANTZ FANON

Just a short time ago it would have seemed like a Quixotic adventure in the colonised, neocolonised, or even the imperialist nations themselves to make any attempt to create

films of decolonisation that turned their back on or actively opposed the System. Until re-cently, film had been synonymous with spectacle or entertainment: in a word, it was one more consumer good. At best, films succeeded in bearing witness to the decay of bour-geois values and testifying to social injustice. As a rule, films only dealt with effect, never with cause; it was cinema of mystification or anti-historicism. It was *surplus value* cinema. Caught up in these conditions, films, the most valuable tool of communication of our times, were destined to satisfy only the ideological and economic interests of the *owners of the film industry*, the lords of the world film market, the great majority of whom were from the United States.

Was it possible to overcome this situation? How could the problem of turning out liberating films be approached when costs came to several thousand dollars and the distribution and exhibition channels were in the hands of the enemy? How could the continuity of work be guaranteed? How could the public be reached? How could system-imposed repression and censorship be vanquished? These questions, which could be multiplied in all directions, led and still lead many people to scepticism or ra-tionalisation: "revolutionary cinema cannot exist before the revolution"; "revolutionary films have been possible only in the liberated countries"; "without the support of revolutionary political power, revolutionary cinema or art is impossible." The mistake was due to taking the same approach to reality and films as did the bourgeoisie. The models of production, distribution, and exhibition continued to be *those of Hollywood* precisely because, in ideology and politics, films had not yet become the vehicle for a clearly drawn differentiation between bourgeois ideology and politics. A reformist policy, as manifested in dialogue with the adversary, in coexistence, and in the relegation of national contradictions to those between two supposedly unique blocs—the USSR and the USA—was and is unable to produce anything but a cinema within the System itself. At best, it can be the *"progressive" wing of Establishment cinema.* When all is said and done, such cinema was doomed to wait until the world conflict was resolved peacefully in favour of socialism in order to change qualitatively. The most daring at-tempts of those filmmakers who strove to conquer the fortress of official cinema ended, as Jean-Luc Godard eloquently put it, with the filmmakers themselves "trapped inside the fortress."

But the questions that were recently raised appeared promising; they arose from a new historical situation to which the filmmaker, as is often the case with the educated strata of our countries, was rather a latecomer: ten years of the Cuban Revolution, the Vietnamese struggle, and the development of a worldwide liberation movement whose moving force is to be found in the Third World countries. *The existence of masses on the worldwide revolutionary plane was the substantial fact without which those questions could not have been posed.* A new historical situation and a new man born in the process of the anti-imperialist struggle demanded a new, revolutionary attitude from the filmmakers of the world. The question of whether or not militant cinema was possible before the revolution began to be replaced, at least within small groups, by the question of whether

or not such a cinema was necessary to contribute to the possibility of revolution. An affirmative answer was the starting point for the first attempts to channel the process of seeking possibilities in numerous countries. Examples are Newsreel, a US New Left film group, the *cinegiornali* of the Italian student movement, the films made by the Etats Généraux du cinéma français, and those of the British and Japanese student movements, all a continuation and deepening of the work of a Joris Ivens or a Chris Marker. Let it suffice to observe the films of a Santiago Alvarez in Cuba, or the cinema being developed by different filmmakers in "the homeland of all," as Bolivar would say, as they seek a revolutionary Latin American cinema.

A profound debate on the role of intellectuals and artists before liberation is today enriching the perspectives of intellectual work all over the world. However, this debate oscillates between two poles: one which proposes to relegate all intellectual work capacity to a specifically political or political-military function, denying perspectives to all artistic activity with the idea that such activity must ineluctably be absorbed by the System, and the other which maintains an inner duality of the intellectual: on the one hand, the "work of art," the "privilege of beauty," an art and a beauty which are not necessarily bound to the needs of the revolutionary political process, and, on the other, a political commitment which generally consists in signing certain anti-imperialist manifestos. In practice, this point of view means the *separation of politics and art*.

This polarity rests, as we see it, on two omissions: first, the conception of culture, science, art, and cinema as univocal and universal terms, and, second, an insufficiently clear idea of the fact that the revolution does not begin with the taking of political power from imperialism and the bourgeoisie, but rather begins at the moment when the masses sense the need for change and their intellectual vanguards begin to study and carry out this change *through activities on different fronts*.

Culture, art, science, and cinema always respond to conflicting class interests. In the neocolonial situation two concepts of culture, art, science, and cinema compete: *that of the rulers and that of the nation*. And this situation will continue, as long as the national concept is not identified with that of the rulers, as long as the status of colony or semi-colony continues in force. Moreover, the duality will be overcome and will reach a single and universal category only when the best values of man emerge from proscription to achieve hegemony, when the liberation of man is universal. In the meantime, there exist *our* culture and *their* culture, *our* cinema and *their* cinema. Because our culture is an impulse towards emancipation, it will remain in existence until emancipation is a reality: *a culture of subversion* which will carry with it an art, a science, and *a cinema of subversion*.

The lack of awareness in regard to these dualities generally leads the intellectual to deal with artistic and scientific expressions as they were "universally conceived" by the classes that rule the world, at best introducing some correction into these expressions. We have not gone deeply enough into developing a revolutionary theatre, architecture, medicine,

psychology, and cinema; into developing a culture *by and for us*. The intellectual takes each of these forms of expression as a unit to be corrected *from within the expression itself*, and not *from without, with its own new methods and models*.

An astronaut or a Ranger mobilises all the scientific resources of imperialism. Psychologists, doctors, politicians, sociologists, mathematicians, and even artists are thrown into the study of everything that serves, *from the vantage point of different speciali-ties*, the preparation of an orbital flight or the massacre of Vietnamese; in the long run, all of these specialities are equally employed to satisfy the needs of imperialism. In Buenos Aires the army eradicates *villas miseria* (urban shanty towns) and in their place puts up "strategic hamlets" with town planning aimed at facilitating military intervention when the time comes. The revolutionary organisations lack specialised fronts not only in *their* medicine, engineering, psychology, and art—but also in *our own revolutionary* engineering, psychology, art, and cinema. In order to be effective, all these fields must recognise the *priorities* of each stage; those required by the struggle for power or those demanded by the already victorious revolution. Examples: creating a political sensitivity to the need to undertake a political-military struggle in order to take power; developing a medicine to serve the needs of combat in rural or urban zones; co-ordinating energies to achieve a 10 million ton sugar harvest as they attempted in Cuba; or elaborating an architecture, a city planning, that will be able to withstand the massive air raids that imperialism can launch at any time. The specific strengthening of each speciality and field subordinate to collective priorities can fill the empty spaces caused by the struggle for liberation and can delineate with greatest efficacy the role of the intellectual in our time. It is evident that revolutionary mass-level culture and awareness can only be achieved after the taking of political power, but it is no less true that the use of scientific and artistic means, together with political-military means, prepares the terrain for the revolution to become reality and facilitates the solution of the problems that will arise with the taking of power.

The intellectual must find through his action the field in which he can rationally perform the most efficient work. Once the front has been determined, his next task is to find out *within that front* exactly what is the enemy's stronghold and where and how he must deploy his forces. It is in this harsh and dramatic daily search that a culture of the revolution will be able to emerge, the basis which will nurture, *beginning right now*, the new man exemplified by Che—not man in the abstract, not the "liberation of man," *but another man*, capable of arising from the ashes of the old, alienated man that we are and which the new man will destroy by starting to stoke the fire *today*.

The anti-imperialist struggle of the peoples of the Third World and of their equivalents inside the imperialist countries constitutes today the axis of the world revolution. *Third cinema* is, in our opinion, the cinema that *recognises in that struggle the most gigantic cultural, scientific, and artistic manifestation of our time*, the great possibility of constructing a liberated personality with each people as the starting point—in a word, the *decolonisation of culture*.

The culture, including the cinema, of a neocolonialised country is just the expression of an overall dependence that generates models and values born from the needs of imperialist expansion.

In order to impose itself, neocolonialism needs to convince the people of a dependent country of their own inferiority. Sooner or later, the inferior man recognises Man with a capital M; this recognition means the destruction of his defences. If you want to be a man, says the oppressor, you have to be like me, speak my language, deny your own being, transform yourself into me. As early as the 17th century the Jesuit missionaries proclaimed the aptitude of the [South American] native for copying European works of art. Copyist, translator, interpreter, at best a spectator, the neocolonialised intellectual will always be encouraged to refuse to assume his creative possibilities. Inhibitions, uprootedness, escapism, cultural cosmopolitanism, artistic imitation, metaphysical exhaustion, betrayal of country—all find fertile soil in which to grow.

Culture becomes bilingual

. . . not due to the use of two languages but because of the conjuncture of two cultural patterns of thinking. One is national, that of the people, and the other is estranging, that of the classes subordinated to outside forces. The admiration that the upper classes express for the US or Europe is the highest expression of their subjection. With the colonialisation of the upper classes the culture of imperialism indirectly introduces among the masses knowledge which cannot be supervised.

Just as they are not masters of the land upon which they walk, the neocolonialised people are not masters of the ideas that envelop them. A knowledge of national reality presupposes going into the web of lies and confusion that arise from dependence. The intellectual is obliged *to refrain from spontaneous thought;* if he does think, he generally runs the risk of doing so in French or English—never in the language of a culture of his own which, like the process of national and social liberation, is still hazy and incipient. Every piece of data, every concept that floats around us, is part of a framework of mirages that is difficult to take apart.

The native bourgeoisie of the port cities such as Buenos Aires, and their respective intellectual elites, constituted, from the very origins of our history, the transmission belt of neocolonial penetration. Behind such watchwords as "Civilisation or barbarism," manufactured in Argentina by Europeanising liberalism, was the attempt to impose a civilisation fully in keeping with the needs of imperialist expansion and the desire to destroy the resistance of the national masses, which were successively called the "rabble," a "bunch of blacks," and "zoological detritus" in our country and the "unwashed hordes" in Bolivia. In this way the ideologists of the semi-countries, past masters in "the play of big words, with an implacable, detailed, and rustic universalism," served as spokesmen of those followers of Disraeli who intelligently proclaimed: "I prefer the rights of the English to the rights of man."

The middle sectors were and are the best recipients of cultural neocolonialism. Their ambivalent class condition, their buffer position between social polarities, and their

broader possibilities of access to *civilisation* offer imperialism a base of social support which has attained considerable importance in some Latin American countries.

> If in an openly colonial situation cultural penetration is the complement of a foreign army of occupation, during certain stages this penetration assumes major priority.
>
> It serves to institutionalise and give a normal appearance to dependence. The main objective of this cultural deformation is to keep the people from realising their neocolonialised position and aspiring to change it. In this way educational colonisation is an effective substitute for the colonial police.

Mass communications tend to complete the destruction of a national awareness and of a collective subjectivity on the way to enlightenment, a destruction which begins as soon as the child has access to these media, the education and culture of the ruling classes. In Argentina, 26 television channels; one million television sets; more than 50 radio stations; hundreds of newspapers, periodicals, and magazines; and thousands of records, films, etc., join their acculturating role of the colonialisation of taste and consciousness to the process of neocolonial education which begins in the university. "Mass communications are more effective for neocolonialism than napalm. What is real, true, and rational is to be found on the margin of the law, just as are the people. Violence, crime, and destruction come to be Peace, Order, and Normality." *Truth, then, amounts to subversion.* Any form of expression or communication that tries to show national reality is subversion.

Cultural penetration, educational colonisation, and mass communications all join forces today in a desperate attempt to absorb, neutralise, or eliminate any expression that responds to an attempt at decolonisation. Neocolonialism makes a serious attempt to castrate, to digest, the cultural forms that arise beyond the bounds of its own aims. Attempts are made to remove from them precisely what makes them effective and dangerous; in short, it tries to depoliticise them. Or, to put it another way, to separate the cultural manifestation from the fight for national independence.

Ideas such as "Beauty in itself is revolutionary" and "All new cinema is revolutionary" are idealistic aspirations that do not touch the neocolonial condition, since they continue to conceive of cinema, art, and beauty as universal abstractions and not as an integral part of the national processes of decolonisation.

Any attempt, no matter how virulent, which does not serve to mobilise, agitate, and politicise sectors of the people, to arm them rationally and perceptibly, in one way or another, for the struggle—is received with indifference or even with pleasure. Virulence, nonconformism, plain rebelliousness, and discontent are just so many more products on the capitalist market; they are *consumer goods.* This is especially true in a situation where *the bourgeoisie is in need of a daily dose of shock and exciting elements of controlled violence*—that is, violence which absorption by the System turns into pure stridency. Examples are the works of a socialist-tinged painting and sculpture which are greedily sought after by the new bourgeoisie to decorate their apartments and mansions; plays full of anger and avant-gardism which are noisily applauded by the ruling classes; the literature of "progressive" writers concerned with semantics and man on the margin

of time and space, which gives an air of democratic broadmindedness to the System's publishing houses and magazines; and the cinema of "challenge," of "argument," promoted by the distribution monopolies and launched by the big commercial outlets.

In reality the area of permitted protest of the System is much greater than the System is willing to admit. This gives the artists the illusion that they are acting "against the system" by going beyond certain narrow limits; they do not realise that even anti-System art can be absorbed and utilised by the System, as both a brake and a necessary self-correction.

Lacking an awareness of how *to utilise what is ours for our true liberation*—in a word, lacking *politicisation*—all of these "progressive" alternatives come to form the leftist wing of the System, the improvement of its cultural products. They will be doomed to carry out the best work on the left that the right is able to accept today and will thus only serve the survival of the latter. "Restore words, dramatic actions, and images to the places where they can carry out a revolutionary role, where they will be useful, where they will become weapons in the struggle." Insert the work as an original fact in the process of liberation, place it first at the service of life itself, ahead of art; *dissolve aesthetics in the life of society*: only in this way, as Fanon said, can decolonisation become possible and culture, cinema, and beauty—at least, what is of greatest importance to us—become *our culture, our films, and our sense of beauty*.

The historical perspectives of Latin America and of the majority of the countries under imperialist domination are headed not towards a lessening of repression but towards an increase. We are heading not for bourgeois-democratic regimes but for dictatorial forms of government. The struggles for democratic freedoms, instead of seizing concessions from the System, move it to cut down on them, given its narrow margin for manoeuvring.

The bourgeois-democratic facade caved in some time ago. The cycle opened during the last century in Latin America with the first attempts at self-affirmation of a national bourgeoisie differentiated from the metropolis (examples are Rosas' federalism in Argentina, the Lopez and Francia regimes in Paraguay, and those of Bengido and Balmaceda in Chile) with a tradition that has continued well into our century: national-bourgeois, national-popular, and democratic-bourgeois attempts were made by Cardenas, Yrigoyen, Haya de la Torre, Vargas, Aguirre Cerda, Perón, and Arbenz. But as far as revolutionary prospects are concerned, the cycle has definitely been completed. The lines allowing for the deepening of the historical attempt of each of those experiences today pass through the sectors that understand the continent's situation as one of war and that are preparing, under the force of circumstances, to make that region the Vietnam of the coming decade. A war in which national liberation can only succeed when it is simultaneously postulated as social liberation—socialism as the only valid perspective of any national liberation process.

At this time in Latin America there is room for neither passivity nor innocence. The intellectual's commitment is measured in terms of risks as well as words and ideas; what he does to further the cause of liberation is what counts. The worker who goes on strike and

thus risks losing his job or even his life, the student who jeopardises his career, the militant who keeps silent under torture: each by his or her action commits us to something much more important than a vague gesture of solidarity.

In a situation in which the "state of law" is replaced by the "state of facts," the intellectual, who is *one more worker*, functioning on a cultural front, must become increasingly radicalised to avoid denial of self and to carry out what is expected of him in our times. The impotence of all reformist concepts has already been exposed sufficiently, not only in politics but also in culture and films—and especially in the latter, *whose history is that of imperialist domination—mainly Yankee.*

While, during the early history (or the prehistory) of the cinema, it was possible to speak of a German, an Italian, or a Swedish cinema clearly differentiated and corresponding to specific national characteristics, today such differences have disappeared. The borders were wiped out along with the expansion of US imperialism and the film model that is imposed: *Hollywood movies.* In our times it is hard to find a film within the field of commercial cinema, including what is known as "author's cinema," in both the capitalist and socialist countries, that manages to avoid the models of Hollywood pictures. The latter have such a fast hold that monumental works such as Bondarchuk's *War and Peace* from the USSR are also monumental examples of the submission to all propositions imposed by the US movie industry (structure, language, etc.) and, consequently, to its concepts.

The placing of the cinema within US models, even in the formal aspect, in language, leads to the adoption of the ideological forms that *gave rise to precisely that language and no other.* Even the appropriation of models which appear to be only technical, industrial, scientific, etc., leads to a conceptual dependency, due to the fact that the cinema is an industry, but differs from other industries in that it has been created and organised in order *to generate certain ideologies.* The 35mm camera, 24 frames per second, arc lights, and a commercial place of exhibition for audiences were conceived not to gratuitously transmit any ideology, but to satisfy, in the first place, the cultural and surplus value needs *of a specific ideology, of a specific world-view: that of US finance capital.*

The mechanistic takeover of a cinema conceived as a show to be exhibited in large theatres with a standard duration, hermetic structures that are born and die on the screen, satisfies, to be sure, the commercial interests of the production groups, but it also leads to the *absorption of forms of the bourgeois world-view* which are the continuation of 19th century art, of bourgeois art: man is accepted only as a passive and consuming object; *rather than having his ability to make history recognised, he is only permitted to read history, contemplate it, listen to it, and undergo it. The cinema as a spectacle aimed at a digesting object is the highest point that can be reached by bourgeois filmmaking.* The world, experience, and the historic process are enclosed within the frame of a painting, the stage of a theatre, and the movie screen; man is viewed as a *consumer of ideology,* and not as the creator of ideology. This notion is the starting point for the wonderful interplay of bourgeois philosophy and the obtaining of surplus value. The result is a cinema studied by motivational analysts, sociologists and psychologists, by the endless

researchers of the dreams and frustrations of the masses, all aimed at selling *movie-life*, reality as it is conceived by the ruling classes.

The first alternative to this type of cinema, which we could call the first cinema, arose with the so-called "author's cinema," "expression cinema," "*nouvelle vague*," "*cinema novo*," or, conventionally, the *second cinema*. This alternative signified a step forward inasmuch as it demanded that the filmmaker be free to express himself in non-standard language and inasmuch as it was an attempt at cultural decolonisation. But such attempts have already reached, or are about to reach, the outer limits of what the system permits. The *second cinema filmmaker* has remained "trapped inside the fortress" as Godard put it, or is on his way to becoming trapped. The search for a market of 200,000 moviegoers in Argentina, a figure that is supposed to cover the costs of an independent local production, the proposal of developing a mechanism of industrial production parallel to that of the System but which would be distributed by the System according to its own norms, the struggle to better the laws protecting the cinema and replacing "bad officials" by "less bad," etc., is a search lacking in viable prospects, unless you consider viable the prospect of becoming institutionalised as "the youthful, angry wing of society"—that is, of neocolonialised or capitalist society.

Real alternatives differing from those offered by the System are only possible if one of two requirements is fulfilled: *making films that the System cannot assimilate and which are foreign to its needs, or making films that directly and explicitly set out to fight the System.* Neither of these requirements fits within the alternatives that are still offered by the *second cinema,* but they can be found in the revolutionary opening towards a cinema outside and against the System, in a cinema of liberation: the *third cinema.*

One of the most effective jobs done by neocolonialism is its cutting off of intellectual sectors, especially artists, from national reality by lining them up behind "universal art and models." It has been very common for intellectuals and artists to be found at the tail end of popular struggle, when they have not actually taken up positions against it. The social layers which have made the greatest contribution to the building of a national culture (understood as an impulse towards decolonisation) have not been precisely the enlightened elites but rather the most exploited and uncivilised sectors. Popular organisations have very rightly distrusted the "intellectual" and the "artist." When they have not been openly used by the bourgeoisie or imperialism, they have certainly been their indirect tools; most of them did not go beyond spouting a policy in favour of "peace and democracy," fearful of anything that had a national ring to it, afraid of contaminating art with politics and the artists with the revolutionary militant. They thus tended to obscure the inner causes determining neocolonialised society and placed in the foreground the outer causes, which, while "they are the condition for change, can never be the basis for change"; in Argentina they replaced the struggle against imperialism and the native oligarchy with the struggle of democracy against fascism, suppressing the fundamental contradiction of a neocolonialised country and replacing it with "a contradiction that was a copy of the world-wide contradiction."

This cutting off of the intellectual and artistic sectors from the processes of national liberation—which, among other things, helps us to understand the limitations in which these processes have been unfolding—today tends to disappear to the extent that artists and intellectuals are beginning to discover the impossibility of destroying the enemy without first joining in a battle for their common interests. The artist is beginning to feel the insufficiency of his nonconformism and individual rebellion. And the revolutionary organisations, in turn, are discovering the vacuums that the struggle for power creates in the cultural sphere. The problems of filmmaking, the ideological limitations of a film-maker in a neocolonialised country, etc., have thus far constituted objective factors in the lack of attention paid to the cinema by the people's organisations. Newspapers and other printed matter, posters and wall propaganda, speeches and other verbal forms of information, enlightenment, and politicisation are still the main means of communication between the organisations and the vanguard layers of the masses. But the new political positions of some filmmakers and the subsequent appearance of films useful for liberation have permitted certain political vanguards to discover the importance of movies. This importance is to be found in the specific meaning of films as a form of communication and because of *their particular characteristics*, characteristics that allow them to draw audiences of different origins, many of them people who might not respond favourably to the announcement of a political speech. Films offer an effective pretext for gathering an audience, in addition to the ideological message they contain.

The capacity for synthesis and the penetration of the film image, the possibilities offered by the *living document*, and *naked reality*, and the power of enlightenment of audiovisual means make the film far more effective than any other tool of communication. It is hardly necessary to point out that those films which achieve an intelligent use of the possibilities of the image, adequate dosage of concepts, language and structure that flow naturally from each theme, and counterpoints of audiovisual narration achieve effective results in the politicisation and mobilisation of cadres and even in work with the masses, where this is possible.

The students who raised barricades on the Avenida 18 de Julio in Montevideo after the showing of *La hora de los hornos (The Hour of the Furnaces)*, the growing demand for films such as those made by Santiago Alvarez and the Cuban documentary film movement, and the debates and meetings that take place after the underground or semipublic showings of *third cinema films* are the beginning of a twisting and difficult road being travelled in the consumer societies by the mass organisations (*Cinegiornali liberi* in Italy, *Zengakuren* documentaries in Japan, etc.). For the first time in Latin America, organisations are ready and willing to employ films for political-cultural ends: the Chilean Partido Socialista provides its cadres with revolutionary film material, while Argentine revolutionary Peronist and non-Peronist groups are taking an interest in doing likewise. Moreover, OSPAAAL (Organisation of Solidarity of the People of Africa, Asia and Latin America) is participating in the production and distribution of films that contribute to the anti-imperialist struggle. The revolutionary organisations are discovering the need for cadres

who, among other things, know how to handle a film camera, tape recorders, and projectors in the most effective way possible. The struggle to seize power from the enemy is the meeting ground of the political and artistic vanguards engaged in a common task which is *enriching to both*.

Some of the circumstances that delayed the use of films as a revolutionary tool until a short time ago were lack of equipment, technical difficulties, the compulsory specialisation of each phase of work, and high costs. The advances that have taken place within each specialisation; the simplification of movie cameras and tape recorders; improvements in the medium itself, such as rapid film that can be shot in normal light; automatic light meters; improved audiovisual synchronisation; and the spread of know-how by means of specialised magazines with large circulations and even through nonspecialised media, have helped to demystify filmmaking and divest it of that almost magic aura that made it seem that films were only within the reach of "artists," "geniuses," and "the privileged." Filmmaking is increasingly within the reach of larger social layers. Chris Marker experimented in France with groups of workers whom he provided with 8mm equipment and some basic instruction in its handling. The goal was to have the worker film *his way of looking at the world, just as if he were writing it*. This has opened up unheard-of prospects for the cinema; above all, *a new conception of filmmaking and the significance of art in our times*.

Imperialism and capitalism, whether in the consumer society or in the neocolonialised country, veil everything behind a screen of images and appearances. The *image of reality* is more important than reality itself. It is a world peopled with fantasies and phantoms in which what is hideous is clothed in beauty, while beauty is disguised as the hideous. On the one hand, fantasy, the imaginary bourgeois universe replete with comfort, equilibrium, sweet reason, order, efficiency, and the possibility to "be someone." And, on the other, the phantoms, we the lazy, we the indolent and underdeveloped, we who cause disorder. When a neocolonialised person accepts his situation, he becomes a Gungha Din, a traitor at the service of the colonialist, an Uncle Tom, a class and racial renegade, or a fool, the easy-going servant and bumpkin; but, when he refuses to accept his situation of oppression, then he turns into a resentful savage, a cannibal. Those who *lose sleep from fear of the hungry*, those who comprise the System, see the revolutionary as a bandit, robber, and rapist; the first battle waged against them is thus not on a political plane, but rather in the police context of law, arrests, etc. The more exploited a man is, the more he is placed on a plane of insignificance. The more he resists, the more he is viewed as a beast. This can be seen in *Africa Addio*, made by the fascist Jacopetti: the African savages, killer animals, wallow in abject anarchy once they escape from white protection. Tarzan died, and in his place were born Lumumbas and Lobegulas, Nkomos, and the Madzimbamutos, and this is something that neocolonialism cannot forgive. Fantasy has been replaced by phantoms and man is turned into an extra who dies so Jacopetti can comfortably film his execution.

I make the revolution; therefore I exist. This is the starting point for the disappearance of fantasy and phantom to make way for living human beings. The cinema of the revolution

is at the same time one of *destruction and construction*: destruction of the image that neoco-lonialism has created of itself and of us, and construction of a throbbing, living reality which recaptures truth in any of its expressions.

The restitution of things to their real place and meaning is an eminently subversive fact both in the neocolonial situation and in the consumer societies. In the former, the seeming ambiguity or pseudo-objectivity in newspapers, literature, etc., and the relative freedom of the people's organisations to provide their own information cease to exist, giving way to overt restriction, when it is a question of television and radio, the two most important System-controlled or monopolised communications media. Last year's May events in France are quite explicit on this point.

In a world where the unreal rules, artistic expression is shoved along the channels of fantasy, fiction, language in code, sign language, and messages whispered between the lines. Art is cut off from the concrete facts—which, from the neocolonialist standpoint, are accusatory testimonies—to turn back on itself, strutting about in a world of abstrac-tions and phantoms, where it becomes "timeless" and history-less. Vietnam can be mentioned, but only far from Vietnam; Latin America can be mentioned, but only far enough away from the continent to be effective, in places *where it is depoliticised* and where it does not lead to action.

The cinema known as documentary, with all the vastness that the concept has today, from educational films to the reconstruction of a fact or a historical event, is perhaps the main basis of revolutionary filmmaking. Every image that documents, bears witness to, refutes or deepens the truth of a situation is something more than a film image or purely artistic fact; it becomes something which the System finds indigestible.

Testimony about a national reality is also an inestimable means of dialogue and knowledge on the world plane. No internationalist form of struggle can be carried out successfully if there is not a mutual exchange of experiences among the people, if the people do not succeed in breaking out of the Balkanisation on the international, conti-nental, and national planes which imperialism is striving to maintain.

There is no knowledge of a reality as long as that reality is not acted upon, *as long as its transformation is not begun on all fronts of struggle*. The well-known quote from Marx deserves constant repetition: *it is not sufficient to interpret the world; it is now a question of transforming it.*

With such an attitude as his starting point, it remains to the filmmaker to discover his own language, a language which will arise from a militant and transforming world-view and from the theme being dealt with. Here it may well be pointed out that certain politi-cal cadres still maintain old dogmatic positions, which ask the artist or filmmaker to provide an apologetic view of reality, *one which is more in line with wishful thinking than with what actually is.* Such positions, which at bottom mask a lack of confidence in the possibilities of reality itself, have in certain cases led to the use of film language as a mere idealised illustration of a fact, to the desire to remove reality's deep contradictions, its dialectic richness, which is precisely the kind of depth which can give a film beauty

and effectiveness. The reality of the revolutionary processes all over the world, in spite of their confused and negative aspects, possesses a dominant line, a synthesis which is so rich and stimulating that it does not need to be schematised with partial or sectarian views.

Pamphlet films, didactic films, report films, essay films, witness-bearing films—any militant form of expression is valid, and it would be absurd to lay down a set of aesthetic work norms. *Be receptive to all that the people have to offer, and offer them the best;* or, as Che put it, *respect the people by giving them quality.* This is a good thing to keep in mind in view of those tendencies which are always latent in the revolutionary artist to lower the level of investigation and the language of a theme, in a kind of neopopulism, down to levels which, while they may be those upon which the masses move, do not help them to get rid of the stumbling blocks left by imperialism. The effectiveness of the best films of militant cinema show that social layers considered backward are able to capture the exact meaning of an association of images, an effect of staging, and any linguistic experimentation placed within the context of a given idea. Furthermore, revolutionary cinema is not fundamentally one which illustrates, documents, or passively establishes a situation: *rather, it attempts to intervene in the situation as an element providing thrust or rectification.* To put it another way, it provides *discovery through transformation.*

The differences that exist between one and another liberation process make it impossible to lay down supposedly universal norms. A cinema which in the consumer society does not attain the level of the reality in which it moves can play a stimulating role in an underdeveloped country, just as a revolutionary cinema in the neocolonial situation will not necessarily be revolutionary if it is mechanically taken to the metropolitan country.

Teaching the handling of guns can be revolutionary where there are potentially or explicitly viable leaders ready to throw themselves into the struggle to take power, but ceases to be revolutionary where the masses still lack sufficient awareness of their situation or where they have already learned to handle guns. Thus, a cinema which insists upon the denunciation of the effects of neocolonial policy is caught up in a reformist game if the consciousness of the masses has already assimilated such knowledge; then the revolutionary thing is to examine the causes, to investigate the ways of organising and arming for the change. That is, imperialism can sponsor films that fight illiteracy, and such pictures will only be inscribed within the contemporary need of imperialist policy, but, in contrast, the making of such films in Cuba after the triumph of the Revolution was clearly revolutionary. Although their starting point was just the fact of teaching, reading and writing, they had a goal which was radically different from that of imperialism: the training of people for liberation, not for subjection.

The model of the perfect work of art, the fully rounded film structured according to the metrics imposed by bourgeois culture, its theoreticians and critics, has served to inhibit the filmmaker in the dependent countries, especially when he has attempted to erect similar models in a reality which *offered him neither the culture, the techniques, nor the*

most primary elements for success. The culture of the metropolis kept the age-old secrets that had given life to its models; the transposition of the latter to the neocolonial reality was always a mechanism of alienation, *since it was not possible for the artist of the dependent country to absorb, in a few years, the secrets of a culture and society elaborated through the centuries in completely different historical circumstances.* The attempt in the sphere of film-making to match the pictures of the ruling countries generally ends in failure, given the existence of two disparate historical realities. And such unsuccessful attempts lead to feelings of frustration and inferiority. Both these feelings arise in the first place from the fear of taking risks along completely new roads *which are almost a total denial of "their cinema."* A fear of recognising the particularities and limitations of dependency in order to discover the *possibilities inherent in that situation* by finding ways of overcoming it *which would of necessity be original.*

The existence of a revolutionary cinema is inconceivable without the constant and methodical exercise of practice, search, and experimentation. It even means committing the new filmmaker to take chances on the unknown, to leap into space at times, exposing himself to failure as does the guerrilla who travels along paths that he himself opens up with machete blows. The possibility of discovering and inventing film forms and structures that serve a more profound vision of our reality resides in the ability to place oneself on the outside limits of the familiar, to make one's way amid constant dangers.

Our time is one of hypothesis rather than of thesis, a time of works in progress—unfinished, unordered, violent works made with the camera in one hand and a rock in the other. Such works cannot be assessed according to the traditional theoretical and critical canons. The ideas for our film theory and criticism will come to life through inhibition-removing practice and experimentation. "Knowledge begins with practice. After acquiring theoretical knowledge through practice, it is necessary to return to practice." Once he has embarked upon this practice, the revolutionary filmmaker will have to overcome countless obstacles; he will experience the loneliness of those who aspire to the praise of the System's promotion media only to find that those media are closed to him. As Godard would say, he will cease to be a bicycle champion to become an anonymous bicycle rider, Vietnamese-style, submerged in a cruel and prolonged war. But he will also discover that there is a receptive audience that looks upon his work as something of its own existence, and that is ready to defend him in a way that it would never do with any world bicycle champion.

In this long war, with the camera as our rifle, we do in fact move into a guerrilla activity. This is why the work of a *film-guerrilla* group is governed by strict disciplinary norms as to both work methods and security. A revolutionary film group is in the same situation as a guerrilla unit: it cannot grow strong without military structures and command concepts. *The group exists as a network of complementary responsibilities, as the sum and synthesis of abilities, inasmuch as it operates harmonically with a leadership that centralises planning work and maintains its continuity.* Experience shows that it is not easy to maintain the cohesion of a group when it is bombarded by the System and its chain

of accomplices frequently disguised as "progressives," when there are no immediate and spectacular outer incentives and the members must undergo the discomforts and tensions of work that is done underground and distributed clandestinely. Many abandon their responsibilities because they underestimate them or because they measure them with values appropriate to System cinema and not underground cinema. The birth of internal conflicts is a reality present in any group, whether or not it possesses ideological maturity. The lack of awareness of such an inner conflict on the psychological or personality plane, etc., the lack of maturity in dealing with problems of relationships, at times leads to ill feeling and rivalries that in turn cause real clashes going beyond ideological or objective differences. All of this means that a basic condition is an awareness of the problems of interpersonal relationships, leadership and areas of competence. What is needed is to speak clearly, mark off work areas, assign responsibilities and take on the job as a rigorous militancy.

Guerrilla filmmaking proletarianises the film worker and breaks down the intellectual aristocracy that the bourgeoisie grants to its followers. In a word, it *democratises*. The filmmaker's tie with reality makes him more a part of his people. Vanguard layers and even masses participate collectively in the work when they realise that it is the continuity of their daily struggle. *La hora de los hornos* shows how a film can be made in hostile circumstances when it has the support and collaboration of militants and cadres from the people.

The revolutionary filmmaker acts with a radically new vision of the role of the producer, team-work, tools, details, etc. Above all, he supplies himself at all levels in order to produce his films, he equips himself at all levels, he learns how to handle the manifold techniques of his craft. His most valuable possessions are the tools of his trade, which form part and parcel of his need to communicate. The camera is the inexhaustible *expropriator of image-weapons;* the projector, *a gun that can shoot 24 frames per second.*

Each member of the group should be familiar, at least in a general way, with the equipment being used: he must be prepared to replace another in any of the phases of production. The myth of irreplaceable technicians must be exploded.

The whole group must grant great importance to the minor details of the production and the security measures needed to protect it. A lack of foresight which in conventional filmmaking would go unnoticed can render virtually useless weeks or months of work. And a failure in guerrilla cinema, just as in the guerrilla struggle itself, can mean the loss of a work or a complete change of plans. "In a guerrilla struggle the concept of failure is present a thousand times over, and victory a myth that only a revolutionary can dream." Every member of the group must have an ability to take care of details, discipline, speed, and, above all, the willingness to overcome the weaknesses of comfort, old habits, and the whole climate of pseudonormality behind which the warfare of everyday life is hidden. Each film is a different operation, a different job requiring variation in methods in order to confuse or refrain from alerting the enemy, especially since the processing laboratories are still in his hands.

The success of the work depends to a great extent on the group's ability to remain silent, on its permanent wariness, a condition that is difficult to achieve in a situation in which apparently nothing is happening and the filmmaker has been accustomed to telling all and sundry about everything that he's doing because the bourgeoisie has trained him precisely on such a basis of prestige and promotion. The watchwords "constant vigilance, constant wariness, constant mobility" have profound validity for guerrilla cinema. You have to give the appearance of working on various projects, split up the material, put it together, take it apart, confuse, neutralise, and throw off the track. All of this is necessary as long as the group doesn't have its own processing equipment, no matter how rudimentary, and there remain certain possibilities in the traditional laboratories.

Group-level co-operation between different countries can serve to assure the completion of a film or the execution of certain phases of work that may not be possible in the country of origin. To this should be added the need for a filing centre for materials to be used by the different groups and the perspective of coordination, on a continent-wide or even worldwide scale, of the continuity of work in each country: periodic regional or international gatherings to exchange experience, contributions, joint planning of work, etc.

At least in the earliest stages the revolutionary filmmaker and the work groups will be the sole producers of their films. They must bear the responsibility of finding ways to facilitate the continuity of work. Guerrilla cinema still doesn't have enough experience to set down standards in this area; what experience there is has shown, above all, the *ability to make use of the concrete situation of each country*. But, regardless of what these situations may be, the preparation of a film cannot be undertaken without a parallel study of its future audience and, consequently, a plan to recover the financial investment. Here, once again, the need arises for closer ties between political and artistic vanguards, since this also serves for the joint study of forms of production, exhibition, and continuity.

A guerrilla film can be aimed only at the distribution mechanisms provided by the revolutionary organisations, including those invented or discovered by the filmmaker themselves. Production, distribution, and economic possibilities for survival must form part of a single strategy. The solution of the problems faced in each of these areas will encourage other people to join in the work of guerrilla filmmaking, which will enlarge its ranks and thus make it less vulnerable.

The distribution of guerrilla films in Latin America is still in swaddling clothes while System reprisals are already a legalised fact. Suffice it to note in Argentina the raids that have occurred during some showings and the recent film suppression law of a clearly fascist character; in Brazil the ever-increasing restrictions placed upon the most militant comrades of *Cinema Novo*; and in Venezuela the banning of *La hora de los hornos;* over almost all the continent censorship prevents any possibility of public distribution.

Without revolutionary films and a public that asks for them, any attempt to open up new ways of distribution would be doomed to failure. But both of these already exist in Latin America. The appearance of the films opened up a road which in some countries, such as Argentina, occurs through showings in apartments and houses to audiences of

never more than 25 people; in other countries, such as Chile, films are shown in parishes, universities, or cultural centres (of which there are fewer every day); and, in the case of Uruguay, showings were given in Montevideo's biggest movie theatre to an audience of 2,500 people, who filled the theatre and made every showing an impassioned anti-imperialist event. But the prospects on the continental plane indicate that the possibility for the continuity of a revolutionary cinema rests upon the strengthening of rigorously underground base structures.

Practice implies mistakes and failures. Some comrades will let themselves be carried away by the success and impunity with which they present the first showings and will tend to relax security measures, while others will go in the opposite direction of excessive precautions or fearfulness, to such an extent that distribution remains circumscribed, limited to a few groups of friends. Only concrete experience in each country will demonstrate which are the best methods there, which do not always lend themselves to application in other situations.

In some places it will be possible to build infrastructures connected to political, student, worker, and other organisations, while in others it will be more suitable to sell prints to organisations which will take charge of obtaining the funds necessary to pay for each print (the cost of the print plus a small margin). This method, wherever possible, would appear to be the most viable, because it permits the decentralisation of distribution; makes possible a more profound political use of the film; and permits the recovery, through the sale of more prints, of the funds invested in the production. It is true that in many countries the organisations still are not fully aware of the importance of this work, or, if they are, may lack the means to undertake it. In such cases other methods can be used: the delivery of prints to encourage distribution and a box-office cut to the organisers of each showing, etc. The ideal goal to be achieved would be producing and distributing guerrilla films with funds obtained from expropriations from the bourgeoisie—that is, *the bourgeoisie would be financing guerrilla cinema with a bit of the surplus value that it gets from the people.* But, as long as the goal is no more than a middle- or long-range aspiration, the alternatives open to revolutionary cinema to recover production and distribution costs are to some extent similar to those obtained for conventional cinema: every spectator should pay the same amount as he pays to see System cinema. Financing, subsidising, equipping, and supporting revolutionary cinema are political responsibilities for revolutionary organisations and militants. A film can be made, but if its distribution does not allow for the recovery of the costs, it will be difficult or impossible to make a second film.

The 16mm film circuits in Europe (20,000 exhibition centres in Sweden, 30,000 in France, etc.) are not the best example for the neocolonialised countries, but they are nevertheless a complementary source for fund raising, especially in a situation in which such circuits can play an important role in publicising the struggles in the Third World, increasingly related as they are to those unfolding in the metropolitan countries. A film on the Venezuelan guerrillas will say more to a European public than twenty explanatory

pamphlets, and the same is true for us with a film on the May events in France or the Berkeley, USA, student struggle.

A *Guerrilla Films International?* And why not? Isn't it true that a kind of new International is arising through the Third World struggles; through OSPAAAL and the revolutionary vanguards of the consumer societies?

A guerrilla cinema, at this stage still within the reach of limited layers of the population, is, nevertheless, *the only cinema of the masses possible today,* since it is the only one involved with the interests, aspirations, and prospects of the vast majority of the people. Every important film produced by a revolutionary cinema will be, explicitly, or not, *a national event of the masses.*

This *cinema of the masses,* which is prevented from reaching beyond the sectors representing the masses, provokes with each showing, as in a revolutionary military incursion, a liberated space, *a decolonised territory.* The showing can be turned into a kind of political event, which, according to Fanon, could be "a liturgical act, a privileged occasion for human beings to hear and be heard."

Militant cinema must be able to extract the infinity of new possibilities that open up for it from the conditions of proscription imposed by the System. The attempt to overcome neocolonial oppression calls for the invention of forms of communication; *it opens up the possibility.*

Before and during the making of *La hora de los hornos* we tried out various methods for the distribution of revolutionary cinema—the little that we had made up to then. Each showing for militants, middle-level cadres, activists, workers, and university students became—without our having set ourselves this aim beforehand—a kind of enlarged cell meeting of which the films were a part but not the most important factor. We thus discovered a new facet of cinema: the participation of people who, until then, were considered spectators.

At times, security reasons obliged us to try to dissolve the group of participants as soon as the showing was over, and we realised that the distribution of that kind of film had little meaning if it was not complemented by the participation of the comrades, if a debate was not opened on the themes suggested by the films.

We also discovered that every comrade who attended such showings did so with full awareness that he was infringing the System's laws and exposing his personal security to eventual repression. This person was no longer a spectator; on the contrary, from the moment he decided to attend the showing, *from the moment he lined himself up on this side* by taking risks and contributing his living experience to the meeting, he became an actor, a more important protagonist than those who appeared in the films. Such a person was seeking other committed people like himself, while he, in turn, became committed to them. The *spectator made way for the actor, who sought himself in others.*

Outside this space which the films momentarily helped to liberate, there was nothing but solitude, noncommunication, distrust, and fear; within the freed space the situation turned everyone into accomplices of the act that was unfolding. The debates arose

spontaneously. As we gained inexperience, we incorporated into the showing various elements (a *mise en scène*) to reinforce the themes of the films, the climate of the showing, the "disinhibiting" of the participants, and the dialogue: recorded music or poems, sculpture and paintings, posters, a programme director who chaired the debate and presented the film and the comrades who were speaking, a glass of wine, a few *mates,* etc. We realised that we had at hand three very valuable factors: 1) The *participant comrade,* the man-actor-accomplice who responded to the summons; 2) The *free space* where that man expressed his concerns and ideas, became politicised, and started to free himself; and 3) The *film,* important only as a detonator or pretext.

We concluded from these data that a film could be much more effective if it were fully aware of these factors and took on the task of subordinating its own form, structure, language, and propositions to that act and to those actors—to put it another way, *if it sought its own liberation in its subordination to and insertion in others, the principal protagonists of life.* With the correct utilisation of the *time* that that group of actor-personages offered us with their diverse histories, the use of the *space* offered by certain comrades, and of the *films* themselves, *it was necessary to try to transform time, energy, and work into freedom-giving energy.* In this way the idea began to grow of structuring what we decided to call the *film* act, the *film action,* one of the forms which we believe assumes great importance in affirming the line of a *third cinema.* A cinema whose first experiment is to be found, perhaps on a rather shaky level, in the second and third parts of *La hora de los hornos* ("*Acto para la liberación*"; above all, starting with "*La resistencia*" and "*Violencia y la liberación*").

> Comrades [we said at the start of "Acto para la liberación"], this is not just a film showing, nor is it a show; rather, it is, above all A MEETING—an act of anti-imperialist unity; this is a place only for those who feel identified with this struggle, because here there is no room for spectators or for accomplices of the enemy; here there is room only for the authors and protagonists of the process which the film attempts to bear witness to and to deepen. The film is the pretext for dialogue, for the seeking and finding of wills. It is a report that we place before you for your consideration, to be debated after the showing.

> The conclusions [we said at another point in the second part] at which you may arrive as the real authors and protagonists of this history are important. The experiences and conclusions that we have assembled have a relative worth; they are of use to the extent that they are useful to you, who are the present and future of liberation. But most important of all is the action that may arise from these conclusions, the unity on the basis of the facts. [This is why the film stops here; it opens out to you so that you can continue it.]

The film act means an open-ended film; it is essentially a way of learning.

The first step in the process of knowledge is the first contact with the things of the outside world, the stage of sensations [*in a film the living fresco of image and sound*]. The second

step is the synthesising of the data provided by the sensations; their ordering and elaboration; the stage of concepts, judgements, opinions, and deductions [*in the film the announcer, the reportings, the didactics, or the narrator who leads the projection act*]. And then comes the third stage, that of knowledge. The active role of knowledge is expressed not only in the active leap from sensory to rational knowledge, but, and what is even more important, in the leap from rational knowledge to revolutionary practice . . . the practice of the transformation of the world. . . . This, in general terms, is the dialectical materialist theory of the unity of knowledge and action [*in the projection of the film act, the participation of the comrades, the action proposals that arise, and the actions themselves that will take place later*].

Moreover, each projection of a film act presupposes a *different setting*, since the space where it takes place, the materials that go to make it up (actors-participants), and the historic time in which it takes place are never the same. This means that the result of each projection act will depend on those who organise it, on those who participate in it, and on the time and place; the possibility of introducing variations, additions, and changes is unlimited. The screening of a film act will always express in one way or another the historical situation in which it takes place; its perspectives are not exhausted in the struggle for power but will instead continue after the taking of power to strengthen the revolution.

The man of the *third cinema*, be it *guerrilla cinema* or a *film act*, with the infinite categories that they contain (film letter, film poem, film essay, film pamphlet, film report, etc.), above all counters the film industry of a cinema of characters with one of themes, that of individuals with that of masses, that of the author with that of the operative group, one of neocolonial misinformation with one of information, one of escape with one that recaptures the truth, that of passivity with that of aggressions. To an institutionalised cinema, it counterposes a guerrilla cinema; to movies as shows, it opposes a film act or action; to a cinema of destruction, one that is both destructive and constructive; to a cinema made for the old kind of human being, for them, it opposes a *cinema fit for a new kind of human being, for what each one of us has the possibility of becoming.*

The decolonisation of the filmmaker and of films will be simultaneous acts to the extent that each contributes to collective decolonisation. The battle begins without, against the enemy who attacks us, but also within, *against the ideas and models of the enemy to be found inside each one of us.* Destruction and construction. Decolonising action rescues with its practice the purest and most vital impulses. It opposes to the colonialisation of minds the revolution of consciousness. The world is scrutinised, unravelled, rediscovered. People are witness to a constant astonishment, a kind of second birth. They recover their early simplicity, their capacity for adventure; their lethargic capacity for indignation comes to life.

Freeing a forbidden truth means setting free the possibility of indignation and subversion. Our truth, that of the new man who builds himself by getting rid of all the defects that still weigh him down, is a bomb of inexhaustible power and, at the same time, *the*

only real possibility of life. Within this attempt, the revolutionary filmmaker ventures with *his subversive observation, sensibility, imagination, and realisation.* The great themes—the history of the country, love and unlove between combatants, the efforts of a people who are awakening—all this is reborn before the lens of the decolonised camera. The film-maker feels for the first time. He discovers that, within the System, nothing fits, while outside of and against the System, everything fits, because everything remains to be done. What appeared yesterday as a preposterous adventure, as we said at the beginning, is posed today as *an inescapable need and possibility.*

Thus far, we have offered ideas and working propositions, which are the sketch of a hypothesis arising from our personal experience and which will have achieved something positive even if they do no more than serve to open a heated dialogue on the new revolutionary film prospects. The vacuums existing in the artistic and scientific fronts of the revolution are sufficiently well known so that the adversary will not try to appropriate them, while we are still unable to do so.

Why films and not some other form of artistic communication? If we choose films as the centre of our propositions and debate, it is because that is our work front and because the birth of a *third cinema* means, at least for us, *the most important revolutionary artistic event of our times.*

FILM MAKERS AND THE POPULAR GOVERNMENT POLITICAL MANIFESTO (Chile, 1970)

Comité de cine de la unidad popular

[First published in Spanish as "Manifiesto de los cineastas de la unidad popular." First published in English in Michael Chanan, ed., *Chilean Cinema* (London: BFI, 1976), 83–84. Trans. Michael Chanan.]

Written in the wake of the 1970 election of Salvador Allende of the Socialist Party of Chile, who became leader of the *Unidad popular* (Popular Unity), this manifesto draws on the utopian Marxist spirit of the times, calling for a new cinema by and for the people of Chile, one that is not dominated by the ideologies of the dominant classes. This call is especially important because of the monopoly held by US interests on Chilean screens at the time.

Chilean film makers, it is time for us all to undertake, together with our people, the great task of national liberation and the construction of socialism.

It is time for us to begin to redeem our own values in order to affirm our cultural and political identity.

Let us no longer allow the dominant classes to uproot the symbols which the people have produced in the course of their long struggle for liberation.

Let us no longer permit national values to be used to uphold the capitalist regime.

Let us start from the class instinct of the people and with this contribute to the making of a class consciousness.

Let us not limit ourselves from going beyond our contradictions; let us develop them and open for ourselves the way which leads to the construction of a lucid and liberating culture.

The long struggle of our people for their emancipation has laid down for us the way to be followed. Let us recover the traces of those great popular struggles falsified by official history, and give back to the people the true version of these struggles as a legitimate and necessary heritage for confronting the present and envisaging the future.

Let us recover the tremendous figure of Balmaceda, anti-oligarchist and anti-imperialist.

Let us reaffirm that Récabarren belongs to the people, that Carrera, O'Higgins, Manuel Rodriguez, Bilbao, as well as the anonymous miner who fell one morning, or the peasant who died without ever having understood the meaning of his life or of his death, constitute the essential foundations from which we emerged.

That the Chilean flag is a flag of struggle and liberation, it is the patrimony of the people and their heritage.

Against an anaemic and neo-colonised culture, a pasture for the consumption of an elite, decadent and sterile petit-bourgeoisie, let us devote our collective will, immersed within the people, to the construction of an authentically NATIONAL and therefore REVOLUTIONARY culture.

Consequently we declare:

1. That before being film makers we are men engaged within the political and social phenomenon of our people, and in their great task: the construction of socialism.

2. That the cinema is an art.

3. That the Chilean cinema, because of an historical imperative, must be a revolutionary art.

4. That we mean by revolutionary that which is realised in conjunction between the artist and his people, united in a common objective: liberation. The people are the generators of action and finally the true creators; the film maker is their instrument of communication.

5. That the revolutionary cinema will not assert itself through decrees. Consequently we will not grant privilege to one particular way of making film; it must be that the course of the struggle determines this.

6. That, meanwhile, we shall regard a cinema removed from the great masses to have become inevitably a product for the consumption of an elite petit bourgeoisie which is incapable of constituting the motor of history. In this case the film maker will see his work politically nullified.

7. That we refuse all sectarianism aimed at the mechanical application of the principles stated above, in the same way that we oppose the imposition of official criteria on the practice of film making.

8. That we maintain that traditional forms of production are a veritable rampart enclosing young film makers. They imply, finally, a clear cultural dependency, for these techniques are derived from aesthetic conceptions foreign to the culture of our peoples.

Against these techniques we contrast research into an original language born from the participation of the film maker in class struggle; this struggle will give rise to its own cultural forms.

9. That we maintain that a film maker with these objectives necessarily implies a different kind of critical evaluation; we assert that the best critic of a revolutionary film is the people to whom it is addressed; who have no need of "mediators who defend and interpret it."

10. That there exists no such thing as a film that is revolutionary in itself. That it becomes such through the contact that it establishes with its public and principally through its influence as a mobilising agent for revolutionary action.

11. That the cinema is a right of the people, and that it is necessary to research those forms which are most appropriate for reaching all Chileans.

12. That the means of production must be available to all workers in the cinema and that, in this sense, there exist no acquired rights; on the contrary, under the Popular Government, expression will not be the privilege of some, but the inalienable right of a people marching towards their final independence.

13. That a people with a culture are a people who struggle, who resist and who free themselves.

CHILEAN FILM MAKERS, WE SHALL OVERCOME!

CONSCIOUSNESS OF A NEED
(Uruguay, 1970)

Mario Handler

[First published in *Cine cubano* 68. First published in English in Zuzana M. Pick, ed., *Latin American Filmmakers and the Third Cinema* (Ottawa: Carleton University Film Studies Program, 1978): 243–248. Trans. Leandro Urbano and Christine Shantz.]

Mario Handler was one of the two cofounders of the *Cinemateca del tercer mundo* in Montevideo in 1969, which functioned as a distribution center for political and militant documentaries that the American conglomerates would not show on their screens. This manifesto, which began as a letter to the left-wing paper *Marcha*, argues that the birth of political cinema can only be tied to the birth of a certain kind of consciousness by Uruguayan intellectuals. Unlike many of the other Latin American film manifestos, Handler's addresses a specific problem facing Uruguay: unlike other countries developing indigenous Third Cinema practices, it lacked a cinema of any real sort.

Look here, *Marcha:* In Uruguay the cinema has always found itself in an exceptionally difficult situation. Now—even more so. At the same time, cinema is needed more than ever, and we have a greater consciousness of this need.

In terms of economic and technical resources today, we are still five years behind Bolivia, ten years behind Chile and Venezuela, then years behind Litorial University, behind Cuba before the revolution; we are behind everyone. It is possible that we have more resources than Paraguay, a country that I do not know much about. What has changed in the past year and a half, since the foundation of *Marcha*'s cinema club, and then that of the Third World Film Library, is fundamentally, the people. We now have a reasonable number of people—fifteen—who believe in a national political cinema and who have the necessary faith, vocation and capacity for organization.

There is still no guarantee of the existence of Uruguayan cinema, and the problem is like an obsession which colours everything we say. In one interview Cosme Alves was amazed that I should say that we would be very content if during the next year we could produce two hours of film. (Naturally, when I say film I don't mean just any film but something of a political and national nature.) This is astonishing for the Brazilians, who produce fifty or sixty full-length films a year, all within the "cinema nôvo"; it is equally astonishing for the Argentinians, Mexicans, and even the Venezuelans and Bolivians, but for us this would be a great ambition. We know that they would not be two wasted hours, that there is a tremendous need for those hours.

The impossibility of showing our films in commercial theatres, the closing down of the I.C.U.B. as a productive institution, which eliminates the courses that did exist, the

attacks from the petty people who steal film from us; all this and more can never force us to change. On the contrary, collectively they have helped us to search, for the first time in the history of Uruguay, for another public, the militant public made up of students, workers and all those who work with culture in a militant sense. We are doing this in Uruguay for the first time just as others are doing it for the first time in other parts of Latin America.

This has been a year for paying off debts generated by previous struggles, for training the group at the personal, individual and collective levels, for establishing contacts with the rest of Latin America and the world, and above all for discussing and deepening our understanding of cinematographic creation as being at the service of the struggle for liberation. That is why we are astonished at times when we show political films from the developed world and our public finds them unacceptable. This discontent of our public is the most persistent incentive for producing our own films, to really express what that militant public is feeling, to discuss and inform about all that which really matters—in my opinion, this is the most salient symptom of the search for independence, on an intellectual level as well as others.

The national and international support we are receiving from political cinema groups (from outside the country) is really impressive. But it is too bad we entered this phase of acceptance and support through the militants, without having gone through a previous phase which we could call industrial or commercial, or at least a phase of purely cultural cinema of a national character; this makes ours a heavy burden. We entered this terrain totally naked, totally lacking in money and equipment, without formally trained people. And that, *Marcha*, is something to be happy about too. It is a difficult situation, but we can be glad of it, because it has meant that our cinema, this Uruguayan cinema which hardly even existed until now, has had to come into the world and be directly political, functional and liberating, for our own struggle to create a worthwhile cinema coincides exactly with the struggle of the people of Uruguay.

So our cinema will never be a cinema of rebellion against the old masters as in almost all other countries, because we have no old masters. It is not the adolescent rebellion of someone fighting against the domination of others in the field of cinema. We skipped that and we fight directly against those who dominate the life of the nation. Luckily all our efforts of times gone by to pass laws which would be protective of cinema, and to achieve a favourable environment for our cinema, have failed. So it is absolutely impossible to make corrupt cinema, not because we are pure, but for objective reasons. Our temptations help us because they are not tempting enough.

Another big irritation is the incredible smallness of Uruguay, and on top of that, its economic structure, which means that since we lack any great industry, we lack something else which has always been there in other places—that is, people who support those who create, even though that support may be indiscriminate, as we see in the developed countries, where they give as much assistance to a painter corrupted by the system as to a film maker who makes an anti-capitalist film, or to a fashion designer who invents a dress

made of feathers. We do not have a single Maecenas (patron of the artist), no support at all from the middle class, not even the support of the market; apparently the Uruguayan market cannot support internal production.

As so we have to turn to outside the country and acquire a foreign public. For reasons of our own conscience, the public we are addressing is the Latin American public; they are the ones who matter to us. After the Latin Americans, the people of the Third World in general and, after that, any militant public of the developed countries. Naturally we know that any economic aid we can obtain from leftist groups in the developed countries has to be in a very limited form. We ask for it, we get it, and in no way do we look down on its political aspects, but the battlefield which concerns us right now is Latin America, and of course the inner workings of imperialism.

In this respect we have progressed enormously. We know that we can count on our Latin American fellows for the same support that we give them. We know that they are working under difficult conditions—sometimes more difficult than our own, sometimes much better than our own, but we also know that we are relying on them, and they on us, and that in this way we are making great progress. If you consider that the first Latin American film festival was held as recently as 1967, Viña del Mer, you can get an idea of the progress we have made. For example, we have a number of agreements now on distribution, with Venezuela. We have agreements with our colleagues in Chile, Brazil, Bolivia, Colombia and Mexico.

Our role within this Latin American framework changes, not every year, but every three months, along with the political conditions of Uruguay. Ten years ago, for example, it would have been conceivable to think of Uruguay as the ideal country for film making in purely intellectual terms. Now, however, the same urgency and originality of revolutionary political struggles in Uruguay are applied to the cinema, making this kind of intellectual exercise unthinkable.

This kind of statement is risky, because in the cultural field Uruguay participates in the European tradition absolutely. It participates in an imitative, admiring, approximate and above all isolated way. Our ignorance with regard to cinema is fortunately not an ignorance in the sense of not having read many books and seen many films, but in the sense that we have not yet made any films; hopefully, this kind of ignorance will allow us to shake off all cultural prejudices and bring a new freshness to the field of expression. New means of expression, directly subordinated to the needs of liberation. We are sure of one thing—as far as choice of theme, exploration of content, and expression of that content, we are sure that we will continue for a long time to concern ourselves with the basic themes in a directly combative way, knowing well that what we have to do is to refer directly to imperialism, to native oligarchy, to corrupt governments and, some day, to those who are fighting. I am in total agreement with the reflections of García Espinosa on this: what we need is to refer directly to the leftists, to the revolutionaries and to make films about them, stating their problems in a vital way and trying to help. We cannot contribute too much in the way of

ideology, but we can contribute towards methods of expression which may help to clarify things.

I should add that we have resisted this report, and other offers to express ourselves publicly, because we are obsessed with our organizational, creative and economic needs. At this time we need equipment; our bond campaign has not gone very well. We need people; this aspect, however, is going well. We need to produce and this is being done with personal sacrifice. Several of our companions are producing at an extremely modest level on their own, without any aid at all. I have resisted this interview, as I have resisted others and even writing about us because I do not really believe in it, in the face of the undeniable fact that it has been a year since we have been able to make a film. The last film was of a militant nature and so turned out rather unsubstantial, an ideology in the void, without concrete content. But this has been a period of preparation and transition; great things are going to come out of it. That is why talking in this case becomes simple speculation, or at most, reporting. If that is not clear, one could say that this interview was purely public relations, and that there is a need for this kind of thing.

MILITANT CINEMA: AN INTERNAL CATEGORY OF THIRD CINEMA (Argentina, 1971)

Octavio Getino and Fernando Solanas

[First published in Spanish in Octavio Getino and Fernando Solanas, *Cine, cultura y descolonización* (Siglo XXI: Mexico City, 1973). First published in English in *Third Text* 25, no. 1 (2011): 52–53. Trans. Jonathan Buchsbaum and Mariano Mestman.]

This text is one of Getino and Solanas's theoretical reflections on Third Cinema after having screened *Hour of the Furnaces* many times throughout Latin America and having done further work with the *Cine liberación* collective. Here, they examine what they contend is the most evolved form of Third Cinema: militant cinema.

In a previous article, we defined three types of cinema: the *first cinema* or overtly commercial cinema based on the American model; the *second cinema*, or "auteur cinema," a variant of first cinema, and similarly subject to the "owners of cinema" or to surplus value cinema; and the *third cinema*, the cinema of liberation.

These notes are meant to develop that work, specifically one of the categories of *third cinema*, its most advanced category: *militant cinema*.

The *third cinema*,

. . . that which recognizes in the anti-imperialist struggles of the people of the Third World and of its equivalents in the heart of the metropolis, the most gigantic cultural, scientific and artistic manifestation of our time,

is an event sufficiently new that it still lacks a rigorous level of analysis and criticism; nonetheless, a fine-tuning of certain definitions is becoming necessary. For example, when the *third cinema* plays a role as militant cinema, what circumstances in unliberated countries delimit the field of *militant cinema* from the rest of *third cinema*? What defines the *militant* nature of a film? What is the role of the *militant cinema* group?

These and other questions are being addressed, at least provisionally, from the different spheres of *third cinema*. Nonetheless, the quality of the responses does not deal adequately with the effectiveness of the completed work. This has been sufficiently important to demand a reasoning that accords with its development: the nine films produced in Chile between 1969 and 1970 for the Popular Unity, the Communist Party, the MIR, the CUTCH; the new channels of political diffusion open in Venezuela with the "Distributor of the Third World"; the construction in Uruguay of the "Third World Cinematheque" and its intensive work in production and exhibition; the creation of small groups of *militant cinema* like "Popular Colombian Cinema" or "Realizadores de Mayo" (Film-makers of May, Argentina, 1969); the development at the national level of Groups of Liberation Cinema (Argentina); the 25,000 participants at projections of *The Hours of the Furnaces* in only eight months during 1970 in our country, tightly linked to work of the political organisations that are forming with hundreds of small actions; the gestation of a current within *militant cinema* at the continental level of support groups in Cuba, Mexico, Venezuela, Colombia, Brazil, Chile, Peru, Uruguay, Bolivia, Argentina. Does all this activity not seem a bit unusual, inasmuch as it is the product of a project with only two or three years of elaboration?

To define, or try out certain definitions of a provisional nature, useful for deeper thinking about this path, is today becoming an essential task, now that the initial stage of mutual exchange has ended. This is because the responsibility that falls to those who are developing the *militant cinema* is much greater than that which corresponded to the directors of *third cinema*. And it is greater precisely because the animators of a *cinema of militants* do not seek only to work on cultural decolonisation, or the recuperation of a national culture, but are proposing a *revolutionary politics* through their militant activity (and here they see their work above all as political-cinematic) that leads to the destruction of neo-colonialism, to the national liberation of our countries and the national construction of Socialism. The responsibility is greater because what is intended is specifically the construction of a *militant revolutionary cinema* (both strategically and tactically), and this task is sufficiently ambitious that the problems and risks that confront it will have to be studied with the greatest possible rigour. But could we establish perhaps hermetic definitions or theses? If we did that, would we not be undermining exactly the greatest virtue and quality of this effort: its characteristic of *hypothesis* and

inconclusiveness? That is, the same quality that characterises the revolutionary projects of our continent.

For these reasons, and even though at times the notes on the topic may sound perhaps excessively definitive, we do not pretend with these comments anything other than *to stimulate* an investigation, *to provoke* a deeper problematisation of the path taken. Practice in itself will not be enough in this process. The process requires already, and with a certain urgency, a critical examination that may well be possible only with practice, but requires a certain distance from it to think through and affirm its development at deeper levels.

FOR COLOMBIA 1971: MILITANCY AND CINEMA (Colombia, 1971)

Carlos Alvarez

[First published in *Cine cubano* 66–67. First published in English in Zuzana M. Pick, ed., *Latin American Filmmakers and the Third Cinema* (Ottawa: Carleton University Film Studies Program, 1978): 180–190. Trans. Leandro Urbina and Christine Shantz.]

Like Mario Handler's Uruguayan manifesto, Carlos Alvarez's was written for a country, Colombia, that did not really have a film industry of which to speak. Alvarez argues for a radical Colombian documentary cinema that cannot be recuperated by the bourgeoisie through recourse to aesthetics or obfuscated through the invocations of auteurs. Instead, he argues for an emergent cinema that closely aligns the filmmakers with farmers, workers, and the people—one that eschews "art" for politics. To achieve these ends, he argues for the greater use of 8 mm film as a militant tool.

In Latin America today, the act of taking up a camera to make a film is dangerous. And this is a good thing.

Social events and their development demand, and themselves give rise to, categorical definitions.

The vacillating men on the fence, on good terms with both God and the Devil, are reminders of more agreeable, less defining historical moments.

The presence of the class struggle within film culture which has always existed but which people have not wanted to recognise up until now, has heightened in the last decade with an increasing violence. The Cuban Revolution was the key event on putting pressure on Latin America to stop talking about the need for a revolution and to begin to act. This pressure was directed more toward the theorizing left—presumably subversive to the bourgeois system—than towards the right, the holder of economic strength. It was an event that disturbed the whole world and divided into two camps the conceptions of the

left which implied the possibility and the necessity of a revolutionary change in the structure of neo-colonial dependence on the continent.

Formerly, the intellectual in good faith could wish for socialist change for the backward and humiliated Latin American republics. Theoretically, it was easy to perceive. The difficult part was to achieve it, to realize it. So one could go on making empty speeches.

After the triumph of the Cuban Revolution and once it had been secured along with the preponderance and precision it gave to the cultural sector, they were left dazzled and either they pined romantically for such a revolution, or they took a little trip to the golden island to see for themselves what a revolution looks like.

Meanwhile the revolutions of each country, which had to be carried out in each country, were never initiated. And, of course, those who did begin it were professionally non-intellectual groups.

In the cinema particularly the initial bedazzlement came through the medium of the French New Wave, with "daring" amorous relationships, subtle formal constructions and an intensified idealism that even the most "revolutionary" were not capable of seeing.

At least five years in the best cases, and eight in the case of Colombia, were spent with this cloudiness of vision.

Now that this experience has settled, it is possible to see more clearly and delimit more exactly the factions in conflict: cinema for alienation and exploitation, of cinema for liberation together with the liberation movements of Latin America.

This is why fence sitters—those who remain neutral—no longer exist, nor have they ever existed. Silence grants consent; he who remains silent thus sides with the powerful, "them," the reaction.

This is the trap of commercial feature films: to entice the masses either through films "with a message," as their proponents maintain, but very diluted for the system is not a foolish fifteen-year-old to let itself be easily taken in; or with apparently innocuous and inoffensive stories on which the system is based, and which treat their directors like submissive collaborators, like useful idiots. Others have straightforwardly commercial interests likely coloured with a leftist or tropicalist tint very much in vogue today and very much valued on the European markets for Latin American cinema.

IN COLOMBIA

This frightening process is a necessary beginning within the trial and error experiences a revolution must go through in order to achieve greater clarity; in this case, in the cultural process which was a harsh experience in Colombia.

The men who went to study abroad and returned to make publicity-oriented documentaries were simply reactionaries, common merchants to whom making films was equivalent to selling mattresses or working as accountants. Norden, Pinto, Luzardo, Angulo, Gonzáles Moreno, Durán, were just that; situated within that subterranean class struggle they tried to hide, a part of the militant reaction, by default or by direct action.

As of 1968, a new generation appears, muted by great internal struggles. These struggles thwart the proliferation of films, but they are necessary insofar as they elucidate the diverse tendencies of the left within a culture; a left not very clearly defined, a left that tolerates extremely feeble lines and dilatory distortions of the straightest path towards the revolution or of the honest and correct ways verified by past experiences in Latin America.

One has to respect that group for in its various hues, in its caustic discussions, it tries at least to place itself in a leftist perspective; at the best of times, though not always, elucidating the factions with a bourgeoisie attesting to and admiring of rebellion.

Not a single feature-length commercial film was produced in Colombia in 1970. One longish film came out, *Y se llamaría Colombia,* a documentary an hour and a half in length with a great display of colour, directed by Francisco Norden by order of the government of Lleras Restrepo. It presents the poor, dependent beggar—Colombia—as the paradise of terrestrial goodness. It is a base one-minute commercial multiplied by ninety, boring and poorly made, a servile lackey effusively praising private enterprise, private property, private exploitation, made by the bipartite regime to support its fallacies.

In the field of shorts, however, Alberto Mejia's *28 de Febrero de 1970* about a massive demonstration by university students in Bogota was made and caused the fall of the Minister of Education, an active member of the Opus Dei; Carlos Alvarez's *Colombia 70,* about the inhumane life of a beggar in Bogota, Gabriela Samper's *El hombre de la sal,* about an old salt processor in Nemocón and his primitive methods, displaced by present mechanization; Julia de Alvarez's *Un dia yo pregunte . . .,* about religious alienation in Colombia, and *Entrevistas sobre planas* by Father Gustavo Perea, Marta Rodríguez and Jorge Silva, showing three interviews with indigenous people of the plateau region of Planas, to the east of the country, where the army tortured them for refusing to inform on and disclose the whereabouts of a group of guerrillas.

Five different works that barely make up an hour of film all put together, but they present old analyses no longer commercialized, no longer diluted; still full of mistakes, but representative of the most honest political and cinematographic tendencies that Colombian cinema has to offer today.

AN INTERMEDIATE SUMMARY

The 1970 experience, richer than any other of these years of struggle, partial successes and petty bourgeois errors, leads to more results than we could have guessed at an earlier date:

1. The definitive affirmation of the documentary as instrumental in effectively speaking out about our reality, and the almost definitive elimination of the feature-length film.

2. The necessary experience for the full utilization of 16mm as the format most accessible to our economic and distributing capabilities.

art at the service of foreign interests, not the international loans that lend to debts of national sovereignty, not the deceit of national democratic parliamentary representation.

8MM AT LAST

It is not an easy task to carry a 16mm projector on your back for ten blocks because there are no buses in that neighbourhood, especially if it is muddy and rainy. But this is only a very small part of the tasks of the Colombian film director. It creates discipline and develops the shoulders that the "intellectuals" have become accustomed to use for carrying books. It is not an obligatory step in the process, but it must be done; if not, who will do it?

Nor will it be easy if the police and the forces of repression discover that this cinema is not agreeable to them. It is not practical to have to run weighted down with a heavy projector. This will be an everyday part of film making, and it must be taken into account starting now. And solutions must be found.

The next step within this rise in militancy and imagination can be tactical. How can we say what we have to say in the most effective way? The biggest problem until now has been the quality of sound in the screenings. The old projectors do not reproduce sound very well; large parts of the films with live interviews are therefore lost, important nuances of sound lose their strength, the sound is too low or disappears altogether, and then—it is not at all unusual—the worst can happen: the sound bulb burns out and the film must be narrated and synchronized with the picture.

Much of the future work, though not all, is being planned in silent 16mm, following the good example set by Mario Handler's *Líber Arce liberarse* which, in spite of everything, still accords enough importance to the projector.

Or in 8mm, with or without sound, with cassette tapes and inaccurate synchronization leaving margins, but these films are effective insofar as their content and our search are concerned. The smaller weight of the projector now permits greater and more rapid mobility and an 8mm film fits into a shirt pocket. Four-minute films give us the key time to speak out, though only briefly, about our reality and provoke discussion about it.

In another area, our meetings are small but extremely effective. Films should not be shown without providing for subsequent discussion, for the latter is the true motivation for the screening. Never should the aim of the showing be visual alone; it is essential to give the participants the chance to confront the situation and its possible solutions.

Thus the film is hardly determinant in revolutionary political discussions. Revolutionary discussions for large groups cannot be organized under present conditions in Latin America. In large groups, the participant becomes "massified" and what we are looking for is precisely the opposite, that each one be individualized, radicalized, that he become a potential soldier or active participant in the revolution.

Within this program where some of those aims have been fulfilled and some hardly planned, Colombian cinema should finally discover its true cultural and political content.

And the directors, they constitute the true road to the revolution, which today is this way and tomorrow could be another, more advanced way.

The alternative will only be resolved with an intensification of the fight and perhaps only then will the best Colombian cinema possible be made: The Revolution.

THE CINEMA: ANOTHER FACE OF COLONISED QUÉBEC (Canada, 1971)

Association professionnelle des cinéastes du Québec

[First posted on the doors of Famous Players movie theaters in Québec in April and May 1971. First published as "Manifeste de l'Association professionnelle des ciné-astes du Québec: Une autre visage du Québec colonisé," *Champ libre* 1 (1971): 77–87. First published in English in *Cineaste* 5, no .3 (1972): 21–26.]

On its surface, the APCQ manifesto, written on behalf of the organization by Ray-mond-Marie Léger, arose in response to the seizing of two Québécois soft-core porn films—*Pile ou face* (Roger Fournier, 1970) and *Après ski* (Roger Cardinal, 1971), both examples of the briefly successful sub-genre dubbed "Maple Syrup porn" by *Variety*—after the films were denounced by members of the Catholic clergy, even though the films had been certified for public screening. Yet the manifesto also addresses the way in which Québécois cinema was historically colonized by English Canada, the clergy, and the United States, arguing that cultural expression should take supremacy over solely capitalist considerations.

I. THE CURRENT SITUATION

Once again the issue of film censorship is occupying the front pages of the newspapers. The debate is taking place in an atmosphere of total confusion: a steady stream of decla-rations and counter-declarations, press conferences and telegrams-supporting, answer-ing, contradicting each other assaults the public from all sides. Political leaders and cult leaders, movie merchants and movie-makers, hurl insults back and forth. The critics for their part seem completely baffled by it all and are content to publish the telegrams and declarations *(Le Devoir, Montreal Star, Québec Presse, Montréal Latin)* or at best to sum-marize the situation superficially *(La Presse)*.[1] All in all, they show themselves quite in-capable of analyzing what is going on.

What then is really at issue, and who are the principals in the debate? There are five distinct groups involved: 1) the "Sexploiters," 2) the Church, 3) the government of Québec, 4) the federal government, and 5) the film-making profession.

The same reality has already shown that to be Marxist is not to know Marxist theory from top to bottom and left to right. It is to do something, to do things, revolutionary actions, to destroy bourgeois society and substitute for it a socialist society. That is, to carry out the Revolution.

And this formidable project must be the framework for all cinema that endeavours to integrate itself into the most active mechanisms of change, that endeavours to be new in the truest sense of the word, that endeavours to reflect present Colombian reality.

Thus the most honest phases of Colombian cinema have been: first, testimonial cinema (Giraldo's *Camilo Torres*); a cinema which investigated social reality (Arzuaga's *Pasado el meridiano*); the cinema of denunciation (Alvarez's *Asalto*); of the discovery of all the flaws of bourgeois society (Mejia's *Carvalho*), of all present reality. A disquieting cinema (Alvarez's *Colombia 70*), to testify to and critically demystify the hidden social structure, distorted and ignored by official newsmen and official film makers.

And today, a militant cinema, which, depending on how well the film makers are integrated into the physical action of revolutionary change, will be able to verify not only the social decomposition of the bourgeoisie, but also the way to banish it definitively, how it must be done and the direction in which the revolutionary process must be guided (*Un dia yo pregunte* . . ., by Julia de Alvarez).

The affirmation of the documentary film and the elimination of the feature-length film no longer pose a problem, no longer give rise to any conflict, but the way must be explored further.

The choice is between the revolutionary and the reactionary and the way is not easy.

Now it is not even enough to make an effective, politically clearly defined, and revolutionary film. We must participate right through until the last stage: the showing, where the film is seen. As a political film, it is actualized only once it is shown to a potentially revolutionary audience, once it has incited the people and motivated them to act in a revolutionary manner.

With the clearer articulation of the goal to be attained, we are arriving at a point in our evolution where only films for the social base, urban or rural, are being prepared.

In the early stages of Latin American and Colombian cinema, due to the immediacy of the audience and to the limitations of the director's political militancy, the only films made were directed towards a university audience. This resulted in a certain intellectual euphemism, in games of spirit. When the people became involved, it was realized that these intellectual gymnastics, though very well intentioned at times, were of no use to those who were in theory recognized to be the ones to carry out the revolution.

The next step, then, is to reach the point of making films about the problems of the people, their doubts, their struggles, their triumphs, the road to their liberation, of making films as close to their social perspective and as political as possible. Once this step is taken, Colombian cinema will begin to express the pulse of Colombian reality. The people, they are Colombian reality, not the buildings they build with their hands, not the

3. The realization that the union, romantically pined for by some film makers, could materialize, not through theoretical postulations but through actual works, once they have been filtered through the political leaning to which the film maker ascribes.

4. The necessary step towards a cinema of social observation and criticism, towards a militant political cinema, actively introduced into the development of revolutionary articulation.

5. The necessity for militant cinema to come from active—not theoretically militant—film makers. A militancy that will affect everything from the organization of the system of film distribution and showings to the everyday political tasks of a revolutionary organization.

6. The studies concerning the growing use of 8mm as an ideal format for the maximal development of the film maker's revolutionary work that will weaken the individual personality of the film maker and reduce it to the status of merely one more cog in that formidable piece of machinery we must start up, or accelerate, or culminate—the revolution.

And so that there are no more doubts, in this country where the National Front invents confusing tags like "the great change" or "the pacific revolution" for that of which we speak, that is not what it is. It is a socialist, Marxist, Leninist revolution.

OUR MAIN OBJECTIVE

With every day that passes, the orientation of Colombian cinema affirms itself with greater clarity and urgency; where Colombian cinema must go, is going, and will go: to the people.

That is why cinema is currently being mobilized towards that objective. Perhaps it is still very little, a beginning, but it is already being done. And the ones who learn the most from that contact are not the people when one tries to speak of their oppressed and vilified realities, but the directors in contact with them, the people, that contemptuous word in the mouths of the bourgeoisie. The bourgeoisie is the class of origin of all the film makers who have gone to the people and who have had to learn painfully that it is this social class that is the source of all real knowledge: a fountain of learning, and the only one that can be changed and restored to its humanity.

This is why the intent is to make popular cinema. For now, only by a few for a few, hopefully many more, but always with a political perspective in mind.

The most advanced Colombian cinema is realized with a political aim and not an artistic one. This does not mean that one should not try to make it in the best possible way. Until now, it has not been possible to prove that the films of this cinema in its most advanced manifestations are beautiful or artistically perfect; what can be assured, however, is that they are politically effective, and that is what matters.

1. The "Sexploiters." These include those who are directly tied to the production of the type of films in question in the debate: producers, directors, actors (in most cases), and above all, the production and distribution companies which invest in and guarantee the distribution of these films with the sole aim of reaping large profits.

The situation is actually quite complex, and this is recognized by everyone. But in no way is it a question of "talented and respected actors" under attack for creating works of art, as the director of *Pile ou face* would have us believe; nor, as its producer has written, is it a matter of recognizing the socially redeeming value of such films. What we have here is simply a cast of characters interested in making big money, and quickly. The recent confessions of the man known as the "father" of *Après ski* bear this out.

To talk of art and "personal expression," not to mention "public taste," is irrelevant to the real issues here.

2. The Church. Those speaking out include, in particular, one specimen of declining ecclesiastical authority (Father Des Marais), one character who is already part of folklore (Brother Bonneville), and one spiritual leader of the working class community (Monseigneur Lavoie). The last named is taking advantage of his parishioners' indignation to reaffirm his authority and amass some political capital, without really taking into account the various questions involved, and with perhaps a certain taste for the sheer spectacle of it all. He is thus giving the police powers a chance to show their stuff and helping the "sexploiters" to make even more money.

The clergy, whether it be aristocratic (Des Marais and Bonneville) or working class (Lavoie), is reacting mechanically to the erotic film scandal in an effort to shore up its eroded position and failing strength against the gains of new financial interests in Québec. It therefore does not represent any consensus of the people and does not care about the political and social consequences which might result from its jeremiads. The clergy is simply defending its interests which are threatened by a petty bourgeoisie which has now detached itself from the Church in order to consolidate its domination of Québec.

3. The Québec Government. Those involved include Minister of Justice Jérôme Choquette and Minister of Cultural Affairs François Cloutier. The former is a man of the Right (so they say) and directs a powerful ministry; the latter is a liberal (so he says) and in this controversy he seems to be following closely the initiatives of the Minister of Justice.

Choquette, a "law and order" man, is allied with the clergy because this gives him a fresh opportunity to reaffirm his authority, and more generally to defend the capitalist "hard line."

Cloutier, the "open" personality and man of good taste (he's kept himself from going to see the two films which have caused the commotion), pleads the cause of the French-Canadian film industry, to which he promises his support in fighting for legislative protection. He thus places the debate in a larger context, but at the same time he avoids having to defend concretely the actions of the Bureau of Film Supervision, the autonomous body which he represents in the National Assembly, and thus tends to sanction the mysterious positions and plans of his colleague in the Justice Ministry.

4. The Federal Government. The organism involved in this question is the Société de développement de l'industrie cinématographique canadienne, or SDICC, which is the co-producer and primary beneficiary of the distribution of *Pile ou face*. The SDICC is a kind of specialized bank, created by Federal law in 1967, which lends money to Canadian producers in order to promote the development of a Canadian feature film industry.

Because of the incoherence of its policies as well as its desire to see profits made quickly, which is to be expected in a state capitalist organism of this type, the SDICC has participated directly in the intensive development of "erotic" productions in Québec. It has invested in all of the films produced by Cinépix, one of the largest producers of such films with the exception of only one entitled *Valérie*.[2] By favouring this kind of production, and allowing itself a monopoly over distribution, the SDICC once again is helping to hold back the birth of an authentic French-Canadian cinema, and one which Québec could afford financially.

For the governments of Québec and Ottawa, more than for any of the other groups involved in this debate, the important issues go well beyond the question of the present or future course of French-Canadian cinema. The issue here is properly a political one, and it may even become an election issue, if we are to believe *La Presse*.

5. The Profession. Professional film-makers have been represented in this debate by the Federation québécoise de l'industrie du cinéma. This Federation is made up of the presidents of the main professional organizations of Québec cinema: Association professionnelles des cinéastes du Québec, Association des producteurs de films du Québec, Association des distributeurs indépendants de films de langue française, Syndicat général du cinéma et de la télévision, Syndicat national du cinéma, Society of Film Makers (Québec), Association des propriétaires de cinémas du Québec, Union des artistes. The federation meets only when specially convened—mainly in times of crisis—and supposedly expresses a consensus in its public statements.

In the current circumstances, the Federation has above all chosen to defend the economic interests of French-Canadian cinema—it is most revealing that it is on this occasion that the Association des Propriétaires de Cinémas has decided to join the Federation after many years of hesitation. The statements issued by the Federation thus have had the tendency to reduce the debate about cinema in Québec to questions of its economic survival. They are silent on the question of its cultural meaning, which is of course as important and problematic.

Although the Federation claims to speak in the name of the people of Québec in the debate, the fact that it places only commercial questions in the foreground makes it objectively the ally of the "Sexploiters."

MEANWHILE, BACK ON EARTH

Yet something seems to be missing. It seems that we have not yet heard from those in whose name everybody seems to be speaking—the *people of Québec,* the "population" which all sides invoke.

This population, whom the Minister of Justice seems so solicitous of when lending an attentive ear to the complaints of Mgr. Lavoie, and which the men of the movie industry pretend to defend when they warn the government against "grave threats to the entire film industry of Québec and injustice toward an entire population," (as if they really served the people of Québec), this population is nevertheless totally absent from the debate. After insulting it by refusing to produce films which spring from its reality and speak to its needs, they offer it films which are false and alienating, and then demand that the population engage in the debate about such films.

But the population is nobody's fool. Several letters to the editor in the Québec papers testify to the uneasiness with which many citizens view the incoherence of the debate.

In sum, the problem goes way beyond the events of the last few weeks: it is the total situation of French-Canadian cinema which we must try to clarify.

II. THE GENERAL SITUATION

The two films which have caused the scandal, *Pile ou face* and *Après ski,* are part of a larger question: the economic and cultural domination of the people of Québec by outside interests.

In contrast to what the loudest voices would have us believe, it is neither artistic interests (freedom of expression) nor the interests of morality (pornography as a mortal sin) which are at stake. At least, not in the main.

Cinema in Québec is controlled by two Anglo-American monopolies—Famous Players–Paramount (producer and holder of the rights to *Après ski*) and Cinépix (producer, distributor and holder of the rights to *Pile ou face*)—once again evidence that Québec is a colony under foreign domination. And it must be understood that these companies participate *daily* in the economic, social, cultural, and political exploitation of the French-Canadian people.

Economic exploitation:

Famous Players belongs to a powerful American cartel, Gulf Oil, the same company which maintains the workers of Shawinigan and Montréal-Est under its yoke, and which netted 300 million dollars profit in 1968.

And for its part Cinépix has become the largest distributor of films in Québec and the largest local producer of feature-length films, thanks to financial help from the Société de Développement de l'industrie du Cinéma d'Ottawa. Cinépix's Québec box-office receipts have enabled the SDICC to increase its production of films in English-speaking Canada (by promoting agreements with Warner-Esso and 20th Century Fox–Shell) while the number of feature-length films made in Québec has scarcely increased since 1967, the year in which the SDICC was established.

Social exploitation:

The stock-holders of these companies are among the 1.6% of the American people who possess 80% of the capital stock of all American companies throughout the world. One entire "gang" owns not only the cinema but the entire world economy. Cinépix is a recent acquisition by an American holding company and its saleability resulted directly from the profits of "sexploitation" both on the level of production in Québec and in the distribution foreign grade-B movies.

Cultural exploitation:

The means of film production here as elsewhere belong to a class of people who use film as one means by which to show that the kind of life it leads is actually the life every-one leads. They impose their ideas, their obsessions (sexual and otherwise) on us and portray people as imbeciles like Saint-Henri's woman in *Pile ou face.*

Film management for the population of Québec is programmed from the top down by the directors of Famous Players and Cinépix; the latter effectively directs and manipulates the program of showings for a large majority of French-Canadian movie theatres and Famous Players *owns* most of the theatres in the biggest cities (Montréal, Québec, Sherbrooke, Rouyn, Val d'Or, Saint-Hyacinthe). Cinépix, where it isn't actually a stock-holder in a theatre (Sorel, Beauharnois, Montréal), has established exclusive distribution agreements in all regions of Québec, especially in rural areas, with such offerings as *Maquerdeau, Variations amoureuses* and *Labyrinthe du sexe.*

Political exploitation:

These companies obviously wield enough influence in the local governments to assure that this state of affairs continues. One need only look at the long-time collusion between the traditional parties, both local and national, and the film companies. For example, Louis St. Laurent, former "Canadian" Prime Minister, and Gerry Martineau, the *éminence grise* of the National Union both sit on the board of directors of Famous Players. Then there is the public treasury, from which the SDICC draws funds to support these exploit-ers of the public.

As in all such closed systems, we as film-makers must play the ideological and eco-nomic game of the monopolies in order to have a place in the sun. Otherwise we must be satisfied with a marginal, impotent role. We cannot participate in the creation of a true French-Canadian cinema, one which would be a dynamic expression of our community at all levels. We too are obliged to create a cinema of evasion and sell our labour and creative power to the "big boss."

The choices open to us are now becoming clear: either to play by the exploiter's rules, or to look for *active solutions* in order to escape from the game entirely.

It is time to take our situation into our own hands, just as the workers of Cabano, Maniwaki, Gaspesie and Abitibi have done.

It is time to disturb the peace of all the exploitive interests in Québec—all the cartels like Famous-Players-Gulf, all the Cinépixes, all the KC Irvings and the Noranda Mines.

III. HISTORICAL BACKGROUND

There is no need to give a complete history of French-Canadian cinema. The facts are well known, and many good analyses have been made. Here are the highlights:

April 30, 1931:

Peter White, a commissioner of the Canadian Ministry of Labor, delivers a report entitled "Investigation Into an Alleged Combine in the Motion Picture Industry in Canada," and offers the following conclusions:

a) "A combine exists in the Motion Picture Industry in Canada, within the meaning of the Combines Investigation Act."

b) "This combine exists and has existed at least since the year 1926."

c) "The combine has operated to the detriment or against the interests of the public."

The report cites as participants in the "combine" Famous Players Canadian Corp. Ltd., United Amusement Corp. Ltd., and Paramount Public Corp. Ltd.

March 18, 1932:

Supreme Court Judge Garrow in Ontario finds the accused companies not guilty and dismisses the case.

November 1, 1963:

The voluminous Report of the Council on Economic Orientation of Québec is issued. It is composed of four sections: 1) Cinema and Culture, 2) Critical and Statistical Study of Film-making Worldwide, 3) The Motion Picture Industry in Québec and Canada, and 4) Report on the Classification Project.

This report savagely denounces the monopolistic practices of Famous Players–United Amusement, calls attention to the urgency of the situation, and offers several recommendations:

a) Abrogation of the "Loi des vues animées" (The Motion Picture Law) and adoption of general film legislation to regulate production, distribution, classification and financial return.

b) Adoption of a policy favoring the production of feature films in Québec by 1) direct subsidies, 2) production loans, and 3) limits on financial return.

c) Assignment of tax monies received from the motion picture industry (in particular the Amusement Tax) to projects which establish and sustain a feature film industry,

following the example of those European countries which have a national motion picture industry.

d) Adoption of a policy of aiding institutions of learning (and the creation of new ones as necessary) which promote the development of film art.

e) Establishment of a General Directorate of Film Art (or a Film Center for Québec) which would group together the existing organizations (Film Office of Québec, Film Censorship Bureau), to which could be added the new services which are necessary for the regulation of the different sectors of the film industry: production, distribution, revenue.

The Québec government chooses to retain only the recommendations contained in the fourth part by bestowing upon the region a Bureau de surveillance du cinéma (Bureau of Film Supervision). In so doing they acknowledge their inability to negotiate with the foreign interests (Famous Players), leaving the population in the clutches of economic and cultural domination and abandoning the indigenous film-makers in their struggle to cope with the problems of production, distribution and control of box-office.

February, 1964:

A memorandum is presented to the Canadian Secretary of State by the Professional Association of Film-makers. It is presented in the name of 104 Association members, or almost all the French-language film-makers in Canada. Article 19 reads: ". . . In effect, the economic interests which control most of the large movie theatres in Canada are subsidiaries of one American production and distribution company—Paramount." While it is illegal in the United States proper for a major producer to control the box-office circuit, American law does not forbid these same interests to control these circuits in foreign countries—in Canada for example. And for its part the Canadian government does nothing to stop them.

March, 1964:

A memorandum is presented to the Prime Minister of Québec (Jean Lesage by the Association of Professional Film-makers). It contains measures which the Association recommends to the government of Québec for promoting the development of a feature film industry in conformity with the economic and cultural needs of the population. Page 9 contains the following.

However, because of the lack of a good distribution system and the insolvency of the State, many films of high quality are shown only in marginal theatres where they reach a very limited public.

This distribution system is the result of the control of French Canadian cinema by Paramount and its Canadian subsidiary, Famous Players Canadian Corporation Limited, which in turn is tied to United Amusement Corporation Limited and Consolidated Theatres Limited . . .

Quebec's film culture is controlled and guided by the program director of Famous Players–United Amusement.

June 23, 1970:
A memorandum from the "Fédération québécoise de l'industrie du cinéma" is given to Prime Minister Robert Bourassa.

January 19, 1971:
The Minister of Cultural Affairs receives a study entitled "The Québec Film Industry and the State," by Arthur Lamothe.

To conclude this brief history, it is worth noting that all of the election platforms of the different political parties since 1962 have contained promises of the following kind: "The government should establish a National Film Center whose specialists are trained in collaboration with organizations which engage in the production and distribution of films."

The problem of film-making in French-speaking Canada is thus not solely an economic problem, as the Fédération Québécoise de l'industrie du Cinéma would have us believe: it is definitely a political problem. The government of Québec (no matter who is in power) has never accepted its responsibility to oppose the invasion by American interests, despite its many promises in this vein. The facade of democracy is becoming more and more transparent, for a small group of reactionaries obviously has more power in government circles than the many organizations which have railed against the situation for the past eight years.

IV. DEMANDS

As a consequence, we demand that the Minister of Cultural Affairs move to rectify the situation before the public by taking the following steps:

1. Denounce the foreign enterprises (Famous Players–Gulf, Cinépix) which dominate and exploit the people of Québec economically and culturally and take sweeping measures to break the production, distribution and box-office monopolies in French-speaking Canada.

2. Propose comprehensive legislation for film production, including provisions for the nationalization of foreign monopolies.

3. Recognize publicly the urgency of such legislation and establish immediately a commission composed of the different professional associations and representatives of popular movements.

4. Affirm the complete and entire responsibility of the government of Québec for film production within its borders by negotiating with Ottawa for repayment of that percentage of federal revenue which accrues from films produced in French Canada.

5. Set a date for the execution of the proposed comprehensive film legislation. Only in this way can we stop the systematic flight of film profits from Québec, and begin to counter the growing alienation of our people resulting in particular from the flood of

American films in which English is the only language. Only by these measures can we increase investment in French-Canadian films, and above all provide the people of Québec with the opportunity to see films which relate to them directly.

WE CLAIM THE RIGHT OF THE PEOPLE OF QUEBEC TO FIND IN FILMS A REFLECTION OF THEMSELVES WHICH IS FAIR, DYNAMIC, AND THOUGHT-PROVOKING.

8 MILLIMETERS VERSUS 8 MILLIONS (Mexico, 1972)

Jaime Humberto Hermosillo, Arturo Ripstein, Paul Leduc, Felipe Cazals, Rafael Castanedo, Eduardo Maldonado, Gustavo Alatriste, Emilio García Riera, David Ramón, Tomás Pérez Turrent, and Fernando Gou

[First published in English in *Wide Angle* 21, no. 3 (1999): 36–41.]

A forerunner to the *Cine pobre* movement in Cuba (see Solás's "Poor Cinema Manifesto" later in this chapter), this manifesto eschews high production costs and instead celebrates and promotes small, Super 8 and other low-budget cinemas as offering the possibility of a richer, more diverse cinema that is not restrained by the censorship that inevitably follows capital.

We hereby declare before the public that the following people: Felipe Cazals, Arturo Ripstein, Paul Leduc, Rafael Castanedo, Eduardo Maldonado, Gustavo Alatriste, Jaime Humberto Hermosillo and the spokesmen Emilio García Riera, David Ramón, Tomás Pérez Turrent and Fernando Gou, are taking advantage of the word "INDEPENDENT" for their commercial and promotional aims and are all going to the most remote region of Mexico to hold a meeting which will be a dialogue with the voices of silence amplified by their official spokesmen.

To this manoeuvre we reply with this declaration of principles:

1) That he who produces a film of over ten thousand pesos cannot be called an independent filmmaker, as this implies subordination to all the norms of censorship existing and to come, and total acceptance of the systems which we have criticised through cinema.

2) For anyone with an honest mental lucidity, a Super-8 film represents the values, the true criticism that can be made of a system, which has virtues and defects; that is, that the economic cost of the film does not correspond to its quality,

because with the twelve million used for the production of *Zapata,* for example, we could have made 10,000 super-8 films which would represent all our historical, social and artistic context.

3) We wish to set forth once and for all that the movement of new Mexican cinema was conceived on May 15, 1970, with the first National Independent Cinema Competition "Luis Buñuel," and that those who preserve or are working in the same spirit can validly represent the spirit of independence of criteria, despite the ideological divisions which the Cooperatives and other groups of independent cinema have to face.

4) We also wish to establish that we will continue to work through the exhibition channels from the humblest to those with the latest technologies, but always with the very clear idea that the language of cinema must be at the service of the community and that we will continue to criticise the faults and errors of the system, likewise, we will make known the existing achievements.

5) To conclude, we are aware that the movement which is emerging here in Mexico, a means of expression through the language of independent cinema, is the most dynamic and has national characteristics so far unrivalled abroad in the world panorama of cinema.

MANIFESTO OF THE PALESTINIAN CINEMA GROUP (Palestine, 1973)

Palestinian Cinema Group

[First published in French as "Manifeste des cinéastes palestiniens," *Écran 73* 18 (1973). First published in English in *Cineaste* 9, no. 3 (1979): 35.]

In the aftermath of the Six Day War of June 1967, there was an increasing sense that radical, pro-Palestinian cinema needed to develop as both an educational and propagandistic tool. The Palestinian Cinema Group, early on in the manifesto paraphrasing Marx and comparing contemporary Arab cinema to Marx's oft-quoted "religion is the opiate of the masses" from *Critique of Hegel's Philosophy of Right* (1843), foregrounds the need to radically redefine Arab cinema so that films are made by and for the people, and their liberation from oppression becomes paramount.

The Arab cinema has for too long delighted in dealing with subjects having no connection to reality or dealing with it in a superficial manner. Based on stereotypes, this approach has created detestable habits among the Arab viewers for whom the cinema has become

a kind of opium. It has led the public away from the real problems, dimming its lucidity and conscience.

At times throughout the history of Arab cinema, of course, there have been serious attempts to express the reality of our world and its problematic, but they have been rapidly smothered by the supporters of reaction who fought ferociously against any emergence of a new cinema.

While recognizing the concern of those attempts, it should nevertheless be made clear that in terms of content they were usually poorly developed and on a formal level were always inadequate. It seems one could never escape the cumbersome heritage of the conventional cinema.

The defeat of June '67, however, was a jarring experience and it raised some fundamental questions. There also appeared, at long last, young talents committed to creating a completely new cinema in the Arab world, film-makers convinced that a complete change must affect the form as well as the content.

These new films raise questions about the reasons for our defeat and take courageous stands in favor of the resistance. It is important, in fact, to develop a Palestinian cinema capable of supporting with dignity the struggle of our people, revealing the actual facts of our situation and describing the stages of our Arab and Palestinian struggle to liberate our land. The cinema to which we aspire will have to devote itself to expressing the present as well as the past and the future. Its unified vigor will entail regrouping of individual efforts: indeed, personal initiatives—whatever their value may be—are doomed to remain inadequate and ineffective.

It's towards this end that we, men of the cinema and literature, distribute this Manifesto and call for the creation of a Palestinian Cinema Association. We assign to it six tasks:

1) Produce films directed by Palestinians on the Palestinian cause and its objectives, films which originate from within an Arab context and which are inspired by a democratic and progressive content.

2) Work for the emergence of a new aesthetic to replace the old, one able to coherently express a new content.

3) Put the entire cinema at the service of the Palestinian revolution and the Arab cause.

4) Conceive films designed to present the Palestinian cause to the whole world.

5) Create a film archive which will gather film and still photograph material on the struggle of the Palestinian people in order to retrace its stages.

6) Strengthen relations with revolutionary and progressive cinema groups throughout the world, participate in film festivals in the name of Palestine and facilitate work of all friendly groups working toward the realization of the objectives of the Palestinian revolution.

The Palestinian Cinema Association considers itself an integral part of the institutions of the Palestinian revolution. Its financing will be assured by the Arab and Palestinian organizations which share its orientation. Its office will be at the Research Center of the Palestinian Liberation Organization.

RESOLUTIONS OF THE THIRD WORLD FILMMAKERS MEETING (Algeria, 1973)

Fernando Birri, Ousmane Sembène, Jorge Silva, Santiago Alvarez, Med Hondo, Jorge Cedron, Moussa Diakite, Flora Gomes, Mohamed Abdelwahad, El Hachmi Cherif, Lamine Merbah, Mache Khaled, Meziani Abdelhakim, Mamadou Sidibe, Mostefa Bouali, and more than twenty other filmmakers

[First published in English in *Cineaste Pamphlet*, no. 1 (New York: Cineaste, 1973).]

Introduction from *Cineaste Pamphlet*, no. 1:

The Third World Filmmakers Meeting, sponsored by the National Office for Cinemato-graphic Commerce and Industry (ONCIC) and the cultural information center, was held in Algiers from December 5 to 14, 1973. The meeting brought together filmmakers from all areas of the third world for the purpose of discussing common problems and goals to lay the ground-work for an organization of third world filmmakers. The filmmak-ers attending the conference organized themselves into separate committees to discuss the specific areas of production and distribution as well as how the filmmaker fits into the political struggle of the third world. The resolutions of the various committees are published here as they were released in Algiers, with only slight modifications in grammar and spelling.

COMMITTEE 1: PEOPLE's CINEMA

The Committee on People's Cinema—the role of cinema and filmmakers in the third world against imperialism and neocolonialism—consisted of the following filmmakers and observers: Fernando Birri (Argentina); Humberto Rios (Bolivia); Manuel Perez (Cuba); Jorge Silva (Columbia); Jorge Cedron (Argentina); Moussa Diakite (Republic of Guinea); Flora Gomes (Guinea-Bissou); Mohamed Abdelwahad (Morocco); El Hachmi

Cherif (Algeria); Lamine Merbah (Algeria); Mache Khaled (Algeria); Fettar Sid Ali (Algeria); Bensalah Mohamed (Algeria); Meziani Abdelhakim (Algeria). Observers: Jan Lindquist (Sweden); Josephine (Guinea-Bissau); and Salvatore Piscicelli (Italy).

The committee met on December 11, 12, and 13, 1973, in Algiers, under the chairmanship of Lamine Merbah. At the close of its deliberations, the committee adopted the following analysis.

So-called underdevelopment is first of all an economic phenomenon which has direct repercussions on the social and cultural sectors. To analyze such a phenomenon we must refer to the dialectics of the development of capitalism on a world scale.

At a historically determined moment in its development, capitalism extended itself beyond the framework of the national European boundaries and spread—a necessary condition for its growth—to other regions of the world in which the forces of production, being only slightly developed, provided favorable ground for the expansion of capitalism through the existence of immense, virgin material resources and available, cheap manpower reserves which constituted a new, potential market for the products of capitalist industry.

Its expansion manifested itself in different regions, given the power relationships, and in different ways:

▸ Through direct and total colonization implying violent invasion and the setting up of an economic and social infrastructure which does not correspond to the real needs of the people but serves more, or exclusively, the interests of the metropolitan countries;

▸ In a more or less disguised manner leaving to the countries in question a pretense of autonomy;

▸ Finally, through a system of domination of a new type—neocolonialism.

The result has been that these countries have undergone, on the one hand, varying degrees of development and, on the other hand, extremely varied levels of dependency with respect to imperialism: domination, influence, and pressures.

The different forms of exploitation and systematic plundering of the natural resources have had grave consequences on the economic, social, and cultural levels for the so-called underdeveloped countries, so that even though these countries are undergoing extremely diversified degrees of development, they face in their struggle for independence and social progress a common enemy—imperialism—which forms the principal obstacle to their development.

Its consequences can be seen in:

▸ The articulation of the economic sectors: imbalance of development on the national level with the creation of poles of economic attraction incompatible with the development of a proportionally planned national economy and with the interests of the popular masses, thereby giving rise to zones of artificial prosperity.

- Imbalance on the regional and continental levels, thereby revealing the determination of imperialism to create zones of attraction favorable for its own expansion and which are presented as models of development in order to retard the people's struggle for real political and economic independence.

The repercussions on the social plane are as serious as they are numerous: they lead to characteristic impoverishment of the majority for the benefit in the first instance of the dominating forces and the national bourgeoisie of which one sector is objectively interested in independent national development, while the other sector is parasitic and comprador, with interests bound to those of the dominating forces.

The differentiations and social inequities have seriously affected the living standard of the people, mainly in the rural areas where the expropriated or impoverished peasants find it impossible to reinvest on the spot in order to subsist. With most of the people reduced to self-consumption, unemployment, and rural exodus, these factors lead to an intensification of unemployment and increased underemployment in the urban centers. In order to legitimize and strengthen its hold over the economies of the colonized and neocolonized countries, imperialism has recourse to a systemic enterprise of deculturation and acculturation of the people of the third world.

Deculturation consists of depersonalizing the people, of discrediting their culture by presenting it as inferior and inoperative, of blocking their specific development, and of disfiguring their history—in other words, creating an actual cultural vacuum favorable to a simultaneous process of acculturation through which the dominator endeavors to make his domination legitimate by introducing his own moral values, his life and thought patterns, his explanation of history: in a word, his culture.

Imperialism, being obliged to take into account that colonized or dominated people have their own culture and defend it, infiltrates the culture of the colonized, entertains relationships with it, and takes over those elements which it believes it can turn to its favor. This is done by using the social forces which they make their own, the retrograde elements of this culture. In this way, the language of the colonized, which is the carrier of culture, becomes inferior or foreign; it is used only in the family circle or in restricted social circles. It is no longer, therefore, a vehicle for education, culture, and science, because in the schools the language of the colonizer is taught, it being indispensable in order to work, to subsist, and to assert oneself. Gradually, it infiltrates the social and even the family relationships of the colonized. Language itself becomes a means of alienation, in that the colonized has a tendency to practice the language of the colonizer, while his own language, as well as his personality, his culture, and his moral values, become foreign to him.

In the same vein, the social sciences, such as sociology, archaeology, and ethnology, for the most part serve the colonizer and the dominant class so as to perfect the work of alienating the people through a pseudoscientific process which has in fact consisted of a retrospective justification for the presence of the colonizer and therefore of the new established order.

This is how sociological studies have attempted to explain social phenomena by fatalistic determinism, foreign to the conscience and the will of man. In the ethnological field, the enterprise has consisted of rooting in the minds of the colonized prejudices of racial and original inferiority and complexes of inadequacy for the mastering of the various acquisitions of knowledge and man's production. Among the colonized people, imperialism has endeavored to play on the pseudoracial and community differences, assigning privilege to one or another ethnic grouping.

As for archaeology, its role in cultural alienation has contributed to distorting history by putting emphasis on the interests and efforts of research and the excavations of historical vestiges which justify the definite paternity of European civilization, sublimated and presented as being eternally superior to other civilizations whose slightest traces have been buried.

Whereas, in certain countries, the national culture has continued to develop while at the same time being retarded by the dominant forces, in other countries, given the long period of direct domination, it has been marked by discontinuity which has blocked it in its specific development, so that all that remains are traces of it which are scarcely capable of serving as a basis for a real cultural renaissance, unless it is raised to the present level of development of national and international productive forces.

It should be stated, however, that the culture of the colonizer, while alienating the colonized peoples, does the same to the people of the colonizing countries who are themselves exploited by the capitalist system. Cultural alienation presents, therefore, a dual character—national against the totality of the colonized people, and social against the working classes in the colonizing countries as well as the colonized countries.

Imperialist economic, political and social domination in order to subsist and to reinforce itself, takes root in an ideological system articulated through various channels and mainly through cinema which is in a position to influence the majority of the popular masses because its essential importance is at one and the same time artistic, esthetic, economic, and sociological, affecting to a major degree the training of the mind. Cinema, also being an industry, is subjected to the same development as material production within the capitalist system and through the very fact that the North American economy is preponderant with respect to world capitalist production, its cinema becomes preponderant as well and succeeds in invading the screens of the capitalist world and consequently those of the third world where it contributes to hiding inequalities and referring them to that ideology which governs the world imperialist system dominated by the United States of America.

With the birth of the national liberation movement, the struggle for independence takes on a certain depth implying, on one hand, the revalorization of national cultural heritage in marking it with a dynamism made necessary by the development of contradictions. On the other hand, it implies the contribution of progressive cultural factors borrowed from the field of universal culture.

THE ROLE OF CINEMA

The role of cinema in this process consists of manufacturing films reflecting the objective conditions in which the struggling peoples are developing, that is, films which bring about disalienation of the colonized peoples at the same time as they contribute sound and objective information for the people of the entire world, including the oppressed classes of the colonizing countries, and place the struggle of their people back in the general context of the struggle of the countries and people of the third world. This requires from the militant filmmaker a dialectical analysis of the sociohistoric phenomenon of colonization.

Reciprocally, cinema in the already liberated countries and in the progressive countries must accomplish, as their own national tasks, active solidarity with the people and filmmakers of countries still under colonial and neocolonial domination, which are struggling for their genuine national sovereignty. The countries enjoying political independence and struggling for varied development are aware that the struggle against imperialism on the political, economic, and social levels is inseparable from its ideological content and that, consequently, action must be taken to seize from imperialism the means for ideological influence and forge new methods adapted in content and form to the interests of the struggle of their peoples. This implies control by the people's state of all the cultural activities and, in respect to cinema, nationalization in the interest of the masses of people: production, distribution, and commercialization. To make such a policy operative, it has been seen that the best path requires quantitative and qualitative development of national production capable, with the acquisition of films from third world and progressive countries, of swinging the balance of the power relationship in favor of using cinema in the interest of the masses. While influencing the general environment, conditions must be created for a greater awareness on the part of the masses for the development of their critical senses and varied participation in the cultural life of their countries.

A firm policy based on principle must be introduced in this field to eliminate once and for all the films which the foreign monopolies continue to impose upon us either directly or indirectly and which generate reactionary culture and, as a result, thought patterns in contradiction with the basic choices of our people.

The question, however, is not one of separating cinema from the overall cultural context which prevails in our countries, for we must consider that, on the one hand, the action of cinema is accompanied by that of other informational and cultural media, and, on the other hand, cinema operates with materials that are drawn from reality and already existing cultural forms of expression in order to function and operate. It is also necessary to be vigilant and to eliminate nefarious actions of the information media, to purify the forms of popular expression (folklore, music, theater, etc.), and to modernize them.

The cinema language being thereby linked to other cultural forms, the development of cinema, while demanding the raising of the general cultural level, contributes to this task in an efficient way and can even become an excellent means for the polarization of the various action fields as well as cultural tradition.

Films being a social act within a historical reality, it follows that the task of the third world filmmaker is no longer limited to the making of films but is extended to other fields of action, such as articulating, fostering, and making the new films understandable to the masses of people by associating himself with the promoters of people's cinemas, clubs, and itinerant film groups in their dynamic action aimed at disalienation and sensitization in favor of a cinema which satisfies the interests of the masses, for at the same time that the struggle against imperialism and for progress develops on the economic, social, and political levels, a greater and greater awareness of the masses develops, associating cinema in a more concrete way in this struggle.

In other words, the question of knowing how cinema will develop is linked in a decisive way to the solutions which must be provided to all the problems with which our peoples are confronted and which cinema must face and contribute to resolving. The task of the third world filmmaker thereby becomes even more important and implies that the struggle waged by cinema for independence, freedom, and progress must go, and already goes, hand in hand with the struggle within and without the field of cinema, but always in alliance with the popular masses for the triumph of the ideas of freedom and progress.

In these conditions, it becomes obvious that freedom of expression and movement, the right to practice cinema and research, are essential demands of filmmakers of the third world—freedoms and rights which they have already committed to invest in the service of the working masses against imperialism, colonialism, and neocolonialism for the general emancipation of their people.

United and in solidarity against American imperialism, at the head of world imperialism, and direct or indirect aggressor in Vietnam, Cambodia, Laos, Palestine, in Africa through the intermediary of NATO, SEATO and CENTO, and in Latin America, hiding itself behind the fascist coup d'état of the Chilean military junta and the other oligarchies in power, the filmmakers present here in Algiers, certain that they express the opinion of their film-maker comrades in the third world, condemn the interventions, aggressions, and pressures of imperialism, condemn the persecutions to which the film-makers of certain third world countries are subjected, and demand the immediate liberation of the filmmakers detained and imprisoned and the cessation of measures restricting their freedom.

COMMITTEE 2: PRODUCTION AND COPRODUCTION

The Committee on Production and Coproduction, appointed by the General Assembly of the Third World Filmmakers Meeting in Algeria, met on December 11, 12, and 13, 1973, under the chairmanship of Ousmane Sembène. The committee, which devoted itself to the problems of film production and coproduction in third world countries, included the following filmmakers and observers: Ousmane Sembène (Senegal); Sergio Castilla (Chile); Santiago Alvarez (Cuba); Sebastien Kainba (Congo); Mamadou Sidibe (Mali); Benamar Bakhti (Algeria); Nourredine Touazi (Algeria); Hedi Ben Hkelifa (Tunisia);

Mostefa Bouali (Palestine); Med Hondo (Mauritania). Observers: Simon Hartog (Great Britain), representing the British filmmakers' union, and Theo Robichet (France). Humberto Rios (Argentina) presented an information report to the committee.

The delegates present, after reporting on the natural production and coproduction conditions and the organization of the cinema industries in their countries, noted that the role of cinema in the third world is to promote culture through films, which are a weapon as well as a means of expression for the development of the awareness of the people, and that the cinema falls within the framework of the class struggle.

Considering:

▶ that the problems of cinema production in the countries of the third world are closely linked to the economic, political, and social realities of each of them; and

▶ that, consequently, cinema activity does not develop in a similar fashion:

◆ in those countries which are waging a liberation struggle,

◆ in those countries which have conquered their political independence and which have founded states,

◆ in those countries which, while being sovereign, are struggling to seize their economic and cultural independence;

◆ that those countries which are waging wars of liberation lack a film infrastructure and specialized cadres and, as a result, their production is limited, achieved in difficult circumstances, and very often is supported by or is dependent upon sporadic initiatives;

▶ that in those countries struggling for their economic and cultural independence, the principal characteristic is a private infrastructure which enables them to realize only a portion of their production within the national territory, the remainder being handled in the capitalist countries.

This leads to an appreciable loss of foreign currency and considerable delays which impede the development of an authentic national production.

Further considering,

▶ that in those countries in which the state assumes the responsibility for production and incorporates it into its cultural activity, there is, nevertheless, in a majority of cases, a lack of technical and industrial development in the cinema field and, as a consequence, production remains limited and does not manage to cover the needs for films in those countries. The national screens, therefore, are submerged with foreign productions coming, for the most part, from the capitalist countries.

▶ that, if we add as well the fact that world production is economically and ideologically controlled by these countries and, in addition, is of very mediocre quality, our screens bring in an ideological product which serves the interests of the colonizers,

creating moreover the habit of seeing films in which lies and social prejudice are the choice subjects and in which these manufacturers of individualistic ideology constantly encourage the habits of an arbitrary and wasteful consumer society;

▶ that coproductions must, first and foremost, be for the countries of the third world, a manifestation of anti-imperialist solidarity, although their characteristics may vary and cover different aspects. We do not believe in coproductions in which an imperialist country participates, given the following risks:

♦ the imperialist country can shed influence through production methods which are foreign to the realities of our countries, and

♦ the examples of coproductions have given rise to cases of profit and the cultural and economic exploitation of our countries.

The participants in the committee therefore concluded that it is necessary to seek jointly concrete means to foster the production and coproduction of national films within the third world countries.

In line with this, a certain number of recommendations were unanimously adopted:

▶ to provide the revolutionary filmmakers of the third world with national cinema infrastructures;

▶ to put aside the conceptions and film production means of capitalist countries and to seek new forms, taking into account the authenticity and the realities of the economic means and possibilities of the third world countries;

▶ to develop national cinema and television agreements for the benefit of the production and distribution of third world films and to seek such agreements where they do not exist and to exchange regular programs;

▶ to organize and develop the teaching of film techniques, to welcome the nationals of countries in which the training is not ensured;

▶ to use all the audiovisual means available for the political, economic, and cultural development of the countries of the third world;

▶ to promote coproductions with independent, revolutionary filmmakers, while leaving to each country the task of determining the characteristics of these productions;

▶ to include in the governmental agreements between countries of the third world those measures likely to facilitate coproductions and film exchanges;

▶ to influence the establishment of coproductions between national organizations of the third world in endeavoring to have them accepted by the governmental and professional institutions of their respective countries (through the influence, in particular, of the acting president of the nonaligned countries, Mr. Houari Boumediene);

- to propose the need for the creation of an organization of third world filmmakers, the permanent secretariat of which should be set up in Cuba. While awaiting the creation of this organization, the Union of Audio-Visual Arts of Algeria (UAAV) will provide a temporary secretariat.

The filmmakers will henceforth keep each other informed of their respective approaches undertaken within the framework of the Pan-African Federation of Cineastes (FEPACI).

COMMITTEE 3: DISTRIBUTION

The Committee in charge of the distribution of third world films, after consideration of the different remarks of the members present, proposes the creation of an office to be called the Third World Cinema Office. It will be composed of four members including a resident coordinator and one representative per continent. The committee, in reply to the offer made by Algeria, proposed that the permanent headquarters of the office be established in Algiers.

The goals of the office will be:

- To coordinate efforts for the production and distribution of third world films,
- To establish and strengthen existing relations between third world filmmakers and cinema industries by:

 - the editing of a permanent information bulletin (filmography, technical data sheets, etc.) in four languages: Arabic, English, French, and Spanish,
 - making a census of existing documentation on third world cinema for the elaboration and distribution of a catalogue on the cinema production of the countries of the third world,
 - fostering other festivals, film markets, and film days on the third-world level, alongside the other existing events,
 - the editing of a general compilation of official cinema legislation in the third world countries (problems of censorship, distribution of film copies, copyright, customs, etc.).

- To take those measures required for the creation of regional and continental organization leading to the creation of a tricontinental organization for film distribution.
- To prospect the foreign markets in order to secure other outlets for the productions of the third world countries (commercial and noncommercial rights, television, and videocassettes).

The office will approach the authorities of the Organization of African Unity (OAU), the Arab League, and United Nations Educational, Scientific, and Cultural Organization

(UNESCO) in order to obtain from these organizations financial assistance for its func-
tioning. It will also approach the authorities of those countries having effective control
of their cinema industries, that is, Algeria, Guinea, Upper Volta, Mali, Uganda, Syria,
and Cuba, as well as other countries which manifest a real desire to struggle against the
imperialist monopoly. In addition to the above-mentioned assistance, the operating bud-
get of the office will be composed of donations, grants, and commissions on all transac-
tions of third world films entrusted to the office.

THE LUZ E AÇÃO MANIFESTO
(Brazil, 1973)

Carlos Diegues, Glauber Rocha, Joaquim Pedro de Andrade, Leon Hirszman, Miguel Faria, Nelson Pereira dos Santos, Walter Lima Jr.

[Published in Portuguese in *Arte em Revista: anos 60* (São Paulo: Centro de Estudos
de Arte Contemporânea, 1979), 5–9. First published in English in Randal Johnson and
Robert Stam, eds., *Brazilian Cinema*, exp. ed. (New York: Columbia University Press,
1995), 91–92. Trans. Randal Johnson and Robert Stam.]

The "Luz e Ação" (Light and action) manifesto, written by key figures of *Cinema novo*,
decries cheap populism and State repression, foregrounding the success of then-
recent Brazilian films such as Nelson Pereira des Santos's *Como era gostoso o meu
Francês* (*How Tasty Was My Little Frenchman*, Brazil, 1971) as examples of progressive,
politically engaged cinema that appealed to mass audiences. Along with anticolonial-
ism, the manifesto also decries sexism and racism in Brazilian cinema.

Since 1968/69, our films have been victims of the cultural exorcism that has swept
the country. New tendencies and emergent standards—official or not—have stifled
us, but at the same time have permitted us time for reflection. And we have been
silent.

The silence has animated old rancors and has permitted the "vengeance" that has
lasted now for four years. In the cultural desert in which Brazil has been transformed,
solitary megalomaniac *cangaceiros* ride the beats of their neuroses, firing wildly at
whatever shows signs of life.

We've had enough.

We're no longer willing to peacefully exist with the slothful silence and suspect ag-
gression that have conspired against our films. We are no longer willing to tolerate the
mental leukemia that is threatening Brazilian culture.

Mental leukemia: white corpuscles have swallowed red corpuscles. Blood no longer warms the body. Leukemic intelligence is manifested through complacency, laziness, and mechanical imitation.

We reject the bureaucratic cinema of statistics and pseudo-industrial myths. Films like *Macunaíma* and *How Tasty Was My Little Frenchman* have broken box-office records. Nothing can justify low-level commercialism.

We reject "the public at any price" blackmail. It has led Brazilian cinema to the most abhorrent deformations: easy laughs at the expense of the weak, racism, sexuality as merchandise, scorn for artistic expression as a scientific and poetic form of knowledge. And we affirm this rejection with the authority of those who have worked consistently and constantly toward a dialectical relationship between spectacle and spectator.

Our most recent films show our desire for a vast and just redistribution of the cultural wealth of the nation. We are opposed to its concentration in the hands of aseptic experimentalism, the self-serving vanguard, and socialite clowns.

For us cinema only has meaning as a permanent invention, on all levels of creation—the search for new modes of production, new thematic areas, new techniques, and linguistic experimentation.

Permanent invention is what distinguishes a good film from a bad one. The pleasure of form, the great utopias, the "sentiment of the world," are rights and duties of the artist. Because one thing, as Drummond says, is always two: the thing itself and its image.

In the name of this permanent invention our cinema formulated the most radical theses to emerge from Brazilian culture during the sixties. A general political and ethical position produced an original and revolutionary esthetic that gained international prestige and influenced modern cinema.

We want to generate new ideas for new situations, and thus keep Brazilian cinema from transforming itself into the newest "old" industry, or the youngest decadent culture, in the world.

We refuse to justify silence or impotence with hypocrisy. Progressively expanding these limits through the exercise of freedom, we will further deepen our work, making it rain in the desert.

As Brazilians, this is our fundamental situation: if we do not put Brazil in our films, they will have failed.

We therefore convoke the cultural producers of our country, particularly those of cinema, to an open dialogue. We repeat: we want to generate new ideas for new situations. This is not a group manifesto, but a collective text of provocation, intended to ignite debate.

Brazilian culture should not have to choose between complaints and conformism, cynicism and vulgarity. The *new* is beyond these alternatives.

PROBLEMS OF FORM AND CONTENT IN REVOLUTIONARY CINEMA (Bolivia, 1976)

Jorge Sanjinés

[First published as "Problemas de la forma y del contenido en el cine revolucionario," in *Ojo al cine* (Cuba) (1976). First published in English in Michael Chanan, ed., *Twenty-Five Years of the New Latin American Cinema* (London: BFI, 1983), 34–38. Trans. Malcolm Coad.]

Jorge Sanjinés's manifesto, like many of the Third Cinema manifestos, disavows the bourgeois notion of the auteur and instead foregrounds the dialectic between collective filmmaking, the film, and the spectator. Using his own *Sangre de cóndor* (*Blood of the Condor*, Bolivia, 1969) as an example, Sanjinés argues for a new kind of politically engaged cinema that offers an alternative to Western modernization. Like Espinosa (see Espinosa, "For an Imperfect Cinema," earlier in this chapter), he foregrounds process over product and offers a salient critical analysis of the ideological dialectic between form and content.

Revolutionary cinema must seek beauty not as an end but as a means. This implies a dialectical relationship between beauty and subject matter. For a work to be effective, this relationship must be correct. If it is not, the result will be nothing more than a pamphlet, perfect in what it says but schematic and gross in its form. The lack of coherent creative form will limit the film's effectiveness, destroy the ideological dynamics of its content, and give us nothing more than an outline and superficiality, without real substance, humanity or love. These qualities can only appear when expression is based in sensibility, and is capable of penetrating through to truth.

COMMUNICATION

We must distinguish between routes so as not to miss our destination. Among pseudo-revolutionary works it is quite common to come across beauty worshipped for its own sake but with some revolutionary theme as its pretext. Such works may seem to exhibit the correct relationship between subject matter and beauty. But the most direct test of such an apparent balance comes when the result is shown to its presumed audience, the people, who are usually touted as the objects of such work. These presumed addressees are often the first to discover the work's lack of any real intention of conveying anything other than the overblown expression of an individual talent, which at the end of the day neither interests them nor has anything to say to them.

The formal choices made by an artist will be governed by his or her ideological inclinations. If the self-proclaimed revolutionary artist continues to believe in his or her right to create without reference to anyone else, and to think that what counts is the release of his/her own "private demons," with no concern for intelligibility, then s/he is locating her/himself clearly within the key ideological postulates of bourgeois art. Opportunism begins by lying to yourself.

Nor are appropriate forms for expressing revolutionary content, which by definition must be widely communicable, to be found in the formal models used to convey other kinds of content. It would be seriously incongruous to use the sensational language of advertising in a work about colonialism. Such language must inevitably obstruct content which is so alien to it. When a sixty-second advertising spot combines zooms into and away from a product with carefully synchronised music, while a song on the soundtrack repeats the name or brand of the product eight or nine times, it probably achieves its objective. The operation is intended to be carried out endless times on the defenceless viewer, who cannot be expected to switch off the television every time the ad is shown. Form and content have thus achieved perfect ideological unity.

But to try to apply such formal principles to other kinds of theme is absurd. The forms and techniques of advertising are based on close study of the viewer's degree of resistance, or defencelessness, when faced with the aggressive image. What is possible in one minute is impossible to sustain for thirty minutes, when time is available to react and saturation begins to be counterproductive. We cannot attack the ideology of imperialism by using its own formal tricks and dishonest techniques, whose *raison d'être* is to stupefy and deceive. Not only do such methods violate revolutionary morality; they also correspond structurally to the ideology and content of imperialism.

For revolutionary art communication must be pursued through the stimulation of reflection, whereas the entire formal machinery of the imperialist media is intended to smother thought and bring the will into submission.

But communicability must not give way to facile simplicity. The profoundest resources of sensibility are required to communicate ideas in all their depth and substance, and to align the finest artistic resources with the audience's own cultural reference points, in order to capture the internal rhythms of the people's own mental life, sensibility and vision of reality. We ask of art and beauty, then, that they become means, without this implying any cheapening of them, as bourgeois thought maintains it must. Such art is as rich as any other, dignified, indeed, by its social nature.

COLLECTIVE WORK

Revolutionary cinema is in the process of taking shape. It is not an easy or rapid matter to transform conceptions of art which bourgeois ideology has interposed very deeply in artists, particularly in those who have been formed within western culture. However, we believe that such a transformation will be achieved, through contact with

the people, their involvement in artistic creation, greater clarity about the goals of popular art, and the abandonment of individualism. Numerous group works and collectively made films already exist, as, very importantly, do examples of popular participation, where the people themselves play roles, make suggestions and become directly involved in the creative act. In such cases, the people are already determining methods of work. Closed scripts begin to disappear and dialogue is born from the people's own prodigiously fertile talent, during the very act of representation. Life itself speaks, in all its force and truth.

As we argued once before in an article on this subject, revolutionary cinema, as it reaches maturity, can only be collective, just as the revolution itself is collective. Popular cinema, whose central protagonist will be the people, will tell individual stories when these have collective meaning. Such stories must help the people's understanding and not that of an isolated individual, and must be an integral part of the collective story. The individual hero must give way to the popular hero, the multiple hero, who in the process of making will not only be the film's internal *raison d'être* but also the dynamic behind its quality, both participant and artist.

LANGUAGE

A film about the people made by an author is not the same as a film made by the people through an author. As the interpreter and translator of the people, such an author becomes their vehicle. When the relations of creation change, so does content and, in a parallel process, form.

In revolutionary cinema the final work will always be the result of individual talents organised in function of the same end, so long as this end captures and transmits the spirit and vigour of a whole people and not the small scale problems of a single person. In bourgeois society such individual problems are blown up out of all proportion. In revolutionary society, however, they are resolved by being set against the shared problems of all. This reduces them to a manageable dimension, where solutions can be found through the problems being embraced within those of all. The neuroses and loneliness which give rise to psychiatric disorders disappear forever.

The artist's fond or apathetic regard for people and objects emerges inevitably in his or her works, escaping his/her control. His/her ideas and feelings are quite unconsciously manifest in the expressive resources s/he uses. His/her attitudes are translated into the forms of languages s/he uses, with the result that a work speaks to us not only of a theme but also of its author.

When we filmed *Blood of the Condor* with the peasants of the remote Kaata community, we certainly intended that the film should be a political contribution, denouncing the *gringos* and presenting a picture of Bolivian social reality. But our fundamental objective was to explore our own aptitudes. We cannot deny this, just as we cannot deny that our relations with the peasant actors were at that time still vertical. We still chose shots

according to our own personal taste, without taking into account their communicability or cultural overtones. The script had to be learned by heart and repeated exactly. In certain scenes we put the emphasis entirely on sound, without paying attention to the needs of the spectators, for whom we claimed we were making the film. They needed images, and complained later when the film was shown to them.

Thanks to the encounter between our work and the people, thanks to the latter's criticisms, suggestions, instruction and complaints, and their confusions due to our ideological errors in relating together form and content, we were able steadily to clarify the language of our films and to incorporate into them the creativity of the people themselves, whose remarkable expressive and interpretative abilities demonstrated a pure sensibility, free of stereotypes and alienation.

During the filming of *Courage of the People,* many scenes were worked out on the actual sites of the historical events we were reconstructing, through discussion with those who had taken part in them and who had a good deal more right than us to decide how things should be done. Furthermore, these protagonists interpreted the events with a force and conviction which professional actors would have found difficult. These *compañeros* not only wanted to convey their experiences with the same intensity with which they had lived them, but also fully understood the political objectives of the film, which made their participation in it an act of militancy. They were perfectly clear about the usefulness of the film as a means of declaring throughout the country the truth of what had happened. So they decided to make use of it as they would a weapon. We, the members of the crew, became instruments of the people's struggle, as they expressed themselves through us!

The script was left open to the people's own very precise memories of events. As happened later during the filming of *The Principal Enemy,* this method stimulated the people to express their own ideas. The peasants used the filming to break the silence of oppression and speak openly, saying to the judge and the boss in the film what they wanted to say to their counterparts in reality. At such moments cinema and reality came together. They were the same thing. In the evident external differences artificiality was clearly present. But the cinematic fact was fused with reality through the people's act of revelation and creation.

Our decision to use long single shots in our recent films was determined by the content itself. We had to film in such a way as to produce involvement and participation by the spectator. It would have been no use in *The Principal Enemy,* for example, to have jumped sharply into close-ups of the murderer as he is being tried by the people in the square, because the surprise which the sudden introduction of a closeup always causes would have undercut the development of the sequence as a whole, whose power comes from within the fact of collective participation in the trial and the participation by the audience of the film which that evokes. The camera movements do no more than mediate the point of view and dramatic needs of the spectator, so that s/he may become a participant. Sometimes the single shot itself includes close-ups, but these never get closer

to the subject than would be widened between people and heads so that by getting closer we can see and hear the prosecutor. But to have intercut a tight close-up would have been brutally to interpose the director's point of view, imposing meanings which should arise from the events themselves. But a close-up which is arrived at from amongst the other people present, as it were, and together with them, carries a different meaning and expresses an attitude more consistent with what is taking place within the frame, and within the substance of the film itself.

During the shooting of *The Principal Enemy*, however, we were often forced to break with our methods for technical reasons. Sound problems due to an inadequate blimp (the covering which dampens the noise of the camera) interrupted the single shot, and meant we had to break up the takes. The high degree of improvisation which results from popular participation made it difficult to control the continuity for cutting purposes. We can justify ourselves to some extent by explaining that, for us at least, the process of filming was continually paralleled by that of discovering new possibilities. It was quite different from the kind of shooting we had learned as our ABC, and more than a few times we were taken by surprise by what was happening.

We could speak of two ways of treating a subject. One is subjective, and fits the needs and attitudes of an individualist, *auteur* cinema. The other is objective, non-psychologistic and sensory, facilitating participation and taking account of the needs of a popular cinema.

Such objective treatment also meets the need to stimulate reflection through our films. For example, a formal consequence of using lengthy shots aimed at integration and participation is the creation of distance which aids calm and objective reflection. Such distance means freedom to think, not only for the audience but also for the collective protagonist, who cannot be submitted to the close-up either physically, because it will not fit into it, or in principle, because it denies freedom of action, which is the freedom to invent. As far as the spectator is concerned, there is no pressure from within the image itself, and none of the tensions of the exaggerated close-up or of the accelerating rhythms which normally mark the resolution of a sequence. Instead, tensions arise from within the people's own drama, while emotional power, which we believe must be achieved if reflection is to be grounded in commitment, affects the spectator through the content itself, with its particular quality, its social intensity and its human significance.

On the other hand, such sequences are not intended to fall into the immobility of theatre, with the spectator confined to a single vantage point. Rather, they contain multiple possibilities for interpreting both internal and external drama, responding to the needs of both the participating spectator and the people as protagonist.

It was not only our search for ideological coherence that helped convince us of the need to do away with the individual protagonist—the hero who is so central to every story in our culture—but also what we had learned of the essential and primordial characteristics of indigenous American culture. The social traditions of our continent's Indians teach them to understand themselves primarily as a group rather than as isolated

individuals. Their way of life is not individualistic. They understand reality through their integration with others, and practice such ideas naturally, as an inseparable part of their vision of the world. Initially it is disconcerting to think of yourself in this way, for it is part of a quite different mode of thought based on a dialectic which is the opposite of individualism. The individualist is set against others, while the Indian only exists through his integration with others. When this equilibrium is upset, the Indian tends to disintegrate and lose his senses. Mariátegui, the great Peruvian political thinker, said when discussing concepts of liberty that the Indian is never less free than when he is alone. I remember that when we filmed an interview recently, a peasant whom we had asked to speak in front of the camera asked for his comrades from his community to be present so that he could speak confidently and naturally. Exactly the reverse of what a town-dweller would have wanted. He would probably have felt more comfortable alone!

Revolutionary art will always be distinguished by what it shows of a people's way of being, and of the spirit of popular cultures which embraces whole communities of people, with their own particular ways of thinking, of conceiving reality and of loving life. The purpose of such art is truth achieved through beauty, while bourgeois art pursues beauty even at the cost of lies. By observing and incorporating popular culture we will be able to develop fully the language of liberating art.

THE DISTRIBUTION OF REVOLUTIONARY CINEMA

The diffusion of revolutionary films is a major problem, and poses questions requiring urgent solutions. Militant, anti-imperialist films suffer particular persecution and censorship in most of the countries where they can best fulfil their purpose. This situation has created a good deal of demoralisation among those who do not understand that the work of a revolutionary film-maker docs not end when his or her film is finished. The problems of distribution are the problems of film-making. The latter cannot come to a halt because of immediate problems, most of which can be solved. A film must not cease to exist because at that precise political moment it cannot be distributed. As long as the problems of one oppressed country are shared by other oppressed countries, this pretext is invalid.

We should take into account that the politics of our countries, or most of them, at any rate, are intensely changeable. Amidst the ebb and flow of contradictions within each country, there are always opportune moments for distribution. What we are talking about is struggle! And in a struggle one must know when and where to shoot, and when to duck down into your trench.

To start censoring ourselves, or to disguise the content of our work by turning into symbols, is to fall into procedures which are both negative and dangerously useful to the enemy, who knows perfectly well how to turn to his advantage material which does not confront him head on.

A fully revolutionary film has the right to exist, and its need for diffusion is implicit in its very nature. Nowadays revolutionaries fight the same enemy everywhere he is to be found. Of course they can do so more satisfactorily in their own medium, but when this is impossible they should look for new positions in the broad battlefield which is the world plundered by imperialism. What cannot be justified is to hang around vegetating in Paris. The revolution takes no holidays, and nor can revolutionaries.

Nowadays revolutionary films can be seen in many European countries, usually on a handful of television channels or in specialist cinemas. This kind of diffusion, like that in the many festivals, creates two rough categories of audience in these countries: the passive consumers of culture and entertainment, who are the majority, and those who watch these films with an attitude consistent with their progressive ideas and who take from them formative information. We believe that the numbers of the latter spectators are growing all the time, and that this justifies distributing our films in Europe. Sometimes, such distribution can also be justified by the income produced by selling copies to television or to distributors, though the film-maker almost always ends up with nothing more than crumbs from such operations.

Revolutionary cinema is also distributed in the United States, in the very entrails of the imperialist enemy. Numerous films are shown in universities and progressive organisations, throwing light on our peoples' problems and exposing within the system itself the atrocities which it brings about in the world it keeps in subjugation. Such showings generate solidarity and strengthen the anti-imperialist struggle of North American progressives, who understand very well that exploitation, dehumanisation and discrimination in the US are just as much the products of capitalist ideology.

But we Latin American film-makers are concerned most of all that our films should be distributed in our countries, whether in our own or sister countries. I have already said that this is difficult and dangerous. Carlos Alvarez, director of *What Is Democracy?*, was imprisoned by the Colombian military, together with his *compañera*, accused of subversion because of his film work. Walter Achugar was detained and tortured in Uruguay. Felix Gomez, of the Ukamau Group in Bolivia, spent eighteen months in a concentration camp because a box was found on him containing props used in our film, *Courage of the People*. Antonio Eguino, director of photography on the same film, was detained for a fortnight, amidst widespread protests in the universities and by many progressive sectors, for the crime of possessing a print of the film. Left-wing film-makers and actors have been imprisoned by Pinochet, and until this day we still have no news of many of them. A substantial number of the most committed Latin American film-makers are forbidden to enter their own countries. But despite persecution and repression, Latin American cinema is still being produced, and in some countries there is a genuine effervescence, which will soon bear fruits in new values and experiences. The circulation of Latin American films may be restricted, but it has never been stopped altogether, and is now growing where conditions allow. In Venezuela, Colombia, Panama, Peru, Ecuador and Mexico, festivals have been organised

and Latin American films are in permanent circulation. In Venezuela and Panama there have even been festivals of Cuban cinema. What is lacking in most of these countries where such diffusion is possible is a properly systematic and organised effort to take this cinema to the people on a really substantial scale. In this connection what is being done now in Ecuador has much to tell us, and we shall return to it in greater detail.

In Bolivia, before the appalling eruption of fascism there, the Ukamau Group's films were being given intensive distribution. *Blood of the Condor* was seen by nearly 250,000 people! We were not content to leave this distribution solely to the conventional commercial circuits, and took the film to the countryside together with projection equipment and a generator to allow the film to be shown in villages where there is no electricity. The results were exciting. The film contributed to the expulsion of the Peace Corps from the country, by encouraging the formation of university and official commissions of inquiry into their suspicious activities, which finally recommended their expulsion.

In Chile, both before and during the Popular Unity government, Latin American films were distributed through the commercial circuits and also in factories and in the countryside. Argentina has seen the interesting experience of groups such as the Liberation Film Group, which carried out an intensive effort to distribute their own films among the workers.

Because of political circumstances there, Ecuador is currently the location of what we believe is one of anti-imperialist cinema's most interesting experiences. Films such as *What Is Democracy?*, *Cerro Pelado*, *The Hour of the Furnaces*, *Compañero President*, *NOW*, *Revolution*, *Ukamau*, *Blood of the Condor*, *Courage of the People* and *The Principal Enemy*, are receiving considerable attention in universities and among the workers. Shared problems and a common cultural identity mean that some of these films have reached a remarkable number of spectators. In only two and a half months *Courage of the People* was seen and discussed by some 40,000 workers in the Quito area alone! On the basis of the available figures, and taking into account distribution to peasants in different parts of the country, we calculate that in a single year approximately 340,000 workers, peasants and students have seen our group's films. We can give this figure because we have followed the distribution of these films particularly closely, and we think that for a relatively small country like Ecuador they are satisfactory. To a great extent they are due to the efficient efforts of the Film Department at the Central University and to the enthusiasm of the *compañeros* at the National Polytechnic's Film Club. Both organisations have concentrated their efforts on grass-roots working-class organisations and trade unions, but have also taken the films into the rural areas. Other universities, trade union and peasant organisations themselves, and third-worldist priests are also making intensive use of the films. It is likely that in the ease of the Ukamau Group's films cultural factors, such as the use of Quechua, which is spoken in Ecuador, in parts of the films, are helping their acceptance by audiences and thus their distribution. But we believe the principal reason for the

success is the audience's identification with the political and social problematic the films deal with. In our discussions with them, audiences have either insisted on the identity of the problems faced in Bolivia and Ecuador, or have simply ignored the nationality of the films, and discussed them as something of their own.

We're going to finish this article by quoting some of the workers and peasants who are currently seeing these films. Beforehand, however, we want to make an appeal that the Ecuadorian experience be studied, and that cinema be taken without delay to the people of our countries, wherever this is possible. The attitudes and practices of cinematheques and other organisations which use these films must change, so that their emphasis on static, exquisitely clean theatres—which runs so contrary to the nature of this cinema—may give way to concern with mobile units functioning in factories and communities, so that permanent communication can be established with the people. Such communication benefits both those who receive and those who give, as this relationship alters during the projection event itself and those who are giving find themselves receiving also.

MANIFESTO OF THE NATIONAL FRONT OF CINEMATOGRAPHERS (Mexico, 1975)

Paul Leduc, Jorge Fons, Raul Araiza, Felipe Cazals, José Estrada, Jaime Humberto Hermosillo, Alberto Isaac, Gonzalo Martínez, Sergio Olhovich, Julián Pastor, Juan Manuel Torres, and Salomón Láiter

[First released in México, D.F., on 19 November 1975. First published in Spanish as "Manifiesto del Frente nacional de cinematografistas," *Otrocine* (Mexico) 1, no. 3 (1975). Trans. Fabiola Caraza.]

Quite unlike the Mexican "New Cinema Group" manifesto of 1961, this manifesto explicitly engages with the politics of the Mexican state and the status of cinema within it, placing Mexican cinema in the rubric of Third Cinema and of Latin American struggles against colonization and dictatorship. Nevertheless, the manifesto does cut some slack to the ruling PRI *(Partido revolucionario institucional)*, which the manifesto scribes argue has changed for the better in the previous six years. While left unstated, these changes come after the state-sanctioned Tlatelolco Massacre on 2 October 1968 during the lead-up to the Olympic games in Mexico City, a moment of political awakening to many and documented by Mexican writer and activist Elena Poniatowska in her book *La noche de Tlatelolco* (1971).

CONSIDERING:

That the Mexican cinema has until recently been one of the main ideological institutions supporting an unjust and dependent social order.

That it has been an active agent of cultural colonialism exploiting the ignorance, the illiteracy and hunger of the country and the continent.

That through alienating products it imposes ideological values and patterns of conduct that have nothing to do with the essence of the Mexican and Latin American man.

That due to the incompetence of the State to dictate a coherent cinematographic policy to the needs of the people; the national cinema was systematically looted by private producers who consciously or unconsciously created a contemptible cinematographic product distracting the people from the real problems and alienating the cinema from its national roots.

ACKNOWLEDGING:

That in the last six years a dynamic of change has begun and it manifests itself mainly in that the State has taken the main (comprehensive) responsibility of production.

That the State has established a partnership with the workers through a so-called "Paquetes" ("Packages") system that offers, at least in appearance, the possibility for the worker to take part in the profits, even though it's minimal in proportion to what he produces.

That the State has opened the gateway regarding subject matter.

That the State has manifested a willingness of change when incorporating a new generation of directors and

That this energetic attitude, especially in the last three years, allows us to portray the present as a time of transition towards the creation of authentic national cinematographic art engaged with the historical destiny and the needs of the great majority.

We are aware that for these changes to be irreversible it is necessary to go into them in depth and develop them. This is the reason why we have decided to setup an active movement similar to those in other historical situations which shaped classical music, mural paintings, the Mexican novel of the Revolution and modern dance, taking into account that we recognize in these movements, the true creators of national art.

WE MANIFEST:

1. That we cannot avoid that Latin America is a continent where there is 32% illiteracy, 40% infant mortality, growing unemployment and subjugation of the working masses that create the wealth which concentrates in the hands of an exploiting minority.

An extremely high percentage of malnutrition created by the systematic exploitation of the people by the dictatorship held up by the imperialism of our continent.

2. That before this reality, the cinema cannot and should not remain alien and on the contrary, our commitment as filmmakers and individuals is to fight for the transformation of society creating a Mexican Cinema tied to the interests of the Third World and of

Latin America, cinema that will emerge from the investigation and analysis of the continental reality.

3. That we are aware that to develop these principles it is essential that the cinematographic creator have direct interference in the decisions relating to the thematic and organizational economic aspect of film.

4. That we reject all mechanisms of censorship that prevent freedom of expression in the cinematographic creation, understanding that this censorship not only can be exercised from the General Management of Cinematography but also in each of the subsequent steps in every project, whether it be in financing, production, distribution, promotion or exhibition.

5. That we propose to narrow the relationships within the cinematographic industry of the continent, understanding that we cannot put off the task of regaining the millions of Spanish speaking spectators who constitute the innate market of our cinema.

6. That the cinema, as a social activity of mankind, can change only in the same measure as the social structures.

7. The ones signing below to the above statements constitute the Fighting Front for the consolidation of a True Mexican Cinematographic Art, assuming the forefront of the Movement and we call to all cinematographic sectors of the country to manifest their fighting support and solidarity to these principles.

THE ALGIERS CHARTER ON AFRICAN CINEMA (Algeria, 1975)

FEPACI (Fédération panafricaine des cinéastes)

[Published in French as "Charte d'Alger du cinéma africain," *Afrique littéraire et artistique* 35 (1975): 100–101. First published in English in Angela Marin, ed., *African Films: The Context of Production* (London: BFI, 1982), 5–6. Trans. Liz Heron.]

Developing on the propositions put forth in the "Resolutions of Third World Film-makers Meeting" in Algiers in 1973, The "Algiers Charter" argues for the necessity of a militant, pan-African cinema to countervail the dominant cinemas of Europe and the United States and the cultural and artistic domination that continues to ensue from this colonization.

For a responsible, free and committed cinema.

This charter was adopted at the Second Congress of the FEPACI (Fédération Panafricaine des Cinéastes) in Algiers, January 1975.

Contemporary African societies are still objectively undergoing an experience of domination exerted on a number of levels: political, economic and cultural. Cultural domination, which is all the more dangerous for being insidious, imposes on our peoples models of behaviour and systems of values whose essential function is to buttress the ideological and economic ascendancy of the imperialist powers. The main channels open to this form of control are supplied by the new technologies of communication: books, the audiovisual, and very specifically the cinema. In this way the economic stranglehold over our countries is increased twofold by a pervading ideological alienation that stems from a massive injection of cultural by-products thrust on the African markets for passive consumption. Moreover, in the face of this condition of cultural domination and deracination, there is a pressing need to reformulate in liberating terms the internal problematic of development and of the part that must be played in this worldwide advance by culture and by the cinema.

To assume a genuinely active role in the process of development, African culture must be popular, democratic and progressive in character, inspired by its own realities and responding to its own needs. It must also be in solidarity with cultural struggles all over the world.

The issue is not to try to catch up with the developed capitalist societies, but rather to allow the masses to take control of the means of their own development, giving them back the cultural initiative by drawing on the resources of a fully liberated popular creativity. Within this perspective the cinema has a vital part to play because it is a means of education, information and consciousness raising, as well as a stimulus to creativity. The accomplishing of these goals implies a questioning by African film-makers of the image they have of themselves, of the nature of their function and their social status and of their general place in society. The stereotyped image of the solitary and marginal creator which is widespread in Western capitalist society must be rejected by African film-makers, who must, on the contrary, see themselves as creative artisans at the service of their people. It also demands great vigilance on their part with regard to imperialism's attempts at ideological recuperation as it redoubles its efforts to maintain, renew and increase its cultural ascendancy.

In this context, African film-makers must be in solidarity with progressive film-makers who are waging anti-imperialist struggles throughout the world. Moreover, the question of commercial profit can be no yardstick for African film-makers. The only relevant criterion of profitability is the knowledge of whether the needs and aspirations of the people are expressed, and not those of specific interest groups. This means that all the structural problems of their national cinema must be of paramount importance to African film-makers.

The commitment demanded from African film-makers should in no way signify subordination. The state must take a leading role in building a national cinema free of the shackles of censorship or any other form of coercion likely to diminish the film-makers' creative scope and the democratic and responsible exercise of their profession. This

freedom of expression for film-makers is in fact one of the prerequisite conditions of their ability to contribute to the development of a critical understanding among the masses and the flowering of their potentialities.

DECLARATION OF PRINCIPLES AND GOALS OF THE NICARAGUAN INSTITUTE OF CINEMA
(Nicaragua, 1979)

Nicaraguan Institute of Cinema

[First published in Spanish as a pamphlet, "Declaración de principios y fines del Instituto Nicaragüense de cine." First published in English in Jonathan Buchsbaum, *Cinema and the Sandinistas: Filmmaking in Revolutionary Nicaragua* (Austin: University of Texas Press, 2003). Trans. Jonathan Buchsbaum.]

After forty-three years of dictatorial rule by the Somoza dynasty propped up by the United States, the Sandinista National Liberation Front (*Frente Sandinista de liberación nacional*, FSLN) overthrew the government in 1979. Realizing that Nicaragua had no cinematic history to speak of, the newly formed Nicaraguan Institute of Cinema faced a different set of challenges than those faced by many Latin American countries. Not only did the institute need to mobilize film to educate the people; it also had to develop a cinema from ground zero. This manifesto addresses these concerns, delineates what the Nicaraguan Institute of Cinema sees as the goals of Nicaraguan film, and puts forth the utopian ideals of building a free film culture from the ground up.

Until the day of the triumph of the Popular Sandinista Revolution, Nicaragua was a country dominated by the most bestial of Latin American dictatorships: the Somocista Dynasty.

This dynasty was nothing more than the expression of a secular domination imposed on our homeland by North American imperialism. Submitted to sacking, exploitation, hunger, and misery by this shady, reactionary, and anti-popular force, Nicaragua also had to confront a systematic and entrenched aggression bent on uprooting its national identity.

In the heat of war against this force, the Sandinista cinema was born, out of the need to gather the cinematic testimony of the most significant moments of this struggle to counter the disinformation promoted by the enemy's news agencies and preserve international solidarity. At the same time it was proposed to conserve for the future generations

the document of the immense sacrifice borne by our people to carry forward its revolutionary war.

In the fulfillment of such tasks germinated what today—upon assumption of the responsibilities of the triumph—is known as the Nicaraguan Institute of Cinema. This is a response to the commitment to recover and develop our National identity. It is at the same time an instrument in the defense of our revolution, in the area of the ideological struggle and a new means of expression of our people in their sacred right to self-determination and its full independence.

In each and every one of our works, we will have to satisfy the immediate needs of mobilization, education, recreation, that the current stage of National reconstruction requires of us, strengthening us to produce cinematic works of permanent value which take their place in the best tradition of progressive and revolutionary cinema that has been produced and is being produced in Latin America, and finally, in universal culture, as part of a regional, continental, and world struggle for the definitive liberation of all oppressed peoples.

To begin the task that we, as the Nicaraguan Institute of Cinema, have proposed for ourselves, we are aware that there exists no tradition of cinematography in Nicaragua.

To create the national cinema out of the legacy of ruin that the dictatorship leaves us is a challenge. With the total economic and material destruction, we have insufficient resources to reach our indicated objectives, but we are sure of being able to fulfill them because the same spirit that brought us victory inspires us.

We benefit immediately from the unique cinematic experience obtained during the war of liberation, and with the valuable and necessary contribution of international Latin American companions who at our side will confront the great challenge that awaits us.

Ours will be a Nicaraguan cinema, launched in search of a cinematic language that must arise from our concrete reality and the specific experiences of our culture.

It will begin with an effort of careful investigation into the roots of our culture, for only thus can it reflect the essence of our historical being and contribute to the development of the revolutionary process and its protagonist: The Nicaraguan people.

In defining today the origins and objectives of the Nicaraguan Institute of Cinema, we make a fraternal appeal to the cinemas and the filmmakers of the whole world, so that, united with the spirit of the General of Free Men, Augusto César Sandino, they support our initiative. We will thus have close bonds of solidarity that in this field of expression will favor the advance and development of our Popular Sandinista Revolution.

A Free Homeland or Death!

WHAT IS THE CINEMA FOR US?
(Mauritania, 1979)

Med Hondo

[First published in English in *Framework* (UK) 11 (1979): 20–21.]

Med Hondo is a Mauritanian filmmaker who has worked extensively in France, best known for his film *Soleil O* (France/Mauritania, 1967). He has done extensive work in dubbing Hollywood films (most notably the roles played by Eddie Murphy) in France. This manifesto addresses both the absence of African and Arab cultures onscreen and decries the colonization of Arab and African cinema screens that profoundly limits the circulation of films made by Arabs and Africans on their screens and abroad, along with the inability of many filmmakers to work in their home countries, forcing them to go and work in the cinema industries of the colonizers.

Throughout the world when people use the term *cinema,* they all refer more or less consciously to a single cinema, which for more than half a century has been created, produced, industrialised, programmed and then shown on the world's screens: *Euro-American cinema.*

This cinema has gradually imposed itself on a set of dominated peoples. With no means of protecting their own cultures, these peoples have been systematically invaded by diverse, cleverly articulated, cinematographic products. The ideologies of these products never "represent" their personality, their collective or private way of life, their cultural codes, and never reflect even minimally on their specific "art," way of thinking, or communicating—in a word, their own history . . . their civilization.

The images this cinema offers systematically exclude the African and the Arab.

It would be dangerous (and impossible) for us to reject this cinema simply as alien—the damage is done. We must get to know it, the better to analyse it and to understand that this cinema has never *really* concerned African and Arab peoples. This seems paradoxical, since it fills all the cinemas, dominates the screens of all African and Arab cities and towns.

But do the masses have any other choice? "Consuming" at least a reflection of one's own people's life and history—past, present and future? . . .

Lawrence of Arabia disseminates an image of Lawrence, not of the Arabs. In *Gentleman of Cocodie* a European is the gentleman hero, and not an Ivory Coast African. Do we have a single image of the experiences of our forefathers and the heroes of African and Arab history? Do we see a single film showing the new reality of cooperation, communication, support, and solidarity among Africans and Arabs?

This may seem exaggerated. Some critics will say that at least one African country, Egypt, produces some relatively important films each year . . . that since independence a number of cineastes have made a future for themselves in African countries. In the whole

continent of Africa, Egypt is only one country, one cultural source, one sector of the market—and few African countries buy Egyptian films. They produce too few films, and the market within Egypt is still dominated by foreign films.

African and Arab film-makers have decided to produce their own films. But despite the films' undoubted quality, they have no chance of being distributed normally, at home or in the dominant countries, except in marginalised circuits—the dead-end art cinemas.

Even a few dozen more film-makers producing films would only achieve a ratio of one to ten thousand. An everyday creative dynamic is necessary. We need to make a radical change in the relation between the dominant Euro-American production and distribution networks and African and Arab production and distribution, which we must control.

Only in this way, in a spirit of creative and stimulating competition among African and Arab film-makers, can we make artistic progress and become "competitive" on the world market. We must first control our own markets, satisfy our own people's desires to liberate their screens, and then establish respectful relations with other peoples, and balanced exchange.

WE MUST CHANGE THE HUMILIATING RELATION BETWEEN DOMINATING AND DOMI-NATED, BETWEEN MASTERS AND SLAVES.

Some flee this catastrophic state of affairs, thinking cinema restricted for Western, Christian and capitalist elites . . . or throwing a cloak of fraternal paternalism over our film-makers, ignoring and discrediting their works, blaming them, in the short term forcing them to a formal and ethical "mimesis"—imitating precisely those cinemas we denounce—in order to become known and be admitted into international cinema; in the end, forcing them into submission, renouncing their own lives, their creativity and their militancy.

Since our independence many of our filmmakers have proved their abilities as *auteurs*. They encounter increasing difficulties in surviving and continuing to work, because their films are seldom distributed and no aid is available. Due to the total lack of a global cultural policy, African and Arab cinema becomes relegated to an exotic and episodic sub-product, limited to aesthetic reviews at festivals, which, although not negligible, are undoubtedly insufficient.

Each year millions of dollars are "harvested" from our continents, taken back to the original countries, and then used to produce new films which are again sent out onto our screens.

50% of the profits of multinational film companies accrue from the screens of the Third World. Thus each of our countries unknowingly contributes substantial finance to the production of films in Paris, New York, London, Rome or Hong Kong. They have no control over them, and reap no financial or moral benefit, being involved in neither the production nor the distribution. In reality, however, they are coerced into being "co-producers." *Their resources are plundered.*

The United States allows less than 13% foreign films to enter its market—and most of these are produced by European subsidiaries controlled by the U.S. majors. They exercise an absolute protectionism.

Most important is the role of the cinema in the construction of peoples' consciousness.

Cinema is the mechanism *par excellence* for penetrating the minds of our peoples, influencing their everyday social behaviour, directing them, and diverting them from their historic national responsibilities. It imposes alien and insidious models and references, and without *apparent* constraint enforces the adoption of modes of behaviour and communication of the dominating ideologies. This damages their own cultural development and blocks true communication between Africans and Arabs, brothers and friends who have been historically united for thousands of years.

This alienation disseminated through the image is all the more dangerous for being insidious, uncontroversial, "accepted," seemingly inoffensive and neutral. It needs no armed forces and no permanent programme of education by those seeking to maintain the division of the African and Arab peoples—their weakness, submission, servitude, their ignorance of each other and of their own history. They forget their positive heritage, united through their foremothers with all humanity. Above all they have no say in the progress of world history.

Dominant imperialism seeks to prevent the portrayal of African and Arab values to other nations; were they to appreciate our values and behaviour they might respond positively to us.

We are not proposing isolation, the closing of frontiers to all Western film, nor any protectionism separating us from the rest of the world. We wish to survive, develop, participate as sovereign peoples in our own specific cultural fields, and fulfil our responsibilities in a world from which we are now excluded.

The night of colonialism caused many quarrels among us; we have yet to assess the full consequences. It poisoned our potential communications with other peoples; we are forced into relations of colonial domination. We have preconceived and false ideas of each other imprinted by racism. They believe themselves "superior" to us; they are unaware of our peoples' roles in world history.

Having been colonised and then subjected to even more pernicious imperialist domination, if we are not entirely responsible for this state of affairs, some intellectuals, writers, film-makers, thinkers, our cultural leaders and policy-makers are also responsible for perpetuating this insatiable domination.

It has never been enough simply to denounce our domination, for they dictate the rules of their game to their own advantage. Some African and Arab film-makers realise that the cinema alone cannot change our disadvantaged position, but they know that it is the best means of education and information and thus of solidarity.

It is imperative to organise our forces, to reassert our different creative potentialities, and fill the void in our national, regional and continental cinemas. We must establish relations of communication and co-operation between our peoples, in a spirit of equality, dignity and justice. We have the will, means and talent to undertake this great enterprise.

Without organisation of resources, we cannot flourish at home, and dozens of African and Arab intellectuals, film-makers, technicians, writers, journalists and leaders have had

to leave their countries, often despite themselves, to contribute to the development and overdevelopment of countries that don't need them, and that use their excesses to dominate us.

This will continue until we grasp the crucial importance of cultural and economic strategy, and create our own networks of film production and distribution, liberating ourselves from all foreign monopolies.

NIAMEY MANIFESTO OF AFRICAN FILMMAKERS (Niger, 1982)

FEPACI (Fédération panafricaine des cinéastes)

The first international conference on cinema was held in Niamey, Niger, March 1–4, 1982. The participants were filmmakers, critics, officials from several African countries, and international cinema experts. The participants recognized the underdevelopment of cinema, including regular film productions in the majority of African countries.

Further, the participants are convinced that African cinema must be committed to asserting the cultural identity of African peoples; be an effective means for international understanding, education, and entertainment; provide an incentive for development; and contribute to national and regional economic policies.

The Conference started by making a serious evaluation of African and international policies on cinema.

The participants then studied proposals for the development of African cinema, production and the financing of productions, and the possibilities of legislation that would promote pan-African strategies for the development of the African cinema industry. They examined ways of implementing the proposals.

The conference finally adopted the following resolutions and recommendations:

GENERAL PRINCIPLES

The participants considered and set up the following principles:

The viability of cinema production is closely tied to the complementary viability of the other four main sectors of cinema, namely the exploitation of cinema theaters, importation of films, distribution of films, and technical infrastructure and training.

There cannot be any viable cinema without the involvement of African states for the organization, the support, the stabilization of cinema, and the encouragement and protection of private public investment in cinema.

It is not possible to have a viable cinema industry on a national level in Africa. The development of national cinema should take into consideration regional and pan-African cooperation by integrating cinema to political and economic ties that already exist between states.

At the present stage of development of audiovisual facilities in the world and particularly in Africa, television should be complementary to cinema.

It is possible to finance African film productions from the present revenue from the millions who patronize cinemas in Africa. What is required is a strategy that will ensure that part of this revenue legitimately returns to the production of films. Production should not rely solely on patronage.

RECOMMENDATIONS

CINEMA MARKET (EXPLOITATION AND PROJECTION)

Every state should organize, support, safeguard, and develop its movie theater market and encourage and collaborate with neighboring states to form a regional common market for the importation and exploitation of films.

Measures to be taken:

a. The setting up of national ticket agencies to monitor receipts of cinemas for the benefit of the exchequer, the cinema owners, and film producers.

b. The provision of cinemas and other appropriate film projection venues and facilities.

c. To make available funds from cinema taxes to encourage exhibitors to expand their cinema circuits, thus enlarging the market.

d. States to exempt taxation on equipment imported for film projections.

e. States to encourage investment to build cinemas by creating incentives for would-be investors.

IMPORTATION AND DISTRIBUTION OF FILMS

We have to control and organize the importation and distribution of foreign films to ensure the projection of African films on national, regional, and continental levels. We have to limit the dependence on foreign suppliers and ensure cultural diversification of foreign films, thus preventing the domination of films from particular areas. All this must be done with the aim of reconquering and enlarging our cultural and economic space.

Measures to be taken:

a. The setting up of national distribution corporations in countries where they don't already exist, be they state run or in the private sector.

b. The setting up of regional film importation companies that would function as cooperatives, e.g., CIDC. Where possible representative film purchasing companies based

in foreign countries should have African status so that taxes related to their activities can be paid in Africa. These companies should promote African films and their diffusion abroad.

c. To strengthen existing importing companies like CIDC by the participation of other states.

d. Enact distribution laws to favor African films nationally, regionally, and continentally. This can be achieved by decreasing the share of revenue to distributors when dealing with African films. This would contribute to the financing of future productions.

PRODUCTION

Cinema productions, whether national, regional or inter-African, should be financed, not necessarily by state funds, but mainly by revenue from distribution and from various forms of cinema taxation including taxes on earnings by foreign films. Thus, cinema will finance cinema.

Measures to be taken to finance productions:

a. The creation of film finance corporations funded by revenue from cinema.

b. The creation of support funds to be administered by the corporations. The support funds help the production of film on the approval of scenarios.

c. The exemption from taxes of imported products and equipment required for the production of films. This would reduce the production costs.

d. Increase of African producers' shares of box office receipts.

e. Advance payments to producers by distributors.

f. Governments to legislate that television participate in financing of film production in various ways.

g. To create by legislation incentives for capital investments in film productions. This can be accomplished by offering tax exemptions.

h. To make bank loans at low interest available to producers by national banks. These loans would be guaranteed by support funds.

i. To have intergovernmental agreements, bilaterally, regionally, and continentally, for the free circulation of technicians, equipment, and other production facilities, and to reciprocal support funds and to infrastructure.

j. To reinforce and encourage the activities of existing production organizations, such as CIPROFILMS (International Center for Film Production), through participation by states by paying subscriptions and by contributions from revenues acquired through cinema taxes.

k. To support the production of short feature films through financing from support funds. These will give added experience to filmmakers and be an additional source of labor for technicians. Cinemas should also be compelled to screen these films.

l. Another source of finance for productions can be obtained from theatrical and non-theatrical rights from distributors and television.

TECHNICAL INFRASTRUCTURE

Measures to be taken:

a. The last twenty years' experience have proved that cinema technical infrastructures were impossible to be maintained and made profitable on a national level because of the high costs of maintenance and management. The conference recommends that the future establishments of these structures should be on regional levels after joint studies and agreements between parties involved.

b. To create archives and film libraries on regional and continental levels.

TRAINING

It is preferable that the training of technicians and other disciplines related to cinema be in centers established in regions and within the framework of any cinema activities in Africa. Wherever foreign technicians are employed it should be obligatory that African technicians are attached.

African filmmakers and technicians working abroad should be encouraged to return to the continent to contribute to the development of African cinema.

Measures to be taken:

a. Vocational training centers should be established to ensure the training of film and television technicians and their absorption in both media.

b. Ensure the training of managerial staff and other nontechnical personnel, e.g., lawyers, producers, production managers, etc.

c. Facilitate efficient distribution, the training in programming, promotion, and public relations.

d. Ensure the training of projectionists, cinema managers, and other activities related to exhibition of films.

e. The development of film critics through continuous dialogue between filmmakers and critics.

LEGISLATION

Cinema legislation of any state should take into consideration the joint development of its cinema industry with that of its neighboring states and also of the region.

NATIONAL FILM CORPORATIONS

National film corporations should be established in every country. The corporations should be autonomous in decision making yet be under a ministry. The role of these corporations should be to centralize all activities and matters relating to cinema in the country. There can be a management committee representing the government and the corporation.

A complementary authority should be established on a regional level to ensure coordination of cinema policies of regions.

FINAL RECOMMENDATION

Any decision made executively or regarding legislation on cinema, nationally or regionally, should be considered by a committee representing the state, filmmakers, cinema professionals, and investors and cinema owners, to avoid individual or bureaucratic decisions arbitrarily being taken against the interests of African cinema. On the other hand, filmmakers should maintain a sense of responsibility and morality in dealing with their governments and others they have dealings with.

BLACK INDEPENDENT FILMMAKING: A STATEMENT BY THE BLACK AUDIO FILM COLLECTIVE (UK, 1983)

John Akomfrah

[First published in Artrage: Inter-Cultural Arts Magazine 3/4 (1983).]

The Black Audio Film Collective (1982–1998)—known for films such as *Handsworth Songs* (John Akomfrah, UK, 1988)—and Sankofa Film and Video were the two key black British independent filmmaking collectives in the United Kingdom under Thatcherism. Influenced by critical theory, in this manifesto by filmmaker John Akomfrah we see both the recognition of the growing number of black British collectives and the concurrent recognition that an independent support network needed to be established to help develop film and video production in minoritarian communities. As well as a statement of purpose, this manifesto outlines the goals of the Black Audio Film Collective in addressing these pressing political and cultural needs.

The area of black independent film-making will soon see the growth of a number of workshops established with the specific aim of catering for black film needs. We will also see a growth in the number of films made by members of these workshops. As in any other field of cultural activity and practice such a development calls for collective debate and discussion. Some of the important issues to be raised will be around the relationship between the workshop organisers and participants in the course. The others should obviously be about the nature and structure of the courses themselves.

Prior to this debate, however, is the task of accounting for the specificity of black independent film-making. What, after all, does "black independent film-making" mean

when present film culture is a largely white affair? And does this posture of independence presuppose a radical difference of film orientation? If this is the case how does one work with difference?

The Black Audio Film Collective has chosen to take up these issues in a very particular way and this is around the question of the "figuration of identity" in cinema. Our point of entry is around the issue of black representation. The Collective was launched with three principal aims. Firstly, to attempt to look critically at how racist ideas and images of black people are structured and presented as self-evident truths in the cinema. What we are interested in here is how these "self-evident truths" become the conventional pattern through which the black presence in cinema is secured.

Secondly, to develop a "forum" for disseminating available film techniques within the independent tradition and to assess their pertinence for black cinema. In this respect our interests did not only lie in devising how best to make "political" films, but also in taking the politics of representation seriously. Such a strategy could take up a number of issues which include emphasising both the form and the content of films, using recent theoretical insights in the practice of film-making.

Thirdly, the strategy was to encourage means of extending the boundaries of black film culture. This would mean attempting to de-mystify in our film practice the process of film production; it would also involve collapsing the distinction between "audience" and "producer." In this ethereal world film-maker equals active agent and audience equals passive consumers of a predetermined product. We have decided to reject such a view in our practice.

Underlying these aims are a number of assumptions about what we consider the present priorities of independent film-making to be. These assumptions are based on our recognition of certain significant achievements in the analysis of race and the media. It is now widely accepted that the media play a crucial role in the production and reproduction of "common sense assumptions" and we know that race and racist ideologies figure prominently in these assumptions. The point now is to realise the implications of these insights in creating a genuinely collective black film culture.

Such a program is also connected with our awareness of the need to go beyond certain present assumptions about the task of black film-making. We recognise that the history of blacks in films reads a legacy of stereotypes and we take the view that such stereotypes, both in mainstream and independent cinema, should be critically evaluated. This can be connected to a number of things that we want to do. We not only want to examine how black culture is misrepresented in film, but also how its apparent transparency is a "realism" in film. It is an attempt to isolate and render intelligible the images and statements which converge to represent black culture in cinema. The search is not for "*the* authentic image" but for an understanding of the diverse codes and strategies of representation.

It could be argued that all this is stale water under a decaying bridge and that we know all this stuff already and that black film-makers already accept their responsibility and are aware of these problems. There is a lot of truth in this. Others may say as long as we are making films and gaining exposure of our work we are keeping black film culture alive.

To place our discussion in a relevant and meaningful context the Black Audio Film Collective in conjunction with Four Corners Cinema will be organising a number of screenings to run with the Colin Roach photography exhibition at Camerawork Gallery.

The series of films and discussions will run under the title *Cinema and Black Representation* and will deal specifically with the complexity of black portrayal in films. The main aim here is to see how film can contain "information" on race, nationality and "ethnicity" with (Presence) or without (Absence) black people in films. With this in mind we hope to cover a number of films and themes ranging from prison movies like *Scum* to Hollywood social criticism films like *Imitation of Life*. What we will be attempting will not be to push all the films into one category of racist films but rather attempting to examine what specific responses these films make to the question of race and ethnicity.

In the end we realise that questions of black representation are not simply those of film criticism but inevitably of film-making. These issues need to be taken up on both fronts. With this in mind we are also making preparations with the GLC Ethnic Minorities' Committee to organise a number of our courses on some of the themes outlined in this article. Neither the dates for the screenings nor film courses have been finalized— both will be advertised when they are.

FROM *BIRTH CERTIFICATE OF THE INTERNATIONAL SCHOOL OF CINEMA AND TELEVISION IN SAN ANTONIO DE LOS BAÑOS, CUBA, NICKNAMED THE SCHOOL OF THREE WORLDS* (Cuba, 1986)

Fernando Birri

[First released at the launch of the school on 15 December 1986]

This manifesto, written by filmmaker and teacher Fernando Birri, outlines the alternative pedagogical strategies of the International School of Cinema and Television in San Antonio de Los Baños, Cuba, and foregrounds a politically informed, participatory style of education that, in the process, redefines third-worldism.

A few days after the beginning of the warm spring of 1986, surrounded by the turquoise blue Caribbean Sea, under a crescent moon, shipwrecked from Utopia, rescued from a

world of imperial injustice and atomic madness, the Foundation for the New Latin American Cinema decided to create the International School of Cinema and Television in San Antonio de Los Baños, Cuba, Nicknamed the School of Three Worlds (Latin America and the Caribbean, Africa and Asia).

The result of needs, experiences and reflections, of criticism and self-criticism over the thirty years of the New Latin American Cinema, this school, before its birth, was located in an itinerant envelope: more precisely, this envelope contained three figures, a red circle, a blue square and a yellow triangle, which today, superimposed upon each other, form the logo of this atypical school.

An atypical school because, as we may perceive in the synthesis of this logo and despite its name, this School is not a scholastic but an anti-scholastic institution, a center that generates creative energy for audiovisual images. (A factory of the eye and the ear, a laboratory of the eye and the ear, an amusement park for the eye and the ear.)

But the concept of the anti-scholasticity of the School must be understood by placing on the other dish of the balance the concept of a "typical" industry, for which it trains its graduates, one of the basic objectives of the School. (Beginning with hands-on training at the ICAIC and the ICHRT—the Cuban Institute of Film Art and Industry and the Cuban Institute for Radio and Television, respectively.)

Audiovisual images, we said. But the word *audiovisual*, no matter how it is said, at the end of this millennium, sounds to me a bit outmoded (we know of persons who can perceive the color of an object by merely touching it, and that flies see landscapes of infrared waves, and that there are sleepwalkers—and gadgets—that can hear plants talking among themselves.) That's why I would rather use the terminology of a "production center for visions and auditions." But, in order to make myself understood in some way, let us say that the School aspires to become a *center of production of the global audiovisual image: Cinema and Television.*

Since this school was basically born of a film movement, these film makers—or rather we film makers—should conscientiously so sway with wildly-disseminated prejudice—or the remnants of this prejudice—about the superiority of cinema over television. An elitist, backward prejudice, which can easily degenerate into a reaction, that makes filmmakers behave today vis-à-vis television, much like certain theatrical step-brothers behaved in the past towards cinema, even denying it a place, the last, the seventh place, in the revolutionary orbits of the heaven of the arts. If there is an audiovisual image par excellence that can express magic and science in a contemporary world, if there is an image that can synthesize the historical evolution of our old dream of a democratic audiovisual image—as a result of its simultaneity with the historical event, its geographic ubiquity, its relatively lower production and consumption costs—that democratic audiovisual image par excellence comes from video and television. If this does not occur in daily practice, but just the opposite, [then] it is indeed, partly our responsibility, not only from a professional or technical viewpoint, but also politically speaking.

In this School, where we all come to teach and to learn at the same time, the undersigned, who has been appointed the director of the school, will also be the first students to major in television. Cinema and television, we said: the training of "filmocrafters" and "telecrafters," or more appropriately, with the invention of the new and ideal term, designed to rectify the division that exists in practice: the training of " filmo-telecrafters."

Hence, the use of celluloid and magnetic tape as the material support for our creative processes; the use of film language and electronic codes, analyzed and implemented in accordance with their specific characteristics and their symbiosis "a synthesis, and not—as occurs in the majority of today's examples—cinema-television syncretism": For cinema, specifically, the use of 35-mm and 16-mm film, and, to a lesser extent, Super-8mm film: for television and video, specifically, electronic brushes of different calibers—and for both, the use of color and black-and-white.

For both, training in the field of fiction (contemporary, historical and futuristic) and in documentary film (audiovisual journalism, newsreels, and documentary films as such).

And in all this, there must be an indissoluble blend of theory and practice in a continuum; a dialectical flux between daily life and the key to its understanding in three worlds subject to the implacable laws of underdevelopment—implacable but not fatalistic—and the tensions involved in the liberation from underdevelopment, in the search for an economic, technical scientific, and spiritual identity: in sum, a historical identity. Sometimes, the praxis which anticipates the theory that interprets it; at other times, the theory that reveals the praxis that implements it, but always in mutual verification within the New. Neither uselessly wasteful abstract realization nor miserably utilitarian empirical pragmatism.

From the standpoint of the economy of what is simply useful, what are the necessities to which this School is intended to provide an answer?

There are basically three needs that have developed from the very first years of New Latin American Cinema (even from the times when this cinema had no name): first, the initiation needs, let us say; second, the finishing needs; and, third, the upgrading needs. Three types of needs that equally respond to marked demands and to creative imperative.

The first is for those who know nothing (nothing at all about cinema and television) and want to learn everything. The answer to this need is the yellow triangle: the basic and standard courses or the "little school." We have called it so, familiarly, in order to differentiate from the complete project, the big school as a whole, global and "trismegistic."

However, when fully functioning this "little school," which will begin with 80 students in the basic and standard courses, will accommodate 240 students of both sexes from the three continents on full scholarships (out of a total 300 students including the other fields, as we will explain later on).

Each country will have a quota of 4 students. This is not on the basis of mathematical or mechanical distribution, but in consideration of the fact that as a result of the exchange

of training disciplines, these groups of four, on returning to their respective countries can form a mini-working crew.

. . .

The average age of the first group is 25; 50 percent are men and 50 percent women. Efforts were made also to try to achieve a balance between the students coming from capital cities and those coming from hinter regions in their respective countries, as well as in the cases of regional or ethnic minorities (the Cearas and the Piauis from the northeast of Brazil or the Zapotecs from Mexico, respectfully).

The African students come from Benin, Cape Verde, Guinea-Bissau, Mozambique, Burkina Faso and South Africa. The first Asian student is comrade Tran Lam from Vietnam.

. . .

Moreover, the curriculum will combine basic training emergency cinema and television (in response to certain specific needs of some of our regions most pressed by underdevelopment or by liberation struggle) with the regular training course for industrial cinema and television (in accordance with the needs of other regions with more developed cinema and television traditions).

. . .

The six-month basic course, in addition to the two pre-admittance tests and the selection of the Evaluating Commission, will serve as the final filter to gain admission to the school's standard course. Moreover, in view of what was stated in the preceding paragraph, the six-month course will also serve as a basic self-training course for emergency cinema, so that the students that are not admitted to the standard course and return to their respective countries have at least elementary cinema and television training.

FeCAViP MANIFESTO (France, 1990)

Federation of Caribbean Audiovisual Professionals

[First released at the creation of the Federation of Caribbean Audiovisual Professionals, Fort de-France, 8 June 1990. First published in English in *Black Camera* 3, no. 1 (2011): 146.]

The creation of FeCAViP in 1990 signaled the beginning of a new transnational organization addressing the needs of the Caribbean and its diaspora and the concurrent awakening to the existence of a pan-Caribbean cinema movement. This manifesto foregrounds yet again the need for international interdependency in relation to the production, distribution, and exhibition of works by filmmakers in emergent cinema cultures, filmmakers who are all too often marginalized both in the Caribbean and in venues such as international film festivals.

We, producers, filmmakers, screenwriters, technicians, and actors of the second Images Caraïbes Festival, 1990, being aware of the need to further develop the space within the Caribbean for professional workers in film and video, reflecting our special needs, and after having made a deep analysis of our reality, acknowledging the importance of film, TV, and video, decided to give ourselves the means in order to obtain the conditions necessary for the realization of the expression of the professionals working in film and video.

So together, we have to:

1. Create, produce, distribute, and broadcast the works of our young Caribbean artists.
2. Contribute to the training of our young artists and technicians.
3. Collect, record, archive, and preserve our cultural heritage.
4. Overcome the existing linguistic, legal, technical, and commercial barriers.
5. Promote Caribbean cinema, video, and TV productions.
6. Develop the exchange of information between Caribbean professionals.
7. Establish relationships between all the associations and audiovisual events of the Caribbean and its diaspora.
8. Create new contacts with countries facing similar problems (in Africa, South America, for example).

In order to achieve our goals, we have decided to create a Federation named the Federation of Caribbean Audiovisual Professionals (FeCAViP).

FINAL COMMUNIQUE OF THE FIRST FRONTLINE FILM FESTIVAL AND WORKSHOP (Zimbabwe, 1990)

SADCC (South African Development Coordination Conference)

[First released at the conclusion of the First Frontline Film Festival and Workshop, held in Harare, Zimbabwe, 15–21 July 1990.]

This manifesto foregrounds the fact that despite many previous statements, declarations, manifestos, and proclamations, the systematic marginalization of African cinemas had not abated in the eight years between Niamey and the Harare Workshop in 1990. This manifesto presses further for the development of pan-African systems of production and distribution.

The First Frontline Film Festival and Workshop held in Harare, Zimbabwe, 15–21 July 1990, under the aegis of the Ministry of Information, Posts and Telecommunications and with the unique support of the OAU, SADCC Secretariat and FEPACI, was a result of the need to identify actions in co-operation in order to reinforce solidarity and friendship among SADCC member states, particularly in the cultural field. It was also motivated by our recognition of the unique geographic and historic nature of this sub-region of the African continent.

While being held under the seemingly "optimistic" atmosphere in the region as regards the liberation of South Africa, the Workshop still regards the situation there as being far from the desired goals of the liberation of Africa.

The Festival was attended by delegates from Angola, Botswana, Lesotho, Malawi, Mozambique, Namibia, Tanzania, Swaziland, Zambia and Zimbabwe, members of the SADCC subgroup of the continent, as well as delegates from the ANC.

We also note the continued and valuable support of the Nordic Council and the Commonwealth Foundation for the development of cinema in the region.

The Festival was also attended by personalities and eminent film-makers from Africa, who brought to the Festival their rich experiences for the benefit of the development of the cinema in the region.

Representatives of progressive forces in the cinema field from Africa and Europe also participated in the Festival.

Being a follow-up of earlier fora and the Niamey and Harare Declarations discussing the film industry in Africa and the Southern African region in particular, the Workshop could not but feel disappointed by the inadequate steps taken towards solving the long-existing problems facing cinema in Africa.

Analysing the existing conditions of cinema in the region the participants note:

1. That there is yet no regional policy and strategy for the development of culture and communication. There is also the absence of viable structures and mechanisms to develop real co-operation within the region. That situation does not permit the valorisation of the cultural-historical heritage and potential existing in the region. The little co-operation that has been undertaken to date has been mainly bilateral and on an ad hoc basis.

2. That there is quite a substantial stock of film equipment in the region which is grossly underutilized due to lack of knowledge of its availability and lack of communication between the owners and prospective users.

3. That in the field of training there doesn't exist a regional policy and programmes to enable the use of the existing facilities and institutions.

4. That there is a total absence of African and even Southern African films being distributed in the region due to the inherited and yet unchanged distribution structures and the lack of promotion of the exhibition of those kinds of films.

5. That the aesthetic development of the African cinema is still very disturbing, requiring greater efforts at instilling an African identity, more so in the areas of language, censorship and the role of women in the cinema.

6. That there is yet no permanent programme for the co-production of films and videos in order to promote the culture and the potential of the region.

7. That the national television networks in the region need to re-orientate themselves and their role in the cultural development of the peoples of this region.

8. That to date national film workers' associations do not exist in most of the countries of the region to help rally film workers towards film development in their countries in the region and continent as a whole.

Therefore, we SADCC delegates to the First Frontline Film Festival and Workshop recommend that:

1. The SADCC Council of Ministers adopt a Declaration on Culture for the SADCC region, outlining and clarifying the relationship between national and regional policies, objectives and responsibilities of member states in the development of film, information, culture and the arts.

2. Regional film-makers and artists and experts from other cultural disciplines wishing to participate be included in the drafting of the proposed Declaration on Culture for the SADCC.

3. Regional film-makers and artists and experts from other cultural disciplines be charged with drafting a programme of action to implement the proposed Cultural Charter for SADCC in such a way that short-term, medium and long-term phases and projects are detailed.

4. All member states of the SADCC which have not yet done so adopt national policies on culture and information incorporating the principles of the OAU Cultural Charter for Africa.

5. All member states of the SADCC place levies on all films, film projects, videos and television programmes from outside Africa in order to create a national film fund for financing training programmes, refurbishment of non-commercial cinema halls, construction of new halls, film production and film distribution.

POCHA MANIFESTO #1 (USA, 1994)

Sandra Peña-Sarmiento

[First published in *Jump Cut* 39 (1994): 105–106.]

This manifesto focuses on Chicana/Chicano culture in the United States and examines the interstitial position filmmakers from this community hold. Peña-Sarmiento draws on her own narrative in order to call for a cinema that does not deny this "in-between" cultural space but celebrates it politically and personally.

All action is limited by, and dependent on, what it is reacting against. . . . At some point we will have to leave . . . to disengage from the dominant culture, write it off altogether as a lost cause, and cross the border to a wholly new and separate territory. . . . The possibilities are numerous once we decide to act and not [simply] react . . .

—GLORIA ANZALDUA

Throughout my life, I've constantly moved between cultures. My father is Mexican-American, my mother Bolivian, and I myself have been born and raised in suburban Southern California. In living a kind of "cultural nomadism" (drifting in and out of "heritages") I grew frustrated with definitions in general—especially those imposed upon me by outside "authorities." This wasn't a simple reaction to the vocabulary of classification, as much as it was a reaction against the resonances (the categories, boundaries and representations *created* by their use) these words carry.

Traditionally it has been the ethnic or third world "other" that has played the role of passive recipient in this word-symbol-power game. For the Latino, this distortion (the representation as greaser, primitive, superstitious, lazy, violent, deceitful, etc.) has resulted not only in anti-immigrant violence and legislation (such as the mass deportations of Mexicans during the depression) but in cultural oppression at the ideological level by forcing many to define themselves as Mexican-American *in relation to* an Anglo-American norm.

The power of "Sight" here cannot be dismissed. To see an image of ourselves or another, as represented in (or conspicuously excluded from) the U.S. Iconography, is to believe the situation exists as it's presented. "Seeing is believing"—and rarely, if ever, do we question sight. We begin to think that "Sancho" and "Maria" do exist (cheating, stealing and seducing honest southwest settlers) in a kind of mythic no man's land of time; that image becomes one that we are ever conscious of living up to even as we try to live it down.

Cultural affirmation movements offer retreat into a romanticized past (Aztlan) as an alternative to the "Anglo norm." Aztlan is groovy, but does not change the oppression women experience within Machismo and now continue to experience within the Chicano

movement. Too many women's aspirations are short-circuited by expectations of future duties as wife, mother, supporter/nurturer. The woman who gives, remains the ideal; the woman who takes is viewed as an abomination and a threat to the community. The Chicano Power movement has not changed our view of the feminine—and so, the idea of "women's fate" as non-active entity is still found at all levels of Chicanismo. For many Chicanas it is far too easy a fate to fall into under supposed pressures of "family" and "heritage."

As a young woman with aspirations for an academic career, not as someone's hip ruca with all the bullshit that role entailed, I found that a negotiated assimilation into mainstream "American" culture was my only other alternative. The problem with these choices (resistance or assimilation) is that they are both reactive and thus continue their dependence upon an ambiguous Anglo "ideal" (the iconography of a 1950s Coke ad).

It wasn't until the advent of "post-modern-post-feminist-post-colonialist" authors such as Gloria Anzaldua, Teshome Gabriel, Trinh Minh-ha, Edward Said and others, that this dilemma—of how and where to place oneself within a world of definitions and categories we ourselves did not create—was finally addressed in print. A redefinition and reclamation of "gender and ethnicity" began taking place. Meanwhile in the arts, poets and painters (Maricela Norte, ASCO, Gomez-Peña . . .) were challenging the validity of a singular Chicano identity and/or experience.

I stumbled upon these literary and artistic movements quite by accident during my early college years and was excited to find people more "established" than I could ever hope to be, venting similar frustrations as mine in such an eloquent and direct manner. Already involved in cinema, I began to seek out the "cultural nomads" within the medium.

The most dynamic area was in Ethnographic Film, the least in U.S. narrative cinema. Wayne Wang (CHAN IS MISSING), Kidlat Tahirnik (THE PERFUMED NIGHTMARE) and Trinh Minh-ha (in questioning "sacred cow" aspects of race relations, ethnic identity, etc.) were initiating discourse—not simply presenting *their* versions of an alternate singular perspective. I wanted to find a similar discourse in Narrative Cinema but found that even in independent films there was a formula "fish out of water" dynamic. The Chicano fish as caught by the Anglo hand flops though the story of his trying to get back to the sea—or settles for a fishbowl of pseudo-Mexican water. Where, I wondered, is a story of how it is living always *between* borders—a Chicano fish that even when he is in the water is out of the water. Outside of Cheech Marin's BORN IN EAST L.A., I found no such questioning of "The Chicano Experience."

After many lean years Chicano films seem to be "suddenly" hitting the market. They follow similar plots, holding up a street-hip male ideal as the new stereotype (LA BAMBA, STAND AND DELIVER, AMERICAN ME). The importance of these films cannot be overlooked: for the first time "mainstream" Hollywood cinema is being acted, written, directed and produced by Latinos. Now that Chicano cinema is beginning to take off, it is important that future representations of the Chicano are not distorted by a singular mythology—there is need for a multiplicity in perspective (as well as a questioning of all perspectives). A Pocha/Pocho "Intro-to-Cultural-Chaos" is needed.

There is no *one* Chicano experience. And I am concerned that this aspect of our diversity is being overlooked. As a Latina, I find the representation of women in Chicano Cinema as victim, virgin, whore, etc., disheartening. It is the father who speaks for the mother, the husband for the wife, the brother for the sister. In cinema, the Chicana takes her place as a silent and passive victim whose fate is dependent upon the men around her. This representation affects tangible social conditions and issues of identity for the Latina in her community. In the same way Mexican-Americans suffered from a cultural bias which was largely propagated by the media, Chicanas continue to suffer from a gender bias found within both the Anglo media and the conventions of their own culture. Now that times are changing for the Latino, they must *also* change for the Latina.

This is a rally call to Pocha Filmmakers! We cannot turn away from our community—nor can we embrace it. We must carve our own non-space to be or not; taking with us our more useful cultural remnants and moving on to create new ones. We must wipe words like "sacred" and "martyr" from our minds, building as we tear down—recreating, reclaiming, renouncing the past, present and future. As filmmakers, our greatest tool and weapon is the visual image. Our work is not so much a writing of ourselves back into history (who reads today anyway?!), but a re-deconstruction of iconography. Through image(s) we will create a base on which to form the beginnings of a new consciousness.

Narrative cinema can reach and "re-educate" a large audience. We are not all(ways) "gang members," maids, gardeners, "American," straight, "Mexican," etc. To prove it we must SHOW it. This goes for all Latino film and video makers; the focus must be in seeing and being seen—in *our* sight—because ultimately, after the story, after the arguments, what's left is an Image . . . an Icon . . . of a chameleon Pocha/Pocho in limbo land.

POOR CINEMA MANIFESTO
(Cuba, 2004)

Humberto Solás

[First released at the First Poor Cinema Film Festival, Gibara, Cuba, 2004. Trans. Fabiola Caraza].

Founded by filmmaker Humberto Solás (1941–2008), the Cine pobre festival championed films made for less than $300,000. The Cine pobre manifesto provides a link back to the radical Latin American models of filmmaking that emerged in the 1960s and to the kind of "Poor Cinema" argued for by Colin McArthur in regard to Scotland (see McArthur, "In Praise of a Poor Cinema," in chap. 2 of this volume). This manifesto also proclaims the intrinsic value of the changes in production and access brought on by the advent of digital technology.

Let's clear up the misunderstandings: "Cinema of the Poor" does not mean cinema which lacks ideas or artistic quality, it means a cinema with a tight budget which is produced in outsider or less developed countries as well as in the bosom of the culturally and economic guiding societies, whether it be within official production programs or may it be independent or alternative cinema.

POOR CINEMA MANIFESTO

The increasing movement towards globalization accentuates the divide between rich and poor cinema. Therefore there is a danger of establishing a single-minded model, sacrificing diversity and legitimacy of the rest of the national and cultural identities.

Today is the technological revolution in cinema; it is the bearer of effective mediums of resistance to this depersonalizing project. When new technological possibilities progressively consolidate, as it is the case with digital video and its larger format 35mm, they notably reduce the economic demands of film production.

When shaking the balance of the elitist character, which has been unabashedly linked to the industry, the consequences are a gradual democratization of the film profession.

To support and take advantage of this reduction in production costs would mean the introduction in an immediate future of social groups and communities that never before have had access to produce film, and at the same time give durability to the budding national cinema.

This will be a bastion to escape the feeling of helplessness before the globalizing vandalism and allow once and for all the legitimization of versatility of styles, legacies and goals of an art form that will not be part of a patrimony of just one country or one imposing definition of the world.

In order for this to effectively happen, we will have to tear down the wall of control of film distribution by single transnational groups, which generate alienation in the audience when they don't have access to the works of their national authors.

This will allow us to fight against the spectacle of gratuitous violence in film, which cripples the audience, especially young audiences.

A gradual move towards engaging the audiences will only come to fruition if all governments put in place legal actions that support the production and distribution of their native cinema.

Only then will cinema finally be out of the Stone Age.

JOLLYWOOD MANIFESTO (Haiti, 2008)

Ciné Institute

[Distributed to students at the Ciné Institute, Jacmel, Haiti.]

David Belle, an American filmmaker, founded the Ciné Institute in Jacmel, Haiti, in 2008. The Institute trains young Haitians in filmmaking and offers screenings of Haitian and international cinema. The "Jollywood Manifesto"—a play on Bollywood and Nollywood, two of the largest film production centers in the world—encourages filmmakers to produce work that addresses Haitian life and foregrounds the need for collective, inclusive, DIY film production.

1. We create simple local stories set in everyday life.

2. We tell our stories with images. We do NOT heavily rely on dialogue.

3. We recognize and use local resources.

4. We use non professional actors. We cast our friends, family, neighbors and associates.

5. We use a small cast and crew.

6. We use natural light.

7. We credit every person who assists in making a film.

8. We are honest and transparent. We are respectful with our cast, crew and community.

9. We are rebranding Haiti and showing the world the richness of our country.

10. We work within a cultural context and for the good of humanity.

11. We are active, and work together to accomplish a better reality for all Haitians.

12. We are active, and we work together to accomplish a better reality for all of us.

THE TORONTO DECLARATION: NO CELEBRATION OF OCCUPATION
(Canada, 2009)

John Greyson, Naomi Klein, Udi Aloni, Elle Flanders,
Richard Fung, Kathy Wazana, Cynthia Wright, b h Yael

[First published online on 9 September 2009: torontodeclaration.blogspot.ca.]

This manifesto, protesting the Toronto International Film Festival's "City-to-City" Spotlight on Tel Aviv in light of Israel's ongoing occupation of Palestinian territories, prompted an acrimonious debate in Canada at the time. The filmmakers and writers involved in writing the manifesto—including social and political activist Naomi Klein and Canadian new Queer Cinema filmmaker John Greyson, who also pulled his film *Covered* (Canada, 2009) from the festival in protest—were accused of anti-Semitism (a perverse accusation, given that five of the signatories are Jewish and one an Israeli) and censorship. Countertexts decrying this supposed act of attempted censorship were released by David Cronenberg, Norman Jewison, and Ivan Reitman, among others.

An Open Letter to the Toronto International Film Festival:
September 2, 2009

As members of the Canadian and international film, culture and media arts communities, we are deeply disturbed by the Toronto International Film Festival's decision to host a celebratory spotlight on Tel Aviv. We protest that TIFF, whether intentionally or not, has become complicit in the Israeli propaganda machine.

In 2008, the Israeli government and Canadian partners Sidney Greenberg of Astral Media, David Asper of Canwest Global Communications and Joel Reitman of MIJO Corporation launched "Brand Israel," a million dollar media and advertising campaign aimed at changing Canadian perceptions of Israel. Brand Israel would take the focus off Israel's treatment of Palestinians and its aggressive wars, and refocus it on achievements in medicine, science and culture. An article in *Canadian Jewish News* quotes Israeli consul general Amir Gissin as saying that Toronto would be the test city for a promotion that could then be deployed around the world. According to Gissin, the culmination of the campaign would be a major Israeli presence at the 2009 Toronto International Film Festival. (Andy Levy-Alzenkopf, "Brand Israel set to launch in GTA," *Canadian Jewish News*, August 28, 2008.)

In 2009, TIFF announced that it would inaugurate its new City to City program with a focus on Tel Aviv. According to program notes by Festival co-director and City to City programmer Cameron Bailey, "The ten films in this year's City to City programme will

showcase the complex currents running through today's Tel Aviv. Celebrating its 100th birthday in 2009, Tel Aviv is a young, dynamic city that, like Toronto, celebrates its diversity."

The emphasis on "diversity" in City to City is empty given the absence of Palestinian filmmakers in the program. Furthermore, what this description does not say is that Tel Aviv is built on destroyed Palestinian villages, and that the city of Jaffa, Palestine's main cultural hub until 1948, was annexed to Tel Aviv after the mass exiling of the Palestinian population. This program ignores the suffering of thousands of former residents and descendants of the Tel Aviv/Jaffa area who currently live in refugee camps in the Occupied Territories or who have been dispersed to other countries, including Canada. Looking at modern, sophisticated Tel Aviv without also considering the city's past and the realities of Israeli occupation of the West Bank and the Gaza strip, would be like rhapsodizing about the beauty and elegant lifestyles in white-only Cape Town or Johannesburg during apartheid without acknowledging the corresponding black townships of Khayelitsha and Soweto.

We do not protest the individual Israeli filmmakers included in City to City, nor do we in any way suggest that Israeli films should be unwelcome at TIFF. However, especially in the wake of this year's brutal assault on Gaza, we object to the use of such an important international festival in staging a propaganda campaign on behalf of what South African Archbishop Desmond Tutu, former U.S. President Jimmy Carter, and UN General Assembly President Miguel d'Escoto Brockmann have all characterized as an apartheid regime.

4

GENDER, FEMINIST, QUEER, SEXUALITY, AND PORN MANIFESTOS

Manifestos played a key role in the development of feminist, queer, and sex-positive film culture, especially in the 1970s. These developments were part of a larger movement of finding new, nonpatriarchal languages to write about gender inequalities in books such as Hélène Cixous's *The Laugh of Medusa* (1975). In the late 1960s, manifestos such as Valerie Solanas's influential *SCUM Manifesto* (1967), the Redstockings Manifesto (1969/70), and Valerie Export's "Women, Art: A Manifesto" (1972) postulated radical new conceptions of the role of women in society, their marginalization under patriarchy, and means by which to break free of it. Andrea Dworkin's *Pornography: Men Possessing Women* (1979) and *Intercourse* (1987) also played a key role, especially for antiporn feminists. Queer manifestos such as Carl Wittman's *A Gay Manifesto* (1970), the ACTION NOW!/ ACT UP "Montreal Manifesto" released during the Fifth International AIDS Conference in 1989, and the Lesbian Avengers' *Out against the Right: The Dyke Manifesto* (1992–1994) emphasized the need for queer visibility and voices in the public sphere. Donna Haraway's "A Cyborg Manifesto: Science, technology, and Socialist Feminism in the Late Twentieth Century" (1991) radically reimagined deterministic and fixed conceptualizations of gender identity.

These were in no way new developments. Historical feminist manifestos targeting representational and political attitudes include Mary Wollstonecraft's *A Vindication of the Rights of Women* (1792) and the suffragette movement's "Manifesto of the Women's Freedom League," published in Britain in 1912. Valentine de Saint-Point's "The Manifesto of Futurist Women" (1912), in which the author argues for an über-woman *(sur femme)* and against the misogyny of Marinetti's manifestos, was published shortly after her common-law partner Ricciotto Canudo's early film manifesto "The Birth of the Sixth Art" (1911). In all of these cases the manifestos postulated ways not just of redefining gender and patriarchy but of reimagining the public sphere and the representational practices associated with it.

Therefore, more so than other manifestos, feminist and queer film manifestos have been greatly preoccupied with the public sphere and its transformation. This makes sense given that so much of second-wave feminism and emergent queer theory was concerned with questions of visibility and the possibility of finding a new feminist voice to combat patriarchy. Perhaps these goals have been best defined by Nancy Fraser. In her attempt to update the notion of the public sphere and infuse it with a sense of feminist principles and a *realpolitik,* Fraser outlines the criticisms that can be leveled against Jürgen Habermas's classical model of the public sphere as a piece of masculinist ideology and analyzes what would be required of a model of contemporary, late-capitalist publics. Fraser begins by pointing to some of the elisions in Habermas's work, specifically ones concerning the lack of roles for women in the public sphere, and the new hierarchy that was put into

place by urban men gathering to form a "public" that eventually gained power in Western European society. She then contends that four of the key points in Habermas's model of the public sphere are highly contentious and need to be rethought if an adequate model of the public sphere in an "actually existing democracy" is to be developed. She states that the points of contention in Habermas's model are (1) that one's societal status is "bracketed at the door"; (2) that the existence of many publics dilutes the democratic strength of one public; (3) that discourse in the public sphere should strive for the "common good" and not examine private interests; and (4) that the public sphere only functions when there is a sharp distinction between the state and civil society. In response to these positions Fraser retorts (1) that "bracketing" is not enough and that one must eliminate social inequality; (2) that a multiplicity of publics allows for a greater range of publics to engage in debate and therefore to effect the "actually existing democracy"; (3) that what is deemed "private" is often masculinist in its ideology and should be included in the public sphere for discussion; and (4) that both strong and weak publics must be allowed to coexist in the new, postbourgeois conception of the public sphere.[1]

This model of a postbourgeois feminist public sphere resonates throughout many of the feminist, queer, and sex-positive manifestos contained in this chapter. Concerned not only with representation but active participation in a newly defined public sphere, these manifestos reimagine not only the cinema but also social relations themselves.

The manifestos in this chapter raise a wide range of questions about sexuality, gender, feminism, queer cinema, and pornography. The chapter begins with "Woman's Place in Photoplay Production," a manifesto on women filmmakers by Alice Guy-Blaché from 1914. The only woman filmmaker, let alone studio owner, in the United States at the time, Blaché argues for women to make films because their "disposition" grants them greater powers of insight into staging, scenography and emotion than that of men. Yoko Ono's "On Film No. 4 (In Taking the Bottoms of 365 Saints of Our Time)," written at the time she was making *Film No. 4: Bottoms* (UK, 1967), addresses the differences between men and women in a very different manner, foregrounding the relationship between masculinity and violence. Ono goes on to argue for a less hierarchical form of filmmaking, one that moves away from the power and mystique of the director-as-*auteur*. Like many of the imaginary film scripts Ono was producing at the time—subsequently published in her book *Grapefruit*—she offers an imaginary script for a film that would include the smiles of everyone on the planet. The "Wet Dream Film Festival Manifesto," cosigned by an iconoclastic and diverse group of individuals including Germaine Greer, Al Goldstein, and Jean Shrimpton, was issued at the first Wet Dream Film Festival in Amsterdam in 1970. While the goals of the festival to produce egalitarian, erotic films from a leftist perspective were perhaps admirable (and the first of many attempts to mobilize nonsexist pornography), Greer, among others, subsequently declared the attempt a failure. Taking a different tact, the "Manifesto for a Non-Sexist Cinema" (1974), issued in Montréal by the Fédération européenne du cinéma progressiste, is a rallying cry against sexism in progressive cinema, taking many of its cues from the emerging "consciousness raising" feminist politics of the United States

and Canada. Laura Mulvey's "Visual Pleasure and Narrative Cinema," one of the most famous and influential essays published in *Screen* in the 1970s, draws its inspiration from a different kind of feminist discourse, which appropriated the psychoanalytic theory of Freud and Lacan to reimagine a feminist language of cinema. Far more a manifesto than a theoretical treatise, "Visual Pleasure and Narrative Cinema" influenced not only Mulvey's own filmmaking practice, with works like *Riddles of the Sphinx* (codirected with Peter Wollen, UK, 1977), but the whole British ciné-feminist movement, which tried to define and deploy a new, feminist language of the cinema. West Germany's "Manifesto of the Women Filmmakers" is a response or, perhaps more accurately, an addendum to another manifesto issued at the Hamburg Film Festival the same year, "Hamburg Declaration of German Filmmakers" (see chapter 2). Like many manifestos by filmmakers that have been marginalized (a reoccurring trope for women of the left), this manifesto calls for access to production and distribution of films made by German women filmmakers.

The "Post Porn Modernist Manifesto," issued by postporn feminist performance artist Annie Sprinkle and some of her colleagues, argues for an inclusive form of pornography that celebrates the bodies and pleasures involved in sexuality. This manifesto is a riposte to the strange alliance of feminists and the Evangelical right in the United States at the time, especially as this unholy coalition unleashed the Reagan-era Meese Report on pornography. If the "Post Porn Modernist Manifesto" is a defense and celebration of pornography and sexuality, then the Danish "Puzzy Power Manifesto: Thoughts on Women and Pornography," inspired by Dogme '95, outlines the rules that must be followed in order to produce feminist-friendly pornography. While Puzzy Power only made three films, two straight and one queer, the manifesto is a political attempt to square the circle between feminism, sexuality, and pornography. Similarly, Ovidie's "My Porn Manifesto," from 2002, addresses pornography from the dual position of the author's being both a feminist and an actor in porn films, challenging along the way the default assumptions of porn audiences and antiporn feminists alike.

Spanish filmmaker Icíar Bollaín's "Cinema with Tits," from 1998, is a provocation in response to the question: is there a woman's cinema? Arguing that the question itself places women at the margins, she argues vehemently that the only difference between men and women making films is their physical differences and to place all women into the category of "women filmmakers" is to limit their ability to explore all aspects of culture, politics, and society. In a similar vein American filmmaker Todd Verow argues in "No More Mr. Nice Gay" that New Queer Cinema is dead and that queer filmmakers should not be limited by branding. Arguing for contentious and challenging forms of queer filmmaking, Verow proposes that labels, no matter how helpful in marketing filmmakers' careers, limit their radical possibilities.

All of these manifestos point to the diversity of explorations of gender and sexuality in the cinema and the ways in which, even after more than one hundred years, debates around gender and sexuality of the non-straight-white-male kind are still relegated to the margins of film production.

WOMAN'S PLACE IN PHOTOPLAY PRODUCTION (USA, 1914)

Alice Guy-Blaché

[First published in *Moving Picture World*, 11 July 1914, 195.]

A filmmaking pioneer and the first female director, Alice Guy-Blaché directed films for Gaumont in France, beginning with *La Fée aux choux* (*The Cabbage Fairy*, 1896), before creating the Solax Company in the United States in 1910. She penned the following statement on the role of women in the cinema. The manifesto does play on some unfortunately sexist stereotypes about the "feminine" nature of women's emotions but nevertheless makes an early and compelling case for female directors' being naturally superior to male ones at a time when the notion of the director as the driving force behind the cinema was inchoate but undoubtedly male.

It has long been a source of wonder to me that many women have not yet seized upon the wonderful opportunities offered to them by the motion-picture art to make their way to fame and fortune as producers of photodramas. Of all the arts there is probably none of which they can make such splendid use of talents so much more natural to a woman than to a man and so necessary to its perfection.

There is no doubt in my mind that a woman's success in many lines of endeavour is still made very difficult by a strong prejudice against one of her sex doing work that has been done only by men for hundreds of years. Of course this prejudice is fast disappearing, and there are many vocations in which it has not been present for a long time. In the arts of acting, music, painting, and literature, woman has long held her place among the most successful workers, and when it is considered how vitally all of these arts enter into the production of motion pictures, one wonders why the names of scores of women are not found among the successful creators of photodrama offerings.

Not only is a woman as well fitted to stage a photodrama as a man, but in many ways she has the distinct advantage over him because of her very nature and because much of the knowledge called for in the telling of a story and the creation of a stage setting is absolutely with her province as a member of the gentler sex. She is an authority on the emotions. For centuries she has given them full play while man has carefully trained himself to control them. She has developed her finer feelings for generations, while being protected from the world by her male companions, and she is naturally religious. In

matters of the heart her superiority is acknowledged, and her deep insight and sensitiveness in the affairs of Cupid give her a wonderful advantage in developing the thread of love that plays such an all-important part in almost every story that is prepared for the screen. All of the distinctive qualities that she possesses come into direct play during the guiding of the actors in making their character drawings and interpreting the different emotions called for by the story. For to think and feel the situation demanded by the play is the secret of successful acting, and sensitiveness to those thoughts and feelings is absolutely essential to the success of the stage director.

The qualities of patience and gentleness possessed to such a high degree by womankind are of inestimable value in the staging of a photodrama. Artistic temperament is a thing to be reckoned with while directing an actor, in spite of the treatment of the subject in the comic papers, and a gentle, soft-voiced director is much more conducive to good work on the part of the performer than the overstern, noisy tyrant of the studio.

Not a small part of the motion-picture director's work, in addition to the preparation of the story for picture-telling and the casting and directing of actors, is the choice of suitable locations for the staging of the exterior scenes and the supervising of the studio settings, props, costumes, etc. In these matters it seems to me that a woman is especially well qualified to obtain the very best results, for she is dealing with subjects that are almost a second nature to her. She takes the measure of every person, every costume, every house, and every piece of furniture that her eye comes into contact with, and the beauty of a stretch of landscape or a single flower impresses her immediately. All of these things are of the greatest value to the creator of a photodrama, and the knowledge of them must be extensive and exact. A woman's magic touch is immediately recognised in a real home. Is it not just as recognisable in the home of the characters of a photoplay?

That women make the theatre possible from the box-office standpoint is an acknowledged fact. Theatre managers know that their appeal must be to the woman if they would succeed, and all of their efforts are naturally in that direction. This being the case, what a rare opportunity is offered to women to use that inborn knowledge of just what does appeal to them to produce photodramas that will contain that inexplicable something which is necessary to the success of every stage or screen production.

There is nothing connected to the staging of a motion picture that a woman cannot do as easily as a man, and there is no reason why she cannot completely master every technicality of the art. The technique of the drama has been mastered by so many women that it is considered as much her field as a man's and its adaptation to picture work in no way removes it from her sphere. The technique of motion-picture photography, like the technique of the drama, is fitted to a woman's activities.

It is hard for me to imagine how I could have obtained my knowledge of photography, for instance, without the months of study spent in the laboratory of the Gaumont Company in Paris at a time when motion-picture photography was in the experimental stage, and carefully continued since [in] my own laboratory in the Solax Studios in this country. It is also necessary to study stage direction by actual participation in the work, in addition

to burning the midnight oil in your library, but both are as suitable, as fascinating, and as remunerative to a woman as to a man.

HANDS OFF LOVE (France, 1927)

Maxime Alexandre, Louis Aragon, Jean Arp, Jacques Baron, Jacques-André Boiffard, André Breton, Jean Carrive, Robert Desnos, Marcel Duhamel, Paul Eluard, Max Ernst, Jean Genbach, Camille Goemans, Paul Hooreman, Eugène Jolas, Michel Leiris, Georges Limbour, Georges Malkine, André Masson, Max Morise, Pierre Naville, Marcel Noll, Paul Nougé, Elliot Paul, Benjamin Péret, Jacques Prévert, Raymond Queneau, Man Ray, Georges Sadoul, Yves Tanguy, Roland Tual, and Pierre Unik

[First published in English in *transition* 6 (Sept. 1927): 155–165. First published in French in *La révolution surréaliste* 9–10 (Oct. 1927).]

Emancipation comes in a wide variety of forms. Here, key surrealists rally to the defense of Charlie Chaplin after the publication of Lita Grey Chaplin's divorce filing of 10 January 1927 as a paperback book entitled *The Complaint of Lita*. The surrealists took the complaint against Chaplin—one of their idols—as an indication of the Puritanism and hypocrisy of the United States and, in their view, of the repugnant valorization of marriage and procreation in bourgeois culture, while concomitantly indicting the opportunism of Grey.

All that can be invoked, that is of true value and force in the world, that is before all else to be defended, all that can place a man no matter what his standing in the discretion of judge let it for an instant be recalled the full meaning of the word judge, how at any moment by some accident your life may be at his mercy, whose decision can have the upper hand of anything, as for instance genius on all this is suddenly projected the startling light of a recent case. Both the nature of the defendant and of the charges against him make it worth while to examine Mrs. Chaplin's suit against her husband (as reported in *The Grand Guignol*). It should be understood that what follows here is based on the belief that the document is an authentic report, and though of course it is Charlie Chaplin's right to deny any of the alleged facts and remarks imputed to him we have here taken the truth of them for granted. What has to be examined is the set of arguments and contentions used against him. These charges are typically characteristic of the average moral

standard of a 1927 America, that is to say those of one of the vastest populated areas, whose opinions tend to spread and impose themselves in other lands, because the States of Northern America are as immense a reservoir of stupidity as of merchandise ever ready to over-flow and particularly to cretinise the amorphous customers of Europe, from all time at the mercy of the highest bidder.

It is monstrous to think that professional secrecy is a rule in the doctor's code—a secrecy which when considered is found to be grounded on the sparing of shame, and which in itself once challenged by the law is no safeguard against the law's condemnation—and to remember that no such code exists for the married woman. But the state of the married woman is a profession like any other from the day that she claims her rights to support, her domestic and sexual pittance. Man, bound by law to live with one woman only has no other alternative than to make her share all his ways, thereby placing himself at her mercy. If therefore she delivers him over to the public spite why is the same law that invests the wife with the most arbitrary rights incapable of being turned against her with all the severity deserved by such breach of faith and libellous intent obviously motivated by the most sordid of interests? And in any case is it not an absurdity that personal habits should be a matter for legislation? But to restrict ourselves to the very episodic scruples of the *virtuous* and *inexperienced* Mrs. Chaplin it is comic to find that by her the practice of fellatio is considered: *abnormal, against nature, perverted, degenerate,* and *indecent.* (*"But all married people do this"* justly replies Chaplin). If a free and truthful discussion of sexual habits were possible it would appear normal, natural, healthy and decent for a judgement to quash the charges brought by a wife thus shown to have *inhumanly* refused herself to such a general, pure and defendable practice. And how then is it permissible to drag in the question of love as does this young person who gave herself willingly in marriage at the age of 16 years and 2 months to a rich man, a man never out of the public eye, on the score of two babies—unless they were found under a gooseberry bush—if as the aforesaid charges imply, defendant did not have *the usual marital relations* with his wife, and that are now brandished by her as the despicable convictive evidence of her own physical exactions? The italics are not ours and the revolting language they emphasize is that of plaintiff and her lawyers, whose main line seems to be to confute a very authentic person with all the jargon of picture magazines representing the young mother who calls her legitimate lover "Dad"; and that with the sole aim of levying on him a tax such as not even the most exigent state could dream of, a tax out of all other considerations imposed first on his genius, aimed at the suppression of his genius, or at the very least at the total discredit of its expression.

The five principal charges brought by Mrs. Chaplin read as follows: 1. This lady was seduced. 2. The seducer advised her to have herself aborted. 3. He agreed to the marriage only when obliged and forced, and with the intention of divorcing. 4. For this reason following a preconceived plan he behaved to her injuriously and cruelly. 5. The proof of these accusations is shown by the immorality of Chaplin's habitual speech and actions, and by his theories concerning all things regarded as most sacred.

The *crime* of seduction is usually a hard one to define, the *criminal* part of it constituting merely the circumstantial side of the seduction. This offence, in which the consent of both parties is involved but the responsibility of one only, is further complicated by the fact that nothing can humanly prove the *victim's* share of initiative or provocation. But in this case the innocent one landed on her feet, and if the seducer did not intend to make an honest (and rich) woman of her, the fact remains that it was the victim with all her naiveté who outdid the seducer's wiles. One wonders at so much perseverance and determination in so young and defenseless a person. That is, unless it appeared to her that the only way of becoming Mrs. Chaplin was by first sleeping with him, after which . . . but then seduction is out of the question; this was business with all its consequences, the possibility of desertion, pregnancy.

At this point, on being pressed to go through with an operation that she qualifies as criminal, the victim already with child at the time of marriage refuses for reasons that are worthy of examination. She complains that her condition may become known, that her fiancé has done everything in his power to make it so. An obvious contradiction: for who would profit by this publicity, who refuses to take the sole means of averting what in California constitutes a scandal? But once married the victim is fully armed; she can spread and publish the fact that an abortive operation was demanded of her. This is a decisive argument, and not the very least of the criminal's remarks concerning this matter which is *a great crime against society both legally and morally and thereby repugnant, horrifying, contrary to the instincts of motherhood and to her sense of the maternal duty of protection and preservation* will be allowed to go unnoted. Everything is henceforth set down, the intimate daily phrases, the circumstances, now and again the date. From the first time that it occurred to the future Mrs. Chaplin to make use of her *instincts,* to pose as a monument of normality (though as yet legally married she repeats and underlines that she loves her fiancé despite his horrifying suggestions) to the moment that once married she becomes a sort of secret spy in the home, we see that she has worked up a veritable martyr's diary, not a tear has been left out. Can the third charge that she brings against her husband be taken to apply first and foremost to herself? Did she *enter into marriage* with the definite intention of issuing therefrom rich and respected? As to the fourth charge, that of the cruel treatment undergone by her during marriage, once examined in detail it becomes necessary to decide whether this is a distinct attempt on Chaplin's part towards the demoralisation of his wife or whether it is the logical result of the daily attitude of a wife bent on amassing grievances, evoking them and taking pride therein. Incidentally let us note a gap in the evidence: Mrs. Chaplin omits to give us the date at which she ceased to *love* her husband. But maybe she loves him still.

To back up her allegations she brings forward (as so many moral proofs of the existence of a premeditated plan that becomes visible in the rest of the evidence) certain remarks of Chaplin's, after which an honest American judge cannot do otherwise than regard the defendant as a cad and a scoundrel. The perfidy of this manoeuvre and its efficacy will be clear to all. Here we have the ideas of Charlot, as we call him in France, his private opinions on

the most burning of questions suddenly thrust before us and in such a direct manner that they cannot fail to throw a singular light on the morality of those films from which we have derived more than mere pleasure, that is to say an almost unequalled critical interest. An unfavourable report, most particularly in that narrow zone of observation to which the American public confines its favourites (and the example of Fatty Arbuckle stands forth) can ruin a man in the space of a day. This is the card played by this model wife. It turns out that her revelations have an importance by her quite unsuspected. She imagined, the fool, the jade, that she was denouncing her husband; but instead she furnishes us simply with the human greatness of a mind who with extreme clarity and justice thought so much that is absolutely condemned in that particular society where everything, his life, his genius even confines him, who found the means of giving the perfect and living expression to his thought without ever betraying its standards, an expression whose humour and force, whose poetry in short, is suddenly thrown into full perspective by the light of [a] certain homely lantern held aloft by one of those bitches that in all countries constitute the *good* mothers, the *good* sisters, the *good* wives, those pests and parasites of all kinds of love and true emotions.

"*Given that during cohabitation of plaintiff and defendant, defendant declared to plaintiff on diverse occasions too numerous to be specified in detail that he was not a partisan of the habit of marriage, that he would be unable to tolerate the conventional restraint imposed by marital relations, and that he was of opinion that a woman could honestly and without disgrace bear children to a man when living with him out of wedlock; given that he also ridiculed and mocked plaintiff's belief in the moral and social conventions pertaining to the state of marriage, the relation of the sexes and the bringing into the world of children, and that he was unconcerned by the laws and statutes of morality, (regarding which he remarked one day to plaintiff that "a certain couple had had five children without being married," adding that this was "an ideal way for a man and a woman to live together")*—this brings us to the essential point of Charlot's vaunted *immorality*. It is to be noted that certain very simple truths still pass as monstrosities, and it is to be hoped that one day they will be recognised as mere human common-sense, the nature of which in this case appears startling by reason of the nature of the accused himself. For everyone that is neither coward nor hypocrite is bound to think thus. And besides, by what argument can the sanctity of a marriage be claimed that was contracted under threat, even if the woman has borne her husband a child? Let her come and complain that her husband used to go straight to his own room, that once, to her horror, he came in drunk, that he did not dine with her, that he did not take her out in society—such arguments are not worth more than a shrug of the shoulders.

But it would seem however that Chaplin did in all good faith try to make their conjugal life possible. But no such luck. He came up against a wall of silliness and stupidity. Everything appears criminal to this woman who believes or pretends to believe that her sole reason of existence is the procreation of brats—of brats that will beget future brats. A noble idea of life! "*What do you want to do—repopulate Los Angeles?*" asks Chaplin outraged. Yet as exacted by her she shall have a second child, only now she must leave him alone, he no more desired paternity to be forced on him than he desired marriage. However, to please Ma he would

have to play the fool with the infants. That is not his style. He is to be found less and less *in the home*. He has his own conception of life; it is being threatened, it is being attacked. And what could bind him to a woman who refuses herself to all he likes, and who accuses him of "*undermining and denaturing* (her) *normal impulses*" . . . of "*demoralising her ideas of the rules of decency*," of "*degrading her conception of morality*," and all because he has tried to make her read certain books in which sexual matters are clearly treated, because he desired her to meet certain people whose way of living had a little of that freedom to which she shows herself such an inveterate enemy. And again, four months before their separation he makes an effort: he suggests their inviting a young girl (who later is said to have the reputation of "*giving herself up to acts of sexual perversion*") and he says to plaintiff that they "*might have a little fun*." This is the last attempt at transforming the domestic hatching-machine into a rational being capable of conjugal affection. Books, the example of others, he has recourse to everything to try and make this blockhead perceive all she is incapable of understanding for herself. But at the end of all this she is amazed at the inequalities of temper in the man to whom she leads such a hell of a life. "*Just you wait, if I go mad one day suddenly I shall kill you*"; and naturally this threat is saved up by her for the list of charges, but on whom does the responsibility of it rest? For a man to become aware of such a possibility, i. e. insanity, murder, seems surely to indicate that he has been subjected to a treatment capable of driving him to insanity and murder? And during these months while the wickedness of a woman and the danger of public opinion have forced on him an insufferable farce he remains none the less in his cage, a living man whose heart has not died.

"*Yes, its true*," he said one day, "*I am in love with someone and I dont care who knows it; I shall go to see her when I please and whether you like it or no; I dont love you and I live with you only because I was forced to marry you*." This is the moral foundation of this man's life, and what it defends is—Love. And in all this matter it so happens that Charlot is simply and solely the defender of love. He says to his wife that the woman he loves is "*wonderful*," that he would be glad for her to know her, etc. This frankness, this honesty, all that in the world is most admirable is now used against him. But the chief argument is a pair of children born against his will.

Here again Chaplin's attitude is very clear. Both times he entreated his wife to have herself aborted. He revealed the truth to her; that this can be and is done, that other women do it, have done it—*for me. For me* signifies not from social concern nor from conveniency, but *for love*. It was useless to call on love with Mrs. Chaplin. Her children were born to her only that she might proclaim that "*the defendant never showed any normal or paternal interest or affection*" (let us here underline this pretty distinction between words) "*for the two children in their minority of plaintiff and defendant*." These infants ! that are doubtless to him just one more link in his bondage, though to the mother the basis of perpetual claims. It is her wish to have a wing built onto the house for them. Charlot refuses: "It is my house, and I dont want it spoilt." This eminently reasonable answer, the milk-bills, the telephone-calls sent and those that weren't the husband's comings and goings, the times he doesn't see his wife, the times he does come to see her at the moment she is entertaining bores,

which may displease him, if he has friends to dinner, if he takes out his wife, if he leaves her at home, all this to Mrs. Chaplin constitutes a cruel and inhuman treatment—but to us it signifies paramountly the will of a man to outplay all that is not love, all that is merely its fierce and hideous caricature. Better than could any book or treatise does this man's conduct make out the case against marriage, against the insensate codification of love.

We recall that admirable moment in *The Imposter* when suddenly in the middle of a social ceremony Charlot sees a very beautiful woman go by, she could not be more alluring, and immediately he abandons his adventure (the role he is playing) to follow her from room to room and out onto the terrace until finally she disappears. At the command of love, he has always been at the command of love, and this is what is very consistently demonstrated by his life and by all his films. Love sudden and immediate, before all else the great, irresistible summons. At such a time everything else is to be abandoned, as for instance, at the minimum, the home. The world and its legal bondages, the housewife with her brats backed up by the figure of the constable, the savings-bank—from these indeed is the rich man of Los Angeles forever running away, as is that other poor devil, the Charlot of miserable suburbs in *The Bank-Clerk* and *The Gold-Rush*. All the fortune morally in his pocket is precisely that one dollar's worth of seduction that is perpetually getting lost, the dollar that one sees eternally falling onto the tiles through his torn trouser-pocket in the cafe scene of *The Emigrant*, a dollar perhaps only in appearance, that can be bent between the teeth, a mere sham that won't be accepted, but that enables you for one brief instant to invite to your table that woman who is like a flash of fire, the *"wonderful"* one, whose face from now on eclipses the sky for you. In this way Chaplin's art finds in his actual life that morality that was ever being expressed in his work with all the circuitousness imposed by social conditions. And finally when Mrs. Chaplin informs us—and she knows the most telling kind of argument—that that unpatriotic American, her husband, intended to export his capital, let us remember the tragic spectacle of the steerage passengers labeled like cattle on the deck of the ship that is going to land Charlot in America; the brutalities of the law's representatives, the cynical examination of the emigrants, the dirty hands fumbling the women on arrival in this land of prohibition, under the classic stare of *Liberty lighting the world*. What the lantern of this particular liberty projects through all his films is the threatening shadow of the cops who run down the poor, the cops popping up at every street corner full of suspicions, beginning with the vagabond's wretched suit, then the stick (that in a curious article Charlot has named his "assurance"), the stick that is always falling, and the hat, the moustache, and so on down to the frightened smile. Let us make no mistake, despite some happy ending the very next time we shall find him again in misery this terrifying pessimist who brings out anew all the meaning of that expression equally current in English and French—a dog's life, "une vie de chien."

A Dog's Life. That is at the very moment the life of a man whose genius won't win him his case; of one on whom everyone's back will be turned, who will be ruined with impunity, from whom all of his means of expression will be taken, who is being demoralised in the most outrageous fashion, for the benefit of a miserable, spiteful little bourgeoisie, and for the sake of the grandest public hypocrisy possible to imagine. A dog's

life. Genius is nothing to the law when matrimony is at stake, the blessed state of matrimony. And anyway as we know, genius is never anything to the law, never.

But this case of Charlot's—above and beyond the public's curiosity and all the underhanded business of the men of law mixed up in the shameless probings into a private life henceforth always tarnished by the law's sinister light—this case of Charlot's today signifies his fate, the fate of genius. It is far more significant than any work on the subject, and establishes the true role and the real worth of genius. That mysterious ascendant that an unequalled power of expression suddenly confers, we understand suddenly its meaning. We understand now just exactly what place in the world is that of genius. Genius takes hold of a man and makes of him an intelligible symbol, and the prey of sombre beasts. Genius serves to point out to the world the moral truth that universal stupidity obscures and endeavours to destroy. Our thanks then to the one who, over there on the immense occidental screen, beyond the horizon where the suns one by one decline, causes to pass your shadows, o great realities of mankind, sole realities perhaps, moral truths whose worth is greater than that of the whole universe. The earth sinks beneath your feet. Our thanks to you above and beyond the victim. Our thanks to you, we are your humble servants.

THE PERFECT FILMIC APPOSITENESS OF MARIA MONTEZ (USA, 1962)

Jack Smith

[First published in *Film Culture* 27 (1962): 28–36.]

In this early and influential queer cinema manifesto, Jack Smith sings the tributes of B-picture, "Queen of Technicolor" star Maria Montez, perhaps best known today for her role in Robert Siodmak's *The Cobra Woman* (USA, 1944). Renowned for the seminal New York underground films *Flaming Creatures* (USA, 1962)—which is in many ways a tribute to the films of Montez—and *Normal Love* (USA, 1963), in this manifesto Smith celebrates the camp aesthetic of Montez's films and acting. In the process he imagines a new queer cinema.

In Paris I can do no wrong, they love me there.

—MARIA MONTEZ

A few years later:

Elle ne désert pas le nom d'actrice.

—A Paris paper reviewing a film she made there

At least in America Maria Montez could believe she was the Cobra woman, the Siren of Atlantis, Scheherazade, etc. She believed and thereby made the people who went to her movies believe. Those who could believe, did. Those who saw the World's Worst Actress just couldn't and they missed the magic. Too bad—their loss. Their magic comes from the most inevitable execution of the conventional pattern of acting. What they can appreciate is what most people agree upon—GOOD PERFS. Therefore you can have GOOD PERFS & no real belief. GOOD PERFS that give you no magic—oh I guess a sort of magic, a magic of sustained efficient operation (like the wonder that the car motor held out so well after a long trip).

But I tell you Maria Montez Moldy Movie Queen, Shoulder pad, gold platform wedgie Siren, Determined, dreambound, Spanish, Irish, Negro?, Indian girl who went to Hollywood from the Dominican Rep. Wretch actress—pathetic as actress, why insist upon her being an actress—why limit her? Don't slander her beautiful womanliness that took joy in her own beauty and all beauty—or whatever in her that turned plaster cornball sets to beauty. Her eye saw not just beauty but incredible, delirious, drug-like hallucinatory beauty.

The vast machinery of a movie company worked overtime to make her vision into sets. They achieved only inept approximations. But one of her atrocious acting sighs suffused a thousand tons of dead plaster with imaginative life and a truth.

Woman and yet imaginator/believer/child/simple pathetically believing with no defenses—a beautiful woman who could fantasy—do you know of a woman like that? There aren't any. Never before, never since—this was an extraordinary unique person. Women—people—don't come in combinations that can/can't happen again:

fantasy—beauty

child—siren

creature—straight etc because each is all these plus its opposite—and to dig one woman is to mysteriously evoke all others and not from watching actresses give PERFS does one feel anything real about woman, about films, about the world, various as it is for all of us, about men. But to see one person—OK if only by some weird accident—exposing herself—having fun, believing in moldiness (still moldy, but if it can be true for her and produces delight—the delight of technicolor movies—then it would be wonderful if it could be true for us).

And in a crazy way it is all true for us because she is one of us. Is it invalid of her to be the way she is? If so, none of us are valid—a position each one of us feels a violation of oneself if taken by another person (whatever our private thots may be). If you think you are invalid you may be the person who ridicules Montez movies. To admit of Maria Montez validities would be to turn on to moldiness, Glamourous Rapture, schizophrenic delight, hopeless naivete, and glittering technicolored trash!

Geef me that Coparah chewel!
Geef me that Coparah chewel!

> —line of dialogue from *Cobra Woman*, possibly the
> greatest line of dialogue in any American flic

Juvenile . . . trash . . .

> —Jesse Zunser, N.Y. reviewer

Juvenile does not equal shameful and trash is the material of creators. It exists whether one approves or not. You may not approve of the Orient but it's half of the world and it's where spaghetti came from. Trash *is* true of Maria Montez flix but so are jewels, Cobra jewels and so is wondrous refinement—

> *Night—the villain / high priest enters the bedroom of the old queen (good) and stabs her in her bed. Seen thru a carved screen in bkgrnd—at that moment—the sacred volcano erupts (orange light flashes) Old queen stares balefully (says something?) and dies. Now the cobra priestess (the evil sister) and the high priest can seize Jon Hall betrothed to / and the good sister (rightful ruler) and imprisons them with no opposition. Persecution of Cobra Island—Crushing offerings demanded for King Cobra—*

> *(Chunk of scenario synopsized)*

There is a (unsophisticated, certainly) validity there—also theatrical drama (the best kind)—also interesting symbolism, delirious hokey, glamour—unattainable (because once possessed) and juvenile at its most passionate.

If you scorn Montez-land (now gone anyway so you are safe from its contamination) you are safely out of something you were involved in once and you resent (in direct ratio to your scorn, even to rage) not being able to go back—resent the closed, rainbow colored gates, resent not being wanted there, being a drag on the industry.

Well, it's gone with the war years (when you know that your flic is going to make money you indulge in hokey—at these times when investments must be certain you must strictly follow banker-logic). Universal probably demolished the permanent Montez-land sets. Vera West committed suicide in her blackmail swimming pool. Montez dead in her bathtub from too much reducing salts. The colors are faded. Reel-Art Co. sold all her flix to T.V.

Montez-land (created of one woman's belief—not an actress') was made manifest on this earth, changed the world—15 to 20 flix they made around her—OK vehicles (the idea of vehicles shouldn't be condemned because it has been abused), vehicles that were medium for her belief therefore necessary, a justice, a need felt—Real—as investment, as lots of work for extras, hilarious to serious persons, beloved to Puerto-Ricans, magic for me, beauty for many, a camp to homos, Fauve American unconsciousness to Europeans etc.

Can't happen again. Fantasies now feature weight lifters who think now how lucky and clever they were to get into the movies & the fabulous pay . . ., think something like that on camera—it's contagious & you share those thots (which is a magical fantasy too but another article on "The Industry"). All are now safe from Maria Montez outrages! I suppose the color prints are destroyed now. Still, up until about 5 yrs ago (when they were bought up by T.V.), Montez reissues cropped up at tiny nabes—every week one or another of them played somewhere in N.Y.C. At that time they were 12 to 17 years old. When they are shown now on T.V. they are badly chopped up, with large chunks missing. The pattern being repeated—their irresistibility resulting in their being cut & stabbed & punished. All are now safe from Montez embarrassment—the tiny nabes are torn down, didn't even make supermarkets—the big nabes have to get back investments so can't be asked (who'd ask) to show them. The art houses are committed to seriousness and importance, essays on celluloid (once it was sermons on celluloid), food for thought imported from THE CONTINENT. No more scoldings from critics . . .

At this moment in movie history there is a feeling of movies being approved of. There is an enveloping cloud of critical happiness—it's OK to love movies now. General approval (nobody knowing who starts it—but it's OK for you and everybody else). It's a pretty diffuse and general thing. Maria Montez flix were particular—you went for your particular reasons, dug them for personal reasons—had specific feelings from them & about them. It was a peculiarly idiosyncratic experience and heartily despised by critics. Critics are writers. They like writing—and written characters. Maria Montez's appeal was on a purely intuitive level. She was the bane of critics—that person whose effect cannot be known by words, described in words, flaunts words (her *image* spoke). Film critics are writers and they are hostile and uneasy in the presence of a visual phenomenon. They are most delighted by bare images that through visual barrenness call thought into play to fill the visual gap. Their bare delights are "purity and evocative." A spectacular, flaming image—since it threatens their critichood need to be able to write—is bad and they attack it throwing in moral extensions and hinting at idiocy in whoever is capable of visually appreciating a visual medium. Montez-land is truly torn down and contemporary sports car Italians follow diagrams to fortunes, conquests, & murders to universal approbation.

Maria Montez was a very particular person:
Off screen she was:
A large, large boned woman
5′9″
Oily
Skin dark,
& gave impression of being dirty
Wore Shalimar perfume

It is a reminder of one's own individuality to value a particular screen personality. It is also a nuttiness (because gratuitous). But you will have nuttiness without Maria

Montez—want more—need all you can get—need what ever you don't have—& need it badly—need what you don't need—need what you hate—need what you have stood against all through the years. Having a favorite star has very human ramifications—not star-like entirely. Stars are not stars, they are people, and what they believe is written on their foreheads (a property of the camera). Having a favorite star is considered ludicrous but it is nothing but non verbal communication the darling of the very person who doesn't believe anything real can exist between a star and a real person. Being a star was an important part of the Montez style. Having Maria Montez as a favorite star has not been gratuitous (tho it was in 1945) since it has left a residue of notions, interesting to me as a film-maker and general film aesthete. No affection can remain gratuitous. Stars who believe nothing are believable in a variety of roles, not to me tho, who have abandoned myself to personal tweakiness.

Those who still underrate Maria Montez should see that the truth of Montez flix is only the truth of them as it exists for those who like them and the fact that others get anything out of them is only important because it is something they could miss and important because it is enjoyment missed. No one wants to miss an enjoyment and it is important to enjoy because it is important to think and enjoying is simply thinking—Not hedonism, not voluptuousness—simply thought. I could go on *to* justify thought but I'm sure that wouldn't be necessary to readers of magazines. There is a world in Montez movies which reacting against turns to void. I can explain their interest for me but I can't turn them into good film technique. Good film technique is a classical attribute. *Zero de Conduite*—perfect film technique, form, length, etc., a classical work—Montez flix are none of these. They are romantic expressions. They came about because (as in the case of Von Sternberg) an inflexible person committed to an obsession was given his way thru some fortuitous circumstance. Results of this sort of thing TRANSCEND FILM TECHNIQUE. Not barely—but resoundingly, meaningfully, with magnificence, with the vigor that one exposed human being always has—and with failure. We cause their downfall (after we have enjoyed them) because they embarrass us grown up as we are and post adolescent / post war / post graduate / post-toasties etc. The movies that were secret (I felt I had to sneak away to see M. M. flix) remain secret somehow and a nation forgets its pleasures, trash,

Somebody saved the Marx Bros. by finding SERIOUS MARXIAN BROTHERS ATTRIBUTES.

Film for these film romanticists (Marx Bros., Von Stroheim, Montez, Judy Canova, Ron Rice, Von Sternberg, etc.) [is] a place. Not the classically inclined conception a strip of stuff (Before a mirror is a place) is a place where it is possible to clown, to pose, to act out fantasies, to not be seen while one gives (Movie sets are sheltered, exclusive places where nobody who doesn't belong can go). Rather the lens range is the place and the film a mirror image that moves as long as the above benighted company's beliefs remained unchallenged, and as far as their own beliefs moved them.

If Maria Montez were still alive she would be defunct. She would be unable to find work (Maybe emasculated mother type parts) She'd be passé, dated, rejected. A highly charged idiosyncratic person (in films) is a rare phenomenon in time as well as quantity. Unfortunately their uniqueness puts a limitation upon itself. Uniqueness of Quantity calling into existence a uniqueness of time to limit itself. We punish such uniqueness, we turn against it—give it only about 5 years (the average life of a star). Once lost these creatures cannot be recovered tho their recovery would be agreeable. Who wouldn't welcome back Veronica Lake who is by this time a thing in the air, a joke, a tragedy, a suffering symbol of downfall, working as a barmaid at Martha Washington Hotels—shorn. We lose them—our creatures. When some rudeness / cutting off of hair out of fear of wartime machinery / makes the believer disbelieve, the believer joins us in our wanting but not being able to believe and is through, first because of the cynicism of movie fans and secondly because of the resultant breakdown of their fantasy.

Corniness is the other side of marvelousness. What person believing in a fantasy can bear to have its other side discovered. Thru accidents, rudenesses, scandals, human weaknesses have cut short those who made movie worlds (movies as place) that were too full to have room for anything but coincidences, politenesses & benightings. But denial is short lived. So will [be] our denial of our personal films. Someday we will value these personal masterpieces. We don't have to do injustice to the film of cutting, camera movement, rhythm, classical feeling, structured, thought loaded (for there's the moldidness of the foreign darling, that it disobeys its own most central rule—that technique by itself can evoke as does poetry). Yet plots that demand serious definite attention spell out the evocation for the images.

On a very obvious level too much dialogue (still a violation even if it is no longer Hollywood-moronic) on an unsuspected level—much use of story furthering (different than Hollywood) images, rich with story furthering detail (more sophisticated than Hollywood details), rich with (more tour de force than H) cutting—all these exist not to create a film for itself but exactly the same effect as Hollywood Oprobriums—a film for a plot—all these tools of film STILL force an emphasis on the story because they each are used still to force an emphasis on the story and we only have a Hollywood disguised in sandals, Rivieras, pallazzos, ascots, etc. A new set of cliches that we aren't familiar enough with yet to see as cliches. European films are not necessarily better than the most Hollywood of our flix, they are only different and that superficially—certainly not more filmic because they are every bit as / plot story word / orientated. This we will see clearly when we start to get tired of their particular set of thought & story cliches. And we must, because these are always oppressive in a film—are the oppressive parts of movies as we know them because they dissipate the film challenge—to use our eyes. To apprehend thru our eyes.

The whole gaudy array of secret-flix, any flic we enjoyed: Judy Canova flix (I don't even remember the names), *I Walked with a Zombie, White Zombie, Hollywood Hotel,* all Montez flix, most Dorothy Lamour sarong flix, a gem called *Night Monster, Cat &*

the Canary, The Pirate, Maureen O'Hara Spanish Galleon flix (all Spanish Galleon flix anyway), all Busby Berkeley flix, *Flower Thief,* all musicals that had production numbers, especially Rio de Janeiro prod. nos., all Marx Bros. flix. Each reader will add to the list.

Above kind of film is valid only when done by one who is its master—not valid in copies. Only valid when done with flair, corniness, and enjoyment. These masterpieces will be remembered because of their peculiar haunting quality—the copies will drop away from memory and the secret film will be faced. We still feel the disgust and insult of the copies and react against the whole body including the originals. The secret films were the most defenseless since they afford to ignore what bad copies caused us to come its demand in order to protect ourselves from the bad copies. And they being the pure expressions have had to take all the blame.

A bad copy film has a way of evoking a feeling of waste that is distressing. Waste of time in months, money in millions—we spent our *own* best part of a dollar—and hope for more film excitement was made guilty in lying sequels—squandered money. The guilt has come to be applied to the flix that were copied. (Who will ever admit having enjoyed a Judy Canova flic?) The flix of the 30's and 40's (even I detest flix of the 50's) are especially guilty because they haven't acquired the respectability of antiquareanism [*sic*]. Anyway the secret flic is also a guilty flic.

These were light films—if we really believed that films are visual it would be possible to believe these rather pure cinema—weak technique, true, but rich imagery. They had a stilted, phony imagery that we choose to object to, but why react against that phoniness. That phoniness could be valued as rich in interest & revealing. Why do we object to not being convinced—why can't we enjoy phoniness? Why resent the patent "phoniness" of these films—because it holds a mirror to our own, possibly.

The primitive allure of movies is a thing of light and shadows. A bad film is one which doesn't flicker and shift and move through lights and shadows, contrasts, textures by way of light. If I have these I don't mind phoniness (or the sincerity of clever actors), simple minded plots (or novelistic "good" plots), nonsense or seriousness (I don't feel nonsense in movies as a threat to my mind since I don't go to movies for the ideas that arise from sensibleness of ideas). Images evoke feelings and ideas that are suggested by feeling. Nonsense on one given night might arouse contemptuous feeling and leave me with ideas of resolution which I might extend to personal problems and thus I might be left with great sense. It's a very personal process—thoughts via images and therefore very varied. More interesting to me than discovering what is a script writer's exact meaning. Images always give rise to a complex of feelings, thots, conjectures, speculations, etc. Why then place any value on good or bad scripts—since the best of scripts detracts most from the visual import. I suspect we are less comfortable in the visual realm than in the literary. Visual truths are blunt, whereas thots can be altered to suit & protect. The eye falls into disuse as a receiver of impressions & films (images) mean nothing without word meanings.

Our great interest in films is partly the challenge it presents us to step into the visual realm. A personality type star appeals to, informs the eye. Maria Montez was remarkable for the gracefulness of her gestures and movement. This gracefulness was a real process of moviemaking. Was a real delight for the eye—was a genuine thing about that person—the acting was lousy but if something genuine got on film why carp about acting—which HAS to be phony anyway—I'd RATHER HAVE atrocious acting. Acting to Maria Montez was hoodwinking. Her real concerns (her conviction of beauty / her beauty) were the main concern—her acting had to be secondary. An applying of one's convictions to one's activity obtains a higher excellence in that activity than that attained by those in that activity who apply the rules established by previous successes by others.

The more rules broken the more enriched becomes the activity as it has had to expand to include what a human view of the activity won't allow it to not include.

What is it we want from film?

A vital experience an imagination
an emotional release
all these & what we want from life
Contact with something
we are not, know not,
think not, feel not, understand not,
therefore: An expansion.

Because Maria Montez who embodies all the above cannot be denied—was not denied—the mass of thoughts we have about film must be added to, to include her acting, since anybody's acting is only the medium of soulful exchange and is not important in itself except at the point that the acting student learns to forget its rules. In Maria Montez's case a high fulfillment was reached without ever having known the rules and those who adore rules could only feel offence, and expressed it in ridicule.

M. M. dreamed she was effective, imagined she acted, cared for nothing but her fantasy (she attracted fantasy movies to herself—that needed her—they would have been ridiculous with any other actress—any other human being). Those who credit dreams became her fans. Only [an] actress can have fans and by a dream coming true she became and actually was and is an actress.

(Go to the T. D. of the NYPL—go to the actress dept., ask for stills of "Maria Montez." Six Gigantic Volumes of delirious photos will come up on the dumb waiter.)

But in my movies I know that I prefer non actor stars to "convincing" actor-stars—only a personality that exposes itself—if through moldiness (human slips can convince me—in movies) and I was very convinced by Maria Montez in her particular case of her great beauty and integrity.

I finish this article—a friend, Davis Gurin, came to tell me "I came to tell you, tonight I saw a young man in the street with a plastic rose in his mouth declaiming—I am Maria Montez, I am M.M." A nutty manifestation, true—but in some way a true state-

ment. Some way we must come to understand that person. Not worth understanding perhaps—but understanding is a process—not the subject it chooses. But that process has a Maria Montez dept. as well as a film dept. and you bought this magazine for a dollar.

ON *FILM NO. 4* (IN TAKING THE BOTTOMS OF 365 SAINTS OF OUR TIME) (UK, 1967)

Yoko Ono

[First self-published in the pamphlet *Thirteen Film Scores by Yoko Ono '68*, in London, 1968. First published in book form in Yoko Ono, *Grapefruit* (London: Peter Owen, 1970).]

Ono's manifesto on her *Film No. 4* is also one of her many instructional, imaginary film scripts (although this particular one did get made). For instance, the film *Rape* (Yoko Ono and John Lennon, UK/Austria, 1969) differs from the conceptual script: a random woman is pursued by a cameraman through a graveyard and then through the streets of London; the film is shot as if it consists of one take, more or less. At first, the woman is coy and flirts with the camera/man. As the pursuit continues, the woman gets nervous and frustrated, taking refuge in her sister's flat. Unbeknownst to her, her sister has provided the film crew with a key to her flat, allowing the crew to unlock the door and follow her in. The woman argues with the cameraman, stands in the corner, and tries calling people on the phone for help. The film ends with the woman cowering, crying, and screaming in the corner of her sister's apartment. The film is an indictment of patriarchal scopophilia, made six years before Laura Mulvey analyzed this phenomenon in her groundbreaking manifesto "Visual Pleasure and Narrative Cinema" (reprinted later in this chapter). The description contained herein of *Smile*, another instructional film script, is also prescient, as the technology required to make the film came to fruition some thirty-five years later in the guise of the World Wide Web.

I wonder how men can get serious at all. They have this delicate long thing hanging outside their bodies, which goes up and down by its own will. First of all having it outside your body is terribly dangerous. If I were a man I would have a fantastic castration complex to the point I wouldn't be able to do a thing. Second, the inconsistency of it, like carrying a chance time alarm or something. If I were a man I would always be laughing at myself. Humour is probably something the male of the species discovered through their own anatomy. But men are so serious. Why? Why violence?

Why hatred? Why war? If people want to make war, they should make a colour war, and paint each others' city up during the night in pinks and greens. Men have such an unusual talent for making a bore out of everything they touch. Art, painting, sculpture, like who wants a cast-iron woman, for instance.

The film world is becoming terribly aristocratic, too. It's professionalism all the way down the line. In any other field: painting, music, etc., people are starting to become iconoclastic. But in the film world—that's where nobody touches it except the director. The director carries the old mystery of the artist. He is creating a universe, a mood, he is unique, etc., etc. This film proves that anybody can be a director.[2] A film-maker in San Francisco wrote to me and asked if he could make the San Francisco version of *No. 4*. That's OK with me. Somebody else wrote from New York, she wants to make a slow-motion version with her own behind. That's OK, too. I'm hoping after seeing this film people will start to make their own home movies like crazy.

In 50 years or so, which is like 10 centuries from now, people will look at the films of the 60's. They will probably comment on Ingmar Bergman as the meaningfully meaningful film-maker, Jean-Luc Godard as the meaningfully meaningless, Antonioni as meaninglessly meaningful, etc., etc. Then they would come to the *No. 4* film and see a sudden swarm of exposed bottoms, that these bottoms, in fact, belonged to people who represented the London scene. And I hope that they would see the 60's was not only the age of achievement, but of laughter. This film, in fact, is like an aimless petition signed by people with their anuses. Next time we wish to make an appeal, we should send this film as the signature list.

My ultimate goal in film-making is to make a film which includes a smiling face snap of every single human being in the world. Of course, I cannot go around the whole world and take the shots myself. I need cooperation from something like the post offices of the world. If everybody would drop a snapshot of themselves and their families to the post office of their town, or allow themselves to be photographed by the nearest photographic studio, this would soon be accomplished.[3]

Of course, this film would need constant adding of footage. Probably nobody would like to see this whole film at once, so you can keep it in a library or something, and when you want to see some particular town's people's smiling faces you can go and check that section of the film. We can also arrange it with a television network so that whenever you want to see faces of a particular location in the world, all you have to do is to press a button and there it is. This way, if Johnson wants to see what sort of people he killed in Viet Nam that day, he only has to turn the channel. Before this you were just part of a figure in the newspapers, but after this you become a smiling face. And when you are born, you will know that if you wanted to, you will have in your life time to communicate with the whole world. That is more than most of us could ask for. Very soon, the age may come where we would not need photographs to communicate, like ESP, etc. It will happen soon, but that will be "After the Film Age."

STATEMENT (USA, 1969)

Kenneth Anger

[Originally published in Tony Rayns, "Lucifer: A Kenneth Anger Kompendium," *Cinema* (UK) 4 (1969): 23.]

A brief manifesto by Kenneth Anger inspired, like so much of his work, by the writings of Aleister Crowley (1875–1947), addressing the "magickal" aspects of his cinema and the way in which film can be seen as capturing its subject for the rapture of the filmmaker.

I have always considered the movies evil; the day that cinema was invented was a black day for mankind. Centuries before photography there were talismans, which actually anticipated photographs, since the dyes they used on the cheap vellum produced patterns when they faded in light. A talisman was a sticky fly-paper trying to trap a spirit—cunningly you printed it on a "photograph" of the demon you wanted to capture in it. Photography is a blatant attempt to steal the soul. The astral body is always just latent in a person, and certain cunning and gifted photographers can take an *image* of the astral body. The whole thing is having an image of someone to *control* them. If you're out of your mind with love, it becomes understandable. *Any* crime is justified in the name of Love. In fact, it shouldn't have to be a "crime": *Anything* is justifiable in the name of Love.

My films are primarily concerned with sexuality in people. My reason for filming has nothing to do with "cinema" at all; it's a transparent excuse for capturing people, the equivalent of saying "Come up & see my etchings" . . . it's wearing a little thin now . . . So I consider myself as working Evil in an evil medium.

WET DREAM FILM FESTIVAL MANIFESTO (The Netherlands, 1970)

S.E.L.F. (Sexual Egalitarianism and Libertarian Fraternity: Germaine Greer, Al Goldstein, Jean Shrimpton, Jay Landeman, Richard Neville, Didi Wadidi, Mike Zwerkin)

A manifesto released at the first Wet Dream Film Festival in Amsterdam in November 1970, S.E.L.F. brought together an unlikely group of writers and curators interested in sexual freedom. The festival itself screened porn films, and S.E.L.F. functioned as the festival judges. The jury members are a strange lot with Greer alongside *Screw* publisher Goldstein. Greer later disavowed the festival as a failure.

When we are unafraid and free from possessiveness it will make little difference what kind of social organization we choose to live under, because we will be open, kind and generous. It is sexual frustration, sexual envy, sexual fear, which permeates all our human relationships and which perverts them. The sexually liberated, the sexually tolerant and the sexually generous individuals are open, tolerant and generous in all their activities. Therefore S.E.L.F (Sexual Egalitarian and Libertarian Fraternity) wishes to encourage sexual freedom, sexual tolerance and sexual generosity.

WOMEN'S CINEMA AS COUNTER-CINEMA (UK, 1973)

Claire Johnston

[First published in Claire Johnston, ed., *Notes on Women's Cinema* (London: SEFT, 1973): 24–31.

Claire Johnston draws on Marx, Freud, and Barthes's conception of myth, and unlike many of the feminist cine-structuralists that followed her, she argues for a cinema that embraces both the political and the popular, dismissing the false dichotomy often postulated between the two forms. In so doing, Johnston analyzes "woman as myth" in the Barthesian sense of the term, and considers how sexist ideology has been normalized through the cinema and the means by which this process of myth-ification can be counteracted.

1. MYTHS OF WOMEN IN THE CINEMA

. . . there arose, identifiable by standard appearance, behaviour and attributes, the well-remembered types of the Vamp and the Straight Girl (perhaps the most convincing modern equivalents of the medieval personifications of the Vices and Virtues), the Family Man and the Villain, the latter marked by a black moustache and walking stick. Nocturnal scenes were printed on blue or green film. A checkered table-cloth meant, once for all, a "poor but honest" milieu; a happy marriage, soon to be endangered by the shadows from the past symbolised by the young wife's pouring of the breakfast coffee for her husband; the first kiss was invariably announced by the lady's gently playing with her partner's necktie and was invariably accompanied by her kicking out with her left foot. The conduct of the characters was predetermined accordingly. (Erwin Panofsky, *Style and Medium in the Motion Pictures* [1934]; and *Film: An Anthology*, ed. D. Talbot [New York, 1959])

Panofsky's detection of the primitive stereotyping which characterised the early cinema could prove useful for discerning the way myths of women have operated in the cinema: why the image of man underwent rapid differentiation, while the primitive stereotyping of women remained with some modifications. Much writing on the stereotyping of women in the cinema takes as its starting point a monolithic view of the media as repressive and manipulative: in this way, Hollywood has been viewed as a dream factory producing an oppressive cultural product. This over-politicised view bears little relation to the ideas on art expressed either by Marx or Lenin, who both pointed to there being no direct connection between the development of art and the material basis of society. The idea of the intentionality of art which this view implies is extremely misleading and retrograde, and short-circuits the possibility of a critique which could prove useful for developing a strategy for women's cinema. If we accept that the developing of female stereotypes was not a conscious strategy of the Hollywood dream machine, what are we left with? Panofsky locates the origins of iconography and stereotype in the cinema in terms of practical necessity; he suggests that in the early cinema the audience had much difficulty deciphering what appeared on the screen. Fixed iconography, then, was introduced to aid understanding and provide the audience with basic facts with which to comprehend the narrative. Iconography as a specific kind of sign or cluster of signs based on certain conventions within the Hollywood genres has been partly responsible for the stereotyping of women within the commercial cinema in general, but the fact that there is a far greater differentiation of men's roles than of women's roles in the history of the cinema relates to sexist ideology itself, and the basic opposition which places man inside history, and woman as ahistoric and eternal. As the cinema developed, the stereotyping of man was increasingly interpreted as contravening the realisation of the notion of "character"; in the case of woman, this was not the case; the dominant ideology presented her as eternal and unchanging, except for modifications in terms of fashion etc. In general, the myths governing the cinema are no different from those governing other cultural products: they relate to a standard value system informing all cultural systems in a given society. Myth uses icons, but the icon is its weakest point. Furthermore, it is possible to use icons, (i.e. conventional configurations) in the face of and against the mythology usually associated with them. In his magisterial work on myth (*Mythologies,* Jonathan Cape, London 1971), the critic Roland Barthes examines how myth, as the signifier of an ideology, operates, by analysing a whole range of items: a national dish, a society wedding, a photograph from *Paris Match*. In his book he analyses how a sign can be emptied of its original denotative meaning and a new connotative meaning superimposed on it. What was a complete sign consisting of a signifier plus a signified, becomes merely the signifier of a new signified, which subtly usurps the place of the original denotation. In this way, the new connotation is mistaken for the natural, obvious and evident denotation: this is what makes it the signifier of the ideology of the society in which it is used.

Myth then, as a form of speech or discourse, represents the major means in which women have been used in the cinema: myth transmits and transforms the ideology of

sexism and renders it invisible—when it is made visible it evaporates—and therefore natural. This process puts the question of the stereotyping of women in a somewhat different light. In the first place, such a view of the way cinema operates challenges the notion that the commercial cinema is more manipulative of the image of woman than the art cinema. It could be argued that precisely because of the iconography of Hollywood, the system offers some resistance to the unconscious workings of myth. Sexist ideology is no less present in the European art cinema because stereotyping appears less obvious; it is in the nature of myth to drain the sign (the image of woman/the function of woman in the narrative) of its meaning and superimpose another which thus appears natural: in fact, a strong argument could be made for the art film inviting a greater invasion from myth. This point assumes considerable importance when considering the emerging women's cinema. The conventional view about women working in Hollywood (Arzner, Weber, Lupino, etc.) is that they had little opportunity for real expression within the dominant sexist ideology; they were token women and little more. In fact, because iconography offers in some ways a greater resistance to the realist characterisations, the mythic qualities of certain stereotypes become far more easily detachable and can be used as a short hand for referring to an ideological tradition in order to provide a critique of it. It is possible to disengage the icons from the myth and thus bring about reverberations within the sexist ideology in which the film is made. Dorothy Arzner certainly made use of such techniques and the work of Nelly Kaplan is particularly important in this respect. As a European director she understands the dangers of myth invading the sign in the art film, and deliberately makes use of Hollywood iconography to counteract this. The use of crazy comedy by some women directors (e.g. Stephanie Rothman) also derives from this insight.

In rejecting a sociological analysis of woman in the cinema we reject any view in terms of realism, for this would involve an acceptance of the apparent natural denotation of the sign and would involve a denial of the reality of myth in operation. Within a sexist ideology and a male-dominated cinema, woman is presented as what she represents for man. Laura Mulvey in her most useful essay on the pop artist Allen Jones ("You Don't Know What You're Doing Do You, Mr Jones?," Laura Mulvey in *Spare Rib*, February 1973), points out that woman as woman is totally absent in Jones' work. The fetishistic image portrayed relates only to male narcissism: woman represents not herself, but a process of displacement, the male phallus. It is probably true to say that despite the enormous emphasis placed on woman as spectacle in the cinema, woman as woman is largely absent. A sociological analysis based on the empirical study of recurring roles and motifs would lead to a critique in terms of an enumeration of the notion of career/home/motherhood/sexuality, an examination of women as the central figures in the narrative etc. If we view the image of woman as sign within the sexist ideology, we see that the portrayal of woman is merely one item subject to the law of verisimilitude, a law which directors worked with or reacted against. The law of verisimilitude (that which determines the impression of realism) in the cinema is precisely responsible for the repression of the image of woman as woman and the celebration of her non-existence.

This point becomes clearer when we look at a film which revolves around a woman entirely and the idea of the female star. In their analysis of Sternberg's *Morocco,* the critics of *Cahiers du Cinema* delineate the system which is in operation: in order that the man remain within the centre of the universe in a text which focuses on the image of woman, the auteur is forced to repress the idea of woman as a social and sexual being (her Otherness) and to deny the opposition man/woman altogether. The woman as sign, then, becomes the pseudo-centre of the filmic discourse. The real opposition posed by the sign is male/non-male, which Sternberg establishes by his use of masculine clothing enveloping the image of Dietrich. This masquerade indicates the absence of man, an absence which is simultaneously negated and recuperated by man. The image of the woman becomes merely the *trace* of the exclusion and repression of Woman. All fetishism, as Freud has observed, is a phallic replacement, a projection of male narcissistic fantasy. The star system as a whole depended on the fetishisation of woman. Much of the work done on the star system concentrates on the star as the focus for false and alienating dreams. This empirical approach is essentially concerned with the effects of the star system and audience reaction. What the fetishisation of the star does indicate is the collective fantasy of phallocentrism. This is particularly interesting when we look at the persona of Mae West. Many women have read into her parody of the star system and her verbal aggression an attempt at the subversion of male domination in the cinema. If we look more closely there are many traces of phallic replacement in her persona which suggest quite the opposite. The voice itself is strongly masculine, suggesting the absence of the male, and establishes a male/non-male dichotomy. The characteristic phallic dress possesses elements of the fetish. The female element which is introduced, the mother image, expresses male oedipal fantasy. In other words, at the unconscious level, the persona of Mae West is entirely consistent with sexist ideology; it in no way subverts existing myths, but reinforces them.

In their first editorial, the editors of *Women and Film* attack the notion of auteur theory, describing it as "an oppressive theory making the director a superstar as if film-making were a one-man show." This is to miss the point. Quite clearly, some developments of the auteur theory have led to a tendency to deify the personality of the (male) director, and Andrew Sarris (the major target for attack in the editorial) is one of the worst offenders in this respect. His derogatory treatment of women directors in *The American Cinema* gives a clear indication of his sexism. Nevertheless, the development of the auteur theory marked an important intervention in film criticism: its polemics challenged the entrenched view of Hollywood as monolithic, and stripped of its normative aspects the classification of films by director has proved an extremely productive way of ordering our experience of the cinema. In demonstrating that Hollywood was at least as interesting as the art cinema, it marked an important step forward. The test of any theory should be the degree to which it produces new knowledge: the auteur theory has certainly achieved this. Further elaborations of the auteur theory (cf. Peter Wollen *Signs and Meanings in the Cinema.* Seeker & Warburg, Cinema One Series, London 1972) have stressed the use of the theory to delin-

eate the unconscious structure of the film. As Peter Wollen says, "the structure is associated with a single director, an individual, not because he has played the role of artist, expressing himself or his vision in the film, but it is through the force of his preoccupations that an unconscious, unintended meaning can be decoded in the film, usually to the surprise of the individual concerned." In this way, Wollen disengages both from the notion of creativity which dominates the notion of "art," and from the idea of intentionality.

In briefly examining the myths of woman which underlie the work of two Hollywood directors, Ford and Hawks, making use of findings and insights derived from auteur analysis, it is possible to see that the image of woman assumes very different meanings within the different texts of each author's work. An analysis in terms of the presence or absence of "positive" heroine figures within the same directors' *oeuvre* would produce a very different view. What Peter Wollen refers to as the "force of the author's preoccupations" (including the obsessions about women) is generated by the psychoanalytic history of the author. This organised network of obsessions is outside the scope of the author's choice.

HAWKS VS FORD

Hawks' films celebrate the solidarity and validity of the exclusive all-male group, dedicated to the life of action and adventure, and a rigid professional ethic. When women intrude into their world, they represent a threat to the very existence of the group. However, women appear to possess "positive" qualities in Hawks' films: they are often career women and show signs of independence and aggression in the face of the male, particularly in his crazy comedies. Robin Wood has pointed out quite correctly that the crazy comedies portray an inverted version of Hawks' universe. The male is often humiliated or depicted as infantile or regressed. Such films as *Bringing Up Baby, His Girl Friday* and *Gentlemen Prefer Blondes* combine, as Robin Wood has said, "farce and horror"; they are "disturbing." For Hawks, there is only the male and the non-male: in order to be accepted into the male universe, the woman must *become* a man; alternatively she becomes woman-as-phallus (Marilyn Monroe in *Gentlemen Prefer Blondes*). This disturbing quality in Hawks' films relates directly to the presence of woman; she is a traumatic presence which must be negated. Ford's is a very different universe, in which women play a pivotal role: it is around their presence that the tensions between the desire for the wandering existence and the desire for settlement/the idea of the wilderness and the idea of the garden revolve. For Ford woman represents the home, and with it the possibility of culture: she becomes a cipher onto which Ford projects his profoundly ambivalent attitude to the concepts of civilization and psychological "wholeness."

While the depiction of women in Hawks involves a direct confrontation with the problematic (traumatic) presence of Woman, a confrontation which results in his need to repress her, Ford's use of woman as a symbol for civilisation considerably complicates the whole question of the repression of woman in his work and leaves room for more progressive elements to emerge (eg *Seven Women* and *Cheyenne Autumn*).

2. TOWARDS A COUNTER-CINEMA

There is no such thing as unmanipulated writing, filming or broadcast-
ing. The question is therefore not whether the media are manipulated,
but who manipulates them. A revolutionary plan should not require the
manipulates to disappear; on the contrary, it must make everyone a
manipulator. (Hans Magnus Enzensberger, "Constituents of a Theory
of Media," *New Left Review* 64)

Enzensberger suggests the major contradiction operating in the media is that between
their present constitution and their revolutionary potential. Quite clearly, a strategic use
of the media, and film in particular, is essential for disseminating our ideas. At the
moment the possibility of feedback is low, though the potential already exists. In the
light of such possibilities, it is particularly important to analyse what the nature of cinema
is and what strategic use can be made of it in all its forms: the political film / the
commercial entertainment film. Polemics for women's creativity are fine as long as we
realise they are polemics. The notion of women's creativity *per se* is as limited as the no-
tion of men's creativity. It is basically an idealist conception which elevates the idea of
the "artist" (involving the pitfall of elitism), and undermines any view of art as a
material thing within a cultural context which forms it and is formed by it. All films or
works of art are products: products of an existing system of economic relations, in the
final analysis. This applies equally to experimental films, poetical films and commercial
entertainment cinema. Film is also an ideological product—the product of bourgeois
ideology. The idea that art is universal and thus potentially androgynous is basically an
idealist notion: art can only be defined as a discourse within a particular conjuncture—for
the purpose of women's cinema, the bourgeois, sexist ideology of male dominated
capitalism. It is important to point out that the workings of ideology do not involve a
process of deception/intentionality. For Marx, ideology is a reality, it is not a lie. Such a
misapprehension can prove extremely misleading; there is no way in which we can
eliminate ideology as if by an effort of will. This is extremely important when it comes to
discussing women's cinema. The tools and techniques of cinema themselves, as part of
reality, are an expression of the prevailing ideology: they are not neutral, as many "revo-
lutionary" film-makers appear to believe. It is idealist mystification to believe that "truth"
can be captured by the camera or that the conditions of a film's production (eg a film
made collectively by women) can *of itself* reflect the conditions of its production. This is
mere utopianism: new meaning has to *be manufactured* within the text of the film. The
camera was developed in order to accurately reproduce reality and safeguard the bourgeois
notion of realism which was being replaced in painting. An element of sexism governing
the technical development of the camera can also be discerned. In fact, the lightweight
camera was developed as early as the 1930's in Nazi Germany for propaganda purposes;
the reason why it was not until the 1950's that it assumed common usage remains
obscure.

Much of the emerging women's cinema has taken its aesthetics from television and cinema verite techniques (eg *Three Lives, Women Talking*); Shirley Clarke's *Portrait of Jason* has been cited as an important influence. These films largely depict images of women talking to [the] camera about their experiences, with little or no intervention by the film-maker. Kate Millett sums up the approach in *Three Lives* by saying, "I did not want to analyse any more, but to express," and "film is a very powerful way to express oneself."

Clearly, if we accept that cinema involves the production of signs, the idea of non-intervention is pure mystification. The sign is always a product. What the camera in fact grasps is the "natural" world of the dominant ideology. Women's cinema cannot afford such idealism; the "truth" of our oppression cannot be "captured" on celluloid with the "innocence" of the camera: it has to be constructed/manufactured.

New meanings have to be created by disrupting the fabric of the male bourgeois cinema within the text of the film. As Peter Wollen points out, "reality is always adaptive." Eisenstein's method is instructive here. In his use of fragmentation as a revolutionary strategy, a concept is generated by the clash of two specific images, so that it serves as an abstract concept in the filmic discourse. This idea of fragmentation as an analytical tool is quite different from the use of fragmentation suggested by Barbara Martineau in her essay. She sees fragmentation as the juxtaposition of disparate dements (cf *Lion's Love*) to bring about emotional reverberations, but these reverberations do not provide a means of understanding within them. In the context of women's cinema such a strategy would be totally recuperable by the dominant ideology: indeed, in that it depends on emotionality and mystery, it invites the invasion of ideology. The ultimate logic of this method is automatic writing developed by the surrealists. Romanticism will not provide us with the necessary tools to construct a women's cinema: our objectification cannot be overcome simply by examining it artistically. It can only be challenged by developing the means to interrogate the male, bourgeois cinema. Furthermore, a desire for change can only come about by drawing on fantasy. The danger of developing a cinema of non-intervention is that it promotes a passive subjectivity at the expense of analysis. Any revolutionary strategy must challenge the depiction of reality; it is not enough to discuss the oppression of women within the text of the film: the language of the cinema / the depiction of reality must also *be* interrogated, so that a break between ideology and text is effected. In this respect, it is instructive to look at films made by women within the Hollywood system which attempted by formal means to bring about a dislocation between sexist ideology and the text of the film; such insights could provide useful guidelines for the emerging women's cinema to draw on.

DOROTHY ARZNER AND IDA LUPINO

Dorothy Arzner and Lois Weber were virtually the only women working in Hollywood during the 1920's and 30's who managed to build up a consistent body of work in the

cinema: unfortunately, very little is known of their work, as yet. An analysis of one of Dorothy Arzner's later films, *Dance, Girl, Dance,* made in 1940 gives some idea of her approach to women's cinema within the sexist ideology—of Hollywood. A conventional vaudeville story, *Dance, Girl, Dance* centres on the lives of a troupe of dancing girls down on their luck. The main characters, Bubbles and Judy are representative of the primitive iconographic depiction of women-vamp and straight-girl described by Panofsky. Working from this crude stereotyping, Arzner succeeds in generating within the text of the film, an internal criticism of it. Bubbles manages to land a job, and Judy becomes the stooge in her act, performing ballet for the amusement of the all-male audience. Arzner's critique centres round the notion of woman as spectacle, as performer within the male universe. The central figures appear in a parody form of the performance, representing opposing poles of the myths of femininity—sexuality vs. grace & innocence. The central contradiction articulating their existence as performers for the pleasure of men is one with which most women would identify; the contradiction between the desire to please and self-expression: Bubbles needs to please the male, while Judy seeks self-expression as a ballet dancer. As the film progresses, a one-way process of the performance is firmly established, involving the humiliation of Judy as the stooge. Towards the end of the film Arzner brings about her tour de force, cracking open the entire fabric of the film and exposing the workings of ideology in the construction of the stereotype of woman. Judy, in a fit of anger, turns on her audience and tells them *how she sees them*. This return of scrutiny in what within the film is assumed as a one-way process constitutes a direct assault on the audience within the film and the audience of the film, and has the effect of directly challenging the entire notion of woman as spectacle.

Ida Lupino's approach to women's cinema is somewhat different. As an independent producer and director working in Hollywood in the 1950's, Lupino chose to work largely within the melodrama, a genre which, more than any other, has presented a less reified view of women, and as Sirk's work indicates, is adaptable for expressing rather than embodying the idea of the oppression of women. An analysis of *Not Wanted,* Lupino's first feature film, gives some idea of the disturbing ambiguity of her films and their relationship to the sexist ideology. Unlike Arzner, Lupino is not concerned with employing purely formal means to obtain her objective; in fact, it is doubtful whether she operates at a conscious level at all in subverting the sexist ideology. The film tells the story of a young girl, Sally Kelton, and is told from her subjective viewpoint and filtered through her imagination. She has an illegitimate child which is eventually adopted; unable to come to terms with losing the child, she snatches one from a pram and ends up in the hands of the authorities. Finally, she finds a substitute for the child in the person of a crippled young man, who, through a process of symbolic castration—in which he is forced to chase her until he can no longer stand, whereupon she takes him up in her arms as he performs child-like gestures—provides the "happy ending." Though Lupino's films in no way explicitly attack or expose the workings of sexist ideology, reverberations within the narrative, produced by the convergence of two irreconcilable strands—Hollywood

myths of woman *v* the female perspective—cause a series of distortions within the very structure of the narrative; the mark of disablement puts the film under the sign of disease and frustration. An example of this process is, for instance, the inverted "happy ending" of the film.

The intention behind pointing to the interest of Hollywood directors like Dorothy Arzner and Ida Lupino is twofold. In the first place it is a polemical attempt to restore the interest of Hollywood from attacks that have been made on it. Secondly, an analysis of the workings of myth and the possibilities of subverting it in the Hollywood system could prove of use in determining a strategy for the subversion of ideology in general.

Perhaps something should be said about the European art film; undoubtedly, it is more open to the invasion of myth than the Hollywood film. This point becomes quite clear when we scrutinise the work of Riefenstahl, Companeez, Trintignant, Varda and others. The films of Agnes Varda are a particularly good example of an *oeuvre* which celebrates bourgeois myths of women, and with it the apparent innocence of the sign. *Le Bonheur* in particular, almost invites a Barthesian analysis! Varda's portrayal of female fantasy constitutes one of the nearest approximations to the facile day-dreams perpetuated by advertising that probably exists in the cinema. Her films appear totally innocent to the workings of myth; indeed, it is the purpose of myth to fabricate an impression of innocence, in which all becomes "natural": Varda's concern for nature is a direct expression of this retreat from history: history is transmuted into nature, involving the elimination of all questions, because all appears "natural." There is no doubt that Varda's work is reactionary: in her rejection of culture and her placement of woman outside history her films mark a retrograde step in women's cinema.

CONCLUSION

What kind of strategy, then, is appropriate at this particular point in time? The development of collective work is obviously a major step forward; as a means of acquiring and sharing skills it constitutes a formidable challenge to male privilege in the film industry as an expression of sisterhood, it suggests a viable alternative to the rigid hierarchical structures of male-dominated cinema and offers real opportunities for a dialogue about the nature of women's cinema within it. At this point in time, a strategy should be developed which embraces both the notion of films as a political tool and film as entertainment. For too long these have been regarded as two opposing poles with little common ground. In order to counter our objectification in the cinema, our collective fantasies must be released: women's cinema must embody the working through of desire: such an objective demands the use of the entertainment film. Ideas derived from the entertainment film, then, should inform the political film, and political ideas should inform the entertainment cinema: a two way process. Finally, a repressive, moralistic assertion that women's cinema *is* collective film-making is misleading and unnecessary: we should seek to operate at all levels: within the male-dominated cinema and outside it. This essay has attempted to

demonstrate the interest of women's films made within the system. Voluntarism and utopianism must be avoided if any revolutionary strategy is to emerge. A collective film *of itself* cannot reflect the condition of its production. What collective methods do provide is the real possibility of examining how cinema works and how we can best interrogate and demystify the workings of ideology: it will be from these insights that a genuinely revolutionary conception of counter-cinema for the women's struggle will come.

MANIFESTO FOR A NON-SEXIST CINEMA (Canada, 1974)

FECIP (Fédération européenne du cinéma progressiste)

[Manifesto ratified at the Fédération européenne du cinéma progressiste conference in Montréal, Quebec, 1974. First published in *Cineaste* 8, no. 4 (1978): 51.]

Like many aspects of the relationship between 1970s feminism and the New Left, the role of cinema in the struggle for global change was fraught. In the "Manifesto for a Non-sexist Cinema" feminists outline for the at-times-patriarchal New Left just exactly what sexism is, how it is often perpetuated in film production, and how it is intrinsically linked to other forms of discrimination and to liberation movements more generally.

1) BEGINNINGS OF THEORETICAL THOUGHT ABOUT SEXISM AND ANTI-SEXISM.

We don't want the recognition of the anti-sexist struggle to be a concession granted to the women's movement, like a bone thrown for us to nibble on, hoping we will stop clamouring.

We want every person to realize that she (or he) is deeply and intimately concerned with this question, whatever may be her (his) age, sex, profession or nationality.

Sexism intermingles insidiously in our most everyday and commonplace activities and—whether man or woman, child, adult or elderly person—freezes us in stereotyped roles by stifling multiple possibilities in each of us. To get away from slogans, we propose first to specify notions of sexism and anti-sexism.

A) SOME DEFINITIONS OF SEXISM.

We think that sexism consists especially of perpetuating feminine and masculine stereo-types without denouncing them.

A sexist film is one that, without criticism, shows sexual, professional or political passivity of women who are reduced to the bedroom, the kitchen, childcare or subordinate tasks if by any chance they are active elsewhere.

A sexist film is one that shows men active sexually, professionally or politically without doing the same for feminine characters and which implies that women are inferior to men in these fields.

A sexist director is one who surrenders to the terrorism of youth and beauty and dares only to employ actresses who are young and beautiful.

A sexist film is one that emphasizes sexual stereotypes about the passivity of women, including their so-called masochism (*Histoire d'O* style). However, thanks particularly to a series of convergent struggles, the criticism of sexism on the screen has improved and instead of remaining solely on the level of denouncement, it seems preferable to develop the initiatives already taken here and there for an anti-sexist cinema.

B) SOME DEFINITIONS OF ANTI-SEXISM.

Anti-sexist films are those which don't perpetuate the traditional partition of male and female roles, without condemning it explicitly or implicitly, as are those films which show struggles to change the current situation.

a) As for women: it is anti-sexist to denounce their particular oppression in the professional field (lower wages than men, more extensive un-employment, etc.) and the denouncement of their specific alienation (terrorism of fashion and beauty, obsession with aging, rivalry between women, taboo of lesbianism, sexual passivity, unwanted pregnancy, abortion performed in poor conditions, rape and physical violence, housekeeping and educational tasks performed, and deeply despised, solely by women, self-disparagement and sometimes self-hate, mythology of self-sacrifice and devotion).

b) As for men: it is anti-sexist to criticize the notion of virility reduced to the ejaculatory ability and the desire for power. As a matter of fact, men are also oppressed by sexism. For example, it is obvious that young boys' sensibilities are systematically castrated. The time and energy of most adult men are consumed by the necessity to build a career and to feed their families. Most certainly, their oppression confers upon them privileges—for instance, they are fed and washed at home—but on the moral level, sexism mutilates them as severely as, from a certain viewpoint, colonialism once mutilated the whites who exploited the Africans or the Asians. The dialectic of master and slave is never innocent.

c) The core of sexist oppression is the present family structure, insofar as it is still dependent upon the patriarchal heritage. In this cell, the mother and the child are bound together and we can observe that men and elderly people are deprived, or deny themselves, of close contacts with children.

All attempts to get out of this situation are anti-sexist, from individual revolt to collective struggle in the sexual, professional, political and ideological fields to obtain equality between men and women.

All efforts to change the female and male roles are anti-sexist. For example, anti-sexist films that demonstrate a genuine and tender relationship between a man and a child, or the sisterhood that is developing between women. Even more, movies are anti-sexist when they show men who are capable of tenderness and sensitivity and women who are strong and efficient and who do not only give birth but also create works. It is important to show the participation of women in the working class, peasant, student and anti-imperialist struggles. We will take as our watchword this well-known phrase: "What a man can do, a woman can also do," but we will complete it with its opposite: "What a woman can do, a man can also do" (except child-bearing!).

It is anti-sexist for men to participate in daily life, in the heart of daily routine, to take care of children and to assume housework tasks (the cost of which, by the way, should be reevaluated and its real value analyzed). Housework is not just a series of robotlike motions but implies a multiplicity of abilities in the same way as management.

An anti-sexist film is one that features elderly people, especially old women, and shows that even with wrinkles and grey hair, we still have a heart, a head and experiences from which everybody can profit.

2) BEGINNINGS OF THOUGHT ABOUT WOMEN'S CREATIVITY.

In the context of the women's liberation movement against patriarchal societies, it is important for women to debate the essential question of feminine creativity. Is there a specific nature of feminine creativity?

We have just begun to know the multiple repressions which, more among women than among men, have stifled our creative potential. But we don't yet know what a thought, a look, a word—if it was to be decolonized, deconditioned of male thinking, of its mental structures centered on the male standard as sole criterion of evaluation for all creativity—could reveal of the specificity of women, of our relation to the language (our mother's language), to our body, to space, to time and to the future.

We don't know anything about creative energy because for centuries we have centered our energy towards expiatory and sacrificial love. We have to learn everything about ourselves. We have to use our energies to liberate everything. Let's not be afraid to seek our unknown self which no present theory, whether Marxist or psychoanalytic, can completely explore.

WOMANIFESTO (USA, 1975)

Feminists in the Media

[First signed and circulated at the final session of the New York conference "Feminists in the Media," New York, 2 February 1975. First published in *Women & Film* 2, no. 7 (1975): 11.]

Like the "Manifesto for a Non-sexist Cinema" of the same year, the "Womanifesto," released at the New York "Feminists in the Media" conference, positions film- and video-making as part of a collective struggle against patriarchy and other forms of oppression.

As feminists working collectively in film and video we see our media as an ongoing process both in terms of the way it is made and the way it is distributed and shown. We are committed to feminist control of the entire process. We do not accept the existing power structure and we are committed to changing it, by the content and structure of our images and by the ways we relate to each other in our work and with our audience. Making and showing our work is an ongoing cyclical process, and we are responsible for changing and developing our approaches as we learn from this experience.

We see ourselves as part of the larger movement of women dedicated to changing society by struggling against oppression as it manifests itself in sexism, heterosexism, racism, classism, agism, and imperialism. Questioning and deepening our understanding of these words and of how language itself can be oppressive is part of our ongoing struggle. We want to affirm and share the positive aspects of our experience as women in celebration.

VISUAL PLEASURE AND NARRATIVE CINEMA (UK, 1975)

Laura Mulvey

[Written in 1973. First published in *Screen* 16, no. 3 (1975): 6–18.]

Influenced by the influx of Lacanian psychoanalysis into critical theory and one of the most infamous, influential, and controversial essays of "screen theory"—and at the center of the so-called theory wars of the late 1980s and early 1990s—Mulvey's "Visual Pleasure and Narrative Cinema" is best understood as the preeminent feminist film manifesto, not only challenging the patriarchal structures of classical Hollywood cinema but also outlining a radical, new feminist film aesthetic. In collaboration with Peter Wollen, Mulvey codirected *Riddles of the Sphinx* (UK, 1977)—one of the few films that can be truly called a "manifesto film"—which applies the principle of the destruction of the pleasure enabled by the male gaze outlined in this essay to bring into being a new, feminist language of the cinema.

I. INTRODUCTION
A. A POLITICAL USE OF PSYCHOANALYSIS

This paper intends to use psychoanalysis to discover where and how the fascination of film is reinforced by pre-existing patterns of fascination already at work within the individual subject and the social formations that have moulded him. It takes as starting point the way film reflects, reveals and even plays on the straight, socially established interpretation of sexual difference which controls images, erotic ways of looking and spectacle. It is helpful to understand what the cinema has been, how its magic has worked in the past, while attempting a theory and a practice which will challenge this cinema of the past. Psychoanalytic theory is thus appropriated here as a political weapon, demonstrating the way the unconscious of patriarchal society has structured film form.

The paradox of phallocentrism in all its manifestations is that it depends on the image of the castrated woman to give order and meaning to its world. An idea of woman stands as lynch pin to the system: it is her lack that produces the phallus as a symbolic presence, it is her desire to make good the lack that the phallus signifies. Recent writing in *Screen* about psychoanalysis and the cinema has not sufficiently brought out the importance of the representation of the female form in a symbolic order in which, in the last resort, it speaks castration and nothing else. To summarize briefly: the function of woman in forming the patriarchal unconscious is two-fold. She first symbolises the castration threat by her real absence of a penis, and second thereby raises her child into the symbolic. Once this has been achieved, her meaning in the process is at an end, it does not last into the world of law and language except as a memory which oscillates between memory of maternal plenitude and memory of lack. Both are posited on nature (or on anatomy in Freud's famous phrase). Woman's desire is subjected to her image as bearer of the bleeding wound, she can exist only in relation to castration and cannot transcend it. She turns her child into the signifier of her own desire to possess a penis (the condition, she imagines, of entry into the symbolic). Either she must gracefully give way to the word, the Name of the Father and the Law, or else struggle to keep her child down with her in the half-light of the imaginary. Woman then stands in patriarchal culture as signifier for the male other, bound by a symbolic order in which man can live out his phantasies and obsessions through linguistic command by imposing them on the silent image of woman still tied to her place as bearer of meaning, not maker of meaning.

There is an obvious interest in this analysis for feminists, a beauty in its exact rendering of the frustration experienced under the phallocentric order. It gets us nearer to the roots of our oppression, it brings an articulation of the problem closer, it faces us with the ultimate challenge: how to fight the unconscious structured like a language (formed critically at the moment of arrival of language) while still caught within the language of the patriarchy. There is no way in which we can produce an alternative out of the blue, but we can begin to make a break by examining patriarchy with the tools it provides, of which psychoanalysis is not the only but an important one. We are still separated by a great gap from

important issues for the female unconscious which are scarcely relevant to psychoanalytic theory: the sexing of the female infant and her relationship to the symbolic, the sexually mature woman as non-mother, maternity outside the signification of the phallus, the vagina. . . . But, at this point, psychoanalytic theory as it now stands can at least advance our understanding of the status quo, of the patriarchal order in which we are caught.

B. DESTRUCTION OF PLEASURE AS A RADICAL WEAPON

As an advanced representation system, the cinema poses questions of the ways the unconscious (formed by the dominant order) structures ways of seeing and pleasure in looking. Cinema has changed over the last few decades. It is no longer the monolithic system based on large capital investment exemplified at its best by Hollywood in the 1930's, 1940's and 1950's. Technological advances (16mm, etc) have changed the economic conditions of cinematic production, which can now be artisanal as well as capitalist. Thus it has been possible for an alternative cinema to develop. However self-conscious and ironic Hollywood managed to be, it always restricted itself to a formal mise-en-scène reflecting the dominant ideological concept of the cinema. The alternative cinema provides a space for a cinema to be born which is radical in both a political and an aesthetic sense and challenges the basic assumptions of the mainstream film. This is not to reject the latter moralistically, but to highlight the ways in which its formal preoccupations reflect the psychical obsessions of the society which produced it, and, further, to stress that the alternative cinema must start specifically by reacting against these obsessions and assumptions. A politically and aesthetically avant-garde cinema is now possible, but it can still only exist as a counterpoint.

The magic of the Hollywood style at its best (and of all the cinema within its sphere of influence) arose, not exclusively, but in one important aspect, from its skilled and satisfying manipulation of visual pleasure. Unchallenged, mainstream film coded the erotic into the language of the dominant patriarchal order. In the highly developed Hollywood cinema it was only through these codes that the alienated subject, torn in his imaginary memory by a sense of loss, by the terror of potential lack in phantasy, came near to finding a glimpse of satisfaction: through its formal beauty and its play on his own formative obsessions.

This article will discuss the interweaving of that erotic pleasure in film, its meaning, and in particular the central place of the image of woman. It is said that analysing pleasure, or beauty, destroys it. That is the intention of this article. The satisfaction and reinforcement of the ego that represent the high point of film history hitherto must be attacked. Not in favour of a reconstructed new pleasure, which cannot exist in the abstract, nor of intellectualised unpleasure, but to make way for a total negation of the ease and plenitude of the narrative fiction film. The alternative is the thrill that comes from leaving the past behind without rejecting it, transcending outworn or oppressive forms, or daring to break with normal pleasurable expectations in order to conceive a new language of desire.

II. PLEASURE IN LOOKING / FASCINATION WITH THE HUMAN FORM

A. The cinema offers a number of possible pleasures. One is scopophilia. There are circumstances in which looking itself is a source of pleasure, just as, in the reverse formation, there is pleasure in being looked at. Originally, in his *Three Essays on Sexuality*, Freud isolated scopophilia as one of the component instincts of sexuality which exist as drives quite independently of the erotogenic zones. At this point he associated scopophilia with taking other people as objects, subjecting them to a controlling and curious gaze. His particular examples center around the voyeuristic activities of children, their desire to see and make sure of the private and the forbidden (curiosity about other people's genital and bodily functions, about the presence or absence of the penis and, retrospectively, about the primal scene). In this analysis scopophilia is essentially active. (Later, in *Instincts and Their Vicissitudes*, Freud developed his theory of scopophilia further, attaching it initially to pre-genital auto-eroticism, after which the pleasure of the look is transferred to others by analogy. There is a close working here of the relationship between the active instinct and its further development in a narcissistic form.) Although the instinct is modified by other factors, in particular the constitution of the ego, it continues to exist as the erotic basis for pleasure in looking at another person as object. At the extreme, it can become fixated into a perversion, producing obsessive voyeurs and Peeping Toms, whose only sexual satisfaction can come from watching, in an active controlling sense, an objectified other.

At first glance, the cinema would seem to be remote from the undercover world of the surreptitious observation of an unknowing and unwilling victim. What is seen of the screen is so manifestly shown. But the mass of mainstream film, and the conventions within which it has consciously evolved, portray a hermetically sealed world which unwinds magically, indifferent to the presence of the audience, producing for them a sense of separation and playing on their voyeuristic phantasy. Moreover, the extreme contrast between the darkness in the auditorium (which also isolates the spectators from one another) and the brilliance of the shifting patterns of light and shade on the screen helps to promote the illusion of voyeuristic separation. Although the film is really being shown, is there to be seen, conditions of screening and narrative conventions give the spectator an illusion of looking in on a private world. Among other things, the position of the spectators in the cinema is blatantly one of repression of their exhibitionism and projection of the repressed desire on to the performer.

B. The cinema satisfies a primordial wish for pleasurable looking, but it also goes further, developing scopophilia in its narcissistic aspect. The conventions of mainstream film focus attention on the human form. Scale, space, stories are all anthropomorphic. Here, curiosity and the wish to look intermingle with a fascination with likeness and recognition: the human face, the human body, the relationship between the human form and its surroundings, the visible presence of the person in the world. Jacques Lacan has

described how the moment when a child recognises its own image in the mirror is crucial for the constitution of the ego. Several aspects of this analysis are relevant here. The mirror phase occurs at a time when the child's physical ambitions outstrip his motor capacity, with the result that his recognition of himself is joyous in that he imagines his mirror image to be more complete, more perfect than he experiences his own body. Recognition is thus overlaid with misrecognition: the image recognised is conceived as the reflected body of the self, but its misrecognition as superior projects this body outside itself as an ideal ego, the alienated subject, which, re-introjected as an ego ideal, gives rise to the future generation of identification with others. This mirror-moment predates language for the child.

Important for this article is the fact that it is an image that constitutes the matrix of the imaginary, of recognition/misrecognition and identification, and hence of the first articulation of the "I" of subjectivity. This is a moment when an older fascination with looking (at the mother's face, for an obvious example) collides with the initial inklings of self-awareness. Hence it is the birth of the long love affair/despair between image and self-image which has found such intensity of expression in film and such joyous recognition in the cinema audience. Quite apart from the extraneous similarities between screen and mirror (the framing of the human form in its surroundings, for instance), the cinema has structures of fascination strong enough to allow temporary loss of ego while simultaneously reinforcing the ego. The sense of forgetting the world as the ego has subsequently come to perceive it (I forgot who I am and where I was) is nostalgically reminiscent of that pre-subjective moment of image recognition. At the same time the cinema has distinguished itself in the production of ego ideals as expressed in particular in the star system, the stars centering both screen presence and screen story as they act out a complex process of likeness and difference (the glamorous impersonates the ordinary).

C. Sections II, A and B have set out two contradictory aspects of the pleasurable structures of looking in the conventional cinematic situation. The first, scopophilic, arises from pleasure in using another person as an object of sexual stimulation through sight. The second, developed through narcissism and the constitution of the ego, comes from identification with the image seen. Thus, in film terms, one implies a separation of the erotic identity of the subject from the object on the screen (active scopophilia), the other demands identification of the ego with the object on the screen through the spectator's fascination with and recognition of his like. The first is a function of the sexual instincts, the second of ego libido. This dichotomy was crucial for Freud. Although he saw the two as interacting and overlaying each other, the tension between instinctual drives and self-preservation continues to be a dramatic polarisation in terms of pleasure. Both are formative structures, mechanisms not meaning. In themselves they have no signification, they have to be attached to an idealisation. Both pursue aims in indifference to perceptual reality, creating the imagised, eroticised concept of the world that forms the perception of the subject and makes a mockery of empirical objectivity. During its history, the cinema

seems to have evolved a particular illusion of reality in which this contradiction between libido and ego has found a beautifully complementary phantasy world. In reality the phantasy world of the screen is subject to the law which produces it. Sexual instincts and identification processes have a meaning within the symbolic order which articulates desire. Desire, born with language, allows the possibility of transcending the instinctual and the imaginary, but its point of reference continually returns to the traumatic moment of its birth: the castration complex. Hence the look, pleasurable in form, can be threatening in content, and it is woman as representation/image that crystallises this paradox.

III. WOMAN AS IMAGE, MAN AS BEARER OF THE LOOK

A. In a world ordered by sexual imbalance, pleasure in looking has been split between active/male and passive/female. The determining male gaze projects its phantasy on to the female form which is styled accordingly. In their traditional exhibitionist role women are simultaneously looked at and displayed, with their appearance coded for strong visual and erotic impact so that they can be said to connote to-be-looked-at-ness. Woman displayed as sexual object is the leit-motif of erotic spectacle: from pin-ups to striptease, from Ziegfeld to Busby Berkeley, she holds the look, plays to and signifies male desire. Mainstream film neatly combined spectacle and narrative. (Note, however, how the musical song-and-dance numbers break the flow of the diegesis.) The presence of woman is an indispensable element of spectacle in normal narrative film, yet her visual presence tends to work against the development of a story line, to freeze the flow of action in moments of erotic contemplation. This alien presence then has to be integrated into cohesion with the narrative. As Budd Boetticher has put it:

> What counts is what the heroine provokes, or rather what she represents. She is the one, or rather the love or fear she inspires in the hero, or else the concern he feels for her, who makes him act the way he does. In herself the woman has not the slightest importance.

(A recent tendency in narrative film has been to dispense with this problem altogether; hence the development of what Molly Haskell has called the "buddy movie," in which the active homosexual eroticism of the central male figures can carry the story without distraction.) Traditionally, the woman displayed has functioned on two levels: as erotic object for the characters within the screen story, and as erotic object for the spectator within the auditorium, with a shifting tension between the looks on either side of the screen. For instance, the device of the show-girl allows the two looks to be unified technically without any apparent break in the diegesis. A woman performs within the narrative, the gaze of the spectator and that of the male characters in the film are neatly combined without breaking narrative verisimilitude. For a moment the sexual impact of the performing woman takes the film into a no-man's-land outside its own time and space. Thus Marilyn

Monroe's first appearance in *The River of No Return* and Lauren Bacall's songs in *To Have or Have Not*. Similarly, conventional close-ups of legs (Dietrich, for instance) or a face (Garbo) integrate into the narrative a different mode of eroticism. One part of a fragmented body destroys the Renaissance space, the illusion of depth demanded by the narrative, it gives flatness, the quality of a cut-out or icon rather than verisimilitude to the screen.

B. An active/passive heterosexual division of labor has similarly controlled narrative structure. According to the principles of the ruling ideology and the psychical structures that back it up, the male figure cannot bear the burden of sexual objectification. Man is reluctant to gaze at his exhibitionist like. Hence the split between spectacle and narrative supports the man's role as the active one of forwarding the story, making things happen. The man controls the film phantasy and also emerges as the representative of power in a further sense: as the bearer of the look of the spectator, transferring it behind the screen to neutralise the extra-diegetic tendencies represented by woman as spectacle. This is made possible through the processes set in motion by structuring the film around a main controlling figure with whom the spectator can identify. As the spectator identifies with the main male protagonist, he projects his look on to that of his like, his screen surrogate, so that the power of the male protagonist as he controls events coincides with the active power of the erotic look, both giving a satisfying sense of omnipotence. A male movie star's glamorous characteristics are thus not those of the erotic object of the gaze, but those of the more perfect, more complete, more powerful ideal ego conceived in the original moment of recognition in front of the mirror. The character in the story can make things happen and control events better than the subject/spectator, just as the image in the mirror was more in control of motor coordination. In contrast to woman as icon, the active male figure (the ego ideal of the identification process) demands a three-dimensional space corresponding to that of the mirror-recognition in which the alienated subject internalised his own representation of this imaginary existence. He is a figure in a landscape. Here the function of film is to reproduce as accurately as possible the so-called natural conditions of human perception. Camera technology (as exemplified by deep focus in particular) and camera movements (determined by the action of the protagonist), combined with invisible editing (demanded by realism) all tend to blur the limits of screen space. The male protagonist is free to command the stage, a stage of spatial illusion in which he articulates the look and creates the action.

C.1 Sections III, A and B have set out a tension between a mode of representation of woman in film and conventions surrounding the diegesis. Each is associated with a look: that of the spectator in direct scopophilic contact with the female form displayed for his enjoyment (connoting male phantasy) and that of the spectator fascinated with the image of his like set in an illusion of natural space, and through him gaining control and possession of the woman within the diegesis. (This tension and the shift from one pole to

the other can structure a single text. Thus both in *Only Angels Have Wings* and in *To Have and Have Not,* the film opens with the woman as object of the combined gaze of spectator and all the male protagonists in the film. She is isolated, glamorous, on display, sexualised. But as the narrative progresses she falls in love with the main male protagonist and becomes his property, losing her outward glamorous characteristics, her generalised sexuality, her show-girl connotations; her eroticism is subjected to the male star alone. By means of identification with him, through participation in his power, the spectator can indirectly possess her too.)

But in psychoanalytic terms, the female figure poses a deeper problem. She also connotes something that the look continually circles around but disavows: her lack of a penis, implying a threat of castration and hence unpleasure. Ultimately, the meaning of woman is sexual difference, the absence of the penis as visually ascertainable, the material evidence on which is based the castration complex essential for the organisation of entrance to the symbolic order and the law of the father. Thus the woman as icon, displayed for the gaze and enjoyment of men, the active controllers of the look, always threatens to evoke the anxiety it originally signified. The male unconscious has two avenues of escape from this castration anxiety: preoccupation with the re-enactment of the original trauma (investigating the woman, demystifying her mystery), counterbalanced by the devaluation, punishment or saving of the guilty object (an avenue typified by the concerns of the film noir); or else complete disavowal of castration by the substitution of a fetish object or turning the represented figure itself into a fetish so that it becomes reassuring rather than dangerous (hence over-valuation, the cult of the female star). This second avenue, fetishistic scopophilia, builds up the physical beauty of the object, transforming it into something satisfying in itself. The first avenue, voyeurism, on the contrary, has associations with sadism: pleasure lies in ascertaining guilt (immediately associated with castration), asserting control and subjecting the guilty person through punishment or forgiveness. This sadistic side fits in well with narrative. Sadism demands a story, depends on making something happen, forcing a change in another person, a battle of will and strength, victory/defeat, all occurring in a linear time with a beginning and an end. Fetishistic scopophilia, on the other hand, can exist outside linear time as the erotic instinct is focused on the look alone. These contradictions and ambiguities can be illustrated more simply by using works by Hitchcock and Sternberg, both of whom take the look almost as the content or subject matter of many of their films. Hitchcock is the more complex, as he uses both mechanisms. Sternberg's work, on the other hand, provides many pure examples of fetishistic scopophilia.

C.2 It is well known that Sternberg once said he would welcome his films being projected upside down so that story and character involvement would not interfere with the spectator's undiluted appreciation of the screen image. This statement is revealing but ingenuous. Ingenuous in that his films do demand that the figure of the woman (Dietrich, in the cycle of films with her, as the ultimate example) should be identifiable.

But revealing in that it emphasises the fact that for him the pictorial space enclosed by the frame is paramount rather than narrative or identification processes. While Hitchcock goes into the investigative side of voyeurism, Sternberg produces the ultimate fetish, taking it to the point where the powerful look of the male protagonist (characteristic of traditional narrative film) is broken in favour of the image in direct erotic rapport with the spectator. The beauty of the woman as object and the screen space coalesce; she is no longer the bearer of guilt but a perfect product, whose body, stylised and fragmented by close-ups, is the content of the film and the direct recipient of the spectator's look. Sternberg plays down the illusion of screen depth; his screen tends to be one-dimensional, as light and shade, lace, steam, foliage, net, streamers, etc., reduce the visual field. There is little or no mediation of the look through the eyes of the main male protagonist. On the contrary, shadowy presences like La Bessiere in *Morocco* act as surrogates for the director, detached as they are from audience identification. Despite Sternberg's insistence that his stories are irrelevant, it is significant that they are concerned with situation, not suspense, and cyclical rather than linear time, while plot complications revolve around misunderstanding rather than conflict. The most important absence is that of the controlling male gaze within the screen scene. The high point of emotional drama in the most typical Dietrich films, her supreme moments of erotic meaning, take place in the absence of the man she loves in the fiction. There are other witnesses, other spectators watching her on the screen, but their gaze is one with, not standing in for, that of the audience. At the end of *Morocco*, Tom Brown has already disappeared into the desert when Amy Jolly kicks off her gold sandals and walks after him. At the end of *Dishonoured*, Kranau is indifferent to the fate of Magda. In both cases, the erotic impact, sanctified by death, is displayed as a spectacle for the audience. The male hero misunderstands and, above all, does not see.

In Hitchcock, by contrast, the male hero does see precisely what the audience sees. However, in the films I shall discuss here, he takes fascination with an image through scopophilic eroticism as the subject of the film. Moreover, in these cases the hero portrays the contradictions and tensions experienced by the spectator. In *Vertigo* in particular, but also in *Marnie* and *Rear Window*, the look is central to the plot, oscillating between voyeurism and fetishistic fascination. As a twist, a further manipulation of the normal viewing process which in some sense reveals it, Hitchcock uses the process of identification normally associated with ideological correctness and the recognition of established morality and shows up its perverted side. Hitchcock has never concealed his interest in voyeurism, cinematic and non-cinematic. His heroes are exemplary of the symbolic order and the law—a policeman (*Vertigo*), a dominant male possessing money and power (*Marnie*)—but their erotic drives lead them into compromised situations. The power to subject another person to the will sadistically or to the gaze voyeuristically is turned on to the woman as the object of both. Power is backed by a certainty of legal right and the established guilt of the woman (evoking castration, psychoanalytically speaking). True perversion is barely concealed under a shallow mask of ideological correctness—the man is on

the right side of the law, the woman on the wrong. Hitchcock's skillful use of identification processes and liberal use of subjective camera from the point of view of the male protagonist draw the spectators deeply into his position, making them share his uneasy gaze. The audience is absorbed into a voyeuristic situation within the screen scene and diegesis which parodies his own in the cinema. In his analysis of *Rear Window*, Douchet takes the film as a metaphor for the cinema. Jeffries is the audience, the events in the apartment block opposite correspond to the screen. As he watches, an erotic dimension is added to his look, a central image to the drama. His girlfriend Lisa had been of little sexual interest to him, more or less a drag, so long as she remained on the spectator side. When she crosses the barrier between his room and the block opposite, their relationship is re-born erotically. He does not merely watch her through his lens, as a distant meaningful image, he also sees her as a guilty intruder exposed by a dangerous man threatening her with punishment, and thus finally saves her. Lisa's exhibitionism has already been established by her obsessive interest in dress and style, in being a passive image of visual perfection; Jeffries' voyeurism and activity have also been established through his work as a photo-journalist, a maker of stories and captor of images. However, his enforced inactivity, binding him to his seat as a spectator, puts him squarely in the phantasy position of the cinema audience.

In *Vertigo*, subjective camera predominates. Apart from flash-back from Judy's point of view, the narrative is woven around what Scottie sees or fails to see. The audience follows the growth of his erotic obsession and subsequent despair precisely from his point of view. Scottie's voyeurism is blatant: he falls in love with a woman he follows and spies on without speaking to. Its sadistic side is equally blatant: he has chosen (and freely chosen, for he had been a successful lawyer) to be a policeman, with all the attendant possibilities of pursuit and investigation. As a result, he follows, watches and falls in love with a perfect image of female beauty and mystery. Once he actually confronts her, his erotic drive is to break her down and force her to tell by persistent cross-questioning. Then, in the second part of the film, he re-enacts his obsessive involvement with the image he loved to watch secretly. He reconstructs Judy as Madeleine, forces her to conform in every detail to the actual physical appearance of his fetish. Her exhibitionism, her masochism, make her an ideal passive counterpart to Scottie's active sadistic voyeurism. She knows her part is to perform, and only by playing it through and then replaying it can she keep Scottie's erotic interest. But in the repetition he does break her down and succeeds in exposing her guilt. His curiosity wins through and she is punished. In *Vertigo*, erotic involvement with the look is disorienting: the spectator's fascination is turned against him as the narrative carries him through and entwines him with the processes that he is himself exercising. The Hitchcock hero here is firmly placed within the symbolic order, in narrative terms. He has all the attributes of the patriarchal super-ego. Hence the spectator, lulled into a false sense of security by the apparent legality of his surrogate, sees through his look and finds himself exposed as complicit, caught in the moral ambiguity of looking.

Far from being simply an aside on the perversion of the police, *Vertigo* focuses on the implications of the active/looking, passive/looked-at split in terms of sexual difference and the power of the male symbolic encapsulated in the hero. Marnie, too, performs for Mark Rutland's gaze and masquerades as the perfect to-be-looked-at image. He, too, is on the side of the law until, drawn in by obsession with her guilt, her secret, he longs to see her in the act of committing a crime, make her confess and thus save her. So he, too, becomes complicit as he acts out the implications of his power. He controls money and words, he can have his cake and eat it.

III. SUMMARY

The psychoanalytic background that has been discussed in this article is relevant to the pleasure and unpleasure offered by traditional narrative film. The scopophilic instinct (pleasure in looking at another person as an erotic object), and, in contradistinction, ego libido (forming identification processes) act as formations, mechanisms, which this cinema has played on. The image of woman as (passive) raw material for the (active) gaze of man takes the argument a step further into the structure of representation, adding a further layer demanded by the ideology of the patriarchal order as it is worked out in its favorite cinematic form—illusionistic narrative film. The argument returns again to the psychoanalytic background in that woman as representation signifies castration, inducing voyeuristic or fetishistic mechanisms to circumvent her threat. None of these interacting layers is intrinsic to film, but it is only in the film form that they can reach a perfect and beautiful contradiction, thanks to the possibility in the cinema of shifting the emphasis of the look. It is the place of the look that defines cinema, the possibility of varying it and exposing it. This is what makes cinema quite different in its voyeuristic potential from, say, strip-tease, theatre, shows, etc. Going far beyond highlighting a woman's to-be-looked-at-ness, cinema builds the way she is to be looked at into the spectacle itself. Playing on the tension between film as controlling the dimension of time (editing, narrative) and film as controlling the dimension of space (changes in distance, editing), cinematic codes create a gaze, a world, and an object, thereby producing an illusion cut to the measure of desire. It is these cinematic codes and their relationship to formative external structures that must be broken down before mainstream film and the pleasure it provides can be challenged.

To begin with (as an ending) the voyeuristic-scopophilic look that is a crucial part of traditional filmic pleasure can itself be broken down. There are three different looks associated with cinema: that of the camera as it records the pro-filmic event, that of the audience as it watches the final product, and that of the characters at each other within the screen illusion. The conventions of narrative film deny the first two and subordinate them to the third, the conscious aim being always to eliminate intrusive camera presence and prevent a distancing awareness in the audience. Without these two absences (the material existence of the recording process, the critical reading of the spectator), fictional drama cannot achieve reality, obviousness and truth. Nevertheless, as this article has

argued, the structure of looking in narrative fiction film contains a contradiction in its own premises: the female image as a castration threat constantly endangers the unity of the diegesis and bursts through the world of illusion as an intrusive, static, one-dimensional fetish. Thus the two looks materially present in time and space are obsessively subordinated to the neurotic needs of the male ego. The camera becomes the mechanism for producing an illusion of Renaissance space, flowing movements compatible with the human eye, an ideology of representation that revolves around the perception of the subject; the camera's look is disavowed in order to create a convincing world in which the spectator's surrogate can perform with verisimilitude. Simultaneously, the look of the audience is denied an intrinsic force: as soon as fetishistic representation of the female image threatens to break the spell of illusion, and erotic image on the screen appears directly (without mediation) to the spectator, the fact of fetishisation, concealing as it does castration fear, freezes the look, fixates the spectator and prevents him from achieving any distance from the image in front of him.

This complex interaction of looks is specific to film. The first blow against the monolithic accumulation of traditional film conventions (already undertaken by radical filmmakers) is to free the look of the camera into its materiality in time and space and the look of the audience into dialectics, passionate detachment. There is no doubt that this destroys the satisfaction, pleasure and privilege of the "invisible guest," and highlights how film has depended on voyeuristic active/passive mechanisms. Women, whose image has continually been stolen and used for this end, cannot view the decline of the traditional film form with anything much more than sentimental regret.

AN EGRET IN THE PORNO SWAMP: NOTES OF SEX IN THE CINEMA (Sweden, 1977)

Vilgot Sjöman

[First published in English in *Cineaste* 8, no. 2 (1977): 18–19.]

In this manifesto for "porn art," Swedish director Vilgot Sjöman, best known for his films *I Am Curious (Yellow)* (*Jag är nyfiken—gul*, Sweden, 1967), and *I Am Curious (Blue)* (*Jag är nyfiken—blå*, Sweden, 1968), traces the history of the representation of sexuality in the cinema from the censorship breakthroughs of the late 1960s through to the late 1970s and the arrival of soft-core porn films like *Emmanuelle* (Just Jaeckin, France, 1974). Sjöman argues that sexual representation needs to be brought into art cinema and not simply be marginalized into pornography. To this extent, his demands for a new kind of representation of sexuality in the cinema foreshadow the arrival of *cinéma brut* and New French Extremism.

1) Here in Sweden it went amazingly fast. Sexual liberalism had scarcely gained a bit of ground before the counteraction began. We promptly found ourselves back in a new puritanism.

Had anything really had time to happen?

Yes. We got sex shops. Suddenly sex clubs lay scattered all around town, with their exploited men and women, and movie theaters showed films containing "porno" scenes. In short, exposure had become possible. Aside from that, however, was anything different?

2) I read a respected film reviewer in a respected daily newspaper. It doesn't seem very different from the time when pornographic films were "top secret" and injurious to morals and were shown only at stag parties or reservists' get-togethers.

He lifts his chin, he wrinkles his nose—with the kind of semi seriousness or mendacity that was regarded as *de rigueur* then—when the lights are turned on again.

Now he sits down at the typewriter to do his review. He has cut off all contact with his own little unconscious. No question of listening to his contradictions, the duplicities of his own feelings. It's the super-ego that now clatters away at the keys, just like 20 years ago.

3) Naturally, this development is a disappointment—in terms of reformist wishful thinking. Isolated voices were raised in the early 60's and said: "In the name of consistency, legalize pornography so we can be spared arbitrary court-drawn boundary lines between artistic and inartistic obscenity."

So books were written and films detonated—and the government didn't intervene; nor did the police; nor did the Ombudsman. The gates of censorship were flung open; and the rats of commercialism swarmed over the movie screens.

Not much else happened. Nevertheless, the struggle had entailed "the artist's freedom of expression." Oh, how pathetic he seems, the artist—an egret, standing on one leg, in the middle of the porno swamp.

4) It seems to be a question of nakedness. It seems to be a question of clothes or no clothes, of "frontal nudity," of the ridiculous dread of showing women's pubic hair or men's sex organs. It seems to be a question of the right to film bodies in the act of sexual intercourse.

This "seems to" is surging forth across country after country—Scandinavia first, then the United States, then the rest of the world.

The egret in the porno swamp, however, looks around in bewilderment. To him, *that* isn't the issue at all.

5) Bunuel has cultivated sexuality ever since he started making films. His films are specimen boxes of what used to be called "perversities"—he touches on everything. See how beautifully she kneels, Catherine Deneuve in *Belle de jour*, dressed as a bride at the coffin in the necrophiliac bordello dream—a film suffused with eroticism.

But Bunuel has no need to strip anyone to nudity.

Not many directors have produced orgies more suggestive than Fellini's in the final sequence of *La dolce vita*. Yet everything there is merely hints, symbols, substitutive games. Nobody is undressed.

Equally suggestive is Antonioni in *Blow Up*—the play in the photo studio, two girls, one man—a play with bodies *in paper*. When this same director exploits the new freedom from censorship in *Zabriskie Point*, however, the result is parodic—a nude parade in the desert!

The neo-puritans thereby gained a trump card—the great artists can manage without nudity. But this is still not what it's all about. It's not a question of "managing without" or of "achieving suggestion" through old hinting games. It's a question of conquering one more bit of humankind, for humankind, by means of the camera. In words, it's already possible.

6) Bergman's *Scenes from a Marriage*—he and she are drifting into a crisis. They awaken to some kind of agonizing new awareness. Outbursts of hatred, accusations, separations. In the midst of their separation, the wife visits her husband at his office. Suddenly, they are making love to each other on the floor in a swirl of aggression and rekindled lust. How does one depict that with the camera?

They have lived together for a long time. They have children. They know each other's bodies and can't very well be shy in front of each other; they don't exactly make love with their clothes on. On the contrary, they're profoundly familiar with each other—in the midst of all their crises. They have their ways of touching, their fondling rituals, their sexual play words, and a myriad of associations that have developed between them during their years together. Their marriage has its erotic history. How does one depict that?

For a long time she had her fixed ideas—from behind was indecent. Just now, on the floor, he reminds her of that. "I.U.D." is a code utterance between them. Neither of them can recall how it became so, but now it is charged with playful lust and desire. He likes to suck one of her breasts for a while before they fall asleep, even if they don't make love—and that, too, is part of "I.U.D." He hates seeing her wearing a sanitary napkin. Accordingly, she forces herself to use a tampon. How does one render such things in a movie?

By means of the dialog, of course. But a movie is pictures.

Make a comparison with anything you wish! Take your own love, and immediately you can see how standardized love is in films. Conventionalized to the maximum! Reality teems with nuances; movies use silhouettes.

What about the movie writer? If he happens to have a fortuitous moment of original erotic creativity at his desk, he can rest assured it will shrivel like butterfly wings in a spotlight the instant the photographer and actors and directors get hold of it. The worry spreads. Clumsiness. Fear of the audience. Worry about one's own censor. Dare we do that? Will it be beautiful that way? "Beautiful!"

It probably ends up with our husband and wife—lets call them Johan and Marianne—performing a wholly film conventional act of film intercourse on the floor of his office. In ultra closeups, or concealed in their clothes. Smiling, as though they wanted to say: "Oh, yes indeed, we do have our own erotic history, but we have no intention of disclosing it to you, dear audience. You're not going to practice your voyeurism on *us!*"

7) Of course, there is a voyeurism problem in all this. There has always been a voyeurism problem involved in this. Actually, it's of no concern to the artist. To him, the only salient issue is whether the scene/image is charged with meaning—humanly important, humanly expressive.

Emotional voyeurism, incidentally, we tolerate in unimagined quantities. It is the driving force in practically all art—and art consumption.

8) There is likewise a problem of exhibitionism involved here. We apply it, however, only to those who exhibit their bodies. Emotional exhibitionism is so taken for granted that we don't even call it exhibitionism.

Bodily exhibitionism is problematic for actors and actresses. Emotional voyeurism *isn't*. Such is the tradition. Actors and actresses gladly expose their faces in closeups, and the camera creeps up close to lips, eyes, forehead, cheeks. Then the projector slings these onto the movie screen, vastly enlarged. The teenager knows every tiny feature in his adored idol's face.

Thus do the "exhibitionist" and "voyeur" meet—but the terms themselves are unpleasant; we shove them aside so as to be left alone with our lustful experience.

Sex in films. My thesis is simple—nothing new is going to happen until first-rate directors and first-rate actors and actresses start making use of the new freedom from censorship. Not till then will we see depictions of human beings in which sex is part of a whole. Not pornographic, not nursery-fixated, but integrated—in the whole human being.

Of course, this will demand actors and actresses who are extraordinarily aware of their own exhibitionism. Actors and actresses not worried about their prestige. Or, rather, actors and actresses who regard their task as so important that they are willing to endure seeing their prestige annihilated in storms of scandal. Such actors and actresses aren't exactly waiting around the next corner. All this would require far too great a degree of self-exposure on their parts.

The director, on the other hand, lives in safety behind the camera. Not much self-exposure is demanded of him—just a marvelous divining rod for what is artistically important.

10) Until that happens, we shall remain stuck in the porno swamp as though in mud. We shall have to put up with these amateurs with lifeless faces from *The Language of Love* to the latest American pornographic films. Men and women with rigid expressions—prepared to yield their bodies and genitals, but incapable of delivering any vestige of psychological expression, apparently in a state of emotional drought. In any case, in a state of performance atrophy—helpless before the camera, utterly stymied.

For only first-rate actors and actresses can bring off truly human depiction. No amateur in the world can replace them when it comes to portraying composite emotions.

11) A little prettifying might possibly occur. A little tidying of the facade, more elegant camera work and photography, but that won't alter the essential issue. *Emmanuelle* is lusciously presented but exploits precisely the factors I've been discussing—expressionless

amateurs in the leading roles—to create the pornographic effect, nothing else. In addition, the film makes use of all the draping cliches of the pornography industry—all bodies are wrapped in candy hues as for the boudoir. Veils, the atmosphere of the harem—no offensive freshness. Therein its fitness for decent company, and therein the reason for its commercial success—this is porno that is presentable everywhere, in proper, first-run movie houses.

And, sure enough, my mailbox begins to rattle. Hollywood postmark: "Paramount Pictures would like to make a sophisticated pornographic film a la *Emmanuelle*. Have you got any ideas?"

12) I get into a discussion with an expert on literature. He apparently doesn't go to movies very often or know much about films, but he's dealt with fiction all his life; he's an associate professor of literature. I inform him of my views, and he lashes out: "What's stopping you from using Bibi Andersson's face with another body, from being anatomical and revealing via various tricks? Surely, you don't really believe that you have to be absolutely true as a director in order to make an artistically true film that presents the whole human being! Or that one can't present the whole human being without showing X-ray sequences of abdominal tremors during coital thrusts."

I gape in amazement. He reads my text about a marriage, and ends up in "anatomical" and "X-ray sequences of coital thrusts." Is it *that* hard to understand what I'm getting at? Or is the subject so sensitive that not even a wise, sober-minded, aesthetically schooled person can control his runaway imagination?

13) For a long time, the idea haunted the film industry that sex sells best if it's a little funky. Sound and picture can be terrible, the acting ghastly, and people still won't complain. On the contrary, that's how they *want* it—sleazy, semi-squalid, vulgar, and by all means a bit disgusting.

Drain the swamp and you'll lose your customers. Air out the staleness and you'll sell fewer tickets. Hence, the amazement over the success of *Emmanuelle*. Look! The same content but in a deluxe package. *That's* what people want! So let's get a move on and make more!

14) Porno is a reducing to essentials. Porno is make-believe. Porno is unreality. So goes the thesis.

Art, on the other hand, has to do with reality. It is prismatic, contradictory, multilayered. And so? And so they inevitably collide—art and porno. The more the artist succeeds in integrating sex into his human depiction, the more prurient interest wanes.

There they stand in the doorway, he and she, some time in the future, eye to eye, naked before each other—and the camera takes in their entire marriage, their erotic biography, as well. They are multifariously depicted—socially rooted, psychologically distinct, politically distinct. Prurient interest thereupon slinks around the corner—it cannot manage to embrace the total human being. It is disturbed by reality; it is irritated by complications, ordinary, human complications.

It was the selfsame prurient interest that was such a ticket-seller, wasn't it? Then what about "integrated sex" when it comes to *business*?

15) I have my own authority on the subject—theatre owner Ljunggren. He shakes his head. "Integrated sex? Shit, that won't sell more tickets for you. And if they won't sell any more tickets for you, then what's the point of these newfangled gimmicks?"

"Artistic achievements?" Sure! But that's not the sort of thing Ljunggren deals with. So I ended my discussion with Ljunggren. I devoted myself to pondering at my desk instead.

My thoughts about "integrated sex"? Those I placed in a box labelled PRIVATE DREAMS.

FOR THE SELF-EXPRESSION OF THE ARAB WOMAN (France, 1978)

Heiny Srour, Salma Baccar, and Magda Wassef

[First published in *CinemArabe* 10–11 (1978). Published in English in *Cineaste* 9, no. 4 (1979): 37.]

Heiny Srour, a London-based Lebanese filmmaker who was the first Arab woman to have a film—*Saat el Fahrir Dakkat* (*The Hour of Liberation*, Lebanon, 1974)—selected for the Cannes Film Festival; Salma Baccar, a Tunisian director; and Magda Wassef, an Egyptian film historian, issued this manifesto on the plight of women and women filmmakers in Arab countries in the late 1970s. They called for support and funds for women filmmakers in the face of rampant patriarchal systems of representations in the cinema that were rampant on both the left and right.

There are numerous obstacles which limit the self-expression of the Arab woman, among them:

- A feudal culture now fused with a bourgeois culture which represents the woman as a sexual object and an inferior, immature being. This image is reproduced through all means of expression, including progressive ones. In this way the woman is conditioned from birth and prepared for a subordinate role. As a result, she loses confidence in herself and society fails to help her develop her intellectual capacities.

- The economic dependence of the woman, trapped at the bottom of the professional ladder, further interferes with her intellectual development.

The legal social status of the Arab woman reinforces this state of dependence; family pressures are followed by marital pressures.

In such conditions it is not surprising how few Arab women have succeeded at realizing themselves through the cinema. The few films which they have made have been

produced under very difficult circumstances. Producers are doubly hesitant when it comes to entrusting millions of dollars to a woman. The difficulties faced by a woman who has decided to express herself through image and sound can be enormous, especially if she is working on her first film.

Given this situation, the three of us—a filmmaker, a critic and a technician in the Arab cinema—have decided to establish an "Assistance Fund" for the self-expression of the Arab woman in the cinema. A yearly prize of 10,000 ff (about $2500) will be awarded to the best script for a short film from those proposals submitted by Arab women undertaking their first film. The prize money will be raised by donations from all those who support women's right of self-expression.

Contributions can be sent to Magda Wassef, 32 rue Lecourbe, 75015 Paris, France.

MANIFESTO OF THE WOMEN FILMMAKERS (West Germany, 1979)

Verband der Filmarbeiterinnen (Petra Haffter, Christiane Kaltenbach, and Hildegard Westbeld)

[First released in October 1979 by Verband der Filmarbeiterinnen in response to the Hamburg Declaration. First published in English in Eric Rentschler, ed., *West German Filmmakers on Film: Visions and Voices* (New York: Holmes and Meier, 1988), 5. Trans. Eric Rentschler.]

A response to the "Hamburg Declaration of German Filmmakers" (see chap. 2 in this volume), this manifesto foregrounds the fact that, despite the rosy picture painted in the latter manifesto, there was still much to be done in terms of the inclusion and support of women in the West German filmmaking community and to counteract the inherent sexism of the industry.

The Association of Women Filmmakers takes the liberty of expanding the Hamburg Declaration of the German Filmmakers to address the demands of women filmmakers. We demand:

1. 50 per cent of all funds for films, production facilities and research projects;
2. 50 per cent of all jobs and training places;
3. 50 per cent of all committee seats;
4. Support for distribution, sale and exhibition of films by women.

Over eighty women film workers from the Federal Republic and West Berlin have signed.

Who we are—the women filmmakers—and why we have organised ourselves has been specified in the constitution of the Association of Women Filmmakers.

From the constitution of the Association:

1.1. Women filmworkers are all women who are or will be working in the film and audio-visual media sectors.

2.2. The goal of the Association is,

— to support, promote and distribute all films by women, which are committed to feminist, emancipatory and non-sexist forms of representation and goals;

— to keep records of, catalogue and, if possible, archive both old and new films by women;

— to contribute to and help out with the publication of reports, journals, books, leaflets and information sheets about women filmmakers and women in film;

— to support women filmmakers in the pursuit of their work by providing information and advice and by maintaining a constant exchange of information;

— to cooperate with both national and foreign institutions and groups with related objects . . .

WIMMIN'S FIRE BRIGADE COMMUNIQUÉ (Canada, 1982)

Wimmin's Fire Brigade

[Issued 22 November 1982.]

The "Wimmin's Fire Brigade" emerged in Vancouver, British Columbia, as an offshoot of the so-called Squamish Five, an anarchist, urban guerrilla group that went by the name Direct Action and undertook a series of bombings. The "Wimmin's Fire Brigade" emerged in order to attack a chain of stores called Red Hot Video, which rented porn videos, many of which women's groups considered exploitative; the stores were also accused of distributing "snuff" films. The group destroyed one store with firebombs and partially burned down another. These attacks greatly destabilized the chain, leaving only one outlet, which finally closed in Victoria, BC, in 2012.

We, the Wimmin's Fire Brigade, claim responsibility for the fire bombing of three Red Hot Video outlets in the Lower Mainland of British Columbia on November 22, 1982. This action is another step towards the destruction of a business that promotes and profits from violence against wimmin and children.

Red Hot Video sells tapes that show wimmin and children being tortured, raped and humiliated. We are not the property of men to be used and abused.

Red Hot Video is part of a multi-billion dollar pornography industry that teaches men to equate sexuality with violence. Although these tapes violate the Criminal Code of Canada and the B.C. guidelines on pornography, all lawful attempts to shut down Red Hot Video have failed because the justice system was created, and is controlled, by rich men to protect their profits and property.

As a result, we are left no viable alternative but to change the situation ourselves through illegal means.

This is an act of self-defense against hate propaganda. We will continue to defend ourselves!

THOUGHTS ON WOMEN'S CINEMA: EATING WORDS, VOICING STRUGGLES (USA, 1986)

Yvonne Rainer

[First published in the *Independent* (US) 10, no. 3 (1987).]

This manifesto by Yvonne Rainer is more tentative in its conclusions than most but also acts as a celebration of the manifesto form itself. Echoing the polyvocality of her films—such as *The Man Who Envied Women* (USA, 1974), *A Film about a Woman Who . . .* (USA, 1985), and *Privilege* (USA, 1990)—Rainer outlines a series of thematic, aesthetic, and theoretical oppositions that pervade feminist filmmaking, arguing for the compelling need for all these contradictions to flourish in feminist works. She then examines her own process of continuously undercutting easy binaries in her own work.

Polemics and manifestos having always served as spark plugs to my energies and imagination, I've been surprised when, following their publication, such statements were taken with what seemed to be excessive seriousness. Thus, in the mid-'60s, when I said "no" to this and "no" to that in dance and theater, I could not foresee that these words would dog my footsteps and beg me to eat them (or at least modify them) for the next twenty years. Such may be the case with my more recent stance toward/against/for narrative conventions in cinema. Raised, as I have been, with this century's western notions of adversarial aesthetics, I continue to have difficulty in accommodating my latest articulation of the narrative "problem"—i.e., according to Teresa de Lauretis's conflation of narrativity itself with

the Oedipus complex, whereby woman's position is constantly reinstated for the consummation or frustration of male desire. The difficulty lies in accommodating this with a conviction that it is of the utmost urgency that women's voices, experience, and consciousness—at whatever stage—be expressed in all their multiplicity and heterogeneity, and in as many formats and styles—narrative or not—from here to queendom come and throughout the kingdom. In relation to the various notions of an avant garde, this latter view, in its emphasis on voicing what has previously gone unheard, gives priority to unmasking and reassessing social relations rather than overturning previously validated aesthetic positions. My personal accommodation becomes more feasible when it is cast in terms of difference rather than opposition and when the question is asked, "Which strategies bring women together in recognition of their common and different economic and sexual oppression, and which strategies do not?" The creation of oppositional categories of women's film or video, or, for starters, film *and* video, begs this question.

For what it's worth, here is a list of useless oppositions. Documentary versus fiction. Work in which the voices carry a unified truth versus work in which truth must be wrested from conflicting or conflicted voices. Work that adheres to traditional codes versus work in which the story is disrupted by stylistic incongruities or digressions (Helke Sanders' *Redupers*, Laura Mulvey and Peter Wollen's *Riddles of the Sphinx*). Work with a beginning, middle, and end versus work that has a beginning and then turns into something else (Marguerite Duras's *Nathalie Granger*). Work in which the characters run away with the movie versus work whose characters never get off the ground (Rabina Rose's *Nightshift*). Work in which women *tell* their herstories (Julia Reichert and Jim Klein's *Union Maids*) versus work in which they parody them (Ana Carolina's *Hearts and Guts*). Work that delivers information in a straightforward manner (Jackie Ochs's *Secret Agent*) versus work in which information accrues slowly, elliptically, or poetically (Trinh Minh-ha's *Naked Spaces*). Work in which the heroine acts versus work in which she does nothing but talk (my *Journeys from Berlin*). Work in which she triumphs versus work in which she fails (Valerie Export's *Invisible Adversaries*). Work in which she is a searcher or dominatrix (Bette Gordon's *Variety*, Monika Treut and Elfi Mikesch's *Seduction: The Cruel Woman*) versus work in which she is a victim (Lynne Tillman and Sheila McLaughlin's *Committed*). Work whose heroines you like (Connie Field's *Rosie the Riveter*, Julie Dash's *Illusions*) versus work whose heroines repel you (Doris Dorrie's *Straight to the Heart*, Chantal Akerman's *je, tu, il, elle*). Work in which you nearly drown in exotic signifiers of femininity (Leslie Thornton's *Adynata*) versus work whose director can't figure out how to dress the heroine, so removes her altogether (my *The Man Who Envied Women*). *All* these films share a potential for political purpose and historical truth.

I could go on *ad infinitum* with these divide-and-conquer oppositions. There is one other example I'm not going to give equal footing with the others but will mention in passing only insofar as it bears a deceptive resemblance to the others: Films in which the heroine marries the man versus films in which she murders him. We have only to look in vain for recent films by women that end in marriage to realize what a long way we've

come, give or take the baby. Marriage at the beginning maybe, but at the end, never. I challenge anyone to name one in recent memory. Murder, on the other hand, is a different story. As Joan Braderman pointed out last spring at the *Gender and Visual Representation* Conference at the University of Massachusetts, in the past ten years a substantial number of women's films have been produced that focus on a murder of a man by a woman or women. To name a few: Akerman's *Jeanne Dielman,* Marlene Garris's *A Question of Silence,* Dorrie's *Straight to the Heart,* Sally Heckel's *A Juror of Her Peers,* Margaretha Von Trotta's *Sheer Madness.*

The phenomenon of man-murder in women's films points to the problematic of representing men. Do we wreak revenge on them (if for no other reason than the cinematic sway they have held over us for so long), turn the tables on them, turn them into celluloid wimps, give them ample screen time in which to speak self-evident macho bullshit, do away with them by murder within the story, or eliminate them *from* the story to begin with? Do we focus on exceptional men who escape the above stereotypes, or do we weave utopian scenarios in which men and women gambol in egalitarian bliss? Lynne Tillman and I pondered the question of whether it is politically useful to allow ourselves to be fascinated with men in our films even as we discussed the strange fascination with the 1986 World Series that had befallen the two of us along with every woman we know.

Following one screening of *The Man Who Envied Women,* a well-known feminist who subscribes to Lacanian psychoanalytic theory asked me why I hadn't made a film about a woman. I was flabbergasted, having been under the impression that I had done just that. But she, taking the title literally and taken in by the prevailing physical presence of the male character, had discounted the pursuing, nagging, questioning female voice on the soundtrack. By staying out of sight my heroine is never caught with her pants down. Does this mean the film is not *about* her?

It's also been noted that my female characters are not heroines. I would qualify that: My heroines are not heroic. They are deeply skeptical of easy solutions and very self-critical, constantly looking for their own complicity in patriarchal configurations. But neither are they cynical or pessimistic. The moments I like best in my films are those that produce—almost simultaneously—both assertion and question. Early on in *TMWEW* the assertion that women can't be committed feminists unless they give up men is uttered as part of a conversation, overheard by a man in the foreground, by a woman who is testing her female companion by quoting yet another woman whose relationship to the speaker is not identified and who never appears. The two speakers are also anonymous and are never seen again once this scene is over. I, the director, am not trying in this scene to persuade my audience of the rightness or wrongness of the statement. What is important is that it be given utterance, because in our culture, outside of a convent, giving up men freely and willingly—that is, without the social coercion of aging—is a highly stigmatized act or downright taboo. The linkage of giving up men, in this scene, with commitment as a feminist, however, is distanced and made arguable through the device of having the spectator become an eavesdropper on the conversation along with the

foregrounded male character, then distanced once more through quotation. "*She told me,*" says this minor, will-o-the-wisp heroine, "that I would never be a committed feminist until I give up men."

Whether an utterance comes across as feminist prescription, call-to-arms, or problem-articulated-ambiguously-to-be-dealt-with-or-not-later-in-the-film is always on my mind in the collecting and framing of texts. If the experience of watching certain kinds of social documentaries is like watching the bouncing ball come down at exactly the right moment on the syllables of the familiar song, watching a film of mine may be more akin to "now you see it, now you don't." You never know when you're going to be hit on the head with the ball, and you aren't always sure what to do when the ball disappears for long stretches of time.

Which brings me to what might be called a method of interrogating my characters and myself when I set out to make a film. Thinking about this has been facilitated by rereading Bill Nichols' essay, "The Voice of Documentary," which poses certain questions that are relevant to both fiction and documentary. To what degree are we to believe a given speaker in a film? Do all the speakers convey a unified vision of a given history? Do the speakers emerge as autonomous shapers of a personal destiny or as subjects conditioned by the contradictions and pressures of a particular historical period? To what degree does a given film convey an independent consciousness, a voice of its own, probing, remembering, sustaining, doubting, functioning as a surrogate for our own consciousness? Do the questioning and believing of such a film question its own operations? Does the activity of fixing meaning in such a film refer to relations outside the film—"out there"—or does the film remain stalled in its own reflexivity? Is reflexivity the only alternative to films that simply suppose that things were as the participant-witnesses recall or state them, or as they appear to the spectator, in the case of fiction films?

Finally: Should a film whose main project is to restore the voice and subjectivity of a previously ignored or suppressed person or segment of the population, should such a film contain argument, contradiction, or express the director's ambivalence with the film either directly, or indirectly, through stylistic interventions? Obviously, we can't afford to be prescriptive about any of this.

My own solution runs to keeping an extradiegetic voice, a voice separate from the characters and story, fairly active in every scene. It need not take the form of a narrating voice, although it often does. Sometimes it takes the form of a *Til Eulenspiegel*-like disruption, as when an anonymous woman enters the frame just before a troubling bit of sexual theory is enunciated, peers into the camera lens, and asks all the menstruating women to leave the theater. Sometimes it operates like a kind of seizure, producing odd behavior in a given character, as when the analyzed in *Journey to Berlin* speaks in baby-talk. Often it comes across in reading or recitation, which has the effect of separating the voice of the character from that of the author.

At this historical moment we still need to search out and be reminded of suppressed histories and struggles: prostitutes, housewives, women of color, lesbians, third-world

people, the aging, working women. The method of representing these histories is a separate and equally important issue. I see no reason why a single film can't use many different methods, which is something I've been saying for years but didn't come close to realizing until *TMWEW*. In this film fictional and documentary modes come into play more fully than in any of my previous work, offsetting the calculation of my still-cherished recitations and readings with the immediacy of dramatic and documentary enactment. These last are, admittedly, the strategies that offer the spectator the most powerful sense of the real. But reality, as we *so* well know, always lies elsewhere, a fact that we nevertheless endlessly seek to disavow and from which we always retreat. I shall continue to remind us of that disavowal by challenging reality's representational proxies with assorted hanky-panky. I hope others continue to do likewise and otherwise.

THE POST PORN MODERNIST MANIFESTO (USA, 1989)

Annie Sprinkle, Veronica Vera, Frank Moores, Candida Royale, Leigh Gates

[Signed in June 1988 in Veronica Vera's apartment in New York City. Published in Annie Sprinkle, *Post-Porn Feminist* (Berkeley, CA: Cleis Press, 1998), 213.]

A sex-positive and anticensorship manifesto at a time when the HIV/AIDS pandemic and AIDS hysteria drove the discourses surrounding representations of sexuality, "The Post Porn Modernist Manifesto" arose in the shadows of the Reagan administration's Meese Commission Report on Pornography, the same government's deathly silence on HIV/AIDS, and the unholy alliance between right-wing evangelicals and antiporn feminists that drove much of the debates surrounding pornography in the 1980s.

Let it be known to all who read these words or witness these events that a new awareness has come over the land. We of the Post Porn Modernist Movement face the challenge of the Rubber Age by acknowledging this moment in our personal sexual evolutions and in the sexual evolution of the planet.

We embrace our genitals as part, not separate, from our spirits.

We utilize sexually explicit words, pictures, performances to communicate our ideas and emotions.

We denounce sexual censorship as anti-art and inhuman.

We empower ourselves by this attitude of sex-positivism.

And with this love of our sexual selves we have fun, heal the world and endure.

STATEMENT OF AFRICAN
WOMEN PROFESSIONALS OF
CINEMA, TELEVISION AND VIDEO
(Burkina Faso, 1991)

FEPACI (Fédération panafricaine des cinéastes)

[Released at the conclusion of "The African Women's Workshop" held at the 12th
FEPACI (Fédération panafricaine de cinéastes) conference, Ouagadougou, 25 to 27
February 1991. Published in Imruh Bakari and Mbye Cham, eds., *African Experiences
of Cinema* (London: BFI, 1996), 35–36.]

Issued as part of the FEPACI conference in 1991, this statement puts into stark con-
trast the marginalized role played by African women in African cinemas, which already
exist at the margins of world film cultures, as evidenced by the Niamey manifesto
(see chap. 3 of this volume), also issued at a FEPACI conference.

After fifty years of cinematographic production and twenty-five years of televisual produc-
tion, how many women are involved? What positions do they occupy and what roles do
they play?

After fifty years of cinematographic production and twenty-five years after televisual
realisation, what images of African women are shown to women of this continent, and
how much have the latter contributed to challenge the established clichés . . . without
women's participation in supervisory positions?

After a half-century of cinematographic production and a quarter-century of televisual
productions, how many pioneers are there? And where are those female pioneers and
film directors who could have been in a position to give their own vision of the world?

The African women's workshop held within the framework of the 12th edition of
FESPACO [Panafrican Film and Television Festival of Ouagadougou] in Ouagadougou
from 25 to 27 February 1991 gathered together a diversity of African film, television and
video professionals.

They came from various African countries and from the Black diaspora: Kenya, Tan-
zania, Zimbabwe, Ghana, South Africa, Nigeria, Burkina Faso, Benin, Tunisia, Camer-
oun, Niger, Côte d'Ivoire, Mali, Rwanda, Congo, Morocco and Chad.

These women fulfil the functions of editors, camerawomen, directors and producers
of televisual programmes, video-makers, film-makers, distributors, compères-producers
in television, producers, actresses.

But even after fifty years of cinematographic productions and twenty-five years of
televisual production, though they fulfil various functions in cinema and television, the
analysis of African women's situation during this workshop has emphasised their insig-

nificant number in audiovisual professions and their difficulty in getting access to training and funds.

It is evident from the testimonies presented over these last three days that even when a woman wants to work in cinema and television professions she is often advised to stick to the latter because they suit her better as they require an attention to detail which is believed to be specifically part of women's character.

So half a century after the beginning of African cinema, a quarter of a century after those of television, the position of women in the various posts in cinematographic and televisual production is far from being satisfactory! Far from being up to the challenge of the third millennium.

And if this situation continues the cinematographic and televisual industry's growth, and even its development, could be hampered.

For if pictures produced by African women do not give another view on African women's reality, then there is a great risk that women themselves, because they are the main educators of children—the citizens of tomorrow—will not he able to show an alternative vision of the world.

Fifty years after the beginning of cinema, twenty-five years after that of television, inequalities and obstacles still persist.

In 1991, almost ten years before the year 2000, African women are still victims of pressures at their place of work, and exploited both as women and as professionals.

In 1991, almost ten years before the third millennium, because they are deprived of their citizenship rights, their access to cinema and television professions remains selective, discriminatory and minimal!

Nevertheless, in 1991, African professional women of cinema and television and video decided to meet in order to exchange their views, to create a framework for free expression, to elaborate an action programme to speed up their integration at all the levels of the production process of cinema and television. A half-century after the birth of cinema, a quarter of a century after that of television, about fifty women from various areas of the continent, fifty women of different political, religious and philosophical backgrounds united for the sake of their professional requirements to express their will to struggle unflinchingly:

—to put forward their female vision of the world;

—to have a controlling position on their pictures.

They decided to set up a working group, a programme of action, in order to continue the action of a few isolated pioneers so that in the future, in the year 2000, there are 10, 50, 100 . . . 1,000 of them and more in the professions of cinema and television.

They call on funding and commissioning organisations from the South and the North, on institutions and associations to give their active, constructive and collaborative support for the development of their projects.

They know that a mobilisation of funds, of human resources, from the South and the North, and mainly women's determination, initiative and responsibility may help to overcome the obstacles!

The working panel is made up of the following members: Aminata Ouedraogo (Burkina Faso), director-producer; Grace Kanyua (Kenya), director-producer; Juanita Ageh-Waterman (Nigeria/London), actress; Alexandra Akoto Duah (Ghana), actress; Sepati Bulane-Hopa (South Africa), director-distributor; Chantal Bagilishya (Rwanda/Paris), distributor; Rose-Elise Mengue-Bekale (Gabon), editor; Kahena Attila (Tunisia), editor.

PUZZY POWER MANIFESTO: THOUGHTS ON WOMEN AND PORNOGRAPHY (Denmark, 1998)

Vibeke Windeløv, Lene Børglum, Gerd Winther, Lili Hendriksen, Christina Loshe, and Mette Nelund

[First released as a manifesto by Zentropa in July 1998.]

After the success of Dogme '95 (see Trier and Vinterberg, "Dogme '95 Manifesto and Vow of Chastity," in chap. 2 of this volume), Lars von Trier and Zentropa, his Danish production company, started producing other manifestos in order to reimagine other genres of cinema. One such manifesto was the "Puzzy Power" manifesto issued in 1998, which championed porn from a women's perspective. Three films have been produced following the manifesto thus far: *Constance* (Knud Vesterskov, Denmark, 1998), *Pink Prison* (Lisbeth Lynghøft, Denmark, 1999)—both of which became porn video bestsellers in Scandinavia—and *All About Anna* (Jessica Nilsson, Denmark, 2005). The "Puzzy Power" manifesto argues that the reason women do not typically like porn is not because it is hardcore but because the films often degrade women. "Puzzy Power," therefore, argues for a feminist hardcore pornographic aesthetic. Unlike the Dogme manifesto, Puzzy Power contains both rules to follow and tropes to avoid ("*What we hate* . . . is the oral sex scene where the woman is coerced to perform fellatio, her hair pulled hard, and come is squirted into her face."). In other words, it combines both the "shalls" and "shall-nots" of manifesto writing.

In the last few years a new generation of women have begun to make themselves felt. Women who have grown up with another attitude to their own bodies and sexuality than used to be the norm. Advertising agencies have been using the male body as a sex symbol along the same lines as the female body for ages, and male striptease acts playing to packed houses emphasise that there are women with the courage to say out loud that they

enjoy looking at a beautiful man's body. This tendency has not yet seriously made its mark in the arts or the pornographic movie.

Traditionally, the blue movie has always been directed exclusively at male wishes and fantasies. So traditional productions tend to be played out in a world that represses women, where the male is all-dominant, drags the woman round by the hair and subjects her to one degrading act after another. Indications are that the general lack of interest shown by women in sexually explicit movies is not so much because they are put off by seeing sex depicted graphically, but by the degrading situations that are inevitably associated with pornography.

The time has come to recognise that women can do and want to do more than has been acknowledged hitherto, and that women can do more and want to do more as regards pornography. There is an increasing tendency for couples to watch sexually explicit material together as a source of mutual inspiration, and it has become completely acceptable to say out loud that women can be sexually stimulated by watching sex depicted in ways that make room for their own kinds of fantasies. But there aren't really any products on the market that consider the woman's point of view as regards these areas.

To meet this need we intend to produce a series of films that present sensuality (or sexually explicit material, if you like) in a way that appeals to women. To serve this end, a group of women have drawn up a statement (see below) on what women would like to see and what they would not like to see in sensual/pornographic movies. This statement is intended to be the "dogma" for Puzzy Power's productions.

Other characteristic traits of our output will be proper plots and artistic content, featuring three-dimensional characters. The whole film unit will be made up of "real" filmmakers who are used to working on fiction for the cinema.

Our films will primarily be produced with a view to video and television distribution. They will not initially be aimed at cinema audiences, but each will be made so that a decision on cinema release may be taken when the time is ripe.

The films will be marketed as trendy and "in," a product you'll be happy to have on your coffee table or video shelf.

Puzzy Power, July 1998.

THE MANIFESTO

The following guidelines were developed by Zentropa in 1998 for the films *Constance* and *Pink Prison* and were also applied as a basis for *All About Anna:* Women like watching erotic or pornographic films if the presentation turns them on rather than off.

PLOT

The films must have plots. Individual sequences must be linked into a logical chain of emotions, fantasies, passions, et cetera so we can relate to the characters and what goes

on between them. It is not enough for four unknown actors to enter stage right, drop their pants and simply get down to it unless this is obviously part of a fantasy or a set-up in which the titillation is inherent in this very occurrence. The plot must be about something erotic. It must not be too extensive or contain too many "non-erotic" components, thus making us forget the erotic aspect and causing the fire to die down. Films must not be too lengthy—short plots are preferable. The plot may spring from one or more female fantasies or situations that could occur in everyday life.

EROTICISM

Feelings, passions, sensuality, intimacy, and the lead-up must be emphasised. The films must be based on woman's pleasure and desire. The senses must be aroused, a play made of titillation, distance and closeness. The woman must be turned on, and her anticipation be built up into insurmountable lust, as the joys of anticipation are and will always be the greatest.

VISUAL STYLE

Images of bodies must be shown that caress the body and its erotic details. The erotic aspect may well lie elsewhere than the genitalia. We must see the beauty of the body, of the male body, too, and he is welcome to offer his body up to us. The body need not be completely naked, as partial concealment can be far more erotic.

SETTING

The films may be set in the past or present. Time and place are not crucial; what matters is what happens in the films. A bared shoulder or ankle can be powerfully erotic, and this kind of slightly "old-fashioned" sensuality may well be incorporated into films set in the present day.

HUMOUR

Subtle humour is welcome; perhaps a comic sequence at the start of a film to break the ice—but fun must not be poked at the sexual act itself.

WHAT IS NOT ALLOWED

There are no restrictions on what may be depicted in the films as long as it is presented in an acceptable way. The only limit is that women must not be subjected to violence or coercion against their will. However, it is fully acceptable to film female fantasies in which the woman is raped/assaulted by an anonymous man/a bit of rough trade, or if it is clear

from the plot that what we are seeing is a woman living out her fantasy, perhaps by agreement with her significant other.

What we hate . . . is the oral sex scene where the woman is coerced to perform fellatio, her hair pulled hard, and come is squirted into her face.

CINEMA WITH TITS (Spain, 1998)

Icíar Bollaín

[First published in Spanish as "Cine con tetas," in Carlos F. Heredero, ed., *La mitad del cielo: Directoras españolas de los años 90* (Málaga: Primer festival de cine español de Málaga, 1998), 51–53. Trans. Fabiola Caraza.]

In this highly ironic manifesto, Spanish filmmaker Icíar Bollaín, director of *Te doy mis ojos* (*Take My Eyes,* Spain, 2003) and *También la lluvia* (*Even the Rain,* Spain, 2010) argues against the very notion of a women's cinema, challenging some of the paradigms of feminist film theory and claiming that the cinema ought to be judged without any recourse to the gender of the filmmaker.

The difference between men and women is basically that men are men and we are women. Men have dicks and we don't. We have tits and they don't. We also have more of a waist and they have less of an ass (some, anyway). And even though it seems obvious, when we make films it turns out everything gets complicated and the media, that is, the ones that actually tell (some of) what happens, scratch their heads and ask us, ask themselves, do two tits see the same as the small ass when they look through the lens?

Is a sequence put together differently when you have a dick? What does the extra bit of waist think of the score? These are metaphysical doubts because the whole world knows it is not the same to sit down with a pair of balls between your legs than without them, whether it is before a moviola or the members of Congress.

But that is the way it is every time films are made, there are questions. In reality the questions arise when they see our tits, I mean the director's tits, because when they see their dicks, I mean the director's dicks, questions don't exist. But questions exist for us, because we notice the difference between directing with or without a dick. (I still don't understand why. Maybe those who have changed sex understand.) Or perhaps it is that they think that something is missing (a dick) and that is why they question how we feel. I feel good thank you.

In any case we are questioned a lot, it must be that they are concerned. It must be that they are overwhelmed by the idea of watching a film made by tits, maybe they think they are going to lose ground, and rightly so, because it should be noticed that there is no other

cinema than the one made by women, let the boys do something too! They might also think they are going to see things from a different perspective and that scares them, now that everything was so organized and explained, every stereotype in its place. Now that we had it clear who was the hero, who was the beauty and who was the bad guy, it seems we came to muddle everything. Perhaps they think one should have a different attitude for a different cinema, cinema with a waist, cinema with more ass and of course, cinema with tits. Perhaps they think one should sit and watch it differently, sitting sideways or crossing the legs a little. Maybe it is they don't know where to put their balls. It happens a bit as well with the cinema they call queer, black, poor. . . . They don't know what to do with their balls. Maybe to air them out would end the problem, or if they choke on them with fear, or if they shrink with excitement, or that they fall off with sadness. . . . Maybe it is best one does not know what to do with one's balls when watching a film with a different perspective. Maybe it is not so serious not to know what to do with them if you take into account that half of the world does not have balls. Maybe it is not so important to have balls.

For example, besides having tits, we are from around here, the Mediterranean area that is, which can also set us apart from other cultures. But nobody questions that, it is assumed, because being European just like having a dick is assumed. I suppose those from other continents will ask themselves what is it like not to be European, even though, in the case of having a dick it's only half the world, in this case non-Europeans are many more.

In the same way, being even more in the minority, we are also asked quite often, this time to all of us, tits and dicks of the entire world, what do we think of not being American and making films outside of Hollywood.

There is the need to have a clear point of reference and a moral scale. Mine is very simple. I like to hear about people, I like to hear how we function, I like to understand what I know and know what others think and feel, I like to hear about something I don't know as if I've already lived it and something I know from a new perspective. I would like to make films that way. We should all be able to make them that way.

Maybe one day we will see a woman as a Member of Congress, a gypsy actor in the role of the General Manager of the Bank of Spain and a black girl following the yellow brick road to talk to a homosexual Wizard of Oz without shocking anyone. But most of all, maybe no one will ask themselves what it would've been like to have that story told by a white, heterosexual man, because that would only be one way of telling a story. Fire, directed by an Indian woman, The Butcher Boy, by an Irish man, . . . by a woman and Suburbia directed by a North American man. I don't know what weighs more in Fire, the fact of being Indian or being a woman or the experience of working as a TV director or . . . and what weighs more in The Butcher Boy, Ireland, that it was based on a novel, the director, the writer? Suburbia was previously a play . . . Cuba the result of three months of shooting without a script. . . . All of them see and matter, each from their perspective, each different from each other. It is more important knowing how to watch than to know how to photograph, says Eve Arnold after a life of watching the world and photographing it.

It is no less important that the possibility exists for equal regard of all notable works.

MY PORN MANIFESTO (France, 2002)

Ovidie

[First published in the *Guardian* (UK), 12 April 2002.]

Another example of a sex-positive, feminist response to pornography by, in this case, former European porn star Ovidie. Entering porn as a militant feminist, and with a background in choreography, dance, and philosophy, her ideas about pornography changed as she met women actors in the industry. She now directs and produces porn by and for women and feminist documentaries such as *Rhabillage* (France, 2011), produced by Jean-Jacques Beineix, which examines the endemic sexism demonstrated toward former porn actresses in France once they leave the industry.

Why did I become a porn star? Let's get two clichés out of the way: it wasn't for the money or for the sex. Whatever you may have heard, making pornographic films in Europe is not a license to print money.

In many countries, the adult video market is dying. With cinemas refusing to screen pornography and producers ineligible for government grants, the main source of income is now television rights. Some "big-budget" films (i.e., those costing about 100,000 euros) take several years to turn a profit.

The economic collapse of the pornographic movie industry (though not of porn websites or amateur videos) has naturally hit the earnings of the genre's workers: actors, directors and technicians. To put it bluntly, it's not financially attractive to be an actress in blue movies, unless you come from a part of the world where living standards are very low, like certain countries in Eastern Europe. That's not my case.

I am one of the lucky ones who have never really suffered from a lack of money. I grew up in an upper middle-class family, and when I began to practice my profession I was a comfortably-off philosophy student newly married to a teacher. My motivation, then, was not money.

Sex? That neither. I have never been an exhibitionist, I don't get my kicks turning men on, I'm not a swinger. On the contrary, I'm rather against sharing one's sexuality with all comers, and believe that the true richness of a sexual act lies in the emotional relationship with the other person.

Nor is my job a turn-on for my husband, who prefers monogamy. I should also point out that porn actors often experience no sexual pleasure while filming. I don't deny that it can happen, but it's not an objective. As in any film genre, the action is not reality but spectacle—and hence false. Acting out a sex scene is still acting.

If I am to properly answer the huge question "Why did I become a porn star?" I must answer a series of little whys.

Why did I start watching pornographic movies? At the time I was a very active militant feminist. The groups of which I was a member firmly condemned porn films. But I soon realized that everything that I and my colleagues professed was founded on consensual clichés. None of us knew anything about the films, either as a spectator or as a participant.

That was the main reason I began to rent adult films: I wanted to know what they contained that was so terrible. And the first films I saw were not at all what I had imagined. The actors' bodies were not caricatures; the women were not submissive but powerfully charismatic; equal emphasis was placed on both male and female pleasure; and the picture quality and direction were sometimes excellent.

Why did I decide to act in these movies? I began to think that feminism and pornography might not be incompatible after all. Since feminists' battleground is sexuality, they have to become involved in its representation—and therefore in pornographic movies. All these new ideas led me into a world where these women whom I had once pitied now seemed admirable and impressive. I wanted to have an equally powerful sexual image.

The other reason was my fascination with the body, as a keen amateur dancer and choreographer interested in the whole area of movement. I see a pornographic scene as a piece of choreography that involves the whole body, in which one must show the emotions by moving, by tensing one's muscles, by trembling and by letting go. It's a very interesting exercise in physical expression.

Why did I become a director? I simply wanted to put on screen my imagination and my feminist aspirations. I wanted to make films where the emotional dimension and sexual practices would be totally different in each pornographic sequence—something I only achieved with my second film, Lilith.

Why have I been so prominent in the media in the past three years, and why did I write my book, Porno Manifesto? It all stems from my militant stance and not from any desire to become a starlet and satisfy my ego. I wanted to defend a profession that is unfairly attacked from all sides, shatter the clichés, and make the public aware of a way of thinking that is all too rare in Europe: pro-sex feminism.

Why do I remain in pornography, and don't I want to move into more respectable spheres? Whatever one might expect, of all the social circles that I have known (straight cinema, art, fashion, university, advertising, TV, etc), it is in the porn trade that I feel most respected. This is a real tribe. I would rather continue in a profession that I love and that respects me than sacrifice everything to make it in a more socially acceptable— but less respectful—branch of entertainment.

Am I likely to leave the profession one day? I won't leave because I have been kicked out, or because I have been let down by my profession. Yet I regularly dream of leaving, partly because the refusal to accept pornographic movies as a proper, serious genre will

eventually be the death of it. I am saddened by the rise of pornography with no artistic merit and the squeezing out of the great directors.

I am also exhausted by the social pressure placed on sex workers—from the people who stare at you in the street, to officials, friends and relations, the media, other branches of show business, anti-porn crusaders and all those who attack us, try to exploit us, shower us with indiscreet and unhealthy questions, or consider us as victims. It's not the little world of pornography that is dangerous or disrespectful to its actors—it's the big world that surrounds it.

NO MORE MR. NICE GAY: A MANIFESTO (USA, 2009)

Todd Verow

[First published in the 2009 Program for the Teddy Awards at the Berlin International Film Festival.]

Written at the behest of the Teddy Awards at the Berlin Film Festival, this manifesto is both a history of, and an elegy for, New Queer Cinema (a term coined by critic B. Ruby Rich). Filmmaker Todd Verow recounts the history of New Queer Cinema and decries the commercialization of queer cinema and the ways in which LGBT film festivals collude in this process.

Sorry, I didn't mean to kill New Queer Cinema. I was young, innocent (well—at the least, more innocent than I am today) when I made my first feature *Frisk* (Berlinale 1996). I hated the book and I suppose, in hindsight—that's why I jumped at the chance to make the film version. I have a natural instinct to destroy in the name of creativity. Besides, we had a blast shooting a big "fuck you" to the growing political correctness of the 90's, and to the mainstreaming of gay culture which started then. A riot broke out at our screening during the San Francisco Lesbian & Gay Film Festival, the editor of *The Advocate* magazine said I should be shot, the writer of the book denounced the film and *The New York Times* declared the film the "ne plus ultra of queercore."

I had arrived in style.

To me, experimental or underground film and queer film were synonymous. When I started making short experimental films and videos, I was inspired by Kenneth Anger, Jack Smith, Andy Warhol, and the Kuchar Brothers (whom I have had the honor of getting to know, having recently acted in one of Mike Kuchar's movies *Vortex* with one of my frequent actors/co-conspirators Philly). None of these film makers gave two shits

about making it in Hollywood. Their work was about their obsessions, it was personal and more often than not, erotically charged. They were all, at one time or another, accused of being pornographic. As if that was a bad thing, as if Art and Pornography was mutually exclusive.

Pornography is when the viewer masturbates; art is when the artist masturbates. "Why can't we all jerk off together?" is what these filmmakers asked. I concur.

The beginning of New Queer Cinema was an exciting time. We were all angry little art terrorists coming out of Act-Up and Queer Nation and ready to take over the world. We weren't politicians—we were artists—so we worked from our guts, our angst and our broken hearts. I was in art school (RISD) a few years behind Todd Haynes (who studied at RISD's sister school Brown University) so I knew of him and his work. Then I went to AFI in Hollywood to study cinematography and worked with Gregg Araki on *Totally F**ked Up*. I remember being at the MOMA in NYC when *The Living End* and *Swoon* premiered at the New Directors/New Films festival and thinking wow this is something, something's happening and somehow I am in the midst of it. It was at MOMA that I first met the actor Craig Chester, we became friends and worked together many times. I went to festivals all over the world and met all kinds of interesting filmmakers, there were festivals cropping up all over the place.

After making my first feature I got a lot of positive and negative attention. Even then I was a work-a-holic and had plenty of ideas and scripts ready to go. I had lots of "meetings," lots of "interest" but I am not a used-car salesman; I lack that gene so nothing went anywhere. My creative partner, James Derek Dwyer and I were living in San Francisco, we had very little money, and he was working a temp job while I was working at the Nob Hill gay porn theater. (I would announce the live shows and make sure the performer came on stage. There was a script that I was supposed to read. I re-wrote it most of the time. Even at a strip club I was desperate to augment.) It was time to get the hell out of California, as far away from Hollywood as we could get. So we scraped together some cash, bought an extremely cheap Hi-8 video camera and moved to Boston. I got an actress friend of mine, Bonnie Dickenson, to come to Boston from Los Angeles and we shot the movie *Little Shots of Happiness* (which world-premiered at the Berlinale 1997). Bonnie was my first "superstar." James and I started our own production company, Bangor Films and we set out to make movies our way, shooting in video with no crew and a hand held camera, using only available light whenever possible and using whatever crappy sound I would capture with the camera microphone. We made the movies with no money, no outside funding. We set out to make 10 movies by the year 2000 and to everyone's surprise (including my own) we managed to do it. None of these movies were "gay films" per se, they certainly had a gay sensibility but the subject matter was not gay. I didn't really think about why that was at the time, I certainly wasn't trying to cross over into the mainstream but looking back now I think after making *Frisk,* I wasn't ready or able to make another gay film until it was something personal, something painfully real. I was ready to do that when I was single again and moved back to NYC in 2001. I bared all (not

just my ass but heart and soul) in *Anonymous* (Berlinale 2004). I decided that if I was going to take shit from people it would be for something personal. After that I delved into my own past, my own demons and make two semi-autobiographical films *Vacationland* (Berlinale 2007) and *Between Something & Nothing*. At the same time I made more experimental features like *Hooks to the Left* (which was entirely shot with a cell phone camera), *Bulldog in the White House* and *XX*. I am often working on several projects at once, it's just how my brain works and I find that my more experimental films inform my more narrative films and vice versa. I am often accused of being "so prolific" (yes, I say "accused" because usually that's the tone that the word is delivered in) as if that is a bad thing. I can't help it—I honestly have a need to make movies; (my newest feature is *The Boy With Sun in His Eyes* coming soon!) to me there is nothing more tragic than a filmmaker who wastes his/her time waiting for permission (i.e. money) to make a film.

Nowadays, filmmakers who spend years getting there [sic] movies made, making compromise after compromise to get any distorted version of their original vision on the screen are not artists, they are businessmen. Artists stay true to their vision and make their work when they are inspired. They don't think about nonsense like marketability and "who is my audience?" They don't care about money and use whatever resources they can get their hands on. They don't give a shit about critics or cultural theorists or gender politics. Fuck them all. More often than not, that's exactly what they need anyway.

New Queer Cinema could never last long. It occurred at a time when people were starved for queer images on screen and so they were willing to "put up with" more experimental, gritty, dangerous films but as soon as less adventurous filmmakers started making shiny happy films, a New Gay-sploitation Cinema took over. Tepid gay and lesbian festival programmers (and exhibitors and distributors) were quick to pick up these non-threatening, "audience pleasers" so they could sell out their opening nights and keep their boards of directors happy—but what was the cost? Why bother going to a festival when you can see these shitty movies on the new pay-per-view gay TV channels? By removing the risk and edge from their programming they also removed their purpose. But even more damning, they encouraged filmmakers to make more "commercial," "accessible" work. If there are no riots (heheheh) or at the very least, heated discussions happening at your festival's screenings then you are not doing your job. Stop programming this shit, and risk the edgier, the grittier stuff. It's out there. It isn't going away. Embrace it. The real art films resist professionalism. If you are a filmmaker worried about your livelihood then get a "real" job! Art isn't a profession. Many of my fellow Americans have long ago lost that train of thought.

So—we as filmmakers must experiment. Mistakes are what makes something art. Mistakes are life. We must resist the traditional narrative structure. Resist closure and embrace ambiguity. Embrace and nurture the audience's intelligence. Throw continuity out the window along with all other filmmaking rules. This is where DOGMA '95 got it wrong; you don't throw out old rules and impose new ones, you must throw them all out. The obsession with "technical perfection" has got to stop! We are in danger of becoming

mannerists (or just downright geeks). Go back to nature, back to life. Life is gritty, dirty, full of shit and blood and semen. It is sticky and messy, sometimes bitter sometimes sweet—sometimes all at once. Shoot with whatever means you have available, don't go chasing the latest greatest resolution, the most expensive, state of the art camera, we are not technicians we are artists. Get your hands dirty. Make ugly beautiful and vice versa. At least have the guts to do what you really believe in—and have the guts to actually believe in something. The world has plenty of (film) critics and cynics. Cynicism is boring. Get passionate. Feel something. Then go tell your audience.

This is an unprecedented, exciting time to be a filmmaker. Access to the means of production and post-production has never been so attainable. (Don't be fooled by the gate-keepers who are trying to make this less so by insisting that the only films that are worthy are the ones shot in HiDef, with the latest expensive camera and presented by the latest most-expensive projector, they are trying to beat us back—flip them the bird and flick on your cheapo Flip video camera!) Anyone can go out and make a movie with a cell phone and edit it on a cheap laptop. And as far as distribution goes you can put it on Youtube yourself and people around the world can see it instantly. And when a distributor wants to pick up your movie and tells you it needs a new sound mix or soundtrack or that it needs to be re-edited or blah-blah tell them to love it or leave it! The essence of the work is intrinsic to the media if you're doing your "job" as an artist correctly. When a festival says that you must transfer your movie to that ancient format of 35mm or the newest super-duper digital format ask them why—you'd be surprised at who doesn't have an answer for this question. We must work together as filmmakers to hold these gate-keepers in line.

So if New Queer Cinema is dead what's next? Well—it's really just the term that's dead, the filmmakers, old and new (and very old) are still out there making cinema. Goodbye "New" (and while we are at it please include "Modern" and "Post-anything") you were never of much use anyway, since you lose your relevance the moment you are uttered. We are not and have never been new, we are a continuance. Cinema and art are our collective conscience. I'd even argue that it's a collective gay conscience in some respects.

So good riddance "Queer" you are out of fashion (or are you? who can keep track?). No one can agree on a term so how about HUMAN. We are all, for better or worse, human beings. We are human, we are sexual. We are "CINEMA" pure and simple. We will not be ghettoized, categorized or dismissed. We're here, we are CINEMA, get used to it!

No more Mr. Nice Gay! Aren't you tired by now of these buff, shiny, happy, pretty pretty gay people in (alleged) comedies about hooking up and being shirtless and oh-so-pretty and oh-so-vacant. No more documentaries about gay marriage and about "how just like everyone else" we are. No more conformity (whatever that is) and whatever happened to "We're here we're queer get used to it!" Stop pretending that AIDS (or at least the devastating effects of AIDS), homophobia (outside and inside the gay culture), violence, rape, oppression, murder, censorship, don't exist. We are outlaws, we are outsiders and

we always will be. You don't need a cock just a camera (and it doesn't have to be a big camera but you have to have the balls to face down the status quo). Pull it out. Stroke it. Dare the audience, the critics, the programmers, etc. to suck it. Create like there is no tomorrow (in this modern world, you never know) and shoot, shoot, shoot!

Now please wipe up after yourself.

BAREFOOT FILMMAKING MANIFESTO (UK, 2009)

Sally Potter

[First published on Potter's website: sallypotter.com/barefoot-filmmaking.]

Renowned feminist filmmaker Sally Potter's manifesto, written when she was preparing her film *Rage* (UK, 2009)—which she described as "naked cinema" at the film's premiere in Berlin—has much in common with many of the DIY manifestos contained herein, from Claude Jutra's "How to Not Make a Canadian Film" (see chap. 2 in this volume) to Humberto Solás's "Poor Cinema Manifesto" (see chap. 3 in this volume), to Steven Soderbergh's "Full Frontal Manifesto" (see chap. 5 in this volume). All share the same goal of maintaining artistic independence and integrity in the face of aesthetic and economic pressures.

The best time to start is now (don't wait)

Take responsibility for everything (it saves time)

Don't blame anyone or anything (including yourself)

Give up being a moviemaker victim (of circumstance, weather, lack of money, mean financiers, vicious critics, greedy distributors, indifferent public, etc.)

You can't always choose what happens while you are making a film, but you can choose your point of view about what happens (creative perspective)

Mistakes are your best teacher (so welcome them)

Turn disaster to advantage (there will be many)

Only work on something you believe in (life is too short to practice insincerity)

Choose your team carefully and honour them (never speak negatively about your colleagues)

Ban the word "compromise" (or the phrase "it will do") (the disappointment in yourself will haunt you later)

Be prepared to work harder than anyone you are employing

Be ruthless—be ready to throw away your favourite bits (you may well be attached to what is familiar rather than what is good)

Aim beyond your limits (and help others to go beyond theirs) (the thrill of the learning curve)

When in doubt, project yourself ten years into the future and look back—what will you be proud of having done? (indecision is a lack of the longer view or wider perspective)

Practice no waste—psychic ecology—prevent brain pollution (don't add to the proliferation of junk)

Be an anorak—keep your sense of wonder and enthusiasm (cynicism will kill your joy and motivation)

Get some sleep when you can (you wont get much later)

DIRTY DIARIES MANIFESTO
(Sweden, 2009)

Mia Engberg

[First published online on the website for the film: dirtydiaries.se]

Mia Engberg's omnibus film *Dirty Diaries* (Sweden, 2009) brings together thirteen short straight and queer porn films made by Swedish feminists. The film led to some controversy over the use of public funds to produce pornography after the Swedish Film Institute funded the film to a total of 500,000 kr. In a similar manner to "Puzzy Power," all of the *Dirty Diaries* shorts follow a series of statements of principles. Unlike Dogme '95 the *Dirty Diaries* manifesto does not dictate a style so much as a feminist, queer positive philosophy of sexual representation.

1. BEAUTIFUL THE WAY WE ARE

To hell with the sick beauty ideals! Deep self-hatred keeps a lot of women's energy and creativity sapped. The energy that could be focused into exploring our own sexuality and power is being drained off into diets and cosmetics. Don't let the commercial powers control your needs and desires.

2. FIGHT FOR YOUR RIGHT TO BE HORNY

Male sexuality is seen as a force of nature that has to be satisfied at all costs while women's sexuality is accepted only if it adapts to men's needs. Be horny on your own terms.

3. A GOOD GIRL IS A BAD GIRL

We are fed up with the cultural cliché that sexually active and independent women are either crazy or lesbian and therefore crazy. We want to see and make movies where Betty Blue, Ophelia and Thelma & Louise don't have to die in the end.

4. SMASH CAPITALISM AND PATRIARCHY

The porn industry is sexist because we live in a patriarchal capitalist society. It makes profit out of people's needs for sex and erotica and women get exploited in the process. To fight sexist porn you have to smash capitalism and patriarchy.

5. AS NASTY AS WE WANNA BE

Enjoy, take charge or let go. Say NO when you want, to be able to say YES when YOU want.

6. LEGAL AND FREE ABORTION IS A HUMAN RIGHT!

Everyone has the right to control their own body. Millions of women suffer from unwanted pregnancies and die from illegal abortions every year. Fuck the moral right for preaching against birth control and sex information.

7. FIGHT THE REAL ENEMY!

Censorship cannot liberate sexuality. It is impossible to change the image of women's sexuality if sexual images in themselves are taboo. Don't attack women for displaying sex. Attack sexism for trying to control our sexuality.

8. STAY QUEER

A lot of opposition to erotica is homophobic and even more transphobic. We don't believe in the fight between the sexes but in the fight against sexes. Identify as any gender you want and make love to whoever you want. Sexuality is diverse.

9. USE PROTECTION

"I'm not saying go out an' do it, but if you do, strap it up before you smack it up." (Missy Elliott)

10. DO IT YOURSELF

Erotica is good and we need it. We truly believe that it is possible to create an alternative to the mainstream porn industry by making sexy films we like.

5

MILITATING HOLLYWOOD

At first one might not assume that manifestos and Hollywood go hand in hand. This selection of manifestos proves otherwise. The chapter begins with a series of manifestos written by right-wing producers, directors, scriptwriters, and journalists about the threat to the American way of life posed by communism. Writers and signatories as diverse as Cecil B. DeMille, Ayn Rand, Walt Disney, and William Randolph Hearst wrote manifestos targeting the Red Scare and Hollywood's role in it. These manifestos speak both to the profound isolationist strand of conservative thought in the United States that was eventually pushed aside, albeit temporarily, by World War II and to the desire for Hollywood to maintain global domination of movie screens. These manifestos can also be seen as foreshadowing the political debates that would emerge in the postwar 1950s, and the rise of the House Un-American Activities Committee.

Yet if one manifesto dominates the chapter, and indeed classical Hollywood cinema, it is the manifesto I contend is the most successful film manifesto of all time, the Motion Picture Production Code. The Code was not written as a bulwark against communism but against an even greater fear on the part of Hollywood: government intervention. The set of rules the Code unleashed led to an unintended series of consequences that codified what has now become known as classical Hollywood cinema. In *Ulysses Unbound* Jon Elster argues that in certain cases censorship has actually helped the creative process. Elster argues that constraints can benefit creativity, whether these constraints are imposed by the artist (as in the case of the Dogme '95 manifesto) or by outside agents. This idea in many ways goes against the grain about what one might think is beneficial to the artist's freedom of expression, but Elster argues that constraint allows new, more artistically compelling aesthetic forms to develop. One of his key examples of outside preconstraint is the Motion Picture Production Code. He writes: "Movie directors were constrained by the code to use indirect means in representing certain themes, notably sexual ones. In some cases at least, the effect of the constraint was to enhance rather than detract from the artistic value of the representation." He goes on to claim that "the idea of leaving something to the viewer's imagination is also central to the argument that the Hays Code, while intended to ban eroticism from the movies, actually enhanced it."[1] While Elster is careful to make the point that this in no way means the Code did not also have a negative impact (he notes that many potential films were never made because of the Code, including Welles's *The Heart of Darkness*), this line of argument does foreground the fact that rule-following, central to so many manifestos, creates new, and at times unforeseen, modes of artistic expression.

There are countless examples of the development of what we could call the indirect language of the Production Code in classical Hollywood cinema; one needs only to think of the final scene in Hitchcock's *North by Northwest* (USA, 1959) to understand the Hays

Code–inspired version of the montage of attractions developed under the Code's guidelines: Roger Thornhill (Cary Grant) and Eve Kendall (Eva Marie Saint) begin to engage in amorous foreplay in the sleeping compartment of a speeding train before Hitchcock cuts to an exterior shot of the train charging full speed into a dark tunnel. In his article on eroticism and the cinema André Bazin makes a similar point when he argues that Marilyn Monroe's subway-grate scene in *The Seven Year Itch* (Billy Wilder, USA, 1955) is more erotic than her *Playboy* centerfold, crediting the censors along the way: "Inventiveness such as this presupposes an extraordinary refinement of the imagination, acquired in the struggle against the rigorous stupidity of a puritan code. Hollywood, in spite and because of the taboos that dominate it, remains the world capital of cinematic eroticism."[2] Bazin also acknowledges the profound downside to censorship but nevertheless understands that the presence of the Code necessitated the development of a new language for Hollywood cinema. Elster concludes his argument by proposing that "the Hays Code raised the level of sophistication of directors, actors, and viewers. Even though some viewers might have *preferred* more direct language, more nudity, and generally fewer indirections, they probably *benefited* from the constraints" (233). One of the key reasons Elster and Bazin make these arguments is that indirect means of expression allowed viewers to become part of the creative process, feeling that they understood what was being said, even if the film itself couldn't state it explicitly. The Code meant that directors and audiences developed a keen sense of metaphor, and in so doing, the spectator, as Elster notes, became an "accomplice" in the creation of subtextual meaning.

Other manifestos in this chapter raise similar issues about the ways in which Hollywood creates meaning for audiences and what kinds of films were best suited to be produced through the studio system. Manny Farber's manifesto on "termite art" champions films that were often left by the wayside in the rising tide of auteurism that was sweeping film criticism in the early 1960s. He celebrates works—B movies, Laurel and Hardy films—that were often disregarded as Andrew Sarris's Americanized version of *auteur* theory—beginning with his "Notes on the Auteur Theory," published in *Film Culture* in 1962 and culminating in the publication of *The American Cinema: Directors and Directions, 1929–1968* in 1968—began to hold sway in the United States. Farber contends that these films, made at the margins, were far more interesting than their big-budget cousins because they were less constrained by financial concerns and studio dictates.

CODE TO GOVERN THE MAKING OF TALKING, SYNCHRONIZED AND SILENT MOTION PICTURES (MOTION PICTURE PRODUCTION CODE) (USA, 1930)

Motion Picture Producers and Distributors of America

[First published as *A Code to Govern the Making of Motion and Talking Pictures* (Hollywood: MPPDA, 1934).]

Written in 1930 by Father Daniel Lord and *Motion Picture Herald* publisher Martin Quigley, and enforced by the Hays Office on behalf of the Motion Picture Producers and Distributors of America, the Motion Picture Production Code is perhaps the most successful film manifesto of all time, guiding and structuring Hollywood cinema from 1934 until the death of the Code and the introduction of the ratings system in 1968. The constraints of the Code inadvertently developed the metaphors and tropes of classical Hollywood cinema. The Code was adopted by the studios in the first instance as a means of self-censorship to avoid the possibility of state censorship. The Code was revised some eleven times between 1934 and 1961, adding provisions on crime, profanity, and cruelty to animals, among other revisions. It was rewritten in 1966, in a fairly desperate attempt to maintain relevance. This attempt did not succeed, and the Code was, for all intents and purposes, dead by 1967, after changing the face of American cinema. The Code that follows is the modified first version from 1930 that was fully implemented by the Hollywood studios in 1934.

Formulated and formally adopted by The Association of Motion Picture Producers, Inc. and The Motion Picture Producers and Distributors of America, Inc. in March 1930.

Motion picture producers recognize the high trust and confidence which have been placed in them by the people of the world and which have made motion pictures a universal form of entertainment.

They recognize their responsibility to the public because of this trust and because entertainment and art are important influences in the life of a nation.

Hence, though regarding motion pictures primarily as entertainment without any explicit purpose of teaching or propaganda, they know that the motion picture within its

own field of entertainment may be directly responsible for spiritual or moral progress, for higher types of social life, and for much correct thinking.

During the rapid transition from silent to talking pictures they have realized the necessity and the opportunity of subscribing to a Code to govern the production of talking pictures and of re-acknowledging this responsibility.

On their part, they ask from the public and from public leaders a sympathetic understanding of their purposes and problems and a spirit of cooperation that will allow them the freedom and opportunity necessary to bring the motion picture to a still higher level of wholesome entertainment for all the people.

GENERAL PRINCIPLES

1. No picture shall be produced that will lower the moral standards of those who see it. Hence the sympathy of the audience should never be thrown to the side of crime, wrongdoing, evil or sin.

2. Correct standards of life, subject only to the requirements of drama and entertainment, shall be presented.

3. Law, natural or human, shall not be ridiculed, nor shall sympathy be created for its violation.

PARTICULAR APPLICATIONS
I. CRIMES AGAINST THE LAW

These shall never be presented in such a way as to throw sympathy with the crime as against law and justice or to inspire others with a desire for imitation.

1. Murder
 a. The technique of murder must be presented in a way that will not inspire imitation.
 b. Brutal killings are not to be presented in detail.
 c. Revenge in modern times shall not be justified.
2. Methods of Crime should not be explicitly presented.
 a. Theft, robbery, safe-cracking, and dynamiting of trains, mines, buildings, etc., should not be detailed in method.
 b. Arson must be subject to the same safeguards.
 c. The use of firearms should be restricted to the essentials.
 d. Methods of smuggling should not be presented.
3. Illegal drug traffic must never be presented.
4. The use of liquor in American life, when not required by the plot or for proper characterization, will not be shown.

II. SEX

The sanctity of the institution of marriage and the home shall be upheld. Pictures shall not infer that low forms of sex relationship are the accepted or common thing.

1. Adultery, sometimes necessary plot material, must not be explicitly treated, or justified, or presented attractively.
2. Scenes of Passion
 a. They should not be introduced when not essential to the plot.
 b. Excessive and lustful kissing, lustful embraces, suggestive postures and gestures, are not to be shown.
 c. In general passion should so be treated that these scenes do not stimulate the lower and baser element.
3. Seduction or Rape
 a. They should never be more than suggested, and only when essential for the plot, and even then never shown by explicit method.
 b. They are never the proper subject for comedy.
4. Sex perversion or any inference to it is forbidden.
5. White slavery shall not be treated.
6. Miscegenation (sex relationships between the white and black races) is forbidden.
7. Sex hygiene and venereal diseases are not subjects for motion pictures.
8. Scenes of actual child birth, in fact or in silhouette, are never to be presented.
9. Children's sex organs are never to be exposed.

III. VULGARITY

The treatment of low, disgusting, unpleasant, though not necessarily evil, subjects should always be subject to the dictates of good taste and a regard for the sensibilities of the audience.

IV. OBSCENITY

Obscenity in word, gesture, reference, song, joke, or by suggestion (even when likely to be understood only by part of the audience) is forbidden.

V. PROFANITY

Pointed profanity (this includes the words, God, Lord, Jesus, Christ—unless used reverently—Hell, S.O.B., damn, Gawd), or every other profane or vulgar expression however used, is forbidden.

VI. COSTUME

1. Complete nudity is never permitted. This includes nudity in fact or in silhouette, or any lecherous or licentious notice thereof by other characters in the picture.
2. Undressing scenes should be avoided, and never used save where essential to the plot.
3. Indecent or undue exposure is forbidden.
4. Dancing or costumes intended to permit undue exposure or indecent movements in the dance are forbidden.

VII. DANCES

1. Dances suggesting or representing sexual actions or indecent passions are forbidden.
2. Dances which emphasize indecent movements are to be regarded as obscene.

VIII. RELIGION

1. No film or episode may throw ridicule on any religious faith.
2. Ministers of religion in their character as ministers of religion should not be used as comic characters or as villains.
3. Ceremonies of any definite religion should be carefully and respectfully handled.

IX. LOCATIONS

The treatment of bedrooms must be governed by good taste and delicacy.

X. NATIONAL FEELINGS

1. The use of the Flag shall be consistently respectful.
2. The history, institutions, prominent people and citizenry of other nations shall be represented fairly.

XI. TITLES

Salacious, indecent, or obscene titles shall not be used.

XII. REPELLENT SUBJECTS

The following subjects must be treated within the careful limits of good taste:

1. Actual hangings or electrocutions as legal punishments for crime.
2. Third degree methods.
3. Brutality and possible gruesomeness.
4. Branding of people or animals.
5. Apparent cruelty to children or animals.
6. The sale of women, or a woman selling her virtue.
7. Surgical operations.

RESOLUTIONS FOR UNIFORM INTERPRETATION

The undersigned members of the Association of Motion Picture Producers, Inc. hereby subscribe to and agree faithfully to conform to the provisions of the following resolution:

WHEREAS, we, the undersigned have this day subscribed and agreed faithfully to conform to a

CODE TO GOVERN THE MAKING OF TALKING, SYNCHRONIZED AND SILENT MOTION PICTURES

Formulated by

Association of Motion Picture Producers, Inc., and the Motion Picture Producers and Distributors of America, Inc.

AND WHEREAS, a uniform interpretation of such Code is essential, and for the promotion of such uniform interpretation and consequent universal conformance by ourselves and the personnel of our respective studios it is believed necessary that additional facilities and procedure be established and maintained:

THEREFORE BE IT RESOLVED that we hereby agree to the following methods of operation:

1. When requested by production managers, the Motion Picture Association of America, Inc., shall secure any facts, information or suggestions concerning the probable reception of stories or the manner in which in its opinion they may best be treated.

2. That each production manager shall submit in confidence a copy of each or any script to the Production Code Administration of the Motion Picture Association of America, Inc. (and of the Association of Motion Picture Producers, Inc., California). The Production Code Administration will give the production manager for his guidance such confidential advice and suggestions as experience, research, and information indicate, designating wherein in its judgment the script departs from the provisions of the Code, or wherein from experience or knowledge it is believed that exception will be taken to the story or treatment.

3. Each production manager of a company belonging to the Motion Picture Association of America, Inc., and any producer proposing to distribute and/or distributing his picture through the facilities of any member of the Motion Picture Association of America, Inc., shall submit to such Production Code Administration every picture he produces before the negative goes to the laboratory for printing. Said Production Code Administration, having seen the picture, shall inform the production manager in writing whether in its opinion the picture conforms or does not conform to the Code, stating specifically wherein

either by theme, treatment, or incident, the picture violates the provisions of the Code. In such latter event, the picture shall not be released until the changes indicated by the Production Code Administration have been made; provided, however, that the production manager may appeal from such opinion of said Production Code Administration, so indicated in writing, to the Board of Directors of the Motion Picture Association of America, Inc., whose finding shall be final, and such production manager and company shall be governed accordingly.

The Production Committee shall be constituted as follows:

Charles H. Christie	William R. Fraser	Warren Doane
Cecil B. DeMille	Sol Lesser	John A. Waldron
E. H. Allen	Irving Thalberg	Joseph M. Schrenk
Hal B. Wallis	Ben Schulberg	Carl Laemmle, Jr.
Sol Wurtzel	Charles Sullivan	J. L. Warner
Abraham Lehr	William LeBaron	

The Board of Directors of the Association of Motion Picture Producers, Inc. may from time to time by unanimous vote make changes in the personnel of this Committee.

When a production manager appeals from a decision of the Association of Motion Picture Producers, Inc. he will so inform its Secretary, who will in rotation designate from the above named Production Committee three members who will immediately examine the picture in question and render its opinion, as provided for above. The Secretary of the Association of Motion Picture Producers, Inc., in designating the members of any such committee will not include members from studios with business alliances with each other or with the studio whose picture is being examined. In the event any of the three so designated are unavoidably absent from the city, the member or members next in order will be selected, under the same provisions. Any such member so unavoidably out of the city when so designated shall be considered at the heads of the list subject to the next call to service.

REASONS SUPPORTING THE PREAMBLE OF THE CODE

I. Theatrical motion pictures, that is, pictures intended for the theatre as distinct from pictures intended for churches, schools, lecture halls, educational movements, social reform movements, etc., are primarily to be regarded as ENTERTAINMENT.

> Mankind has always recognized the importance of entertainment and its value in rebuilding the bodies and souls of human beings.
> But it has always recognized that entertainment can be a character either HELPFUL or HARMFUL to the human race, and in consequence has clearly distinguished between:

a. Entertainment which tends to improve the race, or at least to re-create and rebuild human beings exhausted with the realities of life; and

b. Entertainment which tends to degrade human beings, or to lower their standards of life and living.

Hence the MORAL IMPORTANCE of entertainment is something which has been universally recognized. It enters intimately into the lives of men and women and affects them closely; it occupies their minds and affections during leisure hours; and ultimately touches the whole of their lives. A man may be judged by his standard of entertainment as easily as by the standard of his work.

So correct entertainment raises the whole standard of a nation.

Wrong entertainment lowers the whole living conditions and moral ideals of a race.

Note, for example, the healthy reactions to healthful sports, like baseball, golf; the unhealthy reactions to sports like cockfighting, bullfighting, bear baiting, etc.

Note, too, the effect on ancient nations of gladiatorial combats, the obscene plays of Roman times, etc.

II. Motion pictures are very important as ART.

Though a new art, possibly a combination art, it has the same object as the other arts, the presentation of human thought, emotion, and experience, in terms of an appeal to the soul through the senses.

Here, as in entertainment,

Art enters intimately into the lives of human beings.

Art can be morally good, lifting men to higher levels. This has been done through good music, great painting, authentic fiction, poetry, drama.

Art can be morally evil in its effects. This is the case clearly enough with unclean art, indecent books, suggestive drama. The effect on the lives of men and women is obvious.

Note: It has often been argued that art itself is unmoral, neither good nor bad. This is true of the THING which is music, painting, poetry, etc. But the THING is the PRODUCT of some person's mind, and the intention of that mind was either good or bad morally when it produced the thing. Besides, the thing has its EFFECT upon those who come into contact with it. In both these ways, that is, as a product of a mind and as the cause of definite effects, it has a deep moral significance and unmistakable moral quality.

Hence: The motion pictures, which are the most popular of modern arts for the masses, have their moral quality from the intention of the minds which produce them and from their effects on the moral lives and reactions of their audiences. This gives them a most important morality.

1. They reproduce the morality of the men who use the pictures as a medium for the expression of their ideas and ideals.

2. They affect the moral standards of those who, through the screen, take in these ideas and ideals.

In the case of motion pictures, the effect may be particularly emphasized because no art has so quick and so widespread an appeal to the masses. It has become in an incredibly short period the art of the multitudes.

III. The motion picture, because of its importance as entertainment and because of the trust placed in it by the peoples of the world, has special MORAL OBLIGATIONS:

A. Most arts appeal to the mature. This art appeals at once to every class, mature, immature, developed, undeveloped, law abiding, criminal. Music has its grades for different classes; so has literature and drama. This art of the motion picture, combining as it does the two fundamental appeals of looking at a picture and listening to a story, at once reaches every class of society.

B. By reason of the mobility of film and the ease of picture distribution, and because the possibility of duplicating positives in large quantities, this art reaches places unpenetrated by other forms of art.

C. Because of these two facts, it is difficult to produce films intended for only certain classes of people. The exhibitors' theatres are built for the masses, for the cultivated and the rude, the mature and the immature, the self-respecting and the criminal. Films, unlike books and music, can with difficulty be confined to certain selected groups.

D. The latitude given to film material cannot, in consequence, be as wide as the latitude given to book material. In addition:

 a. A book describes; a film vividly presents. One presents on a cold page; the other by apparently living people.

 b. A book reaches the mind through words merely; a film reaches the eyes and ears through the reproduction of actual events.

 c. The reaction of a reader to a book depends largely on the keenness of the reader's imagination; the reaction to a film depends on the vividness of presentation. Hence many things which might be described or suggested in a book could not possibly be presented in a film.

E. This is also true when comparing the film with the newspaper:

 a. Newspapers present by description, films by actual presentation.

 b. Newspapers are after the fact and present things as having taken place; the film gives the events in the process of enactment and with apparent reality of life.

F. Everything possible in a play is not possible in a film:

 a. Because of the larger audience of the film, and its consequential mixed character. Psychologically, the larger the audience, the lower the moral mass resistance to suggestion.

b. Because through light, enlargement of character, presentation, scenic emphasis, etc., the screen story is brought closer to the audience than the play.

c. The enthusiasm for and interest in the film actors and actresses, developed beyond anything of the sort in history, makes the audience largely sympathetic toward the characters they portray and the stories in which they figure. Hence the audience is more ready to confuse actor and actress and the characters they portray, and it is most receptive of the emotions and ideals presented by the favorite stars.

G. Small communities, remote from sophistication and from the hardening process which often takes place in the ethical and moral standards of larger cities, are easily and readily reached by any sort of film.

H. The grandeur of mass settings, large action, spectacular features, etc., affects and arouses more intensely the emotional side of the audience.

In general, the mobility, popularity, accessibility, emotional appeal, vividness, straightforward presentation of fact in the film make for more intimate contact with a larger audience and for greater emotional appeal. Hence the larger moral responsibilities of the motion pictures.

REASONS UNDERLYING THE GENERAL PRINCIPLES

I. No picture shall be produced which will lower the moral standards of those who see it. Hence the sympathy of the audience should never be thrown to the side of crime, wrong-doing, evil or sin.

This is done:

1. When evil is made to appear attractive and alluring, and good is made to appear unattractive.

2. When the sympathy of the audience is thrown on the side of crime, wrong-doing, evil, sin. The same is true of a film that would throw sympathy against goodness, honor, innocence, purity or honesty.

Note: Sympathy with a person who sins is not the same as sympathy with the sin or crime of which he is guilty. We may feel sorry for the plight of the murderer or even understand the circumstances which led him to his crime: we may not feel sympathy with the wrong which he has done. The presentation of evil is often essential for art or fiction or drama. This in itself is not wrong provided:

a. That evil is not presented alluringly. Even if later in the film the evil is condemned or punished, it must not be allowed to appear so attractive that the audience's emotions are drawn to desire or approve so strongly that later the condemnation is forgotten and only the apparent joy of sin is remembered.

b. That throughout, the audience feels sure that evil is wrong and good is right.

II. Correct standards of life shall, as far as possible, be presented.

A wide knowledge of life and of living is made possible through the film. When right standards are consistently presented, the motion picture exercises the most powerful influences. It builds character, develops right ideals, inculcates correct principles, and all this in attractive story form.

If motion pictures consistently hold up for admiration high types of characters and present stories that will affect lives for the better, they can become the most powerful force for the improvement of mankind.

III. Law, natural or human, shall not be ridiculed, nor shall sympathy be created for its violation.

By natural law is understood the law which is written in the hearts of all mankind, the greater underlying principles of right and justice dictated by conscience.

By human law is understood the law written by civilized nations.

1. The presentation of crimes against the law is often necessary for the carrying out of the plot. But the presentation must not throw sympathy with the crime as against the law nor with the criminal as against those who punish him.

2. The courts of the land should not be presented as unjust. This does not mean that a single court may not be presented as unjust, much less that a single court official must not be presented this way. But the court system of the country must not suffer as a result of this presentation.

REASONS UNDERLYING THE PARTICULAR APPLICATIONS

I. Sin and evil enter into the story of human beings and hence in themselves are valid dramatic material.

II. In the use of this material, it must be distinguished between sin which repels by it very nature, and sins which often attract.

a. In the first class come murder, most theft, many legal crimes, lying, hypocrisy, cruelty, etc.

b. In the second class come sex sins, sins and crimes of apparent heroism, such as banditry, daring thefts, leadership in evil, organized crime, revenge, etc.

The first class needs less care in treatment, as sins and crimes of this class are naturally unattractive. The audience instinctively condemns all such and is repelled.

Hence the important objective must be to avoid the hardening of the audience, especially of those who are young and impressionable, to the thought and fact of crime.

People can become accustomed even to murder, cruelty, brutality, and repellent crimes, if these are too frequently repeated.

The second class needs great care in handling, as the response of human nature to their appeal is obvious. This is treated more fully below.

III. A careful distinction can be made between films intended for general distribution, and films intended for use in theatres restricted to a limited audience. Themes and plots quite appropriate for the latter would be altogether out of place and dangerous in the former.

Note: The practice of using a general theatre and limiting its patronage to "Adults Only" is not completely satisfactory and is only partially effective.

However, maturer minds may easily understand and accept without harm subject matter in plots which do younger people positive harm.

Hence: If there should be created a special type of theatre, catering exclusively to an adult audience, for plays of this character (plays with problem themes, difficult discussions and maturer treatment) it would seem to afford an outlet, which does not now exist, for pictures unsuitable for general distribution but permissible for exhibitions to a restricted audience.

I. CRIMES AGAINST THE LAW

The treatment of crimes against the law must not:

1. Teach methods of crime.
2. Inspire potential criminals with a desire for imitation.
3. Make criminals seem heroic and justified.

Revenge in modern times shall not be justified. In lands and ages of less developed civilization and moral principles, revenge may sometimes be presented. This would be the case especially in places where no law exists to cover the crime because of which revenge is committed.

Because of its evil consequences, the drug traffic should not be presented in any form. The existence of the trade should not be brought to the attention of audiences.

The use of liquor should never be excessively presented. In scenes from American life, the necessities of plot and proper characterization alone justify its use. And in this case, it should be shown with moderation.

II. SEX

Out of a regard for the sanctity of marriage and the home, the triangle, that is, the love of a third party for one already married, needs careful handling. The treatment should not throw sympathy against marriage as an institution.

Scenes of passion must be treated with an honest acknowledgement of human nature and its normal reactions. Many scenes cannot be presented without arousing dangerous emotions on the part of the immature, the young or the criminal classes.

Even within the limits of pure love, certain facts have been universally regarded by lawmakers as outside the limits of safe presentation.

In the case of impure love, the love which society has always regarded as wrong and which has been banned by divine law, the following are important:

1. Impure love must not be presented as attractive and beautiful.
2. It must not be the subject of comedy or farce, or treated as material for laughter.
3. It must not be presented in such a way [as] to arouse passion or morbid curiosity on the part of the audience.
4. It must not be made to seem right and permissible.
5. In general, it must not be detailed in method and manner.

III. VULGARITY; IV. OBSCENITY; V. PROFANITY; HARDLY NEED FURTHER EXPLANATION THAN IS CONTAINED IN THE CODE.

VI. COSTUME

General Principles:

1. The effect of nudity or semi-nudity upon the normal man or woman, and much more upon the young and upon immature persons, has been honestly recognized by all lawmakers and moralists.
2. Hence the fact that the nude or semi-nude body may be beautiful does not make its use in the films moral. For, in addition to its beauty, the effect of the nude or semi-nude body on the normal individual must be taken into consideration.
3. Nudity or semi-nudity used simply to put a "punch" into a picture comes under the head of immoral actions. It is immoral in its effect on the average audience.
4. Nudity can never be permitted as being necessary for the plot. Semi-nudity must not result in undue or indecent exposures.
5. Transparent or translucent materials and silhouette are frequently more suggestive than actual exposure.

VII. DANCES

Dancing in general is recognized as an art and as a beautiful form of expressing human emotions.

But dances which suggest or represent sexual actions, whether performed solo or with two or more; dances intended to excite the emotional reaction of an audience; dances

with movement of the breasts, excessive body movements while the feet are stationary, violate decency and are wrong.

VIII. RELIGION

The reason why ministers of religion may not be comic characters or villains is simply because the attitude taken toward them may easily become the attitude taken toward religion in general. Religion is lowered in the minds of the audience because of the lowering of the audience's respect for a minister.

IX. LOCATIONS

Certain places are so closely and thoroughly associated with sexual life or with sexual sin that their use must be carefully limited.

X. NATIONAL FEELINGS

The just rights, history, and feelings of any nation are entitled to most careful consideration and respectful treatment.

XI. TITLES

As the title of a picture is the brand on that particular type of goods, it must conform to the ethical practices of all such honest business.

XII. REPELLENT SUBJECTS

Such subjects are occasionally necessary for the plot. Their treatment must never offend good taste nor injure the sensibilities of an audience.

RED FILMS: SOVIETS SPREADING DOCTRINE IN U.S. THEATRES (USA, 1935)

William Randolph Hearst

[First published in the *New York American*, 6 March 1935.]

Underlying William Randolph Hearst's lambasting of Soviet films on American screens is an unspoken liaison between Hearst and another manifesto author armed

with the agenda to fill American screens with Hollywood product: the source Hearst cites for his statistics, the *Motion Picture Herald* (1931–1972), was published by Martin Quigley, one of the key architects of the Motion Picture Production Code. Reading this screed, Orson Welles's pastiche of Hearst's bombastic writing style in *Citizen Kane* (1941) seems not far from the truth.

The multi-armed octopus of Moscow has many of its colossal, death-dealing tentacles wound around America.

It silently reaches for a strangle hold on our universities, our industries, our public schools, our labor organizations and our national and our State legislative bodies.

The vowed purpose is the complete annihilation of the United States of America and its democratic institutions and the substitution of the dictatorship of the proletariat, the complete destruction of personal liberty, and, finally, as a matter of course, THE TRANSFERENCE OF THE NATIONAL LAW-MAKING BODY FROM WASHINGTON TO MOSCOW.

The latest propagandist move in this attempt of Russia to conquer America is in the field of the motion picture.

EXHAUSTIVE ANALYSIS

The *Motion Picture Herald* has just concluded the first exhaustive analysis of the activities of the Russian conspirators to make America COMMUNIST-CONSCIOUS through the medium of the films.

THE STARTLING AND INCREDIBLE FACTS REVEALED SHOULD BE IMMEDIATELY LAID BEFORE CONGRESS.

The freedom, rapidity and subtlety with which these enemies of our institutions work ought to BRING America to its feet—before America is KNOCKED OFF ITS FEET! Soviet pictures are being shown in ONE HUNDRED AND FIFTY-TWO theatres in the United States.

These pictures—and every picture that comes out of Russia is pro-Communist and anti-democratic—play to weekly audiences of NINE HUNDRED AND TWENTY THOUSAND PERSONS.

This means that these Communist pictures are shown to nearly FIFTY MILLION PERSONS A YEAR—a great many of them children of an impressionable age.

The Moscow government has ABSOLUTE CONTROL over all Russian picture production and distribution.

The Moscow government CONTROLS all of these 152 American theatres through the AMKINO CORPORATION, of 723 Seventh ave., New York City.

These STALIN-DIRECTED picture houses are planted in the key cities of Baltimore, Boston, Chicago, Cleveland, Detroit, Los Angeles, New York, Philadelphia, Pittsburgh, San Francisco and Washington.

From these places the slimy octopus stretches its coils into the smaller towns.

ONE MOSCOW MASK

One of the masks of the Moscow propagandists is the "Little Theatre" or "Art House."

The Communist motion picture cell, with headquarters in New York City shows its propaganda films at the Cameo and Acme theatres in New York and is now building a "cross-country circuit."

They have acquired in the interests of the Stalin-Amkino revolutionary outfit, theatres in which to show their films in Baltimore, Boston, Washington and Chicago.

The Amkino people admit with a what-are-you-going-to-do-about-it swagger that these Russian films are propaganda.

Mark Aberson, the Hollywood representative of Amkino, says that they are now about "to concentrate on the intellectuals" in America, the inference being that the plain garden variety of citizens is in the bag.

"MADE FOR AMERICA"

For 1935 the Moscow slave-staters, through Amkino, will send us fifteen sound pictures—"Made for America." They have exhibited sixty-two pictures in three years, and "the record shows," says the *Motion Picture Herald*, "LITTLE OR NO OPPOSITION, OFFICIAL OR OTHER-WISE, TO THE PRESENTATION OF SOVIET MOTION PICTURES."

Strict censorship—often in trivial matters—over our American pictures, but ABSOLUTE FREEDOM FOR FOREIGN REVOLUTIONARY PROPAGANDA FILMS!

One of the tricks of the Kremlin-Amkino gang is to exhibit a perfectly innocuous picture once in a while as a smoke-screen for its heavy gun product, like "Shams," "Diary of a Revolutionist," "The Five-Year Plan," "Enemies of Progress," "In the Land of the Soviets," "Three Songs About Lenin," etc., etc., in which the camera performs all the lying tricks about life in Russia that the baby-starving politburo has taught it.

A picture now in production in Moscow and destined for our naïve eyes is "Soviet Russia," the cast including such rugged proletarians as Joe Stalin and his confidential killers and such militaristic-imperialistic comrades as President Kalinin and the Committee of Defense.

The octopus is even holding a "Soviet jubilee" in the United States!

AN ANNIVERSARY

It commemorates the fifteenth anniversary of the Russian motion picture industry. During the jubilee there will be shown to a vast number of Americans everything EXCEPT pictures of the State-ordered starvation of the millions of peasant farmers who refused to be collectivized, the torture chambers of the Cheka and the OGPU, the Czar-like massacre of 126 Russians after the assassination of Kirov, the abject beggary of millions of "blessed proletarians," the eternal procession to Siberia a la Romanoffs, the militarization of children and the perpetual spying of sons on fathers and brothers on sisters.

There is at present a "Soviet Kinema Festival" in Moscow. Of the seven American pictures selected to be shown at this exhibition there is NOT ONE THAT CONCERNS ANYTHING THAT IS DIRECTLY FAVORABLE TO AMERICA. They are all sex pictures or musical comedies, with one exception. And that one exception is a pink propaganda picture based on the depression.

ERECTS BARRIER

While Russia is allowed to go on trying to communize us, she has erected an insurmountable barrier against our own picture product.

ONLY FIVE PER CENT OF THE HOLLYWOOD PRODUCT IS PERMITTED IN RUSSIA—AND AMONG THEM NO PICTURES THAT SHOW AMERICA IN A FAVORABLE LIGHT.

Throwing our product under the bridge, the Amkino officials braggingly state that they have operated profitably every year in America except in 1933.

THIS IS THE ATTITUDE OF A COUNTRY THAT WANTS "TO TRADE WITH US," AND THAT CRINGED AND CRAWLED AND LICKED OUR BOOTS FOR RECOGNITION.

Without let or hindrance on the part of our Congress or our people, these enemies of civilization, freedom, wealth and private property, these barbarians, reactionaries, atavists and successors of the sadistic and lunatic czars are permitted to shout their ravings and parade their insanities before fifty million Americans a year on screen!

HOW LONG, O, AMERICA ARE YOU GOING TO ALLOW THESE BABY-STARVERS, DECADENT FANATICS AND JACK-THE-RIPPERS TO SPIT IN YOUR GOOD-NATURED AND COMPLACENT FACE?

Loyal citizens of America write your Congressmen, write your Legislators and ask them how long they are going to neglect their obvious duty.

STATEMENT OF PRINCIPLES (USA, 1944)

Motion Picture Alliance for the Preservation of American Ideals

[Statement released after the first meeting of the Motion Picture Alliance for the Preservation of American Ideals (MPAPAI), on 4 February 1944.]

A right-wing, anticommunist alliance—including members such as Cecil B. DeMille, Walt Disney, Adolphe Menjou, Ronald Reagan, King Vidor, John Wayne, and Sam Wood—the Motion Picture Alliance for the Preservation of American Ideals was formed to combat the notion that Hollywood was rife with communists and left-wing sympathizers. This manifesto was written while the United States and the USSR were still World War II allies, and Hollywood was producing pro-Soviet films like

Warner Bros.' *Mission to Moscow* (Michael Curtiz, 1943) and MGM's *Song of Russia* (Gregory Ratoff, 1944). The MPAPAI nevertheless places communism and fascism on equal footing. After the war the alliance actively worked in support of HUAC (the House Un-American Activities Committee), providing "friendly" witnesses to testify before Congress.

We believe in, and like, the American way of life: the liberty and freedom which generations before us have fought to create and preserve; the freedom to speak, to think, to live, to worship, to work, and to govern ourselves as individuals, as free men; the right to succeed or fail as free men, according to the measure of our ability and our strength.

Believing in these things, we find ourselves in sharp revolt against a rising tide of communism, fascism, and kindred beliefs, that seek by subversive means to undermine and change this way of life; groups that have forfeited their right to exist in this country of ours, because they seek to achieve their change by means other than the vested procedure of the ballot and to deny the right of the majority opinion of the people to rule.

In our special field of motion pictures, we resent the growing impression that this industry is made of, and dominated by, Communists, radicals, and crackpots. We believe that we represent the vast majority of the people who serve this great medium of expression. But unfortunately it has been an unorganized majority. This has been almost inevitable. The very love of freedom, of the rights of the individual, make this great majority reluctant to organize. But now we must, or we shall meanly lose "the last, best hope on earth."

As Americans, we have no new plan to offer. We want no new plan, we want only to defend against its enemies that which is our priceless heritage; that freedom which has given man, in this country, the fullest life and the richest expression the world has ever known; that system which, in the present emergency, has fathered an effort that, more than any other single factor, will make possible the winning of this war.

As members of the motion-picture industry, we must face and accept an especial responsibility. Motion pictures are inescapably one of the world's greatest forces for influencing public thought and opinion, both at home and abroad. In this fact lies solemn obligation. We refuse to permit the effort of Communist, Fascist, and other totalitarian-minded groups to pervert this powerful medium into an instrument for the dissemination of un-American ideas and beliefs. We pledge ourselves to fight, with every means at our organized command, any effort of any group or individual, to divert the loyalty of the screen from the free America that gave it birth. And to dedicate our work, in the fullest possible measure, to the presentation of the American scene, its standards and its freedoms, its beliefs and its ideals, as we know them and believe in them.

SCREEN GUIDE FOR AMERICANS (USA, 1947)

Ayn Rand

[First published as the pamphlet *Screen Guide for Americans* on behalf of the Motion Picture Alliance for the Preservation of American Ideals, 1947].

Three years after the founding of the MPAPAI, objectivist philosopher, novelist, and screenwriter Ayn Rand wrote the following manifesto for the organization. Rand had a long-standing interest in the cinema: her first published work in the USSR was on actress Pola Negri, and once she immigrated to the United States, she began writing scripts for Cecil B. DeMille and then Universal, along with working in the costume department of RKO. In "Screen Guide for Americans" Rand outlines how not to make a Hollywood film infiltrated with communist ideas.

The influence of Communists in Hollywood is due, not to their own power, but to the unthinking carelessness of those who profess to oppose them. Red propaganda has been put over in some films produced by innocent men, often by loyal Americans who deplore the spread of Communism throughout the world and wonder why it is spreading.

If you wish to protect your pictures from being used for Communistic purposes, the first thing to do is to drop the delusion that political propaganda consists only of political slogans.

Politics is not a separate field in itself. Political ideas do not come out of thin air. They are the result of the *moral premises* which men have accepted. Whatever people believe to be the good, right and proper human actions—*that* will determine their political opinions. If men believe that every independent action is vicious, they will vote for every human measure to control human beings and to suppress human freedom. If men believe that the American system is unjust they will support those who wish to destroy it.

The purpose of the Communists in Hollywood is *not* the production of political movies openly advocating Communism. Their purpose *is to corrupt our moral premises by corrupting non-political movies*—by introducing small, casual bits of propaganda into innocent stories—thus making people absorb the basic premises of Collectivism *by indirection and implication*.

Few people would take Communism straight. But a constant stream of hints, lines, touches and suggestions battering the public from the screen will act like the drops of water that split a rock if continued long enough. The rock they are trying to split is Americanism.

We present below a list of the more common devices used to turn non-political pictures into carriers of political propaganda. It is a guide list for all those who do not wish to help advance the cause of Communism.

It is intended as a guide and not as a forced restriction upon anyone. We are unalterably opposed to any political "industry code," to any group agreement or any manner of forbidding any political opinion to anyone by any form of collective force or pressure. There is no "group insurance" in the field of ideas. Each man has to do his own thinking. We merely offer this list to the independent judgement and the voluntary action of every honest man in the motion picture industry.

1. DON'T TAKE POLITICS LIGHTLY.

Don't fool yourself by saying, "I'm not interested in politics," and then pretending that politics does not exist.

We are living in an age when politics is the most burning question in everybody's mind. The whole world is torn by a great political issue—Freedom or Slavery, which means Americanism or Totalitarianism. Half the world is in ruins after a war fought over political ideas. To pretend at such a time that political ideas are not important and that people pay no attention to them, is worse than irresponsible.

It is the avowed purpose of the Communists to insert propaganda into movies. Therefore, there are only two possible courses of action open to you, if you want to keep your pictures clean of subversive propaganda:

1. If you have no time or inclination to study political ideas—then do not hire Reds to work on your pictures.
2. If you wish to employ Reds, but intend to keep their politics out of your movies—then study political ideas and learn how to recognize propaganda when you see it.

But to hire Communists on the theory that "they won't put over any politics on me" and then remain ignorant and indifferent to the subject of politics, while the Reds are trained propaganda experts—is an attitude for which there can be no excuse.

2. DON'T SMEAR THE FREE ENTERPRISE SYSTEM.

Don't pretend that Americanism and the Free Enterprise System are two different things. They are inseparable, like body and soul. The basic principle of inalienable individual rights, which is Americanism, can be translated into practical reality only in the form of the economic system of Free Enterprise. That was the system established by the American Constitution, the system which made America the best and greatest country on earth. You may preach any other form of economics, if you wish. But if you do so, don't pretend that you are preaching Americanism.

Don't pretend that you are upholding the Free Enterprise System in some vague, general, undefined way, while preaching the specific ideas that oppose it and destroy it.

Don't attack individual rights, individual freedom, private action, private initiative, and private property. These things are essential parts of the Free Enterprise System, without which it cannot exist.

Don't preach the superiority of public ownership as such over private ownership. *Don't* preach or imply that all publicly-owned projects are noble, humanitarian undertakings by the grace of the mere fact that they are publicly-owned—while preaching, at the same time, that private property or the defense of private property rights is the expression of some sort of vicious greed, of anti-social selfishness or evil.

3. DON'T SMEAR INDUSTRIALISTS.

Don't spit into your own face or, worse, pay miserable little rats to do it.

You, as a motion picture producer, are an industrialist. All of us are employees of an industry which gives us a good living. There is an old fable about a pig who filled his belly with acorns, then started digging to undermine the roots of the oak from which the acorns came. Don't let's allow that pig to become our symbol.

Throughout American history, the best of American industrialists were men who embodied the highest virtues: productive genius, energy, initiative, independence, courage. Socially (if "social significance" interests you) they were among the greatest of all benefactors, because it is they who created the opportunities for achieving the unprecedented material wealth of the industrial age.

In our own day, all around us, there are countless examples of self-made men who rose from the ranks and achieved great industrial success through their energy, ability and honest productive effort.

Yet all too often industrialists, bankers, and businessmen are presented on the screen as villains, crooks, chiselers or exploiters. One such picture may be taken as non-political or accidental. A constant stream of such pictures becomes pernicious political propaganda: It creates hatred for all businessmen in the mind of the audience, and makes people receptive to the cause of Communism.

While motion pictures have a strict code that forbids us to offend or insult any group or nation—while we dare not present in an unfavorable light the tiniest Balkan kingdom—we permit ourselves to smear and slander American businessmen in the most irresponsibly dishonest manner.

It is true that there are vicious businessmen—just as there are vicious men in any other class or profession. But we have been practising an outrageous kind of double standard: we do not attack individual representatives of any other group, class or nation, in order not to imply an attack on the whole group; yet when we present individual businessmen as monsters, we claim that no reflection on the whole class of businessmen was intended.

It's got to be one or the other. This sort of double standard can deceive nobody and can serve nobody's purpose except that of the Communists.

It is the *moral*—(no, not just political, but *moral*)—duty of every decent man in the motion picture industry to throw into the ashcan, where it belongs, every story that smears industrialists as such.

4. DON'T SMEAR WEALTH.

In a free society—such as America—wealth is achieved through production, and through the voluntary exchange of one's goods or services. You cannot hold production as evil—nor can you hold as evil a man's right to keep the result of his own effort.

Only savages and Communists get rich by force—that is, by looting the property of others. It is a basic American principle that each man is free to work for his own benefit and to go as far as his ability will carry him; and his property is his—whether he has made one dollar or one million dollars.

If the villain in your story happens to be rich—*don't* permit lines of dialogue suggesting that he is the typical representative of a whole social class, the symbol of all the rich. Keep it clear in your mind *and in your script* that his villainy is due to his own personal character—not to his wealth or class.

If you do not see the difference between wealth honestly produced and wealth looted— you are preaching the ideas of Communism. You are implying that all property and all human labor should belong to the State. And you are inciting men to crime: If all wealth is evil, no matter how acquired, why should a man bother to earn it? He might as well seize it by robbery or expropriation.

It is the proper wish of every decent American to stand on his own feet, earn his own living, and be as good at it as he can—that is, get as rich as he can by honest exchange.

Stop insulting him and stop defaming his proper ambition. Stop giving him—and yourself—a guilt complex by spreading unthinkingly the slogans of Communism. Put an end to that pernicious modern hypocrisy: everybody wants to get rich and almost everybody feels that he must apologise for it.

5. DON'T SMEAR THE PROFIT MOTIVE.

If you denounce the profit motive, what is it that you wish men to do? Work without reward, like slaves, for the benefit of the State?

An industrialist has to be interested in profit. In a free economy, he can make a profit *only* if he makes a good product which people are willing to buy. What do you want him to do? Should he sell his product at a loss? If so, how long is he to remain in business? And at whose expense?

Don't give to your characters—as a sign of villainy, as a damning characteristic—a desire to make money. Nobody wants to, or should, work without payment, and nobody

does—except a slave. There is nothing dishonorable about a pursuit of money in a free economy, because money can be earned only by productive effort.

If what you mean, when you denounce it, is a desire to make money dishonestly or immorally—then say so. Make it dear that what you denounce is dishonesty, not money-making. Make it clear that you are denouncing evil doers, not capitalists. Don't toss out careless generalities which imply that there is no difference between the two. That is what the Communists want you to imply.

6. DON'T SMEAR SUCCESS.

America was made by the idea that personal achievement and personal success are each man's proper and moral goal.

There are many forms of success: spiritual, artistic, industrial, financial. All these forms, in any field of honest endeavor, are good, desirable and admirable. Treat them as such.

Don't permit any disparagement or defamation of personal success. It is the Communists' intention to make people think that personal success is somehow achieved at the expense of others and that every successful man has hurt somebody by becoming successful.

It is the Communists' aim to discourage all personal effort and to drive men into a hopeless, dispirited, gray herd of robots who have lost all personal ambition, who are easy to rule, willing to obey and willing to exist in selfless servitude to the State.

America is based on the ideal of man's dignity and self-respect. Dignity and self-respect are impossible without a sense of personal achievement. When you defame success, you defame human dignity.

America is the land of the self-made man. Say so on the screen.

7. DON'T GLORIFY FAILURE.

Failure, in itself, is not admirable. And when every man meets with failure somewhere in his life, the admirable thing is his courage in *overcoming it—not* the fact that he failed.

Failure is no disgrace—but it is certainly no brand of virtue or nobility, either.

It is the Communists' intention to make men accept misery, depravity and degradation as their natural lot in life. This is done by presenting every kind of failure as sympathetic, as a sign of goodness and virtue—while every kind of success is presented as a sign of evil. This implies that only the evil can succeed under our American system—while the good are to be found in the gutter.

Don't present all the poor as good and all the rich as evil. In judging a man's character, poverty is no disgrace—but it is no virtue, either; wealth is no virtue—but it is certainly no disgrace.

8. DON'T GLORIFY DEPRAVITY.

Don't present sympathetic studies of depravity. Go easy on stories about murderers, perverts and all the rest of that sordid stuff. If you use such stories, *don't* place yourself and the audience on the side of the criminal, *don't* create sympathy for him, *don't* give him excuses and justifications, *don't* imply that he "couldn't help it."

If you preach that a depraved person "couldn't help it," you are destroying the basis of all morality. You are implying that men cannot be held responsible for their evil acts, because man has no power to choose between good and evil; if so, then all moral precepts are futile, and men must resign themselves to the idea that they are helpless, irresponsible animals. *Don't* help to spread such an idea.

When you pick these stories for their purely sensational value, you do not realize that you are dealing with one of the most crucial philosophical issues. These stories represent a profoundly insidious attack on all moral principles and all religious precepts. It is a basic tenet of Marxism that man has no freedom of moral or intellectual choice; that he is only a soulless, witless collection of meat and glands, open to any sort of "conditioning" by anybody. The Communists intend to become the "conditioners."

There is too much horror and depravity in the world at present. If people see nothing but horror and depravity on the screen, you will merely add to their despair on the screen, you will merely add to their despair by driving in the impression that nothing better is possible to men or can be expected of life, which is what the Communists want people to think. Communism thrives on despair. Men without hope are easily ruled.

Don't excuse depravity. *Don't* drool over weaklings as conditioned "victims of circumstances" (or of "background" or of "society") who "couldn't help it." You are actually providing an excuse and an alibi for the worst instincts in the weakest members of your audiences.

Don't tell people that man is a helpless, twisted, drooling, sniveling, neurotic weakling. Show the world an *American* kind of man, for a change.

9. DON'T DEIFY "THE COMMON MAN."

"The common man" is one of the worst slogans of Communism—and too many of us have fallen for it, without thinking.

It is only in Europe—under social caste systems where men are divided into "aristocrats" and "commoners"—that one can talk about defending the "common man." What does the word "common" mean in America?

Under the American system, all men are equal before the law. Therefore, if anyone is classified as "common"—he can be called "common" only in regard to his personal qualities. It then means that he has no outstanding abilities, no outstanding virtues, no outstanding intelligence. Is *that* an object of glorification?

In the Communist doctrine, *it is*. Communism preaches the reign of mediocrity, the destruction of all individuality and all personal distinction, the turning of men into "masses," which means an undivided, undifferentiated, impersonal, average, *common* herd.

In the American doctrine, no man is *common*. Every man's personality is unique—and it is respected as such. He may have qualities which he shares with others; but his virtue is not gauged by how much he resembles others—*that* is the Communist doctrine; his virtue is gauged by his personal distinction, great or small.

In America, no man is scorned or penalized if his ability is small. But neither is he praised, extolled and glorified for the *smallness* of his ability.

America is the land of the *uncommon man*. It is the land where man is free to develop his genius—and to get its just rewards. It is the land where each man tries to develop whatever quality he might possess and to rise to whatever degree he can, great or modest. It is *not* the land where one is taught that one is small and ought to remain small. It is *not* the land where one glorifies or is taught to glory in one's mediocrity.

No self-respecting man in America is or thinks of himself as "little," no matter how poor he might be. *That,* precisely, is the difference between an American working man and a European serf.

Don't ever use any lines about the "common man" or "the little people." It is not the American idea to be either common or "little."

10. DON'T GLORIFY THE COLLECTIVE.

This point requires your careful and thoughtful attention. There is a great difference between free co-operation and forced collectivism. It is the difference between the United States and Soviet Russia. But the Communists are very skillful at hiding the difference and selling you the second under the guise of the first. You might miss it. The audience won't.

Co-operation is the free association of men who work together by voluntary agreement, each deriving from it his own personal benefit.

Collectivism is the forced herding together of men into a group, with the individual having no choice about it, no personal motive, no personal reward, and subordinating himself blindly to the will of others.

Keep this distinction clearly in mind—in order to judge whether what you are asked to glorify is American co-operation or Soviet Collectivism.

Don't preach that everybody should be and act alike.

Don't fall for such drivel as "I don't wanna be dif'rent—I wanna be just like ever'body else." You've heard this one in endless variations. If ever there was an un-American attitude, this is it. America is the country where every man wants to be *different*—and most men succeed at it.

If you preach that it is evil to be different—you teach every particular group of men to hate every other group, every minority, every person, for being different from them; thus you lay the foundation of race hatred.

Don't preach that *all* mass action is good, and *all* individual action is evil. It is true that there are vicious individuals; it is also true that there are vicious groups. Both must be judged by their specific actions—and not treated as an issue of "the one" against "the many," with the many always right and the one always wrong.

Remember that it is the Communists' aim to preach the supremacy, the superiority, the holy virtue of the group—as opposed to the individual. It is not America's aim. Nor yours.

11. DON'T SMEAR AN INDEPENDENT MAN.

This is part of the same issue as the preceding point.

The Communists' chief purpose is to destroy every form of independence—independent work, independent action, independent property, independent thought, an independent mind, or an independent man.

Conformity, alikeness, servility, submission and obedience are necessary to establish a Communist slave-state. Don't help the Communists to teach men to acquire these attitudes.

Don't fall for the old Communist trick of thinking that an independent man or an individualist is one who crushes and exploits others—such as a dictator. An independent man is one who stands alone and respects the same right of others, who does not rule nor serve, who neither sacrifices himself nor others. A dictator—by definition—is the most complete collectivist of all, because he exists by ruling, crushing and exploiting a huge collective of men.

Don't permit the snide little touches which Communists sneak into scripts, all the lines, hints and implications which suggest that something (a person. an attitude. a motive, an emotion) is evil because it is independent (or private. or personal, or single, or individual).

Don't preach that everything done for others is good, while everything done for one's own sake is evil. This damns every form of personal joy and happiness.

Don't preach that everything public spirited is good, while everything personal and private is evil.

Don't make every form of loneliness a sin, and every form of the herd spirit a virtue.

Remember that America is the country of the pioneer, the non-conformist, the inventor, the originator, the innovator. Remember that all great thinkers, artists, scientists were individual, independent men who stood alone, and discovered new directions of achievement—alone.

Don't let yourself be fooled when the Reds tell you that what they want to destroy are men like Hitler or Mussolini. What they want to destroy are men like Shakespeare, Chopin and Edison.

If you doubt this, think of a certain movie, in which a great composer was damned for succumbing, temporarily, to a horrible, vicious, selfish, anti-social sin. That he wanted to sit alone and write music!

12. DON'T USE CURRENT EVENTS CARELESSLY.

A favorite trick of the Communists is to insert into pictures casual lines of dialogue about some important, highly controversial political issue, to insert them as accidental small talk, without any connection to the scene, the plot, or the story.

Don't permit such lines. *Don't* permit snide little slurs at any political party—in a picture which is to be released just before election time.

Don't allow chance remarks of a partisan nature about any current political events.

If you wish to mention politics on the screen, or take sides in a current controversy— then do so fully and openly. Even those who do not agree with you will respect an honest presentation of the side you've chosen. But the seemingly accidental remarks, the casual wisecracks, the cowardly little half-hints are the things that arouse the anger and contempt of all those who uphold the opposite side of the issue. In most of the current issues, that opposite side represents half or more than half of your picture audience.

And it is a sad joke on Hollywood that while we shy away from all controversial subjects on the screen, in order not to antagonize anybody—we arouse more antagonism throughout the country and more resentment against ourselves by one cheap, little smear line in the midst of some musical comedy than we ever would by a whole political treatise.

Of all current questions, be most careful about your attitude toward Soviet Russia. You do not have to make pro-Soviet or anti-Soviet pictures, if you do not wish to take a stand. But if you claim that you wish to remain neutral, *don't* stick into pictures casual lines favourable to Soviet Russia. Look out for remarks that praise Russia directly or indirectly; or statements to the effect that anyone who is anti-Soviet is pro-Fascist; or references to fictitious Soviet achievements.

Don't suggest to the audience that the Russian people are free, secure and happy, that life in Russia is just about the same as in any other country—while actually the Russian people live in constant terror under a bloody, monstrous dictatorship. Look out for speeches that support whatever is in the Soviet interests of the moment, whatever is part of the current Communist party line. *Don't* permit dialogue such as: "The free, peace-loving nations of the world—America, England, and Russia . . ." or, "Free elections, such as Poland . . ." or, "American imperialists ought to get out of China . . ."

13. DON'T SMEAR AMERICAN POLITICAL INSTITUTIONS.

The Communist Party Line takes many turns and makes many changes to meet shifting conditions. But on one objective it has remained fixed: to undermine faith in and ultimately to destroy our America political institutions.

Don't discredit the Congress of the United States by presenting it as an ineffectual body; devoted to mere talk. If you do that—you imply that representative government is no good, and that we ought to have is a dictator.

Don't discredit our free elections. If you do that—you imply that elections should be abolished.

Don't discredit our courts by presenting them as corrupt. If you do that—you lead people to believe that they have no recourse except to violence, since peaceful justice cannot be obtained.

It is true that there have been vicious Congressmen and judges, and politicians who have stolen elections, just as there are vicious men in any profession. But if you present them in a story, be sure to make it clear that you are criticizing particular men—*not the system.* The American system, as such, is the best ever devised in history. If some men do not live up to it—let us damn these men, *not* the system which they betray.

CONCLUSION

These are the things which Communists and their sympathizers try to sneak into pictures intended as non-political—and these are the things which you must keep out of your scripts, if your intention is to make non-political movies.

There is, of course, no reason why you should not make pictures on political themes. In fact, it would be most desirable if there were more pictures advocating the political principles of Americanism, seriously, consistently and dramatically. Serious themes are always good entertainment, if honestly done. But if you attempt such pictures—do not undertake them lightly, carelessly, and with no better equipment than a few trite generalities and safe, benevolent bromides. Be very sure of what you want to say—and say it clearly, specifically, uncompromisingly. Evasions and generalities only help the enemies of Americanism—by giving people the impression that American principles are a collection of weak, inconsistent, meaningless, hypocritical, worn-out old slogans.

There is no obligation on you to make political pictures—if you do not wish to take a strong stand. You are free to confine your work to good, honest. non-political movies. But *there is* a moral obligation on you to present the political ideas of Americanism strongly and honestly—if you undertake pictures with political themes.

And when you make pictures with political themes and implications—*don't* hire Communists to write, direct or produce them. You cannot expect Communists to remain "neutral" and not to insert their own ideas into their work. Take them at their word, not ours. They have declared openly and repeatedly that their first obligation is to the Communist Party, that their first duty is to spread Party propaganda, and that their work in pictures is only a means to an end, the end being the Dictatorship of the Proletariat. You had better believe them about their own stated intentions. Remember that Hitler, too, had stated openly that his aim was world conquest, but nobody believed him or took it seriously until it was too late.

Now a word of warning about the question of free speech. The principle of free speech requires that we do not use police force to forbid the Communists the expression of their ideas—which means that we do not pass laws forbidding them to speak. But the principle of free speech does not require that we furnish the Communists with the means to preach their ideas, and does not imply that we owe them jobs and support to advocate our own destruction at our own expense. The Constitutional guaranty of free speech reads: "Congress shall pass no laws—" It does not require employers to be suckers.

Let the Communists preach what they wish (so long as it remains mere talking) at the expense of those and in the employ of those who share their ideas. Let them create their own motion picture studios, if they can. But let us put an end to their use of our pictures, our studios and our money for the purpose of preaching our expropriation, enslavement and destruction. Freedom of speech does not imply that it is our duty to provide a knife for the murderer who wants to cut our throat.

WHITE ELEPHANT ART VS. TERMITE ART (USA, 1962)

Manny Farber

[First published in *Film Culture* 27 (1962): 9–13.]

A major influence on a whole generation of film and rock critics (including J. Hoberman, Jonathan Rosenbaum, and Greil Marcus), Manny Farber was a painter and film critic who wrote film reviews for, among many other publications, *The Nation*, *New Republic*, and *Artforum*. Farber, in this manifesto published in Jonas Mekas's *Film Culture*, very much going against the dominant critical trends of the time, decries the bloated nature of much of the cinema that strives for high art and respectability— Truffaut in particular is a *bête noire* for him—and instead valorizes the burrowing, termite culture of B movies, *The Big Sleep*, and Laurel and Hardy.

Most of the feckless, listless quality of today's art can be blamed on its drive to break out of a tradition, while, irrationally, hewing to the square, boxed-in shape and gemlike inertia of an old, densely wrought European masterpiece.

Advanced painting has long been suffering from this burnt-out notion of a masterpiece—breaking away from its imprisoning conditions toward a suicidal improvisation, threatening to move nowhere and everywhere, niggling, omnivorous, ambitionless; yet, within the same picture, paying strict obeisance to the canvas edge and, without favoritism, the precious nature of every inch of allowable space. A classic example of this inertia is the Cézanne painting: in his indoorish works of the woods around Aix-en-Provence,

a few spots of tingling, jarring excitement occur where he nibbles away at what he calls his "small sensation," the shifting of a tree trunk, the infinitesimal contests of complimentary colors in a light accent on farmhouse wall. The rest of each canvas is a clogging weight-density-structure-polish amalgam associated with self-aggrandizing masterwork. As he moves away from the unique, personal vision that interests him, his painting turns ungiving and puzzling: a matter of balancing curves for his bunched-in composition, laminating the color, working the painting to the edge. Cézanne ironically left an expose of his dreary finishing work in terrifyingly honest watercolors, an occasional unfinished oil (the pinkish portrait of his wife in sunny, leafed-in patio), where he foregoes everything but his spotting fascination with minute interactions.

The idea of art as an expensive hunk of well-regulated area, both logical and magical, sits heavily over the talent of every modern painter, from Motherwell to Andy Warhol. The private voice of Motherwell (the exciting drama in the meeting places between ambivalent shapes, the aromatic sensuality that comes from laying down thin sheets of cold, artfully clichéish, hedonistic color) is inevitably ruined by having to spread these small pleasures into great contained works. Thrown back constantly on unrewarding endeavors (filling vast egglike shapes, organizing a ten-foot rectangle with its empty corners suggesting Siberian steppes in the coldest time of the year), Motherwell ends up with appalling amounts of plasterish grandeur, a composition so huge and questionably painted that the delicate, electric contours seem to be crushing the shalelike matter inside. The special delight of each painting tycoon (De Kooning's sabrelike lancing of forms; Warhol's minute embrace with the path of illustrator's pen line and block-print tone; James Dine's slog-footed brio, filling a stylized shape from stem to stern with one ungiving color) is usually squandered in pursuit of the continuity, harmony, involved in constructing a masterpiece. The painting, sculpture, assemblage becomes a yawning production of overripe technique shrieking with preciosity, fame, ambition; far inside are tiny pillows holding up the artist's signature, now turned into mannerism by the padding, lechery, faking required to combine today's esthetics with the components of traditional Great Art.

Movies have always been suspiciously addicted to termite-art tendencies. Good work usually arises where the creators (Laurel and Hardy, the team of Howard Hawks and William Faulkner operating on the first half of Raymond Chandler's *The Big Sleep*) seem to have no ambitions towards gilt culture but are involved in a kind of squandering-beaverish endeavor that isn't anywhere or for anything. A peculiar fact about termite-tapeworm-fungus-moss art is that it goes always forward eating its own boundaries, and, likely as not, leaves nothing in its path other than the signs of eager, industrious, unkempt activity.

The most inclusive description of the art is that, termite-like, it feels its way through walls of particularization, with no sign that the artist has any object in mind other than eating away the immediate boundaries of his art, and turning these boundaries into conditions of the next achievement. Laurel and Hardy, in fact, in some of their most

dyspeptic and funniest movies, like *Hog Wild,* contributed some fine parody of men who had read every "How to Succeed" book available; but, when it came to applying their knowledge, reverted instinctively to termite behavior.

One of the good termite performances (John Wayne's bemused cowboy in an unreal stage town inhabited by pallid repetitious actors whose chief trait is a powdered makeup) occurs in John Ford's *The Man Who Shot Liberty Valance.* Better Ford films than this have been marred by a phlegmatically solemn Irish personality that goes for rounded declamatory acting, silhouetted riders along the rim of a mountain with a golden sunset behind them, and repetitions in which big bodies are scrambled together in a rhythmically curving Rosa Bonheurish composition. Wayne's acting is infected by a kind of hoboish spirit, sitting back on its haunches doing a bitter amused counterpoint to the pale, neutral film life around him. In an Arizona town that is too placid, where the cactus was planted last night and nostalgically cast actors do a generalized drunkenness, cowardice, voraciousness, Wayne is the termite actor focusing only on a tiny present area, nibbling at it with engaging professionalism and a hipster sense of how to sit in a chair leaned against the wall, eye a flogging overactor (Lee Marvin). As he moves along at the pace of a tapeworm, Wayne leaves a path that is only bits of shrewd intramural acting—a craggy face filled with bitterness, jealousy, a big body that idles luxuriantly, having long grown tired with roughhouse games played by old wrangler types like John Ford.

The best examples of termite art appear in places other than films, where the spotlight of culture is nowhere in evidence, so that the craftsman can be ornery, wasteful, stubbornly self-involved, doing go for broke art and not caring what comes of it. The occasional newspaper column by a hard work specialist caught up by an exciting event (Joe Alsop or Ted Lewis, during a presidential election), or a fireball technician reawakened during a pennant playoff that brings on stage his favorite villains (Dick Young); the TV production of *The Iceman Cometh,* with its great examples of slothful-buzzing acting by Myron McCormack, Jason Robards, et al.; the last few detective novels of Ross Macdonald and most of Raymond Chandler's ant-crawling verbosity and sober fact-pointing in the letters compiled years back in a slightly noticed book that is a fine running example of popular criticism; the TV debating of William Buckley, before he relinquished his tangential, counterattacking skill and took to flying into propeller blades of issues, like James Meredith's Ole Miss adventures.

In movies, nontermite art is too much in command of writers and directors to permit the omnivorous termite artist to scuttle along for more than a few scenes. Even Wayne's cowboy job peters out in a gun duel that is overwrought with conflicting camera angles, plays of light and dark, ritualized movement and posture. In *The Loneliness of the Long Distance Runner,* the writer (Alan Sillitoe) feels the fragments of a delinquent's career have to be united in a conventional story. The design on which Sillitoe settles—a spoke-like affair with each fragment shown as a memory experienced on practice runs—leads to repetitious scenes of a boy running. Even a gaudily individual track star—a Peter

Snell—would have trouble making these practice runs worth the moviegoer's time, though a cheap ton of pseudo–Bunny Berigan jazz trumpet is thrown on the film's sound track to hop up the neutral dullness of these up-down-around spins through vibrant English countryside.

Masterpiece art, reminiscent of the enameled tobacco humidors and wooden lawn ponies bought at white elephant auctions decades ago, has come to dominate the over-populated arts of TV and movies. The three sins of white elephant art (1) frame the action with an all-over pattern, (2) install every event, character, situation in a frieze of continuities, and (3) treat every inch of the screen and film as a potential area for prizeworthy creativity. *Requiem for a Heavyweight* is so heavily inlaid with ravishing technique that only one scene—an employment office with a nearly illiterate fighter (Anthony Quinn) falling into the hands of an impossibly kind job clerk—can be acted by Quinn's slag blanket type of expendable art, which crawls along using fair insight and a total immersion in the materials of acting. Antonioni's *La Notte* is a good example of the evils of continuity, from its opening scene of a deathly sick noble critic being visited by two dear friends. The scene gets off well, but the director carries the thread of it to agonizing length, embarrassing the viewer with dialogue about art that is sophomorically one dimensional, interweaving an arty shot of a helicopter to fill the time interval, continuing with impos-sible-to-act effects of sadness by Moreau and Mastroianni outside the hospital, and, finally, reels later, a laughable postscript conversation by Moreau-Mastroianni detailing the critic's "meaning" as a friend, as well as a few other very mystifying details about the poor bloke. Tony Richardson's films, beloved by art theater patrons, are surpassing examples of the sin of framing, boxing in an action with a noble idea or camera effect picked from High Art.

In Richardson's films *(A Taste of Honey, The Long Distance Runner)*, a natural directing touch on domesticity involving losers is the main dish (even the air in Richardson's whit-ish rooms seems to be fighting the ragamuffin type who infests Richardson's young or old characters). With his "warm" liking for the materials of direction, a patient staying with confusion, holding to a cop's lead-footed pacelessness that doesn't crawl over details so much as back sluggishly into them. Richardson can stage his remarkable seconds-ticking sedentary act in almost any setup—at night, in front of a glary department store window, or in a train coach with two pairs of kid lovers settling in with surprising, hopped-up animalism. Richardson's ability to give a spectator the feeling of being There, with time to spend, arrives at its peak in homes, apartments, art garrets, a stable-like apart-ment, where he turns into an academic neighbor of Walker Evans, steering the spectator's eyes on hidden rails, into arm patterns, worn wood, inclement feeling hovering in tiny marble eyes, occasionally even making a room appear to take shape as he introduces it to a puffy-faced detective or an expectant girl on her first search for a room of her own. In a kitchen scene with kid thief and job-worn detective irritably gnawing at each other, Richardson's talent for angular disclosures takes the scene apart without pointing or a nearly habitual underlining; nagging through various types of bone-worn, dishrag-gray

material with a fine windup of two unlikable opponents still scraping at each other in a situation that is one of the first to credibly turn the overattempted movie act—showing hard, agonizing existence in the wettest rain and slush.

Richardson's ability with deeply lived-in incident is, nevertheless, invariably dovetailed with his trick of settling a horse collar of gentility around the neck of a scene, giving the image a pattern that suggests practice, skill, guaranteed safe humor. His highly rated stars (from Richard Burton through Tom Courtenay) fall into mock emotion and studied turns, which suggest they are caught up in the enameled sequence of a vaudeville act: Rita Tushingham's sighting over a gun barrel at an amusement park (standard movie place for displaying types who are closer to the plow than the library card) does a broadly familiar comic arrangement of jaw muscle and eyebrow that has the gaiety and almost the size of a dinosaur bone. Another gentility Richardson picked up from fine *objets d'art* (Dubuffet, Larry Rivers, Dick Tracy's creator) consists of setting a network of marring effects to prove his people are ill placed in life. Tom Courtenay (the last angry boy in *Runner*) gets carried away by this cult, belittling, elongating, turning himself into a dervish with a case of Saint Vitus dance, which localizes in his jaw muscles, eyelids. As Richardson gilds his near vagrants with sawtooth mop coiffures and a way of walking on high heels so that each heel seems a different size and both appear to be plunged through the worn flooring, the traits look increasingly elegant and put on (the worst trait: angry eyes that suggest the empty orbs in "Orphan Annie" comic strips). Most of his actors become crashing, unbelievable bores, though there is one nearly likable actor, a chubby Dreiserian girl friend in *Long Distance Runner* who, termite-fashion, almost acts into a state of grace. Package artist Richardson has other boxing-in ploys, running scenes together as Beautiful Travelogue, placing a cosmic symbol around the cross-country running event, which incidentally crushes Michael Redgrave, a headmaster in the fantastic gambol of throwing an entire Borstal community into a swivet over one track event.

The common denominator of these laborious ploys is, actually, the need of the director and writer to overfamiliarize the audience with the picture it's watching: to blow up every situation and character like an affable inner tube with recognizable details and smarmy compassion. Actually, this overfamiliarization serves to reconcile these supposed long-time enemies—academic and Madison Avenue art.

An exemplar of white elephant art, particularly the critic-devouring virtue of filling every pore of a work with glinting, darting Style and creative Vivacity, is François Truffaut. Truffaut's *Shoot the Piano Player* and *Jules et Jim*, two ratchety perpetual-motion machines devised by a French Rube Goldberg, leave behind the more obvious gadgetries of *Requiem for a Heavyweight* and even the cleaner, bladelike journalism of *The 400 Blows*.

Truffaut's concealed message, given away in his Henry Miller-ish, adolescent two-reeler of kids spying on a pair of lovers (one unforgettably daring image: kids sniffing the bicycle seat just vacated by the girl in the typical fashion of voyeuristic pornographic art)

is a kind of reversal of growth, in which people grow backward into childhood. Suicide becomes a game, the houses look like toy boxes—laughter, death, putting out a fire—all seem reduced to some unreal innocence of childhood myths. The real innocence of *Jules et Jim* is in the writing: which depends on the spectator sharing the same wide-eyed or adolescent view of the wickedness of sex that is implicit in the vicious gamesmanship going on between two men and a girl.

Truffaut's stories (all women are villains; the schoolteacher seen through the eyes of a sniveling schoolboy; all heroes are unbelievably innocent, unbelievably persecuted) and characters convey the sense of being attached to a rubber band, although he makes a feint at reproducing the films of the 1930's with their linear freedom and independent veering. From *The 400 Blows* onward, his films are bound in and embarrassed by his having made up his mind what the film is to be about. This decisiveness converts the people and incidents into flat, jiggling mannikins (*400 Blows, Mischief Makers*) in a Mickey Mouse comic book, which is animated by thumbing the pages rapidly. This approach eliminates any stress or challenge, most of all any sense of the film locating an independent shape.

Jules et Jim, the one Truffaut film that seems held down to a gliding motion, is also cartoonlike but in a decorous, suspended way. Again most of the visual effect is an illustration for the current of the sentimental narrative. Truffaut's concentration on making his movie fluent and comprehensible flattens out all complexity and reduces his scenes to scraps of pornography—like someone quoting just the punchline of a well-known dirty joke. So unmotivated is the leapfrogging around beds of the three-way lovers that it leads to endless bits of burlesque. Why does she suddenly pull a gun? (See "villainy of women," above). Why does she drive her car off a bridge? (Villains need to be punished.) Etc.

Jules et Jim seems to have been shot through a scrim which has filtered out everything except Truffaut's dry vivacity with dialogue and his diminutive stippling sensibility. Probably the high point in this love-is-time's-fool film: a languorous afternoon in a chalet (what's become of chalets?) with Jeanne Moreau teasing her two lovers with an endless folksong. Truffaut's lyrics—a patter of vivacious small talk that is supposed to exhibit the writer's sophistication, never mind about what—provides most of the scene's friction, along with an idiot concentration on meaningless details of faces or even furniture (the degree that a rocking chair isn't rocking becomes an impressive substitute for psychology). The point is that, divested of this meaningless vivacity, the scenes themselves are without tension, dramatic or psychological.

The boredom aroused by Truffaut to say nothing of the irritation—comes from his peculiar methods of dehydrating all the life out of his scenes (instant movies?). Thanks to his fondness for doused lighting and for the kind of long shots which hold his actors at thirty paces, especially in bad weather, it's not only the people who are blanked out; the scene itself threatens to evaporate off the edge of the screen. Adding to the effect of evaporation, disappearing: Truffaut's imagery is limited to traveling (running through

meadows, walking in Paris streets, etc.), setups and dialogue scenes where the voices, disembodied and like the freakish chirps in Mel Blanc's *Porky Pig* cartoons, take care of the flying out effect. Truffaut's system holds art at a distance without any actual muscularity or propulsion to peg the film down. As the spectator leans forward to grab the film, it disappears like a released kite.

Antonioni's specialty, the effect of moving as in a chess game, becomes an autocratic kind of direction that robs an actor of his motive powers and most of his spine. A documentarist at heart and one who often suggests both Paul Klee and the cool, deftly neat, "intellectual" Fred Zinnemann in his early *Act of Violence* phase, Antonioni gets his odd, clarity-is-all effects from his taste for chic mannerist art that results in a screen that is glassy, has a side-sliding motion, the feeling of people plastered against stripes or divided by verticals and horizontals; his incapacity with interpersonal relationships turns crowds into stiff waves, lovers into lonely appendages, hanging stiffly from each other, occasionally coming together like clanking sheets of metal but seldom giving the effect of being in communion.

At his best, he turns this mental creeping into an effect of modern misery, loneliness, cavernous guilt-ridden yearning. It often seems that details, a gesture, an ironic wife making a circle in the air with her finger as a thought circles toward her brain, become corroded by solitariness. A pop jazz band appearing at a millionaire's fete becomes the unintentional heart of *La Notte*, pulling together the inchoate center of the film—a vast endless party. Antonioni handles this combo as though it were a vile mess dumped on the lawn of a huge estate. He has his film inhale and exhale, returning for a glimpse of the four-piece outfit playing the same unmodified kitsch music stupidly immobile, totally detached from the party swimming around the music. The film's most affecting shot is one of Jeanne Moreau making tentative stabs with her somber, alienated eyes and mouth, a bit of a dance step, at rapport and friendship with the musicians. Moreau's facial mask, a signature worn by all Antonioni players, seems about to crack from so much sudden uninhibited effort.

The common quality or defect which unites apparently divergent artists like Antonioni, Truffaut, Richardson is fear, a fear of the potential life, rudeness, and outrageousness of a film. Coupled with their storage vault of self-awareness and knowledge of film history, this fear produces an incessant wakefulness.

In Truffaut's films, this wakefulness shows up as dry, fluttering inanity. In Antonioni's films, the mica-schist appearance of the movies, their linear patterns, are hulked into obscurity by Antonioni's own fund of sentimentalism, the need to get a mural-like thinness and interminableness out of his mean patterns.

The absurdity of *La Notte* and *L'Avventura* is that its director is an authentically interesting oddball who doesn't recognize the fact. His talent is for small eccentric microscope studies, like Paul Klee's, of people and things pinned in their grotesquerie to an oppressive social backdrop. Unlike Klee, who stayed small and thus almost evaded affectation, Antonioni's aspiration is to pin the viewer to the wall and slug him with wet towels of

artiness and significance. At one point in *La Notte*, the unhappy wife, taking the director's patented walk through a continent of scenery, stops in a rubbled section to peel a large piece of rusted tin. This ikon close-up of minuscule desolation is probably the most overworked cliché in still photography, but Antonioni, to keep his stories and events moving like great novels through significant material, never stops throwing his Sunday punch. There is an interestingly acted nymphomaniac girl at wit's end trying to rape the dish-rag hero; this is a big event, particularly for the first five minutes of a film. Antonioni overweights this terrorized girl and her interesting mop of straggly hair by pinning her into a typical Band-aid composition—the girl, like a tiny tormented animal, backed against a large horizontal stripe of white wall. It is a pretentiously handsome image that compromises the harrowing effect of the scene.

Whatever the professed theme in these films, the one that dominates in unspoken thought is that the film business is finished with museum art or pastiche art. The best evidence of this disenchantment is the anachronistic slackness of *Jules et Jim, Billy Budd, Two Weeks in Another Town*. They seem to have been dropped into the present from a past which has become useless. This chasm between white-elephant reflexes and termite performances shows itself in an inertia and tight defensiveness which informs the acting of Mickey Rooney in *Requiem for a Heavyweight*, Julie Harris in the same film, and the spiritless survey of a deserted church in *L'Avventura*. Such scenes and actors seem as numb and uninspired by the emotions they are supposed to animate, as hobos trying to draw warmth from an antiquated coal stove. This chasm of inertia seems to testify that the Past of heavily insured, enclosed film art has become unintelligible to contemporary performers, even including those who lived through its period of relevance.

Citizen Kane, in 1941, antedated by several years a crucial change in films from the old flowing naturalistic story, bringing in an iceberg film of hidden meanings. Now the revolution wrought by the exciting but hammy Orson Welles film, reaching its zenith in the 1950's, has run its course and been superceded by a new film technique that turns up like an ugly shrub even in the midst of films that are preponderantly old gems. Oddly enough the film that starts the breaking away is a middle-1950's film, that seems on the surface to be as traditional as *Greed*. Kurosawa's *Ikiru* is a giveaway landmark, suggesting a new self-centering approach. It sums up much of what a termite art aims at: buglike immersion in a small area without point or aim, and, over all, concentration on nailing down one moment without glamorizing it, but forgetting this accomplishment as soon as it has been passed; the feeling that all is expendable, that it can be chopped up and flung down in a different arrangement without ruin.

SUPER FLY: A SUMMARY OF OBJECTIONS BY THE KUUMBA WORKSHOP (USA, 1972)

Kuumba Workshop

[First published in Francis Ward, *"Super Fly": A Political and Cultural Condemnation by the Kuumba Workshop* (Chicago: Institute of Positive Education, 1972), 2.]

This manifesto, written by Francis Ward, one of the founders, along with his wife Val Gray Ward, of the Kuumba Workshop—a well-known Black Arts theatre workshop in Chicago—takes issue with the blaxploitation film *Super Fly* (Gordon Parks, Jr., 1972), not only because of its negative representations but because the film tries to exploit African Americans by selling a grotesque, distorted image of themselves back to them in order to profit.

"Super Fly" . . . A Subtle, Deadly Ripoff

1. The film advocated using dope—the biggest, most destructive killer of Black people in the country.
2. It never deals with the deadly consequences of dope dealing which is sweeping Black communities like a ravaging plague.
3. It glorifies the hustler as hero—another in a long succession of such films which glorify and distort the image and influence of Black hustlers, pimps and studs.
4. "Super Fly" has no positive messages or images for Black people.
5. It has questionable financial backing.
6. It creates the illusion of "victory?" over whites—a deadly dangerous pretense in these times of growing repression when fantasy on screen is no substitute for *real* victory in the liberation struggle.
7. It never shows *why* the realities in the film exist as they do—a serious violation of the principles of Black art, which must show not only that certain realities exist, but why, and give necessary alternatives.
8. It exploits the use of sex, though not quite as grossly as some other films.
9. None of the proceeds from the film have been returned to any Black community.
10. The film is a straight, *unadulterated hustle* of Black people's money and yearning to see themselves on screen.

FULL FRONTAL MANIFESTO
(USA, 2001)

Steven Soderbergh

[Originally sent to prospective actors considering taking a part in Soderbergh's film *Full Frontal*.]

The "Full Frontal" manifesto seems to be inspired in many ways by Dogme '95 (see Trier and Vinterberg, "Dogme '95 Manifesto and Vow of Chastity," in chap. 2 of this volume). Instead of dictating rules for filmmakers, here Soderbergh dictates the rules to the actors reading his script while considering whether to take a role in the film.

Important

If you are an actor considering a role in this film, please note the following:

1. All sets are practical locations.
2. You will drive yourself to the set. If you are unable to drive yourself to the set, a driver will pick you up, but you will probably become the subject of ridicule. Either way, you arrive alone.
3. There will be no craft service, so you should arrive on the set "having had." Meals will vary in quality.
4. You will pick, provide and maintain your own wardrobe.
5. Your will create and maintain your own hair and make-up.
6. There will be no trailers. The company will attempt to provide holding areas near a given location, but don't count on it. If you need to be alone a lot, you're pretty much screwed.
7. Improvisation will be encouraged.
8. You will be interviewed about your character. This material may end up in the finished film.
9. You will be interviewed about other characters. This material may end up in the finished film.
10. You will have fun whether you want to or not.

If any of these guidelines are problematic for you, stop reading now and send this screenplay back to where it came from.

6

THE CREATIVE TREATMENT
OF ACTUALITY

Since its inception, cinema has often been described as a dichotomy between the *actualités* of the Lumière brothers and the fantasies of Georges Méliès. But despite Hitchcock's *bon mot* that "in feature films the director is God; in documentary films God is the director," this dichotomy has always been a false one.[1] As early as 1896, films such as *Démolition d'un mur* brought fantasy into the realm of the Lumières' *actualités*, while the films of Méliès quickly embraced the emergent protodocumentary ethos to give his fantasies a sense of reality in works such as *Le voyage dans la lune* (France, 1902) and *À la conquête du pôle* (France, 1912). This tension between documentary and the real—succinctly codified by Jean-Luc Godard in his oft-cited statement that "if you want to make a documentary you should automatically go to the fiction, and if you want to nourish your fiction you have to come back to reality"[2]—underlies many of the theoretical concerns, ethical practices, filmmaking strategies and film manifestos concerned with documentary cinema. Part of this drive comes from the influential codification of the documentary by John Grierson as "the creative treatment of actuality."[3] Contained within this phrase is the precise dichotomy that pervades documentary cinema and only grows in an age of globalization. In Wim Wenders's documentary on Yasujiro Ozu, *Tokyo-ga* (West Germany, 1985), the filmmaker meets with his New German Cinema colleague Werner Herzog, who was shifting to documentary filmmaking at the time. Herzog states:

> There are few images to be found. One has to dig for them like an archaeologist. One has to search through this ravaged landscape to find anything at all. . . . It's often tied up with risk, of course, which I would never shun, but I see so few people today who dare to address our lack of adequate images. We absolutely need images in tune with our civilization, images that resonate with what is deepest within us. We need to go into war zones, if need be, or anywhere else it takes us . . . to find images that are pure and clear and transparent. . . . I'd go to Mars or Saturn if I could . . . because it's no longer easy here on this Earth to find that something that gives images their transparency the way you could before.

All the manifestos in this chapter address, to one degree or another, this tension, central to the heart of documentary cinema, beginning with the founding manifesto of documentary filmmaking: "First Principles of Documentary," from 1932. Grierson, the founder of the documentary film movements in both the United Kingdom and Canada, argues that the story told by a documentary film must emerge from the footage filmed, that the documentary film cannot be prepackaged, in the manner of the Hollywood studio system, beforehand. Grierson is also fairly scathing about city symphony films, like Walter Ruttmann's *Berlin: Symphony of a Great City* (1927), as he argues quite polemically

that unlike the films of Flaherty, city symphony films are about nothing. Oswell Blakeston's "Manifesto on the Documentary Film," published a year later, is even more polemical, decrying the destruction of documentary by the aesthetics of montage and simplifications offered by educational documentary cinema, proclaiming the need for documentaries that reflect reality and do not simply offer an aestheticized vision of the world, divorced from profilmic reality. The "Declaration of the Group of Thirty" is concerned with a different set of issues, namely the potential demise of short-film production in France. Signed by some of the most notable documentary filmmakers in France at the time (Jacques-Yves Cousteau, Alain Resnais, Alexandre Astruc, and Georges Franju among them), the manifesto is a protest and call to arms against changing film policies in France.

Subsequent manifestos in this chapter address the question of the relationship between documentary film and political action. Two manifestos in particular arise from controversies over what kinds of films are included and elided in film festivals. "Documentary Filmmakers Make Their Case," from the Krakow Group (Bohdan Kosi ski, Krzysztof Kieślowski, and Tomasz Zygadło), outlines the project of what would become the "cinema of moral anxiety," which arose out of the betrayed ideals that followed the post-1968 events in Poland. The YIDFF Manifesto decries the lack of documentary films by Asian filmmakers at the inaugural Yamagata documentary film festival. The manifesto argues that the festival's concentration on international cinema neglects the diversity of new works appearing from Asia.

The manifestos that emerge at the end of the first century of cinema call into question the practices of the past in an attempt to develop new forms of documentary filmmaking. Herzog's "The Minnesota Declaration" is an attack on *cinema verité* as a form of cinematic tourism. Lars von Trier's "Defocus Manifesto" was written as a documentary manifesto while he was making *The Five Obstructions* (*De fem benspænd*, Denmark, 2003), his manifesto film made in collaboration with Jørgen Leth. The "Defocus Manifesto" harks back, in a strange way, to Grierson's call for a need to move away from preordained stories in documentary film. Jill Godmilow's "Kill the Documentary as We Know It" also uses Dogme '95 as a starting point. Godmilow indicts the ethics of documentary filmmaking and, unlike Grierson, is harshly critical of works such as *Nanook of the North* (1922), calling for a new form of ethical documentary that puts the subjects before the film. If this kind of practice does not emerge, Godmilow contends, then the documentary itself, as a way of representing the world, is lost. Jay Ruby's "Ethnographic Cinema (EC): A Manifesto/Provocation" raises similar issues around the ethics of ethnographic filmmaking. Ruby argues that ethnographic filmmaking can't simply be a species of realism or travelogue but must engage with the fieldwork undertaken by anthropologists to have any cultural, political, or explanatory value. Albert Maysles's "Documentary Manifesto" amounts to a statement of the principles that have guided his practice over forty years. Unlike the authors of the previous manifestos, he is not throwing out the history of documentary filmmaking, or the claim that one can capture the real, but he is outlining what kinds of practices documentary filmmakers ought to follow if their films are to have

ethical value. The final manifesto in this chapter, "China Independent Film Festival Manifesto: Shamans * Animals," is a collaborative manifesto that critiques not documentary filmmakers but the critics who claim authority on the ethical values in documentary cinema. A riposte to the kinds of critiques outlined above, this manifesto foregrounds the ongoing debates not only surrounding documentary cinema but its potential role in society and that of the filmmakers who practice it.

TOWARDS A SOCIAL CINEMA
(France, 1930)

Jean Vigo

[Originally delivered as a lecture entitled "Vers un cinéma social" at the premiere of his first film, *À propos de Nice*, at the Théâtre du Vieux-Colombier in Paris on 14 June 1930. First published in English in *Millennium Film Journal* 1, no. 1 (Winter 1977–1978): 21–24. Trans. Stuart Liebman; revised for this publication.]

Vigo's speech at the launch of *À propos de Nice* can be seen as the first statement on what came to be known as the committed documentary. Using Luis Buñuel and Salvador Dalí's *Un chien andalou* as an exemplar, Vigo goes on to argue for a form of committed documentary that strips away the falsities of newsreels and allows the filmmaker's subjectivity and beliefs to be the guiding principle behind his or her work.

You're right if you don't think that we're going to discover America together. I say this to indicate right away the precise import of the words on the scrap of paper you have been given as a promise of more to come.

I'm not concerned today with revealing what social cinema is, no more than I am in strangling it with a formula. Rather, I'm trying to arouse more often your latent need to see good films—filmmakers, please excuse me for the pleonasm—dealing with society and its relationships with individuals and things.

Because, you see, the cinema suffers more from flawed thinking than from a total absence of thought.

At the cinema we treat our minds with a refinement that the Chinese usually reserve for their feet.

On the pretext that the cinema was born yesterday, we speak babytalk, like a daddy who babbles to his darling so that his little babe-in-arms can better understand him.

A camera, after all, is not a pump for creating vacuums.

To aim toward a social cinema would be to consent to work a mine of subjects that reality ceaselessly renews.

It would be to liberate oneself from the two pairs of lips that take 3,000 meters to come together and almost as long to come unstuck.

It would be to avoid the overly artistic subtlety of a pure cinema which contemplates its super-navel from one angle, then from yet another angle, always another angle, a super-angle; that's technique for technique's sake.

It would be to dispense with knowing whether the cinema should be silent *a priori,* or as sonorous as an empty jug, or as 100 percent talking as our war veterans, or in three dimensional relief, in color, with smells, etc.

For, to take another field, why don't we demand that an author tell us if he used a goose quill or a fountain pen to write his latest novel.

These devices are really no more than fairground trinkets.

Besides, the cinema is governed by the laws of the fairground.

To aim at a social cinema would simply be to agree to say something and to stimulate echoes other than those created by the belches of ladies and gentlemen who come to the cinema to aid their digestion.

And by doing so, we will perhaps avoid the magisterial spanking that M. Georges Duhamel[4] administers to us in public.

Today, I would have liked to show you *Un Chien Andalou* which, though an interior drama developed as a poem, nevertheless presents, in my view, all the qualities of a film whose subject has social implications.

M. Luis Bunuel was opposed to its screening, and for these very reasons, I am forced to project *A Propos de Nice* for you and to present it to you myself.

I am sorry, for *Un Chien Andalou* is a major work in every aspect: the assurance of its direction, the artfulness of its lighting, its perfect knowledge of visual and conceptual associations, its sure dream logic, its admirable confrontation between the subconscious and the rational.

Above all I am sorry because, from a social point of view, *Un Chien Andalou* is both an accurate and a courageous film.

Incidentally, I would like to make the point that it is a quite rare kind of film.

I have met M. Bunuel only once and then for only ten minutes. We didn't discuss the scenario of *Un Chien Andalou*. I can therefore speak about it to you all the more freely. Obviously, my comments are personal. Possibly I will get near the truth; without any doubt, I will utter some absurdities.

In order to understand the significance of the film's title, one must remember that M. Bunuel is Spanish.

An Andalusian dog howls—who then is dead?

Our listlessness, which makes us accept all the horrors men have committed on earth, is put to a severe test when we can't bear the sight of a woman's eye cut in two by a razor on the screen. Is it more dreadful than the sight of a cloud veiling a full moon?

Such is the prologue: I must say that it cannot leave us indifferent. It guarantees that, during this film, we will have to watch with something different than our everyday eyes, if I may put it this way.

Throughout the film we are held in the same grip.

From the very first image, we can see in the face of an overgrown child riding down the street on a bicycle without touching the handlebars, hands on his thighs, covered with white frills like so many wings, we can see, I repeat, our ingenuousness that turns to cowardice in contact with a world that we accept (one gets the world one deserves), this world of exaggerated prejudices, of self-denials, and of pathetically romanticized regrets.

M. Bunuel is a fine swordsman who disdains stabbing us in the back.

A kick in the pants to macabre ceremonies, to the final laying out of a being who is no longer there, who is nothing more than a dust-filled hollow on a bed.

A kick in the pants to those who have sullied love by resorting to rape.

A kick in the pants to sadism, of which gawking is its most disguised form.

And let us pluck a little at the reins of the morality with which we harness ourselves. Let's see a bit of what lies at its foundation.

A cork—here, at least, is a weighty argument.

A bowler hat—the wretched bourgeoisie.

Two brothers of the *École Chrétienne*—poor Christ![5]

Two grand pianos crammed with carrion and excrement—our impoverished senti-mentality.

Finally, the donkey in closeup; we were expecting it.

M. Bunuel is terrible.

Shame on those who kill in puberty what they could have been, who look for it in the forests and along the beaches where the sea casts up our memories and regrets until they wither away with the coming of Spring.

Cave canem . . . beware of the dog—it bites.

I say all this to avoid too dry an analysis, image by image, which is in any case something impossible for a good film whose savage poetry must be respected—and only in the hope of stimulating your desire to see or to see again *Un Chien Andalou.*

To aim at a social cinema is therefore simply to underwrite a cinema that deals with provocative subjects, subjects that cut into flesh.

But I want to talk with you more precisely about a social cinema, one that I am closer to: a social documentary or, more precisely, a documented point of view.

In the realm to be explored, the camera is king or, at least, President of the Republic.

I don't know if the result will be a work of art, but I am sure that it will be cinematic—cinematic in the sense that no other art form, no other science could take its place.

Anyone making social documentaries must be slim enough to slip through the keyhole of a Romanian lock and be able to catch Prince Carol jumping out of bed in his shirt tails, assuming, that is, that one thinks such a spectacle worthy of interest. The person who makes social documentaries must be a fellow small enough to fit under the chair of a croupier, that great god of the Monte Carlo casino—and believe me, that's not easy!

A social documentary is distinguished from an ordinary documentary and weekly news-reels by the viewpoint that the author clearly supports in it.

This kind of social documentary demands that one take a position because it dots the i's.

If it doesn't interest an artist, at least a man will find it compelling. And that's worth at least as much.

The camera is aimed at what must be considered a document, which will be treated as a document during the editing.

Obviously, self-conscious acting cannot be tolerated. The subject must be taken unawares by the camera, or else one must surrender all claims to any "documentary" value such a cinema possesses.

And the goal will be attained if one succeeds in revealing the hidden reason behind a gesture, in extracting from a banal person chosen at random his interior beauty or caricature, if one succeeds in revealing the spirit of a collectivity through one of its purely physical manifestations.

And all this with such force that from now on the world, which we, indifferent, have heretofore passed by, will be presented to us, in spite of itself, over and above its outward appearances. A social documentary should open our eyes.[6]

A Propos de Nice is only a simple rough draft of such a cinema.

In this film, by means of a city whose events are significant, we witness a certain world on trial.

In fact, no sooner is the atmosphere of Nice and the kind of life one leads there— and elsewhere, alas!—evoked than the film moves to generalize from the gross festivities by situating them under the sign of the grotesque, of the flesh and of death; these are the last convulsions of a society so little conscious of itself that it is enough to make you so nauseated that you will become an accomplice to a revolutionary solution.

FROM "FIRST PRINCIPLES OF DOCUMENTARY" (UK, 1932)

John Grierson

[First published in *Cinema Quarterly* 1, no. 2 (Winter 1932): 67–72.]

In this first part of his seminal "First Principles of Documentary" (originally published in three parts in three issues of the Edinburgh journal *Cinema Quarterly* between 1932 and 1934), documentary pioneer John Grierson delineates both the remit of documentary filmmaking and the ethical issues that the genre raises. Underlining his commitment to realism, Grierson celebrates Robert Flaherty's *Nanook of the North* (USA, 1922), while dismissing out-of-hand the emergent poetic form of documentary, as exemplified by Walter Ruttmann's city film *Berlin: Die Sinfonie der Großstadt* (Germany, 1927).

Documentary is a clumsy description, but let it stand. The French, who first used the term only meant travelogue. It gave them a solid high-sounding excuse for the shimmying (and otherwise discursive) exoticisms of the Vieux Colombier.[7] Meanwhile documentary has gone on its way. From shimmying exoticisms it has gone on to include dramatic films like *Moana, Earth,* and *Turksib.*[8] And in time it will include other kinds as different in form and intention from *Moana,* as *Moana* was from *Voyage au Congo.*[9]

So far we have regarded all films made from natural material as coming within the category. The use of natural material has been regarded as the vital distinction. Where the camera shot on the spot (whether it shot newsreel items or magazine items or discursive "interests" or dramatised "interests" or educational films or scientific films proper of *Changs* or *Rangos*) in fact was documentary.[10] This array of species is, of course, quite unimaginable in criticism, and we shall have to do something about it. They all represent different qualities of observation, different intentions in observation, and, of course, very different powers and ambitions at the stage of organizing material. I propose, therefore, after a brief word on the lower categories, to use the documentary description exclusively of the higher.

The peacetime newsreel is just a speedy snip-snap of some utterly unimportant ceremony. Its skill is in the speed with which the babblings of a politician (gazing sternly into the camera) are transferred to fifty million relatively unwilling ears in a couple of days or so. The magazine items (one a week) have adopted the original "Tit-Bits" manner of observation. The skill they represent is a purely journalistic skill. They describe novelties novelly. With their money-making eye (their almost only eye) glued like the newsreels to vast and speedy audiences, they avoid on the one hand the consideration of solid material, and escape, on the other, the solid consideration of

any material. Within these limits they are often brilliantly done. But ten in a row would bore the average human to death. Their reaching out for the flippant or popular touch is so completely far-reaching that it dislocates something. Possibly taste; possibly common sense. You may take your choice at those little theatres where you are invited to gad around the world in fifty minutes. It takes only that long—in these days of great invention—to see almost everything.

"Interests" proper improve mightily with every week, though heaven knows why. The market (particularly the British market) is stacked against them. With two-feature programmes the rule, there is neither space for the short *and* the Disney *and* the magazine, nor money left to pay for the short. But by good grace, some of the renters throw in the short with the feature. This considerable branch of cinematic illumination tends, therefore, to be the gift that goes with the pound of tea; and like all gestures of the grocery mind it is not very liable to cost much. Whence my wonder at improving qualities. Consider, however, the very frequent beauty and very great skill of exposition in such Ufa shorts as *Turbulent Timber,* in the sports shorts from Metro-Goldwyn-Mayer, in the *Secrets of Nature* shorts from Bruce Woolfe, and the Fitzpatrick travel talks.[11] Together they have brought the popular lecture to a pitch undreamed of, and even impossible in the days of magic lanterns. In this little we progress.

These films, of course, would not like to be called lecture films, but this, for all their disguises, is what hey are. They do not dramatize, they do not even dramatize an episode: they describe, and even expose, but in any aesthetic sense, only rarely reveal. Herein is their formal limit, and it is unlikely that they will make any considerable contribution to the fuller art of documentary. How indeed can they? Their silent form is cut to the commentary, and shots are arranged arbitrarily to point [to] the gags or conclusions. This is not a matter of complaint, for the lecture film must have increasing value in entertainment, education and propaganda. But it is as well to establish the formal limits of the species.

This indeed is a particularly important limit to record, for beyond the newsmen and the magazine men and the lecturers (comic or interesting or exciting or only rhetorical) one begins to wander into the world of documentary proper, into the only world in which documentary can hope to achieve the ordinary virtues of an art. Here we pass from the plain (or fancy) descriptions of natural material, to arrangements, rearrangements, and creative shapings of it. First principles. (1) We believe that the cinema's capacity for getting around, for observing and selecting from life itself, can be exploited in a new and vital art form. The studio films largely ignore this possibility of opening up the screen on the real world. They photograph acted stories against artificial backgrounds. Documentary would photograph the living scene and the living story. (2) We believe that the original (or native) actor, and the original (or native) scene, are better guides to a screen interpretation of the modern world. They give cinema a greater fund of material. They give it power over a million and one images. They give it power of interpretation over more complex and astonishing happenings in the real world than the studio mind can conjure

up or the studio mechanician recreate. (3) We believe that the materials and the stories thus taken from the raw can be finer (more real in the philosophic sense) than the acted article. Spontaneous gesture has a special value on the screen. Cinema has a sensational capacity for enhancing the movement which tradition has formed or time worn smooth. Its arbitrary rectangle specially reveals movement; it gives it maximum pattern in space and time. Add to this that documentary can achieve an intimacy of knowledge and effect impossible to the shim-sham mechanics of the studio, and the lily-fingered interpretations of the metropolitan actor.

I do not mean in this minor manifesto of beliefs to suggest that the studios cannot in their own manner produce works of art to astonish the world. There is nothing (except the Woolworth intentions of the people who run them) to prevent the studios going really high in the manner of theatre or the manner of fairy tale. My separate claim for documentary is simply that in its use of the living article, there is *also* an opportunity to perform creative work. I mean, too, that the choice of the documentary medium is as gravely distinct a choice as the choice of poetry instead of fiction. Dealing with different material, it is, or should be, dealing with it to different aesthetic issues from those of the studio. I make this distinction to the point of asserting that the young director cannot, in nature, go documentary and go studio both.

In an earlier reference to Flaherty, I have indicated how one great exponent walked away from the studio: how he came to grips with the essential story of the Eskimos, then with the Samoans, then latterly with the people of the Aran Islands: and at what point the documentary director in him diverged from the studio intention of Hollywood. The main point of the story was this. Hollywood wanted to impose a ready-made dramatic shape on the raw material. It wanted Flaherty, in complete injustice to the living drama on the spot, to build his Samoans into a rubber-stamp drama of sharks and bathing belles. It failed in the case of *Moana;* it succeeded (through Van Dyke) in the case of *White Shadows of the South Seas,* and (through Murnau) in the case of *Tabu.* In the last examples it was at the expense of Flaherty, who severed his association with both.

With Flaherty it became an absolute principle that the story must be taken from the location, and that it should be (what he considers) the essential story of the location. His drama, therefore, is a drama of days and nights, of the round of the year's seasons, of the fundamental fights which give his people sustenance, or make their community life possible, or build up the dignity of the tribe.

Such an interpretation of subject-matter reflects, of course, Flaherty's particular philosophy of things. A succeeding documentary exponent is in no way obliged to chase off to the ends of the earth in search of old-time simplicity, and the ancient dignities of man against the sky. Indeed, if I may for the moment represent the opposition, I hope the Neo-Rousseauism implicit in Flaherty's work dies with his own exceptional self. Theory of naturals apart, it represents an escapism, a wan and distant eye, which tends in lesser hands to sentimentalism. However it be shot through with vigour of Lawrentian poetry, it must always fail to develop a form adequate to the more immediate material of the

modern world. For it is not only the fool that has his eyes on the ends of the earth. It is sometimes the poet: sometimes even the great poet, as Cabell in his *Beyond Life* will brightly inform you.[12] This, however, is the very poet who on every classic theory of society from Plato to Trotsky should be removed bodily from the Republic. Loving every Time but his own, and every Life but his own, he avoids coming to grips with the creative job in so far as it concerns society. In the business of ordering most present chaos, he does not use his powers.

Question of theory and practice apart, Flaherty illustrates better than anyone the first principles of documentary. (1) It must master its material on the spot, and come in intimacy to ordering it. Flaherty digs himself in for a year, or two maybe. He lives with his people till the story is told "out of himself." (2) It must follow him in his distinction other forms of drama or, more accurately, other forms of film, than the one he chooses; but it is important to make the primary distinction between a method which describes only the surface values of a subject, and the method which more explosively reveals the reality of it. You photograph the natural life but you also, by your juxtaposition of detail, create an interpretation of it.

This final creative intention established, several methods are possible.

You may, like Flaherty, go for a story form, passing in the ancient manner from the individual to the environment, to the environment transcended or not transcended, to the consequent honours of heroism. Or you may not be so interested in the individual. You may think that the individual life is no longer capable of cross-sectioning reality. You may believe that its particular belly-aches are of no consequence in a world which complex and impersonal forces command, and conclude that the individual as a self-sufficient dramatic figure is outmoded. When Flaherty tells you that it is a devilish noble thing to fight for food in a wilderness, you may, with some justice, observe that you are more concerned with the problem of people fighting for food in the midst of plenty. When he draws your attention to the fact that Nanook's spear is grave in its upheld angle, and finely rigid in its down-pointing bravery, you may, with some justice, observe that no spear, held however bravely by the individual, will master the crazy walrus of international finance. Indeed you may feel that in individualism is a yahoo tradition largely responsible for our present anarchy, and deny at once both the hero of decent heroics (Flaherty) and the hero of indecent ones (studio). In this case, you will feel that you want your drama in terms of some cross-section of reality which will reveal the essentially co-operative or mass nature of society: leaving individuals to find his honours in the swoop of creative social forces. In other words, you are liable to abandon the story form, and seek, like the modern exponent of poetry and painting and prose, a matter and method more satisfactory to the mind and spirit of the time.

Berlin or the Symphony of a City initiated the more modern fashion of finding documentary material on one's doorstep: in events which have no novelty of the unknown, or romance of noble savage on exotic landscape, to recommend them. It represented, slimly, the return from romance to reality.

Berlin was variously reported as made by Ruttmann, or begun by Ruttmann and finished by Freund: certainly it was begun by Ruttmann. In smooth and finely tempo'd visuals, a train swung through suburban mornings into Berlin. Wheels, rails, details of engines, telegraph wires, landscapes and other simple images flowed along in procession, with similar abstracts passing occasionally in and out of the general movement. There followed a sequence of such movements which, in their total effect, created very imposingly the story of a Berlin day. The day began with a processional of workers, the factories got under way, the streets filled: the city's forenoon became a hurly-burly of tangled pedestrians and street cars. There was respite for food: a various respite with contrast of rich and poor. The city started work again, and a shower of rain in the afternoon became a considerable event. The city stopped work and, in further more hectic processional of pubs and cabarets and dancing legs and illuminated sky-signs, finished its day.

In so far as the film was principally concerned with movements and the building of separate images into movements, Ruttmann was justified in calling it a symphony. It meant a break away from the story borrowed from literature, and from the play borrowed from the stage. In *Berlin* cinema swung along according to its own more natural powers: creating dramatic effect from the tempo'd accumulation of single observations. Cavalcanti's *Rien que les heures* and Léger's *Ballet Mécanique* came before *Berlin,* each with a similar attempt to combine images in an emotionally satisfactory sequence of movements. They were too scrappy and had not mastered the art of cutting sufficiently well to create the sense of "march" necessary to the genre. The symphony of Berlin City was both larger in its movements and larger in its vision.

There was one criticism of *Berlin* which, out of appreciation for a fine film and a new and arresting form, the critics failed to make; and time has not justified the omission. For all its ado of workmen and factories and swirl and swing of a great city, Berlin created nothing. Or rather if it created something, it was that shower of rain in the afternoon. The people of the city got up splendidly, they tumbled through their five million hoops impressively, they turned in; and no other issue of God or man emerged than that sudden besmattering spilling of wet on people and pavements.

I urge the criticism because *Berlin* still excites the mind of the young, and the symphony form is still their most popular persuasion. In fifty scenarios presented by the tyros, forty-five are symphonies of Edinburgh or of Ecclefechan or of Paris or of Prague. Day breaks—the people come to work—the factories start—the street cars rattle—lunch hour and the streets again—sport if it is Saturday afternoon—certainly evening and the local dance hall. And so, nothing having happened and nothing positively said about anything, to bed; though Edinburgh is the capital of the country and Ecclefechan, by some power inside itself, was the birthplace of Carlyle, in some ways one of the greatest exponents of this documentary idea.

The little daily doings, however finely symphonized, are not enough. One must pile up beyond doing or process to creation itself, before one hits the higher reaches

of art. In this distinction, creation indicates not the making of things but the making of virtues.

And there's the rub. Critical appreciation of movement they can build easily from their power to observe, and the power to observe they can build from their own good taste, but the real job only begins as they apply ends to their own observation and their movements. The artist need not posit the ends—for that is the work of the critic—but the ends must be there, informing his description and giving finality (beyond space and time) to the slice of life he has chosen. For that larger effect there must be power of poetry or of prophecy. Failing either or both in the highest degree, there must be at least the sociological sense implicit in poetry and prophecy.

The best of the tyros know this. They believe that beauty will come in good time to inhabit the statement which is honest and lucid and deeply felt and which fulfils the best ends of citizenship. They are sensible enough to conceive of art as the by-product of a job of work done. The opposite effort to capture the by-product first (the self-conscious pursuit of beauty; the pursuit of art for art's sake to the exclusion of jobs of work and other pedestrian beginnings), was always a reflection of selfish wealth, selfish leisure and aesthetic decadence.

This sense of social responsibility makes our realist documentary a troubled and difficult art, and particularly in a time like ours. The job of romantic documentary is easy in comparison: easy in the sense that the noble savage is already a figure of romance and the seasons of the year have already been articulated in poetry. Their essential virtues have been declared and can more easily be declared again, and no one will deny them. But realist documentary, with its streets and cities and slums and markets and exchanges and factories, has given itself the job of making poetry where no poet has gone before it, and where no ends, sufficient for the purposes of art, are easily observed. It requires not only taste but also inspiration, which is to say a very laborious, deep-seeing, deep-sympathizing creative effort indeed.

The symphonists have found a way of building such matters of common reality into very pleasant sequences. By uses of tempo and rhythm, and by the large-scale integration of single effects, they capture the eye and impress the mind in the same way as a tattoo or a military parade might do. But by their concentration on mass and movement, they tend to avoid the larger creative job. What more attractive (for a man of visual taste) than to swing wheels and pistons about in ding-dong description of a machine, when he has little to say about the man who tends it, and still less to say about the tin-pan product it spills? And what more comfortable if, in one's heart, there is avoidance of the issue of underpaid labour and meaningless production? For this reason I hold the symphony tradition of cinema for a danger and *Berlin* for the most dangerous of all film models to follow.

Unfortunately, the fashion is with such avoidance as *Berlin* represents. The highbrows bless the symphony for its good looks and, being sheltered rich little souls for the most part, absolve it gladly from further intention. Other factors combine to

obscure one's judgment regarding it. The post-1918 generation, in which all cinema intelligence resides, is apt to veil a particularly violent sense of disillusionment, and a very natural first reaction of impotence, in any smart manner of avoidance which comes to hand. The pursuit of fine form which this genre certainly represents is the safest of asylums.

The objection remains, however. The rebellion from the who-gets-who tradition of commercial cinema to the tradition of pure form in cinema is no great shakes as a rebellion. Dadaism, expressionism, symphonies, are all in the same category. They present new beauties and new shapes; they fail to present new persuasions.

The imagist or more definitely poetic approach might have taken our consideration of documentary a step further, but no great imagist film has arrived to give character to the advance. By imagism I mean the telling of story or illumination of theme by images, as poetry is story or theme told by images: I mean the addition of poetic reference to the "mass" and "march" of the symphonic form.

Drifters was one simple contribution in that direction, but only a simple one. Its subject belonged in part to Flaherty's world, for it had something of the noble savage and certainly a great deal of the elements of nature to play with. It did, however, use steam and smoke and did, in a sense, marshal the effects of a modern industry. Looking back on the film now, I would not stress the tempo effects which it built (for both *Berlin* and *Potemkin* came before it), nor even the rhythmic effects (though I believe they outdid the technical example of *Potemkin* in that direction). What seemed possible of development in the film was the integration of imagery with the movement. The ship at sea, the men casting, the men hauling, were not only seen as functionaries doing something. They were seen as functionaries in half a hundred different ways, and each tended to add something to the illumination as well as the description of them. In other words, the shots were massed together, not only for description and tempo but for commentary on it. One felt impressed by the tough continuing upstanding labour involved, and the feeling shaped the images, determined the background and supplied the extra details which gave colour to the whole. I do not urge the example of *Drifters*, but in theory at least the example is there. If the high bravery of upstanding labour came through the film, as I hope it did, it was made not by the story itself, but by the imagery attendant on it. I put the point, not in praise of the method but in simple analysis of the method.

MANIFESTO ON THE DOCUMENTARY FILM (UK, 1933)

Oswell Blakeston

[First published in *Close Up* (UK) 10, no. 4 (1933).]

This documentary manifesto argues against both the rising tide of postsync documentaries and the influence of Soviet film aesthetics on the documentary film, staking the claim that true documentaries reveal the world, not the plasticity of the cinema.

Years ago the documentary film had value because it presented us with facts: from the documents of four or five years ago it was possible to learn.

We believed, then, that the document film had a rigorous and vigorous future: the clearer presentation of valuable information seemed to define the development of the filmic documentary.

Alas! A camorra of folk on the fringe of moviedom discovered, when talkies came in, that they could no longer afford to finance their own movies: but how desperately they wanted to go on telling their friends that they were in the movies, how pathetically they wanted to horde up a few more lines of print from the trade papers. So, they turned to the film document, realising that this less expensive genre of movie, which can be shot silent and post-synched, offered them the last chance to remain "directors."

All the same, these hangers-on did not intend, and were not capable of adhering to the logical and excellent form of the document. Their shoddy minds were too muddled and doped with meretricious theatricalities to work with the purity of the real film document. They brought to the document outmoded montage belonging to a certain type of emotional drama, and their yards of theatre tinsel, in the form of joking commentaries, together with the rest of their aged properties. The result is that we now have documents about the making of a gramophone which are filled with trick angles and ultra rapid sections of montage, and which teach us nothing about the actual process of gramophone manufacture. We have travel documents which string together all the arty "nookies," the against-the-sky shots of prognathous natives and tree-top silhouettes, while not the slightest attempt is made to catalogue scientifically the customs, flora, mineralogical structure, etcetera, of the country.

Probably, someone will try and twist our manifesto into a statement that a film without artistes cannot be dramatic: but we hold that a film without actors can be intensely dramatic, and also that the document has nothing to do with drama. We want back film documents with real cultural significance. We are infuriated with pseudo-documents that exploit the prestige of the worthwhile documentaries of yesterday: their obscene dramatic

over-layer abolishes their worth for the scholar, the lack of imagination of their directors guarantees their failure as drama.

It would be easy to make a dramatic film without artistes—easy for a Francis Bruguière. In his stills, Bruguière has shown how he can send the horses from an Italian painting thudding across the head of a Grecian statue, or how the spire of an English Cathedral can come to life and penetrate the shadow of a Florentine doorway. Inanimate objects or landscapes can be given, by the camera of a Bruguière, fibres, nerves, arteries, personalities, can be made to take part in a truly magic drama. Such a film would have no need to pose as a document—it would have its own possession.

To repeat: we are incensed because films are shown to the public, who are always about five years behind and have just dimly associated "document" with "culture," under false prestige and false pretences: were these films to be presented to the public as drama, the exhibitors would be lynched.

To repeat: we want documents which will show, with the clarity and logic of a scholar's thesis, the subjects they are supposed to tackle: we want no more filtered skies, "Russian" montage and other vulgarities in our educational productions.

DECLARATION OF THE GROUP OF THIRTY (France, 1953)

Jean Painlevé, Jacques-Yves Cousteau, Alain Resnais, Alexandre Astruc, Georges Franju, Pierre Kast, Jean Mitry, and thirty-seven others

[Launched in Paris, 20 December 1953. First published in French as "Déclaration du groupe des trente," Le technicien du film 2 (1955). Trans. Scott MacKenzie.]

While not only concerned with documentary films, a majority of the signatories of this manifesto were defending the French documentary tradition that had just had a recent resurgence that would only grow over the 1950s, with films as diverse as Alain Resnais's Nuit et brouillard (1955), Jacques-Yves Cousteau and Louis Malle's Le monde du silence (1956), and Chris Marker's Lettre de Sibérie (1957). The Group of Thirty became well known in France as defenders of the short film and ended up in a series of debates about their goals and tactics with other French filmmakers. Here they argue that the short film is the research lab of French filmmaking, where new ideas and concepts develop. In terms of this period of French cinema they are certainly not wrong.

The short film was struggling to stay alive. Today, its death has been decided.

The French School of short films is distinguished by its style, by its demeanor, by the ambition of its subjects. French short films have often found favor with the public. They play the world over. There is not an international festival where they do not play a large role, almost always taking first place.

A recent decree-law allows for the return of the double bill which signifies the disappearance of the short film and makes more difficult the funding of great French films. If this decree is not repealed, if the measures do not give the short film back its rightful place, where it always was, far greater dangers are a concern.

An incomparable cultural tool, an essential means of education and knowledge, a striking spectacle and at the same time an art. No one would have the idea to measure the importance of a literary work by its number of pages, a painting by its size. Beside the novel or even larger works exists the poem, *la nouvelle* or the essay, which often plays the role of fermentation, allows for renewal and brings in new blood.

It's the role the short film stopped playing. Its death will finally be that of cinema, as an art that doesn't move dies.

A group of directors, producers, technicians and friends of the short film, without renouncing their differences in taste, opinion, or convictions, have decided to not passively submit to the perils that menace the short film.

The public in movie theatres like short films of quality. They do not know that tomorrow the pleasure they now take may be frustrated.

Numerous organizations disseminate through the short film culture or scientific knowledge. Tomorrow, they may no longer have films.

Deputies, Senators, Ministers are in charge of administering French heritage. The short film no longer has to show that it plays an important part. Tomorrow this heritage risks being disposed of.

Our group refuses to admit that it is too late. It appeals to the public, to agencies, to parliamentarians. On the answer that is given depends the existence of the French short film.

INITIAL STATEMENT OF THE NEWSREEL (USA, 1967)

New York Newsreel

[First released as a pamphlet in December 1967. First published in Massimo Teodori, ed., *The New Left: A Documentary History* (New York: Bobbs-Merrill, 1969), 387–388.]

This statement setting out the philosophy of the New York Newsreel (now Third World Newsreel) set the stage for a new kind of radicalized, participatory form of filmmaking. New York Newsreel produced and distributed committed documentaries such as Columbia Revolt (1968), Off the Pig (1968), Make Out (1969), and The Woman's

Film (San Francisco Newsreel, 1971) and was the inspiration for many groups that followed in its wake, such as Cine Manifest and the Kartemquin Collective.

These films will be available to anyone. We hope that their relevance will attract audiences who are not usually reached. But they will reach such audiences only if they are brought to them by people who understand what it is to organize, and how to use such films to increase and activate social and political awareness.

We want to emphasize that we are initially directing our work toward those in the society who have already begun their redefinition.

At the start we will use existing networks like SDS, the Underground Press Service, anti-war groups, the Resistance, community projects . . . to find various groups around the country (and abroad) who can use the films effectively, can show them frequently, and who have sufficient contacts in their cities to get the films out to other different groups, like churches, film clubs, anti-poverty groups, neighborhood organizations. . . .

In principle we want to provide prints of the films free of cost to all groups who can use them. Decisions concerning this will depend on our success in raising a substantial sum of money to finance the whole project.

It should be clear that we are trying to do two things at once: (1) create and maintain a permanent newsreel group in New York City, capable of producing at least two films a month . . . and getting 12 to 14 prints of each out to groups across the country; (2) to increase the activity of this group, while enlarging the distribution network, and sparking the creation of similar news-films groups in other major cities of the U.S.

It is not practical for a group in New York to make a film about the Oakland demonstrations . . . or the Detroit rebellion. Each city should not be sending footage to us. They must make their own short films aimed at fulfilling the same needs as ours. Therefore, one of our highest priorities is to aid in the formation of such news-film groups around the country: by sending experienced people, by sharing technical information, by creating a reliable and flexible distribution apparatus.

NOWSREEL, OR THE POTENTIALITIES OF A POLITICAL CINEMA (USA, 1970)

Robert Kramer, New York Newsreel

[First published in *Afterimage* (UK) 1 (1970).]

This statement by Newsreel filmmaker Robert Kramer argues that truly revolutionary cinema can only emerge from a radically new film aesthetic, one that fundamentally rejects realism and the dominant modes of representing lived experience, echoing in a contemporary context Bertolt Brecht's theory of *Verfremdungseffekt* (alienation effect).

To all film-makers who accept the limited, socially determined rules of clarity, of exposition, who think that films must use the accepted vocabulary to "convince," we say essentially: you only work, whatever your reasons, whatever the mechanisms which maintain stability through re-integration; your films are helping to hold it all together, and finally, whatever your descriptions, you have already chosen sides. Dig: your sense of order and form is already a political choice—don't talk to me about "content"—but if you do, I will tell you that you cannot encompass our "content" with those legislated and approved senses, that you do not understand it if you treat it that way. There is no such thing as revolutionary content, revolutionary spirit, laid out for inspection and sale on the bargain basement counter.

We want to make films that unnerve, that shake assumptions, that threaten, that do not soft-sell, but hopefully (an impossible ideal) explode like grenades in peoples' faces, or open minds up like a good can opener.

DOCUMENTARY FILMMAKERS MAKE THEIR CASE (Poland, 1971)

Bohdan Kosiński, Krzysztof Kieślowski, and Tomasz Zygadło

[First published in Polish as "Dokumentarzyści o dokumencie," in *Polityka* 28 (1971). Trans. Aleksandra Kaminska and Monika Murawska.]

This previously untranslated documentary manifesto, issued at the Krakow Film Festival of Short Films in 1971 by Kosiński, Kieślowski, and Zygadło—going under the name "the Krakow Group"—was the first manifestation of a new form of politically and socially engaged Polish documentary to emerge post '68. The manifesto and the ideals behind it in no small part sowed the seeds of the "cinema of moral anxiety," which gained prominence with films made by Kieślowski, Krzysztof Zanussi, Agnieszka Holland, and Andrzej Wajda between 1975 and 1981. Kieślowski became one of Poland's most important filmmakers, with works such as the banned documentary *Workers '71* (codirected by Zygadło, Poland, 1971) and the features *Camera Buff* (*Amator*, Poland, 1975), which was a central "cinema of moral anxiety" work, *Blind Chance* (*Przypadek*, Poland, 1981), *The Decalogue* (*Dekalog*, Poland, 1989), and *The Three Colors* trilogy (France, 1993–1994).

The discussion on documentary film that started at the Eleventh Festival of Short Films in Krakow, and which then moved to the daily and weekly press, was based on the effective (and for many probably convenient) strategy of opposing the young and old filmmakers of the WFD.[13] The Festival's commentators became concerned with the

slogans proclaimed in the undergrounds of Krzysztofory Palace[14] and began checking the birth certificates of the films' authors, dividing them in accordance to age. Then (after applying demographics so creatively to issues of film), they all took the side of the young.

There was however one exception. Zygmunt Kałużyński, a commentator from *Polityka*,[15] has taken the side of the old, or at least one of them, one of the undersigned below. However, despite speaking out differently than the rest, Kałużyński doesn't question the generally accepted rules of this division itself. Quite the opposite. He makes the division into old and young even more sharply and extensively.

The division between old and young documentary filmmakers that was made in Krakow and afterwards is in the best case an intellectual shortcut. It would be much fairer to divide filmmakers according to the quality of their work, interests, artistic styles, to their attitudes towards the issues being debated and according to one's profession. In its worse case, this division, similar to other demagogic segregations, can lead to manipulations that we don't want to be subjected to. The problem is that the clamour raised around the "rebellion of the young" acts like an effective deafening mechanism—because of its noise the voices of our films' protagonists are not heard, even though they have a lot to say on subjects very important to the life of our country.

DOES *ON THE TRACKS* BELONG TO FILMS OF "THE MIDDLE"?

It is to be regretted that the commentator from *Polityka* took more to heart the noise coming from Krzysztofory Palace than the content of the films. This is not the only issue we hold the author of "How I have compromised myself in Krakow" responsible for. Another pertains to a fundamental concern for all journalists. By commending the film *On the Tracks* for its "balanced viewpoint" and assigning to it an exactly "middle" position on the map of journalistic documentary film, Kałużyński causes a disservice to the film.

It is our belief that this kind of opinion is not praise but rather an accusation. Even more, it is a disqualification of the film's value and of the author as a journalist and filmmaker. Journalistic film by nature is offensive, intended as the first line of encounter and confrontation. So it can't be placed somewhere "in the middle," because to be in the middle means to be behind and to avoid struggle.

Does *On the Tracks* really belong to films of "the middle"? Let's think about the character of documentary films we presented in Krakow. These are films aimed at specific negative phenomena in different areas of social and national life in our country. In this way they are similar to critical films, which have surfaced from time to time in the past few years. However, there is something that, we think, distinguishes our "Krakovian" films from others to date. The difference is the result of our disparate approach to the topics at hand. We are interested in that place where everything appears to be right, normally, but where there is also hidden some concealed disease. We try to find this disease and bring it to light. We treat situations like this as models, using them to reveal

the nature and repeatability of a phenomenon and to question the inert structures that distort the meaning and substance of social affairs. These are assumptions that are more difficult than before, but probably more necessary today.

On the basis of these kinds of assumptions we made our films *Factory, Primary School* and *On the Tracks*. Of course each of these films addresses the matter a little differently. Yet each is an extreme film, each expresses opinions in a dynamic way, and each is a film-protest. This applies both to *Factory* and *Primary School* as well as, to no lesser degree, *On the Tracks*, which neither in its intentions nor in its expression can be associated with the terms "moderate film," "balanced," "middle." On the contrary, this film decidedly takes one side, the side of social protest.

LENS AND TAPE RECORDER

In many opinions on documentary film we can sense something that we would call an intellectual and aesthetic anachronism in the attitudes to the genre. The opinions of Kałużyński are not immune to this.

This anachronism is based on the lack of understanding of some objective, inevitable rules that govern the cinema, and particularly documentary film.

And so the main formal objection, used against most positions—the issue of too much dialogue in film, the problem of "overtalking" is, if we look closer to the history of documentary film, the simple consequence of the development of the genre. Because if we have gotten used to this, that the proven domain of documentary film is the observation of human behaviours, acts, the observation of their faces—and this doesn't raise any objections by either critics nor spectators—so why do we not let these people and faces talk? It might seem incredible, but it is true—it is only recently that in Poland we have done documentary sound films, so-called talkies. It is only the widespread use of the synchronized camera that has allowed us to broaden the scope of our registration of that which is so fleeting and which is the greatest aesthetic value of the genre—the image of the world recorded spontaneously, without retouching, "as it truly is." And why should this world be limited just to the physical image? Why do we have to remain on the level of relating customs, to outer description? Why not go deeper—through human words—to human thoughts?

We aren't limiting the function of the word to the conventions of a television interview. On the contrary—most of the films are analytic descriptions of natural and real situations, where people, beyond anything else, just talk. In the reception of the sound layer of documentary film, the acclimatization of the viewer to the most exploited and superficial narrative, which is that of the newsreel, has become an obstacle. In this kind of chronicle the excessive and cheap use of words depreciated this means of expression. Even more, it effaced the relevant difference between words spoken only for information and words caught, observed, provoked, such that they fill deeper functions than mere information alone.

In other words people in our movies—as Kałużyński claims—"gab," because contemporary people really do talk in as interesting ways as they look and behave. Using only words they express that which interests us in them—their attitude to the world and their place in it. "Our eye is a lens, our ear a tape recorder"—says Leacock, the top American documentary filmmaker.

In any case, even if we would have modern—light and portable—film equipment, our protagonists would talk even more, but then we could observe them in more interesting and characteristic situations, as well as in more eye-catching settings. We are also concerned with the static nature of our films, a certain lack of happening, which is technically inevitable. But the "quavering," "vibrating," "colourful" reality that is only afforded to feature film, and that we are being encouraged to emulate, is not always adequate to the intention of a film and quite simply, is not always possible.

This is connected with another objection and other aspects of the "ideal documentary film." This criticism is concerned with domineering individualities, singular protagonists, the interesting people that wind through these talked-about films, and this is closely related to the matter of the monotony of the close-up, which we often use.

Well, in our belief, modern documentary film should take as a theme the individual protagonist, close to the viewer, in whom can be found the reflection or confirmation of problems that concern everyone. It is also a historical pattern in the development of the genre. If documentary film is to be really contemporary, reaching out to people and caring about them—then it should (or at least may) use the best medium capable to convince the viewer—the individualized protagonist. All the elements that we have gotten used to in documentary film—such as descriptions of events, phenomena, collective protagonists—are of course still valuable and our subsequent films will be based on these—but the bottom line is that these are no longer sufficient to tackle very complicated contemporary issues.

Besides, the opinion that the human face, caught for a long time in a close-up can't be fascinating is not only anachronistic but also ridiculous. As Brecht has said, reality must be looked at not stared at.

One more thing is connected with this. The critics after the festival correctly noticed that our films had above all political and social accents: these were simply the most visible and for which we are all the most starved. But these aspects of our films, if we can even speak of some kind of new trend, are not enough to make them distinct. They have been a part of Polish documentary film since its very beginnings—the difference between then and now is in our conclusions. Our intention is to make films, which are not only memorials of particular situations, not only deal with specified social and political problems. Let's say something about that which may not always be noticeable in the productions that are screened. We want the matter we have—the living, real human—to become a material of moral, ethical, ideological generalisations. We wonder about human fate and life. We aren't abandoning the humanist position! We're not just the emergency service!

THE TERMINATION OF THE WFD?

The laboratory of documentary film, the place where we—all documentary filmmakers—can realize our program is the Documentary Film Production Company [Wytwórnia Filmów Dokumentalnych—WFD]. But the issues surrounding the films produced there in mid-1971 can't be reduced to problems of an intellectual and aesthetic nature. Cameras, tape recorders, assembly tables are the tools of our work. The improvement of technical and organizational conditions of the Production Company is an obvious necessity, but even more important is the matter of how much trust we are granted. It isn't even about films taken off the shelves [i.e., censored] but even more importantly, about topics taken off the shelves. In recent months we all finally felt some of that trust. We didn't have to wait long for the effects. Films shown during press conferences, during shows in workplaces, at the Festival in Krakow, initiated discussions on fundamental questions for our country, and so proved their social worth.

And it is right now, when the WFD is making the kinds productions that are expected of it, with socially current values—that there is word about the possible termination of the Production Company. This is taking different forms—from the proposition of transferring the center of feature film production to attempts at subordinating the human—and intellectual—center, to television. The practical point of view is clear—screenings in cinemas must be shortened so all additions must be eliminated. And so also cinematic documentary film. It is not even worth pointing out that in countries where people live in a hurry much more than we do, there are trends to make screenings longer, to create several-hour-long film spectacles. With the termination of documentary film we all irrevocably condemn ourselves to television, with its mediocrity and nondescript programs, with the ruling tastes of bosses, with never-ending arguments about "mass spectatorship" (has someone really tried to analyse their needs?), with its purely technological limits of reception.

People, who today aim at the termination of an autonomous WFD and use the argument that the audiences whistle during the documentary additions, are in most cases the ones responsible for this whistling. It is they, who—having the administrative apparatus at their hands—marked the thematic and intellectual standard of the WFD. They preferred boring, bad, needless films, which were loudly praised on pre-release screenings and through the Commissions of Artistic Evaluation,[16] but in the confrontation with viewers suffered from obvious failure. We can't blame the audience for turning away from documentary film. It was fed up with films in which it couldn't find itself, in which it saw the world full of unfamiliar, arbitrary opinions, nonexistent problems, false people. In this mass production of our documentary films, additionally bolstered by instructive educational films, valuable items disappeared—and it is these kinds of mass productions that audiences associated with the term "addition." These additions were booed. Due to such additions the Cinema Non Stop became increasingly empty and The Cinema of Short Films vanished from television programming.

There arose a problem of exploitation. There are meetings, conferences, debates taking place these days, but it would be enough to make a couple of good films and the problem—which has been artificially created—would cease to exist. People will stop to whistle—what happened in Krakow with its heated debates and the weight of the problems broached, proves that. Indeed there's no other way—and it applies to not only film—we must simply in Poland make a few good things. And when the opportunity for such work finally appears, let the administration for once not impede us.

Despite the many promises by the management of the department of the film industry, the plan of work at the WFD was this year reduced by 30 percent. The danger is not only the stoppage in the production of planned films, but most of all this may result in suspending the supply of people graduating from the School,[17] who have recently rightly found employment in the Production Company. The last few years have shown that failure to stabilize personnel is one of the most dangerous illnesses threatening documentary film. Reducing the number of titles also forecloses flexible programming— which is necessary in a genre so close to reality. So reduction has not only a quantitative meaning, but first of all a qualitative one.

At a time where the whole country has become ground for sharp debate, when people's attitudes have been increasingly polarized, when many places and topics have been opened to public opinion—as well as to the lenses of our cameras—when so many issues have to be wisely considered from different points of view—it is precisely in the summer of this year that we will not abandon the positions we have been able to gain and occupy. Positions that are at once intellectual and aesthetic and—most importantly now from a practical standpoint—organizational.

THE ASIAN FILMMAKERS AT YAMAGATA YIDFF MANIFESTO (Japan, 1989)

Kidlat Tahimik, Stephen Teo, Serge Daney, Manop Udomdej and eight others

[First signed and circulated in Japanese and English at the First Yamagata International Documentary Film Festival on 15 October 1989. First published in Japanese and English in *Asia Symposium 1989* (Yamagata: YIDFF, 2007), 62–63.]

This manifesto, drafted by Kidlat Tahimik from his final remarks at the First Yamagata documentary festival, decries the lack of Asian films screened at the festival and calls for the establishment of a network of Asian filmmakers in the face of the limitations put on film distribution by market motivations and by third world realities.

We, the Asian filmmakers present here, at the Yamagata International Documentary Film Festival '89, call attention to the sad absence of any Asian film in the competition. While this is not the fault of this festival, it puts into focus the fact that major obstacles exist in the making of relevant and interesting documentary films in the Asian region.

Our gathering here notes that the essential ingredients for quality filmmaking in our respective countries are available:

—there is no shortage of energy or passion for documentary films;

—there are enough, even if minimal, technical skills to produce quality social and personal documentaries;

—there are innumerable subjects and themes of universal and humanistic relevance that are crying out to be documented;

—there is no lack of filmmaking talents who can create audiovisual documentation from the *point-of-view of our respective cultures.*

We ask then in earnest (without prejudice to our fellow filmmakers outside our region), why are the documentaries "of quality and of interest" that enter the international exchange of information mainly in the hands of those countries who have the material resources to realise these films?

We, note, with regret, that there exist many obstacles to the opportunities for our films to be produced and disseminated in the real world by political and market motivations. We acknowledge, with sadness, that these institutional roadblocks originate from a complex mix of third-world realities as well as international imbalances. We accept, with concern, that these cannot be eradicated overnight.

But we believe that these obstacles can be overcome only with concerted efforts by ourselves, the Asian filmmakers, for a start ... with support from the energies generated at international gatherings like the YIDFF, committed to the belief that independent social and personal documentaries are invaluable to present and future generations.

Therefore, We The Asian Filmmakers present here, declare our commitment to maintain a network of Asian Filmmakers for the sharing of our visions, as well as our problems and solutions.

We dramatise here, our desire to plant the seeds for the renaissance on independent documentary filmmaking in our region. We affirm here with optimism, our determination to seek, develop and implement approaches to deal with the obstacles, so that future international events like the YIDFF will not be short on good Asian films.

We declare here, the SPIRIT of the independent Asian documentary filmmakers is alive! and will one day, soar with the wind!

MINNESOTA DECLARATION: TRUTH AND FACT IN DOCUMENTARY CINEMA
(Germany, 1999)

Werner Herzog

[First distributed at the Walker Art Center, Minneapolis, Minnesota, on 30 April 1999. First published in Paul Cronin, *Herzog on Herzog* (London: Faber, 2002), 301–302.]

In this manifesto longtime fiction and documentary filmmaker Werner Herzog rants against the precepts of cinéma vérité. He argues for a transcendent form of documentary that abandons the drive for objectivity and distance, which can be seen in many of his recent documentaries, including the 3D documentary *Cave of Forgotten Dreams* (2010).

"LESSONS OF DARKNESS"

1. By dint of declaration the so-called Cinema Verité is devoid of Verité. It reaches a merely superficial truth, the truth of accountants.

2. One well-known representative of Cinema Verité declared publicly that truth can be easily found by taking a camera and trying to be honest. He resembles the night watchman at the Supreme Court who resents the amount of written law and legal procedures. "For me," he says, "there should be only one single law: the bad guys should go to jail." Unfortunately, he is part right, for most of the many, much of the time.

3. Cinema Verité confounds fact and truth, and thus plows only stones. And yet, facts sometimes have a strange and bizarre power that makes their inherent truth seem unbelievable.

4. Fact creates norms, and truth illumination.

5. There are deeper strata of truth in cinema, and there is such a thing as poetic, ecstatic truth. It is mysterious and elusive, and can be reached only through fabrication and imagination and stylization.

6. Filmmakers of Cinema Verité resemble tourists who take pictures amid ancient ruins of facts.

7. Tourism is sin, and travel on foot virtue.

8. Each year at springtime scores of people on snowmobiles crash through the melting ice on the lakes of Minnesota and drown. Pressure is mounting on the new governor to pass a protective law. He, the former wrestler and bodyguard, has the only sage answer to this: "You can't legislate stupidity."

9. The gauntlet is hereby thrown down.

10. The moon is dull. Mother Nature doesn't call, doesn't speak to you, although a glacier eventually farts. And don't you listen to the Song of Life.

11. We ought to be grateful that the Universe out there knows no smile.

12. Life in the oceans must be sheer hell. A vast, merciless hell of permanent and immediate danger. So much of a hell that during evolution some species—including man—crawled, fled onto some small continents of solid land, where the Lessons of Darkness continue.

DEFOCUS MANIFESTO (Denmark, 2000)

Lars von Trier

[First published in Danish in *Berlingske Tidende*, 6 May 2000.]

In part the catalyst for Lars von Trier and Jørgen Leth's *De fem benspænd* (*The Five Obstructions*, Denmark, 2003), this manifesto focuses on what is pushed to the wayside, marginalized, and has been made invisible in documentary filmmaking because of the news media's and documentary film's need to find an overarching "angle" or "story" to tell, leading to documentaries that are overdetermined by the incessant drive for linear, totalizing narrative explanations of events. What Trier posits here, perhaps unwittingly, is, in Michel Foucault's sense of the term, a genealogical form of documentary cinema.

We are searching for something fictional, not factual. Fiction is limited by our imagination and facts by our insight, and the part of the world that we are seeking cannot be encompassed by a "story" or embraced from an "angle."

The subject matter we seek is found in the same reality that inspires fiction-makers; the reality that journalists believe they are describing. But they cannot find this unusual subject matter because their techniques blind them. Nor do they want to find it, because the techniques have become the goal itself.

If one discovers or seeks a story, to say nothing of a point that communicates, then one suppresses it. By emphasising a simple pattern, genuine or artificial; by presenting the world a puzzle picture with solutions chosen in advance.

The story, the point, the disclosure and the sensation have taken this subject matter from us—this; the rest of the world which is not nearly so easy to pass on, but which we cannot live without!

The story is the villain. The theme presented at the expense of all decency. But also the case in which a point's importance is presumably submitted for the audience to evaluate, assisted by viewpoints and facts counterbalanced by their antitheses. The worship of pattern, the one and only, at the expense of the subject matter from which it comes.

This subject matter, which may be life's true treasure, has disappeared before our very eyes.

How do we rediscover it, and how do we impart or describe it? The ultimate challenge of the future—to see without looking: to defocus! In a world where media flock to kneel before the alter of sharpness, draining life out of life in the process, the DEFOCUSISTS will be the communicators of our era—nothing more, nothing less!

KILL THE DOCUMENTARY AS WE KNOW IT (USA, 2002)

Jill Godmilow

[First published in *Journal of Film and Video* 54, no. 2/3 (2002): 3–10. Slightly revised by the author for this publication.]

Inspired by Dogme '95 (see Trier and Vinterberg, "Dogme '95 Manifesto and Vow of Chastity," in chap. 2 of this volume)—although acknowledging the limits of the movement and seeing it as a publicity stunt—this documentary manifesto by film- and video-maker Jill Godmilow lays out a series of practices to produce documentaries that go beyond surface reportage and engage in the world in front of the camera in an ethical manner.

Somewhat ironically, but in all seriousness as well, I hurl out a *dogma* for future non-fiction filmmaking—one that questions the usefulness of the classical realist documentary form as an instrument for publicly shared knowledge.

I interrogate this system of representation that is said to produce sober, unauthored texts—cinematic texts in which the world supposedly *tells itself*, and claims to do so without any ideological intervention from its authors. Not at all ready to abandon making

films with these images but fearful of the ideology they hide, my *dogma* slashes away at the very underpinnings of the myth of the real.

I don't believe in dogmas—I don't trust them. I wrote this for myself, in anger, as a kind of black joke, after I read the Danish DOGME stuff, which I found somewhat ridiculous as a prescription for feature filmmaking. Ridiculous because it borrowed, from the documentary film of all things, some ancient and exhausted conceits that, since Lumière and up to the present, have given the documentary film its *pedigree of the real*—its guarantee of truth telling. Though many documentary filmmakers hide behind this pedigree, most know, from practice, that it is a smokescreen, a guarantee of nothing real—only a stance toward its representations: a disingenuous declaration of honesty.

The DOGME Danes say that in their films the camera must be handheld—no tripods, no inauthentic props can be brought onto the set; no non-diegetic music can be added; no fancy lighting, etc. etc.—*as if the dogme films would be more truthful, thus more powerful, and thus more trustworthy, if they abided by these monastic principles and shunned the glamorous and seductive effects of Hollywood production.* Though many have taken it as a serious political and aesthetic manifesto, my guess is that this DOGME was actually conjured up as a publicity stunt (maybe also a private joke) to draw press attention to these films (and to rationalize their non-Hollywood, low-budget kind of productions). The DOGME films need no rationalization: the techniques they employ are purely pragmatic—a reasonable enough way to concentrate on performances and to avoid the burden of two hours of lighting per shot; a refreshing opportunity to fracture classic film space with shots grabbed from the set in a provocative and spontaneous manner. Cassavetes did all of these things in *Shadows* in 1959. He didn't need a rationale.

A friend of mine claims the DOGME is actually intended as a *parody* of the 60's cinema verité style of filmmaking and its truth claims. This makes some sense, though I think the parody fails, as nothing seems to be able to dislodge the non-fiction film's exclusive hold on the real. I think it's exactly this desperate clutch on pedigree of the real that keeps us reproducing, ad infinitum, a corrupt form of public knowledge—the documentary film.

I bought into filmmaking in the 60's, when developments seemed to promise that independent documentary films could become truly useful, maybe even elegant, intellectual instruments—instruments that could produce significant experience, as important as the experience of reading a book (let's say a book by Faulkner, Thomas Mann, Primo Levi, Norman Mailer, or today, the South African, J. M. Coetzee). These were to be counter-documents—texts that unraveled or at least poked holes in the representation of the world by the *New York Times, Time Magazine,* and *CBS.*

In the U.S., documentaries have become progressively more sensational, more about titillation and desire, and more and more determined by commercial concerns literally untouched, it seems, by the last 40 or so years of continental theory, by cinema theory, or by any kind of critical or political thinking. How is that possible? My analysis is that these films—whatever their purpose, their reason for being, and

whatever their appeal—still trade solely in reality footage as if it were some pure unassailable essence. In spite of contemporary techno-innovations—slick digital effects, sexy music, split screens, etc. all of which intrude on the old "purity" of the documentary form, they all are able to say, and do say, implicitly, about themselves, "Here is reality—and when you've seen this—and you *should* see it—you'll have understood something you need to know." That is, they all claim the pedigree of the real and all the attributes and privileges of "the real." And this is the documentary's albatross—an enormous handicap that paralyzes the filmmaker's ability to go past the surface of reality to profound, subtle, useful propositions about or explanations of the world. It is also what masks the documentary's natural tendency toward pornography—the "pornography of the real." Pornography is the objectifying of a graphic image (turning it from a subject into an object) so that the person or group depicted can be commodified, circulated and consumed without regard to its status as subject. By "pornography of the real" I mean the documentary's exploitation of "real life situations" to produce that titillation of difference which middle class audiences seem to need and enjoy. It's a message that encourages them to feel—in the movie theatre, in the dark, when no one is watching—"Thank God that's not me," or, "thank God I'm not the cause of the problem," while being encouraged to peek at, in the anonymity of the movie theater, the devastated, the distorted, the dispossessed, and the daringly dramatically different.

The documentary film has developed many bad habits over time, which should be broken. I fear these will be as hard to break as it is for me to stop smoking, which I haven't yet. Nevertheless, and in response to *The dogme* guys, here is the first part of the *Documentary Film Dogma, 2001*, a list of eleven "Don'ts," aimed at disabling old documentary habits and setting a new course.

DOCUMENTARY FILM DOGMA

1. Don't produce "real" time and space: your audience is in a movie theatre, in comfortable chairs.

2. Don't produce the surface of things: have a real subject and a real analysis, or at least an intelligent proposition that is larger than the subject of the film. If you forget to think about this before starting to shoot, find it in the editing room, and then put it in the film, somehow.

3. Don't produce freak shows of the oppressed, the different, the criminal, and the primitive. Please don't use your compassion as an excuse for social pornography. Leave the poor freaks alone.

4. Don't produce awe for the rich, the famous, the powerful, the talented, and the highly successful: they are always everywhere and we feel bad enough about ourselves already. The chance to envy, or admire, or hate them, in the cinema doesn't help anybody.

5. Don't make films that celebrate "the old ways" and mourn their loss. Haven't you yourself enjoyed change? How are the "old ways" people different from you?

6. Keep an eye on your own middleclass bias, and on your audience's. Don't make a film that feeds it. Remember that you are producing human consciousness in people who are very vulnerable . . . and alone in the dark.

7. Try not to exploit your social actors: just being seen in your film is not enough compensation for the use of their bodies, voices and experience.

8. Don't address an audience of "rational animals": we (your audience) have not yet evolved beyond the primitive urges of hatred, violence, apathy, and exploitation of the poor and the weak, so don't address us as if we have.

9. Whatever you do, don't make "history." If you can't help yourself, try to remember that you're just telling a story—and at the very least, find a way to acknowledge your authorship.

10. Watch that music: what's it doing? who is it conning?

11. Leave your parents out of this.

ETHNOGRAPHIC CINEMA (EC): A MANIFESTO / A PROVOCATION (USA, 2003)

Jay Ruby

[First published on Ruby's website (http://astro.ocis.temple.edu/~ruby/ruby/) but since removed by the author.]

This manifesto challenges many of the received notions of what constitutes ethnographic cinema. Written at the height of the reimagining of the discipline of cultural anthropology by the likes of Michael Taussig, George E. Marcus, Michael M. J. Fischer, Roger Keesing, and many others (including Ruby himself), Ruby's manifesto argues for an ethnographic cinema that is experimental, exploratory, and noncommercial.

So-called ethnographic films are, in fact, films about culture and not films that pictorially convey ethnographic knowledge. They are produced by professional filmmakers who have little or no knowledge of anthropology and by anthropologists who thoughtlessly follow the dictates of documentary realism.

For a cinema to exist that furthers the purposes of anthropology, the following must occur:

1. EC must be the work of academically educated and academically employed socio-cultural anthropologists. EC can only be a consequence of ethnographic research by trained ethnographers who professionally engage in academic discourse on a regular basis. EC must be an extension of their work as anthropologists, intellectuals and scholars.

2. EC must be avowedly anti-realist, anti-positivist, dissociated from the canons of documentary realism and free to borrow from all forms of cinema—fiction and non-fiction.

3. EC must seek to increase the agency of those imaged with techniques such as multivocality and to reflexively de-center the authority of the maker while at the same time accepting the moral burden of authorship.

4. EC must explore the limits of pictorial media as a means of anthropological expression.

5. If EC is to succeed, it will probably confuse its audience at first. It is therefore essential that its makers be painfully obvious and assist viewers.

6. EC must have modest production values, tiny budgets, low costs for production and distribution if it is to escape the restrictions of the commercial world. EC, therefore, has no economic potential. No one can make a living from its products. It is the act of the scholar seeking to communicate scholarly knowledge.

7. EC must be removed from the economic dictates of public and state television, funding agencies who accept a popularly accessible product and distribution companies who must circulate work that produces income. New forms of funding and distribution must be created.

8. EC acknowledges the inadequacy of all film festivals and other venues currently available. It must seek to create screening and discussion environments that emphasize scholarly debate about the contribution these works make to an anthropological discourse.

REALITY CINEMA MANIFESTO
(Russia, 2005)

Vitaly Manskiy

[First published in Russian in *Iskusstvo kino* 10 (2005). First published in English on Manskiy's website: manski.ru/link7.html.]

Greatly inspired by Dziga Vertov, Russian filmmaker Vitaly Manskiy is known for his provocative documentaries, which blur the distinction between the imagined and the real. Manskiy is also the president of the Moscow documentary film festival ArtDocFest. An agent provocateur in Russia, in this manifesto he outlines his ethics of documentary filmmaking.

MANIFESTO

1. NO SCRIPT. Script and reality are incompatible. Before shooting there shall be determined only the place where the film-making process shall start, sometimes together with characters of the film and the general idea. As of the start of shooting, only real events shall determine the course of dramatic concept. *meanwhile, reality cinema doesn't aspire to state the facts without fear or favor. Reality cinema is not a copy of reality.

2. NO MORAL LIMITS FOR THE AUTHOR WHEN MAKING A FILM. EXCEPT FOR THOSE OF LEGAL NATURE. In order to submerge into the space of the object being shot, it is allowed to use all existing technological methods; an ordinary camera, motion-picture observation, hidden shooting and so on. Ethic questions shall be settled not in the course of shooting, but in the course of editing.

3. THE AUTHOR SHALL NOT BE HOSTAGE OF TECHNOLOGY. It is possible to disregard the film strip, studio sound and light, the angle and the work for the sake of a possibility to shoot the real-time events. Picture quality is not as important as reality.

4. IN THE COURSE OF HIS MOVIE THE AUTHOR SHALL INFORM THE AUDIENCE ON TIME AND PLACE SHOWN IN THE FILM. If it doesn't hurt the objects or the characters being shot.

5. NO ADAPTATION OR RECONSTRUCTION. The author may provoke his characters to do whatever he wants and he himself may take part in it.

6. NO LIMITS IN THE FILM DURATION. Maybe even an eternal live performance.

7. DENIAL OF EXISTENCE OF "THE END." No film can have an end, because reality is perpetual. So the author may create new versions of the film at any time convenient and continue shooting after first public demonstration. In the final caption instead of putting the word "The End" there shall be put the date of the first public demonstration of this film version. In case of making new versions, the date of the first public demonstration shall be indicated after the date (dates) of demonstration of previous versions.

DOCUMENTARY MANIFESTO (USA, 2008)

Albert Maysles

[Published on Maysles's website: mayslesfilms.com/albertmaysles/documentary. html.]

Unlike Herzog's manifesto, the "Documentary Manifesto" by direct cinema pioneer Albert Maysles—codirector of such films as *Gimme Shelter* (1970) and *Grey Gardens* (1976)—articulates a point of view that prioritizes the role played by reality in documentary filmmaking, holding fast to the belief that a dedicated documentarian can capture the truth of the moment and share it with the world.

WHY

As a documentarian I happily place my fate and faith in reality. It is my caretaker, the provider of subjects, themes, experiences—all endowed with the power of truth and the romance of discovery. And the closer I adhere to reality the more honest and authentic my tales. After all, knowledge of the real world is exactly what we need to better understand and therefore possibly to love one another. It's my way of making the world a better place.

HOW

1. Distance oneself from a point of view.
2. Love your subjects.
3. Film events, scenes, sequences; avoid interviews, narration, a host.
4. Work with the best talent.
5. Make it experiential, film experience directly, unstaged, uncontrolled.
6. There is a connection between reality and truth. Remain faithful to both.

- Hold it steady.
- Use manual zoom, not the electronic.
- Read as much of the PD 170 manual as you can.
- Read book or chapter in a photography book on how to compose shots.
- Use the steady device that's in the camera.
- Never use a tripod (exception: filming photographs, for example).
- You'll get a steadier picture the more wide-angle the shot. In a walking shot go very wide angle.
- Hold the beginning and end of each shot. The editor will need that.
- Use no lights. The available light is more authentic.
- Learn the technique but equally important keep your eye open to watch the significant moment. Orson Welles: "The cameraman's camera should have behind its lens the eye of a poet."
- Remember, as a documentarian you are an observer, an author but not a director, a discoverer, not a controller.
- Don't worry that your presence with the camera will change things. Not if you're confident you belong there and understand that in your favor is that of the two instincts, to disclose or to keep a secret, the stronger is to disclose.
- It's not "fly-on-the-wall." That would be mindless. You need to establish rapport even without saying so but through eye contact and empathy.

CHINA INDEPENDENT FILM FESTIVAL MANIFESTO: SHAMANS * ANIMALS (People's Republic of China, 2011)

By several documentary filmmakers who participated and also who did not participate in the festival

[First released as a response to the China Independent Film Festival Documentary Film Symposium, 31 October 2011.]

"China Independent Film Festival Manifesto: Shamans * Animals" is a collaborative manifesto that critiques not documentary filmmaking practices but rather the film critics who claim authority on the ethical values in documentary cinema. This manifesto foregrounds the ongoing debates surrounding not only the ethics of documentary cinema but its potential role in society and that of the filmmakers who practice it.

1/ Demand that film critics buy their own DVDs—Xue Jianqiang

2/ Reject how film critics have become the definers and arbiters of the morals and ethics of documentary film. Rather than simply passing judgement on documentary ethics, film critics should foster a film critique based on artistic intuition that, rooted in intrinsic film language itself, inquires into ethics.

Reject a film critical perspective that is remote from common people, one that abuses a concept like "the lower strata of society." Do you like this concept because you feel that you are in a position of superiority?

Can an intellectual-style round table discussion have any possible constructive nature?

Reject the way intellectuals use conventional concepts and actions to turn fresh and lively documentary experience into something uninteresting.—Cong Feng

3/ If we see cinema as a private garden, is the critic the owner of the garden or only the gardener?—Zhang Chacha

4/ The rigid theorizing of intellectuals turns the flow of discussion into something oppressive and boring.—Gui Shuzhong

5/ For the past few years, it seems that we've abandoned discussing film language. It's more fun discussing the ethics of social differentiation.—Jin Jie

6/ Shoot films like an animal.

Criticize (films) like an animal.

Animals of a different species.—Qiu Jiongjiong

7/ Critics cannot dictate history.

Critics should learn from filmmakers, and not pretend to be their mentors.

Artists teach themselves in the course of shooting their films; they establish their own ethical principles.—Cong Feng

8/ Making documentary cinema reproduces the feeling of making love. The climaxes can't be judged by the critics.—Song Chuan

9/ Respect the diversity of and multiple approaches to creative artistic research.

10/ We're not trying to start a revolution. We're trying to shake people awake (while we get drunk).—Ji Dan

11/ Revolutions are caused by arrogance, nothing more.—Ji Dan

12/ Fortunately documentary filmmakers pay no heed to unreliable theory.—Gui Shuzhong

13/ Theory is inflexible.

Documentary

Jealousy

Excitement

Are fresh and lively

—Gui Shuzhong

14/ Filmmakers speak through their works

Viewers ponder what's on the screen

Here come the critics, squawking and quacking a language of their own.—Jin Jie, Zhang Chacha

15/ If theorists are the ones who can speak, and critics are the ones who can write, then the real thinkers are precisely those who neither speak nor write.—Bai Budan

16/ When ethics are at issue, law is the criterion.—Feng Yu

17/ Where is the moral introspection of certain critics and scholars? Enough with leaders' speeches, already.—Cong Feng

18/ Theory is related to reality. Theory also must keep up with the times. If critics stray from the works of art themselves while discussing theory, then their discussion will become like fog in the wind, vapid and uninteresting.—Gui Shuzhong

19/ [missing]

20/ Talk too much about theory, and you sound pretentious. Overemphasize theory and you sound authoritarian. Life is not a two-sided coin: you have no right to force it to be either one way or the other. Of course, you can use theory to impress the kids. The motivation for documentary comes from a shame of one's own ignorance. There's no place for any talk of an avant garde or of theory.—Hu Xinyu

21/ At present, the critics tend to a kind of literary writing style. Documentary films are treated as literature, as works of art. The critics seem to think they alone have the right to define a rational discursive interpretation of society. But this is in fact an act of cultural despotism, an act that is neither rational with respect to social reality nor with respect to art. Because of this, the rational discourse of the critics is a kind of observation at one remove.—Mao Chenyu

22/ So-called theory is all for self-gratification. Independent film should not be restricted to the society's lowest classes telling stories about each other. It should be diverse and multiple.

Uninteresting, boring, useless.

When you say you're aligned with the lowest levels of society, you are in fact looking with disdain and contempt at the low from on high.

Please use the word "intellectual" correctly and carefully. And please don't use that word at this kind of independent film festival. It is not a term of praise, but rather a pretext to occupy a position high above the ordinary people. Is it really so hard to be modest and put yourself in someone else's position?—Wang Shu

23/ If possible, watch more movies. If you ever have the opportunity, then try to shoot a film. If you've never shot a gun yourself, how can you teach someone else to shoot?—Gui Shuzhong, Cong Feng

24/ Yesterday's forum took place at the Nanjing University's News and Media Institute. Is it the job of our professors and scholars to teach students how [to] make false statements sound like true ones? If those who teach students to lie boast that they are intellectuals, can there still be any filmmakers willing to label themselves "intellectuals?"—Beifang Lao (web alias)

7

STATES, DICTATORSHIPS, THE COMINTERN, AND THEOCRACIES

This chapter considers a series of manifestos that, unlike the others in the book, are State, or quasi-State, sanctioned. In these instances, the manifestos written by members of governments and religious institutions function as means by which to mobilize the cinema for the goals of the State, be they national, political, or theocratic ones. A key precursor is "The Lenin Decree" (see chapter 1), which outlines the role of the cinema in the then-nascent USSR based on the notion that film could bring together the disparate population of the USSR through propaganda. In a similar fashion, Joseph Goebbels, the minister of propaganda and popular enlightenment in Hitler's Nazi government, quickly moved to consolidate the German film industry under the command of the State. In "Creative Film," a speech Goebbels gave at the closure of the International Congress of Film in 1935, he proclaimed what he saw as the role of cinema, not just in the Third Reich but internationally. Under the guise of aesthetics, Goebbels delineated the propagandistic role for the cinema as a means to reflect back the image of the nation put forth by the State as its own. Certainly, the quasi-messianic properties of Goebbels's speech draw on religious rhetoric to argue for a form of transcendence only obtainable by blind adherence to the nation and its goals as propagated by the State.

The introduction to this book paid some attention to the quasi religiosity of film manifestos, of which "Creative Film" is but one salient example. But what of truly religious film manifestos? In the few writings one finds on film manifestos, it is almost always taken as a given that manifestos are inherently left-wing and revolutionary. This unfounded presupposition elides the complex history of manifesto writing and the role it has played in the creation of film cultures. If leftist film manifestos are often seen as a central aspect of modernity, right-wing film manifestos are, in essence, critiques of modernity and the modernist project, as one can see in Goebbels's writings but also in the writings of theologians.

A recurring concern in much Catholic writing on the perils of the cinema is the way in which the cinematic spectatorial space lends itself to a lack of vigilance on the part of the spectator. Ambrogio Damiano Achille Ratti, better known as Pius XI, develops these arguments further and in a startling, one might even say audaciously prescient, move along the way articulates the basis of suture theory some thirty years before Jean-Pierre Oudart. In his seminal essay "Cinema and Suture" Oudart writes:

> The spectator is doubly decentred in the cinema. First what is enunciated, initially, is not the viewer's own discourse, nor anyone else's: it is thus that he comes to posit the signifying object as the signifier of the absence of anyone. Secondly the unreal space of the enunciation leads to the necessary quasi-disappearance of the subject as it enters its

own field and thus submerges, in a sort of hypnotic continuum in which all possibility of discourse is abolished, the relation of alternating eclipse which the subject has to its own discourse; and this relation then demands to be represented within the process of reading the film, which it duplicates.[1]

Although the terminology is distinct, this passage echoes the critique launched by Pius XI, especially in regards to the sublimation that takes place on the spectator's part while watching the cinema. And Pius XI is not alone among Catholic writers to see the cinema this way: in Quebec, Boston, and other predominantly Catholic cities and states, this vision of the cinema's powers can be traced back to the 1910s, if not earlier. What *Vigilanti Cura* does is codify these critiques for the worldwide church.

Furthermore, one cannot discount the importance of this manifesto as a call to arms and a proclamation of how to best live one's material and spiritual life, as papal encyclicals fall under the rubric if not of divine infallibility, then as Pius XII, his successor, wrote in another encyclical: "if the Supreme Pontiffs in their acts, after due consideration, express an opinion on a hitherto controversial matter, it is clear to all that this matter, according to the mind and will of the same Pontiffs, cannot any longer be considered a question of free discussion among theologians."[2] This foregrounds another aspect of manifesto writing writ large: they are monological in nature, preempting any possibility of dissent. Because of his concerns, Pius XI argues that the faithful must take a yearly pledge in church in which they promise to stay away from films that are "offensive to truth and to Christian morality." Here, Pius XI prefigures Dogme—of the Danish, not Catholic, sort—by instituting a pledge as a constitutive part of the manifesto. One must not only agree with the manifesto in question; one must swear allegiance to it. The pledge that was instituted was that of the Legion of Decency and was itself effectively a manifesto, undertaken in American Catholic churches once a year by parishioners. Furthermore, a network of Parish Hall screenings would be instituted and ideally, a world list of condemned films drawn up, a Bizarro-world parallel of *Sight and Sound*'s top one hundred films list; the pope's list included such renowned films as Lubitsch's *Design for Living* (USA, 1933), Sternberg's *The Scarlet Empress* (USA, 1934), Hughes's *The Outlaw* (USA, 1943), Preminger's *The Moon Is Blue* (USA, 1952), and Fellini's *8½* (Italy, 1963). And activism, under the guise of the Legion of Decency and other organizations worldwide, lobbied to make sure films that are mortal sins are not shown. The role of *Vigilanti Cura* should not be underestimated. Its effect on the overall development in the United States of the Production Code's edicts and practices illustrates the profoundly Catholic nature of the censorship movement in that country. The most important reason that *Vigilanti Cura* ought to be taken seriously as a film manifesto is that it does postulate a highly conservative utopian discourse about the cinema and effects the overall development of what I claim is the most successful film manifesto of all time, the Motion Picture Production Code (if one is to judge effect by how a manifesto's plans are implemented in public life).

The use of theological pronouncements as a means to regulate the cinema is by no means limited to Catholicism. Other theocrats have also pronounced on the cinema in similar ways, issuing manifesto-style proclamations. In his first speech on his return to Iran following the Revolution in 1979, Ayatollah Khomeini stated the following about the cinema:

> Why was it necessary to make the cinema a center of vice? We are not opposed to the cinema, to radio, or to television; what we oppose is vice and the use of the media to keep our young people in a state of backwardness and dissipate their energies. We have never opposed these features of modernity in themselves, but when they were brought from Europe to the East, particularly to Iran, unfortunately they were used not in order to advance civilization, but in order to drag us into barbarism. The cinema is a modern invention that ought to be used for the sake of educating the people, but, as you know, it was used instead to corrupt our youth. It is this misuse of the cinema that we are opposed to, a misuse caused by the treacherous policies of our rulers.[3]

Here we see the recurring claim that the cinema itself is fighting a retrograde action against culture and society and can only be righted by political film manifestos that aim to set the course of the cinema back on the right trajectory.

CAPTURE THE FILM! HINTS ON THE USE OF, OUT OF THE USE OF, PROLETARIAN FILM PROPAGANDA (USA, 1925)

Willi Münzenberg

[Originally published in the *Daily Worker*, 23 July 1925.]

Willi Münzenberg (1889–1940) was a German communist organizer and a *Kommunistische Partei Deutschlands* member of the Reichstag from 1924 to 1933. Working close with the Comintern, Münzenberg was renowned as a propagandist. Here he argues that communists must be as successful as capitalists in using films for propaganda instead of turning against the new technology as simply a bourgeois capitalist tool.

Ferdinand Lasalle characterized the press as the new major power. The same can be said of the film, which, in some countries, has already achieved a greater significance than the press itself. The total attendance in the movie theaters of England, France and the United States is perhaps even today greater than the total number of newspaper readers in those countries.

Even if the press were granted the greater numerical dissemination, let it not be forgotten that the film, thru the medium of the visual picture, influences its patrons far more strongly and emphatically than does the printed word its readers.

He then develops the thot of the importance of technical progress in the film world finally convincing the last opponent of its value and permanence.

We must develop the tremendous cultural possibilities of the motion picture in a revolutionary sense. . . . The film must truthfully reflect social conditions instead of the lies and fables with which the bourgeois kind befuddles the workers, etc.

As in many other instances, the working class organizations were the most timid and tardy in the effort to put this new medium to their use. The time is not so far past when social-democratic leaders in common with bourgeois ideologists, in all seriousness proposed to boycott the films because of their competition with the theatre, their flattening of public taste and destruction of literary standards. Only after the war were timid attempts made to put the film into the service of working class propaganda. In various countries

490

workers' organizations arranged "Better Movie Nights" in which, besides the showing of educational and cultural films, criticism of current entertainment films was given. In 1922 in Germany the A.D.G.B. (All German Federation of Trade Unions) tried, thru the establishment of a "Peoples Movie," to produce and exhibit socialistic working class pictures. The attempt was unsuccessful, but it was later repeated by the A.D.G.B. in the production and distribution of the film "The Smithy," which, however, also failed of mass influence. In the main the labor organizations and even the Communist Parties and groups have left this most effective means of propaganda and agitation supposedly in the hands of the enemy.

The bourgeoisie, and especially the extreme nationalists and militarists, very early recognized the significance of the film as a propaganda weapon and constantly and most extensively put it to their service. Particularly far-reaching exploitation of the film took place during the world war, particularly by England and France which spent tremendous sums on film propaganda against the Central Powers in allied and neutral countries. Germany tried in vain to beat the opponent at this game, and even created a special film center for the purpose of pushing nationalist films to fan the war spirit. These films received little distribution outside of Germany and Austria. But it is beyond argument that the war and incitive films contributed very heavily to the creation of the chauvinist insanity in the war, and the post-period showed continued use of the films for the purpose.

While in England and France a whole row of pictures proclaimed the military victory, the German producers were more concerned with awakening a faith in the possibility of a rebirth of the "good old times" of Germany's "greatness." A typical example of this series is the picture "Frederick the Great," which was mightily effective along this very line in petit-bourgeois and "spiessbürger-lichen" circles.

In considering the development of the German film industry it is interesting to note the reflection of the current political tendencies. During the mounting wave of the monarchist movement which culminated openly in the election of Hindenburg there was a decided increase in the production and release of monarchist and militarist films.

The pictures, "The King's Grenadier," "Ash Wednesday," "Reveille," "The Tragedy of Major Redl," etc., are typical examples of this tendency, and it would be very interesting to establish statistically in how many theaters, during the few weeks before the presidential by-elections, these and similar films were shown to the public.

How far film is exploited for definite political ends is shown in the large number of prejudice building films directed by European and American producers against Soviet Russia. For example the film "Death Struggle" *(Todesreigen)* produced in Berlin which for months in practically all German cities conjured up on the screen the most unconscionable concoction of invention and fantasy of terror and horror on the part of the Soviet government against the Russian workers and peasants. In several industrial centers the workers became so enraged at this calumny that, as in Leipsig [*sic*], they smashed up

the projectors and burned the films. The attitude of these workers is entirely understand-
able, but it also recalls its precedent in the early days of capitalism when the workers,
feeling their livelihood threatened by the new machines, smashed the new tools and
set a red cock on the roof of the manufacturer. Only later did the proletarians learn
that it does no good to destroy machines, but that what concerns us is the conquest
of those machines and their application in a manner useful to the workers. Understand-
able tho the action of the Leipsig workers, it shows no workable remedy with which to
meet the evil. Not the destruction of tools and technical equipment, but their conquest
and their turning to the use of the labor movement, for the ideal-world of Communism.
One of the most pressing tasks confronting Communist parties on the field of agitation
and propaganda is the conquest of this supremely important propaganda weapon until
now the monopoly of the ruling class, we must wrest it from them and turn it against
them.

THE LEGION OF DECENCY PLEDGE (USA, 1934)

Archbishop John McNicholas

The first draft of the Legion of Decency pledge was written by Archbishop of Cincinnati
John McNicholas in 1933. The final version, printed here, was ratified by the Legion
in 1938, and the pledge was taken each year on the Feast of the Immaculate Concep-
tion, on December 8. The Legion rated films as either A (morally unobjectionable), B
(morally objectionable in part), or C (condemned by the Legion of Decency). Viewing
condemned films endangered one's eternal soul. The most critical blow against this
system came with the court cases surrounding Rossellini's "Il miracolo," the first half
of his omnibus film L'amore (Italy, 1948), which screened in the United States in 1950.
In 1952, the United States Supreme Court, in Joseph Burstyn, Inc v. Wilson, determined
that a film could not be banned on the grounds of sacrilege, which all but eliminated
film censorship in the USA, a major First Amendment win.

In the name of the Father and of the Son and of the Holy Ghost. Amen. I condemn
all indecent and immoral motion pictures, and those which glorify crime or criminals.
I promise to do all that I can to strengthen public opinion against the production of
indecent and immoral films, and to unite with all who protest against them. I
acknowledge my obligation to form a right conscience about pictures that are
dangerous to my moral life. I pledge myself to remain away from them. I promise,
further, to stay away altogether from places of amusement which show them as a
matter of policy.

CREATIVE FILM (Germany, 1935)

Joseph Goebbels

[First published in German in Curt Belling, *Der Film in Staat und Partei* (Berlin: Verlag "Der Film," 1936). First published in English in David S. Hull, *Film in the Third Reich: A Study of the German Cinema, 1933–1945* (Berkeley: University of California Press, 1969), 70–72.]

On 25 April 1935, German Reich Minister of Public Enlightenment and Propaganda Joseph Goebbels opened the German International Film Congress at the Kroll Opera in Berlin. Along with inviting participants from approximately forty nations, totaling some two thousand delegates, Goebbels gave this speech at the Closure of the International Congress before the closing screening of *Das Mädchen Johanna* (Gustav Ucicky, 1935), a retelling of the Joan of Arc narrative, with Joan espousing the words of Hitler. In his speech Goebbels argued that film must eschew vulgar populism and radical aesthetic experimentation and instead show the lives of the people of a country as they are. Needless to say the lives of the people "as they are" was being determined by the State and its own propagandistic vision of the Greater German Reich.

It is the most noble task of art to bridge the gap between politics and economics. Art supplies the people with a solid ground on which they can disregard the conflicts of their interests and work constructively together, hand in hand. Art is the most noble cultural expression of a nation. Each nation creates its own specific art and style. Even the greatest artistic genius is in the last analysis a child of his nation and draws his boldest strivings for immortality from the roots of his native soil. International importance belongs to the kind of art which is deeply rooted in its national and folk origin, but whose rooted creativity is so dynamically charged that it goes beyond the boundaries of its native cultural realm and, because of its deep human values, is able to move the hearts of men in all countries and nations.

I realize that I am making high demands on creative movie production and its makers when I apply these age-old laws to it. From this derives for the film art, both in its national and international significance, a number of principles, which I consider essential if this most modern art is to prove and maintain its vital force and take its place of equality among the traditional and historical art forms. These principles form the foundation upon which the film has to prove its strength.

Permit me to develop these sketchy hints:

1. Like any other art form the film has its own laws. Only by obeying these laws can it preserve its own character. These laws differ from those of the stage. The superiority of the stage over the film must be discarded. The stage has its own language and so does the film. Things which are possible in the dim light of the

proscenium become utterly unmasked in the harsh klieg lights of the movies. Relying upon its century-old tradition the theatre will try with might and main to maintain a position of condescending sponsorship over the movies. For the film it is a vital artistic necessity to stand on its own feet and to break the hold of the stage.

2. The film must rid itself of the vulgar platitudes of mass entertainment, yet it must not permit itself to lose touch with the people. The taste of the audience is not an unalterable fact that has to be accepted. This taste can be educated both for better or for worse. The artistic quality of the film depends upon the decision to educate the audience in a practical manner even at the cost of financial sacrifices.

3. This does not mean that the movies have to cater to anaemic aestheticism. On the contrary, just because of its wide reach the movies, more than any other form of art, must be an art of the people in the highest sense of the word. Being an art of the people it has to portray the joys and sorrows which move the people. It cannot escape the exigencies of our time and escape into a dreamland of unreality which only exists in the heads of ivory tower directors and scenarists and nowhere else.

4. There is no art which cannot support itself. Material sacrifices which are made for art's sake are being squared by ideal attainments. It is a matter of course that governments support the construction of great state buildings which immortalize the creative expression of a period, governments also support the theatre whose productions reflect the tragic and comic passions of the time, they also extend subsidies to picture galleries which house the people's artistic treasures. It must become equally a matter of course for governments to support the art of the film and to support cultural values, unless it foregoes the chance to place the film on the same footing with other art forms. In that case lamentations about *kitsch* and deterioration of movie standards are merely bigoted attempts to gloss over a sin of omission.

5. Like every other art form the movies must be closely related to the present and its problems. Film subjects, even though they may go back into previous historical eras and draw from foreign countries have to express the spirit of our time in order to speak to our time. In this sense, the film like any other form of art carries, as paradoxical and absurd as this may sound, the tendencies of its epoch to which it speaks and for which it works creatively.

6. Films that are based on these exigencies, while stressing the specific character of a nation, will tend to bring different nations closer together. The film is a cultural bridge between nations and increases international understanding.

7. The movies have the task to create with honesty and naturalness evidence for their very being. Empty pathos should be as foreign to the film as trashy sentimentality, a legacy passed on to it from the stage. An honest and natural

film art, which gives our time living and plastic expression, can become an important means for the creation of a better, purer, and more realistic world of artistic potentialities.

If the movies adhere to these basic principles, they will conquer the world as a new form of artistic manifestation.

Germany has the honest intention to erect bridges that will connect all nations, but in back of us the greatness of life is waiting to find artistic expression. There is no other choice: We must lay hold of it and be part of it.

Let us start with the firm determination to be natural the way life is natural! Let us remain truthful so as to accomplish the effect of truth. Let us depict things, which fill and move the hearts of men so as to move these men's hearts and to transport them into a better world by revealing to them the eternal.

VIGILANTI CURA: ON MOTION PICTURES (Vatican City, 1936)

Pope Pius XI

[First published as a papal encyclical in Latin and English on 29 June 1936.]

This manifesto, written by the Italian Ambrogio Damiano Achille Ratti, is one of the most influential film manifestos ever written, accomplishing nothing less than changing the course of North American and, to a lesser extent, Western European cinema. One reason that Achille Ratti does not appear in most film histories is that he wrote under a nom de plume and is much better known as Pope Pius XI. *Vigilante Cura* is a papal encyclical on the motion picture in praise of the arrival of the Legion of Decency and deploring the sinful nature of most cinema. These edicts determined to a large degree the kinds of images that would be seen on American (and therefore world) screens. Also, one should not underestimate its impact on European cinemas, as both Vittorio De Sica's *Landri di biciclette* (Italy, 1949) and Roberto Rossellini's *L'amore* (Italy, 1948) were attacked by Catholics in light of this encyclical and the movements that sprang from it. *Vigilante Cura* also outlined the moral implications that watching "condemned" films had for one's soul. Like the far better known modernist manifestos, this text was a call to arms—though in this case for devout, right-wing Catholics.

INTRODUCTION

In following with vigilant eye, as Our Pastoral Office requires, the beneficent work of Our Brethren in the Episcopate and of the faithful, it has been highly pleasing to Us to learn of the fruits already gathered and of the progress which continues to be

made by that prudent initiative launched more than two years ago as a holy crusade against the abuses of the motion pictures and entrusted in a special manner to the "*Legion of Decency.*"

This excellent experiment now offers Us a most welcome opportunity of manifesting more fully Our thought in regard to a matter which touches intimately the moral and religious life of the entire Christian people.

First of all, We express Our gratitude to the Hierarchy of the United States of America and to the faithful who cooperated with them, for the important results already achieved, under their direction and guidance, by the "*Legion of Decency.*" And Our gratitude is all the livelier for the fact that We were deeply anguished to note with each passing day the lamentable progress—*magni passus extra viam*—of the motion picture art and industry in the portrayal of sin and vice.

I. PREVIOUS WARNINGS RECALLED

As often as the occasion has presented itself, We have considered it the duty of Our high Office to direct to this condition the attention not only of the Episcopate and the Clergy but also of all men who are right-minded and solicitous for the public weal.

In the Encyclical "*Divini illius Magistri,*" We had already deplored that "potent instrumentalities of publicity (such as the cinema) which might be of great advantage to learning and to education were they properly directed by healthy principles, often unfortunately serve as an incentive to evil passions and are subordinated to sordid gain."

THE INFLUENCE OF THE MOTION PICTURE

In August 1934, addressing Ourselves to a delegation of the International Federation of the Motion Picture Press, We pointed out the very great importance which the motion picture has acquired in our days and its vast influence alike in the promotion of good and in the insinuation of evil, and We called to mind that it is necessary to apply to the cinema the supreme rule which must direct and regulate the great gift of art in order that it may not find itself in continual conflict with Christian morality or even with simple human morality based upon the natural law. The essential purpose of art, its raison d'être, is to assist in the perfection of the moral personality, which is man, and for this reason it must itself be moral. And We concluded amidst the manifest approval of that elect body—the memory is still dear to Us—by recommending to them the necessity of making the motion picture "*moral, an influence for good morals, an educator.*"

And even recently, in April of this year, when We had the happiness of receiving in audience a group of delegates to the International Congress of the Motion Picture Press, held at Rome, We again drew attention to the gravity of the problem and We warmly exhorted all men of goodwill, in the name not only of religion but also of the true moral and civil welfare of the people, to use every means in their power, such as the Press, to

make of the cinema a valuable auxiliary of instruction and education rather than of destruction and ruin of souls.

THE NEEDS OF THE ENTIRE CATHOLIC WORLD

The subject, however, is of such paramount importance in itself and because of the present condition of society that We deem it necessary to return to it again, not alone for the purpose of making particular recommendations as on past occasions but rather with a universal outlook which, while embracing the needs of your own dioceses, Venerable Brethren, takes into consideration those of the entire Catholic world.

It is, in fact, urgently necessary to make provision that in this field also the progress of the arts, of the sciences, and of human technique and industry, since they are all true gifts of God, may be ordained to His glory and to the salvation of souls and may be made to serve in a practical way to promote the extension of the Kingdom of God upon earth. Thus, as the Church bids us pray, we may all profit by them but in such a manner as not to lose the goods eternal: *"sic transeamus per bona temporalia ut non admittamus aeterna."*

Now then, it is a certainty which can readily be verified that the more marvellous the progress of the motion picture art and industry, the more pernicious and deadly has it shown itself to morality and to religion and even to the very decencies of human society.

The directors of the industry in the United States recognised this fact themselves when they confessed that the responsibility before the people and the world was their very own. In an agreement entered into by common accord in March, 1930, and solemnly sealed, signed, and published in the Press, they formally pledged themselves to safeguard for the future the moral welfare of the patrons of the cinema.

It is promised in this agreement that no film which lowers the moral standard of the spectators, which casts discredit upon natural or human law or arouses sympathy for their violation, will be produced.

PROMISES NOT CARRIED OUT

Nevertheless, in spite of this wise and spontaneously taken decision, those responsible showed themselves incapable of carrying it into effect and it appeared that the producers and the operators were not disposed to stand by the principles to which they had bound themselves. Since, therefore, the above-mentioned undertaking proved to have but slight effect and since the parade of vice and crime continued on the screen, the road seemed almost closed to those who sought honest diversion in the motion picture.

In this crisis, you, Venerable Brethren, were among the first to study the means of safeguarding the souls entrusted to your care, and you launched the *"Legion of Decency"* as a crusade for public morality designed to revitalize the ideals of natural and Christian

rectitude. Far from you was the thought of doing damage to the motion picture industry: rather indeed did you arm it beforehand against the ruin which menaces every form of recreation which, in the guise of art, degenerates into corruption.

THE "LEGION OF DECENCY" PLEDGE

Your leadership called forth the prompt and devoted loyalty of your faithful people, and millions of American Catholics signed the pledge of the *"Legion of Decency"* binding themselves not to attend any motion picture which was offensive to Catholic moral principles or proper standards of living. We are thus able to proclaim joyfully that few problems of these latter times have so closely united Bishops and people as the one resolved by cooperation in this holy crusade. Not only Catholics but also high-minded Protestants, Jews, and many others accepted your lead and joined their efforts with yours in restoring wise standards, both artistic and moral, to the cinema.

It is an exceedingly great comfort to Us to note the outstanding success of the crusade. Because of your vigilance and because of the pressure which has been brought to bear by public opinion, the motion picture has shown an improvement from the moral standpoint: crime and vice are portrayed less frequently; sin is no longer so openly approved and acclaimed; false ideals of life are no longer presented in so flagrant a manner to the impressionable minds of youth.

A USEFUL IMPETUS

Although in certain quarters it was predicted that the artistic values of the motion picture would be seriously impaired by the reform insisted upon by the *"Legion of Decency,"* it appears that quite the contrary has happened and that the *"Legion of Decency"* has given no little impetus to the efforts to advance the cinema on the road to noble artistic significance by directing it towards the production of classic masterpieces as well as of original creations of uncommon worth.

Nor have the financial investments of the industry suffered, as was gratuitously foretold, for many of those who stayed away from the motion picture theatre because it outraged morality are patronizing it now that they are able to enjoy clean films which are not offensive to good morals or dangerous to Christian virtue.

When you started your crusade, it was said that your efforts would be of short duration and that the effects would not be lasting because, as the vigilance of Bishops and faithful gradually diminished, the producers would be free to return again to their former methods. It is not difficult to understand why certain of these might be desirous of going back to the sinister themes which pander to base desires and which you had proscribed. While the representation of subjects of real artistic value and the portrayal of the vicissitudes of human virtue require intellectual effort, toil, ability, and at times considerable outlay of money, it is often relatively easy to attract a certain type of person and certain classes

of people to a theatre which presents picture plays calculated to inflame the passions and to arouse the lower instincts latent in the human heart.

An unceasing and universal vigilance must, on the contrary, convince the producers that the "*Legion of Decency*" has not been started as a crusade of short duration, soon to be neglected and forgotten, but that the Bishops of the United States are determined, at all times and at all costs, to safeguard the recreation of the people whatever form that recreation may take.

II. THE POWER OF THE CINEMA

Recreation, in its manifold varieties, has become a necessity for people who work under the fatiguing conditions of modern industry, but it must be worthy of the rational nature of man and therefore must be morally healthy. It must be elevated to the rank of a positive factor for good and must seek to arouse noble sentiments. A people who, in time of repose, give themselves to diversions which violate decency, honour, or morality, to recreations which, especially to the young, constitute occasions of sin, are in grave danger of losing their greatness and even their national power.

It admits of no discussion that the motion picture has achieved these last years a position of universal importance among modern means of diversion.

THE MOST POPULAR FORM OF AMUSEMENT

There is no need to point out the fact that millions of people go to the motion pictures every day; that motion picture theatres are being opened in ever increasing number in civilized and semi-civilized countries; that the motion picture has become the most popular form of diversion which is offered for the leisure hours not only of the rich but of all classes of society.

At the same time, there does not exist today a means of influencing the masses more potent than the cinema. The reason for this is to be sought for in the very nature of the pictures projected upon the screen, in the popularity of motion picture plays, and in the circumstances which accompany them.

The power of the motion picture consists in this, that it speaks by means of vivid and concrete imagery which the mind takes in with enjoyment and without fatigue. Even the crudest and most primitive minds which have neither the capacity nor the desire to make the efforts necessary for abstraction or deductive reasoning are captivated by the cinema. In place of the effort which reading or listening demands, there is the continued pleasure of a succession of concrete and, so to speak, living pictures.

This power is still greater in the talking picture for the reason that interpretation becomes even easier and the charm of music is added to the action of the drama. Dances and variety acts which are sometimes introduced between the films serve to increase the stimulation of the passions.

IT MUST BE ELEVATED

Since then the cinema is in reality a sort of object lesson which, for good or for evil, teaches the majority of men more effectively than abstract reasoning, it must be elevated to conformity with the aims of a Christian conscience and saved from depraving and demoralizing effects.

Everyone knows what damage is done to the soul by bad motion pictures. They are occasions of sin; they seduce young people along the ways of evil by glorifying the passions; they show life under a false light; they cloud ideals; they destroy pure love, respect for marriage, affection for the family. They are capable also of creating prejudices among individuals and misunderstandings among nations, among social classes, among entire races.

On the other hand, good motion pictures are capable of exercising a profoundly moral influence upon those who see them. In addition to affording recreation, they are able to arouse noble ideals of life, to communicate valuable conceptions, to impart a better knowledge of the history and the beauties of the Fatherland and of other countries, to present truth and virtue under attractive forms, to create, or at least to favour understanding among nations, social classes, and races, to champion the cause of justice, to give new life to the claims of virtue, and to contribute positively to the genesis of a just social order in the world.

IT SPEAKS NOT TO INDIVIDUALS BUT TO MULTITUDES

These considerations take on greater seriousness from the fact that the cinema speaks not to individuals but to multitudes, and that it does so in circumstances of time and place and surroundings which are most apt to arouse unusual enthusiasm for the good as well as for the bad and to conduce to that collective exaltation which, as experience teaches us, may assume the most morbid forms.

The motion picture is viewed by people who are seated in a dark theatre and whose faculties, mental, physical, and often spiritual, are relaxed. One does not need to go far in search of these theatres: they are close to the home, to the church, and to the school and they thus bring the cinema into the very centre of popular life.

Moreover, stories and actions are presented, through the cinema, by men and women whose natural gifts are increased by training and embellished by every known art, in a manner which may possibly become an additional source of corruption, especially to the young. Further, the motion picture has enlisted in its service luxurious appointments, pleasing music, the vigour of realism, every form of whim and fancy. For this very reason, it attracts and fascinates particularly the young, the adolescent, and even the child. Thus at the very age when the moral sense is being formed and when the notions and sentiments of justice and rectitude, of duty and obligation and of ideals of life are being developed, the motion picture with its direct propaganda assumes a position of commanding influence.

It is unfortunate that, in the present state of affairs, this influence is frequently exerted for evil. So much so that when one thinks of the havoc wrought in the souls of youth and of childhood, of the loss of innocence so often suffered in the motion picture theatres, there comes to mind the terrible condemnation pronounced by Our Lord upon the corrupters of little ones: *"whosoever shall scandalize one of these little ones who believe in Me, it were better for him that a millstone be hanged about his neck and that he be drowned in the depths of the sea."*

IT MUST NOT BE A SCHOOL OF CORRUPTION

It is therefore one of the supreme necessities, of our times to watch and to labour to the end that the motion picture be no longer a school of corruption but that it be transformed into an effectual instrument for the education and the elevation of mankind.

And here We record with pleasure that certain Governments, in their anxiety for the influence exercised by the cinema in the moral and educational fields, have, with the aid of upright and honest persons, especially fathers and mothers of families, set up reviewing commissions and have constituted other agencies which have to do with motion picture production in an effort to direct the cinema for inspiration to the national works of great poets and writers.

It was most fitting and desirable that you, Venerable Brethren, should have exercised a special watchfulness over the motion picture industry which in your country is so highly developed and which has great influence in other quarters of the globe. It is equally the duty of the Bishops of the entire Catholic world to unite in vigilance over this universal and potent form of entertainment and instruction, to the end that they may be able to place a ban on bad motion pictures because they are an offence to the moral and religious sentiments and because they are in opposition to the Christian spirit and to its ethical principles. There must be no weariness in combating whatever contributes to the lessening of the people's sense of decency and of honour.

This is an obligation which binds not only the Bishops but also the faithful and all decent men who are solicitous for the decorum and moral health of the family, of the nation, and of human society in general. In what, then, must this vigilance consist?

III. A WORK FOR CATHOLIC ACTION

The problem of the production of moral films would be solved radically if it were possible for us to have production wholly inspired by the principles of Christian morality. We can never sufficiently praise all those who have dedicated themselves or who are to dedicate themselves to the noble cause of raising the standard of the motion picture to meet the needs of education and the requirements of the Christian conscience. For this purpose, they must make full use of the technical ability of experts and not permit the waste of effort and of money by the employment of amateurs.

But since We know how difficult it is to organize such an industry, especially because of considerations of a financial nature, and since on the other hand it is necessary to influence the production of all films so that they may contain nothing harmful from a religious, moral, or social viewpoint, Pastors of souls must exercise their vigilance over films wherever they may be produced and offered to Christian peoples.

TO THE BISHOPS OF ALL COUNTRIES

As to the motion picture industry itself, We exhort the Bishops of all countries, but in particular you, Venerable Brethren, to address an appeal to those Catholics who hold important positions in this industry. Let them take serious thought of their duties and of the responsibility which they have as children of the Church to use their influence and authority for the promotion of principles of sound morality in the films which they produce or aid in producing. There are surely many Catholics among the executives, directors, authors, and actors who take part in this business, and it is unfortunate that their influence has not always been in accordance with their Faith and with their ideals. You will do well, Venerable Brethren, to pledge them to bring their profession into harmony with their conscience as respectable men and followers of Jesus Christ.

In this as in every other field of the apostolate, Pastors of souls will surely find their best fellow workers in those who fight in the ranks of Catholic Action, and in this letter We cannot refrain from addressing to them a warm appeal that they give to this cause their full contribution and their unwearying and unfailing activity.

From time to time, the Bishops will do well to recall to the motion picture industry that, amid the cares of their pastoral ministry, they are under obligation to interest themselves in every form of decent and healthy recreation because they are responsible before God for the moral welfare of their people even during their time of leisure.

THE MORAL FIBRE OF A NATION

Their sacred calling constrains them to proclaim clearly and openly that unhealthy and impure entertainment destroys the moral fibre of a nation. They will likewise remind the motion picture industry that the demands which they make regard not only the Catholics but all who patronize the cinema.

In particular, you, Venerable Brethren of the United States, will be able to insist with justice that the industry of your country has recognized and accepted its responsibility before society.

The Bishops of the whole world will take care to make clear to the leaders of the motion picture industry that a force of such power and universality as the cinema can be directed, with great utility, to the highest ends of individual and social improvement. Why indeed should there be question merely of avoiding what is evil? The motion picture should not be simply a means of diversion, a light relaxation to occupy an idle hour; with

its magnificent power, it can and must be a bearer of light and a positive guide to what is good.

And now, in view of the gravity of the subject, We consider it timely to come down to certain practical indications.

A YEARLY PROMISE FROM THE FAITHFUL

Above all, all Pastors of souls will undertake to obtain each year from their people a pledge similar to the one already alluded to which is given by their American brothers and in which they promise to stay away from motion picture plays which are offensive to truth and to Christian morality.

The most efficacious manner of obtaining these pledges or promises is through the parish church or school and by enlisting the earnest cooperation of all fathers and mothers of families who are conscious of their grave responsibilities.

The Bishops will also be able to avail themselves of the Catholic Press for the purpose of bringing home to the people the moral beauty and the effectiveness of this promise.

The fulfilment of this pledge supposes that the people be told plainly which films are permitted to all, which are permitted with reservations, and which are harmful or positively bad. This requires the prompt, regular, and frequent publication of classified lists of motion picture plays so as to make the information readily accessible to all. Special bulletins or other timely publications, such as the daily Catholic Press, may be used for this purpose.

Were it possible, it would in itself be desirable to establish a single list for the entire world because all live under the same moral law. Since, however, there is here question of pictures which interest all classes of society, the great and the humble, the learned and the unlettered, the judgment passed upon a film cannot be the same in each case and in all respects. Indeed circumstances, usages, and forms vary from country to country so that it does not seem practical to have a single list for all the world. If, however, films were classified in each country in the manner indicated above, the resultant list would offer in principle the guidance needed.

A NATIONAL REVIEWING OFFICE

Therefore, it will be necessary that in each country the Bishops set up a permanent national reviewing office in order to be able to promote good motion pictures, classify the others, and bring this judgment to the knowledge of priests and faithful. It will be very proper to entrust this agency to the central organization of Catholic Action which is dependent on the Bishops. At all events, it must be clearly laid down that this service of information, in order to function organically and with efficiency, must be on a national basis and that it must be carried on by a single centre of responsibility. Should grave reasons really require it, the Bishops, in their own dioceses and through their diocesan

reviewing committees, will be able to apply to the national list—which must use standards adaptable to the whole nation—such severer criterions as may be demanded by the character of the region, and they may even censor films which were admitted to the general list.

FILMS IN PARISH HALLS

The above-mentioned Office will likewise look after the organization of existing motion picture theatres belonging to parishes and to Catholic associations so that they may be guaranteed reviewed and approved films. Through the organization of these halls, which are often known to the cinema industry as good clients, it will be possible to advance a new claim, namely that the industry produce motion pictures which conform entirely to our standards. Such films may then readily be shown not only in the Catholic halls but also in others.

We realize that the establishment of such an Office will involve a certain sacrifice, a certain expense for Catholics of the various countries. Yet the great importance of the motion picture and the necessity of safeguarding the morality of the Christian people and of the entire nation makes this sacrifice more than justified. Indeed the effectiveness of our schools, of our Catholic associations, and even of our churches is lessened and endangered by the plague of evil and pernicious motion pictures.

Care must be taken that the Office is composed of persons who are familiar with the technique of the motion picture and who are, at the same time, well grounded in the principles of Catholic morality and doctrine. They must, in addition, be under the guidance and the direct supervision of a priest chosen by the Bishops.

EXCHANGE OF INFORMATION

A mutual exchange of advice and information between the Offices of the various countries will conduce to greater efficiency and harmony in the work of reviewing films, while due consideration will be given to varying conditions and circumstances. It will thus be possible to achieve unity of outlook in the judgments and in the communications which appear in the Catholic Press of the world.

These Offices will profit not only from the experiments made in the United States but also from the work which Catholics in other countries have achieved in the motion picture field.

Even if employees of the Office—with the best of good will and intentions—should make an occasional mistake, as happens in all human affairs, the Bishops, in their pastoral prudence, will know how to apply effective remedies and to safeguard in every possible way the authority and prestige of the Office itself. This may be done by strengthening the staff with more influential men or by replacing those who have shown themselves not entirely suited to so delicate a position of trust.

If the Bishops of the world assume their share in the exercise of this painstaking vigilance over the motion picture—and of this We who know their pastoral zeal have no doubt—they will certainly accomplish a great work for the protection of the morality of their people in their hours of leisure and recreation. They will win the approbation and the approval of all right thinking men, Catholic and non-Catholic, and they will help to assure that a great international force—the motion picture—shall be directed towards the noble end of promoting the highest ideals and the truest standards of life.

That these wishes and prayers which We pour forth from a father's heart may gain in virtue, We implore the help of the grace of God and in pledge thereof We impart to you, Venerable Brethren, and to the Clergy and people entrusted to you, Our loving Apostolic Benediction.

Given at Rome, at St Peter's, the 29th day of June, Feast of SS Peter and Paul, in the year 1936, the fifteenth of Our Pontificate.

FOUR CARDINAL POINTS OF *A REVOLUÇÃO DE MAIO* (Portugal, 1937)

António Lopes Ribeiro

[Originally published in Portuguese as "Os quarto pontos cardeais de A Revolução de Maio," *Cinéfilo* 9 (459), 5 June 1937. First published in English in "Edinburgh Film Festival Special Portuguese Cinema Dossier," *Framework* 15/16/17 (1981): 46.]

This manifesto by director António Lopes Ribeiro reflects the "Estado Novo," or New State, philosophy of Portuguese dictator António de Oliveira Salazar, who came to power in 1927. Lopes Ribeiro was consciously producing propaganda for Salazar and looked to Eisenstein's *Potemkin* (USSR, 1925) as a model. *A Revolução de Maio* is one of the few films that could be called "Estado Novo" cinema, celebrating as it does the tenth anniversary of the Salazar regime. The final line of the manifesto demonstrates a self-reflexivity that is often lacking in the work of propagandists.

I made this film in order to:

1. Serve the Portuguese cinema.

In spite of the efforts of about 10 people of good will, our cinema should still be considered infantile and I use the term in a non-pejorative sense. On the contrary, it is precisely in childhood that we may find a great spontaneity, freshness which is to be the measure of the future that lies before us. Only six sound films have been completed in Portugal and two more are almost finished. Ours is a very complex industry that keeps pace with a

subtle art: a national cinema cannot expect to achieve perfection after such a small number of films.

2. Serve the Portuguese people.

The Portuguese public of Brazil, the colonies, of Europe, America, Africa and Portugal demands films in their own language. I am committed to them and to the principle of providing one more film wholly aware of the great responsibility that a spectacle of that nature must provide . . .

3. Serve the propaganda machine of Portugal.

If I have succeeded in not spoiling by my incompetence (and certainly not by my lack of love) the formidable spectacle that occurred before the cameras I had at my disposal: the most beautiful landscapes of Portugal, the most beautiful costumes, our best artists, and wonderful work of "Estado Novo," our Army, our Navy, our Airforce—then, it is certain that *A Revolução de Maio* will be a most efficient propaganda weapon for Portugal.

4. Serve the Salazar regime.

In our uncertain world, Salazar represents a unique example of co-ordination between thought and action and all his actions are connected to the heart. If I am not mistaken, if the film succeeds in communicating to each spectator, not the respect owed to him and on which he can rely, but just my enthusiasm, my admiration for the Man and his work, then I am convinced that all these former points can be contained in this one. By serving Salazar I have implicitly served Portugal, the public and the cinema of Portugal. I hope I am not mistaken.

FROM *ON THE ART OF CINEMA*
(North Korea, 1973)

Kim Jong-il

[First published in English as chapter 1 of *On the Art of Cinema* (Pyongyang, Korea: Foreign Languages Publishing House, 1987), 1–13.]

In *On the Art of Cinema* (1973), Kim Jong-il's massive manifesto on the future of North Korean cinema, he foregrounds the North Korean Marxist theory of *Juche* (the idea of a post-Stalinist self-sufficiency arising from the nation's subjects), which delineates the proper mode of aesthetic expression in North Korean society. *Juche* foregrounds the way in which all art must work in the function of building, sustaining, and supporting the State through the principles of self-reliance, independence, and being master of one's own actions. Here we see in theory, if not in practice, the ultimate idea of art working for and conforming to the dictates of the State and, indeed, that these goals are the only reason for artistic creation in the first place. Artistic autonomy gives way to becoming an artistic automaton, with the cinema imagining the world the State puts forward as its ultimate goal and as the ultimate reflection of the people, who are coexistent and at one with the State itself.

> Like the leading article of the Party paper, the cinema should have great appeal and move ahead of the realities. Thus, it should play a mobilizing role in each stage of the revolutionary struggle.
>
> —KIM IL-SUNG

If cinematic art is to be developed to meet the requirements of the Juche age, it is necessary to bring about a fundamental change in film-making. From the time of the emergence of cinema art to this day, many changes and advances have been made in artistic and technical matters, as a result of the changes in the times and social institutions, but the vestiges of the old system and methods have not yet been overcome in creative work. There still remain remnants of capitalist and dogmatic ideas to a considerable extent, particularly in the system and methods of direction, which constitutes the nucleus of film-making. Unless the old pattern is broken completely and a new system and methods of creation are established in direction, it will be impossible to accomplish the tasks set before the cinema, which has entered a new stage of development.

Today the cinema has the task of contributing to the development of people to be true communists and to the revolutionization and working-classization of the whole of society. In order to carry out this historic task successfully, it is necessary, above all, to revolutionize direction, which holds the reins of film-making.

To revolutionize direction means to completely eradicate capitalist elements and the remaining dogmatism from the realm of directing and establish a new Juche-inspired system and methods of directing.

In establishing the new system and methods of directing it is particularly important to clarify the duty of the director and continually enhance his role in keeping with the intrinsic nature of socialist society and the character of revolutionary cinema.

The director is the commander of the creative group. He should have the overall responsibility for artistic creation, production organization and ideological education and guide all the members of the creative team in film-making.

The director in the socialist system of film-making is fundamentally different from the "director" in capitalist society.

In the capitalist system of film-making the director is called "director" but, in fact, the right of supervision and control over film production is entirely in the hands of the tycoons of the film-making industry who have the money, whereas the directors are nothing but their agents.

In capitalist society the director is shackled by the reactionary governmental policy of commercializing the cinema and by the capitalists' money, so that he is a mere worker who obeys the will of the film-making industrialists whether he likes it or not. On the other hand, in socialist society the director is an independent and creative artist who is responsible to the Party and the people for the cinema. Therefore, in the socialist system of film-making the director is not a mere worker who makes films but the commander, the chief who assumes full responsibility for everything ranging

from the film itself to the political and ideological life of those who take part in film-making. The director should be the commander of the creative group because of the characteristic features of direction. In the cinema, which is a comprehensive art, directing is an art of guidance which coordinates the creativity of all the artists to make an integrated interpretation.

Just as victory in battle depends on the leadership ability of the commander, so the fate of the film depends on the director's art of guidance. Even though he works to make a good film, the director cannot do so if he has no ability to guide the creative team in a coordinated way to realize his creative conceptions. The film is conceived and completed by the director, but it cannot be created without the collective efforts and wisdom of the creative team. Therefore, success in film-making depends on how the director works with all the artists, technicians and production and supply personnel in the creative group.

If the director is to unite the creative group with one ideology and one purpose and make an excellent film of high ideological and artistic value, he must free himself once and for all from the old domineering and bureaucratic system and methods of direction, under which the direction-first policy is pursued, the boss-gang relationship within the creative group is established, arbitrary decisions are made and creative workers are dealt with through orders and commands. If the director resorts to bureaucracy and shouts down or ignores the creative team, it will break their unity and cohesion in ideology and purpose which constitute the basis of collective creation, and deprive him of his potential to create films and bind him hand and foot. The old system and methods of directing not only do not conform with the intrinsic nature of our socialist system, where the unity and cohesion of the popular masses underlie social relations, but also do not conform with the collectivity of film-making and the intrinsic nature of direction.

In film directing, the basic factor is also to work well with the artists, technicians and production and supply personnel who are directly involved in film-making. This is the essential requirement of the Juche-inspired system of directing. This system is our system of directing under which the director becomes the commander of the creative group and pushes ahead with creative work as a whole in a coordinated way, giving precedence to political work and putting the main emphasis on working with the people who make films. This system embodies the fundamental features of the socialist system and the basic principle of the Juche idea that man is the master of everything and decides every-thing. Hence, it fully conforms with the collective nature of film-making and the charac-teristic features of direction.

Since the film is made through the joint efforts and wisdom of many people, every participant in the production should fulfil his role and responsibility like the master he is, and this collective should firmly unite with one ideology and will in order to perform creative assignments jointly. This fundamental requirement which emanates from the characteristic features of film-making can never be met by the old system of directing; it can be properly met only by the system which attaches basic importance to working with people, working with the creative team.

Under the new system of direction, film-making becomes the work of the director himself as well as the joint work of the entire creative group, and both the director and creative team assume the responsibility for creation. Therefore, everybody buckles down to creation voluntarily. Also, while making films, the director helps and leads all the members of the collective, and the creative staff learn from one another in the course of their work. Such communist ethics in creation and the revolutionary way of life are demonstrated to the full. Thus everybody is closely knit in the collectivist spirit and rises up as one in the creative work to attain the common objectives.

Under the new system of direction, the director is responsible not only for the creative work of the team but also for their political and ideological life. Therefore, he regularly conducts political work and ideological education closely combined with their creative activities and, accordingly, the process of creation becomes that of revolutionizing and working-classizing them.

In short, the system of directing based on working with people not only accords with the intrinsic nature of film-making and direction, but also enables the director to extricate himself from domineering and bureaucratic tendencies and decisively improve his ability to guide creation; it also enables him to eradicate deviation towards the idea of art for art's sake, which gives exclusive precedence to artistic creation and to advance both creative work and the work of making the collective revolutionary.

The strength of the new system lies in the fact that it guarantees the solid unity and cohesion of the creative group based on the Juche idea and gives full play to the awareness and creativity of all the members, and the director's guidance goes deep into the creative work and life so as to bring about an uninterrupted flow of innovation.

Under the new system the director should emphasize artistic guidance to the creative workers.

The basic duty of the creative group is to make revolutionary films of high ideological and artistic value, which make an effective contribution to arming people fully with the Party's monolithic ideology and which imbue the whole of society with the great Juche idea. Whether this duty is carried out at the right time and properly depends on how the director works with the members of the creative team.

The creative workers are the main figures who directly execute the revolutionary tasks devolving on their group. The director's plan is realized through these workers and all assignments of presentation arising in the course of creation are also carried out by them. Therefore, the director should work well with the creative workers and improve his role as their guide. Then, the creative group will be able to carry out the revolutionary tasks facing it successfully.

The first thing the director must do in his work with the creative workers is to bring about a consensus of opinion with regard to the production. This is the basic guarantee for successful creation and is the starting point of the director's work. If each creative worker has his own views on the production, the director cannot lead them to perform

the same presentation assignment and creative activities are thrown into confusion from the outset.

The director must carefully analyse the general characteristics of the content and form of a production, so that the creative workers can all understand and accept it.

In analysing and considering a production the director should not be too egotistical. Every artist has his own creative individuality and may have different views on a production. If the director does not take this into account and holds to his own views and ignores the opinions of other creative workers, it will be difficult to establish a uniform view on a production.

The interpretation of a production should be understood by everybody and win their consent; when it is accepted by everyone as their own, the work will be done effectively.

The director must always put forward his opinions on a production and create an atmosphere of free discussion so that many constructive views can be voiced, and he must sincerely accept the views of the creative workers. Once agreement is reached in discussion, the director must quickly act on it and base the production on it firmly and, then, must never deviate from it, whatever happens. If the director falters, the whole collective will do so and, if this happens, the production will fail.

When all the creative workers fully understand the production, the director must begin to work with each person individually.

Artistic guidance to individual creative workers must always be specific. If the director only gives general guidance and indications, he cannot give them any substantial help or lead them confidently to achieve his aims.

Taking into consideration the characteristic features and requirements of a production, the director should clearly tell the creative workers their assignments for its representation and the ways and means of carrying them out and consult them on problems which they may come across in the course of their work. Only then can his guidance conform with their work.

For example, take guidance to the acting. The role and position of the characters to be represented by actors and actresses throughout the presentation and their personalities should be analysed and, on this basis, the direction of acting should be set and the tasks of presentation and methods of acting for each stage and situation of the drama should be specifically taught. When the director's guidance is precise, then his plan will agree with that of the creative team and their work will proceed smoothly.

The important factor in the director's guidance of the interpretation is to help the creative workers to have a clear understanding of the seed of a given production and present it well.

The ideological kernel of a production is the seed which the director and all the other creative workers should bring into flower through their collective efforts and wisdom. It is not only the basis of the interpretation by individual creative workers, but also the foundation on which they all combine to produce one single cinematic presentation. When all interpretations are conducted on the basis of one seed, they form the compo-

nents of one cinematic presentation because they are built on the same foundation, although various forms of presentation are created by different artists with different personalities. Therefore, the director should be very careful that none of the creative team loses the seed or introduces anything which has nothing to do with it.

Another aspect in which the director must make a great effort in his guidance to the presentation is to ensure that the creative interaction between artists is efficient and to lead their teamwork correctly.

Basically, a comprehensive artistic presentation cannot be achieved properly by the talents or efforts of individual artists. When every artist establishes a close working relationship with the others and carries out the teamwork efficiently, the different elements which make up the comprehensive presentation will harmonize well with each other.

The director should always be in the centre of creative operations and provide a close link between the activities of individual members of the creative team, taking care to prevent possible friction and departmentalist tendencies amongst them.

The director should guide the artists correctly so that they exhibit a high degree of independence and initiative in the course of creation. Giving full play to their independence and initiative is the main factor which increases their sense of responsibility and rouses their creative ardour and imagination. Creative cooperation between the director and the creative workers and amongst the workers themselves is only successfully achieved when each plays his part properly in his appointed post.

The director must guide the creative workers in a very strict yet enlightened manner. For their part, the creative workers have to accept and understand each of his plans and carry them out in a creative manner. In this way the director should give guidance on the principle of making the creative workers in charge of individual fields of presentation assume full responsibility for their own creative work. This is effective artistic guidance.

The original ideas of creative workers in film-making should be used to perfect the harmony of a comprehensive interpretation, while at the same time giving life to the personality of individual artistic portrayals. The director should be talented enough to maintain the originality of the creative workers and raise the level of interpretation in each field and, on this basis, achieve the harmony of the whole film. This is creation in the true sense of the word.

In his efforts to ensure that the creative workers express their original ideas, the director should not allow the harmony of the overall interpretation to be destroyed, nor should he suppress this originality in order to guarantee the harmony of interpretation.

The director, the commander of the creative group, should also work well with the production and supply personnel.

The director should be responsible for the production of films and must advance this work in a coordinated manner.

Film-making, which is complex in content and large in scale, cannot move forward unless it is flawlessly supported by production organization. In film-making the processes of creation and production are inseparably linked. If production is not well organized,

the whole process of creation and production cannot run smoothly. It is only when production is well organized that it is possible to make an excellent film in a short time and with a small amount of manpower, funds and materials.

Production organization helps to ensure success in film-making. It moves the creative group in a unified and planned way so that all fields and units are well geared to each other, observing strict order and discipline, and it also makes rational use of materials and technical means and controls financial and supply activities. This is an important task which the director must control in a responsible manner.

The director should not work with production, technical and supply personnel in an administrative and technical manner just because production organization is administrative and technical in content. Administrative and technical guidance runs counter to the intrinsic nature of the Juche-inspired system of directing, and prevents production, technical and supply personnel from being actively drawn into film-making. In his guidance of production organization the director should work with people sincerely.

One of the major criteria for the new type of director is that he is the ideological educator of the creative group. The director should be responsible for their politico-ideological life and keep intensifying their politico-ideological education, so as to lead them to perform their mission conscientiously as revolutionary artists.

The unity of ideology and purpose of the creative team is a major factor for ensuring the successful completion of a film. Even if the director has the talent and skill to fuse together the diverse elements of interpretation organically, a harmonious film cannot be made with this alone. No production of high ideological and artistic value can evolve out of a creative group whose members are not united ideologically and in which discipline and order have not been established.

The unity of ideology and purpose of the creative team is not only a basic requirement for maintaining consistency throughout a film but it also has an important bearing on waging the speed campaign, establishing a revolutionary spirit of creation and hastening the revolutionization and working-classization of all the personnel.

Education in the Party's monolithic ideology is basic to the ideological education of the creative team. This work should always precede creative work and should be conducted forcefully throughout the creative battle.

Ideological education by the director is aimed at equipping the creative team fully with the Party's lines and policies so as to make better revolutionary films more rapidly. So, when ideological education is combined with creative work, great vitality can be demonstrated and artists can be roused to the creative battle.

The director must keep a grip on ideological education throughout the whole course of creative work, and give absolute priority to political work at each stage of the creative process. The new system of directing proves effective only when the director gives absolute priority to political work in everything that is done. The system is meaningless if the director neglects political work and remains as bureaucratic as ever.

To give priority to political work and keep raising the political awareness of the creative staff so that they willingly participate in film-making is an application in film-making of the fundamental requirements of our Party's traditional revolutionary work method. The director should fully adhere to this revolutionary method of creation. Whatever he produces, the director must thoroughly explain its ideological content and artistic features to all the creative staff and tell them in full about the purpose and significance of the production, so as to encourage them to take part in creative work with great revolutionary zeal.

The director should take control of working with the creative team and energetically conduct political work prior to all other work. It is only then that he can satisfactorily perform his role as artistic leader, production organizer and ideological educator and become a distinguished commander of the creative group.

8

ARCHIVES, MUSEUMS, FESTIVALS, AND CINEMATHEQUES

Publicly and privately funded institutions, film archives, museums, film festivals, and cinematheques hold quite a different status, in regard to the manifestos written on their behalf, than do those of solitary artists or groups of artists. Yet because of the cinema's fairly recent emergence, its status as both art and popular entertainment, and the rise of neoliberalism in the last third of the twentieth century, these institutions have often been attacked by state funding agencies, governments, and artists who feel they are not fulfilling their mandate. In the series of manifestos that follow, we see that the role of these institutions and the function they play in society is under continuous scrutiny. The manifestos in this chapter can therefore be broadly defined as being one of two kinds: manifestos written by organizations and manifestos written on behalf of organizations.

Unlike manifestos covering other aspects of cinema in this book, the film archive manifestos demonstrate a surprising level of continuity from the first archive manifesto (and indeed the earliest manifesto in the book) from 1898 on through to the archive manifestos that address the current state of film preservation. If Bolesław Matuszewski's "A New Source of History" proclaims that the emerging art of the cinema must be preserved because of its specific powers of documenting the world, subsequent manifestos foreground the fact that the worlds documented by the cinema are in many cases slipping away because of a lack of archives and archival space, the instability of film stock, the apathy of governments, and the digital revolution. For instance, Hye Bossin's "Plea for a Canadian Film Archive" makes the nationalist case, arguing that the fragile nature of the Canadian film industry necessitates an archive because of the dispersed and often marginal nature of Canadian film production. In every other manifesto, an argument is made for the necessity of preserving film for historical, cultural, national, and political reasons in the face of, at best, benign neglect. These manifestos thereby articulate the weight of history placed on the shoulders of cinema during the last century, namely as a privileged and universal—or cursed Borgesian—archive or motivator of action.

Many of the manifestos on film archives directly or indirectly address, in one way or another, the philosophical battle that took place between Henri Langlois, cofounder and director of the Cinémathèque française, and Ernest Lindgren, curator of the National Film Archive at the British Film Institute from 1935 to 1973. To frame the debates around film archiving manifestos, it serves us well to look at this dispute in some detail. Langlois championed the screening and collecting of all films, without judgment. Screening of all films was crucial because if films weren't shown, then preserving them was, in his eyes, useless. To this end he became an unsurpassed champion/defender of the cinema to a degree that even filmmakers could not attain. One of the key functions of archives, at least in the Langlois school of thought, is the catholic nature of their collections, and the

ability to see the diversity of cinema in all its manifestations. Limits are placed on cineastes to which archivists are not subjected. There are many reasons for this, and as François Truffaut notes, cineastes are not the best keepers of film history: "When one becomes a filmmaker after having been a *cinéphile,* the number of specific problems to be solved makes one forget one's admirations and obliges one to create all sorts of personal laws, which soon become so constraining that the filmmaker loses all freshness when confronted with the work of colleagues who have forged other laws and carried them through."[1] Ernest Lindgren, in contrast, was perhaps stereotyped in the image of the traditional British civil servant. He believed in closely selecting the films that archives collected and chose for preservation. Unlike Langlois, he could be seen as a gatekeeper. These two tendencies in archiving—programming versus preservation—still hold today and were at the center of a storm that brewed around film archiving in the 1960s. Indeed, one of the most famous incidents in the history of film archives is *l'affaire Langlois,* where the Gaullist state, through the actions of André Malraux, attempted to oust Langlois from the Cinémathèque française in the spring of 1968.

This development was a long time brewing. A year and a half before *l'affaire Langlois,* Jean-Luc Godard, in what could be described both as a manifesto on Langlois's importance and an indicator of the storm clouds brewing, noted:

> The whole world, as you know, envies us this museum. It is not in New York that one can learn how Sternberg invented studio lighting the better to reveal to the world the woman he loved. It is not in Moscow that one can follow the sad Mexican epic of Sergei Eisenstein. It is here. . . .
>
> [Langlois] is grudged the price of a few prints, whose incredible luminosity will shortly astonish you. He is reproved over his choice of laboratory, whereas no one would dream of haggling over the colours used by the artists of the Ecole de Paris when they repaint the ceiling of the Opéra.[2]

Langlois was known as a great programmer of films and taught the history of the cinema through his screenings to the generation of filmmakers who would become the French *nouvelle vague.* However, because he channeled almost all his funding toward screenings and his *Musée du cinéma,* preservation fell very much by the wayside. For these reasons, and because no one, including the French government that was funding him, knew exactly *what* films he had, the government moved to put in place a bureaucrat named Pierre Barbin to oversee the Cinémathèque. This ouster led to a series of protests that foreshadowed the events of May '68 (indeed Daniel Cohn-Bendit, one of the main agitators during the May '68 uprising, was present at the protests at the Cinémathèque). During the protests tracts were distributed that anticipated the Situationist ones of May '68. One written by Truffaut proclaimed: "Don't go to the Cinémathèque. Let it become an imaginary museum until Langlois's return."[3] Another tract from the "Children of the Cinémathèque" read:

Using bureaucratic pretexts, the worst enemies of culture have recaptured this bastion of liberty.

Don't stand there and let them get away with it. Freedom is taken, not received. All those who love the cinema, in France and throughout the world, are with you and with Henri Langlois.[4]

Although Langlois was eventually reinstalled as a result of the protests (and because behind the scenes, the American studios threatened to pull all their films if Langlois was let go), this battle threw into relief the differing philosophies of film archiving. Lindgren himself was angered and taken aback by the uncritical press coverage of Langlois in 1968. He wrote an unpublished letter (held in his papers at the BFI) that he was going to send to the *Listener* but that he, perhaps wisely, as Penelope Houston notes, refrained from sending. Houston suggests that the letter constitutes a manifesto of its own: "The collection amounted, Lindgren said, to about 7,000 reels of film in excellent condition—those that were in more or less regular use for screenings. There were reckoned to be some 200,000 reels in storage elsewhere, acetate and nitrate indiscriminately jumbled together, of which only some 20 per cent was believed to be in good shape. 'If more detailed examination confirms this analysis, the Cinémathèque under Langlois will not have been a saviour of the cinema's heritage . . . but one of its most massive destroyers.'"[5] Lindgren believed that because of Langlois's shoddy preservation techniques, and the negligence he demonstrated toward film preservation, the perception of him as the savior of cinema was utterly groundless. Lindgren, like many other traditional preservationists, also felt angry about living in the shadow of the myth of Langlois. In recent years (this myth having faded to some degree after Langlois's death in 1977) the philosophy of Lindgren has grown greatly in stature and in many ways represents the ethos of contemporary film archives. This can be seen in the final manifesto in this chapter, by archivist Paolo Cherchi Usai. "The Lindgren Manifesto" places the question of film preservation into larger cultural and political contexts, foregrounding the way in which, under contemporary capitalism and neoliberalism, the saving of films is often very far down on the list of government priorities. Despite these acrimonious debates, each of the manifestos contained herein functions as a plea to save the cinema's past and, in so doing, the record of the world, documented through moving images, as it once was.

A NEW SOURCE OF HISTORY: THE CREATION OF A DEPOSITORY FOR HISTORICAL CINEMATOGRAPHY
(Poland/France, 1898)

Bolesław Matuszewski

[First published in French as *Une nouvelle source de l'histoire* (Paris: Imprimerie Noizette et Cie, 1898). First published in English in *Film History* 7, no. 3 (1995): 222–224.]

The oldest film manifesto in this book, and probably the first, Bolesław Matuszewski's manifesto arguing for the creation of a film archive is prescient in the way it postulates the role to be played by cinema as a historical document. The manifesto is all the more impressive as it is written three short years after the invention of cinema in France by the Lumière brothers.

It would be a mistake to believe that all the categories of *representational documents* which come to the aid of History have a place in Museums and Libraries. Unlike medallions, illuminated pottery, sculpture, etc., which are collected and classified, photography, for example, has no special department. To speak the truth, the documents it provides are rarely of a clearly historical nature, and above all, there are too many of them! Still, one day or another, someone will classify all the portraits of men who have had a marked influence on the life of their times. However, by then that will only be backtracking, and from now on the issue is to go forward in this direction; and official circles have already welcomed the idea of creating in Paris a Cinematographic Museum or Depository.

This collection, of necessity limited to begin with, would grow as the interest of cinematographic photographers moves from purely recreational or fantastic subjects toward actions and events of documentary interest; from the slice of life as human interest to the slice of life as the cross-section of a nation and a people. Animated photography will then have changed from a simple pastime to an agreeable method of studying the past; or rather, since it permits seeing the past directly, it will eliminate, at least at certain important points, the need for investigation and study.

In addition it could become a singularly effective teaching method. How many vague descriptions we will abandon the day a class can watch, projected in precise and moving

images, the calm or troubled faces of a deliberating assembly, the meeting of chiefs of state ready to sign an alliance, the departure of troops and squadrons, or even the mobile and changing physiognomy of cities! But it may be a long time before we can draw upon this auxiliary source for teaching history. First we must accumulate these exterior manifestations of history so later they can be unfolded before the eyes of those who did not witness them.

One problem may trouble our thinking an instant—for the historic event does not always take place where it is expected. History is far from being composed uniquely of planned ceremonies, organized in advance and ready to pose for the cameras. There are the beginnings of action, initial movements, unexpected events which elude the camera exactly as they escape the news agencies.

No doubt the effects of history are always easier to seize than the causes. But one thing makes another clearer; these effects, fully brought to light by the cinema, will provide clear insights into causes which heretofore have remained in semi-obscurity. And to lay hands not on everything that exists but on everything that can be grasped is already an excellent achievement for any source of information, scientific or historic. Even oral accounts and written documents do not give us the complete course of the events they describe, but nevertheless History exists, true after all, in the larger spectrum even if its details are often distorted. And then the cinematographic photographer is indiscreet by profession; on the lookout for any opening, his instinct will often make him guess where things are going to happen that later become historic causes. He is more likely to be criticized for his excess of zeal than lamented for his timidity! Natural curiosity or the lure of profit, and often a combination of the two make him inventive and bold. Authorized to appear at somewhat ceremonious functions, he will rack his brains to insinuate himself without authority into others, and most of the time he will know how to find the occasions and places where tomorrow's history is about to develop. He is not the sort to be frightened by a movement of the people or the beginnings of a riot, and even in a war it isn't hard to imagine him bracing his camera against the same epaulements as the first-line guns, and catching at least part of the action. He'll slip in wherever the sun touches. . . . If only for the First Empire and the Revolution, to choose examples, we could reproduce the scenes which animated photography easily brings back to life, we could have resolved some perhaps accessory but nonetheless perplexing questions, and saved floods of useless ink!

Thus this cinematographic print in which a scene is made up of a thousand images, and which, unreeled between a focused light source and a white sheet makes the dead and the absent stand up and walk, this simple band of printed celluloid constitutes not only a proof of history but a fragment of history itself, and a history which has not grown faint, which does not need a genius to resuscitate it. It is there, barely asleep, and like those elementary organisms which after years of dormancy are revitalized by a bit of warmth and humidity, in order to reawaken and relive the hours of the past, it only needs a little light projected through a lens into the heart of darkness!

The cinematographer does not record the whole of history perhaps, but at least that part he gives us is uncontestable and of absolute truth. Ordinary photography can be retouched, even to the point of transformation. But just try to make identical changes on a thousand or twelve-hundred microscopic images! It can be said that intrinsic to animated photography is an authenticity, exactitude and precision which belong to it alone. It is the epitome of the truthful and infallible eye-witness. It can verify verbal testimony, and if human witnesses contradict each other about an event, it can resolve the disagreement by silencing the one it belies.

Imagine a military or naval manoeuvre whose phases have been collected on film by a cinematographer: any debate can be rapidly brought to a close, . . . he can establish with mathematical precision the distances separating places in the scenes he has photographed. Generally he has clear indications to back up his attestation of the time of day, season and climatic conditions surrounding the event. Even what escapes the naked eye, the imperceptible progress of things in motion, is seized by the lens at the distant horizon and followed up to the foreground. Ideally, other historic documents should possess the same degree of certainty and clarity.

The issue now is to give this perhaps privileged source of historical evidence the same authority, official existence and accessibility as other already well established archives. It is being arranged at the highest echelons of the government, and in addition the ways and means do not seem so difficult to find. It will be sufficient to give the cinematographic proofs of historical nature a section in a museum, a shelf in a library or a cupboard in the archives. Their official depository will be at the Bibliothèque Nationale, the library of the Institut de France, under the care of one of the Academies concerned with History, in the Archives Nationales, or even in the Musée de Versailles. It's merely a question of choosing and deciding. Once it is established, there will be no lack of endowments as gifts or even motivated by financial interest. The price of cinematographic projection equipment, like reels of film themselves, very high at the outset, is diminishing rapidly and falling within the reach of mere amateurs of photography. Many of them, not even including the professionals, are beginning to be interested in the cinematographic applications of this art, and ask nothing better than to contribute to the constitution of History. Those who do not bring their collections themselves will leave them freely as a legacy. A competent committee will accept or reject the proposed documents according to their historic value. The negative reels it accepts will be sealed into marked, catalogued cases. They will be the prototypes which will not be touched. The same committee will decide the conditions under which positive copies may be lent out, and will put on reserve those which for special reasons of propriety can only be released to the public after a certain number of years. The same is done for certain public records. A curator of the chosen establishment will care for the originally limited new collection, and an institution of the future will be founded. Paris will have its Depository of *Historical Cinematography*.

The creation of this foundation is indispensable and will sooner or later come to pass in some great European city. I should like to contribute to its establishment here in Paris

where I have been welcomed with such easy good grace. And at this point I modestly request to enter the picture.

As the photographer of the Emperor of Russia, and on his express orders, I have been able to catch a cinematographer's-eye view of, among other curious tableaux, the important scenes and intimate incidents of the visit made by the President of the French Republic to St. Petersburg in September 1897.

These shots, which the initiative of such a high authority permitted me to take, were projected before his very eyes, after which I was able, for some sixty consecutive showings, to offer the same spectacle to the soldiers in Parisian military bases. I was surprised and charmed by the effect they produced on these simple souls to whom I had the opportunity to show the physiognomy of a foreign land and its people, the concept of ceremonies so foreign to them, in short, the manifestations of a great nation.

I offer this not uninteresting series of cinematographic exposures as the basis for the establishment of the new Museum. I have had the good fortune to take films of persons of considerable importance, and with their support perhaps I will be able to see these archives of a new genre founded in Paris.

I have described why I augur a rapid and easy development for this depository. I shall contribute to it myself. In addition to the scenes I have mentioned, I already have a great many others to my credit: the coronation of His Majesty Nicolas II, the Russian visits of the two other emperors, and the Jubilee of Queen Victoria of England. Most recently I was able to photograph in Paris parts of completely unexpected and compelling events. I propose to collect throughout Europe reproductions of all scenes which would seem to me to be of historic interest, and to send them to the future Depository.

My example will be imitated . . . if you are only so good as to encourage this simple but new idea, making suggestions of your own to improve it, and above all giving it the wide publicity it needs to thrive and be fruitful.

THE FILM PRAYER (USA, c. 1920)

A. P. Hollis

[First distributed in film canisters starting circa 1920.]

Written in 1920 as a cautionary note to film projectionists, this manifesto had a worldwide circulation inside film canisters and was reprinted widely in trade journals and film catalogues, most notably in Eastman Kodak's. The "Prayer" was still in circulation in the 1950s in Crawley Films film canisters. This is the only manifesto written from film stock's point of view.

I AM FILM, not steel; O user, have mercy. I front dangers whenever I travel the whirling wheels of mechanism. Over the sprocket wheels, held tight by the idlers, I am forced by the motor's magic might. If a careless hand misthreads me, I have no alternative but to go to my death. If the pull on the takeup reel is too violent, I am torn to shreds. If dirt collects in the aperture, my film of beauty is streaked and marred, and I must face my beholders—a thing ashamed and bespoiled. Please, if I break, NEVER fasten me with pins which lacerate the fingers of my inspectors.

I travel many miles in tin cans. I am tossed on heavy trucks, sideways and upside down. Please see that my first few coils do not slip loose in my shipping case, and become bruised and wounded beyond my power to heal. Put me in my own can. Scrape off all old labels on my shipping case so I will not go astray.

Speed me on my way. Others are waiting to see me. THE NEXT DAY IS THE LAST DAY I SHOULD BE HELD. Have a heart for the other fellow who is waiting, and for my owner who will get the blame.

I am a delicate ribbon of film—misuse me and I disappoint thousands; cherish me, and I delight and instruct the world.

THE FILM SOCIETY (UK, 1925)

Iris Barry

[First published in the *Spectator* (UK), July 1925.]

Film critic and future cofounder of the Museum of Modern Art's Film Library, Iris Barry was highly active in the London film scene in the 1920s, writing extensively on film for the London newspaper the *Spectator*. Here Barry announces the founding of the Film Society, and, in so doing, writes a manifesto clarifying its goals and arguing for its cultural importance.

The Film Society has been founded in the belief that there are in this country a large number of people who regard the cinema with the liveliest interest, and who would welcome an opportunity seldom afforded the general public of witnessing films of intrinsic merit, whether new or old.

It is felt to be of the utmost importance that films of the type proposed should be available to the Press, and to the film trade itself, including present and (what is more important) future British film producers, editors, cameramen, titling experts and actors. For, although such intelligent films as *Nju* or *The Last Laugh* may not be what is desired by the greatest number of people, yet there can be no question but that they embody certain improvements in technique that are as essential to commercial as they are to experimental cinematography.

It is important that films of this type should not only be shown under the best conditions to the most actively minded people both inside and outside the film world, but that they should, from time to time, be revived. This will be done. In this way standards of taste and of executive ability may be raised and a critical tradition established. This cannot but affect future production, by founding a clearing-house for all films having pretensions to sincerity.

FILMLIGA MANIFESTO
(The Netherlands, 1927)

Joris Ivens *(Technical Advisor)*, Henrik Scholte *(Chairman)*, Men'no Ter Bbaak *(Secr. Treasurer)*, Hans Ivens *(Secretary)*, Charlie Toorop, L. J. Jordan, Cees Laseur, Hans Van Meerten, Ed Pelster *(Technical Advisor)*

[First published in Dutch in *Filmliga* 1 (1927). Translated into English in Joris Ivens, *The Camera and I* (New York: International Publishers, 1969), 21–22.]

The "Filmliga Manifesto" demonstrates the rise in interest in a number of film societies in Europe that decried the state of commercial cinema and called for a return to the European avant-garde traditions of the cinema. The aforementioned London Film Society had many of the same goals, as did *Studio des Ursulines* in Paris, mentioned in this manifesto and still operating today.

Die Nibelungen, The Big Parade, Potemkin, Mother, Meniemontant, Variete.

FILM IS AT STAKE

Once in a hundred times we see film, the rest of the time we see movies.

The herd, commercial cliches, America, *Kitsch*.

In this arena films and movies are natural opponents. We believe in the pure autonomous film. The future of film as art is doomed if we do not take the matter into our own hands.

This is what we intend to do.

We want to see the experimental work produced in the French, German and Russian avant garde ateliers. We want to work towards film criticism that is in itself original, constructive and independent.

We have therefore founded

FILMLIGA AMSTERDAM

For the purpose of showing to limited audiences those films one does not see in the movie theatres or which one discovers only by accident.

We have one advantage: good films are not expensive, for the very reason that they are not in demand. Good films lie profitless in the vaults of Paris and Berlin. We will buy these.

During the 1927–28 season we will present in Amsterdam:

12 SUNDAY MATINEES

Each matinee will include the first showing in the Netherlands of a new feature-length film for those people genuinely interested in film. Following the example of the Studio des Ursulines in Paris, we will revive such old films of Asta Nielsen and Charlie Chaplin, which have unfortunately disappeared, alongside *à la Querschnitt* [i.e., potpourri] films.

These will be shown in a hall to be selected later. In case this is not possible we are making arrangements for the use of a small theatre in the city. Outstanding technical advisors will assist in arranging our programs. If you believe in the film of tomorrow and if you are bored with available programs, then join us, all you need do is fill out the attached form. We ask you to contribute

EIGHT GULDEN

(Which may be paid in two installments), which means sixty-five cents for each matinee, less than the usual price of a movie matinee.

On the next page is a tentative list of the films we plan to show. Let us hear your choice. This will determine the final selection and help us to progress.

STATEMENT OF PURPOSES (USA, 1948)

Amos Vogel, Cinema 16

[One-sheet first distributed to Cinema 16 members and potential members in 1948.]

This statement was used to solicit members for Amos Vogel's groundbreaking film society Cinema 16 (1947–1963). The statement highlights Vogel's interest in screening and bringing to light cinematic detritus, a very different goal from that of institutions like MoMA. An early pioneer in screening American experimental cinema, Vogel was quite catholic in his tastes and did not delineate an absolutist line between experimental work and other forms of marginal cinema, screening documentaries and industrial and scientific films alongside experimental cinema.

CINEMA 16 is a cultural, non-profit organization devoted to the presentation of outstanding 16mm documentary, educational, scientific and experimental films.

CINEMA 16 endeavours to serve a double purpose. By its screening of superior and avant-garde films, it will contribute to the growing appreciation of film as one of the most powerful art forms. By its screening of documentary as well as scientific and educational pictures, it will provide its audience with a more mature realization of the nature of this world and of its manifold problems.

The complexities of industrial society, the contraction of the world into an interdependent whole, the advance of modern science and technique impel modern man toward greater knowledge and a more profound understanding of his world.

It is to the credit of the documentary film makers that they have attempted to provide this knowledge and understanding. Together with the scientific, educational and experimental producers, they have given us a comprehensive and multi-colored interpretation of life. Unadorned and free of Hollywood tinsel, they have recreated the stark reality, the poignancy, the brutality of life. By their cinematic dissemination of knowledge about other cultures and peoples, as well as topical social problems, they have aimed at greater international and interracial understanding and tolerance.

Yet their creations are gathering dust on film library shelves, where a vast potential audience—numbering in the millions—can never see them. Shall this audience continue unaware of these hundreds of thought-provoking, artistically-satisfying and socially purposeful films?

It is the aim of CINEMA 16 to bring together this audience and these films. CINEMA 16 will thereby advance the appreciation of the motion picture not merely as an art, but as a powerful social force.

SPECIFICALLY:

1. CINEMA 16 will screen at regular intervals outstanding documentaries, factual and sociological films. It will present the classics of a Flaherty, Grierson, Ivens

and Cavalcanti as well as newest releases dealing with the life of man, be he a Navajo Indian, a Southern sharecropper, a Trappist monk or a "displaced" human being.

2. CINEMA 16 will screen superior educational and scientific films, hitherto made use of only by schools and the medical profession. It will show films dealing with psychology and psychiatry, biology and chemistry, art appreciation and literature. It will present newest releases in micro-photography as well as such classics as Professor Pavlov's film on conditional reflexes.

3. CINEMA 16 will screen the best in experimental and avant-garde films. It will show expressionist, surrealist and abstract films, presenting such pioneers as Fernand Leger, Man Ray, Watson-Webber, Maya Deren.

4. CINEMA 16 will encourage the production of new amateur and professional documentary and experimental films. First, it will provide an audience for new releases of special interest by both exhibiting and distribution. Secondly, by sponsoring film contests, it will provide recognition to individual film producers. Thirdly, by purchases and rentals of prints, by establishing regular booking circuits in various cities for films of this type, it will provide funds for amateur and professional producers to help them carry on their work.

5. CINEMA 16 will invite well-known directors, producers and cinematographers to lecture before its audiences and to participate with them in forums on motion picture appreciation and technique.

6. CINEMA 16 will at all times encourage the presentation of foreign masterpieces of the documentary and experimental screen. The American public must be made aware of the truly international aspects of the fact and art film movement.

7. The final goal of CINEMA 16 is the creation of permanent "CINEMA 16" movie houses in the major cities of the nation, in which the documentary and experimental film will for the first time find a proud home of its own. The existence of such theatres in England and France testifies to the feasibility of this plan.

CINEMA 16 is determined to bridge the gap which exists between documentary film production and the people. By bringing purposeful films to the general public, film groups, labor unions and schools, CINEMA 16 will contribute to a greater realization of the problems facing man in the atomic age.

THE IMPORTANCE OF FILM ARCHIVES
(UK, 1948)

Ernest Lindgren

[First published in *Penguin Film Review* 5 (1948): 47–52.]

Ernest Lindgren was curator of the National Film Archive at the British Film Institute from 1935 until his death in 1973. In many ways he was the antithesis of the Cinémathèque française curator Henri Langlois; where Langlois wanted to save every film possible, collecting them to the point of not being able to preserve them, Lindgren was more selective and meticulous in his acquisitions. In this manifesto Lindgren outlines his vision of the Utopian film archive.

The film is a new kind of historical record; the film is a new art form. True; but unless the records are kept, history will gain nothing; and unless technicians and the film-going public have the opportunity to study the finest film works of the past, and the cinema is able to acquire something in the nature of a tradition, it will be seriously limited in its development as an art. These are the justifications for a film archive.

A film archive, properly speaking, can never be anything but a national concern; commercial films seldom come into private hands, and in any case, the preservation of film requires facilities which are normally beyond private resources. Unfortunately, national action is nearly always tardy, and perhaps that is why the national film archive movement is barely a dozen years old. In 1935 the British Film Institute decided to form its National Film Library; at almost precisely the same time the Museum of Modern Art Film Library in New York was started by John Abbott and Iris Barry, and a few months later Henri Langlois was launching the Cinémathèque Française in Paris. Today there are national archives of one kind or another in Belgium, Canada, Czechoslovakia, Holland, Italy, Norway, Poland, Sweden, Switzerland and the U.S.S.R.

The word "archive" rings with a deathly sound in the world of the cinema, which is so young, vital and dynamic, eager for the future and impatient of the past; but there is no reason why a film archive should be a mausoleum. Perhaps the most direct and graphic way for me to describe the functions of a film archive is to present the picture of the future of our own National Film Library which I always cherish in the back of my mind, the Utopian ideal which I cling to in face of the shortages of money accommodation and staff which at present make its realisation impossible.

Through one side of the vestibule of a large and attractive building in the heart of the metropolis, one passes into an exhibition hall occupying an area of some 3,000 square feet. The exhibits illustrate every aspect of film production and film history. There are frames of stills from all the best-known productions of all countries, a representative collection of the designs of the finest art directors, models of studios and of film sets,

specimens of posters of all countries and periods, a collection of apparatus dating back to the earliest types, and specially designed wall-charts to explain the processes of production and distribution. The production of animated cartoons, scientific films and the like are demonstrated, and in the centre of the hall there is a special exhibit devoted to some current film of interest—a *Henry V* or an *Overlanders*.

Attached to the exhibition hall, and accessible through it, is a small cinema of some 500 seats, attractively designed and representing the last word in comfort. Here a programme of film classics is shown three times a day; the programme is changed once every week, and although each programme or group of programmes is self contained and illustrates some such topic as *The Foundations of Modern Technique*, *The Realist Trend in the British Film*, *The Comedy of Chaplin* or *Films of Travel and Exploration*, they are so arranged that in the course of a year the whole history of the cinema, silent and sound, in all countries is effectively surveyed. There is a modest charge to the public for admission to the exhibition hall and cinema combined, but *bona fide* students are in certain circumstances admitted at a reduced fee, and certain of the film programmes are reserved for students only.

Returning to the vestibule, we can make our way to other parts of the building. There is a well-equipped book library and reading-room where the student can work. There is a large library of stills numbering many thousands, suitably arranged and indexed, for the use of the student, the author, the journalist, the lecturer and the compiler of film-strips and exhibitions. The originals never leave the Library, but in an adjacent photographic-room copies can be made in an hour or two, and are supplied at cost. There is a large and representative store of film scripts, and virtually all the scripts of British films, and the most important foreign ones, are kept here and may be consulted. The Library also has a music department, where important film-music scores are kept, either originals or photostat copies; here also is a collection of discs of recorded film music, commercial or private, which the student can play in a sound-proof cubicle adjoining. Elsewhere in the building are other cubicles where individual students with suitable credentials may examine films, either on a 16-mm. projector, or on a viewing apparatus of the Moviola type. Finally, there is a small lecture hall, with accommodation for some 200 people, where public lectures on various aspects of the film are given from time to time.

Quite as important as the facilities provided for the public on the Library premises, however, are the services which it can distribute abroad. In order to see the Portland Vase, one must perforce visit the British Museum; but in the case of a film, it is not the copy itself which is of interest so much as what is seen on the screen. Contrary to general museum practice, therefore, the film archive need not restrict its benefits to those able to visit the archive building, but by the circulation of film prints can extend them to all parts of the country (and even, in our own case, beyond, to the Dominions and Colonies of the Commonwealth).

One of the most active departments of my Utopian National Film Library, therefore, is its Lending Section. It contains 35-mm. and 16-mm. prints of all the most important

films in the history of the cinema, from the earliest films of the Lumière brothers to the latest masterpiece withdrawn from commercial circulation: it also has extracts from important films, prepared for the use of lecturers, composite films illustrating particular developments and periods and styles of production, and instructional films on film technique and methods of production; last but not perhaps least, it has a collection of film strips for the use of lecturers. All this material is supplied at reasonable rates of hire to schools, museums, libraries, universities and film societies. The service, in short, is essentially non-commercial and educational. It is available only to those who are enrolled members of a recognised educational group or society.

The Library also has an exhibitions department where traveling exhibitions of stills, wall-charts, art designs, posters and models are prepared for circulation to museums, art galleries and libraries. Each exhibition may be on show at any particular place for anything from a week to a month, and usually an officer is also sent with it to arrange the exhibition, to show parties round, to give public lectures and to show relevant 16-mm. films from the Library. The organisation concerned pays a weekly rental fee which largely covers the cost of the exhibition and its display.

All these are the public services which this ideal archive would perform, but we have still said nothing of the fundamental archive activity on which all this is based, namely, the permanent preservation of films. Film is one of the most ephemeral and perishable materials imaginable. It is bulky and expensive to store, so that film companies junk every copy the moment it has ceased to have any considerable commercial value. Moreover, standard cinematograph film, employing a nitro-cellulose support, is not only highly inflammable, but within a comparatively short time (possibly between fifty and a hundred years) it is liable to become unstable and disintegrate; if kept under unsuitable conditions it will do so much sooner. The chief function of the film archive, therefore, is to acquire copies of historically valuable films and to preserve them in perpetuity by storing them under the best possible conditions.

Films are chosen for preservation by a selection committee. Current commercial films selected are deposited with the archive, as books are deposited with the British Museum Library, under the terms of the Copyright Act. Private films are acquired by gift or purchase. Many films are obtained from archives abroad, either by exchange or purchase.

The copies thus received are never used for projection: for this purpose dupe prints must be made. The originals are treated as master prints, and are kept in specially constructed storage vaults erected on a country site of several acres. The temperature and humidity in the vaults are carefully controlled, and the films are subjected to chemical tests at regular intervals to check their condition. When a print appears unstable under test, a new copy must be made, and this in its turn is preserved. This new copy is made on cellulose acetate stock, which is far more stable than celluloid and also non inflammable. In ten or fifty years' time the scientists may have found an even more durable substitute.

It is useless, of course, to have a vast quantity of film unless a particular film, or even a particular section of a film, can be readily identified and found. Beside the testing laboratory at the vaults, therefore, stands the cataloguing room, where three or four trained assistants work through the archive's new acquisitions and catalogue and index them in detail.

This, or something like it, is the National Film Library of the future I like to imagine. How near or how far away it may be I dare not contemplate. A careful assessment of costs indicates that such a Library could be maintained for something less than £50,000 a year, which is roughly a quarter the cost of the British Museum, a third of the cost of the Natural History Museum and a half that of the Science Museum. The benefits it would confer on the public, the student, the apprentice film technician and the film industry (depending so entirely as it does on public interest) are incalculable. The important thing about my idealistic picture for our present purpose, however, is that it represents a goal for which all the national film archives are striving, and towards which they have all begun to move in varying degree. In the United States the Museum of Modern Art Film Library has a theatre in which a great range of film programmes are shown to the public; it runs a well-stocked circulating library of film appreciation programmes for American colleges and universities, and it selects the current films which are to be deposited with the Library of Congress under American copyright law. Here in Great Britain we have as yet no cinema, and our Lending Section is extremely small; on the other hand, we have devoted a great deal of attention to the technique of preservation, and our film vaults and our system of chemical tests are the envy of many other archives. In France and Czechoslovakia, there appears to be a lack of adequate storage facilities, but the Cinémathèque Française and the Czech Film Archive are extremely active in organising both displays of films and exhibitions. The Czech exhibition on *Fifty Years of Cinema,* which showed first in Prague, and afterwards in Brno and Bratislava, was probably the finest of its kind which has been assembled anywhere. So one could continue through the rest in turn. Each of us, inadequately equipped and financed, is tackling some part of the whole, but never quite the whole; some are only at the beginning. The war has helped none of us, and post-war conditions are scarcely more favourable. Yet the archive movement will grow, and the existing archives themselves will grow, because they are all manned by small groups of enthusiasts who carry the picture of an ideal archive in their minds, and believe that it is worth working for in foul weather or in fair.

Much of the strength of the national archive movement lies in the ability of the national archives to co-operate with each other, to exchange films, museum material and information, and for this purpose they have combined to form an International Federation which has its headquarters in Paris. The post-war conference of the Federation was held last July, and although it is still in the formative stage and has numerous difficulties to surmount, its members have the highest hopes for its future.

A PLEA FOR A CANADIAN FILM ARCHIVE (Canada, 1949)

Hye Bossin

[First published in *Canadian Film Weekly*, 26 January 1949, 9.]

In this manifesto Hye Bossin, the editor of the trade journal *Canadian Film Weekly* (1941–1970), argues that a Canadian film archive is needed to preserve Canadian film heritage, an idea that was developing in many "small" countries at the time.

Canada, even though it has the largest and most successful documentary organisation in the world as a government agency, has yet no film archives.[6] Yet there are many Canadian films dating back to the early 1900s. Some were made by government departments, others were shot for the CPR by Guy Bradford, a cameraman imported from England.[7] They show pictures of life in another day. Then there are film records of sporting events involving Canadian champions; feature films made before and after World War I in various parts of the Dominion. There are the early newsreels made by Ernest Ouimet of Montreal.[8] If some effort is not made to gather these soon they may be lost forever. If searched out now they could provide the basis for a library which could be enlarged by the films of Canadian life which have been made by the National Film Board and others.

A Canadian Film Archive in Ottawa is one of the aims of the Toronto Film Study Group (prospectively the Toronto branch of the National Film Society) which is headed by Gerald Pratley, CBC writer. The purpose of the Canadian Film Archive will be "to trace, catalogue, assemble, exhibit and circulate a library of film programmes so that the motion picture may be studied and enjoyed as any other of the arts is studied and enjoyed."

This worthy desire to create a Canadian film library equivalent to those of the New York Museum of Modern Art and the British Film Institute should be supported but the first need is a government depository of early pictures of our country.

Another example of the lack of interest in Canadian motion picture industry background is that virtually no history of biography of a local or national nature is to be found in the Toronto Reference Library, probably the largest English language reference library in Canada. Recently this publication offered the library copies of historical and biographical articles which appeared in it during the past eight years. These were welcomed by the Chief Librarian, C. R. Sanderson, and will be placed in scrapbooks.

Canadian industry folk, like their British colleagues, could provide the same type of material from which the History Committee of their Institute worked in preparing material for its book. The Canadian Picture Pioneers, a national organisation, already has

much material in its archives. Perhaps it is that organisation which should see that some of it, in acceptable form, finds its way into reference libraries or print.

Even now, when Canada has just begun the march towards its great destiny, it is strange that such a powerful industry and art as the moving picture should be without historic records in places designed to house them. How ridiculous will it seem several generations from now?

OPEN LETTER TO FILM-MAKERS OF THE WORLD (USA, 1966)

Jonas Mekas

[First published in *Cinim* (UK) 1 (1966): 5–8.]

Written for *Cinim*, a short-lived journal published by the London Film-Makers' Co-op, Mekas's "Open Letter" proselytizes the New American Cinema and how its distribution practices can be deployed in the United Kingdom. Mekas condemns contemporary film festivals and their promotion of "new cinema," arguing in the process for radically new forms of film exhibition and distribution.

I would like to speak to you through this open letter. Although some specific feelings expressed may be personal, I'll be speaking in the name of the independent film-makers of America who have delegated me to do so. You don't often see us at film festivals. Very often, the "independent" American films that you see at Pesaro, at Oberhausen, or Mannheim have very little to do with what we are doing. There is a special festival-minded breed of film-makers, and you find them in every country, who will get their films into any festival, no matter how bad or indifferent their work is. Whereas some of our best film-makers, those who are doing really exciting work, cannot afford the festival prints of their films or, simply, aren't interested in film festivals. There is a feeling in the air that film festivals have become commercial and bureaucratic fairs at which we would feel very much out of place. Even the most advanced ones, like Pesaro, are working within the same commercial festival tradition; they do not truly reflect what's really going on in cinema. At least we know they do not represent or reflect the new American cinema. Yes, what about Pesaro? To select the new American films for the current festival, it delegated a French film critic to do it.

Now, this critic, no matter how much we respect him, doesn't know much about what's happening in America: his knowledge of American cinema comes from Paris releases and from film festivals. So we told him: we know best what we have, what's really happening new in our cinema, what would really be of interest for a festival of new cinema.

This year, for instance, we would have sent Stan Brakhage's *Songs*, Gregory Markopoulos' *Galaxie*, Harry Smith's *Heaven and Earth Magic*, Tony Conrad's *Flicker*, Andy Warhol's *My Hustler*, Bruce Baillie's *Quixote*. But the festival representative seemed to be very clear in his mind what kind of films he wanted. He had a very definite conception of what "new cinema" is or should be. He wanted something that already corresponded to that conception. He wanted more of "cinéma vérité," for instance. And he didn't even look at the truly NEW AND IMPORTANT WORK DONE IN AMERICA TODAY, the work that would have been a real discovery for the festival. And this happens with that festival whose main aim is to serve the CINEMA.

Or take the Cannes Film Festival. I was asked, this Spring, by the Festival to suggest what, if anything, there is that they should consider bringing to the *Semaine de la Critique*. I wrote to them approximately this: "When you ask about films suitable for the *Semaine de la Critique*, you still have in mind the same type of film you saw four years ago. I could suggest a few titles of that kind of cinema—but since our cinema has changed and is still changing, it would be wrong to help you to continue that dream. Yes, there are the other, and truly new films to take to Cannes. But what's the use even suggesting? What's the use telling you that Andy Warhol has taken Cinéma Vérité into completely new areas and has produced some of the most important contemporary cinema? Or Brakhage's *Songs*? Cannes wouldn't even consider 8mm films. Or Gerd Stern, or Robert Whitman, or Nam June Paik? They can't even be previewed! You still think in old terms. You still think that everything that is really good and new in American cinema can be packed up, wrapped up and shipped to you like any other movie, for previewing. This is no longer true. Very often, you have to bring the film-maker, and one or two technicians, and even equipment. For what they are doing, very often are film evenings, cinema evenings, but no films in the usual, conventional sense. These evenings, like some of the evenings of Gerd Stern (USCO), or Andy Warhol, or Jerry Joffen, or Stan Vanderbeek—with multiple projections and multiple sound systems, and with live participation, would shock Cannes into new visual, kinesthetic perceptions and into the cinema of the future. They would realize that there is truly new cinema, that something revolutionary is happening in cinema. Etc. I ended by suggesting six programs to take to Cannes. And what do you think happened? A representative of Cannes came to New York, looked at some familiar work, ignored whatever new and revolutionary was happening, ignored film-makers' suggestions, and went back to Paris, declaring to the Press, before leaving, that he has found no interesting work done here and that, therefore, the young American directors will not be represented at Cannes this year.

Dear colleagues, film-makers and film critics: the conception of film festivals must be changed. Bureaucracy has got to go. Film-makers should decide what should be shown; they know what's happening. Money should be used not for importing stars or for publicity but for paying for the prints of the films shown, for the shipping of films, or for importing film-makers, their technicians, their equipment (for inter-media shows). For instance, even if [the] Pesaro representative would have seen and liked *Songs* or *Galaxie*,

the film-makers wouldn't [*sic*] have afforded to make prints of these films for sending to the festival. Cinema is changing, but the film festivals have remained the same—that's what's wrong.

I went into the film festival aspect in more detail only to show that the new film-maker (and that goes for all countries) can not trust any commercial (or State; or one that is based on commercial tradition) film financing, film production, film distribution, film exhibition or film promotion set-ups and organizations. WE HAVE TO START EVERYTHING FROM SCRATCH, FROM THE BEGINNING. NO COMPROMISES, HOWEVER SMALL.

Five years ago, the young American film-makers got fed up with what we saw around. We started by abandoning all commercial illusions. We started from scratch. We did our work, no matter what distributors or film critics said. The new American cinema grew up like a child, from nothing, not even wanted. Our critics even say that, like children, we don't listen to our parents; we are irresponsible; we use dirty language; we masturbate; we are oversensitive; and other such things of young natural growth. There is much that they don't like about us; there is much that isn't mature or "perfect." We aren't even "beautiful" sometimes. Some of us have pimples on our faces. BUT WE REFUSE TO USE PLASTIC SURGERY TO CHANGE OUR FACES AND OUR SOULS INTO THE FACES AND SOULS YOU WOULD LIKE TO SEE. Take us as we are, or go your own way—we say. We keep seeing attacks and distortions of our work in French, German, Russian film periodicals—articles usually written by people who have seen only one or two of our films. We stopped bothering about them: we couldn't care less what they say, because we know that what we are doing is beautiful, is important, is changing the face of cinema around the world, is an expression of the changing times, is coming out of our hearts & out of the needs of our souls, and we have a great responsibility to continue that way, not to compromise it, not to betray it—and the dangers & the temptations are many.

Since all commercial film-distribution and film-financing organizations are set-up on a private business basis and not to help the film-maker to continue making films,—four years ago, the independent film-makers of America organized their own film distribution center, the Film-Makers' Cooperative, which is run by the film-makers themselves. We decided not to give our work to any of the commercial distributors. We developed a more human working system. We stuck together, we grew and expanded. Through the Cooperative, we increased our outlets ten-fold. We created a distribution circuit embracing colleges, universities, film societies, art theaters, art galleries and museums.

The circuit is still growing. By now we can make a film for $10,000 and get the money back with no great effort. Many of our films have been sponsored by the Coop, by advancing money from the coming rentals. At this moment we are setting up 100 theaters (friendly theaters) across the country for the distribution of our work. For this purpose a new division has just been created—the Film-Makers' Distribution Center, which will work in conjunction with the Coop. Fifteen theaters have already pledged to exhibit all our new work. This new set-up, in about a year from now, should make us free to increase our budgets—if the need arises—to $100,000 or even $200,000 with no great risks

involved and with no commercial distributor or investor dictating to us what we should or shouldn't do. To promote the idea of free cinema, of new cinema, and to assist some of our European colleagues, this October we are opening a branch of the Film-Makers' Cooperative in London. Arrangements are being made for a distribution center and for a theater, through which our work will be easily available and with little unnecessary shipping expenses to any place in Europe. Through this London center, we also hope that some of the European new cinema—the European Avant-garde cinema—will be able to reach New York.

We want to stress that the Film-Makers' Co-operative and the Center do not divide films into any budget, length, or subject categories. We take cinema as a whole. We are letting all film-makers know that any film-maker who has an extra print of his film (all prints at all times at the Coop and the Center remain the property of the film-maker) can send it to the New York or London branches of the Coop and the film will be distributed, no matter how much or how little it cost to make. We are not categorizing films. Each film at the Coop requires special treatment, each film has its own audience; each film has its own life. At this point, we would like to urge you—and I direct this Open Letter to the independent film-makers of the world, to anybody whose life is cinema, who is making and must make films—to create Film-Makers' Cooperatives of your own, in your own countries. There is no other visible solution. There is no other way of escaping the grip of the commercial set-ups. This net of international Coops could then exchange among themselves and help each other beyond the boundaries of their own countries. The boundaries are bound to disappear and very soon. With the changing times, with the new spirit in the air, with communications and speed increasing, it would be too bad if we were to delay action. We have to surround the earth with our films, lovingly, like with our hands. We have to abandon the commercial distribution methods. With whom are we competing? With ourselves? The film-makers should set up cooperative distribution centers, coops, and eliminate all the competitive and negative spirit that still pervades cinema. Let's not worry about the big commercial success and the audience of millions. If the health and freedom of our art needs it we should be willing to retreat to our own homes, to our friends' homes: cinema as a home movie. The art of cinema can not be created with money but with love; it can not be created by compromises but by purity of our attitude. Certain simple truths sound like preaching. But I don't mean to preach.

This is an expression of an attitude which I share with many other film-makers.

A note on the Financial Set-Up of the Film-Makers' Cooperative: The film-maker deposits his print with the Coop. That print is his membership card. During our yearly meeting, film-makers elect an advisory board of film-makers to supervise and to advise the running of the Coop. The film-maker remains the owner of all his prints. He can take them out whenever he wants to. No contracts of any kind are signed. Trust is the basis at the Coop. That's the first condition. Income: 75% of the rentals (from gross) goes to the film-maker, 25% goes to the Coop, to cover the running expenses, the shipping etc. The London branch, the rentals in Europe being much lower, will (at least for

the time being) operate on 50% to the Coop, 50% to the film-maker (from the gross) basis. The film-maker is allowed (and encouraged) to distribute the same film through other distributors—as long as the other distributor doesn't object to the Coop's distribution of the film and works on humanly acceptable terms. We have been trying to break up the monopolistic film distribution idea. It would be ridiculous to try to sell, for instance, a book through only one bookshop, or rent it thru only one library. But that is what we still find in film distribution. Films should be distributed through as many different distribution centers as possible. By this coming Christmas the Coop is placing film prints, on 16mm and 8mm for sale in bookshops, in record shops and in general stores. It is time that we revolutionize, bring up to date the methods of film distribution and exhibition. The prints of our films soon will be in every home, on the shelves, like books, so that one can pick them up and look at them whenever one feels like doing so. Film-makers of the world: let's do it now. Let's go home and start from there. Let us not waste time with any of the old-fashioned set-ups: they are not for us. They are ugly, sick leftovers of egoism and competition. They are from another world. They don't wish us any good. They drag us down. Let's spread the new vibrations of the spirit across the world and keep us growing and keep us in love.

Which brings me to my last point: the social engagement. There is all this talk going about our being irresponsible, about the new cinema (all over the world) being socially disengaged. Don't listen to that. We are the most deeply engaged cinema there is. When the film critics say that we are not reflecting the social realities, they mean we are not reflecting those social realities which THEY THINK ARE IMPORTANT and those are, usually, the realities (or aspects of reality) of yesterday, not today. Film critics and the public go by inertion [sic] carrying yesterday's engagements on their backs. Artists, when we are really creating from our hearts, we deal with the changing, new realities, new content of the spirit, and we say that we are closest to the pulse of man's heart, we know where it hurts him and what he needs and where he is going or should go. Let's not become weak, let's not give in to the blabber of the press, or film-distributors, or film critics, or politicians: we have to do what we have to do.

During the last two years, Film-Makers' Cooperative has sent Expositions of our work to various places of the world. We are watching what is happening in new cinema around the world. And often we are alarmed. Most of the time, what's called the New Cinema by *Cahiers du Cinéma* or *Cinema 66* we find is only another variant of the same old cinema. Beware: Dorian Grey is at large! Dorian Grey, the dandy of the supposed New Cinema, will die soon and you'll see his shriveled, dry, old body appearing slowly from under the beautiful make-up. Beware of film-critics: with their terms and categories they keep you tied down to certain established ideas of the "new." Film-makers: there is very little New Cinema at Pesaro, or Cannes, or Oberhausen, or Karlovy-Vary. Let's not fool ourselves. There will be little new cinema at any film festival unless the festivals change; change immediately and drastically and totally. The feeling is in the air, however, that things are beginning, will begin to move, are moving. Already, and the movement will increase in speed, until it

reaches the speed of light and sparks fire. The commercial, competitive empires are crumbling. Let's not even waste energy in fighting them, in kicking them: surely, they will fall by themselves. It is more important to do our own creative work, the work of building, no matter on what budget, on what size of film or how long a film; no matter whether film festivals or theaters will or will not show our work; no matter how many people will see it: we have to do it the way we feel it should be done when we really listen to ourselves, our deepest intuitions. That's the only way of doing it. That's what we (I) wanted to communicate to you. A few facts about ourselves, a few feelings, a few passions. And we hope you are with us. We are with you. There is really no distance between us.

A DECLARATION FROM THE COMMITTEE FOR THE DEFENSE OF *LA CINÉMATHÈQUE FRANÇAISE* (France, 1968)

Committee for the Defense of *La Cinémathèque française:* Jean Renoir, Alain Resnais, Henri Alekan, Jean-Luc Godard, Pierre Kast, Jacques Rivette, François Truffaut, Jacques Doniol-Valcroze, J.-G. Albicocco, Alexandre Astruc, Roland Barthes, Robert Benayoun, Claude Berri, Mag Modard, Robert Bresson, Marcel Brion, Philippe de Broca, Marcel Carné, Claude Chabrol, H. Chapier, Henri-Georges Clouzot, Philippe Labro, Jean-Paul le Chanois, Claude Lelouch, Claude Mauriac, Jean Rouch

[First published in *Cahiers du cinéma* 201 (1968). Translated by Scott MacKenzie.]

A call-to-arms published in *Cahiers du cinéma* to raise funds to defend Henri Langlois, the founder of the Cinémathèque française, who had just been ousted by André Malraux, DeGaulle's culture minister. Filmmakers from around the world blocked their films from being screened until Langlois was reinstated; the demonstrations outside the Cinémathèque in April 1968 in many ways set the stage for the events of May '68 in Paris.

The Committee for the Defense of la Cinémathèque française proposes: 1) the reestablishment of the normal functioning of la Cinémathèque française, 2) to take all actions to

respect the integrity of la Cinémathèque française and its liberty. The Committee will continue its activity beyond the reinstatement of Henri Langlois as Artistic and Technical Director, a reinstatement required by all the film profession and the spectators of la Cinémathèque française.

FILMMAKERS VERSUS THE MUSEUM OF MODERN ART (USA, 1969)

Hollis Frampton, Ken Jacobs, and Michael Snow

[First published in *Filmmakers Newsletter* 2, no. 7 (1969): 1–2.]

This letter, written to MoMA, speaks to the desire on the part of experimental filmmakers for MoMA not to function as a gatekeeper in regard to New American cinema and argues for the need of a true film museum that will preserve cinematic works for the future.

To the Public Hearings Committee Art Workers' Coalition

Gentlemen:

As filmmakers, we wish to bring to your attention the following points concerning the Museum of Modern Art as a whole, and its Film Department in particular:

1) The Museum's repeated assertion of its own "private" nature, in reply to a variety of requests from the art community on behalf of the whole community, is socially retrograde, reminiscent of 19th Century *laissez-faire* arguments. That private institutions used and supported by the public have public responsibilities is knowledge at least as old as the Sherman Act.

2) In view of its tax-exempt status as a nonprofit organization, the Museum is, like churches, quite obviously supported by the public. Therefore, like churches, it should limit its admission charge to a voluntary donation.

3) We support plastic and graphic artists in their demand that the Museum return to the terms of its 1947 agreement with the Whitney and Metropolitan Museums, whereunder work was to be sold after 20 years, the proceeds of such sales going to finance the purchase and exhibition of new works by living artists. However, we retain important reservations with respect to film. It is plain that the archival functions so admirably fulfilled thus far by the Film Dept. are in no way comparable to the formation of a permanent collection by the Fine Arts Dept., since the work of the former is to preserve for future circulation artifacts which run high risks in the present, while the

latter, in an attempt to eliminate present risks, tends to limit severely the availability of works or remove them from view entirely.

4) We demand the fullest possible autonomy for the Museum's Film Dept. consonant with the acknowledged kinship film bears to the other visual arts. The Museum at large must recognize both the separateness of film with respect to the other fine arts and its absolute parity with them; or risk the embarrassment of being the last intellectual organism in the community to do so.

5) In line with this new departmental autonomy and recognition of film, we demand that the Museum allocate *appropriate* funds to the Film Dept. to carry on its work and expand its programs.

We gloss the word "appropriate" as follows:

The Museum has reportedly admitted that the largest number of its paying visitors come to see the daily film programs. We therefore suggest that the Museum give to the Film Dept., for its own uses, all admissions paid during the sixty minutes immediately prior to each film showing plus a portion of the total operating budget and endowment income proportionate to the number of membership cards shown during that same time period.

Of course the Department must retain the entire net proceeds of its rental program and of all Museum publications relating to film. In addition, it must be made possible that the Department receive, for its specific use, grants, gifts, and bequests as well as a fraction of all monies left or made available to the Museum at large, in accordance with the importance of film art to the community (as evidenced by its admitted drawing power).

6) Such expanded resources should make possible the elimination of certain deficiencies and abuses in the following respects:

6a) The Film Dept. has recently undertaken to acquire new films for its Archive. We consider this necessary and laudable. But the Dept. has been driven, unwillingly and presumably through penury, to ask for films at or near laboratory cost.

Now we are aware of the Museum's general policy of buying paintings and sculpture below market (i.e. gallery) prices, and we deplore that policy for its bumptious immaturity of viewpoint. But to ask for films "at cost" starves our persons and insults our art, however much we may admire the archival program and wish to help it, since it presumes to single us out among all artists and, indeed, among all persons who perform work in our society—in questioning our right to be paid for our work at all.

Furthermore, we are thus asked to become philanthropists, benefactors of the institution, in spite of the fact that film is an art made cruelly expensive by commercial rates (tax deductible for commercial movie makers as "legitimate business expenses"). As for philanthropy, that is typically an activity of persons of great means who make no art at all.

6b) The Film Dept., desiring to show new work to the public, has been unable to pay either a nominal rental (about $1 per minute) for the use of films shown to large paid audiences or any honorarium to filmmakers appearing personally. This must be

from sheer lack of money, since members of the Department have repeatedly expressed regret over this state of affairs.

6c) In a tentative agreement of October 31, 1967, between the Film Department and the New York Film-Makers' Cooperative, the Dept. was to distribute new films under its regular rental system on an agreeable basis of shared costs and returns. Filmmakers viewed such an arrangement favorably as tending to show new work to a wide audience: film is, after all, an art to be seen and enjoyed and not merely buried in storage vaults. However, nothing has come of that agreement—presumably because the Museum would not spare the Film Dept. funds to hold up its end of the bargain.

7) We are profoundly puzzled by the Film Department's action in arrogating to itself the privileges of a pre-selection jury for a recent international film festival, the XV Kurzfilmtage at Oberhausen, Germany. In a word, they decided who might and might not have their films shown abroad. Bearing in mind that the Museum was, in all probability, acting on a request from the festival organizers, we ask nevertheless whether the Department will attempt to pre-screen films for the next Belgian festival, for instance; and whether, had they done so for the last one, they would, in fact, have chosen the films which, at Knokke-le-Zoute, bore witness to the tremendous innovative vitality of the New American cinema.

But there is a more crucial problem hiding here.

Film festivals had their origin in a desire on the part of responsible persons of sensibility to bring new films to their own locales. Prizes were offered as bait. The films brought visitors, the visitors spent money, the innkeepers were delighted.

But now festival juries presume to judge which films are "best." In a world which let the *Divine Comedy* lie fallow for centuries and lost half the work of Bach, they decide which works are to be rewarded and which ignored.

As an institution dedicated to expounding the most advanced principles in the arts, the Museum must *instigate* a continuing dialogue in the film community, concerning whether the competitive mode is really germane to the arts.

There is a crucial distinction between the roles of middleman and mediator, and the Museum's usefulness to the community rests precisely upon a constant effort to maintain that distinction in critical focus.

Meanwhile, we offer for the Museum's reflection the fact that last month the good burghers fattened in the festival town of Oberhausen, while in America the vivid and ebullient art film went begging. Does the Museum love the art of film as we do? Then they must perform an *act* of love for our art that will somehow compare with our own in making it.

8) Finally, we wish to state, both as a reminder to the Museum and as encouragement to those working in other arts and now anxiously considering alternatives to the Museum-and-gallery hierarchy, that filmmakers long ago abandoned all hope of using the established commercial channels for distribution and exhibition. We have our own cooperative distributors, our own theaters, our own publications and lecture bureau—

but: above all, our own free and uncoerced judgment of what may be done with our work, by whom, how, and when. We feel that we best serve our own needs and, ultimately, those of the community as a whole by these means.

We have always had a school: the Museum's film department was our grammar school and university, as 42nd Street and our own Cinematheque have been our graduate school. The film department was and is unique in the world, and no one has valued the Museum more, or for better reason, than we filmmakers.

What we do not have is a Museum, an impersonal public repository where our most permanent work will be maintained in trust for the whole people, to teach, to move, and to delight them: because we believe that art belongs to the whole people. It is part of our small permanent human wealth, since it is never diminished in use; it can be possessed only in understanding and never through mere ownership.

So we call upon the Museum of Modern Art to become *our* museum, in the largest sense. As filmmakers, as artists, and as human beings, we cannot demand less.

ANTHOLOGY FILM ARCHIVES MANIFESTO (USA, 1970)

P. Adams Sitney

[First released upon the opening of Anthology Film Archives in New York on 1 December 1970. First published in P. Adams Sitney, ed., *The Essential Cinema: Essays on the Films in the Anthology Film Archives*, vol. I (New York: Anthology Film Archives, 1975), vi–xii.

Anthology Film Archives was founded in 1969 by Jonas Mekas, Jerome Hill, P. Adams Sitney, Peter Kubelka, and Stan Brakhage. The goal of the archive was to establish a comprehensive collection of the "masterworks" of art cinema (broadly defined by experimental film, European cinema, and some silent Hollywood films) that would screen continuously and be called "The Essential Cinema." The following manifesto, written by P. Adams Sitney, sets out this (never completed) goal at the inauguration of Anthology in 1970.

When it opened on December 1, 1970, Anthology Film Archives issued the following manifesto, which summarized its polemical position:

The cinematheques of the world generally collect and show the multiple manifestations of film: as document, history, industry, mass communication. . . . Anthology Film Archives is the first film museum exclusively devoted to the film as an art. What are the essentials of the film experience? Which films embody the heights of the art of cinema?

The creation of Anthology Film Archives has been an ambitious attempt to provide an-
swers to these questions; the first of which is physical—to construct a theater in which
films can be seen under the best conditions; and second critical—to define the art of film
in terms of selected works which indicate its essences and parameters.

One of the guiding principles of this new film museum is that a great film must be seen
many times. For that reason the entire collection will be presented in repeated cycles. With
three different programs each day, an anthology of one hundred programs (approximately
equivalent to our present collection) can be repeated monthly. In this way frequent periodic
viewing will be possible for the dedicated spectator. The cycle will also provide a unique
opportunity for students of the medium to see a concentrated history of the art of film
within a period of four or five weeks. One would have to travel extensively and spend a few
years in film museums to acquire the cinematic education of equal magnitude.

TOWARD AN ETHNOGRAPHIC
FILM ARCHIVE (USA, 1971)

Alan Lomax

[First published in *Filmmakers Newsletter* 4, no. 4 (1971): 31–38.]

Alan Lomax's (1915–2002) commitment to ethnography and ethnomusicology was
quite single-handedly what preserved much of the American folk, country, and blues
musical traditions in the early to mid-twentieth century. First at the Library of Con-
gress from 1937 to 1942, and subsequently on his own, Lomax recorded folksinger
Woody Guthrie, blues singers Lead Belly and Muddy Waters, and jazz pianist Jelly
Roll Morton, among countless others. His manifesto extends Lomax's philosophy of
recording music and the spoken word, adapting that philosophy to cinema and call-
ing for a national ethnographic archive to preserve these films for posterity.

One of the great opportunities and urgent tasks of this generation is for the anthropolo-
gist to use the sound film to make a complete record of the life ways of the human species.

The human race has come to a big turning in the road—to the successful climax of
man's long effort to control his physical environment. Many, many ingenious systems
of organization and communication have been evolved in this long struggle to maintain
the continuity of the species and to satisfy increasingly complex needs. Now most of these
cultural types will fast disappear. If action is not taken now, not only will science have
lost invaluable data, but much of the human race will have lost its history and its ances-
tors, as well as a vast treasure of human creativity in adaptive patterns, in communication
systems, and in life styles.

Electronic devices now make it easy to record, store, retrieve, and reproduce these patterns. Moreover, it is clear from recent studies of style and culture (such as my own on song and dance) that a great part of this data is still there to be recorded, at least in vestigial form. Furthermore, enough film exists and enough film analysis has been done to convince me that no data is comparable to what we can have from a well-organized sound-film survey of our species. The work of Bateson, Mead, Birdwhistell, and their colleagues shows that the impress of culture and communicative models is captured on film and may be retrieved from it. Good sound films are multi-leveled and almost infinitely rich recordings of multi-layered, clearly structured inter-action patterns, communication patterns, and stylistic controls.

But not only can ethnographic film be a fundamental research tool for the historian and social scientist in the future, it will also serve three other functions:

1) A full and eloquent sound-film record will enable the whole human race to know itself in objective terms, and the use of this material will make for a communication system that represents all culture and all histories, not just our own. The principles of cultural equity will come into function in this better balanced communicative system. Subordinate to this larger view are the purposes of education within our own culture. If we establish a baseline in planetary self-knowledge, the educational needs of the young people in this culture will also be taken care of.

2) This total human record will be a resource for our less varied future—of body style, behavior pattern, group organization, mind and body skills—all of which can be represented and captured easily in film, almost none of which can be communicated through print, since film records the whole of a process, print only the steps. Thus the achievements in speech, in rhythm, and in body can be stored up for the human future.

3) Feedback and cultural renewal. We do not know how much demoralization the loss of culture, language, and tradition bring about, except that it is great and long-lasting. All strong cultures depend upon a matured and crystallized self-image. As things are at present, the simpler economies and nonliterate folk of the planet—in whom our human variety really reposes—struggle vainly to maintain a healthy self-awareness. They need technical help in preserving and adapting their extra-verbal and oral traditions, for there is no time to reduce them all to print. In any case, print leaves out the non-verbal.

· · ·

Even more urgent is the matter of feedback—the voices and the images of the under-privileged are, unlike ours, seldom or never amplified and repeated by the big communication systems. Quite naturally then, these people fall into despair—their enforced silence convinces them that they have nothing to contribute. But broadcasting sound and

film, especially song, dance, drama, narrative, ritual, and the like, can put the human race on terms of parity, communication-wise, for all aesthetic systems carry their own message of perfection. For example, the vitality of folkways, given parity, is evidenced by their comeback in India and the Balkans. We have seen in the U.S. how the expressive styles of the backward Southern Appalachian and Southern Black communities have thrived and developed (even though subject to a corrupt commercial influence) simply because they had communication space on records and radio. If we film now with the purpose of feeding back to the carriers of all human traditions, we will learn, as we work, about how to foster all culture and all expressive models. We will have gained time and somewhat postponed the otherwise inevitable cultural grey-out.

It is only within such a broad perspective that the plans for a national ethnographic film program ought to be conceived. In what follows I shall not address myself to detailed matters concerning the establishment of the National Film Archive, its location, and its techniques for preservation, for others have been at work on this and have made excellent suggestions. One point, however, should be obvious. There is in no one country the finances or the housing to take care of this gigantic enterprise. The U.S. Ethnographic Film Archive should have the responsibility of looking after only a certain portion of the footage and the task, but beyond this it must collaborate and work out standards of indexing, filming, and preservation with other centers in this country and abroad. Therefore, it is of primary importance to establish the ethnographic film enterprise on an international basis. Americans were slow to begin making ethnographic films, and even now our performance is not equal to that of the French, the Italians, the Germans, the Canadians, and the British. The job cannot be done without the Musée de L'Homme, Gosfilmofund, BBC, the Canadian Film Board, the German Encyclopedia Cinematographica, and other foreign groups. Therefore, a major and primary task is to establish these working relationships, and for this we need a minimal plan that all can agree upon. The following proffers some ideas for this plan.

A FILMED ETHNOGRAPHIC SAMPLE

Our first obligation as scientists is to make sure that, minimally, we have a filmed record of all the main families of human culture. G. P. Murdock and his center have developed a Standard Cultural Sample of reasonable size. My own recent factor analysis of the Murdock sample indicates that a minimum of about sixty culture styles could represent the full range of human social and expressive structures. Within some such frame we can begin work on the Standard Filmed Sample—in terms of the following steps:

1) Study the extent of ethnographic footage and determine which members of the World Sample have been filmed with reasonable adequacy (as have the Netsilik, the Kung, and the Miao, for example).

2) Promulgation of a listing (or preferably a basic library) of this Preliminary Film Sample so that ethnologists and kineseologists here and abroad can

begin to use it and to prepare recommendations for further filming that will represent the range of culture patterns.

3) Plans for films to complete the sample. Our prime goal here is a standard library of human culture to be used by all social scientists—a universally shared body of data to serve as a source for illustration and a base for discussion. Thus the whole human species will become known for the first time.

4) Establishment of standards. A commission on ethnographic film should be convened in order to make preliminary recommendations for: a) minimal standards for filming; b) an outline of activities and topics so that future film documents will be more comparable; c) plans to meet the requirements of film analysts; d) editorial and indexing procedures that will protect the data.

5) An International Commission. Since the cooperation of museums, television networks, and governments will be necessary to finance this task, one necessary step is to establish a working commission concerned with the question. This group should be small and should bring together the best of film administrators whose job is to carry out the suggestions of the ethnographic planning group.

URGENT ANTHROPOLOGY

Film is the most flexible and most honest medium to represent the cultures which are partially extinct or on the edge of disappearing. This enterprise, since it is so extensive, cannot be subject to the level of scientific control applied to the Standard Cultural Sample. Again, however, the same approach may be helpful.

1) From the findings of the Committee on Urgent Anthropology and elsewhere, establish a list of those cultures that ought to be filmed immediately.

2) Research the extant footage of these cultures.

3) Establish a Committee for Urgent Ethnographic Film to commission low-budget films of the cultures that urgently require documentation.

4) Set up a plan and develop a handbook so as to involve all interested agencies and individuals in shooting high-quality footage of these cultures. Here the use of 8mm film should be encouraged.

5) Feedback. This film should, of course, be archived. But perhaps the most important function is *in situ* and in the culture territories it represents. Our most important job is to make sure that culture members see their own films, understand them, and offer suggestions for their improvement. I therefore recommend that careful experimental work in feedback be initiated immediately. Moreover, the United Nations and other agencies should be brought into the picture to initiate feedback in all world areas.

6) Example: North America. Although the cultures of North America have probably been studied more thoroughly by linguists and ethnologists than those of any other continent, this came early; and the amount of available modern film of Indian behavior is paltry compared to other world regions (such as Australia, for instance). The full cooperation of the tribes is essential to this work, and this is a problem, since American Indians have good reason to feel that our science has made little contribution to their welfare. It may be possible to enlist the help a well as the financial interest of the tribes in making these films, provided they are convinced of their importance for the Indian. Thus far in our work with Choreometrics we have been able to find behaviors that clearly establish the antiquity, the staying-power, and the aesthetic validity of Amerindian continental and area culture styles. Such evidence can win Indian cooperation in creating an Amerindian film record to match those of other continents. This enterprise is "urgent anthropology" so far as the American anthropologists are concerned, and so it seems to me, too.

7) The number of subjects that come under the heading of urgent ethnographic films is very large, but so also are the number of 8 and 16mm filmmakers who want to help. The Commission on Urgent Anthropology must set up and continually improve standards for the non-specialist filmmaker or field worker who, in the past, shot so much of the best documentary film. If we provide a handbook to guide the amateur and training programs for the field cameramen, we can hope to put all the cultures and unique life ways of mankind in the film record before modern technology communications have obliterated them.

FILM RESEARCH

The total corpus of film of human beings shot and stored since the invention of the movie camera is the richest data bank of human behavior we have. One of the ironies of this era is that the American motion picture industry has not built up a Motion Picture Museum—an International Archive of Sound and Vision—as a monument to Hollywood and the art that all the world regards as so American. But perhaps the Ethnographic Film Archive must come first, to prove what a fabulously interesting and useful place such an electronic museum could be. At this writing, of course, the cinema corpus is virtually unused by the human sciences, both because the stuff is so hard to get at and so expensive, and because film analysis techniques are new and unfamiliar. Only in the past two decades have techniques for the study of human behavior on film—such as kinesics and its offshoots—begun to develop. Only quite recently have social scientists begun to turn to filmmaking, and then too frequently it's as if they were or wished to become great artists in the medium. Indeed, most ethnographic film conferences consist of a display of the *art* of cinema, in terms of *films,* most of which are simply bad, rather than in discussion of

the complex and pertinent questions of what is in the films, how film can be used as data, and so on. Today there is a rush toward the field, but all too often as a means of personal expression and with little consideration, in many cases, of the scientific interests which should be paramount in anthropology. Without, therefore, gainsaying the importance of additions that filmmakers now wish to make to the cinematic corpus, the anthropologist is obliged, it strikes me, to find, evaluate, and learn to utilize the relevant footage that already exists.

I am impatient with colleagues who demand that before they begin to work they must have footage that meets all their research requirements. For me this is a technique for postponement. In the first place, many of the cultures and much of the behavioral patterns in this footage can never be filmed again—the cultures are gone and the life ways have changed. Second, these documents give our fledgling science the time-depth it needs—provided we are willing to do what every historian does: learn to evaluate the evidence he has. In other words, since motion pictures of human behavior are layer cakes of structured communication patterns, there *is* ethnographic data of some sort in all documentary footage (which hasn't been chopped absolutely to pieces), if not at a fine-grained level, then at a grosser one. This is not to say that we should not have data standards and that they should not improve, but rather that our fledgling science should learn to use what is already in the record. A primary problem is, then, to find and preserve the extant footage.

FINDING THE FOOTAGE

Ted Carpenter and many others have discovered that there is a world of invaluable ethnographic film in the hands of amateur enthusiasts, government bureaus, and movie and TV companies. One learns with shock that it is a regular practice of business to destroy old footage in order to save storage bills, and one knows (from experiences with the recording industry) that the documentary, the everyday, the folk, the primitive is always the first to go, while all prints of Pola Negri and Rudolph Valentino are preserved forever. It should become our business to change those attitudes. An initial display of research interest and enthusiasm about what the industry has done would certainly slow this process down (that, too, we found with the recording industry). We could then face the problem of paying storage until we can store this footage, electronically or otherwise. Stimulating examples of using this footage as scientific evidence, either in compiled films or in writing about human history, would also tend to slow this process of destroying data.

It is even more shocking to learn that most editors, including very many ethnographic filmmakers, cut up the original negs in the process of editing their display film, so that much valuable field data is destroyed. No ethnographic documentaries should be financed, sponsored, or shot unless there is a budget to keep one or two complete prints of all footage with a complete shot list. An International Film Commission or other appointed body should take the following steps:

1) Through the United Nations, or by other means, address an appeal to all the government agencies that make film—especially the TV corporations such as BBC, RAJ, and others—briefing them and asking for their cooperation in preserving and making their footage available. Some film ethnographer in each country can then, hopefully, be commissioned to examine and report on collections of the ethnographic film there.

2) Ask Margaret Mead and Ted Carpenter, as a committee of two, to go after the participation of the American film industry. Also, we should find Senators who are interested in sponsoring the legislation that will show the government concern.

3) Commission two full-time researchers—in the U.S. and Europe—to look over the field. Eventually the International Commission on Ethnographic Film should have several full-time researchers—in North America, Europe, South America, the Soviet Union, the Mid-East, Near East, India, and the Far East. Here again, of course, the Europeans are far ahead of the Americans and should lead—Jean Rouch and his Ethnographic Film Center, the people at the Encyclopedia Cinematographica in Germany.

4) Establish a program of graduate degrees in film research, both here and abroad.

5) Before systematic viewing and indexing begins, a computerizable system for film subject and sequence indexing should be devised for all researchers to use.

6) Initiate the development of an international system of electronic storage and retrieval of sound-on-film and videotape.

STUDYING THE FOOTAGE

Few film professionals are yet trained in the techniques for seeing the structure in behavior. This training in observation can bring rigor into the human sciences and an undreamed-of sensitivity to the ethnographic filmmakers. The savants in the field—scholars like Gregory Bateson, Haxey Smith, Margaret Mead, Paul Byers, William Condon. Albert Schefflen, and especially Raymond Birdwhistell—should be aided in setting up orientation and training programs.

Several methods exist, each useful for working at a different depth in the visible stream. Among them are: Micro-analysis of inter-personal synchrony (William Condon); the kinesis-linguistic level (Ray Birdwhistell); and the Choreometric cross-cultural rating.

Each of these ways in will contribute to an emerging science of human ethnology. An important step, still to be taken, is to develop the concepts and the methods by means of which the social science filmmaker can record the gross visible patterns of familial, community, economic, and political systems at work.

STANDARDS

It would be possible to hedge this beautiful field about with such a thicket of rules and caveats that it would lose the independent and creative souls, like Flaherty, who have shot so much of the best ethnographic footage. This would be disastrous, for in order to reach and move the mass audience, ethnography wants all the art, all the cinematic skill it can enlist. The field will continue to need big, beautiful films, as well as straightforward data, and both needs *can* be met. The documentary artist can, as a side-line, shoot some of the footage science requires, so long as its specifications are kept reasonably simple and clear. To help the professional (with his commitment to the mass media) avoid perpetuating visual and cultural stereotypes is a subtler problem. Here visual anthropology can make a major contribution as it learns more about how culture pattern is symbolized in visible behavior. First there are other, more obvious problems created by amateurs playing Flaherty, by professionals using a shooting and editing style suitable for gangster films, but especially by those who make footage that is technically bad and painfully dehumanizing. Incompetent and insensitive cameramen are simply belittling the underprivileged people of the world in the name of truth and documentary filming. There is an ocean of ethnographic footage faulted by wrong exposures and focus, demeaning angles, unkind lighting, follow-shots that miss, and endless scenes in which the cameraman's awkwardness is reflected in the bodies of his victims. One frequent and maddening practice is to pose a village group like a police line-up and shoot along the row of nervous faces from slightly above. Such inexpert and unsympathetic camerawork and lighting is not to be condoned and should not be supported, since the footage is likely to be the principal surviving record of the ancestors of many human groups.

Another besetting sin is the eternal use of the close-up and the endless zooming-in to shoot faces and hands. This is a bad but understandable practice in the West where the hands and face are the only uncovered body parts, but makes no sense at all when simpler, undraped peoples are being photographed. It reflects the cameraman's nervous search for something he can like and understand, but distorts the event. Constant change of distance and angle and dramatic editing that makes hash of the continuity of interaction destroys the value of the filmed data, imposing the conventions of the Western art film on non-Western behavior. Mead and Birdwhistell long ago observed that when a cameraman changed shots it was because he couldn't bear to look any longer, and they advocate the use of fixed, automatic cameras in gathering data. Sandor Kirsch has found that the European film editor cuts his film to a tempo of 5 to 8 seconds per edit—about breath rate. In the Choreometric survey we found that even the best of filmmakers shot and chopped their footage to fit the dimensions of Western movement form, no matter what its source or phrase organization happened to be. There can be no question that documentary film will be more truthful when filmmakers learn how to shoot and edit within the conventions of the visible communication system employed by those being filmed. Basic elements such as the use of space, energy, timing, and body parts emphasized,

along with the subtler interaction and communication patterns, change drastically from one culture region to another. Documentaries filmed with these considerations in mind should not only be more truthful but more beautiful as well. Therefore, since the means now exist for discovering these visual and behavioral conventions, the collaboration of visual anthropologists and filmmakers will certainly be productive of better films. A set of minimum standards, including some of the following suggestions, would help immediately.

1) No one should be backed or encouraged to film in the field unless he is not only a competent but also an empathetic cameraman. Grant committees should have expert review boards to sift out the culls.

2) Practicing filmmaking on primitive or folk groups should be frowned upon. They are unlikely to be filmed twice. Thus this footage may be the only record many groups will ever have of their forebears.

3) A certain proportion of all ethnographic film footage should consist of uninterrupted long and midshots of whole groups in which the observer can study the interaction of all present, in context. A kinesic committee should set up the ground rules for this footage.

4) Filmmakers should be trained to observe and adapt their shooting style to the main behavioral patterns of the culture.

5) A minimal list of situations and behaviors should be photographed in each culture—main productive cycle, child rearing, family meals, dancing, free interaction, etc., etc.—This list should also be standardized.

6) Wherever possible, shooting should be done in synchronous sound or with lavish use of wild-track sound. All sound and music in the finished film (narration excluded) should be from the place.

7) The negative or one inter-neg copy of all field footage should be labeled and stored.

8) Editing should, so far as possible, reflect the non-verbal conventions of the culture from which the picture comes, not those of the editor.

9) Finally and most important—the ethnographic film, wherever possible, should be shot, supervised, or at least planned in collaboration with the most knowledgeable ethnologist, folklorist, or social scientist available.

THE AUDIENCE

There are at least five audiences for ethnographic film, all with different requirements.

1) The people and the culture who figure in the films should get to see this footage whenever possible, both in local screenings and over local TV. The ethnologist

has a strong motivation to give these showings, for at them he can learn more about how the people see their own culture. This is the place where field use of videotape machines should make for great progress in anthropology. Even so, the healthy effect of feedback should be the principal goal. Indeed, the social function of these showings, per culture or culture area, would be the same as our daytime serials, women's hours, sports shows, newscasts, interview shows, etc.—the reinforcement of culture pattern.

2) For the people in the surrounding nation or culture, the needs, situation, and potential of the group need to be better understood in the group. Tactful, regional, big-media use of the footage should be part of any overall film plan, wherever possible. Emphasis might fall on the inter-dependency of groups in an ecological territory.

3) Scientific analysts will want all or part of the unedited footage. Split screen, slow motion and speech stretching, close-ups, and rapidly iterating film loops—every laboratory optical trick in the business can serve the purpose of scientific illustration. Our national archive should have a large special effects department to serve the profession. At any rate, scientific editing of footage will often differ from that used for other types of audiences.

4) Students. There are at least two audiences—children and young adults—and at least three new sophisticated teaching approaches in various stages of development:

 a) The cultural episode, as developed by Tim Asch and John Marshall, with its multi-dimensional, in-depth treatment of cultural motifs that give the "feel" of character and motivation;

 b) The stylistic comparative approach where the student gains a world perspective by applying a set of qualitative measures cross-culturally;

 c) The total experience, in which the student views then studies a whole way of life.

 In this classroom slot there are many approaches and scores of films, and perhaps a certain lack of sophistication. It's my feeling that if more emphasis were put on field technique and scientific analysis of the footage, the effectiveness of films in the classroom would quickly improve. The problem is not how to teach anthropology, but how anthropology can use film to illumine the human destiny. Without any method to work through to the structures of visible human events, teachers and students often have very little to talk about after a film viewing.

5) The General Audience. This is the audience that too many ethnographic filmmakers aim to capture, without the means or the money or the knowhow. We are all so caught up in the Hollywood success pattern that we feel that if a

film doesn't make it on American TV or in general theatrical distribution, it is somehow a failure in the medium. One tends to forget the enormous 16mm and foreign audiences of today, the huge 8mm and cartridge audiences just around the corner, as well as the scientific and humane uses, referred to above, which should be the central concerns of the anthropologist. Even so, the splendid success of the Netsilik film on CBS last spring was wonderful news. It shows us that the very best field film can win the great mass audience for the people and the ideas we cherish, if ethnographers have the money, time, and the right collaboration. Yet it is important to remember that the Netsilik was a one-shot affair, instantly swamped in the tide of ordinary TV, and that, even in Europe, where ethnographic film is regularly programmed, it is a drop in the bucket and without very notable effect on public attitudes. One reason, I suspect, is that the members of our practical Western culture do not like to look at their victims. But another is that anthropologists have not been able to make quite clear what their films were saying. If films about the animal world outsell our views of culture pattern, this is because we do not motivate our audiences to look at—nor teach them to see—what we see in the footage, as the natural sciences have. The public has a great interest in the natural environment and the fate of threatened animal species, but shows little concern about the disappearance of cultures.

A far greater intellectual and emotional feedback can come from ethnographic film when we learn how to look at it. Here is the real educational problem, here is a genuine goal for a scientific discipline—to teach man how to see and understand the structures of human behavior in their visible manifestations. That is what the study of body language, movement style, and the total context of communication has to offer. With the teaching of Birdwhistell, Mead, Schefflen, or Bartenieff, the most prosaic footage of the most ordinary human event becomes endlessly fascinating. The public will find it so as well when they discover that sensitive filming and sophisticated viewing will bring enriched understanding of the big human problems—communication, personal development, mating, child-rearing, work, illness, and peace.

BROOKLYN BABYLON CINEMA
MANIFESTO (USA, 1998)

Scott Miller Berry and Stephen Kent Jusick

[Originally circulated as a flyer announcing the birth of Brooklyn Babylon Cinema, 6 November 1996.]

The "Brooklyn Babylon Cinema Manifesto" demonstrates the importance of post-punk, queer, and DIY cultures in the creation of microscenes in the face of mainstream cinema and the domination of old guard avant-garde by capital. This manifesto is emblematic of the third generation American independent cinema scene, where high art aspirations are eschewed and a profoundly political interaction with popular culture comes to the forefront of experimental work. The two cofounders of "Brooklyn Babylon" continue to support queer and experimental work outside mainstream galleries and festivals: Jusick is now Executive Director of MIX NYC, the New York queer experimental film festival, and Berry is the Executive Director of the Images Festival in Toronto.

WHAT GOES AROUND COMES AROUND

In these days of Mayoral fiat and rampant real estate speculation (the result of runaway capitalism), the people of New York City find themselves under attack in our own home, and alienated from our happily hurried way of life. This screening sets out to demonstrate how the excesses of the 80's homophobia, overspending, genocide by inaction are not so far removed from today. Tonight's selection of films shows that AIDS phobia is STILL being used to desexualize gay culture. The juxtaposition of explicit lesbian sex films (from 1973 and 1993) shows how incendiary this imagery remains. AIDS lingers on and even while the mortality rate is declining, the infection rate continues apace. So we present the somber meditation of "Two Marches" which reminds us that dashed expectations are nothing new while Stuart Gaffney's video essays pull us into the present dilemma of problematic AIDS treatments. Jan Oxenberg's classic is disruptive of homosexual complacency, underscoring the need for a dynamic identity politics that embraces the stone butch as much as the trans-lesbianism of Texas Tomboy. This program is defiantly experimental, because we believe that the narrative strategies employed by even such "transgressive" and "controversial" films as *Happiness* and *Boogie Nights* serve to comfort the viewer and distract the authentic expression of the individual. These films are the color of blood.

An anonymous band of renegades is pleased to announce the debut of Brooklyn Babylon Cinema, a monthly screening of film and video. Brooklyn because that's where we are. Babylon because it connotes the type of moving-image media we present: the profane, the filthy, the rejected. But this also includes the visionary, the naive and the

artful. Babylon because of Kenneth Anger's indelible linking of the word to the sordid side of Hollywood, which is the only side we'd want to see. Babylon because we can go from Michael Snow to Guy Debord to *Forbidden Zone* to secrets from the Prelinger Archives, to Vaginal Davis videos.

Formats accepted: Super-8, Regular 8, 16mm, VHS and 3/4 video, filmstrips, slide shows, performance incorporating film or video. Submit VHS preview tapes with some sort of description or statement to: P.O. Box 20900, Tompkins Sq. Station, NY, NY 10009.

We prefer queer work, experimental work, political/progressive docs, works about alternative music. We also have concerts; it's always all ages and usually $5. Sometimes we can pay fees, but visiting makers will get a homecooked meal and can crash at the space.

Friday November 6th, 1998, 8:00 p.m., $5

DON'T THROW FILM AWAY: THE FIAF 70th ANNIVERSARY MANIFESTO (France, 2008)

Hisashi Okajima and La fédération internationale des archives du film Manifesto Working Group

[First adopted by La fédération internationale des archives du film at its General Assembly in Paris, April 2008. Final version released September 2008, adopting recommendations from the General Assembly. First published in *Journal of Film Preservation* 77/78 (2008): 5–6.]

The FIAF manifesto is in many ways the antithesis to the pragmatism underlying Paolo Cherchi Usai's "Lindgren Manifesto," which follows. A full-throated defense of analog film in the face of the digital revolution, the FIAF manifesto makes the case that any and all film, no matter its aesthetic, political, or historical significance, ought to be saved. If Cherchi Usai is channeling the pragmatism of Ernest Lindgren, the FIAF manifesto is much more in the tradition of Henri Langlois.

Motion picture film forms an indispensable part of our cultural heritage and a unique record of our history and our daily lives. Film archives, both public and private, are the organizations responsible for acquiring, safeguarding, documenting and making films available to current and future generations for study and pleasure. The International Federation of Film Archives (FIAF) and its affiliates comprising more than 150 archives in over 77 countries have rescued over two million films in the last seventy years. However for some genres, geographical regions and periods of film history the survival rate is known

to be considerably less than 10% of the titles produced. On the occasion of its 70th anniversary, FIAF offers the world a new slogan: "DON'T THROW FILM AWAY." If you are not sufficiently equipped to keep film yourself, then FIAF and its members will gladly help you locate an archive that is. Film is culturally irreplaceable, and can last a long time, especially in expert hands. While fully recognizing that moving image technology is currently driven by the progress achieved in the digital field, the members of FIAF are determined to *continue to acquire film and preserve it as film*. This strategy is complementary to the development of efficient methods for the preservation of the digital-born heritage. FIAF affiliates urge all those who make and look after films, whether they be professionals or amateurs, and the government officials in all nations responsible for safeguarding the world cinema heritage, to help pursue this mission. The slogan "DON'T THROW FILM AWAY" means that film must not be discarded, even though those who hold it may think they have adequately secured the content by transferring it onto a more stable film carrier or by scanning it into the digital domain at a resolution which apparently does not entail any significant loss of data. Film archives and museums are committed to preserve film on film because:

- A film is either created under the direct supervision of a filmmaker or is the record of an historical moment captured by a cameraman. Both types are potentially important artifacts and part of the world's cultural heritage. Film is a tangible and "human-eye readable" entity which needs to be treated with great care, like other museum or historic objects.

- Although film can be physically and chemically fragile, it is a stable material that can survive for centuries, as long as it is stored and cared for appropriately. Its life expectancy has already proved much longer than moving image carriers like videotape that were developed after film. Digital information has value only if it can be interpreted, and digital information carriers are also vulnerable to physical and chemical deterioration while the hardware and software needed for interpretation are liable to obsolescence.

- Film is currently the optimal archival storage medium for moving images. It is one of the most standardized and international products available and it remains a medium with high resolution potential. The data it contains does not need regular migration nor does its operating system require frequent updating.

- The film elements held in archive vaults are the original materials from which all copies are derived. One can determine from them whether a copy is complete or not. The more digital technology is developed, the easier it will be to change or even arbitrarily alter content. Unjustified alteration or unfair distortion, however, can always be detected by comparison with the original film provided it has been properly stored.

Never throw film away, even after you think something better comes along. No matter what technologies emerge for moving images in the future, existing film copies

connect us to the achievements and certainties of the past. FILM PRINTS WILL LAST—DON'T THROW FILM AWAY.

THE LINDGREN MANIFESTO: THE FILM CURATOR OF THE FUTURE (Italy, 2010)

Paolo Cherchi Usai

[First delivered at the Ernest Lindgren Memorial Lecture, South Bank, London, 24 August 2010. First published in *Journal of Film Preservation* 84 (2011): 4. Slightly revised by the author for this publication.]

Film archivist Paolo Cherchi Usai is the senior curator of the Motion Picture Department at George Eastman House and cofounder and codirector of the Pordenone Silent Film Festival. In this manifesto, named after the founding curator of the BFI National Archive, Cherchi Usai challenges many of the sacred cows of film archiving, arguing that a pragmatic approach to archiving must develop in the face of both the *realpolitik* of contemporary State funding and the chemical and chimerical state of film stock.

1. Restoration is not possible and it is not desirable, regardless of its object or purpose. Obedience to this principle is the most responsible approach to film preservation.

2. Preserve everything is a curse to posterity. Posterity won't be grateful for sheer accumulation. Posterity wants us to make choices. It is therefore immoral to preserve everything; selecting is a virtue.

3. If film had been treated properly from the very beginning, there would be less of a need for film preservation today and citizens would have had access to a history of cinema of their choice.

4. The end of film is a good thing for cinema, both as an art and as an artifact. Stop whining.

5. If you work for a cultural institution, make knowledge with money. If you work for an industry, make money with knowledge. If you work for yourself, make both, in the order that's right for you. Decide what you want, and then say it. But don't lie.

6. A good curator will never claim to act as such. Curatorship is a pledge of unselfishness.

7. Turning silver grains into pixels is not right or wrong per se; the real problem with digital restoration is its false message that moving images have no history, its delusion of eternity.

8. Digital is an endangered medium, and migration its terminal disease. Digital needs to be preserved before its demise.

9. We are constantly making images; we are constantly losing images, like any human body generating and destroying cells in the course of its biological life. We are not conscious of this, which is as good as it is inevitable.

10. Knowing that a cause is lost is not a good enough reason not to fight for it.

11. A film curator must look for necessary choices, with the ultimate goal of becoming unnecessary.

12. Governments want to save, not give, money. Offer them economical solutions; therefore, explain to them why the money they give to massive digitization is wasted. Give them better options. Treating with the utmost care what has survived. Better yet, doing nothing. Let moving images live and die on their own terms.

13. Honor your visual experience and reject the notion of "content." Protect your freedom of sight. Exercise civil disobedience.

14. People can and should be able to live without moving images.

FILM FESTIVAL FORM: A MANIFESTO (UK, 2012)

Mark Cousins

[First published on the Film Festival Academy website (www.filmfestivalacademy.net) in 2012].

UK film critic Mark Cousins laments the profit-driven, limo-polluted, red-carpet nature of contemporary film festivals and argues that, instead of reliance on faux-Hollywood glamour, they ought to radically challenge audiences about the nature of politics, of spectatorship, and of the cinema itself. He decries the function of the film festival as an alternative distribution center of the cinema and condemns this form of festival as a simple adjunct of commercial cinema.

The Oberhausen Manifesto helped launch the New German Cinema; the Danish Dogme 95 manifesto brought new ideas to, and detoxed, 90s cinema. The film festival world could do with

a manifesto too . . . • In Italy in the 1930s, Mussolini launched the world's first film festival, Venice, to celebrate fascist ideas and aesthetics. To counter this, two alternative festivals were launched, one in a former fishing town, Cannes, and one in the "Athens of the North," a centre of the Enlightenment, Edinburgh. • Now there are thousands of film festivals. They are a cultural idea that is spreading like a Richard Dawkins meme. • As the elite of the festival circuit clink another glass of champagne at party after party to salute a venerable old festival or the launch of a new one, it would be no surprise if their smiles were a little strained. Masked by glamour and ubiquity, the world of film festivals is, in fact, in crisis. • There are too many of them chasing world premieres and film celebrities. • *But they are also chasing a too narrow idea of what a film festival can be.* • Marco Muller says that film festivals should "reveal what the markets hide." Toronto International Film Festival's Piers Handling called this counter-market an "alternative distribution network." In *European Cinema: Face to Face with Hollywood,* Thomas Elsaesser says that this network has created "symbolic agoras of a new democracy." • Muller, Handling and Elsaesser each think that the purpose of a film festival is to act counter to the mainstream, cookie-cutter cinema that prevails in most parts. To show a broader geographic, stylistic and thematic range of films than is usually available to audiences. • GREAT! • Except that that's the content of a film festival, just as the content of Picasso's *Guernica* is the bombing of a town, like the content of The Smiths' "There is a Light That Never Goes Out" is the suicidal intensity of love, like the content of *Singin' in the Rain* is the rapture of love. • What's exciting about *Guernica* is how its black and white, graphic, epic, mythic imagery shows us the tragedy in a new way. What's exciting about The Smiths song is the daring of the word and music cadences and ironies ("to die by your side, what a heavenly way to die"). What's exciting about *Singin' in the Rain* is that camera rising up to look down, from where the rain is falling, from where we think of the spirit to be, at this man who is so in love that night-time rain feels great. • In other words, *what's exciting is their form.* • Film festivals are undergoing formal torpor. Too many of them use the same techniques—a main competition, sidebars, awards, late-night genre cinema, prizes, VIP areas, photo-calls, etc. • There's a simple way of shaking film festivals out of this torpor: we should think of them as *authored,* just as films are authored. We should think of them as *narratives*—stories lasting ten days or two weeks, just as films are narratives. We should think of them as shows being produced on stages, where each has a mise-en-scène just as a film has a mise-en-scène. A film festival is a shape, a response to the lay of the land and light of a city, or to a flood in Pakistan, or the threat to bomb Iran. • The people who run film festivals must think of themselves as *storytellers and stylists.* They must ask themselves what the narrative structure of their event is, and its aesthetic. Most of all they must, as the best filmmakers do, challenge themselves to do things differently. • It's about time that, in the spirit of Dyonisus or Guy Debord or Rilke or Patti Smith or Djibril Diop Mambety or Ritwik Ghatak or Samira Makhmalbaf, film festivals realise that they are poetry not prose. • Too many film festivals in the world are enthralled by their function as the alternative shop window for film industries. Film festivals should be more

sceptical about business and industry. They should be the conscience of the film world. • There should, therefore, be no red carpets at film festivals. No limos. No VIP rooms. • These things will begin to strip out the excess and ponciness of film festivals—their mannerism—and return them to something purer and more beautiful, inclusive and alive. • Festival directors should use their most discrepant ideas: their funniest, most moving, sexiest thought about films. Start a film in one cinema and finish it in another—the audience runs between. Get Godard to recut Spielberg. • Festivals should be radically about joy, about countering alienation, about telling the world of money and commodity that— ha ha—it doesn't know the secrets of the human heart or the inexpressible, stupendous need to be with other human beings. • Film festivals should be naked in front of the innovative, divine, political, honest facts of life. They should lob a thought bomb to show that cynicism is a false lead, art is amazing, cinema is, as Roland Barthes sort of said, "light from a distant star." • And there's the whole issue of festivity itself to restore to the centre of the world of film festivals. Like music festivals, film festivals should realise that, especially in the age of online, it's the offline communality of film festivals, the fact that we are all getting together to do the same thing, that is part of the source of their joy.

9

SOUNDS AND SILENCE

The four manifestos that compose this chapter all revolve around the question of sound in the cinema. Perhaps it is not surprising that three of the four were written on the cusp of sound cinema. Many filmmakers, critics, and theorists were convinced that the advent of sound would strip away from the cinema its specificity and its universalism. Indeed, even for filmmakers who mastered sound, there was a lingering feeling that the silent image constituted the true cinema. Alfred Hitchcock, who made ten silent films in the United Kingdom between 1925 and 1929, often argued that a good sound film ought to be perfectly comprehensible to an audience even if the sound were turned off. The first three manifestos address the arrival of film sound at the end of the 1920s. The first, and most famous, sound manifesto, "A Statement on Sound," by Sergei Eisenstein, Vsevolod Pudovkin, and Grigori Alexandrov, published in 1928, argues for contrapuntal sound, eventually achieved in some parts of Eisenstein's *Alexander Nevsky* (USSR, 1938), most notably in the battle on the ice between Novgorod and the Teutonic knights. This manifesto is especially relevant given that in the late 1920s socialist realism had not replaced the early formalism of Soviet cinema; the films of the period were still focused on the plasticity of the cinema that Bazin later decried; the naturalism of sound presented specific aesthetic problems for Russian formalists. In "A Rejection of the Talkies," written as part of the press material for *City Lights* (USA, 1931), Chaplin defends the use of synchronized sound but, like his Soviet *cineaste* compatriots, decries the use of sound as a substitute for the international language of the silent cinema as he defines it. For Chaplin the specificity and universal appeal of the cinema lies in its use of pantomime, and he argues that sound can easily eradicate this aspect of the cinema through an overreliance on explanatory dialogue in lieu of pantomimic acting. Basil Wright and B. Vivian Braun raise similar issues; like the aforementioned manifestos, "A Dialogue on Sound: A Manifesto" derides the "talkies." Wright and Braun develop in a practical manner many of the points raised in "A Statement on Sound," foregrounding again the contrapuntal use of sound, raising a clarion call that sound can easily overdetermine an image, killing its meaning in the process. The "Amalfi Manifesto," written some thirty years after the advent of sound, examines the way in which overdubbing has functioned in Italian cinema and decries the lack of imagination in the soundscapes of Italian films. Unlike the other sound manifestos presented here, the "Amalfi Manifesto" concerns itself with the problems of antirealism and argues that dubbing detaches actors from their roles, creating a degree of alienation for the audience through the break in verisimilitude. It argues for a "unitary plane of style," urging a more complete and total cinema, one that does not break apart sound and image.

A STATEMENT ON SOUND (USSR, 1928)

Sergei Eisenstein, Vsevolod Pudovkin, and Grigori Alexandrov

[First published in Russian in *Zhizn iskusstva* 32 (1928): 4–5. First published in English in the *New York Herald Tribune*, 21 September 1928.]

Eisenstein, Pudovkin, and Alexandrov argue for sound to be used in the cinema in such a way that it does not simply illustrate the images on the screen and that the use of sound to provide an added level of naturalism to the screen will destroy the principles of montage and the specificity of cinema itself. As such, they argue for the use of nonsynchronized, contrapuntal sound to develop the sonic aspect of the cinema along the same lines of those the Soviets developed for montage.

The dream of a sound film has come true. With the invention of a practical sound film, the Americans have placed it on the first step of substantial and rapid realization. Germany is working intensively in the same direction. The whole world is talking about the silent thing that has learned to talk.

We who work in the U.S.S.R. are aware that with our technical potential we shall not move ahead to a practical realization of the sound film in the near future. At the same time we consider it opportune to state a number of principal premises of a theoretical nature, for in the accounts of the invention it appears that this advance in films is being employed in an incorrect direction. Meanwhile, a misconception of the potentialities within this new technical discovery may not only hinder the development and perfection of the cinema as an art but also threaten to destroy all its present formal achievements.

At present, the film, working with visual images, has a powerful effect on a person and has rightfully taken one of the first places among the arts.

It is known that the basic (and only) means that has brought the cinema to such a powerfully effective strength is MONTAGE. The affirmation of montage, as the chief means of effect, has become the indisputable axiom on which the worldwide culture of the cinema has been built.

The success of Soviet films on the world's screens is due, to a significant degree, to those methods of montage which they first revealed and consolidated.

Therefore, for the further development of the cinema, the important moments will be only those that strengthen and broaden the montage methods of affecting the spectator.

Examining each new discovery from this viewpoint, it is easy to show the insignificance of the color and the stereoscopic film in comparison with the vast significance of SOUND.

Sound recording is a two-edged invention, and it is most probable that its use will proceed along the line of least resistance, i.e., along the line of satisfying simple curiosity.

In the first place there will be commercial exploitation of the most salable merchandise, TALKING FILMS. Those in which sound recording will proceed on a naturalistic level, exactly corresponding with the movement on the screen, and providing a certain "illusion" of talking people, of audible objects, etc.

A first period of sensations does not injure the development of a new art, but it is the second period that is fearful in this case, a second period that will take the place of the fading virginity and purity of this first perception of new technical possibilities, and will assert an epoch of its automatic utilization for "highly cultured dramas" and other photographed performances of a theatrical sort.

To use sound in this way will destroy the culture of montage, for every ADHESION of sound to a visual montage piece increases its inertia as a montage piece, and increases the independence of its meaning-and this will undoubtedly be to the detriment of montage, operating in the first place not on the montage pieces but on their JUXTAPOSITION.

ONLY A CONTRAPUNTAL USE of sound in relation to the visual montage piece will afford a new potentiality of montage development and perfection.

THE FIRST EXPERIMENTAL WORK WITH SOUND MUST BE DIRECTED ALONG THE LINE OF ITS DISTINCT NONSYNCHRONIZATION WITH THE VISUAL IMAGES. And only such an attack will give the necessary palpability which will later lead to the creation of an ORCHESTRAL COUNTERPOINT of visual and aural images.

This new technical discovery is not an accidental moment in film history but an organic way out of a whole series of impasses that have seemed hopeless to the cultured cinematic avant-garde.

The FIRST IMPASSE is the subtitle and all the unavailing attempts to tie it into the montage composition, as a montage piece (such as breaking it up into phrases and even words, increasing and decreasing the size of type used, employing camera movement, animation, and so on).

The SECOND IMPASSE is the EXPLANATORY pieces (for example, certain inserted close-ups) that burden the montage composition and retard the tempo.

The tasks of theme and story grow more complicated every day; attempts to solve these by methods of "visual" montage alone either lead to unsolved problems or force the director to resort to fanciful montage structures, arousing the fearsome eventuality of meaninglessness and reactionary decadence.

Sound, treated as a new montage element (as a factor divorced from the visual image), will inevitably introduce new means of enormous power to the expression and solution of the most complicated tasks that now oppress us with the impossibility of overcoming them by means of an imperfect film method, working only with visual images.

The CONTRAPUNTAL METHOD of constructing the sound film will not only not weaken the INTERNATIONAL CINEMA but will bring its significance to unprecedented power and cultural height.

Such a method for constructing the sound film will not confine it to a national market, as must happen with the photographing of plays, but will give a greater possibility than ever before for the circulation throughout the world of a filmically expressed idea.

A REJECTION OF THE TALKIES
(USA, 1931)

Charlie Chaplin

[Originally published as part of the Exhibitors Campaign Book for *City Lights* and printed in numerous languages.]

Charlie Chaplin's statement on sound is a defense of silent cinema as a universal language. Much like the avant-garde filmmakers of the time, and philosophers such as Rudolf Arnheim, who published *Film als Kunst (Film as Art)* a year later, Chaplin argued that simply adding sound to motion pictures takes away from their specificity and their ability to communicate across languages and, indeed, nations.

Because the silent or nondialogue picture has been temporarily pushed aside in the hysteria attending the introduction of speech by no means indicates that it is extinct or that the motion picture screen has seen the last of it. *City Lights* is evidence of this. In New York it is presented at the George M. Cohan Theater beginning Feb. 6. It is nondialogue but synchronized film.

Why did I continue to make nondialogue films? The silent picture, first of all, is a universal means of expression. Talking pictures necessarily have a limited field, they are held down to the particular tongue of particular races. I am confident that the future will see a return of interest of nontalking productions because there is a constant demand for a medium that is universal in its utility. It is axiomatic that true drama must be universal in its appeal—the word elemental might be better—and I believe the medium of presentation should also be a universal rather than a restricted one.

Understand, I consider the talking picture a valuable addition to the dramatic art regardless of its limitations, but I regard it only as an addition, not as a substitute. Certainly it cannot be a substitute for the motion picture that has advanced as a pantomimic art form so notably during its brief twenty years of storytelling. After all pantomime has always been the universal means of communication. It existed as the universal tool long before language was born. Pantomime serves well where languages are in the conflict of

a common ignorance. Primitive folk used the sign language before they were able to form an intelligible word.

At what point in the world's history pantomime first made its appearance is speculative. Undoubtedly it greatly antedates the first records of its part in Greek culture. It reached a highly definite development in Rome and was a distinct factor in the medieval mystery plays. Ancient Egypt was adept in its use, and in the sacrificial rites of Druidism and in the war dances of the aborigines of all lands it has a fixed place.

Pantomime lies at the base of any form of drama. In the silent form of the photoplay it is the keynote. In the vocal form it must always be an essential, because nonvisual drama leads altogether too much to the imagination. If there is any doubt of this, an example is the radio play.

Action is more generally understood than words. The lift of an eyebrow, however faint, may convey more than a hundred words. Like the Chinese symbolism it will mean different things, according to its scenic connotation. Listen to a description of some unfamiliar object—an African warthog, for example—then describe it; observe a picture of the animal and then note the variety of astonishment.

We hear a great deal about children not going to the movies anymore, and it is undoubtedly true that hundreds of thousands of prospective film patrons, of future filmgoers, young tots who formerly thrilled to the silent screen, do not attend any more because they are unable to follow the dialogue of talking pictures readily. On the other hand, they do follow action unerringly. This is because the eye is better trained than the ear. There is nothing in *City Lights* that a child won't follow easily and understand.

I am a comedian and I know that pantomime is more important in comedy than it is in pure drama. It may be even more effective in farce than in straight comedy. These two differ in that the former implies the attainment of humour without logical action—in fact, rather the reverse; and the latter achieves this attainment as the outcome of sheer legitimate motivation. Silent comedy is more satisfactory entertainment for the masses than talking comedy, because most comedy depends on swiftness of action, and an event can happen and be laughed at before it can be told in words. Of course, pantomime is invaluable in drama, too, because it serves to effect the gradual transition from farce to pathos or from comedy to tragedy much more smoothly and with less effort than speech can ever do.

I base this statement on recent observations; the sudden arrival of dialogue in motion pictures is causing many of our actors to forget the elementals of the art of acting. Pantomime, I have always believed and still believe, is the prime qualification of a successful screen player. A truly capable actor must possess a thorough grounding in pantomime. Consider the Irvings, Coquelins, Bernhardts, Duses, Mansfields, and Booths, and you will find at the root of their art pantomime.

My screen character remains speechless from choice. *City Lights* is synchronized and certain sound effects are part of the comedy, but it is a nondialogue picture because I preferred that it be that, for the reasons I have given.

A DIALOGUE ON SOUND:
A MANIFESTO (UK, 1934)

Basil Wright and B. Vivian Braun

[First published in *Film Art* (UK) 2 (1934): 28–29.]

This manifesto by British director and producer Basil Wright, best known for *Song of Ceylon* (UK, 1934), and B. Vivian Braun, director of *Beyond This Open Road* (UK, 1934), argues for the orchestration of sound and decries the use of dialogue or natural sounds to simply anchor the image. The manifesto echoes some of the points raised by Chaplin but is also somewhat critical of the notion of contrapuntal sound put forth by the Soviets.

Wright:First we must realise that films have always been sound films, even in the silent days. The bigger the orchestra the better the film appeared.

Vivian Braun: Quite. And now that talk has been made possible. Do you consider it as good an adjunct as music?

W.:No, because a good "talkie" is a stage play possibly improved by the mechanical advantages of the camera. e.g.. pans, close-ups, [and] cutting.

V.B.:You mean that "talkies" are not films?

W.:"Talkies" are technically film, but cinematically they are not.

V.B.:Then the only thing to do is to separate "talkies" and sound films into different categories from the start.

W.:Yes, and so we need not discuss "talkies" any further. Let's go on to sound film proper. To begin with, what do the aesthetes say about sound film?

V.B.:A great deal. Firstly they crack up contrapuntal sound and sound imagery as grand artistic effects.

I believe this was originally due to a typical aesthetic reaction when the talking film first came; they refused to recognize them, quite rightly, and then when a year had passed and talking films had not wilted under their disapproval they went to the other extreme.

W.:Yes. I remember the hanging scene in The Virginian came in for a lot of praise.

V.B.:Still the aesthetes (I am never quite clear as to who these folk are) have a good deal on their side.

W.:Of course they have; most of the opinions are good solid cinema theory, but the difficulty is that they are unaware of this. It doesn't harm the theory, but it vitiates the practice.

V.B.:Well perhaps we had better analyze the advantages of sound and in particular the advantages of sound imagery, if any, and counterpoint.

W.:*But we must not forget that the film is visual so much so that the perfect film should be satisfactory from every point of view without sound, and, therefore, shown in complete silence.*

V.B.:BUT THIS IS NOT TO SAY THAT THE PERFECT FILM COULD NOT BE SUPER-PERFECTED BY THE USE OF SOUND AS AN ADJUNCT.

W.:*The use of sound imagistically, the crosscutting of sound and visuals (counterpoint) can undoubtedly be effective, but this does not mean to say that good visuals could not get the same effect more legitimately—in fact I begin to wonder if sound has any advantage at all.*

V.B.:Yes it has. It can and does undoubtedly intensify the effect of visuals. But it does not necessarily create that effect. The wrong sound (so powerful is sound) can kill the image.

W.:*Yes. And I happen to have seen my pet sequence killed stone dead by the addition of Bach's music, which happens to be better than any film yet made. It killed my visuals because it was too powerful.*

V.B.:Which reminds us that one of the most potent arts is sound.

W.:*What do we mean by sound in connection with film?*

V.B.:Before you start your film you have available every sound in the world from the lark's song to Mae West's voice to the Jupiter symphony to the internal combustion engine.

W.:*And the human voice is no greater in value than any other sound.*

V.B.:When synchronizing your film you select, from all the sounds, those you require. If you put natural sound corresponding to visual image, and in particular concentrate on the human voice, you make a "talkie."

W.:*If you put any natural sound which doesn't correspond with the visual action, you make a dull highbrow film!*

V.B.:If you make a good visual film which is self-contained without any sound, you will find that the only sound which will really intensify your visuals is abstract sound.

W.:*Music is abstract.*

V.B.:But music confines itself, very rightly, to noises produced by a limited number of special instruments. You are at liberty to orchestrate any sound in the world.

W.:*Once orchestrated they will become as abstract as music. Orchestrated abstract sound is the true complement to film. It can intensify the value of, say, an aeroplane in flight in a way which natural aeroplane sound could not achieve—*

V.B.: Because natural sound is uncontrolled. No art is uncontrolled. Abstract sound is completely controlled by the artist, in this case the director of the film. The director

must create his sound as well as his visuals, and as he cannot create natural sound he must orchestrate it for his own purpose.

W.: When he can do this as well as Cézanne orchestrated nature onto canvas, the first real film will have been made.

AMALFI MANIFESTO (Italy, 1967)

Michelangelo Antonioni, Bernardo Bertolucci, Pier Paolo Pasolini, Gillo Pontecorvo, Marco Bellocchio, Vittorio Cottafavi, Vittorio De Sica, Alberto Lattuada, Alfredo Leonardi, Valentino Orsini, Brunello Rondi, Francesco Rosi, Paolo Taviani, Vittorio Taviani

[First published in Italian as "Il manifesto di Amalfi," *Filmcritica* (February 1968): 95. First published in English in *Sight and Sound* 37, no. 3 (1968): 145.]

The dubbing of actors in Italian films stretches back to the emergence of sound. In this manifesto, issued at a symposium on film sound in Amalfi, many of Italy's key filmmakers of the 1960s take a stance against dubbing, arguing that the practice impedes the possibility of Italian cinema producing total works of art and leaves films open to ideological manipulation and censoring by producers and distributors.

Contemporary developments in theoretical studies on the sound film imply the need to take up a position at the outset against the systematic abuse of dubbing, which consistently compromises the expressive values of film. The actors themselves acquire from the habit of post-synchronisation (generally carried out with other people's voices) an increasing detachment from the character they are playing. The techniques of dubbing and the use of stock sound-effects deprive films of the support, on the unitary plane of style, of elements which should be integral to them, and at the same time they subject the film to the manoeuvres and mystifications on the part of producers and distributors, whose final effect has an ideological character. The post-synchronisation of Italian films, when not required for expressive reasons, and the dubbing and translation of foreign films, are two equally absurd and unacceptable sides of one and the same problem . . .

The abolition of the indiscriminate use of dubbing, whose existence compromises the very possibility of an Italian sound cinema, is a vital aspect of the battle to safeguard linguistic research, to protect effective freedom of expression, and to realise and develop a total cinema.

10

THE DIGITAL REVOLUTION

The manifestos in this chapter address, in various ways, the rise of digital technology and its impact on the cinema. Many, responding to the challenges set out by the Dogme '95 manifesto (which offers a seemingly utopian potential for cinema when conveyed through digital video and handheld camera immediacy, with ensuing challenges to feature-film conventions in narrative, characterization, sound, and cinematography), raise issues surrounding the DIY approach to filmmaking and are particularly concerned with the ways in which young, aspiring filmmakers can make films inexpensively, while at the same time addressing the specificity of the digital image. The digital image's easy mutability, replicability, and dispensability are all of particular concern here.

Related aspects discussed in this chapter concern the rise of multiple screening formats and the ongoing question of convergence. As Janine Marchessault and Susan Lord note in their introduction to *Fluid Screens, Expanded Cinema:* "The stories consumed in the industrialized democracies of the world are received through a multiplicity of hybrid and networked screens, creating a fragmented reception that increasingly characterizes our waking hours."[1] The manifestos in this chapter reflect the fragmentation of screen sites and the perils and possibilities that emerge from this development. Stan VanDer-Beek's "Culture: Intercom and Expanded Cinema: A Proposal and Manifesto," an expanded cinema manifesto from 1966, foreshadows the world of interconnectivity that the digital can open up. Ana Kronschnabl's well-known "Pluginmanifesto" also foregrounds the DIY aesthetic, outlining at the same time the need for a new form of cinema to accompany the new ways in which films are viewed in a digital and virtual world. Other manifestos, such as Khavn de la Cruz's "Digital Dekalogo," address questions of access in the face of rising film production costs and the face of globalization. Samira Makhmalbaf's "The Digital Revolution and the Future of Cinema" addresses access, as well, but Makhmalbaf also maps out the ways in which digital production has changed not only our means of access but how we understand the cinema itself.

CULTURE: INTERCOM AND EXPANDED CINEMA: A PROPOSAL AND MANIFESTO (USA, 1966)

Stan VanDerBeek

[First published in *Film Culture* 40 (1966): 15–18.]

Using the phrase "expanded cinema" four years before Gene Youngblood's ground-breaking book *Expanded Cinema* (1970), Stan VanDerBeek's manifesto proposes, among other things, a "movie-drome": a screening process that will help transcend the gap between the developed and developing world in a time when it often seems that the planet is on the precipice of nuclear destruction.

I should like to share with you a vision I have had concerning motion pictures. This vision concerns the immediate use of motion pictures . . . or expanded cinema, as a tool for world communication . . . and opens the future of what I like to call "Ethos-Cinema." Motion pictures may be the most important means for world communication. At this moment motion pictures are the art form of our time.

We are on the verge of a new world/new technology/a new art.

When artists shall deal with the world as a work of art.

When we shall make motion pictures into an emotional experience tool that shall move art and life closer together.

All this is about to happen.

And it is not a second too soon. We are on the verge of a new world new technologies new arts

"CULTURE: INTERCOM" AND EXPANDED CINEMA.

It is imperative that we quickly find some way for the entire level of world human understanding to rise to a new human scale.

This scale is the world . . .

The technological explosion of this last half-century, and the implied future are overwhelming, man is running the machines of his own invention.

while the machine that is man . . . runs the risk of running wild.

Technological research, development and involvement of the world community has almost completely out-distanced the emotional-sociological (socio-"logical") comprehension of this technology.

It is imperative that each and every member of the world community, regardless of age and cultural background, join the 20th century as quickly as possible.

The "technique-power" and "culture-over-reach" that is just beginning to explode in many parts of the earth, is happening so quickly that it has put the logical fulcrum of man's intelligence so far outside himself that he cannot judge or estimate the results of his acts before he commits them. The process of life as an experiment on earth has never been made clearer.

It is this danger . . . that man does not have time to talk to himself . . .

that man does not have means to talk to other men . . .

the world hangs by a thread of verbs and nouns.

Language and culture-semantics are as explosive as nuclear energy.

It is imperative that we (the world's artists) invent a new world language . . . that we invent a non-verbal international picture-language . . .

I propose the following:

That immediate research begin on the possibility of an international picture-language using fundamentally motion pictures.

That we research immediately existing audio-visual devices, to combine these devices into an educational tool, that I shall call an "experience machine" or a "culture-intercom."
. . .

The establishment of audio-visual research centers . . . preferably on an international scale . . .

These centers to explore the existing audio-visual hardware . . .

The development of new image-making devices . . .

(the storage and transfer of image materials, motion pictures, television, computers, video-tape, etc. . . .)

In short, a complete examination of all audio-visual devices and procedures, with the idea in mind to find the best combination of such machines for non-verbal inter-change.

The training of artists on an international basis in the use of these image tools.

The immediate development of prototype theatres, hereafter called "Movie-Dromes" that incorporate the use of such projection hardware.

The immediate research and development of imago-events and performances in the "Movie-Drome." . . .

I shall call these prototype presentations: "Movie-Murals," "Ethos-Cinema," "Newsreel of Dreams," "Feedback," "Image libraries" . . .

The "movie-drome" would operate as follows . . .

In a spherical dome, simultaneous images of all sorts—would be projected on the entire dome-screen . . . the audience lies down at the outer edge of the dome with their feet towards the center, thus almost the complete field of view is the dome-screen. Thousands of images would be projected on this screen . . . this image-flow could be compared to the "collage" form of the newspaper, or the three ring circus . . . (both of which suffice the audience with an [sic] collision of facts and data) . . . the audience takes what it can or

wants from the presentation . . . and makes its own conclusions . . . each member of the audience will build his own references from the image-flow, in the best sense of the word the visual material is to be presented and each individual makes his own conclusions or realizations.

A particular example . . .

To prepare an hour-long presentation in the "movie-drome" using all sorts of multi-plex images, depicting the course of western civilization since the time of the Egyptians to the present . . . a rapid panoply of graphic: and light calling upon thousands of images, both still and in motion (with appropriate "sound-images"). It would be possible to compress the last three thousand years of western life into such an aspect ratio that we, the audience, can grasp the flow of man, time, and forms of life that have lead [sic] us *up to the very moment* . . . details are not important, it is the total scale of life that is . . . in other words . . . using the past and the immediate present to help us understand the likely future. . . .

Endless filmic variations of this idea are possible in each field of man's endeavor . . . science, math, geography . . . art, poetry, dance, biology, etc. . . . Endless interpretations and variations of this idea by *each* culture group and nationality that take it on as a project . . . to be presented in turn to each other culture group . . . (by telstar, film exchange, "film-mobiles," traveling shows, etc. . . .). The purpose and effect of such image-flow, and image density, (also to be called "visual-velocity"), is to both deal with logical understanding, and to penetrate to unconscious levels, the use of such "emotion-xspictures" would be to reach for the "emotional denominator" of all men . . .

The basis of human life thought and understanding that is non-verbal to provide images that inspire basic intuitive instinct of self-realization to inspire all men to good will and "inter and intra-realization" . . .

When I talk of the movie-dromes as image libraries, it is understood that such "life-theatres" would use some of the coming techniques (video tape and computer inter-play) and thus be real communication and storage centers, that is, by satellite, each dome could receive its images from a world wide library source, store them and program a feedback presentation to the local community that lived near the center, this news-reel feedback, could authentically review the total world image "reality" in an hour long show that gave each member of the audience a sense of the entire world picture . . . the let us say world's work of the month put into an hour.

"Intra-communitronics," or dialogues with other centers would be likely, and instant reference material via transmission television and telephone could be called for and received at 186,000 m.p.s. . . . from anywhere in the world.

Thus I call this presentation, a "newsreel of ideas, of dreams, a movie-mural."

An image library, a culture de-compression chamber, a culture-inter-com" . . . my concept is in effect the maximum use of the maximum information devices that we *now* have at our disposal. . . .

Certain things might happen . . . if an individual is exposed to an overwhelming information experience . . .

It might be possible to re-order the levels of awareness of any person . . . it certainly will re-order the structure of motion pictures as we know them . . .

Cinema will become a "performing" art . . . and image-library.

I foresee that such centers will have its artist in residence who will orchestrate the image material he has at his disposal . . .

And will lead to a totally new international art form . . .

That in probing for the "emotional denominator," it would be possible by the visual "power" of such a presentation to reach any age or culture group irregardless of culture and background.

The "experience machine" could bring anyone on earth *up to the twentieth century.*

As the current growth rate risk of explosions to human flesh continues, the risk of survival increases accordingly.

It now stands at 200 pound of TNT per human pound of flesh . . . per human on earth.

There are an estimated 700 million people who are unlettered in the world . . . we have no time to lose.

Or miscalculate . . .

The world and self-education process must find a quick solution to re-order itself a revision of itself, an awareness of itself . . .

That is, each man, must somehow realize the enormous scale of human life and accomplishments on earth right now . . .

Man must find a way to leap over his own prejudices, apprehensions . . .

The means are on hand . . . here and now . . .

In technology and the extension of the senses . . .

To summarise:

My concern is for a way for the over-developing technology of part of the world to help the underdeveloped emotional-sociology of *all* of the world to catch up to the twentieth century . . . to counter-balance technique and logic—and to do it now, quickly . . .

My concern is for world peace and harmony . . .

The appreciation of individual minds . . .

The interlocking of good wills on an international exchange basis . . .

The interchange of images and ideas . . .

A realization of the process of "realization" of self-education . . .

In short: a way for all men to have fore-knowledge

By Advantageous use of past and immediate knowledge . . .

Mankind faces the immediate future with doubt on one hand and molecular energy on the other . . .

He must move quickly and surely to preserve his future . . .

He must realize the present . . .

The here and now . . . right now.

An international picture-language is a tool to build the future . . .

THE DIGITAL REVOLUTION AND THE FUTURE CINEMA (Iran, 2000)

Samira Makhmalbaf

[First presented as a lecture at the 2000 Cannes Film Festival on 9 May 2000.]

In this manifesto on the future of cinema Iranian director Samira Makhmalbaf, like many of those writing around the time of the centenary of the cinema, addresses its supposed death and sees the digital revolution as a means by which to both democratize access to filmmaking and allow people from impoverished nations to create cinema.

Cinema has always been at the mercy of political power, particularly in the East, financial capital, particularly in the West, and the concentration of means of production, anywhere in the world. The individual creativity of artists throughout the twentieth century has much suffered from the whimsical practices of this odd combination of forces. The situation at the threshold of the twenty-first century seems to have altered radically. With astonishing technological innovations now coming to fruition, artists no longer seem to be totally vulnerable to these impediments.

In the near future, the camera could very well turn into the simulacrum of a pen, comfortably put at the disposal of the artist, right in the palm of her hand. If, as it has been suggested, "the wheel is the advancement of the human feet," then we might also say that the camera is the advancement of the creative eye of the filmmaker.

Earlier in the twentieth century, because of the overwhelming weight of the camera, the difficulty of operating it, and the need for technical support, this eye was cast like a heavy burden on the thoughts and emotions of the filmmaker. But today, following the digital revolution, I can very easily imagine a camera as light and small as a pair of eye-glasses, or even a pair of soft-lenses comfortably and unnoticeably placed inside the eye and on the cornea.

Three modes of external control have historically stifled the creative process for a filmmaker: political, financial and technological. Today with the digital revolution, the camera will bypass all such controls and be placed squarely at the disposal of the artist. The genuine birth of the author cinema is yet to be celebrated after the invention of the "camera-pen," for we will then be at the dawn of a whole new history in our profession. As filmmaking becomes as inexpensive as writing, the centrality of capital in creative process will be radically diminished.

The distribution of our work will of course continue to be at the mercy of capital. Equally compromised will be governmental control and censorship, because we will be able to "screen" our film on the Internet and have it watched by millions around the globe in the privacy of their own living rooms. But that will not be the end of censorship because

self-censorship for fear of persecution by religious fanaticism and terror will continue to thwart the creative imagination.

If the camera is turned into a pen, the filmmaker into an author, and the intervening harassment of power, capital and the means of production are all eliminated, or at least radically compromised, are we not then at the threshold of a whole new technological change in the very essence of cinema as a public media? I tend to believe that because of the increasingly individual nature of cinematic production, as well as spectatorship, the cinema of the twentieth century will become the literature of the twenty-first century.

Are we then attending an historical moment when cinema is being in effect eulogised? Is cinema about to die? François Truffaut made a film about the death of literature with the appearance of cinema. If Truffaut were alive today, would he not be tempted to try it again and make a film about the death of cinema at the hand of author digital? Or would he not imagine the granddaughter of Tarkovsky or Ford preserving the films of their grandfather somewhere in the North Pole?

I tend to think that the digital revolution is really the latest achievement of technological knowledge and not the summation of what artists still have to say. It is as if this revolution has been launched against certain cinema-related professions, and not against cinema itself. We will continue to have the centrality of scenario, creative editing, mise-en-scene, decoupage and acting. Perhaps the most affected aspects of the digital revolution will be the actual act of filming, light, sound and post-production laboratory works. But certainly not cinema itself.

In the last decade of the twentieth century, the unbalanced relation between the artist and the technician had reached a critical point that could have very well resulted in the death of cinema. Today, though, the relation is reversed and the technological advancements of the instruments of production may in fact result in the death of cinema as an industry and once again give the priority to cinema as an art. The digital revolution will reduce the technical aspect of filmmaking to a minimum and will, instead, maximise the centrality of the filmmaker. Thus, once again the centrality of the human aspect of cinema will overcome the intermediary function of its instruments, and film as an art form will reclaim its original posture.

It seems to me that with the priority of cinema over technique, we will begin to witness the birth of real auteur filmmakers. We still lack the presence of artists, philosophers, sociologists or poets among the filmmakers. Cinema is still in the hands of technicians. Most film schools throughout the world teach the technical rather than the creative aspects of filmmaking. Of course the question will always remain whether or not the creative aspects of filmmaking can really be taught. Whatever the case may be, cinema is today by and large limited to those who have access to expensive cameras. For about six billion inhabitants of the world, today we produce something around 3,000 films every year. Not more than 1,000 cameras are the instruments of this sum of annual cinematic production. When the demographic number of digital cameras improves dramatically, a massive

number of camera-less authors will have an unprecedented opportunity to express their virgin ideas. Under the emerging technological democracy, political and financial hurdles can no longer thwart the effervescence of this thriving art.

Lets imagine a world in which painting a picture would be as difficult as making a film and that the ideas of Dali, Van Gogh or Picasso were to be implemented by a group of technicians. The digital revolution is like giving the potential equivalents of Van Gogh and Picasso a brush for the first time. If PhotoShop or Windows 98 software programs can render Monet, Manet, Pissaro [sic], Cézanne or Matisse redundant, then the digital camera can also make Truffaut, Ray, and Bergman redundant. The digital camera is the death of Hollywood production and not the death of cinema. . . . But would an astronomical increase in the number of auteurs not result in the death of the very idea of the auteur?

The ease with which just about anyone can become a filmmaker will undoubtedly result in an astronomical increase in the annual and per capita film production in every society. The increase in the supply of films will result in a decrease in demand. This will lead to an aggressive competition to overcome the generated noise that levels everything. The competition among the producers will be translated into competition among filmmakers and the potential audience will soon find itself in a huge supermarket, incapable of choosing a favourite product. By the end of the twentieth century, the filmmakers were in a position of power and choice. Would the digital revolution and its ancillary consequence of a massive increase in film production result in a stalemate where there are more people to make films than those who are willing to sit quiet in a dark room for a sustained period of time and actually watch a film? What if buying and operating a camera is as easy as buying a pen and writing with it? Certainly there have never been as many great creative writers as there have been pens in the world. Nor would the inexpensive availability of [a] digital camera mean the disappearance of the creative filmmaker. But cinema as an art will certainly lose its multitudinous audience. The general appeal of cinema may thus be fractured into more specific attractions, and a division of labour and market may take place in world cinema. Gradually, in fact, the audience, as consumers, may begin to dictate the terms of its expectations, and cinematic narrative may begin to be deeply affected by the expectations of its viewers.

In its technological growth, the camera gradually metamorphosed into a monster that in order to register the reality that faced it first had to kill that reality. Remember the scene where the camera and the band of technicians behind it are all gathered to register a close-up of an actor, while the director was trying to convince the actor that she was alone and had no hope of meeting anyone for the longest time. The wretched actor was put in the unenviable position of trying to ignore the platoon of people behind the camera. But now the smaller the camera gets the less it will impose its distorting presence on the nature of reality facing it. The observation of reality will become more direct, more intimate, to the point that the camera can now be literally considered as the very eye of the filmmaker.

If despite all its democratic intentions, Italian neo-realism could not surpass the technical limitations of cinema and witness the daily, routine realities, today such movements as Dogma 95 take full advantage of such technological advancements and reach for what Italian neo-realism could not achieve. We may very soon reach a point when a visual journalism will be possible, and cinema, just like journalism, may be able to perform its critical function in safeguarding democracy. An event may take place on a Saturday, on the basis of which a film may be made on Sunday, screened on Monday and thus have an immediate effect on the daily making of history.

Will the digital revolution result in a situation where cinema becomes an increasingly individual form of art? If feature films can now be produced with a small digital camera and then watched on the Internet on a personal computer, will that technological marvel result in the elimination of the very idea of a collective audience as the defining moment of a cinematic experience?

Imagine state-of-the-art home audio-visual equipment with screens as big as a wall of a living room. In such cases one may think of cinema, just like literature, to become an individual form of art and lose its social function. If the concentration of the means of production in the past had thwarted the creative imagination, cinema still had a particularly social function because of the communal nature of its spectatorship. Any artist, at the moment of creation, imagines herself in front of an audience. That is constitutional to the creative act. If imagining this collective audience is denied the artist then the result will have a catalytic effect on the creative process. On the part of the audience the effect is equally detrimental. If we deny the audience the pleasure of watching a film in the presence of others, cinema will lose one of its distinct and defining characters.

I believe that cinema has much benefited from the social nature of humanity and will not abandon it easily, neither will technological advancement so swiftly change our communal character. Today, most French people have coffee and coffeemakers at home. Why is it that street-side cafes are so full of people? It is the same urge that will bring people to movie houses. Cannes is yet another good example. Although cinema is still a very social event, the need to be part of an even larger crowd brings us together here at Cannes. The pleasure of watching a film here at Cannes is incomparably higher than watching the same film in a smaller festival, in a more modest theatre, and in the company of only a few people. Thus whatever the status of technological innovations, private screening, production and spectatorship, this collective urge will continue to guarantee the social function of cinema as an art form. The social nature of creative imagination will prevent the radical individualisation of cinema even beyond the privatisation of the means of production and spectatorship. The creative act has a vested interest in its remaining social, because eliminating the audience from the mind of an artist will thwart the creative process.

Art is ultimately intended and targeted towards its audience. In this respect art is very much like religious practices. Believing individuals can practice their piety in the privacy of their homes. But the social function of religion inevitably brings people out to

communal practices. If from performing one's religious rituals to drinking a cup of coffee continue to be social acts despite the abundant possibility of their privatisation then the collective need to watch movies in the presence of a crowd will also persist. The irony of this whole development is that in its historical growth cinema gradually found itself in a predicament that like architecture every aspect of its execution was contingent on something else. With the digital revolution, cinema can now retrieve its own status as an art form and yet by virtue of the same development it sees its own social function endangered.

What would be the relationship of the digital revolution to the civil function of imagination and the possibility of a more democratic cinema?

By far the most significant event in the digital revolution is the reversal of the political control in some countries (particularly in the East), and of financial control in others (particularly in the West).

There is another, equally important, consequence to the digital revolution. People in the less prosperous parts of the world have so far been at the receiving end of cinema as an art form. The history of cinema begins with wealthy and powerful nations making film not just about themselves but also about others. This is a slanted relation of power.

Today, one hundred years into the history of cinema, this undemocratic and unjust relation of power shows itself by the fact that not a single film is shown from the entire African continent in Cannes this year. Does Africa have nothing to say? Are Africans incapable of expressing themselves in visual terms? Or is it the unjust distribution of the means of production that has denied African artists this possibility. Another example in the unjust distribution of the means of production is comparing my own family with a nation-state like Syria. During the last year, Syria has produced only one film, and my family two and a half feature films!

With the same logic that the per capita production of film in my family was increased by my father sharing his knowledge and facilities with the rest of the family, the digital revolution will put such knowledge and facilities at the disposal of a larger community of artists. Imagine new, more diversified, and far more democratic sections of the Cannes Film Festival in the year 2010, all occasioned by the digital revolution.

Another crucial consequence of the digital revolution is that cinema will lose its monological, prophetic voice and a far more globally predicated dialogue will emerge. Right now some 3,000 films are produced annually for a global population of some 6 billion people, that is to say one film per 20 million people. But not all these 3,000 films have the opportunity of actually being screened. Competition with Hollywood is intense throughout the world. National cinemas are putting up an heroic resistance to Hollywood cinema. Many movie theatres are monopolised by Hollywood productions. There are movie theatres that are reserved for yet-to-be-made films in Hollywood, while the national cinemas are on the verge of destruction.

When there were few books people considered what was written superior truth and if a book was found in a remote village they would attribute its origin to heavenly sources.

When books became abundant, this absolute and sacred assumption was broken and earthly auteurs lost their heavenly presumptions. In the age of the scarcity of cinematic productions *Titanic* has the function of that heavenly book and our world [is] very much like that small village.

The prevailing cinematic view of the world is that of the First World imposed on the Third World. Africa has been seen from the French point of view and not from the African point of view, nor have the French and Americans been seen from the African point of view. The digital revolution will surpass that imbalance. The First World will thus lose its centrality of vision as the dominant view of the world. The globality of our situation will no longer leave any credibility for the assumptions of a centre and a periphery to the world. We are now beyond the point of thinking that we received the technique from the West and then added to it our own substance. As a filmmaker, I will no longer be just an Iranian attending a film festival. I am a citizen of the world. Because from now on the global citizenship is no longer defined by the brick and mortar of houses or the printed words of the press, but by the collective force of an expansive visual vocabulary.

A certain degree of techno-phobia has always accompanied the art of cinema. One can only imagine the fear and anxiety that the first generation of moviegoers felt. Or the first time the French saw [the] Lumières' train on the screen. The cinema of our future will not be immune to technological challenges and opportunities that are taking place around us. Beyond the techno-phobia of the previous generations, however, the new generation will play with these technological gadgets as toys of a whole new game.

It seems to me that this very conference is convened out of a techno-phobic impulse and as a collective mode of therapeutic exercise to alleviate this techno-phobia. Whereas I believe we should consider this event a ritual funeral for technology. Technology has now progressed so much that [it] is no longer technological! All we need [to know] in order to master the operation of a digital camera is how to turn a few buttons, as if unbuttoning our jacket in a dark room. One of our conclusions at the closing of this conference could very well be that after the digital revolution we are all cured of our techno-phobia.

A new fear will now preoccupy filmmakers, and that is whether or not I as an artist have something to say that other people with a digital camera in their hand do not. There is a story in Mathnavi of Rumi, one of our greatest poets, that once a grammarian mounted a ship and headed for the sea. Upon the calm and quite [*sic*] sea he had a conversation with the captain and asked him if he knew anything of syntax and morphology. "No," answered the captain. "Half of your life is wasted," retorted the learned grammarian. A short while later, the ship is caught in the middle of a huge storm. "Do you know how to swim?" asks the captain. "No," says the grammarian. "All your life is wasted," assures the captain.

Twenty years ago if someone wanted to enter the profession of filmmaking she would have been asked if she knew its technique. If she did not she would have been told that she was illiterate about half of the art. Some 20 years later the only question she needs to answer is if she has art.

THE PLUGINMANIFESTO (UK, 2001)

Ana Kronschnabl

["The Pluginmanifesto" was launched at the Watershed Media Centre, Bristol, on 17 May 2001. Published in Ana Kronschnabl and Tomas Rawlings, *Plug In Turn On: A Guide to Internet Filmmaking* (London: Marion Boyars, 2004).]

This manifesto is one of the first to consider the specificity and aesthetics of online film in the age of YouTube. Arguing that the structures that dominate Hollywood film are not conducive to the Internet, the pluginmanifesto postulates a digital cinema made with the specificity of online audiences in mind.

First came the Dogme 95 manifesto, where a collective of directors founded in Copenhagen in spring 1995 expressed the goal of countering "certain tendencies" towards "cosmetics" over content in the cinema today. They remarked, "Today a technological storm is raging, the result of which will be the ultimate democratisation of the cinema." We agree, and now the online film website plugincinema.com is launching the pluginmanifesto, where filmmakers are asked to take advantage of the digital technology revolution.

The pluginmanifesto version 1.1

IT IS CURRENTLY EASIER TO DESCRIBE WHAT AN ONLINE FILM IS NOT THAN WHAT IT IS . . .

Films are familiar to us all, Hollywood films at least. So much so that it is difficult for us to think about film in any other terms. So we must start with experimentation; play with the conventions. Allow yourself the freedom to move in and out of them, adapting them, using them where appropriate. Freed from prescription, it is easier to see the other possibilities open to us in terms of form and structure as well as content.

A FILM MADE FOR VIEWING ON THE INTERNET IS NOT 1_HOURS LONG.

The traditional length of a film—approximately 1 hour 30 minutes—seems right somehow. Much longer and we become restless, much shorter and we feel cheated. Plays also last the same approximate length of time. However, it is the viewing *context* that seems to be the most important element. The short film (10 to 15 minutes) seems the ideal length for the internet. It is the length of time we want to stop for a coffee at work, the length of time we spend having a smoke, or the length of time we don't mind spending viewing a film we don't find easily accessible.

IT DOES NOT HAVE TO HAVE A NARRATIVE—STRUCTURE CAN COME FROM A VARIETY OF MEANS.

Narrative evolved as an intrinsic part of Hollywood filmmaking. Examine other filmmakers such as Deren, Vertov, Godard and Brakhage to see how they structured their films outside the Hollywood narrative tradition. Structure can be created in many ways using colour, music, chapter headings, etc. as a shape from which you can hang the images. Or the structure can simply emerge from within the film, by allowing the content to shape itself.

FORGET HOLLYWOOD . . . FILM CAN BE ART!

It was decided early on in the development of the Hollywood ethos that films were products and not art. Independent filmmakers and artists have always known this to be ill-conceived and have preferred to make films with genuine artistic merit. This usually takes place outside the traditional studio system, although on occasion it happens from within. Film was hijacked very early on in its career. Claim it back! The difference is in the overt aim of the film: whether it is intended to communicate and inform as well as entertain or to simply make money.

LIMITATIONS CAN BE CREATIVE—IF YOU DO NOT HAVE A WIND MACHINE, USE A FAN. IF YOU DO NOT HAVE THE BANDWIDTH, DO NOT EXPECT THE CINEMA.

Filmmaking on the internet is at a truly exciting time. As so little exists that has been designed specifically for viewing on the net, much has been carried across from other mediums such as TV and film. This is not good. It means that the work being shown cannot be appreciated in the form it was originally intended and it also does web films a disservice because audiences complain about the lack of quality: their expectations are for the traditional film, seen in its familiar context. In the same way that film found its own form in relation to theatre, and TV in relation to film, the web filmmaker needs to search for the appropriate form for films on the internet. It is incumbent on the independent filmmaker to be at the forefront of these new technologies less [sic] they be subsumed by the media conglomerates. Independent filmmakers, geeks and artists have an ideal opportunity to experiment and push these technologies creatively and the time is right to do so.

USE CODECS AND COMPRESSION CREATIVELY.

Use the tools that are appropriate for the job. Filmmaking for the internet is not filmmaking for the cinema. We should be taking the tools invented for the medium such as Flash, html, compression algorithms etc. and pushing them to see what they can do in creative terms: our creative terms. That is the job of the filmmaker and artist. The camera and celluloid defined films for the cinema; computers and the internet will define media for the new millennium.

FILMMAKERS AND GEEKS SHOULD BE FRIENDS.

Filmmakers, in order to be good at their craft, have always had to have a certain level of technical knowledge. Many of the short films appearing on the internet have been made by those familiar with the technology, rather than traditional filmmakers. This is no bad thing, however, how much better would those films be if people who have spent their lives learning the craft got together with people who could make the technology work for them? Co-operative and artistic endeavours, the clash of long term assumptions and traditional approaches with new ideas can produce surprising and challenging new work.

NEVER FORGET THE MEDIUM AND THE VIEWING CONTEXT.

Above all, don't believe the hype! Convergence is certainly happening but the potential of these mediums is only just being glimpsed. What is made for the internet currently can enlighten the forms of the future. The challenge is to create these forms now. This is not a televisual system that sits in the corner of our living rooms, but the internet: a huge system of information storage and retrieval for individual users, with no centralised control. Seize the day! and make your work available to millions of people. Be part of shaping the world's next great art form.

DIGITAL DEKALOGO: A MANIFESTO FOR A FILMLESS PHILIPPINES
(The Philippines, 2003)

Khavn de la Cruz

[First written in 2003. First published in the *Philippine Daily Inquirer*, 31 October 2006.]

One of many manifestos by Philippine filmmaker Khavn de la Cruz—whose work is best described as part of international trash cinema—"Digital Dekalogo," like Samira Makhmalbaf's manifesto, addresses the freedom to make films offered by digital technologies to marginalized filmmakers and film cultures, Filipinos in particular.

Film is dead. It is dead as long as the economy is dead, when public taste and creativity are dead, when the imagination of multinational movie companies is dead. At millions of pesos per film production, there is not going to be a lot of happy days for the genuine filmmaker, the true artist who wants to make movies, not brainless displays of breasts and gunfire.

But technology has freed us. Digital film, with its qualities of mobility, flexibility, intimacy and accessibility, is the apt medium for a Third World Country like the Philippines. Ironically, the digital revolution has reduced the emphasis on technology and has reasserted the centrality of the filmmaker, the importance of the human condition over visual junk food.

Film is dead. Please omit the flowers.

I. Economics: A minute of celluloid film including processing costs around P1500. A minute of digital film costs around 3P. Do the math. A galaxy of difference.[2]

II. The only way to make a film is to shoot it. Shoot when you can. Do not delay. If you can finish everything in a day, why not? Sloth is the enemy of the Muse. The shadow filmmaker has now run out of excuses.

III. Your digital camera will not turn you into an instant Von Trier, Figgis, or Soderbergh. Your attitude toward filmmaking should be that of an amateur: half-serious, playful, light, not heavy, thus without baggage. There are no mistakes. The important thing is you learn.

IV. Utilise all the elements within your resources. If you have a knack for music, score your own soundtrack. If you have writing skills, craft your own screenplay. If you have money, invest in gear. If you have none of the above, make sure you have good friends.

V. Work within a minimized budget, cast, crew, location, and shooting schedule. Artificial lighting is not a necessity. The story is king. Everything else follows.

VI. Work with what you have. Release the bricoleur within. You are not a studio. Accept your present condition. Start here.

VII. Forget celebrities. Fuck the star system. Work only with those who are willing to work with you, and those who are dedicated to the craft. Avoid pretentious hangers-on with hidden agendas. Use a lie detector if needed.

VIII. Work with humble, patient, passionate, and courageously creative people. Ignore people that are the opposite.

IX. If you are alone, do not worry. Digital technology has reduced the crew into an option, rather than a must. Making a film by yourself is now possible. The pat is dead. Those who do not change will die.

X. Create first, criticise later. Take care of the quantity. God will take care of the quality—that is, assuming you believe in God. A filmmaker makes films, period.

In the name of the revolution,
Khavn

11

AESTHETICS AND THE FUTURES
OF THE CINEMA

Although prophecies about the future of the cinema and its imminent death emerged almost as soon as the cinema itself, in recent years, with the arrival of digital technology and the celebration/wake of the centenary of the medium in 1995, they have taken on a new urgency. This urgency is tied to changes in the ways that films are produced, distributed, and consumed. Responding to these changes, Susan Sontag famously, during the cinema's centenary, penned its obituary, or at the very least, the obituary of *cinephilia*. In "A Century of Cinema" Sontag wrote: "Cinema's hundred years appear to have the shape of a life cycle: an inevitable birth, the steady accumulation of glories, and the onset in the last decade of an ignominious, irreversible decline. . . . If cinephilia is dead," she concludes, "then movies are dead . . . no matter how many movies, even very good ones, go on being made. If cinema can be resurrected, it will only be through the birth of a new kind of cine-love."[1] She notes that the practices of what she calls the "capitalist and would-be capitalist world—which is to say everywhere" (117)—leads to a product that offers only superficial entertainment. But what Sontag really laments is the death of cinephilia, of a profound conviction that only the cinema mattered, that it was indeed an instantiation of *Gesamtkunstwerk*: "Cinema had apostles (it was like religion). Cinema was a crusade. Cinema was a world view. Lovers of poetry and opera or dance don't think there is *only* poetry or opera or dance. But lovers of cinema could think there was only cinema. That movies encapsulated everything—and they did. It was both the book of art and the book of life" (118). The death of cinephilia was brought on, according to Sontag, by many things: the rise of capital and blockbusters, yes, but also by a proliferation of screens:

> To see a great film only on television isn't to have really seen that film. . . .
>
> No amount of mourning will revive the vanished rituals—erotic, ruminative—of the darkened theatre. . . . Images now appear in any size and on a variety of surfaces: on a screen in a theatre, on home screens as small as the palm of your hand or as big as a wall, on disco walls and mega-screens hanging above sports arenas and the outsides of tall public buildings. The sheer ubiquity of moving images has steadily undermined the standards people once had both for cinema as art at its most serious and for cinema as popular entertainment. (118–119)

The mourning that Sontag undergoes for a certain moment of cinema history is both understandable and wrongheaded. The cinema—from 8.5 mm amateur films of the 1920s to the expanded cinema Stan VanDerBeek addresses in his manifesto contained herein—has always found ways to break out of the studio/art cinema, or "Hollywood/ Mosfilm," paradigms. Similarly, audiences never constituted a collective identity of

cinephiles; the supposition that they did plays exactly into capitalist or totalitarian assumptions that they should. The manifestos contained in this chapter trace this particular aspect of cinema history, namely its interest in defining itself as a completely distinct and epistemologically privileged art form. Concentrating on new screens, like YouTube, and on the artisanal and low-budget DIY movements that can be seen as responses to dominant modes of filmmaking practice, the manifestos in this section call into being a new kind of cine-love that demonstrates the strength and resilience of the cinema when it is understood to be diverse, dynamic, and heterogeneous.

Ricciotto Canudo's "The Birth of the Sixth Art," from 1911, argues for maintaining the specificity of cinema and for the new medium not simply to rely on older forms of art as an aesthetic. Only by developing a new language of the cinema can film take its place as the sixth art. Alexandre Astruc's "The Birth of a New Avant Garde: *La caméra-stylo*" argues that the cinema has not achieved its greatest possibilities because it has been so encumbered by narrative. He argues that the cinema has the potential to be essayistic, to be philosophical, and to engage in any manner of discourse. It is a tool that can be used many ways, and as of yet, he argues, it has not.

Ingmar Bergman's "The Snakeskin," in contrast, is a far more personal manifesto. Writing during the making of *Persona* (1966), Bergman reflects on his artistic practice and the role that the cinema plays as he looks for a way forward in his work after one of his many bouts with depression. In a similar vein Jean-Luc Godard's short manifesto issued with the release of *La Chinoise* (1967) foreshadows the kinds of aesthetic and political choices he makes after *Weekend* (1968) and his move into political filmmaking and his Dziga Vertov period. The "Direct Action Cinema Manifesto" and the "Remodernist Film Manifesto" can be seen as responses to Dogme '95. Like Dogme, both manifestos set out rules for reimagining a new and relevant form of filmmaking. Jia Zhangke's "The Age of Amateur Cinema Will Return" is a final invocation for getting films back into the hands of the people, a concern that has run throughout the history of film manifestos from the earliest days to the present.

THE BIRTH OF THE SIXTH ART
(France, 1911)

Ricciotto Canudo

[First published in French as "Naissance d'une sixième art," Les entretiens idéalistes, 25 October 1911. First published in English in Framework 13 (1980): 3–7.]

This early film manifesto by Ricciotto Canudo argues that the emergence of cinema as a sixth art, as a "plastic art in motion," arises from its fusion of science and art and from its ability to do the opposite of what painting does: instead of capturing a still moment, the cinema allows for the aesthetic documentation of velocity and movement, changing the way in which one represents the world and its elements, foreshadowing what Jim Davis would write about the cinema and art some forty years later (see Davis's "The Only Dynamic Art," in chap. 2 of this volume).

I.

It is surprising to find how everyone has, either by fare or some universal telepathy, the same aesthetic conception of the natural environment. From the most ancient people of the east to those more recently discovered by our geographical heroes, we can find in all peoples the same manifestations of the aesthetic sense; Music, with its complimentary art, Poetry; and Agriculture, with its own two compliments, Sculpture and Painting. The whole aesthetic life of the world developed itself in these five expressions of Art. Assuredly, a sixth artistic manifestation seems to us now absurd and even unthinkable; for thousands of years, in fact, no people have been capable of conceiving it. But we are witnessing the birth of such a sixth art. This statement, made in a twilight hour such as this, still ill-defined and uncertain like all eras of transition, is repugnant to our scientific mentality. We are living between two twilights: the eve of one world, and the dawn of another. Twilight is vague, all outlines are confused; only eyes sharpened by a will to discover the primal and invisible signs of things and beings can find a bearing through the misty vision of the *anima mundi*. However, the sixth art imposes itself on the unquiet and scrutinous spirit. It will be a superb conciliation of the Rhythms of Space (the Plastic Arts) and the Rhythms of Time (Music and Poetry).

II.

The theater has so far best realized such a conciliation, but in an ephemeral manner because the plastic characteristics of the theater are identified with those of the actors, and consequently are always different. The new manifestation of Art should really be more precisely *a Painting and Sculpture developing in Time,* as in music and poetry, which realise themselves by transforming air into rhythm for the duration of their execution.

The cinematograph, so vulgar in name, points the way. A man of genius, who by definition is a miracle just as beauty is an unexpected surprise, will perform this task of mediation which at present seems to us barely imaginable. He will find the ways, hitherto inconceivable, of an art which will appear for yet a long time marvellous and grotesque. He is the unknown individual who tomorrow will induce the powerful current of a new aesthetic function, whence, in a most astonishing apotheosis, the *Plastic Art in Motion* will arise.

III.

The cinematograph is composed of significant elements "representative" in the sense used by Emerson rather than the theatrical sense of the term, which are already classifiable.

There are two aspects of it: the *symbolic* and the *real,* both absolutely modern; that is to say only possible in our era, composed of certain essential elements of modern spirit and energy.

The *symbolic aspect* is that of velocity. Velocity possesses the potential for a great series of combinations, of interlocking activities, combining to create a spectacle that is a series of visions and images tied together in a vibrant agglomeration, similar to a living organism. This spectacle is produced exactly by the excess of movement to be found in film, those mysterious reels impressed by life itself. The reels of the engraved celluloid unroll in front of and within the beam of light so rapidly that the presentation lasts for the shortest possible time. No theater could offer half the changes of set and location provided by the cinematograph with such vertiginous rapidity, even if equipped with the most extraordinarily modern machinery.

Yet more than the motion of images and the speed of representation, what is truly symbolic in relation to velocity are the actions of the characters. We see the most tumultuous, the most inverisimilitudinous scenes unfolding with a speed that appears impossible in real life. This precipitation of movement is regulated with such mathematical and mechanical precision that it would satisfy the most financial runner. Our age has destroyed most earnestly, with a thousand extremely complex means, the love of restfulness, symbolized by the smoking of a patriarchal pipe at the domestic hearth. Who is still able to enjoy a pipe by the fire in peace these days, without listening to the jarring noise

of cars, animating outside, day and night, in every way, an irresistible desire for spaces to conquer? The cinematograph can satisfy the most impatient racer. The motorist who has just finished the craziest of races and becomes a spectator at one of these shows will certainly not feel a sense of slowness; images of life will flicker in front of him with the speed of the distances covered. The Cinematograph, moreover, will present to him the farthest countries, the most unknown people, the least known of human customs, moving, shaking, throbbing before the spectator transported by the extreme rapidity of the representation. Here is the second symbol of modern life constituted by the cinematograph, an "instructive" symbol found in its rudimentary state in the display of "freaks" at the old fairgrounds. It is the symbolic destruction of distances by the immediate connaissance of the most diverse countries, similar to the real destruction of distances performed for a hundred years now by monsters of steel.

The *real aspect* of the cinematograph is made up of elements which arouse the interest and wonder of the modern audience. It is increasingly evident that present day humanity actively seeks its own show, the most meaningful representation of itself. The theater of perennial adultery, the sole theme of the bourgeois stage, is at last being disdained, and there is a movement towards a theater of new, profoundly modern Poets; the rebirth of Tragedy is heralded in numerous confused open-air spectacles representing disordered, incoherent, but intensely willed effort. Suddenly, the cinematograph has become popular, summing up at once all the values of a still eminently scientific age, entrusted to Calculus rather than to the operations of Fantasy *(Fantasia)*, and has imposed itself in a peculiar way as a new kind of theater, a scientific theater built with precise calculations, a mechanical mode of expression. Restless humanity has welcomed it with joy. It is precisely this theater of plastic Art in motion which seems to have brought us the rich promise of the *Festival* which has been longed for unconsciously, the ultimate evolution of the ancient *Festival* taking place in the temples, the theaters, the fairgrounds of each generation. The thesis of a plastic Art in motion has recreated the *Festival*. It has created it scientifically rather than *aesthetically,* and for this reason it is succeeding in this age, although fatally and irresistibly moving towards the attainment of Aesthetics.

IV.

The careful observer who seeks in every movement of the masses a meaning that is in some way eternal, simultaneously traditional and new, cannot fail to register the following considerations of a general psychological order.

At the cinematographic theater, as at the fairground, men became children again. Performances take place between the two pathetic extremes of general emotivity: the *very touching* and the *very comical.* The posters contain and conjoin these two promises of heightened emotion. They should move swiftly, as in life, from one to another. And a primal, childlike humanity forgets itself, allows itself to be transported into a

whirlpool of ultra-rapid representations with an abandon hardly to be found in our prose theater.

At the cinematograph theater, everything is done to retain the attention, almost in suspension, to retain an iron hold on the minds of the audience bolted to the animated screen. The quick gesture, which affirms itself with monstrous precision and clockwork regularity, exalts the modern audience used to living at an ever-increasing velocity. "Real" life is therefore represented in its quintessence, *stylized in speed*.

V.

I move on now to a great aesthetic problem, which must be emphasized. Art has always been essentially a stylization of life into stillness; the better an artist has been able to express the greater number of "typical" conditions, that is, the synthetic and immutable states of souls and forms, the greater the recognition he has attained. The cinematograph, on the contrary, achieves the greatest mobility in the representation of life. The thought that it might open the unsuspected horizon of a new art different from all pre-existing manifestations cannot fail to appeal to an emancipated mind, free from all traditions and constraints. The ancient painters and engravers of prehistoric caves who reproduced on reindeer bones the contracted movements of a galloping horse, of the artists who sculpted cavalcades on the Parthenon friezes, also developed the device of stylizing certain aspects of life in clear, incisive movements. But the cinematograph does nor merely reproduce one aspect; it represents the whole of life in action, and in such action that, even when the succession of its characteristic events unravel slowly, in life, it is developed with as much speed as possible.

In this way cinematography heightens the basic psychic condition of western life which manifests itself in action, just as eastern life manifests itself in contemplation. The whole history of western life reaches to people in the dynamism characteristic of our age, while the whole of humanity rejoices, having found again its childhood in this new *Festival*. We could not imagine a more complex or more precise movement. Scientific thought with all its energy, synthesizing a thousand discoveries and inventions, has created out of and for itself this sublime spectacle. The cinematographic visions pass before its eyes with all the electrical vibrations of light, and in all the external manifestations if its inner life.

The cinematograph is thus the theater of a new Pantomime, consecrated *Painting in motion*, it constitutes the complete manifestation of a unique creation by modern man. As the modern Pantomime, it is the new *dance of manifestations*. Now it is necessary to ask of the cinematograph, is it to be accepted within the confines of the arts?

It is not yet an art, because it lacks the freedom of choice peculiar to plastic *interpretation*, conditioned as it is to being the *copy* of a subject, the condition that prevents photography from becoming an art. In executing the design of a tree on a canvas, the painter expresses without any doubt, unconsciously and in a particular and clear configuration, his global interpretation of the vegetative soul, that is of all the conceptual elements de-

posited deep in his creative spirit by an examination of the trees he has seen in his life; as Poe said, with the "eyes of dream." With that particular form he synthesizes corresponding souls and his art, I repeat, will gain in intensity in proportion to the artist's skill in *immobilizing* the essence of things and their universal meanings in a particular and dear configuration. Whoever contented himself with copying the outlines, with imitating the colors of a subject, would be a poor painter; the great artist extends a fragment of his cosmic soul in the representation of a plastic form.

Arts are the greater the less they *imitate* and the more they *evoke* by means of a synthesis. A photographer, on the other hand, does not have the faculty of choice and elaboration fundamental to Aesthetics; he can only put together the forms he wishes to reproduce, which he really is not reproducing, limiting himself to cutting out images with the aid of the luminous mechanism of a lens and a chemical composition. The cinematograph, therefore, cannot today be an art. But for several reasons, the cinematographic theater is the first abode of the new art—art which we can just barely conceive. Can this abode become a "temple" for aesthetics?

A desire for an aesthetic organization drives entrepreneurs towards certain kinds of research. In an age lacking in imagination, such as ours, when an excess of documentation is everywhere, weakening artistic creativity, and patience games are triumphing over expressions of creative talent, the cinematograph offers the paroxysm of the spectacle: objective life represented in a wholly exterior manner, on the one hand with rapid miming, on the other with documentaries. The great fables of the past are retold, mimed by ad hoc actors chosen from the most important stars. What is shown above all is the appearance rather than the essence of contemporary life, from sardine fishing in the Mediterranean to the marvel of flying steel and the indomitable human courage of the races at Dieppe or the aviation week at Rheims.

But the entertainment makers are already experimenting with other things. It is their aim that this new mimetic representation of "total life" take ever deeper root, and Gabrielle D'Annunzio has dreamed up a great Italian heroic pantomime for the cinematograph. It is well known that there exist in Paris societies which organize a kind of "trust" for cinematographic spectacles among writers. Hitherto the theater has offered writers the best chance of becoming rich quickly; but the cinematograph requires less work and offers better returns. At this moment hundreds of talented people, attracted by the promise of immediate and universal success, are concentrating their energies towards the creation of the modern Pantomime. And it will come out of their strenuous efforts and from the probable genius of one of them. The day such work is given to the world will mark the birthday of a wholly new art.

VI.

The cinematograph is not only the perfect outcome of the achievements of modern science, which it summarizes wonderfully. It also represents, in a disconcerting but impor-

tant way, the most recent product of contemporary theater. It is not the exaggeration of a principle, bur its most logical and ultimate development. The "bourgeois" dramatics, like all of our playwrights, should spontaneously acknowledge the cinematograph as their most discreet representative, and should in consequence ready themselves for its support by making use of it, because the so-called psychological, social drama, etc., is nothing bur a degeneration of the original comic theater, counterposed with the tragic theater of fantasy and spiritual ennoblement, the theater of Aristophanes and Plautus. Vitruvius, describing as an architect the many different sets used in ancient performances, talks about the solemnity of columns and temples of the tragic theater, about the wood of the satyric theater, and about sylvan adventures and the houses of the middle classes where the *commedias* took place. The latter were but the representation of daily life in its psychological and social aspects, that is, of customs and characteristics.

Shakespeare, who synthesized for the theatrical art the wild and artistic vigor of the great talents of his race, by his own predecessors, was himself the precursor of our own psychological theater. And above all he was the great dramatist of the theater without music. This theatrical form is absurd when applied to tragedy (in this sense the very important, but not truly brilliant art of Racine and Corneille, undoubtedly more deeply tragic in a collective and religious sense, is an art of aberration). On the other hand, a theater without music is not at all absurd if it represents an ephemeral life, everyday life, to capture some of its aspects without pretending, and in any case without being able to fix its "activity" in a profound sense. This is the reason, then, why comedy, from Aristotle to Becque, or Porto-Riche to Hervieu, continues to exist and to be enjoyed, even in its altered form which has become "serious," called drama. The basis of such dramas is the portrayal of common contemporary life, and for this very reason this type of theater is realistic, or as the Italians called it, *rivista*. All our playwrights writing for the indoor theater (as against the small band of new poets of the open-air theaters) mean to portray life as accurately as possible by copying it. Impresarios, theater directors, take this principle to extremes, to the point of attributing more importance to a painstakingly photographic scenography than to the works themselves.

Now, all the cinematograph does is to exalt the principle of the representation of life in its total and exclusively exterior "truth."

It is the triumph of that artistic view called by Cézanne with sacred disdain: *l'œil photographique.*

VII.

The cinematograph, on the other hand, adds to this type of theater the element of *absolutely accurate* speed, in this way inducing a new kind of pleasure that the spectator discovers in the extreme precision of the spectacle. In fact, none of the actors moving on the illusory stage will betray his part, nor would the mathematical development of the action lag for a fraction of a second. All movement is regulated with clockwork precision.

The scenic illusion is therefore less engaging, in a sense less physical, but terribly absorbing. And this life, regulated as if by clockwork, makes one think of the triumph of modern scientific principle as a new Alviman, master of the mechanics of the world in Manichean doctrine.

The rapid communion of viral energies between the two opposite poles of the *very touching* and the *very comical* produces in the spectator a sense of relaxation. Everything which in real life presents itself as an obstacle, the inevitable slowness of movements and actions in space, is as if suppressed in the cinematograph. Moreover, the *very comical* soothes the mind, lightening existence of the weight of the somber social cape, imposed by the thousand conventions of the community and representing all kinds of hierarchies. The comic can suppress hierarchies, it can join together the most different beings, give an extraordinary impression of the mixture of the most separate universes, which in real life are irreducibly distinct from one another. Since the comic is essentially irreverent, it gives a deep sense of relief to individuals oppressed in every moment of their real lives by social discriminations, so emphatically present. This sense of relief is one of the factors of that nervous motion of contraction and expansion called laughter. Life is *simplified* by the grotesque, which is nothing other than the deformation *per excessum* or *per defectum* of the established forms. The grotesque, at least in this sense, relieves life of its inescapable grimness and releases it into laughter.

Caricature is based on the display and masterful combination of the most minimal facets of the human soul, its weak spots, which gush forth from the irony of social life, which is itself, after all, somewhat ironical and insane. With irony, in the convulsive motion of laughter, caricature provokes in man this feeling of extreme lightness, because irony throws over its raised shoulders Zarathustra's "dancing and laughing" cape of many colors.

The ancients were able to perceive in irony the roots of Tragedy. They crowned their tragic spectacles in laughter, in the farce. Conversely, we precede rather than follow the dramatic spectacle with Farce, immediately upon the raising of the curtain, because we have forgotten the significance of some of the truths discovered by our forebears. Yet the need for an *ironic spectacle* persists. And the Farce of the Orestes Tetralogy of Aeschylus, the Farce which could not be found, must have been originally immensely rich in humor to have been able to lighten the spirit of the elegant Athenian women oppressed by the sacred terror of Cassandra. Now I do not know of anything more superbly grotesque than the antics of film comics. People appear in such an extravagant manner that no magician could pull anything like them our of a hat; movements and vision change so rapidly that no man of flesh and blood could present so many to his fellows, without the help of that stunning mixture of chemistry and mechanics, that extraordinary creator of emotions that is the cinematograph. A new comic type is thus created. He is the man of blunders and metamorphoses who can be squashed under a wardrobe of mirrors, or fall head-first breaking through all four floors of a four-story building, only to climb up out of the chimney to reappear on the roof in the guise of a genuine snake.

The complexity of this new kind of spectacle is surprising. The whole of human activity throughout the centuries had contributed to its composition. When artists of genius bestow rhythms of Thought and Art on this spectacle, the new Aesthetics will show the cinematographic theater some of its most significant aspects.

In fact the cinematographic theater *is the first new theater*, the first authentic and fundamental theater of our time. When it becomes truly aesthetic, complemented with a worthy musical score played by a good orchestra, even if only representing life, real life, momentarily fixed by the photographic lens, we shall be able to feel then our first *sacred* emotion, we shall have a glimpse of the spirits, *moving* towards a vision of the temple, where Theater and Museum will once more be restored for a new religious communion of the spectacle and Aesthetics. The cinematograph as it is today will evoke for the historians of the future the image of the first extremely rudimentary wooden cheaters, where goats have their throats slashed and the primitive "goat song" and "tragedy" were danced, before the stone apotheosis consecrated by Lycurgus, even before Aeschylus' birth, to the Dionysian theater.

The modern public possess an admirable power of "abstraction" since it can enjoy some of the most absolute abstractions in life. In the Olympia, for instance, it was possible to see the spectators finally applauding a phonograph placed on the stage and adorned with flowers whose shining copper trumpet had just finished playing a love duet.... The machine was triumphant, the public applauded the ghostly sound of far away or even dead actors. It is with such an attitude that the public go to the cinematographic theater. Moreover, the cinematograph brings, in the midst of even the smallest human settlement, the spectacle of distant, enjoyable, moving or instructive things: it spreads culture and stimulates everywhere the eternal desire for the representation of life in its totality.

On the walls of the cinematographic theater at times one can see inscriptions commemorating the latest achievements of this prodigious invention which accelerates our knowledge of universal events and reproduces everywhere life and the experience of life since 1830 to the present day. Among the latest heroes are Renault, Edison, Lumière, the Pathé brothers.... But what is striking, characteristic, and significant, even more than the spectacle itself, is the uniform will of the spectators, who belong to all social classes, from the lowest and least educated to the most intellectual.

It is desire for a new *Festival*, for a new joyous unanimity, realized at a show, in a place where together, all men can forget in greater or lesser measure, their isolated individuality. This forgetting, soul of any religion and spirit of any aesthetic, will one day be superbly triumphant. And the Theater, which still holds the vague promise of something never dreamt of in previous ages: *the creation of a sixth art, the plastic Art in motion*, having already achieved the rudimentary form of the modern pantomime.

Present day life lends itself to such victory . . .

The elder Franconi, last hero of the circus, mourned the already certain decadence of the circus, attributing it more to the passion for the cinematograph than to the circus-like

performance of the music hall. The fact is that the collective psyche has been impressed by sports in which it takes part intensely, and with which it has complicated its own real existence, turning them into an industry more than anything else. Our age has therefore created various *heroic industries,* aviation being the most brilliant of them. Our sportsmen no longer regard sport merely as pleasure, the most impetuous, the healthiest of pleasures. A golden ring more rigid than iron, the business circle, holds them in an inescapable grip. Why then sit in a chair watching others do acrobatic exercises and somersaults, content with a very pale image of what life gives so lavishly in the shapes of a thousand modern sports?

Summing up, then, painting consists of the still representation of a gesture, an attitude, or a whole body of gestures and attitudes, or yet again of certain significant representations of living beings and of objects. But who could have dreamt of *successive series of pictures* strung together? A successive series of paintings, that is of certain moods of living beings and objects put together in an event—that is what life is, without doubt. Each passing minute composes, decomposes, transforms an incalculable number of pictures before our eyes. The successful cinematograph film can fix and reproduce them *ad infinitum.* In fixing them, it performs an action previously reserved to painting, or to that weak, merely mechanical copy of painting which is photography. By presenting a succession of gestures, of represented attitudes, just as real life does in transporting the picture from space, where it existed immobile and enduring, into time, where it appears and is immediately transformed, the cinematograph can allow us a glimpse of what it could become if a real, valid, directing idea could co-ordinate the pictures it produces along the ideal and profoundly significant line of a central aesthetic principle. We are able, therefore, to think of a plastic Art in motion, the sixth art. Who could have done it before now? No one, because the spiritual development of mankind had not yet succeeded in experiencing such a strong desire for the reconciliation of Science and Art, for the complex representation of life as a whole. The cinematograph renews more strongly every day the promise of such a great conciliation, not only between Science and Art, but between the Rhythms of Time and the Rhythms of Space.

THE BIRTH OF A NEW AVANT GARDE:
LA CAMÉRA-STYLO (France, 1948)

Alexandre Astruc

[First published in French as "Naissance d'une nouvelle avant-garde," in *Écran*, no. 144 (30 March 1948). First published in English in Peter Graham, ed., *The New Wave* (London: Secker and Warburg, 1968), 17–23.]

In this manifesto, filmmaker and critic Alexandre Astruc first articulates his conception of *la caméra-stylo,* arguing the cinema can accomplish all that writing can but

has been limited by its connection to narrative and to superficial fairground spectacle. Once the cinema transcends these self-imposed limitations, it will manifest its ability to address the most philosophical and abstract concerns of the era. This kind of cinema, prophesied by Astruc, reaches it apotheosis with Guy Debord's final feature, *In girum imus nocte et consumimur igni* (France, 1978), where Debord states in voice-over: "It is society and not technology that has made the cinema what it is. The cinema could have been historical examination, theory, essay, memories. It could have been the film I am making at this moment."

WHAT INTERESTS ME IN THE CINEMA IS ABSTRACTION.
—ORSON WELLES

One cannot help noticing that something is happening in the cinema at the moment. Our sensibilities have been in danger of getting blunted by those everyday films which, year in year out, show their tired and conventional faces to the world.

The cinema of today is getting a new face. How can one tell? Simply by using one's eyes. Only a film critic could fail to notice striking facial transformation which is taking place before our eyes. In which films can this new beauty be found? Precisely those which have been ignored by the critics. It is not just a coincidence that Renoir's *La Règle du Jeu*, Welles's films, and Bresson's *Les Dames du Bois de Boulogne*, all films which establish the foundation of a new future for the cinema, have escaped the attention of critics who in any case were not capable of spotting them.

But it is significant that the films which fail to obtain the blessing of the critics are precisely those which myself and several of my friends all agree about. We see in them, if you like, something of the prophetic. That's why I am talking about *avant-garde*. There is always an *avant-garde* when something new takes place . . .

To come to the point: the cinema is quite simply becoming a means of expression, just as all the other arts have been before it, and in particular painting and the novel. After having been successively a fairground attraction, an amusement analogous to boulevard theatre, or a means of preserving the images of an era, it is gradually becoming a language. By language, I mean a form in which and by which an artist can express his thoughts, however abstract they may be, or translate his obsessions exactly as he does in the contemporary essay or novel. That is why I would like to call this new age of cinema the age of *caméra-stylo* (camera-pen). This metaphor has a very precise sense. By it I mean that the cinema will gradually break free from the tyranny of what is visual, from the image for its own sake, from the immediate and concrete demands of the narrative, to become a means of writing just as flexible and subtle as written language. This art, although blessed with an enormous potential, is an easy prey to prejudice; it cannot go on forever ploughing the same field of realism and social fantasy which has been bequeathed to it by the popular novel. It can tackle any subject, any genre. The most philosophical meditations on human production, psychology, metaphysics, ideas, and passions lie well within its province. I will even go so far as to say that contemporary ideas and philosophies

of life are such that only the cinema can do justice to them. Maurice Nadeau wrote in an article in the newspaper *Combat:* If Descartes lived today, he would write novels. With all due respect to Nadeau, a Descartes of today would already have shut himself up in his bedroom with a 16mm camera and some film, and would be writing his philosophy on film: for his *Discours de la Méthode* would today be of such a kind that only the cinema could express it satisfactorily.

It must be understood that up to now the cinema has been nothing more than a show. This is due to the basic fact that all films are projected in an auditorium. But with the development of 16mm and television, the day is not far off when everyone will possess a projector, will go to the local bookstore and hire films written on any subject, of any form, from literary criticism and novels to mathematics, history, and general science. From that moment on, it will no longer be possible to speak of *the* cinema. There will be *several* cinemas just as today there are several literatures, for the cinema, like literature, is not so much a particular art as a language which can express any sphere of thought.

This idea of the cinema expressing ideas is not perhaps a new one. Feyder has said: I could make a film with Montesquieu's *L'Esprit des Lois.* But Feyder was thinking of illustrating it with pictures just as Eisenstein had thought of illustrating Marx's *Capital* in book fashion. What I am trying to say is that the cinema is now moving towards a form which is making it such a precise language that it will soon be possible to write ideas directly on film without even having to resort to those heavy associations of images that were the delight of the silent cinema. In other words, in order to suggest the passing of time, there is no need to show falling leaves and then apple trees in blossom; and in order to suggest that a hero wants to make love there are surely other ways of going about it than showing a saucepan of milk boiling over on to the stove, as Clouzot does in *Quai des Orfèvres.*

The fundamental problem of the cinema is how to express thought. The creation of this language has preoccupied all the theoreticians and writers in the history of the cinema, from Eisenstein down to the scriptwriters and adaptors of the sound cinema.

But neither the silent cinema, because it was the slave of a static conception of the image, nor the classical sound cinema, as it has existed right up to now, has been able to solve this problem satisfactorily. The silent cinema thought it could get out of it through editing and the juxtaposition of images. Remember Eisenstein's famous statement: Editing is for me the means of giving movement (i.e. an idea) to two static images. And when sound came, he was content to adapt theatrical devices.

One of the fundamental phenomena of the last few years has been the growing realisation of the dynamic, i.e. significant, character of the cinematic image. Every film, because its primary function is to move, i.e. to take place in time, is a theorem. It is a series of images which, from one end to the other, have an inexorable logic (or better even, a dialectic) of their own. We have come to realise that the meaning which the silent cinema tried to give birth to through symbolic association exists within the image itself, in the development of the narrative, in every gesture of the characters, in every line of

dialogue, in those camera movements which relate objects to objects and characters to objects. All thought, like all feeling, is a relationship between one human being and another human being or certain objects which form part of his universe. It is by clarifying these relationships, by making a tangible allusion, that the cinema can really make itself the vehicle of thought. From today onwards, it will be possible for the cinema to produce works which are equivalent, in their profundity and meaning, to the novels of Faulkner and Malraux, to the essays of Sartre and Camus. Moreover we already have a significant example: Malraux's *L'Espoir,* the film which he directed from his own novel, in which, perhaps for the first time ever, film language is the exact equivalent of literary language.

Let us now have a look at the way people make concessions to the supposed (but fallacious) requirements of the cinema. Script-writers who adapt Balzac or Dostoyevsky excuse the idiotic transformations they impose on the works from which they construct their scenarios by pleading that the cinema is incapable of rendering every psychological or metaphysical overtone. In their hands, Balzac becomes a collection of engravings in which fashion has the most important place, and Dostoyevsky suddenly begins to resemble the novels of Joseph Kessel, with Russian-style drinking-bouts in night-clubs and troika races in the snow. Well, the only cause of these compressions is laziness and lack of imagination. The cinema of today is capable of expressing any kind of reality. What interests us is the creation of this new language. We have no desire to rehash those poetic documentaries and surrealist films of twenty-five years ago every time we manage to escape the demands of a commercial industry. Let's face it: between the pure cinema of the 1920s and filmed theatre, there is plenty of room for a different and individual kind of film-making.

This of course implies that the scriptwriter directs his own scripts; or rather, that the scriptwriter ceases to exist, for in this kind of film-making the distinction between author and director loses all meaning. Direction is no longer a means of illustrating or presenting a scene, but a true act of writing. The film-maker/author writes with his camera as a writer writes with his pen. In an art in which a length of film and sound-track is put in motion and proceeds, by means of a certain form and a certain story (there can even be no story at all—it matters little), to evolve a philosophy of life, how can one possibly distinguish between the man who conceives the work and the man who writes it? Could one imagine a Faulkner novel written by someone other than Faulkner? And would *Citizen Kane* be satisfactory in any other form than that given to it by Orson Welles?

Let me say once again that I realise the term *avant-garde* savours of the surrealist and so-called abstract films of the 1920s. But that *avant-garde* is already old hat. It was trying to create a specific domain for the cinema; we on the contrary are seeking to broaden it and make it the most extensive and clearest language there is. Problems such as the translation into cinematic terms of verbal tenses and logical relationships interest us much more than the creation of the exclusively visual and static art dreamt of by the surrealists. In any case, they were doing no more than make cinematic adaptations of their experiments in painting and poetry.

So there we are. This has nothing to do with a school, or even a movement. Perhaps it could simply be called a tendency: a new awareness, a desire to transform the cinema and hasten the advent of an exciting future. Of course, no tendency can be so called unless it has something concrete to show for itself. The films will come, they will see the light of day—make no mistake about it. The economic and material difficulties of the cinema create the strange paradox whereby one can talk about something which does not yet exist; for although we know what we want, we do not know whether, when, and how we will be able to do it. But the cinema cannot but develop. It is an art that cannot live by looking back over the past and chewing over the nostalgic memories of an age gone by. Already it is looking to the future; for the future, in the cinema as elsewhere, is the only thing that matters.

FROM *PREFACE TO FILM* (UK, 1954)

Raymond Williams

[Originally published in Raymond Williams and Michael Orrom, *Preface to Film* (London: Film Drama Limited, 1954).]

Raymond Williams wrote this manifesto as he was trying to raise money from the British Film Institute to make his first film, after attempting to write a screenplay for a documentary on agriculture for Paul Rotha. Coauthored with Michael Orrom in 1954 (they each wrote separate chapters), and self-published by the two authors, the book from which these excerpts are drawn is quite off the radar in film studies and cultural studies, as well as in examinations of Williams's work. This neglect is perplexing, especially since this is the work in which Williams first elucidates one of his best-known concepts: the "structure of feeling." In coining this key term of his critical practice, Williams also makes a case for film as "total expression," arguing that the "structure of feeling" can be best understood through the cinema because of its ability to draw on and in some cases supersede the best aspects of the dramatic tradition.

Our enquiry in this book springs from an attempt to solve, in practice, problems of present-day work in the film. We are presenting a case for what we believe to be a new approach to film-making. We discuss theory, but this is not a text-book of theory of the film; it is, rather, intended as a starting point for actual production, and may be regarded, in this sense, as a manifesto. . . .

Film, in its main uses, is a particular medium within the general tradition of drama. Its essential novelty, as a dramatic medium, is that it offers different and, in certain respects, wholly new conditions of performance. Film is, in fact, from the standpoint of the general dramatic tradition, a particular kind of performance, which is also unique in the

fact that the performance which it embodies is recorded and final. It is, that is to say, a *total performance*, which cannot be distinguished from the work that is being performed.

The greater part of the written theory and criticism of film, as well as a large part of actual film-making, has been severely limited in effectiveness because the relation of this new medium to the wide and general dramatic tradition has been neglected or even denied. Indeed, in the majority of books about film, the distinction of the film from all other arts is almost axiomatic. And we find, as a result, that terms like *stagey* and *literary* are, in this special vocabulary, modes of adverse criticism or rejection. But while it is obvious that film is a new and distinct medium, and while it is certain that anyone who is not fully aware of this will be unable to use the medium well, the distinction being made in the use of *stagey* and *literary* is not between film, on the one hand, and drama and literature on the other, but between the methods of film and the methods of a certain kind of play, or of the novel. Yet a particular kind of play is not the whole of drama, although in most periods most people tend to believe that the kind of play to which they are used is equivalent to drama as a whole. Nor is the novel the only literary form, although it is now so dominant that many people draw their ideas of what is *literary* from their experience of novel reading. Thus, while it is necessary to distinguish the medium of film from the mediums of the average contemporary play or novel, it does not follow that the film has no relation, as an art, to drama; nor indeed, since in one important sense drama is a literary form, that the film has not an important relation to literature as a whole. To point out that the methods of *Citizen Kane* are different from the methods of *Candida* does not refute the general relation; it is really saying no more than the dramatic methods of Ibsen are different from those of Shakespeare or Sophocles or the Nō plays of Japan. Dramatic methods change, in the work of dramatic writers; and so also the conditions of performance of this work change. But all are changes within the dramatic tradition; and this is also the case with film, covering the changed conditions of performance, and the changed dramatic methods which these have made necessary.

The most emphatic insistence on the necessary conventions of the film medium is indeed perfectly compatible with a full recognition of the place it has in the general dramatic tradition. And the film has suffered because this recognition has not been widely made; for, because there was no such recognition, it did not mean that the tradition had no influence. It means, and for sixty years has meant, that the influence has been casual and indirect; so that those parts of the tradition which became influential were not the result of choices from the tradition as a whole, but rather the result of local and accidental contacts. The consequence is that while mediocre and irrelevant elements have had a definite effect, good and relevant elements have often been neglected. The film-maker who asserts that he is using his new medium without reference to the general tradition of drama and literature is plainly deceiving himself.

In fact, the great majority of contemporary films are far too closely tied to the methods of the average contemporary play or novel (are often, indeed, merely inferior substitutes for them), while, beyond the range of these habits, a wide and fertile area of the dramatic

tradition remains relatively unexplored. The major creative experiments in film still lie ahead of us; and we shall be the more strong and the more free to enter upon them if we can draw upon the general tradition of drama, and refuse to be bound by the limits of current habits and terms.

I shall discuss in this essay: first, the general nature of drama; second, the nature of dramatic conventions; third, the conventions, and the habits, of the drama and film of our own time; and fourth, the concept of *total performance,* which is the film's particular opportunity. . . .

FILM AS A DRAMATIC FORM

If, as has been argued, drama is a kind of creative work which is distinguished by performance, or the intention of performance, and by the element that has been called imitation, and if, further, it cannot be limited to equation with any particular mode within these elements, it appears to follow that film, in its main uses, is obviously a kind of drama, and that it is useful to have it recognized as such. The qualification "in its main uses" is necessary because it is clear that film is often used for the ordinary purposes of record, without any artistic intention, as for instance in newsreels of public events, recording of scientific experiments, and so on. There is an intermediate category, *documentary,* which is sometimes merely a record, and sometimes a creative work employing special conventions (the use of actual places and actual operations; of persons in their own right rather than actors; and of selection of theme in a social problem, social process, or similar subject, rather than in a "story" in the ordinary sense). Documentary, as a term, covers either plain record, or this special convention, or sometimes a mixture of both. In certain of its examples it shades into the main use of film: what is usually called the "story film," or the "feature film," recognizable in either case, by its elements of performance and imitation, as drama. One possible source of verbal confusion may be noted here.

It is nowadays a common practice, among middlemen both in the theatre and the cinema, to use *drama* in a still further specialized sense. A poster invites us to see "the X Players in a season of West End Comedies and Dramas"; a studio's publicity informs us that after her career in comedies and musicals, Miss Y is now being groomed for a starring role in a drama. What drama means, in such contexts, is fairly obvious; it is no longer the activity as a whole, which has commonly included comedies, tragedies, melodramas (the original word for *musicals*), and indeed almost every possible variation and combination of these types, but is limited to themes and treatments which off duty would probably be called "heavies." Often, it means a kind of tragedy, but the metaphorical extension of this word to cover actual events has, at some levels, almost erased the original; since *tragedy* is now used so often to describe accidents, or the results of a violent crime, it is understandable that middlemen hesitate to invite patrons to choose a tragedy as their entertainment. Drama, in this specialized sense, in fact covers more than what would have been called *tragedy;* at times it seems to mean anything that is not comedy,

burlesque, farce or pantomime, and is paraphrased as "serious play." Since a comedy can be very serious, the distinction is not always helpful, and in general the confusion of terms, in the publicity context, is so great that it could hardly be reduced to order without the invention of a new language (a task which at times the publicity agents seem almost to be undertaking). But the point need not here detain us further; it is mentioned merely to prevent confusion in the main argument.

Returning now to the main proposition that film, in its main uses, is a form of drama, in its wide traditional sense, we must note one particular objection, which arises from a technical property of film itself. It may be argued that in spite of all I have said earlier, the film is "not really" drama, because it is recorded on celluloid, "canned," and sent out to audiences who cannot then affect it. The audience, it is said, is a vital element in all drama, but in film it is only present when the performance has been finished. This denies the exercise of fruitful "participation" by the audience, which has always been recognized as valuable.

On formal grounds the point is, I think, altogether too marginal to deny the film's status as drama; but something needs to be said about it, under two heads: first, its effect upon the audience, and second, its, effect on the performers. On the first point, the real issue is the effect of the conditions of watching film. It is an immensely powerful medium, and in the darkened auditorium the dominating screen, with its very large, moving figures, its very loud sound, its simultaneous appeal to eye and ear, can, it seems obvious, exercise a kind of "hypnotic" effect which very readily promotes phantasy and easy emotional indulgence. In the theatre, of course, once the auditorium had been darkened so that lighting effects could be gained, a similar condition has prevailed, but is perhaps less intense. The point is very important because there can be no doubt that it allows speculators to impose very crude emotions (which outside the cinema might be recognized and rejected), and also because it allows inferior artists to gain apparent effects by a process of powerful suggestion rather than of artistic expression. This is made easier when, as is now the case, audiences are disproportionately immature as individuals (as a breakdown of attendance figures into age-groups will show). I do not want to underestimate the problem, and I think in fact we do not yet really know enough about it to come to any definite conclusions.

But it is possible, I think, to see the issue as one in which a very powerful dramatic medium (containing the degree of creating illusion on which, technically, all art depends) has, for reasons that bear on the state of society as a whole and not merely on the medium itself, been widely abused. There have, after all, been similar abuses of the novel, of the play, and of rhetoric. The argument points, I think, at this stage, to the maximum effort to promote films which are themselves emotionally disciplined. Whether the conditions of film-watching will finally hinder their communication can only be tested when this has, on a reasonable scale, been done. . . .

In principle, it seems clear that the dramatic conventions of any given period are fundamentally related to the structure of feeling in that period. I use the phrase *structure*

of feeling because it seems to me more accurate, in this context, than *ideas* or *general life*. All the products of a community in a given period are, we now commonly believe, essentially related, although in practice, and in detail, this is not always easy to see. In the study of a period, we may be able to reconstruct, with more or less accuracy, the material life, the general social organization, and, to a large extent, the dominant ideas. It is not necessary to discuss here which, if any, of these aspects is, in the whole complex, determining; an important institution like the drama will, in all probability, take its colour in varying degrees from them all. But while we may, in the study of a past period, separate out particular aspects of life, and treat them as if they were self-contained, it is obvious that this is only how they may be studied, not how they were experienced. We examine each element as a precipitate, but in the living experience of the time every element was in solution, an inseparable part of a complex whole. And it seems to be true, from the nature of art, that it is from such a totality that the artist draws; it is in art, primarily, that the effect of the totality, the dominant structure of feeling, is expressed and embodied. To relate a work of art to any part of that observed totality may, in varying degrees, be useful; but it is a common experience, in analysis, to realize that when one has measured the work against the separable parts, there yet remains some element for which there is no external counterpart. This element, I believe, is what I have named the *structure of feeling* of a period, and it is only realizable through experience of the work of art itself, as a whole. . . .

FILM AS TOTAL EXPRESSION

The moving-picture camera itself is, I think, a most effective agent for the kind of controlled total effect which I have been urging. For any film is a total performance, not only in the sense that it is inseparable from the work being performed (as, essentially, in my view, the best drama has to be inseparable), but also in that every element in its performance is, or is capable of being, under the direct control of the original conception. To write adequately for film is, essentially, to write for speech, movement and design, as necessarily related parts of a whole; and the control of the pen over the total conception ought to become, directly, the control of the camera. I do not say that this cannot be done in the theatre—it is a question of methods of production, and of our understanding of the nature of performance. But, for a variety of reasons, the control is in some ways easier to conceive in film: the fact that a film is a finished performance—recorded and final—is perhaps the most important factor.

The majority tradition in the film, as in the theatre, has been the naturalist *habit,* with an understandably large emphasis on spectacle. The genuine use of a naturalist *convention* has, in a minority of films, been an important refining element in the tradition. In the rejection of naturalism, there has been a clear line of experiment, as fruitful, in some ways, as the corresponding movement in the theatre. There has never, of course, in this experimental work, been the same emphasis on language as in the general experiments—

for example, the verse drama. Indeed, the outstanding failure of the film, as a whole form, has been its use of dramatic speech. For although, since the coming of sound, the majority of films have depended to an excessive degree on dialogue, which has allowed them to neglect significant movement and design, nearly all this dialogue, even in films which have been vitally interesting, has been of the familiar naturalist kind—the tentative slur of approximation rather than the precise, patterned intensity of which dramatic speech is capable. Where it has not been this, it bas been either sentimental rhetoric, or else mere spoken stage directions—things said to explain the situation and its development.

The kind of film which has most nearly realized the ideal of a wholly conceived drama, in which action, movement and design bear a continuous and necessary vital relationship, is the German expressionist film of the twenties. I believe this form was limited, as art, by the fact that its structure of feeling, which adequate conventions were found to express, was a very special case, which needed unusual psychological conditions in the audience for its full communication. As a principle, however, the integration of these films is notable. Yet it has always seemed to me significant that the most successful examples were in the silent film. For, if one looks at expressionist drama as a whole, one sees a very exciting new convention of movement and design, which has been achieved, however, at the cost of a radical neglect of speech. The words spoken in the normal expressionist play are (perhaps as a direct result of the theory; at least so some of its proponents argued) fragmentary, disjointed, typified—the cry, the exclamation, the slogan, rather than the full dramatic word. And of course that kind of use of words could be realized, without much loss, in the sub-titles of a silent film. There are certainly other reasons why there have been hardly any good expressionist films in sound, but it is clear that the use of sound, particularly for dramatic speech, would have presented the expressionists with very difficult problems, which might have ruined such conventional integration as they had achieved.

I have said that to write adequately for film is to write for speech, movement and design, but this point can be misunderstood if it is not considered in the context of the principle of integration to which I referred it. For example, it may have been remarked that when I was discussing the naturalist play and the novel I came to the point where a character, by the rules of probability, could say or do practically nothing, although that was the moment of crisis. The naturalist play, I argued, could not really get past such moments, whereas the novel evidently could: "words and pictures formed in her mind." The phrase, obviously, should have suggested the film, because of course it is clear that, at such a moment, the film would have a greater range than the play (it could, for example, associate certain images and scenes), and might even, by the use of a narrator's voice, equal the capacity of the novel in comment, analysis, description of submerged feeling, and so on. Except in fairly obvious descriptive ways, this latter method has barely been used; the former—associated images—has of course been used widely, but remains, essentially, the kind of separate action which Stanislavsky made famous.

Now I think the good naturalist film could be made much better, in many cases, by the use of such a narrative convention, aiming not merely at description but also at analysis and commentary. It is this faculty, I suppose, which has led some writers to call the film a kind of novel. Now the formal distinction is clear: the novel remains wholly verbal, the film, even with the narrative voice added, is performance and imitation—that is to say, drama. But this kind of distinction is less important than the point which arises when the convention of a narrating voice is considered in detail. The point will illustrate very well what I mean by integration. If such a "narration" is employed as a thing in itself, communicating matters which the acted performance can not, then, while it may be an important refinement of the naturalist film, it can hardly promote any dramatic integration. Used according to the principle of integration, such a voice would be part of the action; not a side-element. That is to say, it would follow and bear a necessary relation to the movement and design, which could then hardly be naturalist, for the movement and design would have to be expressing what the voice is also expressing, or else (as indeed often happens) they would be merely "accompanying visuals."

This example illustrates the general principle which I believe must govern the making of the dramatic film: the principle of integrated expression and performance, in which each of the elements being used—speech, music, movement, design—bears a controlled, necessary and direct relation, at the moment of expression, to any other that is being then used. All will bear towards a single end, which is the single conception, expressed through various directly interrelating means. How this principle relates to contemporary, and possible, film techniques is the subject of Michael Orrom's essay.

CONCLUSION

My final point is a general one, indicating the context of the present proposals. I have said that naturalism was a response to changes in the structure of feeling, which, in the event, it could not wholly express. The structure of feeling, as I have been calling it, lies deeply embedded in our lives; it cannot be merely extracted and summarized; it is perhaps only in art—and this is the importance of art—that it can be realized, and communicated, as a whole experience.

The apparent motive of the arguments in this book is technical; a response to difficulties in a particular medium, and a search for different conventions. A technical emphasis is, therefore, inevitable. But if what I have said about the full meaning of convention is accepted, the technical enquiry may be seen as the necessary form of the larger change: an enquiry into means of communicating that form of experience which is the origin of the problem, and the source of this kind of new approach. If the new conventions can be gained, it will be the communicated experience that finally matters, for us and for the audience. But the artist has not only to feel; he must to the extent that he is an artist, find ways of realizing and communicating, wholly and definitively, the moving experience. Only when he has found such ways can the personal vision be confirmed in the public view.

THE SNAKESKIN (Sweden, 1965)

Ingmar Bergman

[Originally delivered *in absentia* in Amsterdam in Swedish in 1965, upon receiving the Erasmus Prize. Published in Swedish as "Ormskinnet. En betraktelse skriven till utdelningen av Erasmuspriset i Amsterdam 1965," in *Expressen*, August 1965. First published in English in an unabridged form in *Cahiers du cinéma in English* 11 (1967): 24–29.]

Written upon Bergman's receiving the Erasmus Prize, this manifesto demonstrates the filmmaker's despair at the possibility of creating art, in the cinema or in any artistic medium. Ironically, perhaps, Bergman wrote this on the precipice of releasing *Persona* (Sweden, 1966), perhaps his best-known work of the 1960s. Indeed, the film pointed to a radical break in his aesthetic: he followed it with *Vargtimmen* (*Hour of the Wolf*, 1968), *Skammen* (*Shame*, 1968) and *En passion* (*The Passion of Anna*, 1969), all of which deploy quasi-Brechtian aesthetics to address both the personal and political, the latter being a new area of exploration for Bergman.

Artistic creation has always, to me, manifested itself as hunger. I have acknowledged this need with a certain satisfaction but I have never, in all my life, asked myself why this hunger has arisen and craved appeasement. In recent years, as it diminishes and is transformed into something else, I have become anxious to find out the cause of my "artistic activity."

A very early childhood memory is my need to show off my achievements: skill in drawing, the art of tossing a ball against a wall, my first effort at swimming.

I remember I felt a very strong need to draw the attention of the grown-ups to these manifestations of my presence in the world. I felt I never got enough attention from my fellow men. So, when reality was no longer sufficient, I began to fantasize, entertain my playmates with tremendous stories about my secret adventures. They were embarrassing lies that hopelessly failed against the level-headed scepticism of the world. I finally withdrew and kept my dream world to myself. A young child wanting human contact and obsessed by his imagination had been hurt and transformed into a cunning and suspicious daydreamer.

But a daydreamer is not an artist outside his dreams.

The need to get people to listen, to correspond, to live in the warmth of a community was still there. It became stronger the more I became imprisoned in loneliness.

It is fairly obvious that the cinema became my means of expression. I made myself understood in a language that bypassed the words—which I lacked—and music—which I did not master—and painting, which left me indifferent. With cinema, I suddenly had an opportunity to communicate with the world around me in a language that is literally spoken from soul to soul in phrases that escape the control of the intellect in an almost voluptuous way.

With all the child's repressed hunger, I threw myself into my medium and for twenty years I have indefatigably and in a kind of frenzy brought about dreams, mental experiences, fantasies, fits of lunacy, neuroses, religious controversies and sheer lies. My hunger has been eternally new. Money, fame and success have been amazing but, at bottom, insignificant consequences of my rampagings. In saying this I do not underestimate what I may perchance have achieved. I think it has had, and perhaps has, its importance. But security for me is that I can see the past in a new and less romantic light. Art as self-satisfaction can, of course, have its importance—especially for the artist.

Today the situation is less complicated, less interesting, above all less glamorous.

To be quite frank I experience art—not only the film art—as being meaningless. By that I mean that art no longer has the power and possibility to influence the development of our lives.

Literature, painting, music, film and theatre beget and bring forth themselves. New mutations, new combinations arise and are destroyed, the movement seems—from the outside—nervously vital, the artists' magnificent zeal to project to themselves, and to a more and more distracted public, pictures of a world that no longer cares what they like or think. In a few places artists are punished, art is considered dangerous and worth stifling and directing. On the whole, however, art is free, shameless, irresponsible and, as I said: the movement is intense, almost feverish, like, it seems to me, a snakeskin full of ants. The snake itself has long been dead, eaten, deprived of its poison, but the skin moves, filled with meddlesome life.

If I now find that I happen to be one of these ants, I must ask myself whether there is any reason to continue the activity. The answer is in the affirmative. Although I think that the theatre-stage is a beloved old courtesan who has seen better days—although I and many others find the Wild West more stimulating than Antonioni or Bergman—although the new music gives us the suffocating feeling of mathematical air rarification—although painting and sculpture are sterile and languish in their own paralyzing freedom—although literature has been transformed into a cairn of words without message or danger.

There are poets who never write poems because they form their lives as poems, actors who never appear on stage but play their lives as marvelous dramas. There are painters who never paint because they close their eyes and create the most beautiful paintings on the inside of their eyelids. There are filmmakers who live their films and would never misuse their talents to materialize them in reality.

In the same way, I think that people today can dispense with the theatre because they exist in the middle of a drama, the different phases of which incessantly produce local tragedies. They do not need music because every minute their hearing is bombarded with veritable sound hurricanes that have reached and passed the level of endurance. They do not need poetry because the new idea of the universe has transformed them into functional animals bound to interesting but, from a poetical point of view, unusable problems of metabolic disturbance.

Man (as I experience myself and the world around me) has made himself free, terribly and dizzyingly free. Religion and art are kept alive for the sake of sentimentality, as a conventional politeness towards the past, a benevolent solicitude of leisure's increasingly nervous citizens. I am still talking about my own subjective vision. I hope, and am perfectly sure, that others have a more balanced and objective conception.

If I take all this tediousness into consideration and in spite of everything assert that I wish to continue to make art, it is for a very simple reason (I disregard the purely material one).

That reason is *curiosity*. A boundless, insatiable, perpetual regeneration, an unbearable curiosity that drives me on, that never lets me rest, that completely replaces that past hunger for community.

I feel like a long-term prisoner suddenly confronted with the crashing, shrieking, snorting of life. I am seized by an ungovernable curiosity. I note, I observe, I keep my eyes open. Everything is unreal, fantastic, frightening or ridiculous. I catch a flying grain of dust—perhaps it is a film. What significance does it have?—none at all, but *I* find it interesting, and consequently it is a film. I wander round with my grain of dust and in mirth or melancholy I am preoccupied. I jostle among the other ants, together we accomplish a colossal task. The snakeskin moves.

This and only this is *my* truth. I do not ask that it shall be valid for anyone else, and as a consolation for eternity it is, of course, rather meager. As a basis for artistic activity in the coming years it is completely sufficient, at least for me.

To be an artist for one's own satisfaction is not always so agreeable. But it has one great advantage: the artist co-exists with every living creature that lives only for its own sake. Altogether, it makes a pretty large brotherhood existing egoistically on the hot, dirty earth under a cold and empty sky.

MANIFESTO (Italy, 1965)

Roberto Rossellini, Bernardo Bertolucci, Tinto Brass, Gianni Amico, Adriano Apra, Gian Vittorio Baldi, and Vittorio Cottafavi

[First released on 13 July 1965 at the Foreign Press Room, Rome. First published in French in *Cahiers du cinéma*, no. 171 (1965): 7–8.]

This manifesto, written primarily by Rossellini, offers a utopian account of the possibilities of moving images in a world that he and the cosignatories see as eroding despite all the material and technological progress that has been made. In essence this is an educational film manifesto, arguing for the total use of cinema to allow humankind to understand its place in the world and in history. To this end it is similar in its inspiration to global undertakings such as Edward Steichen's *The Family of Man* (1955).

It is among the most dramatic features of modern civilisation that the vast improvement in the standard of living, resulting from scientific and technical advances, has brought with it, not a taste of happiness and moral well-being, but a disconcerting impression of disturbance and sickness. There is a vague feeling abroad that our civilization is only temporary, and already inwardly eroded. Agitation, violence, indifference, boredom, anguish, spiritual inertia and passive recognition are all expressed in every level, by individuals and socially. Modern man in the so-called "developed" countries no longer seems to have awareness of himself or of those things around him. And the chief testimony to all these developments is modern art.

What are we to conclude from it all?

Should we turn our backs on this civilisation of ours, claiming as it does to be rational and positive, but apparently unable to find any point of equilibrium?—No, definitely not. But we must act to obviate the confusion, the imbalance and disproportion we see growing worse each day. In modern art there is something to be detected which may perhaps provide the key to the present state of derangement: literature, drama, poetry, etc. do not seem to have taken account of what has happened in the world since [the] giddy race of progress began, due to the great scientific and technical discoveries, in the second half of the 18th century, changing the shape of the world and society. Artists have, without a shadow of doubt, remained indifferent to machinery, which has carried out the most difficult, complicated jobs with unfailing accuracy and extraordinary speed—and so changed man's destiny. Artists have failed to draw inspiration either from the invention and extension of new sources of artificial energy, or from man himself; man, who after thousands of years of toil and struggle, has finally mastered the forces of nature, driving the time of death further and further back, increasing his own safety and well-being. WE challenge anyone to point to five works, in any artistic field, which have taken their inspiration from these conquests.

It is our intention to do what has so far remained undone. We work in the cinema and in television, and we intend to make films and programs to help man recognise the actual horizons of his world. We want to show, in an interesting but scientifically correct way, down to the smallest details, everything that art, or the cultural products distributed by the audiovisual media, have so far failed to show—things they have, still worse, ridiculed and abused.

We wish, again, to present man with the guidelines of his own history, and depict drama, comedy and satire, the struggles, the experiences and the psychology of the people who have made the world what it is today, making it a criterion to fuse together entertainment, information and culture.

The past two hundred years, which have seen the birth and growth of our civilization as it is today, provide us with a wealth of material and dramatic inspiration.

We are convinced that with this kind of work we can help to develop information media which, with education, will be indispensible [sic] to the process of enlightenment through [which] man will be able to win back happiness, by giving him an understanding of his own importance, his own position in the history of the world.

MANIFESTO ON THE RELEASE OF
LA CHINOISE (France, 1967)

Jean-Luc Godard

[First released as part of the press materials for *La Chinoise*, 30 August 1967. First published in *Jean-Luc Godard par Jean-Luc Godard* (Paris: Edition Belfond / Collection Cahiers du cinéma, 1968). First published in English in *Godard on Godard* (New York: Da Capo, 1972), 243. Trans. Tom Milne.].

Godard's pre-Maoist manifesto on his film about the limits of revolution, *La Chinoise*, which slightly precedes his revolutionary Dziga Vertov period.

Fifty years after the October Revolution, the American industry rules cinema the world over. There is nothing much to add to this statement of fact. Except that on our own modest level we too should provoke two or three Vietnams in the bosom of the vast Hollywood-Cinecittá-Mosfilm-Pinewood-etc. empire, and, both economically and aesthetically, struggling on two fronts as it were, create cinemas which are national, free, brotherly, comradely and bonded in friendship.

DIRECT ACTION CINEMA MANIFESTO
(USA, 1985)

Rob Nilsson

[Written in 1985. Published on Rob Nilsson's website: citizencinema.net/direct-action/.]

A former member of the leftist filmmaking collective Cine Manifest, a pioneer in using video and digital formats to make features, and the first American director to win awards at both Cannes and Sundance, Rob Nilsson combines in his "Direct Action Manifesto" aspects of politically committed collective filmmaking from the 1960s and 1970s with the improvisational techniques of John Cassavetes. A pioneer in American indie film, Nilsson has made some twenty-four features, many using improv techniques and video to keep costs down. He also runs Citizen Cinema, a collaborative acting workshop collective dedicated to making features and based on the principles of the "Direct Action Cinema" manifesto.

Direct Action Cinema is . . .

. . . a practice created to allow actors and technicians high freedom and deep responsibility to create memorable cinema. It is a dynamic jazz ensemble of actors, camera, sound, directors, and editors that creates and interprets together, seeking the unexpected, the extraordinary, the miracles only a well-prepared combo can play.

» Create a situation, define and develop a character. Combine the two and watch them collide, attract, and repel. Build drama from this dynamic, closer to the way life happens to us and we happen back.

» Grow a narrative with the story spine hidden, accreting like a coral reef from within and according to its own inner energies.

» Reject the film as short story dictum promoted by Hollywood and the film schools. Smash the iron ball and chain of excessive plot. Create a poetic cinema based not on writing but on observing. Mistrust your ideas and trust your experiences. Discover, don't prescribe.

» Build a cinema not of auteurs but of interpreters. Film is not a director's medium. The magicians who bottle the genie are the actors. The magician who lets the genie out of the bottle is the editor.

» In acting—situations, rich discords, conflict, laughter, human dilemma, emotion.

» In editing—a scavenger hunt for the miraculous.

» Fear is the last barrier. Our path is towards our fear!

REMODERNIST FILM MANIFESTO
(USA, 2008)

Jesse Richards

[First published 27 August 2008 on jesse-richards.blogspot.ca]

An offshoot of Stuckism, a movement started by Billy Childish and Charles Thomson, remodernism argues for a move away from the irony and cynicism of postmodernism and a rediscovery of the spiritual aspects of art. Jesse Richards's "Remodernist Film Manifesto" applies the ideas of remodernism to cinema, arguing for a gritty, DIY style of filmmaking that harks back to the No Wave films of the 1970s—like those of the Cinema of Transgression—embracing Super 8 and 16 mm production and rejecting the technical constraints of Dogme '95. In many ways what Richards is arguing for is similar to what Paul Schrader called the "transcendent style" in his book *Transcendental Style in Film: Ozu, Bresson, Dreyer* (1972).

1. Art manifestos, despite the good intentions of the writer should always "be taken with a grain of salt" as the cliché goes, because they are subject to the ego, pretensions, and plain old ignorance and stupidity of their authors. This goes all the way back to the Die Brücke manifesto of 1906, and continues through time to this one that you're reading now. A healthy wariness of manifestos is understood and encouraged. However, the ideas put forth here are meant sincerely and with the hope of bringing inspiration and change to others, as well as to myself.

2. Remodernism seeks a new spirituality in art. Therefore, remodernist film seeks a new spirituality in cinema. Spiritual film does not mean films about Jesus or the Buddha. Spiritual film is not about religion. It is cinema concerned with humanity and an understanding of the simple truths and moments of humanity. Spiritual film is really ALL about these moments.

3. Cinema could be one of the perfect methods of creative expression, due to the ability of the filmmaker to sculpt with image, sound and the feeling of time. For the most part, the creative possibilities of cinema have been squandered. Cinema is not a painting, a novel, a play, or a still photograph. The rules and methods used to create cinema should not be tied to these other creative endeavors. Cinema should NOT be thought of as being "all about telling a story." Story is a convention of writing, and should not necessarily be considered a convention of filmmaking.

4. The Japanese ideas of *wabi-sabi* (the beauty of imperfection) and *mono no aware* (the awareness of the transience of things and the bittersweet feelings that accompany their passing), have the ability to show the truth of existence, and should always be considered when making the remodernist film.

5. An artificial sense of "perfection" should never be imposed on a remodernist film. Flaws should be accepted and even encouraged. To that end, a remodernist filmmaker should consider the use of film, and particularly film like Super-8mm and 16mm because these mediums entail more of a risk and a requirement to leave things up to chance, as opposed to digital video. Digital video is for people who are afraid of, and unwilling to make mistakes—. Video leads to a boring and sterile cinema. Mistakes and failures make your work honest and human.

6. Film, particularly Super-8mm film, has a rawness, and an ability to capture the poetic essence of life, that video has never been able to accomplish.

7. Intuition is a powerful tool for honest communication. Your intuition will always tell you if you are making something honest, so use of intuition is key in all stages of remodernist filmmaking.

8. Any product or result of human creativity is inherently subjective, due to the beliefs, biases and knowledge of the person creating the work. Work that

attempts to be objective will always be subjective, only instead it will be subjective in a dishonest way. Objective films are inherently dishonest. Stanley Kubrick, who desperately and pathetically tried to make objective films, instead made dishonest and boring films.

9. The remodernist film is always subjective and never aspires to be objective.

10. Remodernist film is not Dogme '95. We do not have a pretentious checklist that must be followed precisely. This manifesto should be viewed only as a collection of ideas and hints whose author may be mocked and insulted at will.

11. The remodernist filmmaker must always have the courage to fail, even hoping to fail, and to find the honesty, beauty and humanity in failure.

12. The remodernist filmmaker should never expect to be thanked or congratulated. Instead, insults and criticism should be welcomed. You must be willing to go ignored and overlooked.

13. The remodernist filmmaker should be accepting of their influences, and should have the bravery to copy from them in their quest for understanding of themselves.

14. Remodernist film should be a stripped down, minimal, lyrical, punk kind of filmmaking, and is a close relative to the No-Wave Cinema that came out of New York's Lower East Side in the 1970's.

15. Remodernist film is for the young, and for those who are older but still have the courage to look at the world through eyes as if they are children.

—The only exceptions to Point 5 about video are Harris Smith and Peter Rinaldi; to my mind they are the only people who have made honest and worthwhile use of this medium.

This manifesto may be appended/added to in the future, as further ideas develop.

The following is for further study for those interested in what has influenced remodernist film philosophy.

HONORARY REMODERNIST FILMMAKERS

Amos Poe, and all of the No-Wave filmmakers, Andrei Tarkovsky, Jean Vigo, Kenji Mizoguchi, Maurice Pialat, Yasujiro Ozu, Wolf Howard, Billy Childish

OTHER INFLUENTIAL ARTISTS/ART GROUPS/IDEAS

Die Brücke, Les Fauves, Stuckism, The Defastenists, Vincent Van Gogh, Edvard Munch, Mono no aware, Wabi-sabi

"The Foreigner"—Amos Poe; "Zerkalo"—Andrei Tarkovsky; "Andrei Rublev"—Andrei Tarkovsky; "Zéro de conduite"—Jean Vigo; "L'Atalante"—Jean Vigo; "Ugetsu Monogatari"—Kenji Mizoguchi; "A Nos Amours"—Maurice Pialat; "Tokyo Story"—Yasujiro Ozu

THE AGE OF AMATEUR CINEMA WILL RETURN (People's Republic of China, 2010)

Jia Zhangke

[First published in Zhang Xianmin and Zhang Yaxuan, eds., *One Person's Impression: Complete Guidebook to DV* (Yigeren de yingxiang: DV wanquan shouce) (Beijing: China Youth Publishing, 2003). First published in English on the dGenerate website: dgeneratefilms.com. Trans. by Yuqian Yan.]

In a restaurant far away from downtown Pusan, Tony Rayns discussed with me some issues on films on behalf of the British magazine *Sight & Sound*.

For some reason, conversations about films always get people trapped into sentimental feelings. In order to get out of this mood, Tony brought up a new topic and asked me, "What do you think will become the driving force for the development of films in the future?" Without hesitation, I replied, "The age of amateur cinema will return." This was the most truthful and vivid feeling I had, and I had been continually reinforcing my opinion every time I was asked about the prospects of films.

It certainly challenges the so-called professional filmmakers. Those who strictly follow professional principles and exhaustively describe the marketing ability they possess have long lost their power of thought. They pay too much attention to whether the film is good enough to reflect their professional competencies. For example, the picture should be as delicate as an oil painting, or the mise-en-scene is supposed to match that of Antonioni's films; even the twinkling spotlight needs to be right on the face of the actor. They repeatedly fathom the professional mindset, cautioning themselves against any amateur act that breaks the established classical rules. Conscience and sincerity, which are crucial to filmmaking, are completely diluted by these facts.

What is left? Rigid concepts and preexisting prejudice. These people are indifferent to innovations; they are not even able to make a judgment. Ironically, they always tell other people: don't repeat yourself. You need variation.

In fact, some directors have already been vigilant against this situation. Japanese director Oguri Khei once expressed his worries that, though in the past ten years film produc-

tion in Asia has improved to almost the same level as world-class standards, the artistic spirit of films has largely declined. During the selection process of the Hong Kong International Film Festival that took place earlier, Huang Ailing said, "What hides behind the myth of high-cost production is the loss of cultural faith."

Turning on the TV in Korea, what I saw was the same satellite TV channels as those I got in Beijing. I was disappointed. In a few years, young people throughout Asia will probably sing the same song, be attracted to the same clothes; girls will wear the same makeup and carry the same handbag. What kind of world is this turning into? It is precisely in this cultural environment that only independent films that remain committed to the depiction of local culture can provide some cultural diversity. I feel more and more strongly that people can only achieve emotional communication and equal position through diversity. The trend of globalization will make this world become tedious.

Therefore, I say, the age of amateur cinema will return.

This is a group of real film enthusiasts who have unquenchable passion for film.

They naturally exceed the existing professional evaluation method because they are open to more promising film forms.

Their film modes are always unexpected, but the emotion and sentiments they invest in their films are always precise and palpable.

They ignore the so-called professional methods, so they have more chance to be innovative. They refuse to follow the standardized principles, so they acquire more diverse ideas and values. They free themselves from conventional customs and restraints to an infinite space for creation; at the same time, they are earnest and responsible because they persist with the conscience and conduct of intellectuals.

APPENDIX

WHAT IS A "MANIFESTO FILM"?

Despite the increasing preponderance of the term *manifesto film* in both film criticism and theory, I don't believe that, as a discipline, we have fully addressed the question of whether there is such a thing as a "manifesto film."[1] One might assume that there must be such a thing, as the past hundreds of pages contain a litany of manifestos all calling new forms of cinema into being. Wouldn't the films made under the precepts of these manifestos constitute manifesto films? If one delves into the question a bit further, however, a straightforward answer is not so readily apparent. Throughout this book I have argued that manifestos are a form of writing and a very specific form of speech act; as such, one must question whether film can perform the same epistemological function as the written word.

The term itself has often been deployed with an incredible vagueness. For instance, Michel Marie calls René Clair's *Sous les toits de Paris* (France, 1929) a "manifesto film" for an "aesthetic revolution: a sound cinema which would be musical, part-talking and part-sung, but in which synchronized dialogue would never play a dominant dramatic role."[2] Louis Bayman writes that *La terra trema* (Italy, 1948) is "almost a manifesto film for neorealism."[3] And Yves Lever argues that Gilles Groulx and Michel Brault's *Les raquetteurs* (Québec, 1958) is a "manifesto film" for Québécois cinema, but I suspect that what he means is that the film points to a turning point in the emergence of a new documentary film practice in Québec, not that the film itself argues for a new way of filmmaking.[4] The term *manifesto film* cannot simply be critical shorthand for "first."

If there are indeed films that fit this label, I contend that first and foremost they must raise questions about the nature of the cinema through a self-reflexive analysis of film form itself. Often, but not always, made by filmmakers who have written manifestos, the films in question present the imagined future of the cinema postulated by the manifestos in material form. This is certainly true of the "manifesto films" of filmmakers as diverse as Guy Debord, Laura Mulvey and Peter Wollen, Hans-Jürgen Syberberg, Jean-Luc Godard, and Tony Conrad. While I've stated that a manifesto film must be a self-reflexive examination of film form, it must also speak to the emergence of a new film practice that goes beyond the film in question. For example, Fellini's 8½ (Italy, 1963) is a film about the film onscreen, as Christian Metz notes: "8½ is the film of 8½ being made: the 'film in the film' is, in this case, the film itself."[5] Yet, 8½ is only about 8½, unlike Riddles of the Sphinx, which is not only a self-reflexive examination of film form but also an attempt to discover a new language of the cinema.

Another question that arises from the "manifesto film" is whether it can be considered a genre. If one were to answer in the affirmative, it could only be with the proviso that it is a genre that emerges and is defined a posteriori, much like the film noir of classical Hollywood. The genre of the manifesto film is taxonomic in nature, created by writers and critics to categorize the emergence of certain tendencies in the cinema. This does not mean that certain films are intended to be manifestos—Hour of the Furnaces (1968) can certainly be understood as such—but that a manifesto film genre is a construct built retrospectively upon a body of distinct films.

This genre, as it has emerged, can be seen as having some distinct characteristics, consisting of a certain kind of reflexive examination on the properties of the cinema through the cinematic process itself. This process can be aesthetic, formal, or political in nature. Yet the simple use of self-reflexivity as a means by which to examine cinematic form is a necessary but not sufficient reason to describe a work as a manifesto film. To be considered as such, the work must address cinematic form, production, and representation and take these as its sole or major areas of inquiry. Furthermore, this examination must center on the emergence of a new form of cinema. The question raised by these films can be stated thus: the cinema must be reimagined, and this is the way to reimagine it.

Manifesto films do have a strikingly discursive and didactic nature. Indeed, many of their voice-overs have been published as distinct texts that are read as manifestos. This begins to lead us toward an answer to the question of whether or not there is a manifesto film genre, as it would be counterintuitive to suggest that the voice-overs of films like Isidore Isou's Traité de bave et d'éternité (France, 1951) or Guy Debord's Critique de la séparation (France, 1961) are manifestos but the films themselves are not. The analytical problem one faces here is that film manifestos function as documents that call certain new forms of cinema into being, while the films themselves are more easily understood as instantiations of these calls to arms.

In Isou's film, for example, the main character, Daniel, declaims in voice-over in a ciné-club what he sees as the problems facing cinematic representation, proposing in the process Isou's concept of "discrepant cinema," stating, in essence, that dominant cinema is bloated, engorged, and decaying: "I think first of all that the cinema is too rich. It is obese. It has reached its limits, its maximum. The moment it attempts to grow any further, the cinema will explode. Suffering from a case of congestion, this pig stuffed with fat will rip apart into a thousand pieces. I announce the destruction of the cinema, the first apocalyptic sign of disjunction, of this bloated and pot-bellied organism called film."

For Isou anticinema is not the destruction of *cinema-qua-cinema* but a turn to a new phase of cinematic production, one that through formal innovations chisels away at the beached whales of Hollywood cinema and French *cinéma du qualité*. Significantly, Isou proposes his new form of cinema, discrepant cinema, through filmmaking and then writes the theory itself later.

This raises another salient point about manifesto films: in most, though by no means all, cases, manifesto films are not the first films made by filmmakers. The reason for this, I believe, is simple: a filmmaker needs to develop his or her practice before being in the position to reflect cogently on cinematic form. The exception to the rule is often films made by theorists or other writers on the cinema (such as Laura Mulvey, Fernando Solanas, Tony Conrad)—in their cases, their reflections on the cinema, its potential, and its utopian possibilities have taken place on the written page, and their manifesto films become instantiations of the practices they have previously imagined.

It is perhaps instructional to briefly look at a few exemplars of this mode of filmmaking. Tony Conrad's *The Flicker* (USA, 1966) explores the nature of the cinema's illusionist properties through an examination of the way in which films produce the illusion of movement. During its thirty-minute running time the film alternates, with increasing frequency, black-and-white frames of celluloid, creating a pulsating visual effect that can purportedly induce epileptic seizures in some viewers. Keewatin Dewdney wrote in his manifesto on "discontinuous films": "Tony Conrad's *The Flicker* is a raw, archetypal statement about the nature of film, a statement which few understood. *The Flicker* revealed at one stroke that the projector, not the camera, is the film-maker's true medium."[6] By rewriting the history of cinema, by placing the projector at the forefront of the cinema, *The Flicker* functions as a manifesto film by reimagining the cinema through the process of filmmaking itself.

Another example is Laura Mulvey and Peter Wollen's *Riddles of the Sphinx* (UK, 1977), which represents the cinematic instantiation of the concept of the destruction of visual pleasure first articulated in Mulvey's seminal feminist film manifesto "Visual Pleasure and Narrative Cinema." In the film, Mulvey and Wollen examine film form and its patriarchal representations by breaking with both classical Hollywood narrative form and the dominant account of women offered by psychoanalysis in order to attempt to bring into being a new, nonpatriarchal language of the cinema. As Mulvey noted in retrospect: "The film used the Sphinx as an emblem with which to hang a question mark over the Oedipus complex, to illustrate the extent to which it represents a riddle for women committed to Freudian theory but still determined to think about psychoanalysis radically or, as I have said before, with poetic license."[7] Mulvey goes on to note that she and Wollen were attempting to shift the narrative perspective to that of the Mother in the Oedipal triangle. To do so, Mulvey and Wollen broke the film down into chapters, most notably in the middle section of the film, where the narrative takes place, into a series of 360-degree pans.

The formal experimentations of filmmakers such as Conrad and Mulvey and Wollen raise a salient question: if film manifestos project the need for new forms of cinema, and filmmakers such as those referenced throughout this volume produce works demonstrating new forms of cinema, are the films in question truly "manifesto films" or simply the product of the manifestos themselves? This raises a broader question about whether any aesthetic text can function as a manifesto or if, alternatively, such texts are always only works responding to

manifestos. I argue that the foregoing films are "manifesto films" because of the fact that they bring an experiential level of analysis to the act of reimagining the cinema that simply writing about it cannot. That said, the true manifesto film is part of an extremely small genre or set of films, numbering in the low dozens, not the hundreds or, indeed, thousands.

TEN EXAMPLES OF MANIFESTO FILMS

Treatise on Slime and Eternity (Isidore Isou, France, 1951)

Critique of Separation (Guy Debord, France, 1961)

The Flicker (Tony Conrad, USA, 1966)

Hour of the Furnaces (Fernando Solanas and Octavio Getino, Argentina, 1968)

Letter to Jane (Jean-Pierre Gorin and Jean-Luc Godard, France, 1972)

Society of the Spectacle (Guy Debord, France, 1973)

Riddles of the Sphinx (Laura Mulvey and Peter Wollen, UK, 1977)

Hitler: A Film from Germany (Hans-Jürgen Syberberg, West Germany, 1977)

Histoire(s) du cinéma (Jean-Luc Godard, France, 1988–1998)

10 on Ten (Abbas Kiarostami, Iran, 2004)

NOTES

INTRODUCTION

1. See Noël Carroll, "Prospects for Film Theory: A Personal Perspective," in David Bordwell and Noël Carroll, eds., *Post-Theory: Reconstructing Film Studies* (Madison: University of Wisconsin Press, 1996), 37–68; and Gregory Currie, "The Film Theory That Never Was: A Nervous Manifesto," in Richard Allen and Murray Smith, eds., *Film Theory and Philosophy* (Oxford: Oxford University Press, 1997), 42–59.
2. Most of the work undertaken on film manifestos thus far has focused on Dogme '95. See, for instance, Richard Kelly, *The Name of This Book Is Dogme 95* (New York: Faber and Faber, 2000); and Mette Hjort and Scott MacKenzie, eds., *Purity and Provocation: Dogma 95* (London: BFI, 2003).
3. Fredric Jameson, "The Politics of Utopia," *New Left Review* 25 (2004): 35–54, 41.
4. Janet Lyon, *Manifestoes: Provocations of the Modern* (Ithaca, NY: Cornell University Press, 1999), 9.
5. Louis Althusser, "Theory and Political Practice," in *Machiavelli and Us* (London: Verso, 1999), 13.
6. Louis Althusser, "Machiavelli's Solitude," in *Machiavelli and Us* (London: Verso, 1999): 127.
7. Greil Marcus, *Lipstick Traces: A Secret History of the Twentieth Century* (Cambridge, MA: Harvard University Press, 1989), 23.
8. Karl Mannheim, *Ideology and Utopia* (1936; New York: Harvest Books, 1968), 192.

9. Paul Ricoeur, *Essays on Ideology and Utopia* (New York: Columbia University Press, 1986), 273–274.

10. Ibid., 283.

11. Susan Buck-Morss, *The Dialectics of Seeing: Walter Benjamin and the Arcades Project* (Cambridge, MA: MIT Press, 1989), 219.

12. Fredric Jameson, *The Political Unconscious: Narrative as a Socially Symbolic Act* (Ithaca, NY: Cornell University Press, 1981), 296.

13. Jameson, "The Politics of Utopia," 36.

14. See Buñuel's preface to the script of *Un chien andalou*, originally published in *La révolution surréaliste* 12 (1929), translated and reprinted in chapter 1 of this volume.

15. Karl Marx, "Theses on Feuerbach," in Karl Marx and Friedrich Engels, *The German Ideology* (New York: International Publishers, 1970), 123.

CHAPTER 1. THE AVANT-GARDE(S)

1. The RSFSR is the Russian Soviet Federative Socialist Republic, the largest republic in the former Soviet Union.

2. The quality of being truly cinematic.

3. Alexander Scriabin, a Russian composer who developed atonal music.

4. A French social science and history journal that began publishing in 1929.

5. A 1923 UK film codirected by Graham Cutts and Alfred Hitchcock, though the latter is uncredited.

6. Queen Elizabeth II.

7. The US attorney general James P. McGranery, who banned Chaplin from reentering the States in 1952.

8. Sam Katzman (1901–1973) was an American low-budget film producer and director who did indeed give Rice film stock.

9. I had originally thought that the title at the end of the 16 mm prints circulating during the 1970s and 1980s of Vertov's *Man with a Movie Camera* (Кінец) was a futurist portmanteau word in Russian: Kino [cinema] + Konets [(The) End]. I had thought that the odd spelling of the word (with an "i" instead of "и") was simply a preorthographic reform spelling. I was mistaken; it was simply the Ukrainian word for "[The] End." Ironically, in the five current DVD versions of the work I have seen, this title has been replaced with a video intertitle using the Russian word "Конец." Current practice is a historical "correction" since the work was produced by the All Ukrainian Photo-Cinema Directorate (VUFKU) Всеукраинское фотокиноуправление (ВУФКУ) and very likely bore the Ukrainian version of the word at the end, which would have been easily understandable by any literate Russian.

10. Sitney has, since the writing of this text, rewritten *Visionary Film* several times and has significantly revised the films he has included and to some degree the logic of their inclusion. The current edition includes a significantly greater number of women than the edition in print at the time this text was written.

11. A few years ago, P. Adams Sitney, my colleague at Princeton—how times change—informed me that Frampton had in fact appropriated the story from him.

12. Other rumors suggested that Warhol pulled the films "off the market" because he had no model releases and thought he would be constantly hounded for money from the people who had participated in them. It is said that he had already been hounded by some of the actors when the films were in distribution.

13. Several years subsequent to the writing of this text, Debord's films were released on DVD along with his final effort, *Guy Debord, son art et son temps,* a video made in collaboration with Brigitte Cornand and broadcast after his death in 1994 in a special Soirée Guy Debord on Canal+, during which two of his earlier films were also broadcast. Around the same time the DVDs were released, the films also circulated in newly struck 35 mm prints, poorly subtitled. There were several problems with the initial DVD release, which I pointed out in an article published in *Artforum.* The problems have now more or less been quietly addressed.

14. At the time, I naively thought the *Village Voice* could not get any worse. I was so wrong that it will be difficult for those not alive at the time of the writing of this article to believe that the *Village Voice* could ever have been taken seriously as even an arbiter of taste, let alone as a vehicle for cultural criticism, or that it merited any mention whatsoever.

CHAPTER 2. NATIONAL AND TRANSNATIONAL CINEMAS

1. François Truffaut, "'The Evolution of the New Wave': Truffaut in Interview with Jean-Louis Comolli, Jean Narboni (extracts)," in Jim Hillier, ed., *Cahiers du cinéma: The 1960s—New Wave, New Cinema, Reevaluating Hollywood* (Cambridge: Harvard University Press, 1986), 107.

2. Ib Bondeberg, "Lars von Trier Interview," in Mette Hjort and Ib Bondeberg, eds., *The Danish Directors: Dialogues on a Contemporary National Cinema* (Bristol: Intellect Press, 2001), 222.

3. Elder refers here to a retrospective of Canadian films mounted by the Festival of Festivals (now the Toronto International Film Festival) in 1984. Piers Handling, Peter Harcourt, and Elder were among the programmers of the retrospective.

4. Capital Cost Allowance films were films financed by Canadian investors being able to write off their losses on their investment. Therefore, it was in their best interest for the films to be financial failures.

5. The NPN (National Party of Nigeria) was founded in 1979 and disbanded in 1983.

6. A critique of the policies of particular institutions is a separate question from the personal qualities and professional competence of those institutions' officers. I would like to put on record my thanks to Kate Swan, director, and Ivan Mactaggart, administrator, of the SFPF, who have invariably been friendly, helpful, and efficient in any dealings I have had with them.

CHAPTER 3. THIRD CINEMAS, COLONIALISM, DECOLONIZATION, AND POSTCOLONIALISM

1. The newspapers cited here are all French Montreal newspapers, with the exception of the *Montreal Star,* which is a defunct English-language paper.

2. *Valérie* was the first of the Maple Syrup porn films and a huge hit in Quebec in 1968.

CHAPTER 4. GENDER, FEMINIST, QUEER, SEXUALITY, AND PORN MANIFESTOS

1. Nancy Fraser, "Rethinking the Public Sphere: A Contribution to the Critique of Actually Existing Democracy," in Craig Calhoun, ed., *Habermas and the Public Sphere* (Cambridge, MA: MIT Press, 1992), 109–142, 127.
2. Here Ono is referring to the rise of the director-as-auteur, as well as to the Fluxus-inspired notion that anyone can and should make art, as exemplified in George Maciunas's *Fluxus Manifesto* (1963).
3. After a fashion, Ono has accomplished her goal to make the *Smile* film, through the use of new media. Her *Smile* website and *Smile* app for the iPhone allow anyone (and therefore everyone) to upload their face into her project. See www.smilesfilm.com.

CHAPTER 5. MILITATING HOLLYWOOD

1. Jon Elster, *Ulysses Unbound: Studies in Rationality, Precommitment, and Constraints* (Cambridge: Cambridge University Press, 2000), 229, 232.
2. André Bazin, *What Is Cinema? Essays Selected and Translated by Hugh Gray*, 2 vols. (Berkeley: University of California Press, 1971), 2:172.

CHAPTER 6. THE CREATIVE TREATMENT OF ACTUALITY

1. See François Truffaut, *Hitchcock*, rev ed. (New York: Touchstone, 1983), 238.
2. See, e.g., Tyler Malone, review of *This Is Not a Film, PMc Magazine*, March 2012, http://pmc-mag.com/2012/03/this-is-not-a-film/?full=content; see also Mojtaba Mirtahmasb, "Jafar Panahi's *This Is Not a Film* Press Kit," 2011.
3. John Grierson, "The Documentary Producer," *Cinema Quarterly* 2, no. 1 (1933): 7–9, 8.
4. Georges Duhamel (1884–1966), French author, physician and moralist, became a member of the Académie française in 1935.—Trans.
5. The École chrétienne is a charitable religious institution devoted to educating the children of the poor.—Trans.
6. Vigo uses the phrase *dessiller les yeux*, which means not only "to open someone's eyes (to facts) but also "to undeceive someone."—Trans.
7. The Théâtre du Vieux-Colombier, in Paris, was founded in 1913 by playwright and critic Jacques Copeau in an attempt to revitalize French theater and is now part of la Comédie-Française.
8. *Moana* is the second film by Robert Flaherty (US, 1926), shot in Samoa; *Earth*, by Alexander Dovzhenko (USSR, 1930) is about collectivization in the Ukraine; and *Turksib* (1929) is a Soviet documentary directed by Victor A. Turin about the construction of a train line through central Asia.
9. *Voyage au Congo* was a three-volume "journal" by French explorer Jean-Baptiste Douville, published in 1832, which turned out to be a hoax travelogue.
10. *Chang* is a 1927 quasi documentary about a poor famer in Thailand, directed by Merian C. Cooper and Ernest B. Schoedsack . In the same vein *Rango* is a 1931 quasi-documentary by Schoedsack.

11. H. Bruce Woolfe (1880–1965) was a British director of instructional films; James Anthony Fitzpatrick (1894–1980) was an American director of travel documentaries for the American and UK markets.

12. *Beyond Life* was an early book, from 1919, in the Book of Manuel series, by American fantasist James Branch Cabell.

13. WFD: Wytwórnia Filmów Dokumentalnych, a.k.a. the Documentary Film Production Company.

14. The popular Polish name for this aristocratic townhouse in Krakow's main square is "Pod Krzysztoforami" or literally "Under St. Christopher." Its basement, or underground, was an artistic hub from the 1930s onward.

15. *Polityka* was a popular leftist weekly publication.

16. During this period governmental commissions evaluated different cultural products: movies, books, songs and singers, etc., and these commissions declared whether something was deemed to be "art" or not. This was a common form of censorship. A more severe form would take place when the commissions were used to silence a creator under the pretext of art.

17. This is a reference to the Film School in Łódź. All authors of this manifesto were graduates from the School: Kosiński in 1955, Kieślowski in 1968 (diploma 2 years later), and Zygadło in 1970 (diploma 1976).

CHAPTER 7. STATES, DICTATORSHIPS, THE COMINTERN, AND THEOCRACIES

1. Jean-Pierre Oudart, "Cinema and Suture," *Screen* 18, no. 4 (1977): 35–47, 38.

2. Pope Pius XII, *Humani generis,* in Anne Fremantle, ed., *The Papal Encyclicals in Their Historical Context* (New York: Mentor, 1956), 283–288.

3. Ruhollah Khomeini, *Islam and Revolution: Writings and Declarations of Imam Khomeini,* trans. Hamid Algar (Berkeley, CA: Mizan, 1981), 258.

CHAPTER 8. ARCHIVES, MUSEUMS, FESTIVALS, AND CINEMATHEQUES

1. François Truffaut, foreword to *A Passion for Films: Henri Langlois and the Cinémathèque Française,* by Richard Roud (New York: Viking, 1983), xiii.

2. Jean-Luc Godard, *Godard on Godard,* trans. and ed. Tom Milne (1968; New York: Da Capo, 1986), 236.

3. François Truffaut, quoted in Glenn Myrent and Georges P. Langlois, *Henri Langlois: First Citizen of Cinema* (New York: Twayne, 1995), 244.

4. Quoted in ibid., 245.

5. Penelope Houston, *Keepers of the Frame: The Film Archives* (London: BFI, 1994), 114–115.

6. Bossin is referring to the National Film Board of Canada / Office National du film, founded in 1939 by John Grierson.

7. The CPR is the Canadian Pacific Railway. F. Guy Bradford immigrated to Canada in 1903. He then started London Bioscope, a traveling company that screened local and imported films.

8. Unfortunately, most of Léo-Ernest Ouimet's (1877–1972) films were already destroyed by the time Bossin wrote this piece. Ouimet burned most of them when he left the film business.

CHAPTER 10. THE DIGITAL REVOLUTION

1. Janine Marchessault and Susan Lord, eds., *Fluid Screens, Expanded Cinema* (Toronto: University of Toronto Press, 2007), 5.
2. In 2003, fifteen hundred Philippine pesos equaled USD 27.78; three pesos was less than two cents.

CHAPTER 11. AESTHETICS AND THE FUTURES OF THE CINEMA

1. Susan Sontag, "A Century of Cinema" (1995), in *Where the Stress Falls* (New York: Picador, 2002), 117–122, 117, 122 (subsequent citations of this source are given parenthetically in the text).

APPENDIX. WHAT IS A "MANIFESTO FILM"?

1. Originally this book was going to include transcripts of the voice-overs of various films, such as Isou's *Traité de bave et d'éternité* and Debord's *Critique de la séparation*, as instantiations of film manifestos. Yet this seemed wrong, given that the text in question would be separated from the images.
2. See Michel Marie, "Let's Sing It One More Time: René Clair's *Sous le toits de Paris* (1930)," in Susan Hayward and Ginette Vincendeau, eds., *French Cinema: Texts and Contexts* (London: Routledge, 1990), 53.
3. Louis Bayman, "The Earth Trembles," in Louis Bayman, ed., *Directory of World Cinema: Italy* (Chicago: University of Chicago Press/Intellect, 2011), 64–66, 65.
4. See Yves Lever, *Le cinéma de la révolution tranquille de Panoramique à Valérie* (Montréal: Bibliothèque nationale du Québec, 1991), 32.
5. Christian Metz, "Mirror Construction in Fellini's *8½*," in *Film Language: A Semiotics of the Cinema* (New York: Oxford University Press, 1974), 232 (emphasis in the original).
6. Keewatin A. Dewdney, "Discontinuous Films," *Canadian Journal of Film Studies* 10, no. 1 (2001): 96–105 (reprinted in chapter 1 of this volume).
7. Laura Mulvey, "The Oedipus Myth: Beyond *Riddles of the Sphinx*," *Public* 2 (1988): 19–43, 19.

ACKNOWLEDGMENTS OF PERMISSIONS

Permission to reproduce in this volume the following materials has been graciously granted by the publishers, organizations, individuals, and others listed below. Works are listed here in the order that they appear in this volume.

1. THE AVANT-GARDE(S)

Vladimir Ilyich Lenin, "Lenin Decree" with permission of Elena Pinto Simon.

Blaise Cendrars, "The ABCs of Cinema" with permission of Esther Allen and Monique Chefdor.

Dziga Vertov, "WE: Variant of a Manifesto" with permission of Elena Pinto Simon.

Sergei Eisenstein, "The Method of Making Workers' Films" with permission of Elena Pinto Simon.

The Surrealist Group, "Manifesto of the Surrealists Concerning *L'Age d'or*" with permission of the BFI.

Le Corbusier, "Spirit of Truth" with permission of Richard Abel.

László Moholy-Nagy, "An Open Letter to the Film Industry and to All Who Are Interested in the Evolution of the Good Film" with permission of the BFI.

Maya Deren, "A Statement of Principles" from *Film Culture*, courtesy of Anthology Film Archives. All Rights Reserved.

New American Cinema Group, "The First Statement of the New American Cinema Group," from *Film Culture* courtesy of Anthology Film Archives. All Rights Reserved.

Ron Rice, "Foundation for the Invention and Creation of Absurd Movies" from *Film Culture* courtesy of Anthology Film Archives. All Rights Reserved.

Stan Brakhage, "From *Metaphors on Vision*" with permission of Marylin Brakhage.

Takahiko Iimura, Koichiro Ishizaki, et al., "Film Andepandan [Independents] Manifesto" with permission of Takahiko Iimura.

Arthur Cantrill and Corinne Cantrill, "Cinema Manifesto" with permission of Arthur Cantrill.

Hollis Frampton, "For a Metahistory of Film: Commonplace Notes and Hypotheses" with permission of Marion Faller.

Gregory Markopoulos, "Elements of the Void" with permission of Robert Beavers.

JoAnn Elam and Chuck Kleinhans, "Small Gauge Manifesto" with permission of Chuck Kleinhans.

Nick Zedd, "Cinema of Transgression Manifesto" with permission of Nick Zedd.

Keith Sanborn, "Modern, All Too Modern" with permission of Keith Sanborn, © Keith Sanborn, all rights reserved.

Jonas Mekas, "Anti-100 Years of Cinema Manifesto" courtesy of Jonas Mekas. All Rights Reserved.

Jan Švankmajer, "The Decalogue" with permission of ATHANOR.

Philip Hoffman, "Your Film Farm Manifesto on Process Cinema" with permission of Philip Hoffman.

2. NATIONAL AND TRANSNATIONAL CINEMAS

Octavio Paz, "Buñuel the Poet" with permission of Michael Schmidt.

Cesare Zavattini, "Some Ideas on the Cinema" with permission of the BFI.

Juan Antonio Bardem, "Salamanca Manifesto & Conclusions of the Congress of Salamanca" with permission of the BFI.

Alexander Kluge, Edgar Reitz, et al., "The Oberhausen Manifesto" with permission of Eric Rentschler.

Joseph von Sternberg, Alexander Kluge, et al., "The Mannheim Declaration" with permission of Eric Rentschler.

Manuel Revuelta, Antonio Artero, Joachin Jordà, and Julián Marcos, "Sitges Manifesto" with permission of the BFI.

Thierry Derocles, Michel Demoule, Claude Chabrol, and Marin Karmitz, "From "The Estates General of the French Cinema, May 1968"" courtesy the John Logie Baird Centre.

Rainer Werner Fassbinder, Werner Herzog, Wim Wenders, et al., "Hamburg Declaration of German Filmmakers" with permission of Eric Rentschler.

Lars Von Trier, "Manifesto I" with permission of Zentropa.

Lars Von Trier, "Manifesto II" with permission of Zentropa.

Lars Von Trier, "Manifesto III: I Confess!" with permission of Zentropa.

R. Bruce Elder, "The Cinema We Need" with permission of R. Bruce Elder.

Young DEFA Filmmakers, "Manifesto of 1988" with permission of Roger P. Minert.

Colin McArthur, "In Praise of a Poor Cinema" with permission of the BFI.

Lars Von Trier and Thomas Vingerberg, "Dogme '95 Manifesto and Vow of Chastity" with permission of Zentropa.

Dimas Djayadinigrat, Enison Sinaro, et al., "I Sinema Manifesto" with permission of Dimas Djayadinigrat.

3. THIRD CINEMAS, COLONIALISM, DECOLONIZATION, AND POSTCOLONIALISM

Fernando Birri, "Cinema and Underdevelopment" with permission of Michael Chanan.

Glauber Rocha, "The Aesthetics of Hunger" with permission of Michael Chanan.

Julio García Espinosa, "For an Imperfect Cinema" with permission of *Jump Cut*.

Fernando Solanas and Octavio Getino, "Towards a Third Cinema: Notes and Experiences for the Development of a Cinema of Liberation in the Third World" with permission of Michael Chanan.

Comité de cine de la unidad popular, "Film Makers and the Popular Government Political Manifesto" with permission of Michael Chanan.

Mario Handler, "Consciousness of a Need" with permission of Zuzana M. Pick.

Octavio Getino and Fernando Solanas, "Militant Cinema: An Internal Category of Third Cinema" with permission of Jonathan Buchsbaum.

Carlos Alvarez, "For Colombia 1971: Militancy and Cinema" with permission of Zuzana M. Pick.

Association professionnelle des cineastes du Québec, "The Cinema: Another Face of Colonised Québec" with permission of *Cineaste*.

Jaime Humberto Hermosillo, Arturo Ripstein, Paul Leduc, et al., "8 Millimeters versus 8 Millions" with permission of *Wide Angle*.

Palestinian Cinema Group, "Manifesto of the Palestinian Cinema Group" with permission of *Cineaste*.

Carlos Diegues, Glauber Rocha, et al., "The Luz e Ação Manifesto" with permission of Robert Stam.

Jorge Sanjinés, "Problems of Form and Content in Revolutionary Cinema" with permission of Michael Chanan.

Nicaraguan Institute of Cinema, "Declaration of Principles and Goals of the Nicaraguan Institute of Cinema" with permission of Jonathan Buchsbaum.

John Akromfrah, "Black Independent Filmmaking: A Statement by the Black Audio Film Collective" with permission of John Akomfrah.

Fernando Birri, "From *Birth Certificate of the International School of Cinema and Television in San Antonio de Los Baños, Cuba, Nicknamed the School of Three Worlds*" with permission of Fernando Birri.

Sandra Peña-Sarmiento, "Pocha Manifesto #1" with permission of Sandra Peña-Sarmiento and *Jump Cut*.

4. GENDER, FEMINIST, QUEER, SEXUALITY, AND PORN MANIFESTOS

Jack Smith, "The Perfect Filmic Appositeness of Maria Montez" from *Film Culture* courtesy of Anthology Film Archives. All Rights Reserved.

Claire Johnston, "Women's Cinema as Counter-Cinema" courtesy the John Logie Baird Centre.

Laura Mulvey, "Visual Pleasure and Narrative Cinema" courtesy the John Logie Baird Centre.

Vilgot Sjöman, "An Egret in the Porno Swamp: Notes of Sex in the Cinema" with permission of *Cineaste*.

Verband der Filmarbeiterinnen, "Manifesto of the Women Filmmakers" with permission of Eric Rentschler.

Yvonne Rainer, "Thoughts on Women's Cinema: Eating Words, Voicing Struggles" with permission of Yvonne Rainer.

Vibeke Windeløv, Lene Børglum, et al., "Puzzy Power Manifesto: Thoughts on Women and Pornography" with permission of Zentropa.

Todd Verow, "No More Mr. Nice Gay: A Manifesto" with permission of Todd Verow.

5. MILITATING HOLLYWOOD

Manny Farber, "White Elephant Art vs. Termite Art" from *Film Culture* courtesy of Anthology Film Archives. All Rights Reserved.

6. THE CREATIVE TREATMENT OF ACTUALITY

Jean Vigo, "Towards a Social Cinema" with permission of Stuart Liebman.

New York Newsreel, "Initial Statement of the Newsreel" with permission of Third World Newsreel.

Kidlat Tahimik, Stephen Teo, et al., "The Asian Filmmakers at Yamagata YIDFF Manifesto" with permission of YIDFF.

Lars Von Trier, "Defocus Manifesto" with permission of Zentropa.

Jill Godmilow, "Kill the Documentary as We Know It" with permission of Jill Godmilow.

Jay Ruby, "Ethnographic Cinema (EC): A Manifesto/A Provocation" with permission of Jay Ruby.

Vitaly Manskiy, "Reality Cinema Manifesto" with permission of Vitaly Manskiy.

Several documentary filmmakers, "China Independent Film Festival Manifesto: Shamans * Animals" with permission of Shelly Kraicer.

8. ARCHIVES, MUSEUMS, FESTIVALS, AND CINEMATHEQUES

Joris Ivens, Henrik Scholte, Men'no Ter Bbaak, et al., "Filmliga Manifesto" with permission of the Joris Ivens Foundation.

Jonas Mekas, "Open Letter to Film-Makers of the World" courtesy of Jonas Mekas. All Rights Reserved.

Hollis Frampton, Ken Jacobs, and Michael Snow, "Filmmakers versus the Museum of Modern Art" with permission of Michael Snow.

P. Adams Sitney, "Anthology Film Archives Manifesto" from *Film Culture* courtesy of Anthology Film Archives. All Rights Reserved.

Alan Lomax, "Toward an Ethnographic Film Archive" with permission of Odyssey Productions.

Scott Miller Berry and Stephen Kent Jusick, "Brooklyn Babylon Cinema Manifesto" with permission of Scott Miller Berry.

Paolo Cherchi Usai, "The Lindgren Manifesto: The Film Curator of the Future" with permission of Paolo Cherchi Usai.

Mark Cousins, "Film Festival Form: A Manifesto" with permission of Mark Cousins.

9. SOUNDS AND SILENCE

Charlie Chaplin, "A Rejection of the Talkies" with permission of Roy Export.

Michelangelo Antonioni, Bernardo Bertolucci, Pier Paolo Pasolini, et al., "Amalfi Manifesto" with permission of the BFI.

10. THE DIGITAL REVOLUTION

Stan VanDerBeek, "Culture: Intercom and Expanded Cinema: A Proposal and Manifesto" from *Film Culture* courtesy of Anthology Film Archives. All Rights Reserved.

Khavn de la Cruz, "Digital Dekalogo: A Manifesto for a Filmless Philippines" with permission of Khavn de la Cruz.

11. AESTHETICS AND THE FUTURES OF THE CINEMA

Alexandre Astruc, "The Birth of a New Avant Garde: *La caméra-stylo*" with permission of the BFI.

Ingmar Bergman, "The Snakeskin" with permission of the Ingmar Bergman Foundation.

Rob Nilsson, "Direct Action Cinema Manifesto" with permission of Rob Nilsson.

Jesse Richards, "Remodernist Film Manifesto" with permission of Jesse Richards.

Jia Zhangke, "The Age of Amateur Cinema Will Return" with permission of Kevin B. Lee and dGenerate Films.

INDEX